SECOND EDITION

A Legal Primer on Managing Museum Collections

Marie C. Malaro

SMITHSONIAN INSTITUTION PRESS

Washington and London

Copy editor: D. Teddy Diggs
Production editor: Ruth G. Thomson
Designer: Janice Wheeler

Library of Congress Cataloging-in-Publication Data
Malaro, Marie C.
 A legal primer on managing museum collections / Marie C. Malaro. — 2nd ed.
 p. cm.
 Includes bibliographical references and index.
 ISBN 1-56098-762-6 (cloth : alk. paper). — ISBN 1-56098-787-1 (paper : alk. paper)
 1. Museums—Law and legislation—United States. I. Title.
 KF4305.M35 1998
 344.73.′093—dc21 97-11780

British Library Cataloguing-in-Publication Data available

Manufactured in the United States of America
05 04 03 02 01 00 99 98 5 4 3 2 1

⊗ The paper used in this publication meets the minimum requirements of the American National Standard for Information Sciences—Permanence of Paper for Printed Library Materials ANSI Z39.48–1984.

Contents

Figures

Preface

For a number of years, the Smithsonian Institution, with the cooperation of the American Association of Museums, has joined with the American Law Institute–American Bar Association (ALI-ABA) Committee on Continuing Professional Education to present an annual course of study entitled "Legal Problems of Museum Administration." The purpose of the course is to highlight current legal issues that have relevance for the museum community. These issues are numerous, varied, and often complex. Frequently, the more experienced professionals attending the course express dismay at the amount of material that has to be digested, so pity the novice who leaves with bulging briefcase and glazed eyes. Where to begin? How to survive? This book, like the original 1985 edition, draws on my experience as a frequent lecturer at the ALI-ABA seminars, as a legal adviser for a major museum complex, and as the director of a graduate program in museum studies.

The book was written with particular purposes in mind. First of all, it is for the "novice," whether he or she is the attorney who is occasionally called on to advise a museum or the new museum staff member or trustee who must wrestle with a myriad of administrative problems without the benefit of constant professional advice. For the nonlawyer, issues are explained simply, without heavy reliance on legal terminology. The objective is to give sufficient background information so that intelligent decisions can be made regarding the appropriate time to call legal counsel. The information contained in the book should not be considered legal advice or relied on as such. For the lawyer, there are case citations and references to legal texts and articles, which may aid in researching particular problems. Much of this legal reference material has been placed in footnotes. Footnotes are a necessary evil in any text that deals with the law. It is possible to state a legal principle or issue simply; the difficulty usually lies in applying that principle or issue to the situation at hand. Footnotes in close proximity to the text serve the lawyer, but they also remind the nonlawyer that invariably there are many "ifs" and "buts" to consider when making a legal judgment.

Second, the book focuses on collection-related issues. "Legal Problems of Museum Ad-

ministration" can cover such varied topics as employee benefit plans, postal regulations, and stock loan programs, but information on these topics is available in many publications devoted to nonprofit organizations. Collections, on the other hand, are unique to museums. To keep this volume within reasonable limits, I have emphasized the legal problems associated with this distinctive feature.

Third, the book was written with an eye toward prevention. The best way to avoid legal entanglements is to think before acting. One must understand the obligations, the limits of authority, and the possible consequences of contemplated actions. Rather than offer a first-aid manual that lists instructions on how to handle each emergency situation, this text strives to encourage a thoughtful and well-informed approach to museum administration so that the patient can stay healthy. The book should be read with this in mind.

When I began writing the first edition of this book years ago, I had every intention of striving for objectivity and of concentrating on legal principles as they may relate to collection management issues in museums. This approach was not strictly adhered to in the first edition, and I purposefully set it aside for this revised edition. Experience has demonstrated that many collection-related legal problems have no simple solutions, and once they have occurred, a museum has locked itself into painful expenditures of time and resources that could have been avoided. If the objective is to prevent such occurrences, a knowledge of legal ramifications must shape the way a museum approaches its collecting activity. In other words, legal advice is used most effectively in the policy-making process so that long-term consequences of actions can be considered before policy is established. Thus, I frequently drift into policy areas, and there is a bit of preaching here and there. Also, issues of particular interest to me receive more expansive treatment. Read the book, therefore, as one lawyer's viewpoint on issues associated with collection management, and by all means, feel free to disagree. Any issue of consequence deserves spirited debate.

Acknowledgments

In revising this book, I am again greatly indebted to many of my professional colleagues who generously answered questions or provided background material. Certain individuals deserve particular mention. Ildiko DeAngelis, an attorney for the Smithsonian Institution, was a source of constant legal advice, and the sections on copyright and associated rights are essentially her work. Mildred Glover, another Smithsonian attorney, gave generously of her time in reviewing the manuscript. And special recognition is due Bonnie Morgan, who has served as my legal assistant for all published books. I truly could not do without her.

Introduction

Over the last three decades, museums have moved into the limelight, and they have found that being on stage can be challenging, exhilarating, and all too often, frustrating. What was once a rather uncomplicated and exclusive domain has now become an administrator's nightmare.

It was rare, years ago, for anyone to question the caliber or form of governance in a museum. This is no longer the case today. As a more educated and affluent society discovers its local museums, there are cries for openness, participation, and change. Objects that once passed silently in and out of museum collections are now the subject of national and international debate. Artists are more vocal, and emerging groups of university-trained museum professionals are questioning traditional practices. One can add to this mix baffling copyright issues, more convoluted tax laws, and ever-growing governmental regulations. What legal problems could a museum have today? Perhaps it is more realistic to ask, "Where does one begin?"

Properly used, the law provides a means for freedom, for expression, and for growth. Consider, for instance, the familiar traffic light. This is a simple example of the law in action. By setting in motion a prescribed order, the traffic light permits us to proceed with assurance from point to point simply because, through the mechanism of the law, we have determined in advance who will have the right-of-way. It is this positive function of the law that can so benefit the museum profession. When doubt and confusion reign, it is time to learn the rules of the road. Only when the rules are known can one plan a course of action and travel with some confidence through unfamiliar and hazardous territory.

To use the law in this positive way, one must start with some very basic knowledge. Legal controversies have as many shades as an artist's palette; unless certain legal principles are understood, there is little chance that real or potential problems will be spotted in a timely manner. Even more important, without a comfortable knowledge of the fundamental rights and obligations involved in museum administration, one is ill-equipped to take preventive

measures so that legal controversies are avoided. Accordingly, this book is arranged as follows. First, the legal nature of a museum is examined, as well as the various consequences that flow from this status. Discussed are the responsibilities placed on the board members of a museum, the privileges enjoyed by a museum, and the obligations imposed. Next, entities that may be able to question the quality of governance in a museum are examined. These range from the state attorney general to the local citizens' group. The balance, and major portion, of the book discusses particular collection-related problems that have legal overtones. Because the emphasis is on prevention, this portion of the text begins with a section on collection management policies. Such policies are suggested as a practical method for ensuring a comprehensive approach to the many issues that affect collection management. The format for such a policy is then used to discuss individual issues as they relate to accessions, deaccessions, loans, and so forth.

Museum professionals are urged to use the text as a checklist for assessing the well-being of their organization's collection-related practices. If read from cover to cover, the book highlights most issues that, if addressed early and objectively, foster good management and a dedication to excellence. For those museums that have collection management policies, the text can be a useful tool for review; for museums without collection management policies, it offers a framework on which to build.

It should be remembered that this text focuses on legal aspects of collection management and does not elaborate on ethical and professional standards. A museum that strives only to satisfy the law aims low. The melding of sound legal concepts with thoughtfully adopted ethical and professional standards will produce policies designed to foster excellence and public confidence.

Footnote Abbreviations and Citations

Below is a list of frequently cited abbreviations, followed by an explanation of the sequence used in citing articles, books, cases, and other reference materials.

Abbreviations

COMPILATIONS OF STATUTES AND REGULATIONS

Am. Jur. 2d	*American Jurisprudence Second* (a general legal encyclopedia)
C.J.S.	*Corpus Juris Secundum* (a general legal encyclopedia)
★C.F.R.	*Code of Federal Regulations* (a subject-matter/agency-matter compilation of federal regulations)
★Fed. Reg.	*Federal Register* (the daily publication of the federal government; contains new and proposed federal regulations and notices of other current federal agency business)
★Stat.	*Statutes at Large* (a chronological compilation of U.S. statutes)
★U.S.C.	*United States Code* (the official publication of U.S. statutes, organized by subject matter)

CASE REPORTER NAMES

The following regional reporters of state court decisions are published by the West Company, St. Paul, Minnesota. The "2d" after the initial(s) of the reporter means "second series." In addition, many states have their own reporter system for decisions. The titles of these reporter systems usually contain the name of the state.

A.	*Atlantic Reporter*
N.E.	*North Eastern Reporter*

★Published by the U.S. Government Printing Office in Washington, D.C.

N.W.	*North Western Reporter*
P.	*Pacific Reporter*
S.E.	*South Eastern Reporter*
So.	*Southern Reporter*
S.W.	*South Western Reporter*

Official reporters of decisions made by federal courts follow. These are published by the U.S. Government Printing Office.

F.	*Federal Reporter* (reports decisions of the U.S. courts of appeals)
F. Supp.	*Federal Supplement* (reports decisions of the federal district courts)
U.S.	*Supreme Court Reporter* (reports decisions of the U.S. Supreme Court)

Other reporters of U.S. Supreme Court decisions are the following:

| S. Ct. | *Supreme Court Reporter* (a West Company publication) |
| L.Ed. | *Lawyer's Edition* (a Lawyer's Cooperative publication) |

Citations

ARTICLES

First Initial and Surname of Author, "Article Name," volume number, *Journal Name* beginning page number (issue number, date).

BOOKS

First Initial and Surname of Author or Editor, *Book Title* (Place of publication: Publisher, Year of publication).

CASES

Name of Case, volume number / Name of Reporter / beginning page number (court if not known through reporter, year of decision).

U.S.C. OR C.F.R.

Title number / U.S.C. or C.F.R. / section or part number.

FED. REG. OR STAT.

Volume number / *Fed. Reg.* or Stat. / beginning page number.

When another number appears after the beginning page number, this number is the page from which the material was actually taken.

For copies of frequently cited articles from publications of the American Law Institute–American Bar Association, write to ALI-ABA Committee on Continuing Professional Education, 4025 Chestnut Street, Philadelphia, PA 19104.

PART ONE

The Museum

What Is a Museum?
What Is Required of Its Board Members?

A. Museum Defined

A *museum* can be defined as "a public or private nonprofit agency or institution organized on a permanent basis for essentially educational or aesthetic purposes which, utilizing a professional staff, owns or utilizes tangible objects, cares for them, and exhibits them to the public on a regular basis."[1] For the purposes of this text, the words "public" and "private" need some clarification. Each of these terms is subject to various interpretations. For ex-

1. Definition used in Museum Services Act, 20 U.S.C. § 968(4). See 45 C.F.R. pt. 1180 for amplification of the scope of this definition. An "art museum" in the traditional sense is defined by the Association of Art Museum Directors as "a permanent, nonprofit institution, essentially educational and humanistic in purpose, which owns, studies, and cares for works of art, and on some regular schedule exhibits and interprets them to the public. The definition of the art museum has been extended to include institutions that do not have collections but whose mission is nonetheless primarily dedicated to exhibitions and related programs." Association of Art Museum Directors, *Professional Practices in Art Museums* (New York: Association of Art Museum Directors, 1991, amended 1992). The word *museum*, it is claimed, first referred to the "temple of the muses," built by Ptolemy in A.D. 2 in Alexandria, where performances of music, dance, and poetry took place at a site adjoining a library and collection of antiquities. See B. Robertson, "The Museum and the Democratic Fallacy," *Art in America* 58

ample, a museum can be classified as "private" if it was incorporated by private initiative and if most of its support comes from the private sector. That same museum, however, may be "public" in the sense that it is an institution open to the public and dedicated to a public purpose. Similarly, a museum that was established through private philanthropy but that receives substantial subsidies from the government can fall into either category. A museum can be chartered by the legislature of a government and yet still be "private" in the sense that it is not a part of that government. (It is common to find philanthropic organizations specifically chartered by legislative enactments.) Every museum, however, is in the business of managing collection objects for the benefit of the public, and when questions concern this unique aspect of their work, all museums, whether "public" or "private," share common problems.[2] The observations made in this book, therefore, should have relevance for all museums, irrespective of the "public" or "private" designation. Museums that are not autonomous (they do not report directly to their own governing boards because, for example, they are part of governmental units or larger educational organizations) do have more complex problems in the area of governance. But sorting out appropriate lines of authority and articulating policies for such museums still require a grasp of principles applicable to general museum operation.[3] Also, zoos, botanical gardens, and the like may have unique problems because of the nature of their collections, but the essentials of good collection management (articulation of a collection philosophy, clear delegation of authority, and procedures for record-keeping and accountability) are still germane.[4]

Most museums can be classified as charitable corporations. For ease of discussion, this term will generally be used here. For lawyers, I should note that this simplification is not made casually. Within different states and to varying degrees, distinctions are made between

(July–Aug. 1971). For the evolution of the American Association of Museums' definition of "museum," see K. Starr, "In Defense of Accreditation," *Museum News* 5 (Jan.–Feb. 1982). For texts that describe the history and practices of museums, see E. Alexander, *Museums in Motion: An Introduction to the History and Functions of Museums* (Walnut Creek, Calif.: Published for the American Association of Museums by Alta Mira Press, 1996), and G. Burcaw, *Introduction to Museum Work,* 2d ed. (Walnut Creek, Calif.: Alta Mira Press, 1995).

2. Professor Milton Katz of Harvard Law School describes a museum as "a privately organized public institution." He explains that a museum is public in the sense that it devotes all its resources to educational purposes and none to the pecuniary advantage of any person (other than compensation for services rendered). A museum is private because it is nongovernmental and derives its resources from gifts by private donors. J. Nason, *Trustees and the Future of Foundations* (New York: Council on Foundations, 1977), 10–11.

3. *Museum News* (Jan.–Feb. 1980) has several articles on special problems of university museums: M. King, "University Museums Staffs: Whom Do They Serve?"; B. Waller, "Museums in the Grove of Academe"; and M. Christison, "Professional Practices in University Art Museums." The Southern Arts Federation published *Trustee Handbook* (1977), which discusses the lines of authority in a state- or city-owned museum, and Association of Art Museum Directors, *Professional Practices in Art Museums* (New York: Association of Art Museum Directors, 1981, amended 1992), addresses—in Article 67 and Appendix C—"University and College Museums." See also A. Ullberg, "Selected Materials on the Public/Private Museum: Who's in Charge of What?" in American Law Institute–American Bar Association (ALI-ABA), *Course of Studies Materials: Legal Problems of Museum Administration* (Philadelphia: ALI-ABA, 1992). Another source of information is the Association of College and University Museums. The address of this professional organization can be found in the current issue of *The Official Museum Directory,* a publication of the American Association of Museums, Washington, D.C.

4. See, for example, J. Luoma, "Prison or Ark?" 84 *Audubon* 102 (No. 6, Nov. 1982).

charitable corporations and charitable trusts. The law of the locality should always be checked in this regard, but when cases concern the quality of governance in museums, courts do not seem overly concerned with this distinction. One surrogate's court in New York, a court that usually oversees the management of trusts, argued that the museum involved in the case before it was not a true trust:

The term "trust" used by the lawyers and the courts, in addition to its classic usage, encompasses a variety of fiduciary relationships. . . . As a legal concept it is not readily susceptible to a precise definition.

. . . .

Those who are charged with the responsibility of operating the museum have fiduciary responsibilities with regard to the proper utilization of the property and funds conveyed to them . . . even assuming *arguendo,* that there is not a trust in the literal sense. A fiduciary is legally accountable for his stewardship. . . . This publicly aired controversy has only served to create doubt in the minds of the people . . . as to whether the . . . Museum is being efficaciously operated and administered in accordance with the testamentary wishes of its benefactors. It would, therefore, be in the public interest for the Surrogate to entertain the proceedings in question and conduct an appropriate inquiry as to the validity of these charges.[5]

A charitable corporation, true to its name, is an organization established in a corporate form for the purpose of pursuing a charitable purpose or purposes.[6] From the legal standpoint, a charitable corporation is a hybrid still in the process of development, with attributes of both trust organizations and business corporations. Therefore, understanding the traditional or

5. *In re Estate of Vanderbilt,* 109 Misc. 2d 914, 441 N.Y.S.2d 153 (Sur. Ct. 1981), 157. Usually a museum is established in a corporate form under its state's procedures for the formation of nonprofit corporations. (A nonprofit corporation can make money, but once legitimate expenses are paid, any profit must be used to further the purposes of the organization.) If a museum is not incorporated, it will probably be classified as a charitable trust. For the purposes of the subject matter of this text, observations made concerning charitable corporations will usually apply to charitable trusts. The rather tortured distinctions sometimes made by courts between charitable trusts and charitable corporations appear to be more form than substance when applied to collection-related issues. See A. Scott, *The Law of Trusts* § 348, 3d ed. (Boston: Little Brown and Co., 1967) [hereafter *Scott on Trusts* (3d ed.)]; T. Blackwell, "The Charitable Corporation and the Charitable Trust," 24 *Wash. U. L.Q.* 1 (1938); K. Karst, "The Efficiency of the Charitable Dollar: Unfulfilled State Responsibility," 73 *Harv. L. Rev.* 433 (1960); Note, "The Charitable Corporation," 64 *Harv. L. Rev.* 1168 (1951); *Holt v. College of Osteopathic Physicians and Surgeons,* 61 Cal. 2d 750, 40 Cal. Rptr. 244, 394 P.2d 932 (1964); *Lynch v. Spilman,* 67 Cal. 2d 251, 62 Cal. Rptr. 12, 431 P.2d 636 (1967). In many such cases, the real issue is the degree of oversight that should be exerted by the courts. See, for example, the *Corporation of Mercer University v. Smith,* 258 Ga. 509, 371 S.E.2d 858, 1988 Ga. LEXIS 379 (1988).

6. The term "charity" is defined quite broadly in the law. As stated by Professor G. Bogert, a noted authority on the law of trusts, "to the non-legal mind the word [*charity*] often means 'almsgiving' or 'liberality to the poor,' or 'that which is given to relieve the needy'; whereas in the law the word has a much broader meaning and includes a large number of other acts working toward the social welfare." G. Bogert, *The Law of Trusts and Trustees,* rev. 2d ed., § 369 (St. Paul, Minn.: West Pub. Co., 1977). See also *Restatement (Second) of Trusts* § 368 (St. Paul, Minn.: American Law Institute, 1987); *People ex rel. Scott v. George F. Harding Museum,* 58 Ill. App. 3d 408, 374 N.E.2d 756 (1st Dist. 1978) (this case held that a museum fell within the purview of Illinois'

common-law concept of a "trust," and how a traditional trust differs from a business corporation, can lead to an appreciation of the present legal status of the charitable corporation.

B. A Trust

Essentially, a trust is a fiduciary relationship whereby a party (known as a *trustee*) holds property that must be administered for the benefit of others (known as the *beneficiaries*). A trustee, even though he or she has legal title to trust property, may not use that property for personal purposes but may use trust assets only for the benefit of the individual or group that is the beneficiary of the trust and in accordance with the terms of the trust instrument.[7]

In its pure form, a trust relationship imposes a very high degree of responsibility on the trustee. The trustee is charged with affirmative duties to protect, preserve, and increase the trust assets. At a minimum, the trustee must exercise the skill and care of a person of ordinary prudence in carrying out these functions, but if the trustee possesses a greater skill, then more exacting standards are required.[8] Nor can a trustee blame personal inadequacies on the conduct of a fellow trustee: "The principle of contributory or comparative fault or neglect as between co-trustees plays no role in measuring the proper discharge of the high duty imposed by law on each trustee. . . . [It is] incumbent upon each to comply with the fiduciary standards required of a trustee irrespective of the default of the other."[9]

Trustees also have a strict responsibility not to self-deal with trust assets. In other words, trustees must go to great pains to see that they do not personally benefit from the trustee role. To put it rather graphically, trustees must step out of their everyday role, leaving personal ambitions aside, and step into the trustee role, diligently pursuing the interests of the trust for the good of the trust beneficiaries. The responsibility not to self-deal is based on the trustee's duty of loyalty, "the most fundamental duty owed by the trustee to the beneficiaries."[10] This duty is deemed breached, for example, even when the trustee, acting in good

Charitable Trust Act); 12 A.L.R.2d 849, § 9 (an extensive annotation on the validity of trusts created for the dissemination and preservation of material of historic or educational interest); *Richardson v. Essex Institute,* 208 Mass. 311, 94 N.E. 262 (1911) (the trust for the preservation of a historic house was held to be a public charity).

7. The expression "terms of the trust" is usually interpreted in the broad sense: "[I]t is not limited to express provisions of the trust instrument, but includes whatever may be gathered as to the intention of the settlor [the creator of the trust] from the trust instrument as interpreted in the light of all the circumstances, and any other indication of the intention of the settlor which is admissible in evidence." *Scott on Trusts* § 186 (3d ed.). See also *Restatement (Second) of Trusts* § 186; *Attorney General v. President and Fellows of Harvard College,* 350 Mass. 125, 213 N.E.2d 840 (1966).

8. *Scott on Trusts* §§ 174, 176, 181 (3d ed.). See also *In re Estate of Lohm,* 440 Pa. 268, 269 A.2d 451 (1970); *In re Mendenhall,* 484 Pa. 77, 398 A.2d 951 (1979); *Manchester Band of Pomo Indians, Inc. v. U.S.,* 363 F. Supp. 1238 (N.D. Cal. 1973); *Zehner v. Alexander,* 89 (Penn. 39th Jud. Dist., Franklin County, Ct. of C.P., Orphans' Ct. Div.) 262 (May 25, 1979) (also known as the *Wilson College* case).

9. *Henley v. Birmingham Trust Nat'l Bank,* 295 Ala. 38, 322 So.2d 688, 693 (1975).

10. *Scott on Trusts* § 170 (3d ed.).

faith, purchases trust property for personal use and pays fair consideration.[11] A prudent trustee, therefore, avoids even the appearance of a conflict of interest.[12]

The trustee also has a duty to be obedient to the terms of the trust. This requires faithfully carrying out the purposes of the trust. The main reason for establishing a trust situation is to ensure the performance of articulated trust purposes. "What more formidable cause of action could exist than the assertion that the trustees are failing to carry out the mandates of the indenture under which they operate?"[13]

In addition to the duties of care, loyalty, and obedience, trust law also imposes limitations on the ability to delegate. This is interpreted to mean that a trustee cannot delegate to others tasks that the trustee reasonably can be required to perform.[14] Clearly, the trustee cannot delegate to another, even to a cotrustee, the entire administration of the trust, but under certain circumstances, the authority to perform specific acts may be delegated.[15] The following are relevant considerations when deciding on the propriety of a delegation to perform specific acts:

1. How much discretion is involved?
2. What are the value and the character of the property involved?
3. Is the act one that requires a special skill not possessed by the trustee?

When there has been a proper delegation to a cotrustee or other person, the trustee still must exercise general supervision over the conduct of that individual.[16]

The above clearly shows that the standard of conduct required of a traditional trustee is quite exacting. Trustees must give serious attention to their duties, must be aggressive in pursuing the interests of the beneficiaries in accordance with trust purposes, must be ex-

11. *Restatement (Second) of Trusts* § 170 (1959). Some states have laws that specifically forbid such self-dealing. If a trustee makes a full disclosure to the beneficiaries and purchases with their consent, possibly a sale of this nature would survive challenge.

12. An interesting case on the fiduciary duty not to self-deal is *In re Estate of Rothko,* 43 N.Y. 2d 305, 401 N.Y.S.2d 449, 372 N.E.2d 291 (1977), on remand, *In re Estate of Rothko,* 95 Misc. 2d 492, 407 N.Y.S.2d 954 (1978). In this case, the executors (fiduciaries) of Mark Rothko's estate were removed and surcharged for engaging or acquiescing in estate transactions that were tainted by self-interest. One of the executors was an officer in an art gallery that was retained to dispose of estate assets. Another executor was an artist who signed, with the same art gallery, a favorable agency agreement of his own after the estate transaction was consummated.

13. *Commonwealth v. Barnes Foundation,* 398 Pa. 458, 159 A.2d 500, 505 (1960).

14. *Winthrop v. Attorney General,* 128 Mass. 258 (1880); *Harvard College v. Attorney General,* 228 Mass. 396, 117 N.E. 903 (1917).

15. Nor can a cotrustee assume joint trustee power. See *Restatement (Second) of Trusts* §§ 194, 383 (1959); *Stuart v. Continental Illinois Nat'l Bank and Trust Co.,* 68 Ill. 2d 502, 369 N.E.2d 1262 (1977), *cert. denied,* 444 U.S. 844 (1979). Nor is a trustee relieved of his or her obligations when they are voluntarily assumed and performed by another. See *Petition of United States on behalf of Smithsonian Institution v. Harbor Branch Foundation,* 485 F. Supp. 1222 (D.D.C. 1980).

16. *Restatement (Second) of Trusts* § 171 (1959). See also *Scott on Trusts* § 171 (3d ed.); *In re Estate of Lohm,* 440 Pa. 268, 269 A.2d 451, 47 A.L.R.3d 499 (1970); Uniform Trustees' Powers Act § 4 (1964).

tremely careful to avoid conflicts of interest or even the appearance of conflicts of interest, and as a rule, must not delegate their responsibilities. It bears repeating that trustees are held to an objective standard of care. Even if trustees do their best, their best may not be good enough. As one legal scholar explains: "[The trustee] is under a duty in administering the trust to exercise such care and skill as a man of ordinary prudence would exercise, and he is liable for a loss resulting from his failure to comply with this standard, even though he does the best he can."[17]

Perhaps one of the most quoted descriptions of the trustee's standard of conduct is contained in a decision by Judge Benjamin N. Cardoza during his tenure as chief judge of the New York Court of Appeals. In *Meinhard v. Salmon*,[18] Cardoza said:

Many forms of conduct permissible in a workaday world for those acting at arm's length, are forbidden to those bound by fiduciary ties. A trustee is held to something stricter than the morals of the market place. Not honesty alone, but the punctilio of an honor the most sensitive, is then the standard of behavior. As to this there has developed a tradition that is unbending and inveterate. Uncompromising rigidity has been the attitude of courts of equity when petitioned to undermine the rule of undivided loyalty by the "disintegrating erosion" of particular exceptions. . . . Only thus has the level of conduct for fiduciaries been kept at a level higher than that trodden by the crowd. It will not consciously be lowered by any judgment of this court.[19]

C. A For-Profit Corporation

Compare the duties of the trustee with the responsibilities of a director of a business (for-profit) corporation. The assets of the business corporation are held by the corporation ultimately for the benefit of the stockholders. The directors and the employees also have a great monetary self-interest in the success of the corporation. As a practical matter, the directors are subject to continued oversight by their stockholders, and invariably, the measure of success is in the balance sheet—whether sufficient profit has been made—because the ultimate purpose of every business corporation is to make money. If the stockholders are not satisfied with performance, they have effective methods for registering their discontent. Recognizing this, the law imposes a less demanding standard of conduct on the officers of a business corporation than it does on trustees. It permits the law of the marketplace to

17. *Scott on Trusts* § 201 at 1650 (3d ed.), see also § 174. Uniform Trustees' Powers Act § 1(3) (1964). See also M. Fremont-Smith, *Foundations and Government: State and Federal Law and Supervision* (New York: Russell Sage Foundation, 1965), for a general discussion of the role of a trustee. *Stark v. United States Trust Co.*, 445 F. Supp. 670 (S.D.N.Y. 1978), analyzes New York law on the duty of trustees. *Stuart v. Continental Illinois Nat'l Bank and Trust Co.*, 68 Ill. 2d 502, 369 N.E.2d 1262 (1977), *cert. denied*, 444 U.S. 844 (1979), held that a trustee is personally liable for any loss occasioned by a violation of his or her duties as trustee. The rule applies when the violation is the result of negligence or mere oversight as well as when the trustee is wrongfully motivated.

18. 249 N.Y. 458, 164 N.E. 545, 62 A.L.R. 1 (1928).

19. Ibid., 546. This is not to suggest that all courts have been as conscientious in maintaining for traditional trustees a "level of conduct higher than that trodden by the crowd."

prevail, and as a rule, it does not step in and hold officers of a business corporation personally liable for mistakes of judgment unless there has been gross negligence or fraud.[20] In other words, an officer of a business corporation can be somewhat less punctilious and still stay within the law.

D. The Charitable Corporation

Floating somewhere between the concept of a traditional trust and that of a business corporation is the charitable corporation. The charitable corporation shares attributes of the traditional trust in that the corporation holds property for the benefit of others. Just as the trustee of a traditional trust holds legal title to trust property but can use this property only for the good of the beneficiaries, the charitable corporation holds its property under an obligation to use that property in the pursuit of certain public benefits.[21] "[T]he assets of charitable corporations are deemed to be impressed with a charitable trust by virtue of the declaration of corporate purposes."[22] Although the beneficiary of a traditional trust is a named individual or group of individuals and the beneficiary of a charitable corporation is the public at large or a broad segment of the public, the indefinite nature of the beneficiary of a charitable corporation does not relieve those charged with the governance of the corporation of a high degree of responsibility.[23]

20. For example, in *Kamin v. American Express Co.,* 86 Misc. 2d 809, 383 N.Y.S.2d 807, 811, *aff'd,* 54 A.D. 2d 654, 387 N.Y.S.2d 993 (1976), directors were sued under the New York Business Corporation Law, which permits an action against a director for "the neglect of or failure to perform, or other violation of his duties in the management and disposition of corporate assets committed to his charge." The court stated: "This does not mean that a director is chargeable with ordinary negligence for having made an improper decision or having acted imprudently. The 'neglect' referred to in the statute is neglect of duties (i.e., malfeasance or nonfeasance) and not misjudgment. To allege that a director 'negligently permitted the declaration and payment' of a dividend without alleging fraud, dishonesty or nonfeasance, is to state merely that a decision was taken with which one disagrees."

21. Volumes have been written regarding the proper characterization of gifts to charitable organizations, as distinct from the issue (discussed in footnote 5) of how the organization itself should be characterized. Does such a gift vest absolute title in the organization, or does it create a trust obligation? See T. Blackwell, "The Charitable Corporation and the Charitable Trust," 24 *Wash. U. L.Q.* 1 (1938); J. Eubank et al., "Duties of Charitable Trust Trustees and Charitable Corporation Directors," 2 *Real Prop. Prob. and Tr. J.* 545 (1967). Today, it may be more helpful to focus on the fact that, as far as gifts to charitable organizations are concerned, form is not as important as function, that is, to administer conscientiously the assets for the charitable purpose. See K. Karst, "The Efficiency of the Charitable Dollar: Unfulfilled State Responsibility," 73 *Harv. L. Rev.* 433 (1960), and Note, "The Charitable Corporation," 64 *Harv. L. Rev.* 1168 (1951). In certain cases, however, form becomes important. See, for instance, *Crane v. Morristown School Foundation,* 120 N.J. Eq. 583, 187 A. 632 (1936), where creditors tried to reach school endowment funds, and *In re the Edwin Forrest Home,* No. 154 (Penn., Philadelphia Ct. of C.P., Orphans' Ct. Div., April 24, 1981) (Opinion of Court *en banc* 1982), where the issue was whether a nonprofit organization must account as a trustee under the State's Probate, Estates, and Fiduciaries Code. It could be argued that the court's reasoning is frequently result-oriented.

22. *American Center for Education Inc. v. Cavnar,* 80 Cal. App. 3d 476, 145 Cal. Rptr. 736, 742 (1978).

23. *Scott on Trusts* § 379 (3d ed.); *St. Joseph's Hospital v. Bennett,* 281 N.Y. 115, 22 N.E.2d 305 (1939); *Estate of Becker,* 270 Cal. App. 2d 31, 75 Cal. Rptr. 359 (1969).

On the other hand, the charitable corporation is not unlike the business corporation in that it can be a fairly complicated operation to run and one that must deal with many of the realities of the business world. A common example of a traditional trust is a fund set up to benefit minor children or an incapacitated individual. The trustee of such a trust usually has a relatively limited scope of activities; most duties can be managed personally with ease. The trustee is not faced with the hiring and supervision of staff, with the oversight of major programs and properties, and with the innumerable problems involved in running a service for the public. These, however, are the concerns that face a board charged with the supervision of a charitable corporation, and the magnitude of these tasks makes it unrealistic to expect that the board members can adhere to the standard for personal attention required of the traditional trustee.[24] Yet the charitable corporation has control over valuable property dedicated to the public, and the public cannot effectively monitor the board's activity, as do stockholders in a corporation, especially considering the difficulty involved in measuring a nonprofit's success. What, then, should be the standard of conduct imposed on board members who govern charitable corporations?[25] Are such board members required to follow the strict standard imposed on trustees of traditional trusts, or can they adhere to the more relaxed business standard?

E. The Standard of Conduct Imposed on Boards of Charitable Corporations

Fortunately or unfortunately, the courts are now being forced to deal with this specific issue—the standard of conduct expected of nonprofit boards—because the public has become more interested in the management of charitable corporations. People are much more aware that these organizations should be run for their benefit, and therefore they feel justified in questioning the management of such organizations. But before looking at the issue of quality of management, we need to consider the question of the powers of trustees of charitable corporations. The general rule is that a charitable organization, whether in trust form or corporate form, has such powers as are specifically conferred on it in its enabling instrument, as well as the implied powers necessary to carry out its stated purposes.

Regarding the trust form of such organizations, *Scott on Trusts* states: "The trustees of a charitable trust, like the trustees of a private trust, have such powers as are conferred upon them in specific words by the terms of the trust or are necessary or appropriate to carry out the purpose of the trust and are not forbidden by the terms of the trust. . . . [T]he fact that a charitable trust may continue for an indefinite period may have the effect of giving the trustees more extensive powers than they have in the case of a private trust which is of

24. Most board members of charitable corporations serve without compensation, but as stated in *Scott on Trusts* § 174 at 1410 (3d ed.), "The trustee is held to the standard of a man of ordinary prudence whether he receives compensation or whether he acts gratuitously."

25. Governors of charitable corporations may be called trustees, regents, supervisors, etc. When used in this text, the term "board member" or "trustee" should be construed to cover members of whatever body actually governs the charitable corporation.

limited duration."[26] Regarding the corporate form of such organizations, case law instructs: "The powers of the persons who act as directors of a charitable nonprofit corporation, whether called directors or trustees, are prescribed in the statute of incorporation, in the instrument creating the corporation, and those implied powers which are necessary and proper to carry out the purposes for which the charity was created and which are not in conflict with expressions in the instrument creating the charity."[27]

Given that the boards of charitable corporations (no matter which form) have specific as well as implied powers to carry out their stated purposes,[28] it is also important to understand that boards have "discretion" in determining how to achieve the purposes of the organization. In other words, when making judgments, a board is given the benefit of the doubt if all else appears to be in order. "It is a settled principle that trustees having powers to exercise discretion will not be interfered with so long as they are acting *bona fide*. To do so would be to substitute the discretion of the court for that of the trustees."[29]

Now we will turn to the issue of the standard used by courts to judge board conduct. Recently, numerous cases alleging mismanagement have been brought against board members and officers of charitable corporations; of course, in each of these cases, the basic issue is the standard of conduct required of such individuals. A 1974 case that merits close scrutiny involved a hospital, not a museum, but it is considered a landmark decision and is frequently cited on the issue of nonprofit board member liability. The case is *Stern v. Lucy Webb Hayes National Training School for Deaconesses and Missionaries* or, as it is more commonly known, the *Sibley Hospital* case.[30] The defendant school was founded as a trust but was later incorporated under the Nonprofit Corporation Act of the District of Columbia. Subsequently, the school established the Sibley Memorial Hospital, and over the years, the hospital became the chief function of the school. This suit was brought as a class action against certain members of the hospital's board of trustees, six financial institutions, and the hospital itself. The main allegations were that (1) the defendant trustees conspired to enrich themselves and certain financial institutions with which they were affiliated by favoring those institutions in financial dealings with the hospital and (2) the defendant trustees breached their

26. *Scott on Trusts* § 380 (3d ed.).

27. *Midlantic Nat'l Bank v. Frank G. Thompson Foundation*, 170 N.J. Super. 128, 405 A.2d 866, 869 (1979). As this quotation notes, the state statutes that provide for the establishment of nonprofit organizations invariably list a whole range of powers that such organizations are assumed to have unless the charter of a particular organization specifically limits such powers.

28. It is important to distinguish between powers to carry out the charitable organization's stated purpose and powers to change the purpose of or to alter a specific restriction placed on the organization. In these latter situations, boards are much more limited and usually need to seek court approval in *cy pres* or equitable deviation petitions. As stated in *Taylor v. Baldwin*, 362 Mo. 1224, 247 S.W.2d 741, 750 (1952): "The point of demarcation at which the courts will interfere with the discretion of those governing a public charity reasonably is the point of substantial departure by the . . . [board] from the dominant purpose of the charity."

29. *Shelton v. King*, 229 U.S. 90, 94 (1913).

30. 381 F. Supp. 1003 (D.D.C. 1974) and also 367 F. Supp. 536 (D.D.C. 1973) (order granting plaintiffs standing to sue). An earlier case of interest is *United States v. Mount Vernon Mortg. Corp.*, 128 F. Supp. 629 (D.D.C. 1954), *aff'd*, 236 F.2d 724 (D.C. Cir. 1956), *cert. denied*, 352 U.S. 988 (1957), in which the United States, as *parens patriae*, sued trustees of a charitable foundation for improper transfer of foundation property.

fiduciary duties of care and loyalty in the management of Sibley's funds.[31] The financial institutions were named as coconspirators.

At the time of the suit, the hospital was required, under its bylaws, to be run by a board of from twenty-five to thirty-five "trustees" who were to meet at least twice a year. There were also three committees: an Executive Committee empowered to open bank accounts, pay mortgages, and enter into contracts; a Finance Committee to review the budget; and an Investment Committee. In fact, however, for over eighteen years, the hospital had been run almost exclusively by two trustee officers, the hospital administrator and the treasurer. The Finance and the Investment Committees never met, and the board and the Executive Committee were dominated by the administrator and the treasurer. The facts also demonstrated that the hospital maintained excessively large, noninterest-bearing accounts in financial institutions run by certain defendant trustees, that a substantial hospital mortgage was held by a syndicate organized by certain defendant trustees, and that the hospital retained the investment services of a firm controlled by one of the defendant trustees. Regarding the last two arrangements, the mortgage was deemed "fair" and the fee for the investment service "equitable" when compared with similar services offered in the area.

A crucial factor in the case was the standard of conduct assigned to the "trustees" of this charitable corporation. Under traditional trust law, trustees cannot delegate major responsibilities, they must avoid conflict-of-interest situations because of their duty of loyalty, and they have an affirmative duty to protect, preserve, and increase trust assets, as would a "man of ordinary prudence." Under corporate law, directors, as a rule, are not held liable for their actions unless "gross negligence" or fraud has been found, and transactions between the corporation and a director are not necessarily void.[32] The court in the *Sibley Hospital* case stated: "The applicable law is unsettled. The charitable corporation is a relatively new legal entity which does not fit neatly into the established common law categories of corporation and trust. . . . [T]he modern trend is to apply corporate rather than trust principles in determining the liability of the directors of charitable corporations, because their functions are virtually indistinguishable from those of their 'pure' corporate counterparts."[33]

The "indistinguishable" feature was essentially that corporate directors and board members of large charitable corporations have many areas of responsibility, whereas the traditional trustee is charged mainly with the management of the trust funds.[34] The court moder-

31. 381 F. Supp. 1007 (D.D.C. 1974).

32. Usually such transactions are voidable at the option of the corporation. It is assumed that because of the profit motive, the actions of directors will be closely watched by those having a pecuniary interest in the corporation.

33. 381 F. Supp. 1013 (D.D.C. 1974).

34. Compare, for instance, *Blankenship v. Boyle,* 329 F. Supp. 1089 (D.D.C. 1971), which was decided by the same judge who rendered the decision in the *Sibley Hospital* case. *Blankenship* involved the management of a large union welfare fund by a group of trustees. The major charges were that excessive cash deposits were maintained in a bank account by the union trustees and that this practice benefited the union and the bank

ated its endorsement of the corporate standard, however, by specifically noting that the management of a charitable corporation imposes "severe obligations" on board members because such an organization is not closely regulated by any public entity, it is not subject to scrutiny by stockholders, and frequently its board is self-perpetuating.

After analyzing the facts and conflicting case law,[35] the court held as follows:

[A] director or so-called trustee of a charitable hospital organized under the Non-Profit Corporation Act of the District of Columbia [citation omitted] is in default of his fiduciary duty to manage the financial and investment affairs of the hospital if it has been shown by a preponderance of the evidence that:

(1) While assigned to a particular committee of the Board having general financial or investment responsibility under the by-laws of the corporation, he has failed to use due diligence in supervising the actions of those officers, employees or outside experts to whom the responsibility for making day-to-day financial or investment decision has been delegated; or

(2) He knowingly permitted the hospital to enter into a business transaction with himself or with any corporation, partnership or association in which he then had a substantial interest or held a position as trustee, director, general manager or principal officer without having previously informed the persons charged with approving that transaction of his interest or position and of any significant reasons, unknown to or not fully appreciated by such persons, why the transaction might not be in the best interests of the hospital; or

(3) Except as required by the preceding paragraph, he actively participated in or voted in favor of a decision by the Board or any committee or subcommittee thereof to transact business with himself or with any corporation, partnership or association in which he then had a substantial interest or held a position as trustee, director, general manager or principal officer; or

(4) He otherwise failed to perform his duties honestly, in good faith, and with a reasonable amount of diligence and care.[36]

Even though this less stringent standard was used, in the *Sibley Hospital* case the trustee defendants were found guilty of breaching their fiduciary duties to supervise the manage-

rather than the beneficiaries of the trust, the union members. Evidence in the case demonstrated that management of the trust fund was a complex operation, that the trustees did not hold regular meetings, and that there was no set procedure for deciding policy questions. Despite the complex nature of the trust, the court favored the trust standard. It held that in view of the fiduciary obligation to maximize the trust income by prudent investment, the burden of justifying their conduct fell on the trustees. The trustees could not sustain this burden. The court required the removal of two trustees and ordered major management changes in the fund's administration.

35. See, for instance, *George Pepperdine Foundation v. Pepperdine,* 126 Cal. App. 2d 154, 271 P.2d 600 (1954), a case illustrating the view that hard cases make bad law. *Pepperdine* was overruled in part by *Holt v. College of Osteopathic Physicians and Surgeons,* 61 Cal. 2d 750, 40 Cal. Rptr. 244, 394 P.2d 932 (1964). See also *Lynch v. John M. Redfield Foundation,* 9 Cal. App. 3d 293, 88 Cal. Rptr. 86 (1970), where the court held corporate trustees to the traditional trust standard regarding investment duties. (Note that as of 1980, California has in effect a comprehensive nonprofit corporation law that spells out standards of conduct. Cal. Corp. Code §§ 5000-10831).

36. 381 F. Supp. 1015 (D.D.C. 1974).

ment of the hospital's investments. In granting relief, however, the court was lenient be-cause, as it pointed out, the hospital had already instituted reforms, there was no evidence that any of the trustees were involved in fraudulent practices or profited personally, and this was a case of "first impressions." This last reason deserves special attention. The court in effect was saying, "We are giving you another chance, but now that we have clarified the nature and scope of trustee obligations in a nonprofit, nonmember charitable institution, board members in this jurisdiction, beware!"[37]

The court's decision in the *Sibley Hospital* case was not, as some claim, a wholehearted endorsement of the business (corporate) standard for judging nonprofit board conduct; it was a cautious, middle-of-the-road approach that appreciated that charitable corporations were different and needed a standard of their own.[38] Under the court's tests, board members may delegate day-to-day financial and investment decisions if they use diligence in supervis-ing this delegated authority. The criteria mentioned earlier in this chapter for judging a proper delegation by a traditional trustee permit a trustee to delegate (but retain super-vision) if the subject requires a special skill not possessed by the trustee. Also, under the court's test, a board member may not actively participate in a vote in favor of a transaction that would be a conflict of interest for the member under the trustee test, and if a board member knows that the charitable organization is contemplating such a transaction, the member must fully disclose his or her activities and any other known pertinent information. Here again, the *Sibley Hospital* standard can be reconciled with the traditional trustee stan-dard. Neither standard permits direct participation in a conflict-of-interest situation, but the *Sibley* test recognizes that there are practical ways in which a board member can be isolated from a particular decision without undermining confidence in the management of the or-ganization. Due to the complexities of managing a charitable organization, the size of and frequent division of responsibilities within a board permit an individual member, on occa-sion, to defer to the informed judgment of peers. This type of situation historically did not exist in a traditional trust, and hence the very strict conflict-of-interest rule was deemed necessary to ensure loyalty of service.[39] But perhaps the key to the *Sibley Hospital* decision can be found in the fourth and last test described in the case. Here the court said that a board member would be found in default of duty if "he otherwise failed to perform his

37. For an analysis of the *Sibley Hospital* case, see M. Mace, "Standards of Care for Trustees," *Harv. Bus. Rev.* 14 (Jan.–Feb. 1976).

38. Years later the need for a separate standard of conduct for nonprofit trustees is being demonstrated. In the 1990s, boards of nonprofit hospitals began selling their organizations to for-profits, and those who endorse the "business" standard of conduct for nonprofit boards find themselves without strong legal arguments to pro-tect the public. A series of scandals in the early 1990s concerning nonprofit boards' failures to police the con-duct of chief executive officers also puts into question the wisdom of a very relaxed standard of conduct for nonprofit boards.

39. See also C. Welles, *Conflicts of Interest: Nonprofit Institutions, Report to the Twentieth Century Fund Steering Committee on Conflicts of Interest in the Securities Markets* (New York: Twentieth Century Fund, 1977). The revised nonprofit corporation law that went into effect in California in 1980 approves this concept of reasonable delega-tion with continued oversight. Cal. Corp. Code § 5210.

duties honestly, *in good faith,* and with a reasonable amount of diligence and care."[40] Under the traditional trustee test, good faith will not save a trustee who fails to perform as "a man of ordinary prudence" in carrying out the required duties. The traditional trustee must meet this objective standard. On the other hand, the corporate business standard usually requires only that a director avoid gross negligence and fraud. *Sibley Hospital,* in stressing good faith, puts forth a more subjective test, one that permits the court to consider the power and obligations of public trustees, the importance of protecting the public, and the realities of board membership. The test, if carefully followed, still places a formidable burden on the defendant. To support a finding of good faith, the defendant must be able to demonstrate to the court that as a board member, the defendant pursued his or her "severe obligations" to the public with a reasonable degree of diligence and intelligence and did not in fact breach the duty of loyalty.[41]

F. The Standard Applied to Museums

What standard of conduct would a court impose today on board members of a museum when collection-related matters are at issue?[42] (Note that the focus is on collection-related matters, which make up the core work of a museum.) Resolving this question with certainty is difficult because several of the more interesting cases on this point were settled before final judgments were rendered by the courts. However, the charges filed in the cases alone reflect some prevailing opinions regarding proper board conduct.

40. 381 F. Supp. 1015 (D.D.C. 1974) (emphasis added).

41. Compare, for example, the decision in *Zehner v. Alexander,* 89 (Penn. 39th Jud. Dist., Franklin County, Ct. of C. P., Orphans' Ct. Div.) 262 (May 25, 1979) (known as the *Wilson College* case). The trustees of Wilson College voted to close the school because of declining enrollment. The decision was challenged in court. The closing was enjoined, and two trustees were ordered removed, one for gross negligence and the other for conflict of interest (she was the president of another college) and for failure to use her special expertise. Here, apparently, the court did not think the trustees tried hard enough to avoid closing the school and thus found grounds for overruling their judgment. But see *Rowan v. Pasadena Art Museum,* No. C 322817 (Cal. Sup. Ct., L.A. County, Sept. 22, 1981), which stressed the broad discretion vested in trustees. In this case, however, the trustees were able to show that the decision in question was carefully considered in accordance with promulgated internal procedures. In *Mountain Top Youth Camp, Inc. v. Lyon,* 20 N.C. App. 694, 202 S.E.2d 498 (1974), the court adopted a test similar to that used in the *Sibley Hospital* case. Although the courts seem to take different paths in these cases, a key issue in each is whether the trustees appear to have made good-faith efforts to carry out their responsibilities.

42. See G. Marsh, "Governance of Non-Profit Organizations: An Appropriate Standard of Conduct for Trustees and Directors of Museums and Other Cultural Institutions," 85 *Dick. L. Rev.* 607 (1981); A. Geolot, "Note: The Fiduciary Duties of Loyalty and Care Associated with the Directors and Trustees of Charitable Organizations," 64 *Va. L. Rev.* 449 (April 1978); J. Nason, *Trustees and the Future of Foundations* (New York: Council on Foundations, 1977); W. Abbott and C. Kornblum, "The Jurisdiction of the Attorney General over Corporate Fiduciaries under the New California Nonprofit Corporation Law," 13 *U.S.F. L. Rev.* 753 (summer 1979); D. Kurtz, *Board Liability: Guide for Nonprofit Directors* (Mt. Kisco, N.Y.: Moyer Bell Limited, 1988); G. Overton, ed., *Guidebook for Directors of Nonprofit Corporations* (Chicago, Ill.: American Bar Association, 1993).

In the well-publicized *Museum of the American Indian* case,[43] the museum trustees and officers personally were sued by the attorney general of the state of New York for mismanagement. Among the charges listed by the attorney general were the following:

1. The trustees and officers failed to keep complete and contemporaneous records of all collection objects.
2. The trustees and officers permitted questionable accession and deaccession practices.
3. The trustees and officers were involved in self-dealing. (It was alleged, for example, that trustees obtained artifacts and other benefits from the museum and that gifts to the museum from trustees were valued at inflated figures for income tax purposes.)

Essentially, the attorney general of the state of New York was saying that under his interpretation of the law, a museum, as a charitable corporation, has certain obligations to members of the public (as the beneficiaries). These obligations impose on the board members of the museum a standard of conduct that requires, at a minimum, that the board members themselves establish acceptable policies concerning the acquisition of collection items, the disposal of such items, and the records to be kept of such transactions.[44]

After much negotiation with the attorneys for the defendants, the state attorney general entered into a stipulation that held in abeyance further court action. Under the terms of the stipulation, the museum agreed to have a complete inventory of its collection performed by an independent party. This inventory was to be made available to the attorney general and the public. Also, the museum agreed that the director would be relieved of all administrative authority, that no new administrator would be appointed without the prior consent of the attorney general, and that any new administrator would not have unfettered author-

43. *Lefkowitz v. The Museum of the American Indian Heye Foundation,* Index No. 41416/75 (N.Y. Sup. Ct., N.Y. County, June 27, 1975). Many years after this case was settled, the Museum of the American Indian became a part of the Smithsonian Institution and took the name "National Museum of the American Indian."

44. When investigating the case of *Lefkowitz v. Kan,* Index No. 40082/78 (N.Y. Sup. Ct., N.Y. County, Jan. 3, 1983) (compromise agreement), the attorney general of New York questioned the museum's purchase of several art objects once owned by a member of the museum's board. The attorney general argued that in New York, such a sale amounted to "self-dealing" by a fiduciary. This particular aspect of the case was settled when the attorney general and all parties concerned reached an agreement that required the following:

1. All transactions between the museum and the board member were to be reconsidered after the board member made full disclosure of his or her interests. If the museum's board rejected any piece, the board member was to refund the full purchase price.
2. The board members would not purchase, sell, or exchange any materials from, to, or with the museum without advance written disclosure to the museum's board and to the attorney general.
3. The museum's board would establish a committee to draft a comprehensive code of ethics. Pending the adoption of this code, the museum would not purchase, sell, or exchange collection objects with board members or staff.

(Statement of Louis Lefkowitz, Attorney General of New York, by Charles Brody, Assistant Attorney General, May 19, 1978)

ity to acquire items for the collection or to dispose of items from the collection. While the inventory was in progress, the board of trustees of the museum was reconstituted and a new administrator was hired. Shortly thereafter, the museum published a comprehensive collection management policy statement.[45]

The *Museum of the American Indian* case had hardly faded from the news when some of the trustees and a former director of a museum of fine arts in Washington State were sued by the state attorney general for mismanagement of museum assets.[46] Although the museum is a charitable corporation, the complaint by the attorney general was couched in traditional trustee language. Among the charges in the complaint were the following:

1. The director, without the permission of the trustees, sold assets of the museum.
2. The director did not keep proper accounts of proceeds recovered from such sales.
3. The director and the trustees failed to maintain the collection in proper condition.
4. The director and the trustees failed to maintain the museum building in reasonable repair.
5. The trustees did not exercise adequate supervision over the director with regard to acquisitions.
6. Trustees were permitted to purchase or borrow items from the collection or to otherwise benefit from their trustee status, practices that amounted to self-dealing.

The attorney general alleged that the trustees "failed to exercise the standard of care of a prudent man," and that hence, as trustees, they were personally liable for resulting damages, whether caused by them directly or by the director.[47] From the list of charges, it appears that this attorney general also believed that the standard of care applicable to board members of a museum requires that the board members set policy concerning the acquisition, disposal, and care of collection objects and that they demonstrate active oversight of museum operation. The case was dismissed after the attorney general and the defendants entered into a stipulation in which the museum agreed to pursue its remedies against one individual deemed largely responsible for the mismanagement.

In 1976, the attorney general of Illinois brought charges against the officials of the George F. Harding Museum, alleging mismanagement of the museum collections and funds and self-dealing. The attorney general argued that the officials were "common law trustees" and

45. The collection policy was adopted by the board of trustees of the Museum of the American Indian, Heye Foundation, on June 29, 1977, and was published in *Indian Notes* 22 (No. 1, 1978), a publication of that museum. The collection policy provided that all accessions, except certain field collections made by staff, and all deaccessions required the approval of the board of trustees. This requirement, which was part of the stipulation entered into with the attorney general, was rather stringent for a museum of this size and type.

46. *State of Washington v. Leppaluoto,* No. 11781 (Wash. Super. Ct., Klickitat County, April 1977). The trustees filed a countersuit against the attorney general, alleging breach of an earlier agreement between the trustees and the attorney general regarding reorganization of the museum.

47. If a museum director is permitted to perform actions that should be reserved for the trustees, the trustees may be held liable. If there is a proper delegation of authority to the museum director but the trustees fail to oversee generally the exercise of their delegated power, the trustees may be held liable.

thus should be held to a strict standard of conduct. The case developed into a long, hard-fought legal battle, with at least nine law firms involved in the representation of the defendants.[48] The attorney general's position was sufficiently strong, however, to convince the defendants that they should consent to an arrangement whereby the collections of the museum (and title thereto) were transferred to the Art Institute of Chicago and whereby the George F. Harding Museum, for all practical purposes, ceased to exist as a collecting organization. The transfer arrangement went into effect in 1982, but charges against individual officials of the museum were not resolved until 1989.[49]

Actual court decisions (distinct from settlements) involving museum management also tend to require more of museum officials than the bare business standard. In the *Hill-Stead Museum* case,[50] the trustees were questioned about responsibilities to insure the museum's collections and to provide adequate security against fire and theft. In deciding the matter, the Connecticut court quoted the traditional trustee standard of care: "It is the duty of the trustees to exercise that care and prudence which an ordinarily prudent person would who was entrusted with the management of like property for another."[51] In *Rowan v. Pasadena Art Museum*,[52] the defendant trustees were absolved from charges that they had failed to preserve and maintain the museum's collections, had failed to exhibit properly, had failed to establish certain collection management policies, and had failed to receive reasonable amounts for the sale of certain collection items. The standard of conduct applied by the court stressed "good faith":

Members of the board of directors of the corporation [the museum] are undoubtedly fiduciaries, and as such are required to act in the highest good faith toward the beneficiary, i.e., the public. . . . Acting within their broad discretion, the trustees must assume responsibility for making decisions regarding all of the affairs of the museum. . . . So long as the trustees act in good faith and exercise reasonable care as contrasted with a clear abuse of discretion, the decisions must be left in the hands of the trustees where it has been placed by the law.[53]

In this case, the trustees were able to show that promulgated internal policies were in place in the museum and that, in making decisions, the trustees adhered to these policies. In other words, the trustees showed that they took their work seriously.

48. *People ex rel. Scott v. Silverstein,* No. 76 CH 6446 (Ill., Cook County Cir. Ct., Oct. 1976) and 408 N.E.2d 243 (1980). See also *People ex rel. Scott v. George F. Harding Museum,* 58 Ill. App. 3d 408, 374 N.E.2d 756 (1978), and *People ex rel. Scott v. Silverstein,* 412 N.E.2d 692 (1980) *rev'd,* 429 N.E.2d 483 (1981).

49. In *Hardman v. Feinstein,* No. 827127 (Cal. Supp. Ct., San Francisco County, July 1984), several citizens filed suit against the trustees of the Fine Arts Museum of San Francisco, charging mismanagement of the collections because of poor inventory methods, improper disposal of certain works, and lax security. The case was not pressed but is of interest regarding the plaintiffs' perception of the accountability of museum trustees.

50. *Harris v. Attorney General,* 31 Conn. Supp. 93, 324 A.2d 279 (1974).

51. Ibid., 287.

52. No. C 322817 (Cal. Sup. Ct., L.A. County, Sept. 22, 1981).

53. Ibid., 6.

G. Conclusions

From the foregoing cases, certain conclusions can be drawn concerning board responsibility for the management of a museum.[54]

Duty of Care. Under prevailing law, board members of a museum will be held at least to the duty of care imposed on directors of a business corporation. In other words, they are invariably liable for gross negligence and fraud. However, if the matter at issue directly concerns collection policy (the core function of the museum), courts have been inclined to expect a higher standard, one that requires evidence of good-faith efforts on the part of board members to set reasonable policy, to follow policy, and to exercise reasonable oversight.[55] This tendency to expect board members of a nonprofit organization to pay closer attention to the core function of the nonprofit is understandable. Unlike a for-profit organization, a nonprofit cannot determine its success by studying a balance sheet. The purpose of the nonprofit is not to make money but to provide a quality product or service (as described in its charter) to a particular segment of the public. Because of the very nature of a nonprofit's activity, outsiders experience extreme difficulty in judging, in a timely manner, the quality of governance. In such a situation, it is important, if public confidence is to be maintained, to demand that a board do more than just avoid gross negligence and purposeful wrongdoing. At the very least, the board should be under obligation to institute policies reasonably designed to further the mission of the organization and should also be able to demonstrate good-faith efforts to monitor such policy.[56] If there is a tendency on the part

54. The cases just described involve charges filed against board members and directors of museums for violations of fiduciary duties. Are staff members of museums immune from such suits? This question was raised in the case of *Lefkowitz v. Kan,* Index No. 40082/78 (N.Y. Sup. Ct., N.Y. County, Jan. 3, 1983) (compromise agreement). In this case, which was settled by a compromise agreement dated January 3, 1983, the attorney general of New York alleged that the defendant, a curator, violated a fiduciary responsibility owed the museum when he arranged certain deaccession sales involving a dealer with whom the curator did business personally. The settlement agreement stated that although no museum policy required the disclosure of the curator's personal transactions with the dealer, the situation created "at least the appearance of an impropriety" and that "full and candid disclosure of personal transactions are required by present codes of ethics and fiduciary law."

55. This "higher standard" does not mean that a board must be able to show that its decisions were always correct but rather that a board must be able to show that it made reasonable efforts to address major responsibilities. For a more detailed discussion of museum board responsibility, see M. Malaro, *Museum Governance: Mission, Ethics, Policy* (Washington, D.C.: Smithsonian Institution Press, 1994), and W. Boyd, "Museum Accountability: Law, Rules, Ethics, and Accreditation," 34 *Curator* 165 (American Museum of Natural History) (No. 3, Sept. 1991).

56. If, for example, the matter at issue concerned the museum's investment policy (not the core purpose of the museum), a court may be inclined to quote the business corporation standard of care. Here the "auxiliary activity" (the management of the museum's investments) must be carried out in the marketplace subject to marketplace pressures, and measuring success or failure is relatively easy. Thus, judging by a business standard makes more sense. See W. Cary and C. Bright, *The Developing Law of Endowment Funds: "The Law and the Lore" Revisited,* Report to the Ford Foundation (New York: Ford Foundation, 1974), and the Uniform Management of Institutional Funds Act, prefatory note. See also *Midlantic Nat'l Bank v. Frank G. Thompson Foundation,* 170 N.J. Super. 128, 405 A.2d 866 (1979). But see *Attorney General v. Olson,* 346 Mass. 190, 191 N.E.2d 132 (1963), where the trust standard was applied but was liberally construed in favor of the trustees. G. Marsh, "Governance of

of courts—and the public—to expect a nonprofit board to pay particular attention to the organization's core functions, then a museum board should give attention to the establishment and monitoring of a prudent collection management policy for the museum. Ethical codes promulgated by the museum profession underscore this responsibility. These codes do not have the force of law, but they do reflect standards considered essential if the integrity of the profession is to be maintained.[57]

Duty of Loyalty. Case law and guidelines promulgated by the legal profession for nonprofit boards stress the importance of the interests of the organization over personal interests or those of a third party. A board member must take seriously, therefore, the obligation to disclose in advance to fellow board members any possible conflicts of interest, giving full details and removing himself or herself from further discussion and from voting if such matters in fact come before the board. In turn, when a board is on notice that a member has a conflict of interest, the real and apparent effects of this conflict must be carefully weighed in the decision process. A prudent board has a well-established procedure for addressing conflicts of interest, and the procedure is an integral part of the organization's total collection management structure.[58]

Duty of Obedience. Finally, the law cautions nonprofit board members about the duty of obedience—the obligation to focus on the specific mission of the organization. For museums, this has particular relevance. What a museum collects, how it collects, and the segment of the public to be served are invariably circumscribed by the charter of the museum. When

Non-Profit Organizations: An Appropriate Standard of Conduct for Trustees and Directors of Museums and Other Cultural Institutions," 85 *Dick. L. Rev.* 607 (1981) presents another analysis of a museum trustee's responsibilities, as does S. Weil in the chapter entitled "Breach of Trust, Remedies, and Standards in the American Private Art Museum" in his book *Beauty and the Beasts: On Museums, Art, the Law, and the Market* (Washington, D.C.: Smithsonian Institution Press, 1983). See also C. Sherrell-Leo and R. Meyer, "The Buck Stops Here—and Other Trustee Responsibilities," 39 *History News* 28 (No. 3, March 1984), and M. Malaro in the chapter entitled "On Trusteeship" in *Museum Governance: Mission, Ethics, Policy* (Washington, D.C.: Smithsonian Institution Press, 1994).

57. The section on "governance" in the "Code of Ethics for Museums" adopted by the American Association of Museums (Washington, D.C.) in 1994 states: "Museum Governance in its various forms is a public trust responsible for the institution's service to society. The governing authority protects and enhances the museum's collections and programs and its physical, human, and financial resources. It ensures that all these resources support the museum's mission. . . . Thus the governing authority ensures that: . . . [P]olicies are articulated and prudent oversight is practiced." The *Code of Professional Ethics* promulgated by the International Council of Museums (Paris: ICOM, 1990) states in § 3.1: "Each museum authority (i.e., museum board) should adopt and publish a written statement of its collecting policy. This policy should be reviewed from time to time, and at least once every five years."

58. The *Restatement on Restitution* § 197 (St. Paul, Minn.: American Law Institute, 1937) provides that where a fiduciary in violation of his or her duty to the beneficiary receives or retains any profit, the fiduciary holds what is received on a constructive trust for the beneficiary. In other words, the profits must be turned over to the beneficiary. Under this doctrine, a museum trustee could be charged with the return of any profit he or she might make at the expense of the museum. Interestingly, in California the attorney general's office has found self-dealing to be the "single most troublesome charitable trust enforcement problem." W. Abbott and C. Kornblum, "The Jurisdiction of the Attorney General over Corporate Fiduciaries under the New California Nonprofit Corporation Law," 13 *U.S.F. L. Rev.* 753, 777 (summer 1979). See also D. Kurtz, *Board Liability: Guide for Nonprofit Directors* (Mt. Kisco, N.Y.: Moyer Bell Limited, 1988), 59–84.

establishing a collection management policy, a museum must stay within the boundaries drawn by its charter. Also, although a museum board has discretion in deciding how its mission is to be accomplished, careful adherence to the duty of obedience means selecting goals carefully. The question should not be merely, "Is this goal relevant to our mission?" The harder question needs to be asked: "Is this a wise goal in light of our anticipated resources?" Collecting without focus and overcollecting to the point where the museum cannot effectively care for or utilize objects are examples of failure to give sufficient attention to the duty of obedience. "Those who are responsible for the governance and management of museums must . . . recognize that they are unlikely ever to have enough funds to operate their institutions at the level of activity that could be justified in an ideal world. Instead, they must make difficult choices of what to do with the limited funds available."[59] Trustees who take their duty of obedience seriously also understand the importance of trying to make the "right" choice.

59. Martin Feldstein, ed., *The Economics of Art Museums* (Chicago, Ill.: U. of Chicago Press, 1991), 7.

CHAPTER II

Museums Are Accountable to Whom?

A. Role of the Attorney General

According to figures published by the American Association of Fund-Raising Counsel Trust for Philanthropy, contributions to the nation's charitable organizations totaled some $143.9 billion in 1995.[1] Charities are "big business," and yet, as noted in the previous chapter, a charity is not a "business" as this term is traditionally used. Charitable organizations occupy such a unique and prominent role in the United States that they are often referred to as "the third sector," after government and business.[2] To keep government on course, we have elaborate systems of checks and balances, and businesses must answer to stockholders, customers, the Internal Revenue Service, and innumerable other governmental entities. The third sector has its watchdogs also, and here again there is an area of evolving law.

1. "Giving USA," 1996 edition, published by the American Association of Fund-Raising Counsel Trust for Philanthropy, New York, N.Y. This estimate takes into consideration both cash and in-kind gifts but not the value of volunteer services.

2. For an explanation of "the third sector," see Chapter 1 of M. Malaro, *Museum Governance: Mission, Ethics, Policy* (Washington, D.C.: Smithsonian Institution Press, 1994); W. Powell, ed., *The Nonprofit Sector: A Research Handbook* (New Haven: Yale U. Press, 1987); L. Salamon, *America's Nonprofit Sector: A Primer* (New York: Foundation Center, 1992); V. Hodgkinson and R. Lyman, *The Future of the Nonprofit Sector: Challenges, Changes, and Policy Considerations* (San Francisco: Jossey-Boss, 1989).

Traditionally, the enforcement of charitable trusts or gifts to charities has been assigned to the attorney general of the state in which the charity is located.[3] This practice stems from English law: For centuries, suits were brought by the king's attorney general to enforce charitable trusts, the king being the guardian of such trusts. The practice was adopted in this country for practical as well as historic reasons. The community has a substantial interest in the enforcement of a charitable gift because it is the beneficiary; yet individual members of the community cannot be expected to police the administration of the gift. Such a situation could result in no oversight, since few, if any, individuals would assume the financial costs of court action, or it could result in the harassment of trustees (those charged with administering the gift), since many citizens might see fit to bring a variety of actions based on their individual theories of wrongdoing. The realistic solution was to look to the attorney general of the state to oversee the management of charities.[4]

A concise statement of the customary interpretation of this rule can be found in *Dickey v. Volker:*[5]

An individual member of the public has no vested interest in the property or funds of the [charitable] trust. In common with other members, he has an interest in the charitable use. He has no right of action for the mismanagement or misuse of the fund. Any action on this account must be

3. Most states have statutes setting forth the attorney general's duties in this regard, but even in the absence of statutes, the attorney general usually is found to have the power to oversee charities as a common-law incident of the office. (As explained in Chapter I, the terms "charity," "charitable trust," and "charitable corporation" are used interchangeably in this text because in most museum activity, the precise form of the organization is not controlling.) In some states the power to oversee charities is vested, by statute, in a state agent other than the attorney general. See 15 *Am. Jur. 2d,* "Charities," § 144 (1976). See also *Scott on Trusts* § 391 (3d ed.) and *Restatement (Second) of Trusts* § 391 (1959). The law regarding charitable corporations and charitable trusts developed unevenly in the various states. Interpretations reflected local social and political views as well as efforts to assimilate English precedent. Even today, when a question arises concerning the oversight of a charitable corporation or trust, a museum should carefully check the law of the particular jurisdiction. Two articles that describe the growth of the various legal theories in this country are T. Blackwell, "The Charitable Corporation and the Charitable Trust," 24 *Wash. U. L.Q.* 1 (1938), and Note, "The Enforcement of Charitable Trusts in America: A History of Evolving Social Attitudes," 54 *Va. L. Rev.* 436 (April 1968). For a concise discussion, see C. Hantizis, "The Role of the Attorney General in Supervising Charitable Organizations," in American Law Institute–American Bar Association (ALI-ABA), *Course of Studies Materials: Legal Problems of Museum Administration* (Philadelphia: ALI-ABA, 1985). Regarding particular state laws, see W. Abbott and C. Kornblum, "The Jurisdiction of the Attorney General over Corporate Fiduciaries under the New California Nonprofit Corporation Law," 13 *U.S.F. L. Rev.* 753 (summer 1979), and *Lefkowitz v. Lebensfeld,* 51 N.Y. 2d 442, 415 N.E.2d 919, 434 N.Y.S.2d 929 (1980). For the views of several state attorneys general, see H. Bograd, "The Role of State Attorneys General in Relation to Troubled Nonprofits," *PONPO Working Paper,* No. 206 (New Haven: Program on Non-Profit Organizations, Yale U., 1994).

4. The role of the attorney general is to see that the trustees do not abuse their discretion. It is not the attorney general's role to control their discretion. *Conway v. Emeny,* 139 Conn. 612, 96 A.2d 221 (1953). In *Lefkowitz v. Lebensfeld,* 51 N.Y. 2d 442, 415 N.E.2d 919, 434 N.Y.S.2d 929 (1980), the court discusses the history in New York of the attorney general's authority over charities and of the attorney general's limitations regarding the enforcement of obligations owed to a charity.

5. 321 Mo. 235, 11 S.W.2d 278 (1928), *cert. denied,* 49 S. Ct. 252 (1929). The decision contains extensive annotations on the then existing interpretation of the power to enforce charitable trusts.

taken by the Attorney General as the representative of the public. However, those with a special interest may enforce the trust, or a localized or grouped charity may be enforced by a class suit. In such suits it is proper and often necessary to make the Attorney General a party defendant.[6]

Similar instruction was given in *People ex rel. Ellert v. Cogswell:*[7]

This action is based upon averments of a public trust. It is brought to remedy abuses in the management of this trust. It is not only the right, but the duty, of the attorney general to prosecute such an action. The state as *parens patriae* [literally, "father of the country"] superintends the management of all public charities or trusts, and, in these matters, acts through her attorney general. Generally speaking, such an action will not be entertained at all unless the attorney general is a party to it. Such was the rule at common law, and it has not been changed in this state.[8]

Certainly over the years attorneys general have not been preoccupied with the supervision of museums. Attorneys general have many responsibilities, and with limited time and resources, they naturally focus their efforts on law enforcement matters of major public interest. But since the mid-1980s, issues relating to nonprofit activity have been headline news, causing some attorneys general to become much more involved in matters of direct concern to nonprofits and, accordingly, to museums and also causing some attorneys general to define more clearly their policies regarding oversight of nonprofit activity.

Several nonprofit issues have attracted substantial public attention over the past decade or so.

Nonprofit Compensation. This subject was brought forcefully to the attention of the public in 1992 when newspaper stories began to question the salary, lifestyle, and management practices of the president of United Way of America. United Way is one of the largest charities in the country, and news reports described the president as being grossly overcompensated, living lavishly, and favoring family and friends in managing the charity's assets. The United Way case caused inquiry into the compensation practices of other charities, a good number of which reported paying to certain high-level officials salaries and benefits that seemed excessive. At the 1992 annual conference of the National Association of State Charity Officials (with members largely drawn from offices of attorneys general), the topic of nonprofit compensation was identified as one that needed the continued close attention of oversight authorities.

Fund-Raising Activities. The methods used by some nonprofits to raise money began to spark criticism. Quite often, but not always, the situations involved outside fund-raising firms; according to the general complaint, a disproportionate share of the money raised was being used to pay fund-raising expenses, not to further the public-service work of the nonprofit organizations. In light of these reports, states began to enact statutes that placed limi-

6. Ibid., 246.

7. 113 Cal. 129, 45 P. 270 (1896).

8. *People ex rel. Ellert v. Cogswell,* 45 P. 270, 271 (Cal. 1896); see also *Parker v. May,* 59 Mass. 336, 5 Cush. 336 (1850); *United States v. Mount Vernon Mortgage Corp.,* 128 F. Supp. 629 (D.D.C. 1954), *aff'd,* 236 F.2d 724 (D.C. Cir. 1956), *cert. denied,* 352 U.S. 988 (1957).

tations on fund-raising costs or that required fund-raisers to make certain disclosures when soliciting donations. These statutes ran into constitutional (free speech) problems. Many states then strengthened reporting requirements on fund-raising activity. Now, in an effort to educate their publics, a growing number of attorneys general publish detailed annual reports on nonprofit fund-raising activities in their states. As fund-raising becomes more competitive, it is unlikely that the interest of state attorneys general in fund-raising will wane.

Accountability of Nonprofits. The reticence of some nonprofits to give out information to the public has become a matter of growing concern especially when nonprofits refuse to release information on matters such as compensation of staff, sources of income, and donor relations. When a public-service organization refuses to give out information of this type, the public tends to become suspicious, and often the attorney general of a state, as the protector of the public's interest in charitable activity, is called on to examine more closely the operations of the organization.

Deaccessioning. For museums, the matter of deaccessioning has been thrust to the forefront as more collecting organizations have been forced to consider deaccessioning because of economic conditions. As a result, attorneys general find themselves involved in an increasing number of controversial deaccessioning proposals.

Financial Instability. Some nonprofit boards, including museum boards, have remained relatively complacent as their organizations have moved steadily toward insolvency. A natural question is, "At what point in such cases, if at all, do board members expose themselves to liability for failure to take decisive action?" For museum boards, there is an added consideration. When insolvency may mean not just curtailment of a public service but also irreparable harm to a unique asset—the museum's collections—should this affect the level of attention expected of board members?

All of the above matters ultimately raise the issue of board liability. As explained in the previous chapter, the law spells out the standard of conduct for nonprofit board members in the broadest of terms; few cases apply the standard to museum boards. This means that when an attorney general is asked to look into a complaint alleging museum mismanagement, there is little precedent to offer guidance in determining whether there is culpable negligence. Lacking strong precedent, the average attorney general does not take an aggressive stand but seeks some defensible compromise. Few attorneys general want to sue nonprofit board members and thus discourage volunteer service, but in the near future, this could change. If public dissatisfaction with the governance of nonprofits, including museums, continues to grow, attorneys general may have no choice but to initiate more legal actions against nonprofit board members in order to establish clearer guidance concerning acceptable board conduct. Warning signs are signaling that the days of nonprofit board complacency may be over.[9]

9. For a discussion of nonprofit board members' traditionally limited exposure to liability, see C. Swords, "An Examination of Nonprofit Board Members Exposures to Liability," in American Law Institute–American Bar Association (ALI-ABA), *Course of Studies Materials: Legal Problems of Museum Administration* (Philadelphia: ALI-ABA, 1990). Note that Pub. L. 104–168 of 1996 gives the IRS added authority to check excess compensation awarded officials of charitable organizations.

To encourage self-improvement and ward off the need for court action or more regulatory control, some attorneys general have taken an active role in educating nonprofit boards about their responsibilities. This is being done through educational brochures and seminars. Some attorneys general are even willing to give informal advice to boards facing difficult problems. Practices in this area differ from state to state, but it is always sensible for a museum to inquire about educational services that may be offered by the office of the attorney general in its state.[10]

B. Can Donors Sue?

Based on the traditional rule that the enforcement of charitable trusts is reserved to the attorney general, donors and heirs of donors usually are denied standing to sue for the enforcement of such trusts.[11] Having made a gift for the benefit of the public, a donor is viewed as having no stronger claim to that gift than any other member of the public. This view, commonly accepted when an unrestricted gift is at issue, should certainly be considered by a museum as a defense when faced with a lawsuit brought by a displeased donor.

Regarding conditional gifts or those gifts that reserve a right to revoke or terminate, authorities divide over whether donors, or their representatives, can sue for enforcement. If donors are permitted to sue, there is the added question of whether they can sue individually, in their own names, or only with the attorney general as a consenting party.[12] The *Restatement of Trusts* favors the view that the attorney general is a necessary party in any such suit, following the theory, perhaps, that a gift to charity, even though conditional, involves a public interest that must be represented.[13]

Decisions regarding the standing of donors to enforce conditional gifts turn on the particular facts of each case, and it would appear that courts have little trouble in fashioning theories to support desired results. In *Amato v. The Metropolitan Museum of Art,*[14] for instance, a restricted bequest was made to the museum. The museum had six months in which to accept the gift; otherwise the bequest passed to the donor's daughter. The museum accepted. Years later, the daughter sued, claiming that the museum had not honored the re-

10. For a study of the approach to preventive education taken by attorneys general in New York, Massachusetts, and Pennsylvania, see H. Bograd, "The Role of State Attorneys General in Relation to Troubled Nonprofits," *PONPO Working Paper,* No. 206 (New Haven: Program on Non-Profit Organizations, Yale U., 1994). For examples of instructive pamphlets published by attorneys general, see Mass. Attorney General's Office, *The Attorney General's Guide for Board Members of Charitable Organizations* (Boston, Mass.: Commonwealth of Mass., Office of the Attorney General, 1993), and *Fiduciary Duties of Directors of Charitable Organizations* (St. Paul, Minn.: Minnesota's Attorney General's Office, Charitable Division, 1993).

11. *Scott on Trusts* § 391 (3d ed.). Compare the arguments of the plaintiffs in the *Pasadena Museum* case mentioned later in this chapter. See also *Herzog Foundation v. Univ. of Bridgeport,* 243 Conn. 1, 699 A.2d 995 (1997).

12. 15 Am. Jur. 2d *Charities* § 143 (1976).

13. *Restatement (Second) of Trusts* § 391 comment f (1957).

14. No. 15122/79 (N.Y. Sup. Ct., N.Y. County, Sept. 1979). See also *In re Stuart's Estate,* 183 Misc. 20, 46 N.Y.S.2d 911 (1944).

striction. The court denied relief, one of the grounds being that once the museum accepted the gift, any interest the daughter had in the property terminated. Since the daughter now had no special interest, she lacked standing to sue.

Another court approach that inhibits donor intervention is the theory that a conditional or restricted gift does not fail just because its terms cannot be followed exactly. For instance, if carrying out the terms of a restricted gift proves impractical or impossible, a museum may seek court approval to alter the restriction in either a *cy pres* action[15] or a petition for deviation.[16] If the court approves the change, there is deemed to be no failure of the gift because the general charitable intent of the donor is still being effected. If there is no failure, the donor and the donor's heirs have nothing to enforce in court.[17]

In *Abrams v. The Maryland Historical Society*,[18] heirs of a donor sued to prevent the sale of an object given to the historical society, claiming that the society accepted the gift with the understanding that the object would never be sold. Some evidence supported the claim, namely, correspondence from individual members of the society's board of trustees, and there was no executed deed of gift. The court ruled that the heirs had no standing to sue: "Gifts cannot be presumed to be conditional. Their conditions must be clearly set forth." But years later, in a somewhat similar case in the same state, the issue of "standing to sue" was not mentioned by the court in its opinion.[19] In this later instance, the donor, not the heirs of the donor, sued a local historical society in an effort to stop the deaccessioning of objects given a number of years earlier. The historical society prevailed in this case on the merits. Perhaps when a donor is still living and involved with the community, there is a reluctance to invoke procedural grounds that stop a suit, the feeling being that a court hearing on the merits will be therapeutic.

C. Expanding the Concept of Standing to Sue

With the public becoming more interested in the management of charitable organizations, not only is more pressure being placed on attorneys general, but questions are also being raised as to whether there should be more effective ways to monitor charities than by relying mainly on the initiative and interest of attorneys general. One avenue being explored is the possible expansion of the "standing to sue" concept.

15. If a charitable trust lacks a proper trustee or if the trust proves impossible or impracticable for other reasons, the court may apply the *cy pres* doctrine and approve an alternative means for carrying out the general charitable intent. See Section E(1), "Restricted Gifts," in Chapter IV for more information on *cy pres*.

16. Questions concerning a donor's ability to sue a museum invariably require a close look at the particular circumstances. For a more detailed discussion of this issue, see the Section E(1), "Restricted Gifts," in Chapter IV.

17. See *Cleveland Museum of Art v. O'Neill*, 57 Ohio Op. 250, 129 N.E.2d 669 (1955). In *O'Hara v. Grand Lodge Independent Order of Good Templars*, 213 Cal. 131, 2 P.2d 21 (1931), the court indicated that *cy pres* action taken by a charity without prior court approval could be confirmed later by the court to avoid intervention of the donor.

18. Equity No. A-58791/A513/1979 (Md. Cir. Ct. for Baltimore City, June 1979).

19. *Taussig v. Historic Annapolis*, Case #C-93-4451 (Md. Cir. Ct. for Anne Arundel County, Feb. 15, 1995).

In the prevailing majority view, the attorney general is a necessary party in a suit alleging mismanagement of a charity, but the attorney general cannot be compelled to be a party.[20] Can, then, an individual or group force a charity into court without the cooperation of the attorney general? Creative arguments are being fashioned to support a broader concept of standing to sue for alleged mismanagement of charitable organizations.[21] If the public's interest in nonprofit management continues to escalate, some of these arguments could lead to legislative changes.[22] And cases can already be found in which courts have seen fit to expand the class of individuals who can question board governance in nonprofit organizations. Of interest here is the *Wilson College* case.[23]

Wilson College is a charitable corporation that was chartered by the state of Pennsylvania in 1869 for the purpose of educating young women. It is managed by a board of trustees. In 1979, the trustees of the college voted to close the school because of declining enrollment. One trustee, several students, a few alumnae/donors, and a faculty member sued the majority of the trustees for negligence and requested the court to enjoin the closing and to remove the defendant trustees from office. The attorney general entered an appearance on behalf of the state. Without elaborating its reason, the court concluded that the trustee, the alumnae/donors, and the faculty member had standing to sue but that the students, "while having a distinct and unique interest in the proceeding," did not have "legal standing to maintain it."[24]

20. In *Dickey v. Volker,* 321 Mo. 235, 11 S.W.2d 278, 62 A.L.R. 858 (1928), it was argued that the attorney general, by challenging the plaintiff's right to bring such a suit, violated the plaintiff's constitutional right to due process of the law. The court struck down this argument. It pointed out that the plaintiff had established no property right in the charitable trust (i.e., no special interest) and that therefore he was not entitled to any trial. In *Wiegand v. Barnes Foundation,* 374 Pa. 149, 97 A.2d 81, 83 (1953), the plaintiff, as a citizen and a reporter for a major newspaper, sued a local charitable corporation. The suit was brought with the consent of the attorney general. When the court held that the plaintiff did not have standing to sue because he had no special interest, the plaintiff argued that he had the consent of the attorney general to sue. The court said: "[T]he protection of the public generally against the failure of a corporation to perform the duties required by its charter is the concern of the sovereign, and any action undertaken for such purpose must be by the Attorney General on its behalf. In the absence of statutory authority, the Attorney General may not delegate the conduct or control of the suit."

21. See, for example, K. Karst, "The Efficiency of the Charitable Dollar: Unfulfilled State Responsibility," 73 *Harv. L. Rev.* 433 (1960). Professor Karst suggests the establishment of state boards to monitor and coordinate the activities of private charities. See also J. Fishman, "The Development of Nonprofit Corporation Law and an Agenda for Reform," 34 *Emory L.J.* 617 (No. 34, 1985), and A. Ben-Ner and T. Van Hoomissen, "The Governance of Nonprofit Organizations: Law and Public Policy," 4 *Nonprofit Mgmt. and Leadership* 393 [PONPO Working Paper, No. 195 (New Haven: Program on Non-Profit Organizations, Yale U., 1993)].

22. Note, for example, the experience in California. When California adopted a new comprehensive nonprofit corporation law in 1980, the new statute spelled out a broader class of individuals who could challenge the quality of nonprofit board action. See also *Rowan v. Pasadena Art Museum,* No. C322817 (Cal. Sup. Ct. L.A. County, Sept. 22, 1981), which interprets the 1980 California nonprofit corporation law regarding standing to sue.

23. *Zehner v. Alexander,* 89 (Penn. 39th Jud. Dist., Franklin County, Ct. of C.P., Orphans' Ct. Div.) 262 (May 25, 1979).

24. See also *Miller v. Alderhold,* 228 Ga. 65, 184 S.E.2d 172 (1971), where students in a college sued to challenge a board of trustees' decision to sell certain college land. The students argued that the college was a charitable trust and that they had standing because they were beneficiaries of the trust. The court rejected the argu-

The *Sibley Hospital* case,[25] which was discussed in Chapter I in relation to the issue of board liability, also dealt with the issue of standing. The plaintiff in that case was the parent of a child who had been a patient at the hospital, and he brought the action on behalf of all patients who were forced to pay higher hospital fees because of the alleged mismanagement by the hospital trustees. On the issue of standing, the court said: "Plaintiffs purporting to represent a class of users of the Hospital's services have a sufficient special interest to challenge the conduct of the trustees operating this charitable institution. This is especially so here, for neither the District of Columbia nor the hospital has taken any action to question the conduct brought into issue by the . . . complaint."[26]

The courts of New Jersey and Maryland have taken liberal views in decisions concerning standing to sue charities. In the case of *Patterson v. The Patterson General Hospital,*[27] the city and two residents of the city were permitted to sue Patterson General Hospital, a charitable corporation that was alleged to have deviated from its trust purposes. The court said:

It must be conceded that in this state, and throughout the country as a whole, supervision of the administration of charities has been neglected. Charities in this state, whether or not incorporated, are, in general, only subject to the supervision of the Attorney General. The manifold duties of this office make readily understandable the facts that such supervision is necessarily sporadic. . . . While public supervision of the administration of charities remains inadequate, a liberal rule as to the standing of a plaintiff to complain about the administration of a charitable trust or charitable corporation seems decidedly in the public interest.[28]

This view was reinforced by a similar holding in *Cinnaminson v. First Camden National Bank and Trust Co.*[29] and was echoed in *Gordon v. City of Baltimore.*[30] In the *Gordon* case, a taxpayer was granted standing to challenge the transfer of a library from one private charitable institution to another. Since the latter institution received considerable money from the city for its operating expenses, the court reasoned that if the library was accepted, the city would

ment on the ground that the college was a charitable corporation and hence had no specific beneficiaries. The *Miller* case was affirmed in the *Corporation of Mercer University v. Smith,* 258 Ga. 509, 371 S.E.2d 858 (1988). The issue of "trust" versus "corporation" can be a murky one, as can the issue of the ramifications of either status regarding "standing to sue." See, for example, *Art Institute of Chicago v. Castle,* 9 Ill. App. 2d 473, 133 N.E.2d 748 (1956); *Stuart v. Continental Illinois Nat'l Bank and Trust Co.,* 68 Ill. 2d 502, 369 N.E.2d 1262 (1977), appeal after remand 75 Ill. 2d 22, 387 N.E.2d 312 (1979), *cert. denied* 100 S. Ct. 86 (1979); *Jones v. Grant,* 344 So.2d 1210 (Ala. 1977).

25. *Stern v. Lucy Webb Hayes National Training School for Deaconesses and Missionaries,* 367 F. Supp. 536 (D.D.C. 1973) (order granting standing of plaintiffs to sue); 381 F. Supp. 1003 (D.D.C. 1974) (final decision).

26. *Stern v. Lucy Webb Hayes National Training School for Deaconesses and Missionaries,* No. 267–73 (D.D.C. June 8, 1973) (order granting standing of plaintiffs to sue). When this case was decided, the District of Columbia did not function as a "state" and did not have a traditional Office of Attorney General.

27. 97 N.J. Super. 514, 235 A.2d 487 (1967).

28. Ibid., 495.

29. 99 N.J. Super. 115, 238 A.2d 701 (1968).

30. 258 Md. 682, 267 A.2d 98 (1970). See also *Lord v. Wilmington,* 332 A.2d 414 (Del. 1975), *aff'd,* 378 A.2d 635 (Del. 1977).

be called on to increase its support, and thus the taxpayer had a sufficient pecuniary interest to bring suit.

D. Museum Cases Involving the Issue of Standing to Sue

The trend to enlarge the concept of "standing to sue" should be of considerable interest to museums, as illustrated by two cases. One concerns the Carnegie Institute's attempt to deaccession two of its collections; the other involves the problems encountered by the Pasadena Art Museum when it put several of its works up for auction.

In January 1979, the Carnegie Institute of Pittsburgh petitioned the Pennsylvania Court for approval to sell at public sale substantially all of its coin and stamp collections.[31] The court petition approach was taken because of the volume of material at issue.[32] In its petition, the institute explained that (1) the stamp and coin collections marked for sale were unrestricted gifts to the museum, (2) the institute had never had the funds to provide professional staff and security for the collections and thus had never been able to make the collections truly available to the public, (3) the institute had determined that retention of these collections would not effectively promote the broader purpose for which the museum was formed, and (4) it would be in the best interests of the people of Pittsburgh for the institute to sell substantially all of these collections.[33] The attorney general was made a party to the proceeding, and he entered a brief on behalf of the public. When it became evident to the court that there was much public sentiment both for and against the proposed sale, a six-month stay was ordered so that interested parties could offer alternative solutions. At the expiration of the six months, another hearing was held. Present at the hearing and offering testimony was a local historical society. The historical society had submitted the only offer for an alternative method of disposition, but the offer had not been accepted.[34] The record on the case was then closed, but further time was given to the institute to effect a compromise. Several months later, an agreement was reached between the institute and the attorney general, and this was submitted to the court. The agreement permitted the institute to sell the collections, with certain limited exceptions. The historical society objected to the proposed agreement as well as the sale, but the court approved the agreement, stating that the interest of the public would be served by adjusting the matter by mutual concession. On the issue of the historical society's standing to be heard, the court said:

31. *In re Carnegie Institute,* No. 208 of 1979 (Penn. Ct. of C.P., Allegheny County, Orphans' Ct. Div., May 14, 1980). The Carnegie Institute maintains two museums in Pittsburgh: the Carnegie Museum of Natural History; and the Museum of Art, Carnegie Institute. The Carnegie Museum of Natural History was the petitioner in this case.

32. See Chapter V, Section B(2)(b), "The Proper Authority to Approve a Decision to Deaccession."

33. The Carnegie had offered the collections to other educational organizations in the area, but none were able to purchase and maintain the collections.

34. The historical society had offered to accept the collections as a gift.

Initially it is observed that charitable trusts are enforced by the Attorney General, not individual members of the public. In the absence of statutory authority, a person who has no special interest cannot maintain a suit for the enforcement of a charitable trust, nor may the Attorney General delegate the control of such a suit. . . . This is a necessity since if one individual person could interpose objections, any other individual person could also either raise objections or give support and as the decision on one individual objection would not be a bar to another individual objection, there would be no end to litigation. Therefore, while the position of the Historical Society is appreciated as well as the individual expressions of interest, there does not appear in the record of these proceedings sufficient evidence to deny giving effect to the agreement reached between petitioner [the institute] and the Attorney General.[35]

The historical society filed exceptions to the court's decision. It gave several reasons why it should have standing to participate in the proceedings, including the following:

1. The society was a nonprofit corporation chartered for the preservation of the culture and heritage of western Pennsylvania, which was the subject of the case. Therefore, the society had a special interest.
2. Many of the members of the society were stamp and coin collectors, and they thus had an interest in the preservation of the collections.
3. The historical society's submission of an alternative plan within the designated six-month period gave it a special interest that should be heard.
4. The attorney general did not adequately represent the public in the case, and therefore the society should be heard.
5. The court should hear all available evidence on the case and should not merely accept the institute and the attorney general's assertions that the proposed sale was in the best interest of the public.
6. The court should apply the *cy pres* doctrine and should award the collections to the historical society as successor trustee.[36]

The issue of standing became moot when the Carnegie Institute, believing protracted litigation would be counterproductive, amended its petition to the court. It requested permission to sell a major portion of its stamp collection only, with the understanding that the fate of the coin collection would not be pressed at that time. All parties interested in the matter agreed to this amended petition, and court approval was given in December 1980 for the sale of the described stamp collection. Two years had been spent in court on the matter.

Further ramifications of the "standing to sue" concept were raised in *Rowan v. Pasadena*

35. *In re Carnegie Institute,* No. 208 of 1979 (Penn. Ct. of C.P., Allegheny County, Orphans' Ct. Div., May 14, 1980), 2–3.

36. Compare *In re Estate of Nevil,* 414 Pa. 122, 199 A.2d 419 (1964), where a charitable organization, in a position similar to that of the historical society in the *Carnegie* case, was denied standing to challenge the court's action.

Art Museum, in which legal steps were taken to halt a scheduled sale of certain works of art from the collections of the Pasadena Art Museum.[37] The museum had deaccessioned several works, which were scheduled to be sold at a major New York auction house. Shortly before the sale, three former trustees of the museum obtained from a California court a temporary restraining order enjoining the sale. The former trustees alleged that the proposed sale would violate the trust obligations of the museum. On the issue of their "standing" to bring the action, they argued that their position as former trustees was "functionally equivalent" to that of minority trustees and that, hence, they were entitled to standing. In addition, they cited the following "personal and private interests":

1. They were individual contributors to the museum, and thus they personally should be entitled to enforce the conditions under which their gifts were made.
2. As former trustees, they had made express representations to other contributors. They considered themselves morally responsible for these representations, and some contributors might seek to hold them legally responsible. (Regarding reasons 1 and 2, the plaintiffs offered no evidence that the gifts in question were conditional. We can only assume that the gifts were made without express conditions and that the gist of the plaintiffs' argument was that any contributor to a museum acquires a special interest that entitles him or her to standing to sue.)
3. As former trustees, they had a right to vindicate the actions that they had taken as trustees and that related to the proposed sale.

In its decision on the jurisdictional aspects of the *Rowan* case, the court had to interpret California's new Corporation Code. Section 5142 of the code lists the following as having standing to sue a public-benefit (i.e., charitable) corporation:

1. The charitable corporation itself
2. An officer of the corporation
3. A director of the corporation
4. A person with a reversionary, contractual, or property interest in the assets of the corporation
5. The attorney general or any person granted relator status by the attorney general

The court considered this list to be an exclusive one, and it then proceeded to analyze whether the plaintiffs fell within category 2, 3, or 4. It determined that Section 5142 was

37. *Rowan v. Pasadena Art Museum,* No. C322817 (Cal. Sup. Ct., L.A. County, Sept. 22, 1981). Suits of this type are becoming more prevalent. A short time after the planned art sale by the Pasadena Museum was halted by a California court order, a similar restraining order was granted by a Pennsylvania court stopping another auction sale of artworks belonging to the Edwin Forrest Home for Retired Actors. The restraining order was sought because of the claim that the proposed sale violated the terms of Forrest's trust. *In re the Edwin Forrest*

not intended to give standing to former members, directors, or officers; thus categories 2 and 3 were unavailable to the plaintiffs.[38] The court indicated that category 4 might permit separate causes of actions by individual donors seeking relief for the museum's failure to abide by the terms of their particular gifts, but the court added that in this case the plaintiffs had failed to frame their complaint in this manner. In other words, the relief sought must be specifically related to the violated promise; the mere fact that one is a donor does not confer standing to question generally the actions of the museum. Regarding category 5, the court conceded that the attorney general had not granted formal relator status,[39] but the plaintiffs contended that there had been an informal grant of such status. As a practical solution, the court allowed the attorney general a short period of time in which to determine if he wanted to grant such formal status and thus secure a category 5 basis for proceeding to a trial on the merits. Subsequently, the plaintiffs did obtain formal relator status.[40]

Good arguments can be made for and against the expansion of the standing to sue rule, but few would deny that if public disillusionment with much that is now going on in the nonprofit sector continues, there will be added pressure to open more avenues of recourse for those who are discontent. If standing to sue does expand, museum trustees will find it harder to resolve controversial management issues quickly. Prior approval of proposed action by the attorney general may not protect them from lawsuits, more individual trustees may be encouraged to question board decisions through court action, and more dissatisfied third parties may decide it is worth the effort to test their ability to obtain court review of trustee decisions. But this should not discourage the prudent trustee. Good internal procedures for decision making and adherence to those procedures invariably protect members of a board from personal liability for mismanagement.[41]

Home, No. 154 of 1981 (Penn., Philadelphia Ct. of C.P., Orphans' Ct. Div., April 24, 1981) (Opinion of Court en banc, 1982). See Chapter V for other cases in which restraining orders have been sought in order to stop scheduled deaccession sales.

38. See also *American Center for Education Inc. v. Cavnar*, 80 Cal. App. 3d 476, 145 Cal. Rptr. 736, 742 (1978).

39. Relator status essentially means that the attorney general expressly permits the individual to sue in the attorney general's stead.

40. If a museum finds itself embroiled in a public debate over the interpretation of, for example, a restricted gift, it can initiate a declaratory judgment action. Here the museum asks the court to interpret the disputed language, the hope being that the court interpretation of what the language actually means will avoid protracted litigation. The declaratory judgment approach usually avoids the "standing to sue" issue but does provide a vehicle for airing the viewpoints of all arguing parties.

41. J. Merryman, "Securing Greater Trustee and Staff Accountability," in American Law Institute–American Bar Association (ALI-ABA), *Course of Studies Materials: Legal Problems of Museum Administration* (Philadelphia: ALI-ABA, 1985), argues that carefully expanding "standing to sue" could be beneficial and suggests elements of a well-drafted statute in this regard. L. Miller et al., "Selling Off the Nation's Not-For-Profit Hospitals: The Legal Basis for Oversight" (paper presented at the National Association of Attorneys General Charitable Trusts and Solicitations Seminar, Williamsburg, Va., 1995), urged attorneys general to consider authorizing private parties to bring actions to challenge the growing number of sales of nonprofit hospitals to for-profit entities. See also H. Hansmann, "Reforming Nonprofit Corporation Law," 129 *U. Pa. L. Rev.* 497, 600 (1981).

E. Oversight by Taxing Authorities

A museum, as a charity, occupies a favored position in the U.S. tax structure. "Charity" status provides a dual sustenance: It substantially renders the museum's revenues exempt from taxation, and it provides strong tax incentives for donations to the museum.[42] On the other hand, this privileged status also is a basis for a good deal of oversight of museum operations by the taxing authority.[43] Just how the government should control a charity through this tax power is a subject of much debate. A general understanding of the issues involved is helpful if one wants to respond intelligently to some of the more subtle tax-related problems that can face a museum. The issues are easier to illustrate in a historical setting.

Early in the 1900s, when the U.S. income tax system was taking root, it was acknowledged that charitable organizations were beneficial to the country and that the tax structure should foster rather than inhibit their growth. Charities had played a dominant role in the growth of the country. True to their pioneering spirit, the forefathers looked first to their community, not to the government, for basic social services. Innumerable voluntary organizations sprang up to satisfy community needs, and these organizations became accepted as part of the American way of life.[44] A major study on philanthropy, commonly known as the "Filer Report," describes this phenomenon as a reflection of "a national belief in the philosophy of pluralism and in the profound importance to society of individual initiative."[45] To

42. Outside the scope of this text is the issue of unrelated business income, income that subjects even a charity to taxation. Three publications of interest on this subject are J. Gilbert, "Museums and the Internal Revenue Code: Corporate Sponsorship and the Unrelated Business Income Tax," in American Law Institute–American Bar Association (ALI-ABA), *Course of Studies Materials: Legal Problems of Museum Administration* (Philadelphia: ALI-ABA, 1993); Memorandum of Chairman Pickle to Committee Members, "Draft Report Describing Recommendations on the Unrelated Business Income Tax, Oversight Subcommittee of the Committee on Ways and Means, U.S. House of Representatives, June 23, 1988"; and E. Aprill, "Lessons from the UBIT Debate," 45 *Tax Notes* 1105 (Nov. 27, 1989).

43. Provisions of the federal Internal Revenue Code are frequently mirrored by a state's revenue statutes. Both federal and state authorities, therefore, may assert supervision over a charity through the tax medium. On the state and local level, charities are frequently exempt from property taxes, but not always. Much depends on the interpretation of the applicable statute. For example, in the early 1980s, New York City began refusing property tax exemptions to certain educational organizations that did not have a curriculum or a faculty, but this interpretation of the law was reversed after widespread protest from cultural organizations. See the decision concerning the Asian Society as reported in the *New York Law Journal* (March 7, 1983) and *Art in America* 216 (Sept. 1983). Since the mid-1980s, more and more state and local authorities have been revising their statutes so as to restrict access to property tax exemption. This movement has been motivated not only by a need for more tax revenue but also by the perceived commercial overtones of some nonprofit activities. See also Chapter XII, "Tax Considerations Relevant to Gifts."

44. The "Filer Report," referred to in the following footnote, states that even today, there are many more voluntarily supported educational, cultural, and social organizations in the United States than in other countries, where state-run charitable organizations are the rule. An excellent selection of essays on the growth of voluntary organizations in the United States is B. O'Connell, ed., *America's Voluntary Spirit: A Book of Readings* (New York: Foundation Center, 1983).

45. Commission on Private Philanthropy and Public Needs, *Giving in America, toward a Stronger Voluntary Sector: Report to the Commission on Private Philanthropy and Public Needs* (Washington, D.C.: Commission on Private

foster these perceived public benefits of pluralism and self-help, the early tax code protected and encouraged charities by granting them tax-exempt status and by devising the charitable contribution deduction. In effect, the early tax structure encouraged diversity and sheltered charities from direct government control. As long as an organization could meet the definition given in the tax code—that it was "organized and operated exclusively for . . . educational purposes"[46]—it was ensured the favored tax-exempt status.

In later years, with the rise of a more enlightened social conscience in this country, government began to play a greater role in providing some of the services formerly left to the nonprofit sector. An effective way for the government to increase its role in this sphere proved to be the grant process wherein the government makes available to nonprofit organizations various forms of "federal financial assistance" designed to support the public-service work of such organizations. But these grants come with "strings": Nonprofits receiving the grants must conform to a variety of government social programs as a condition for the aid.[47] Most nonprofit organizations seek available grants and accept the strings. But some nonprofit organizations choose not to participate either because they object to certain of the policies imposed or because they view the grant process as an unwarranted intrusion by the government into the ideological independence of the nonprofit sector. To draw this second group into conformity with government-endorsed social policies, a new theory for justifying tax-exempt status is being touted, with considerable success. This theory equates tax-exempt status with a government expenditure. That is, the tax exemption is characterized as a sum actually owed the government but allotted, by way of the tax structure, to the charitable organization.[48] Under this approach, nonprofits are not viewed as "self-help" segments of society that received their support directly from private philanthropy but are considered recipients of public funds.

At first glance, these differing philosophic characterizations of a tax exemption may seem sophomoric quibbling, but there is a crucial distinction in end results. If, for example, a tax exemption is considered to be just what its name implies—a decision that an entity is not subject to a tax—then the only legitimate interest of the taxing authority in that entity is to see that the exemption is honestly obtained and maintained. Under this theory, called here "the traditional theory," oversight requirements imposed by the taxing authority essentially amount to maintaining and disclosing records that document true charitable activity on the part of the organization. On the other hand, if a tax exemption is viewed as an efficient way of returning to an entity its tax payment in the form of a government grant (that is, public largesse), then the mandate of the supervising government authority is more pervasive and the charity's entitlement to privileged status is far more tenuous. Under this

Philanthropy and Public Needs, 1975), known as the "Filer Report." In 1995, some in the nonprofit sector attempted to initiate a movement for a second study—similar in magnitude to the "Filer Report"—of the current status of the nonprofit sector. These efforts were unsuccessful.

46. 26 U.S.C. § 501(c)(3).

47. See the following section.

48. See S. Surrey, "Federal Income Tax Reform: The Varied Approaches Necessary to Replace Tax Expenditures with Direct Governmental Assistance," 84 *Harv. L. Rev.* 352 (1970).

theory, called here "the more modern theory," government oversight can take on the additional dimension of requiring charities to adhere to standards, programs, and procedures designed to further national, social, and economic goals that are deemed appropriate for recipients of public largesse.[49]

The two described theories, if followed logically, give very different dimensions to the nonprofit sector. One emphasizes the sector's independence; the other, the more modern theory, makes the sector much more dependent on the will of the majority. Which theory is better? Finding the answer is not simple, since either theory carried to extremes brings problems.[50] The preferred ground lies somewhere in between. But maintaining a middle ground—one where diversity and individual initiative can flourish without serious abuse—requires informed vigilance on the part of those who operate in the nonprofit sector. The key is maintaining public confidence in the overall integrity of the sector. A public that sees the nonprofit sector as essentially trustworthy is more willing to accept the traditional theory of tax-exempt status because even though the public may not sympathize with some nonprofit activity, it accepts the importance of allowing unpopular activity if that activity is honestly pursued. However, a public disillusioned by real or apparent abuses of status by nonprofits is much more willing to support the more modern theory, which legitimizes broad governmental control of the nonprofit sector through the tax mechanism. This is an old story: The greater the freedom sought, the more important it is to demonstrate integrity. The lesson for nonprofits is that their conduct—in other words, the level of trust they are able to maintain with the public—governs to a great extent whether the traditional view or the more modern view of nonprofit tax status prevails at a particular time. Simply put, for nonprofits, "trust" and "taxes" are directly linked.

F. As Recipients of Federal Financial Assistance

The phrase "federal financial assistance" should, by now, be quite familiar to the museum community. If a museum receives support that falls within the definition of federal financial assistance, it can expect that support to come with many strings attached:

49. L. Stone, "Federal Tax Support of Charities and Other Exempt Organizations: The Need for a National Policy," 20 *U.S. Cal. L. Center Tax Inst.* 27 (1968); J. Kurtz, "Tax Incentives: Their Use and Misuse," 20 *U.S. Cal. L. Center Tax Inst.* 1 (1968); H. Friendly, "The Dartmouth College Case and the Public-Private Penumbra," 12 *Tex. Q. (2d Supp.)* 141 (1969). For a complete discussion of taxes as they relate to nonprofits, see J. Simon, "The Tax Treatment of Nonprofit Organizations: A Review of Federal and State Policy," in W. Powell, ed., *The Nonprofit Sector: A Research Handbook* (New Haven: Yale U. Press, 1987).

50. The case of *Bob Jones University v. United States* highlights this [461 U.S. 574, 76 L.Ed. 2d 157, 103 S. Ct. 2017 (1983)]. In that case, Bob Jones University had a policy that forbade interracial dating and marriage—a policy based on religious philosophy. The university accepted no federal money. A group challenged the school's tax-exempt status on the "modern" theory that tax-exempt status is actually federal support. The U.S. Supreme Court carefully avoided following this line of reasoning because if tax-exempt status is truly equivalent to federal support, then under the doctrine of separation of church and state, no religious organization could enjoy tax-exempt status. Years later the university sought a ruling on the tax status of its museum. See *Bob Jones University Museum and Gallery v. Commissioner of Internal Revenue*, T.C. memo 1996–247.

- Requiring that the museum avoid certain described activity
- Requiring that the museum provide certain services or engage in certain activities
- Making the museum liable to the government for failure to adhere to various regulations
- Making the museum liable to third parties for failure to adhere to various regulations

Thus, "federal financial assistance" brings other layers of oversight that can have a dramatic impact on the administration and budget of a museum. From both legal and management points of view, it is important for a museum to understand, right from the start, the range of "strings" it must accept with any particular form of federal financial assistance.

Federal financial assistance is usually defined broadly to mean

[a]ny grant, entitlement, loan, contract (other than a procurement contract or a contract of insurance or guaranty), or any other arrangement by which the [federal] agency provides or otherwise makes available assistance in the form of

(a) funds
(b) services of federal personnel; or
(c) real and personal property or any interest in or use of property including:
 (1) transfers or leases of such property for less than fair market value or for reduced consideration; and
 (2) proceeds from a subsequent transfer or lease of such property if the federal share of its fair market value is not returned to the Federal Government.

To be a "recipient" of federal financial assistance, one need not receive the assistance directly from a federal agency. By administrative interpretation, the definition of a "recipient" includes any successor, assignee, or transferee of the original recipient but excludes the ultimate beneficiary of the assistance. Thus, if museum programs receive federal funds dispensed by a state arts agency or if museum activities are supported by municipal funds acquired from federal revenue-sharing, such indirect support is considered federal financial assistance, and the affected programs and activities must be administered in compliance with the federal statute or statutes in question. Even if federal financial assistance provides only partial support for a program or activity, as a general rule the entire program or activity must be in compliance. Similarly, if the assistance covers any portion of overhead or general operating expenses of an organization, all the organization's programs and activities are affected.[51]

From the above definition of federal financial assistance, we see that a museum can become a "recipient" in a variety of ways. The most common is through the grant process,

51. The definition and the explanation of "federal financial assistance" are general ones. The definition given in the text is the one most commonly used in federal grant programs as of 1997. A museum needs to read carefully the definition and its interpretations that might apply to any specific support that the museum receives and that falls under this general category.

which will be used here to enumerate the usual "strings" that a museum accepts as a "recipient" of government assistance. When a museum accepts a grant from the National Endowment for the Arts, the National Endowment for the Humanities, the Institute for Museum Services, or some other federal government agency, it immediately certifies that it will or will continue to comply with certain federal laws and/or regulations that concern civil rights, drug avoidance, lobbying activity, payment of federal debts, and interaction with organizations or individuals that have been barred from participation in certain federal programs or convicted of certain serious offenses.[52]

Regarding civil rights, a museum must certify compliance with the following laws:

The applicant certifies that it will comply with the following nondiscrimination statutes and their implementing regulations: (a) Title VI of the Civil Rights Act of 1964, as amended (42 U.S.C. 2000d *et seq.*), which provides that no person in the United States shall, on the ground of race, color, or national origin, be excluded from participation in, be denied the benefits of, or be otherwise subjected to discrimination under any program or activity for which the applicant received federal financial assistance; (b) Section 504 of the Rehabilitation Act of 1973, as amended (29 U.S.C. 794), which prohibits discrimination on the basis of handicap in programs and activities receiving federal financial assistance;[53] (c) Title IX of the Education Amendments of 1972, as amended (20 U.S.C. 1681 *et seq.*), which prohibits discrimination on the basis of sex in education programs and activities receiving federal financial assistance; and (d) the Age Discrimination Act of 1975, as amended (42 U.S.C. 6101 *et seq.*) which prohibits discrimination on the basis of age in programs and activities receiving federal financial assistance, except that actions which reasonably take age into account as a factor necessary for the normal operation or achievement of any statutory objective of the project or activity shall not violate this statute.

On drug avoidance, the Drug-Free Workplace Act of 1988 (Pub. L. 100–690) states:

(A) The grantee (i.e., the museum receiving the grant) certifies that it will or will continue to provide a drug-free workplace by

(a) publishing a statement notifying employees that the unlawful manufacture, distribution, dispensing, possession or use of a controlled substance is prohibited in the grantee's workplace and specifying the actions that will be taken against employees for violation of such prohibitions;

(b) establishing an ongoing drug-free awareness program to inform employees about (1) the dangers of drug abuse in the workplace; (2) the grantee's policy of maintaining a drug-free workplace; (3) any available drug counseling, rehabilitation, and employee assistance programs; and (4) the penalties that may be imposed on employees for drug abuse violations occurring in the workplace;

52. The certifications that follow are as they appear in the 1996 grant application instructions published by the National Endowment for the Humanities. These certifications tend to be standard among federal granting organizations, but current versions should be consulted for possible new statutory or regulatory language.

53. The Americans with Disabilities Act (ADA) of 1990 expanded protection for the disabled to all museums, not just those receiving federal financial assistance. See Section E of Chapter XVI for more information on access for the disabled.

(c) making it a requirement that each employee to be engaged in the performance of the grant be given a copy of the statement required by paragraph (a);

(d) notifying the employee in the statement required by paragraph (a) that, as a condition of employment under the grant, the employee will (1) abide by the terms of the statement; and (2) notify the employer in writing of his or her conviction for a violation of a criminal drug statute occurring in the workplace not later than five calendar days after such conviction;

(e) notifying the agency (i.e., the agency awarding the grant) in writing within ten calendar days after receiving notice under subparagraph (d)(2) from an employee or otherwise receiving actual notice of such conviction. Employers of convicted employees must provide notice, including position title, to every grant officer on whose grant activity the convicted employee was working, unless the federal agency has designated a central point for the receipt of such notices. Notices shall include the identification number(s) of each affected grant;

(f) taking one of the following actions, within 30 calendar days of receiving notice under subparagraph (d)(2), with respect to any employee who is so convicted: (1) taking appropriate personnel action against such an employee, up to and including termination consistent with the requirements of the Rehabilitation Act of 1973, as amended; or (2) requiring such employee to participate satisfactorily in a drug abuse assistance or rehabilitation program approved for such purposes by a federal, state, or local health, law enforcement, or other appropriate agency;

(g) making a good faith effort to continue to maintain a drug-free workplace through implementation of paragraphs (a), (b), (c), (d), (e), and (f).

(B) The applicant shall either identify the site(s) for the performance of work done in connection with the project in the application material or shall keep this information on file in its office so that it is available for federal inspection. The street address, city, county, state, and zip code should be provided whenever possible.

Regarding lobbying, if the federal financial assistance in question is more than $100,000, the following certifications apply.[54]

The undersigned (i.e., the museum official that accepts the grant award on behalf of the museum) certifies, to the best of his or her knowledge and belief, that:

(1) No federal appropriated funds have been paid or will be paid, by or on behalf of the undersigned, to any person for influencing or attempting to influence an officer or employee of any agency, a Member of Congress, an officer or employee of Congress, or an employee of a Member of Congress in connection with the awarding of a federal contract, the making of a federal grant, the making of a federal loan, the entering into of a cooperative agreement, and the extension, continuation, renewal, amendment, or modification of a federal contract, grant, loan, or cooperative agreement.

(2) If any funds other than federal appropriated funds have been paid or will be paid to any per-

54. See 45 C.F.R. § 1168.

son (other than a regularly employed officer or employee of the applicant) for influencing or attempting to influence an officer or employee of any agency, a Member of Congress, an officer or employee of Congress, or an employee of a Member of Congress in connection with this federal contract, grant, loan, or cooperative agreement, the undersigned shall complete and submit Standard Form LLL, "Disclosure of Lobbying Activities," in accordance with its instructions.

(3) The undersigned shall require that the language of this certification be included in the award documents for all subawards at all tiers (including subcontracts, subgrants, and contracts under grants, loans, and cooperative agreements) and that all subrecipients shall certify and disclose accordingly.

Regarding debt status, the following certification is required:[55] "The applicant certifies to the best of its knowledge and belief, that it is not delinquent in the repayment of any federal debt."

Finally, the grant recipient certifies the following regarding debarment and suspension:[56]

The prospective primary participant (applicant) certifies to the best of its knowledge and belief that it and its principals: (a) are not presently debarred, suspended, proposed for debarment, declared ineligible, or voluntarily excluded from covered transactions by any federal department or agency; (b) have not within a three-year period preceding this proposal been convicted of or had a civil judgment rendered against them for commission of fraud or a criminal offense in connection with obtaining, attempting to obtain, or performing a public (federal, state, or local) transaction or contract under public transaction; violation of federal or state antitrust statutes or commission of embezzlement, theft, forgery, bribery, falsification or destruction of records, making false statements, or receiving stolen property; (c) are not presently indicted for or otherwise criminally or civilly charged by a government entity (federal, state, or local) with commission of any of the offenses enumerated in paragraph (b) of this certification; and (d) have not within a three-year period preceding this application/proposal had one or more public transactions (federal, state, or local) terminated for cause or default.

Information on how these certifications can affect a particular situation within a museum can usually be obtained from the government organization offering the grant. Also, considerable literature has been published on the various aspects of the civil rights statutes covered by the certifications and on the Drug-Free Workplace Act.

Another statute that is important to museums but that is not specifically mentioned in many government grant applications is the Native American Graves Protection and Repatriation Act.[57] This 1990 statute addresses the rights of Native Americans to certain human remains, funerary objects, sacred objects, and objects of cultural patrimony with which they

55. See O.M.B. Circular A-129.

56. See 45 C.F.R. § 1169.

57. Pub. L. 101–601, 25 U.S.C. §§ 3001–3013 (1990). See Section D(6)(f) of Chapter IV for a more detailed discussion of this statute.

are affiliated, and it affects collections of museums that receive "federal funds" as distinct from "federal financial assistance." The regulations interpreting the act define the phrase "receives federal funds" to mean

[t]he receipt of funds by a museum after November 16, 1990 [the date the statute went into effect], from a Federal agency through any grant, loan, contract (other than a procurement contract), or other arrangement by which a Federal agency makes or made available to a museum assistance in the form of funds. Federal funds provided for any purpose that are received by a larger entity of which the museum is a part are considered Federal funds, for the purposes of these regulations. For example, if a museum is a part of a state or local government or a private university and the state or local government or private university receives Federal funds for any purpose, the museum is considered to receive Federal funds for the purpose of these regulations.[58]

In other words, the term "federal funds" is defined more narrowly; it covers only the receipt of money. The term "federal financial assistance" covers not just funds but also goods, services, and other benefits. A museum should note, however, that whether it receives "federal funds" or "federal financial assistance," the scope of the impact on the organization is the same.

58. 43 C.F.R. § 10.2(iii).

PART TWO

The Collection

Collection Management Policies

A. Why a Collection Management Policy?

- "Our museum has quite a few objects that we have had for years, but we aren't sure if we own them. We would like to dispose of the objects. Can we?"
- "Every year, our museum ends up taking objects we don't really want. How can we control this?"
- "Frequently, staff members are asked to provide appraisals for donors. We oblige but feel uneasy about it. How should these situations be handled?"

These are common questions from the museum community. The queries themselves reflect a degree of uncertainty regarding the role of the museum and the responsibilities of its officers and staff. Without clear direction, poor decisions are bound to be made, and for a museum, many such "mistakes" have no easy solutions. The best approach is prevention, and today an almost essential preventive measure is the adoption and implementation of a collection management policy.

A collection management policy is a detailed written statement that explains why a museum is in operation and how it goes about its business. The policy articulates the museum's professional standards regarding objects left in its care and serves as a guide for the staff and as a source of information for the public.

A good collection management policy covers a broad range of topics:

1. The purpose of the museum and its collection goals
2. The method of acquiring objects for the collections
3. The method of disposing of objects from the collections
4. Incoming and outgoing loan policies
5. The handling of objects left in the custody of the museum
6. The care and control of collection objects generally
7. Access to collection objects
8. Insurance procedures relating to collection objects
9. The records that are to be kept of collection activities, when these records are to be made, and where they are to be maintained

Each of the above-mentioned topics raises a host of issues that must be considered if comprehensive and practical guidance is to be offered in the policy itself. Many of these issues are listed in the following section, "Guidelines for Preparing a Collection Management Policy." The very exercise of reviewing and coming to terms with these issues provides a worthwhile educational opportunity for museum officers and staff. All who participate in writing or revising a collection management policy cannot help but emerge with a better appreciation of their respective roles and with a firmer grasp of important basic principles.

The guidelines should not be viewed as a rigid format for the preparation of a collection management policy. Their purpose is to provoke thought and discussion. The form and content of any policy rests essentially with the individual museum, and it should be tailored to the needs of the museum. A collection management policy is not unlike a pair of eyeglasses; both are effective aids to perception only if individually prescribed and faithfully used. For example, some museums do not maintain collections but focus on exhibiting the works of others. Some children's museums collect not to preserve but to have objects for "hands-on" use in educational activities. Some museums operate under restrictions that forbid additional collecting and/or lending and/or deaccessioning. Zoos, botanical gardens, and the like have collections that multiply and die. The size of the organization will affect the resulting collection management policy as well. The small historic house may find itself able to produce efficiently a relatively brief but workable document. On the other extreme

might be the National Park Service, which found itself in the late 1980s with an estimated collection of over 25 million objects of every description scattered throughout the country. Clearly, just to bring the National Park Service collection under control would take years of effort and communication and many pages of policy.[1]

Drafting a collection management policy is not an easy task. It requires much communication among staff members and much frank discussion between staff and board members (or, for the government museum, appropriate agency officials). Areas of uncertainty or disagreement must be resolved and adjustments made. The objective in drafting the policy is not to attempt to solve all possible problems but to define areas of responsibility and to set forth guidelines for those charged with making certain decisions. The completed policy should be approved by the board or entity charged with the overall governance of the museum, and once in effect, the policy should serve as a formal delegation of responsibilities.[2]

As noted in the Preface, one of the objectives of this text is to stress "prevention." For this reason, it is urged that the text be used as a tool for drafting or perfecting a collection management policy.[3] Each chapter serves this end. Chapters I and II, on the nature of a museum and its accountability, provide essential background material for understanding the role of a museum, the duties of governing boards, and the obligations owed the public. Chapter III, this chapter, introduces the general topic of collection management and provides guidelines for drafting a collection management policy. Subsequent chapters discuss specific collection problems, but these chapters should not be read in isolation. They presuppose an understanding of the material in the preceding chapters.

B. Guidelines for Preparing a Collection Management Policy

These guidelines are offered as a checklist for the museum interested in drafting or revising a collection management policy.[4] Most of the issues raised in the guidelines are treated in detail in the following chapters. Chapters I and II, which concern the legal nature of a

1. For a publication devoted to the collection problems of children's museums, see *Hand to Hand* (San Diego: Association of Youth Museums, 1991–92). For an overview of the National Park Service's plan for collection management, see "National Park Service Plan for Museum Collections Management," a document submitted to the U.S. Congress in 1987 by the National Park Service in conjunction with its 1988 budget as set forth in House Report 99–714 on Pub. L. 99–500 and Pub. L. 99–591. Since the late 1980s, the National Park Service has made considerable progress in implementing this plan, and it has produced many worthwhile publications on the subject of collection management. The Curatorial Services Division of the Cultural Resources Branch of the National Park Service, Washington, D.C., is an excellent source of information on the National Park Service's activity in collection management.

2. See Chapter I, Sections E, F, and G.

3. As of 1984, the Accreditation Commission of the American Association of Museums considers a written collection policy essential for a museum that is seeking accreditation.

4. This section is based on presentations made by the author in 1979 and 1981 to the American Law Institute–American Bar Association seminars on "Legal Problems of Museum Administration," copyright 1979 and 1981 by the American Law Institute. The presentations are reprinted with the concurrence of the American Law Institute–American Bar Association Committee on Continuing Professional Education.

museum and its accountability, are suggested as useful preliminaries. These first two chapters stress the importance of addressing the following points before beginning work on a collection management policy:

- The need to clarify the status of the museum at issue. Is it a nonprofit organization? Is it a government-controlled entity? Is it part of a larger educational organization (such as a unit within a college or university)?
- The need to identify and assemble all documents that establish the purpose of the museum and that may place limitations or conditions on the functioning of the museum.
- The need to clarify lines of authority and to identify who, ultimately, has the power to approve policy for the museum at issue.
- The need to be familiar with outside authorities that do or could have oversight of certain museum activities.

1. GENERAL COMMENTS

A collection management policy is a comprehensive written statement that sets forth the goals of a museum and explains how these goals are pursued through collection activity. One of the main functions of the policy is to guide staff members in carrying out their responsibilities. The policy, therefore, must be detailed enough to provide useful instruction and yet avoid procedural minutiae. (The latter are subject to frequent revision and are more appropriately handled in supplementary documents.) Flexibility is essential also to permit prudent ad hoc decisions. These objectives can be achieved by taking the following actions:

- Clearly define areas of responsibility.
- Where possible, delegate final decision-making authority to one individual or group.
- Establish policy, but where appropriate, permit decision-making authorities to grant exceptions in unusual circumstances.
- Stress the maintenance of complete, written records regarding all collection-related decisions.[5]

2. DEFINITIONS

The following terms are used in these guidelines:

- A *collection object* is an item that has been or is in the process of being accessioned into the collections.
- *Accessioning* is the formal process used to accept and record an item as a collection object.

5. In a museum, the registrar plays a key role in designing and maintaining record-keeping systems. Two publications that describe the range of duties that normally fall under the purview of the registrar are M. Case, ed., *Registrars on Record: Essays on Museum Management,* (Washington, D.C.: American Association of Museums, 1988), and D. Dudley and I. Wilkinson et al., *Museum Registration Methods* (Washington, D.C.: American Association of Museums, 1979) (in process of revision as of 1997).

- *Deaccessioning*[6] is the formal process used to remove an object from the collections permanently or, when an object has been lost or destroyed, the formal process used to document the loss in the collection records.
- *Loans* are temporary assignments of collection objects from the museum or temporary assignments of similar objects to the museum for stated museum purposes, such as exhibition and research. These assignments do not involve a change in ownership.
- *Objects placed in the custody of the museum* are items that are not owned by the museum but are left temporarily in the museum for other than loan purposes, such as for attribution, identification, or examination for possible gift or purchase.

3. DRAFTING THE POLICY

a. Statement of Purpose and Description of Collections

The introductory "statement of purpose" should be written so that it sets forth basic information:

- The purpose of the museum
- The present scope and uses of the museum's collections
- The more immediate goals of the museum as they relate to the collections

Statutes and legal documents pertinent to the establishment of the museum should be explained,[7] as well as the role of any museum boards or committees involved in collection procedures. If the museum maintains more than one type of collection (for example, permanent collection, study collection, school collection), the statement of purpose section may be a convenient place to describe each type and its rationale. When a museum lists more than one type of collection, differences in the handling of these collections, if any, should be noted appropriately in its collection management policy.

 The drafting of the statement of purpose (sometimes called a "mission statement") can prove to be a challenge, both for the small organization that has very limited financial resources and for the larger organization that must contend with more decentralized control. How focused must collecting be in order to ensure sufficient depth? What portions of time and money should be allocated to collecting? to exhibits? to educational outreach? Has there been a realistic appraisal of the resources needed to support a collection (record-keeping, storage, conservation, exhibits)? Each of these questions, and others, must be considered

6. The term *deaccessioning* is generally accepted in the museum community, though it is not always found in a dictionary. Some postulate that it is a corruption of the word *decess,* but many others explain it as an amalgamation of *de* ("to do the opposite of") and *accession.*

7. Care should be taken to ensure that the activities of the museum are in accord with its articles of incorporation, charter, or other founding document. See, for example, *Queen of Angels Hospital v. Younger,* 66 Cal. App. 3d 359, 136 Cal. Rptr. 36 (1977); *Holt v. College of Osteopathic Physicians and Surgeons,* 61 Cal. 2d 750, 394 P.2d 932, 40 Cal. Rptr. 244 (1964); *Rowan v. Pasadena Art Museum,* No. C 322817 (Cal. Sup. Ct., L.A. County, Sept. 22, 1981).

before a realistic statement of purpose can be produced.[8] One article that describes a particular historical society's efforts to draft a statement of purpose put it this way: "What the committee was actually wrestling with was a question of finding a comfortable middle ground between the ideal and carelessness. . . . Few, if any, historical organizations have the personnel or funding to pursue the ideal. What is necessary is to have an understanding of professional standards and then to develop a plan that best approaches the ideal, based on the organization's resources."[9]

Because the statement of purpose is a very crucial element in any collection management policy, it is prudent to go back and thoughtfully reexamine the articulated purpose after the entire policy has been drafted. What has been learned in the drafting process should provide a basis for more critical review. And when a collection management policy has been written well, it serves as a constant reminder that no addition to the collection is "free." The statement of purpose stands as a stern guard at the entry door.

Some museums find it useful to go a step beyond a statement of purpose and add a statement of collecting strategy. The latter more precisely articulates the organization's philosophy of collecting. Museums within the Smithsonian Institution are now required to add collecting strategy statements to their collection management policies; these statements are described as follows: "Collecting strategy statements define the collecting parameters, goals, and objectives of each museum in relation to its mission and collections. At a minimum, these statements provide a rationale for collecting; specify collection types that the museum actively seeks to acquire; and rationalize collection disposals. Collecting strategy statements ensure logical, responsible collections growth by establishing well-defined goals and priorities that guide collecting activities."[10]

A final comment on the statement of purpose concerns a subject that is being raised more frequently as museums become increasingly aware of the cost of assembling and maintaining collections. The subject is the feasibility of regional or national collecting plans. In essence, these plans propose coordination among sister museums (organizations that are in the same geographical area or that collect in the same discipline), whereby each museum is assigned a specific collecting focus that is part of a master plan designed to ensure adequate coverage of a broad spectrum of collecting. Two arguments are given in favor of such plans: (1) without such coordination, there are both duplications and gaps in the resources available to the public; and (2) with an assigned focus, an organization can collect more efficiently and economically. In countries where museums are controlled by the government, mandated collecting plans of this nature are possible.[11] In the United States, where

8. Examples of serious cases of overcollecting (collecting without consideration of the ability to maintain) include the Museum of American Indian, Heye Foundation (New York), and the New York Historical Society. For a thought-provoking essay on "growth" within museums, see S. Weil, "A Brief Meditation on Museums and the Metaphor of Institutional Growth," *A Cabinet of Curiosities* (Washington, D.C.: Smithsonian Institution Press, 1995).

9. K. Broenneke and K. Petersen, "Planning for Change," 39 *History News* 12, 14 (No. 8, August 1984).

10. *Smithsonian Directive 600* (1996).

11. Sweden has a national system of collection, known as SAMDOK, designed to cover all major areas of collecting associated with the home, the workplace, and the public-commercial arena.

most collecting organizations are not government controlled, statutorily mandated collection plans would be illegal. Accordingly, for most nonprofit museums, the issue of regional or national collecting plans is an interesting option for individual organizations to consider but is not a matter for legislative control.[12]

The subject of regional or national collecting plans is raised more frequently with regard to contemporary collecting in the history field and with regard to archaeological collecting. In contemporary history, the central problem is the massive amount of ever-changing products that can be collected. In the archaeology field, the concern is the quality of the database that results from haphazard excavation and insufficient attention to curation decisions.[13] As early as 1984, *Museums for a New Century: A Report of the Commission on Museums for a New Century* spoke strongly in favor of cooperative collecting. It made this recommendation:

The aggregate national significance of museum collections, the vast number of objects that might potentially be collected and the limited resources available to museums mandate that careful thought be given to their growth and care. We urge museums with similar interests to develop the elements of coordinated policies on what objects, artifacts and specimens are to be collected, how and by which institution. Such policies, when appropriate, should be self-governing policies developed by the professional organizations within each discipline.[14]

Despite the clear call for cooperative effort, movement has been slow in this direction.

b. Acquisition of Objects

Objects may be added to collections by means of gifts, bequests, purchases, exchanges, fieldwork acquisitions, or any other transactions by which title to the objects passes to the museum. Some basic questions should be considered when determining whether an object should be added to a collection (that is, "accessioned"):

- Is the object consistent with the collections goals of the museum?
- Is the object so unusual that it presents an exceptional opportunity for the museum and thus should be given preferential consideration?
- If the object is offered for sale, might it or a comparable object be obtained by gift or bequest?
- Can the proper care be given to the object?

12. Of course, a nonprofit could be bound by donor-imposed conditions that restrict the organization from altering its collection focus. Before seriously considering any alteration in collecting focus, each nonprofit must first examine its founding documents.

13. See, for example, L. Sullivan, "Managing Archeological Resources from the Museum Perspective," *Technical Brief No. 13,* ISSN 1057-1574 (Washington, D.C.: Cultural Resources, National Park Service, Department of the Interior, 1992). Such problems are seen more in archaeological collections because this is one area in which federal and state statutes regulate the removal of archaeological material from government-controlled lands. Unfortunately, these statutes have never been implemented with a concern for good, long-term curation of the material.

14. *Museums for a New Century: A Report of the Commission on Museums for a New Century* (Washington, D.C.: American Association of Museums, 1984), 39.

- Is the object something that clearly would be more appropriate for another collecting organization?
- Will the object be used in the foreseeable future and is there a good-faith intention to keep it in the museum's collection for the foreseeable future?
- Is the provenance of the object satisfactory, and how is this decision made?
- Is the object encumbered with conditions set by the donor (for example, a requirement that it be permanently displayed)? How are decisions made on such matters and by whom?
- Is the use of the object restricted or encumbered (1) by an intellectual property right (copyright, patent, trademark, or trade name) or (2) by its nature (for example, obscene, defamatory, potentially an invasion of privacy, physically hazardous)? How are decisions made on matters of this nature and by whom?
- Will the acceptance of the object result, in all probability, in major future expenses for the museum (for example, because it needs conservation or maintenance or because it opens a new area of collecting)?

The policy should clearly state the procedures to be followed in accessioning, who makes the final decision, what records must be made of the process, when the records are to be made and by whom, and where the records are to be maintained.

In determining the procedure and the appropriate level of authority for accepting items for the collections, a museum may have to make distinctions on the basis of such factors as size or extent of the objects, value, cost of maintenance, and restrictions on use.

As a general rule, objects should not be accepted unless they are destined for particular collections for the foreseeable future. Exceptions to this rule should be permitted only with the knowledge of the donors and with due consideration to the satisfactory disposition of unwanted objects.[15]

Advice should be given regarding the appraisal of objects by the staff in response to outside requests. As a rule, museums avoid making formal appraisals, especially at the request of donors or prospective donors. Deviations from the museum's standard practice should require the approval of an appropriate museum official.[16]

c. Deaccessioning

As a general rule, collection objects may be deaccessioned unless there are specific restrictions to the contrary. Again, some basic questions should be considered when determining whether an object should be removed from a collection:

- Are there any restrictions that may prohibit removal? What is the procedure for resolving such questions?

15. See Chapter IV, Section A, "The Meaning of the Word *Accession*," and Chapter XII, "Tax Considerations Relevant to Gifts."

16. See Chapter XIII, "Appraisals and Authentications."

- Is the object no longer relevant and useful to the purposes and activities of the museum?
- Is there a danger of not being able to preserve the object properly?
- Has the object deteriorated beyond usefulness?
- Is it doubtful that the object can be used in the foreseeable future?
- Is there a need to weed out redundant items?
- Is there a need to improve or strengthen another area of the collections in order to further the goals of the museum?
- Have the interests and reactions of the public been considered?

The above considerations assume that a deaccession is voluntary. But some removals are not voluntary, for example when it is established that the museum does not have good title to the object or when an object has been stolen or lost and there is little hope of retrieval. For these cases, at some point, the museum must consider deaccessioning the object—with complete documentation as to why the action is being taken—so that accession records accurately reflect what is in the collection.

The policy should clearly state the procedures to be followed in deaccessioning, such as who makes the final decision, what records must be made of the process, when the records are to be made and by whom, and when the type and value of the object under consideration may dictate additional precautions, such as the need for a higher level of approval than ordinarily required or for outside appraisals.

The issue of acceptable methods of disposal also should be addressed. The following are some basic questions:

- May objects be disposed of by exchange, donation, or sale?
- Will preference be given to any particular method(s) of disposal?
- Will scholarly or cultural organizations be preferred as recipients over private individuals or commercial entities?
- Will local or national interests be given weight in deciding on the recipient?
- If an object has seriously deteriorated, may it be designated for other uses or destroyed?
- If donors of items to be deaccessioned are alive, as a matter of courtesy are they to be notified of the intent to deaccession?
- How are the funds realized from deaccession sales to be used?[17]

d. Loans

Outgoing Loans. In general, museums expect to lend objects only to similar institutions. The major reasons for this practice are to afford the loaned object sufficient environmental protection, to ensure adequate safety precautions, to encourage research on and public enjoy-

17. Note in Chapter V the discussion on the use of such funds.

ment of the object, and to avoid use of the object for private gain. In drafting loan statements, the museum should bear these reasons in mind. Also, it is recognized that justifiable distinctions can be made between the loan of a painting and, say, the loan of a plant specimen. The following are some of the matters that should be addressed:

- When are loans from the collection made and for what purposes? To whom will loans be made?
- Who has the authority to approve loans from the collection?
- If unusual restrictions are to be placed on a proposed outgoing loan, who must approve the loan?
- Will items be lent if there is a question whether they can withstand travel, extra handling, or climate changes? How are such matters resolved?
- To ensure proper accounting, the museum should make all loans for specified periods of time (with options for renewal). How is this rule implemented?
- What procedures must be followed by the staff in proposing and processing a loan? What is the museum's policy regarding facilities reports on prospective borrowers? What records are necessary, when must they be made and by whom, and where are these records to be maintained?
- Who has the responsibility for monitoring a loan? What procedures are to be followed in connection with a loan that is about to expire or a loan that is overdue?

Incoming Loans. The following questions, some of which are identical to those applying to outgoing loans, should be addressed in connection with incoming loans:

- When are objects borrowed and for what purposes? From whom may objects be borrowed?
- Who has the authority to approve an incoming loan?
- If a prospective lender places unusual restrictions on a proposed loan, who in the museum must approve the loan and ensure compliance?
- How are decisions reached concerning the provenance of an item that may be the subject of an incoming loan? (The mere possession of an object of doubtful provenance can have ethical ramifications and/or legal consequences.)[18]
- Will items be borrowed if there is a question whether they can withstand travel, extra handling, or climate changes? How are such matters to be resolved?
- What procedures must be followed by the staff in proposing and processing an incoming loan? What records are necessary, when must they be made and by whom, and where are these records to be maintained?
- Who has the responsibility for monitoring a loan? for packing and shipping the material when it is to be returned?

18. See the discussion in Chapter IV, Section D, "Circumstances That Can Affect the Quality of Title."

e. Objects Placed in the Custody of the Museum

It is prudent for a museum to record, in some predetermined manner and within a reasonable time, every object that is placed in its care. This means there should also be a registration method for objects, other than loans, that are left temporarily in the custody of the museum for such purposes as attribution, examination, and identification. In addition, the registration method should be designed to encourage periodic review of these objects to ensure expeditious handling. Existing museum practices should be reviewed with these considerations in mind.

The authority to accept objects placed in the custody of the museum should be clearly delegated to specific individuals.

f. Care of the Collections

Guidance on the topic of care of the collections should touch on a range of issues, such as the following:

- At all times, staff members should be aware of their responsibilities to preserve and protect collection objects. This rather obvious point warrants repetition in the collection management policy.
- Are the collections, whether on exhibition or in storage, adequately protected against fire, theft, vandalism, and natural disaster, as well as harmful light, temperature extremes, humidity, and dirt? Are there established procedures for handling such emergencies and providing proper environmental conditions? Who in the museum has oversight responsibilities in these areas?
- Conservation of collection items is a continuing responsibility. Should there be a delegation of responsibilities to appropriate staff members to monitor conservation needs?
- Appropriate attention should be given to the packing and shipping of collection items moving in or out of the museum. Who bears the responsibility for monitoring this?
- Ideally, no collection item should ever leave its assigned exhibition or storage spot unless a written record of such movement is made and the record centrally filed.

g. Records

The following issues concern the adequacy of a museum's record systems:

- Each museum should have established systems for preservation of the data on collections. Collection records may be divided into two general categories. The first includes records that are commonly associated with registration functions. These primarily document the legal status of an object within the museum or on loan from the museum and that object's movement and care while under the control of the museum. The second category includes records associated with curatorial functions. These provide a broad body of information that establishes the object's proper place and importance within its cultural or scientific sphere.

- Good registration records normally include a descriptive catalog record as well as evidence of legal ownership or possession of all objects. These record systems should relate to objects by a unique museum number (for example, accession number, loan number) and should provide for easy retrieval of object information as well as current object locations. Records of accessioned objects should further reflect the prior history of ownership of each object and all activity of the object (loan, exhibit, restoration, deaccession). Records of objects on loan to the museum should reflect all activity of the objects while under the control of the museum.
- Collection records should be timely made, housed in secure locations, and physically preserved by proper handling and storage methods.
- A duplicate copy of registration records should be made and should be stored outside the museum as a security precaution.
- Automated record systems should be designed so as to incorporate the above-described criteria and to provide security for the integrity of the records.

h. Insurance

Concerning insurance, the following are some questions that should be addressed:

- If funds are limited, what is the proper role of insurance versus, for instance, protection, conservation, packing, and transportation requirements?
- Is insurance to be carried on the museum's collections when these collections are in the custody of the museum? If so, are collections insured at full value or at a fraction of value?
- Must outgoing loans be insured? If so, by whom? Who pays?
- Must incoming loans be insured? If so, by whom? Who pays?
- Should objects that are left in the custody of the museum be insured?
- What records must be kept regarding insurance and by whom?
- Who has the authority to approve deviations from established insurance procedures?

i. Inventories

To police collection activities, a museum should establish inventory procedures. These procedures usually address several topics:

- Uniform method of maintaining inventory records
- Periodic comprehensive inventories
- Spot-checking of inventories
- Procedures to be followed if collection items appear to be missing

j. Access to the Collections

This section covers such topics as the following:

- Who has access to the collections? (This concerns actual physical access as well as access to copies of the collection or collection-related material.)
- When can access be denied and by whom?
- Are fees to be charged for record reproduction work? Before answering these questions, a museum should review any "freedom of information," "open meeting," and/or "privacy" laws in effect in the locality to determine whether they apply to the museum. (A government-controlled museum may have more complex problems in the area of access.)

The Acquisition of Objects

Accessioning

7. Laws Protecting Plants and Wildlife (and Parts Thereof)

 a. Lacey Act

 b. Convention on International Trade in Endangered Species of Wild Fauna and Flora (CITES)

 c. Endangered Species Act

 d. Marine Mammal Protection Act

 e. Migratory Bird Treaty Act

 f. Bald and Golden Eagle Protection Act

 g. The Wild Exotic Bird Conservation Act

 h. African Elephant Conservation Act

 i. Antarctic Conservation Act

 j. Application to Museums

8. Laws Protecting Antiquities and Historic Properties

 a. Antiquities Act of 1906

 b. Archaeological Resources Protection Act of 1979

 c. National Historic Preservation Act of 1966

 d. Impact of Antiquities Laws on Collections

E. Circumstances That Can Affect the Completeness of Title

1. Restricted Gifts

 a. The Offer of Restricted Gifts

 b. Is the Gift Restricted?

 c. Interpretation of Restrictive Language

 d. Relief from Restrictions

2. Copyright Considerations

 a. What Is Copyright?

 b. Has Copyright Expired?

 c. Was Copyright Lost?

 d. Who Owns the Copyright?

 e. How Is Copyright Transferred?

 f. What If the Museum Owns No Copyright Interests? Fair Use

 g. Requests for Permission to Reproduce Museum Holdings

 h. Electronic Uses

 i. Fair Use in the Electronic Environment

 j. Special Considerations with Internet Uses

 k. Additional Information on Copyright Issues

3. Other Restrictions on Use: Artists' Rights and Content-Related Rights

 a. Artists' Rights: *Droit Moral*—the Visual Artists Rights Act of 1990
 b. Artists' Rights: *Droit de Suite*
 c. Content-Related Rights: Privacy, Publicity, First Amendment

F. Acquisition Procedures

1. Role of the Collection Management Policy
2. Deeds of Gift
3. High-Risk Acquisitions
4. Special Tax Considerations

A. The Meaning of the Word "Accession"

A museum may acquire objects in numerous ways, and objects may be sought for a variety of reasons. The method of acquisition or the intended purpose can raise special considerations; therefore, some preliminary observations are in order.

 The subject of this chapter is the acquisition of objects for the collections, or "accessioning." Accessioning is the formal process used to accept and record an item as a collection object. The term *accessioning* should be used with precision.[1] A museum may maintain various types of collections. Permanent collections usually contain the choicest objects, whereas study collections have related objects, or those of lesser quality, that contribute to the understanding and appreciation of the permanent collection. School collections frequently consist of expendable material useful for instruction, and an exhibit or "prop" collection may be made up of objects that are used as background material for museum exhibitions. Archival or book collections that supplement the object collections are common. The word *collection* implies permanence; so should the word *accession*. A museum should accession only those objects that it intends to retain for the foreseeable future.[2] For instance, if a museum accepts the donation of an object for the purpose of placing that object in its annual auction sale, the object may be acquired, but it should not be accessioned. There is no requisite intent to retain. Indiscriminate accessioning can create a poor image. Most donors expect that objects given to a museum will be preserved for public use. A museum that routinely accessions all donations, whether it intends to keep them or not, may soon lose the confidence of its public. In addition, it may find itself in an awkward position with the Internal Revenue Service (IRS). An object given to a museum for its "related use"—a use that qualifies the museum for the § 501(c)(3) federal tax status—carries the most favorable tax consequences

 1. See also Section F, "Acquisition Procedures."

 2. This is not to imply that once accessioned, an object can never be removed from the collection. (See Chapter V, "The Disposal of Objects: Deaccessioning.") Experience and changing circumstances may justify removal. However, if a museum wants to maintain its integrity, each decision to accession should be made thoughtfully and in good faith. If accessioning is used merely to "cool" (i.e., hold for a discrete period) gifts before disposal, a serious lack of professional ethics is evident.

for the donor.[3] That same object given to the museum for an unrelated use has less favorable tax advantages.[4] For a museum, the IRS considers additions to the collections as a related use, but fund-raising (even when the funds will be used to purchase objects for the collections) does not fall into this category. If all donations of objects are accepted and acknowledged by a museum in the same manner, regardless of the intended use, there may be the appearance of collusion, with tax consequences.[5] It is not wrong for a museum to accept donations of objects for an auction or for immediate exchange, but such transfers should be carried out in a forthright manner. Donors should be apprised of the intended use, the method of recording the gift should be distinct from an accession, and acknowledgments should be phrased accordingly. Without tax incentives and generous donors, museums could not flourish. A lack of candor on the part of museums in the handling of donations could jeopardize either or both of these benefits.

History museums that collect contemporary material culture often point out that they have a particularly difficult time deciding when to accession. In the consumer-driven U.S. society, the life of a new product may be short. The curator who waits to determine whether an object is significant enough to acquire for the collection may then have to pay dearly for it. Should the curator instead overcollect while contemporary products are plentiful and then weed out the collection at a later time? Would such a practice run afoul of tax laws? Would it disillusion donors? Would it lead to chaos in the museum storage areas? The answers all depend—on the degree of discipline used, on the value of the objects at issue, and on the care and regularity used by the museum in periodically reviewing the significance of the objects. If a museum is contemplating initiating such an approach to contemporary collecting, it should bear these points in mind. If third parties later question the practice, the museum will be expected to have complete records on all objects acquired and on the fate of each object. Without doubt, these records will have to be disclosed, and they, not the words of a public affairs officer, will be the museum's answer to any charge. In other words, if a museum is confident enough of the prudence of its property acquisition procedures that it is willing to make their application a matter of public record, then the museum probably has little to worry about.

3. Such gifts of capital gain property may normally be deducted at their fair market value. See Chapter XII, "Tax Considerations Relevant to Gifts."

4. The fair market value of a gift of tangible personal property that is put to an unrelated use by the charitable organization must be reduced by 100 percent of its appreciation. ("Appreciation" is fair market value minus the donor's basis in the property.) See IRS Publication No. 526, "Income Tax Deductions for Contributions," for additional information. See also IRS Code § 170(e)(1)(B), IRS Regulations § 1.170A-4(b)(3), and Chapter XII.

5. The IRS takes the position that a gift of tangible personal property to a charitable organization may be treated as put to a related use if (1) the taxpayer establishes that the property is not in fact put to an unrelated use by the donee; or (2) at the time of the contribution or at the time the contribution is treated as made, it is reasonable to anticipate that the property will not be put to an unrelated use by the donee (see IRS Publication No. 526, "Income Tax Deductions for Contributions," and IRS Regulation § 1.170A-4(b)(3)(ii). See also Chapter XII, noting especially Section C, "Concept of 'Unrelated Use.'" Note also the discussion in Chapter V, Section B(2)(e), which explains IRS notification requirements when certain gifts are transferred by a museum within two years of receipt.

Another observation on the acquisition process deserves mention. Wherever possible, transfers of groups of objects should be culled before material is accessioned. A museum may be tempted to accession everything in a large group and wait until later to weed out noncollection-quality items. Technically, accessioning is a thoughtful process by which only appropriate material is added to a collection. Also, what has been accessioned should not be removed permanently from a collection unless it has gone through a carefully documented deaccession process. The expedient "accession everything for now" approach muddies the water and, in the long run, can be more time-consuming and expensive. There are, however, situations in which accessioning by relatively unculled batch or lot may be prudent. For example, natural history specimens that result from field collecting may come to the museum when there is no staff expert in that particular area. Critical culling is not possible, but the material may clearly be worth preserving for later evaluation. The sensible solution may be to accession by batch, with careful documentation of the source. This secures the material and places it on record for the interested scholar.[6] To avoid abuse of this practice (and the consequent storage problems), a museum is advised to have clear procedures regulating its use. At the other extreme is inordinate delay in culling and recording—a practice clearly at odds with the purposes of the museum. Often the obvious, but rarely popular, solution is for the museum not only to require that accessioning be accomplished promptly and precisely but also to allocate sufficient resources so that this can be done.

Collection objects can be acquired in a variety of ways: gift, bequest, purchase, exchange, or any other method that transfers title to the museum. Once an object has been accessioned, however, obligations are imposed. The item must be properly stored, maintained, conserved, documented, and made available for the benefit of the public. The best time to avoid many problems, therefore, is at the acquisition stage. Every item offered should be carefully weighed with regard to its suitability for the collections, its provenance, and the ability of the museum to care for the object and use it effectively. In reality, not even a gift is free. Each acquisition places demands on the museum's resources.[7]

These same considerations should be borne in mind for bequests or potential bequests of objects.[8] It is sometimes assumed that a bequest must be accepted. This is not so. When a museum is notified that it is a beneficiary under a will, the first order of business is to determine the exact nature of the bequest and whether it is suitable for acceptance. A copy of the will, or a pertinent portion thereof, should be obtained from the estate so that the nature of the gift can be verified. (The will, or the portion thereof, is also an important part of the accession records of any bequest that is accepted.) Normally, the notice to the museum that it is a beneficiary under a will contains the name of the person charged with representing the estate (he or she may have the title "executor," "executrix," "administrator,"

6. If a batch or lot accession has been determined to be appropriate, museum procedures regarding the deaccessioning of items within that batch or lot may be more relaxed. See Chapter V, Section B(2)(b), "The Proper Authority to Approve a Decision to Deaccession."

7. See Chapter VII, "Unclaimed Loans," footnote 22, on the cost of maintaining collection objects.

8. A bequest is something left or given under a will, as distinct from a gift, which is given during the life of the donor.

or "administratrix") and, possibly, the name of the attorney who is assisting in representing the estate. If an attorney is listed, the museum should direct its correspondence to him or her. Where no attorney is noted, correspondence should go to the person representing the estate.[9] At this point, the bequeathed object should be seen or pictures obtained in order to assist in deliberations concerning its suitability for the collections.[10] A museum may decide to take or not to take the object, or if the bequest is a group of objects, it may decide to take all the objects, a portion of the objects, or none of them. In any event, the party representing the estate should be promptly notified of the museum's desires. At some point, the museum may be asked to provide evidence of its tax-exempt status—the IRS notice verifying § 501(c)(3) status and evidence of state tax status—because the tax status of beneficiaries can affect the tax consequences of an estate.

It is not unusual for a potential benefactor to mention to a museum an intended bequest. There is no better time to discuss frankly the proposed bequest. If the intended gift is not appropriate, more suitable organizations can be suggested. If unacceptable restrictions will be imposed, the museum can explain its reservations. As a rule, donors appreciate candor as well as tact, since such treatment is the only way they can be assured that their generosity will be welcomed and put to effective use. At the same time, the intended recipient museum can anticipate a welcomed addition, not a possible problem.

Note the word "anticipate." A will does not take effect until the party dies. A person is free to change a will at any time, and even though a copy of the will may have been given to a museum, this does not limit the person's ability to change the will at any time. However, the statement that "a person is free to change a will at any time" needs to be qualified by the fact that the terms of a will do not necessarily void an enforceable pledge made during life. (See Chapter XI, "Promised Gifts.") In other words, if an individual made an enforceable pledge (i.e., contract) during life, the terms of a will that appear to alter that pledge may well not control. Instead, the *inter vivos* (during life) enforceable gift may control. These are situations that need to be examined on their own merits with the advice of counsel.

Although a will takes effect at death, other events can prevent the distribution or enjoyment of a bequest. For example, if the estate is found to be in debt, bequests may have to be used to offset the debt, or there could be a successful challenge to the validity of the will. Sometimes, warning signs signal that a bequest may be in jeopardy. Very long delays in the

9. It is important that the museum deal with the appropriate party representing an estate (the person appointed by the court to represent the estate, or the attorney advising that person). If the museum is in doubt on this issue, it should seek legal advice. If the museum is approached by heirs of the deceased and the museum is offered property formerly belonging to the deceased "in memory of the deceased" (in other words, the property was not bequeathed to the museum in the will), this is not a bequest situation. It is a gift from the heirs. In such situations, the museum should seek legal advice if there is any question of the ability of the offering party to pass full and clear title.

10. There may be instances when circumstances show that the decedent left property to the museum either for accessioning or, in the discretion of the museum, for immediate sale to benefit the museum. In estate tax situations (as distinct from income tax situations), the "related use" question normally does not arise. The exception concerns certain situations involving copyright; see Internal Revenue Code § 2055(c)(4), Regulation § 20.2055–2(E). But there can be public perception problems. Each such case should be carefully weighed so that the museum is satisfied that a decision to accept and sell is prudent in light of all other considerations.

administration of an estate, threatened or actual challenges to the validity of a will, evidence of incompetence on the part of the personal representative—all are signals that caution is advisable. The fact that a bequest has already been released to the museum does not necessarily mean that the bequest is secure. "Preliminary distribution" (distribution before a court approves the final estate accounting) happens rather frequently in order to safeguard fragile or important objects. But not until a court has officially "closed" an estate is there assurance that the bequest is secure. If a museum has possession of a bequest before this closure takes place, it should take notice of all warning signs of trouble. Heed the old saying: Don't count your chickens before they're hatched.[11]

B. Delegation of Authority to Accept Objects

If it is important to select carefully those objects to be accessioned, it is equally important to specify who has the authority to accept objects for the collections. When one individual or group clearly bears responsibility for the decision, thoughtful attention is encouraged. Many an object has found its way into a collection because no one said "yes" or "no"; the accession just happened. This likelihood greatly decreases when someone must accept responsibility for the occurrence. Specific delegation of authority is also a protection for staff members, permitting them to proceed with confidence. For example, if an object is left with the attendant at the reception desk or is sent in by a well-intentioned friend of the museum, any staff member in a well-run organization can explain that there can be no immediate decision regarding acceptance, since certain procedures must be followed. The staff member can then issue a custody receipt if the object is to remain for evaluation, and the prospective donor is promptly and fairly informed of museum practice.

If the authority to accept objects is not clearly defined, additional opportunities for error arise. An agreement to purchase an object can bind even though the signer for the museum had apparent but not real authority. A "Receipt and Release" form, used by many probate courts to verify distribution of bequests, must be signed by a museum official authorized to accept property on behalf of the organization. It should be clear within a museum who has the authority to execute such an instrument. If a donor requests acknowledgment of a gift for tax purposes, and any staff member feels free to oblige, the museum could be embarrassed by careless errors that place its credibility in doubt. When a museum clearly states who has the authority to purchase for the collections, to accept property for the collections, and to acknowledge gifts, many unpleasant consequences can be avoided.

11. See I. DeAngelis, "Wills and Estates Checklist for Museum Staff Administering Bequests," and N. Ward, "Bequests: What Should a Museum Do to Protect Its Interests as Beneficiary under a Will?" both in American Law Institute–American Bar Association (ALI-ABA), *Course of Studies Materials: Legal Problems of Museum Administration* (Philadelphia: ALI-ABA, 1994). See also B. Wolff, "Processing Bequests: From Notice of Probate to Receipt and Beyond," in American Law Institute–American Bar Association (ALI-ABA), *Course of Studies Materials: Legal Problems of Museum Administration* (Philadelphia: ALI-ABA, 1996), for a detailed discussion of procedural matters.

C. What Is Title?

Regarding personal property, *title* may be defined as the possession of rights of ownership in that property. This simple definition, however, needs qualification and clarification. Title involves questions of completeness and questions of quality.

For the layperson, *title* invariably means the right to possess an object indefinitely, but such a right to possess does not always include complete control of the use of the object. Separate from the right of possession are, for example, copyright interests, trademark rights, and any specific interest that the previous owner may have reserved by placing limitations on the use of an object (what a museum would call a "restricted gift"). When a museum acquires an object, therefore, attention should be given to the "completeness" of title. The museum should understand exactly what rights it is acquiring and whether there is proper documentation of these rights.

Of similar importance is the quality of title. For purposes of this discussion, *quality* includes not just the assurance that one has received "good title"—in other words, the ability to enjoy undisturbed use of the rights that pass—but also the assurance that the object acquired is as represented. When acquiring an object, therefore, the museum must also consider the quality of title offered and the sufficiency of the documentation presented to support the represented quality.

Various aspects of these title considerations of particular interest to museums are discussed in the following sections.

D. Circumstances That Can Affect the Quality of Title

1. THE STATUS OF THE TRANSFEROR

What should a museum do when Mr. X asserts that a highly prized clock that has been in the museum's collection for years is in fact his? He explains that Mr. Y, who allegedly donated the piece, was his uncle but that Mr. Y did not own the clock. The clock had been left to Mr. X's father under the grandfather's will, and he, Mr. X, is the sole heir of his father. He produces two family wills to support his claim.

This is not an uncommon problem for a museum, and it is difficult to resolve such a claim when parties to the original transaction are long dead. Although the claiming party may have the burden of proof, the museum may find it difficult to refute even a thin claim if there is no evidence that the museum ever questioned the donor regarding ownership.[12]

A museum should not assume that a transferor is the owner of the object. As a practical matter, a museum cannot quiz every donor, but it can take some precautions. The museum's "deed of gift" form can be worded so that the transferring party is required to affirm

12. The party having the burden of proof in a lawsuit must come forward with a preponderance of evidence in order to prevail. In other words, more in the way of convincing evidence is required of the one with the burden of proof.

that he or she is the owner of the object in question or is the owner's authorized agent for the purpose of passing title. This at least raises the issue, and in signing the deed of gift, the donor specifically defends his or her ability to pass title. Such an affirmation in the deed of gift will also caution those uncertain of title to pause so that this matter may be aired before any documents are signed. But certainly, the insertion of the affirmation in the gift form does not solve all problems; it is merely an attempt to avoid faulty transfers and to provide some defense for the museum if title is challenged after the death of the donor.

There are no substitutes for common sense and a bit of skepticism when accepting objects for the museum, regardless of how carefully drawn the deed of gift may be. A museum should ask where and how the donor acquired the item, if this is not self-evident. Background information on any object destined for the collections is useful from a research point of view, and in addition, such questioning may establish whether the museum needs to delve further into the issue of quality of title. For instance, if the donor is married, might the spouse also have an interest in the object? If there is doubt, perhaps both should sign the deed of gift. Is the donor a minor? If so, the gift may be void or voidable. Local statutes should be consulted, and the gift should probably be confirmed after the donor reaches majority. If an object belonged to a recently deceased individual, be sure that the person offering it has full authority to pass good title. If the object was not specifically bequeathed to the transferor, other heirs may share an interest in it. In some cases, a museum may want to have all appropriate heirs sign the deed of gift or may want to request that the signing individual produce a delegation of authority from the other heirs. These are but a few of the situations that can arise, and each situation has its unique circumstances. The best protection is to educate staff members to be alert, to ask questions, and to seek professional advice when in doubt.

The status of the transferor in a sale can be crucial. The following incident is an illustration. Museum X purchased a much-desired picture from Dealer Y. Dealer Y enjoyed a good reputation, and no one thought to ask any questions. The painting was entrusted to the museum, and a simple statement was signed to the effect that the museum would pay $40,000 for the work. Before payment was made, the museum was informed by an attorney representing Mr. Z that Mr. Z owned the picture and that he had canceled his agency agreement with Dealer Y. Dealer Y's attorney then called to say that his client owned a part-interest in the painting and that the full sale price was not to be paid to Mr. Z. The museum was in the proverbial middle. Even if it chose to return the painting to avoid problems presented by payment, it did not know where to send the work without provoking a lawsuit. The museum's only alternative was to pick up the telephone and call its attorney. All the trouble resulted because nobody asked at the proper time, "Who owns this painting?"

In the above case, after a period of time, the disputing parties were able to resolve their differences by negotiation, and the museum was instructed to make payment in accordance with mutually acceptable terms. If negotiation had not been successful, however, the museum would have faced some hard decisions. It would have had to explore whether it had an enforceable sale contract and, if so, what options were available to it. Possibly, it could

have attempted to obtain the rivals' permission to place the purchase price in an escrow account pending resolution of the dispute between the two. If the facts indicated that Dealer Y did not pass good title, remedies against him would have to be weighed. If the museum wanted to wash its hands of the entire matter and return the painting, the merits of an action of interpleader would have to be considered. In an interpleader action, the museum, claiming no interest in the property, would entrust it to the court and name as defendants the rival parties. Each defendant would then have to argue his claimed interest to the court. The court's resolution of the dispute between the defendants would absolve the museum from further action by either defendant. No matter which way it turned, the museum would have incurred expenses for professional assistance in protecting its interests. The simple message in this tale is that prudent inquiries asked before entering into an agreement can offer better protection than an army of attorneys after the fact.

In other situations, the status of the transferor can interrupt a museum's quiet enjoyment of a gift. In several instances over the past few years, donors have been found guilty of fraudulently procuring money—money they ultimately gave to charities. When these donors later became bankrupt, their creditors were successful at times in suing the charities for the return of the donated funds. Courts ordered these returns even though the charities were unaware of the donors' misdeeds and may have already spent the donations in furthering their charitable work. Similar situations can arise when donors make charitable contributions within one year prior to filing for bankruptcy, even though there may have been no fraudulent procurement of money. Federal bankruptcy law bars the transfer of assets within the year before filing for bankruptcy unless value was received by the donor in return.[13] Although predicting such occurrences may be difficult, museums should not assume that their nonprofit status will protect them from an order to return donations.

2. MISREPRESENTATION BY THE SELLER

If a museum has acquired a collection object only to find that it did not receive good title or that the object is not what was bargained for, the law may offer a remedy (provided the museum can show damages). Very often, however, proving one's case can be a stumbling block. There is a legal cause of action called "misrepresentation," which is defined to mean

13. In *Julia Christians v. Crystal Evangelical Free Church*, 1996 W.L. 223998 (8th Cir. Minn.), a church that was a charitable donee was able to retain a gift made by donors within one year of bankruptcy, but the decision rested on a federal statute (the Religious Freedom Restoration Act of 1993) and, hence, may be of slight comfort to museums. In the case of *City of Boerne v. Flores,* decided by the U.S. Supreme Court on June 25, 1997, the Religious Freedom Restoration Act was declared unconstitutional, thus removing any special protection that religious organizations might have in later challenges of this nature. In the "New Era" scandal, a massive Pennsylvania-based scheme to fraudulently manipulate charitable donations, many charities that unwittingly became involved are, as of early 1997, voluntarily returning portions of donations they received in order to relieve losses suffered by other charities. See "New Era Philanthropy Settlement Could Recoup Money for Charities," *Chronicle of Philanthropy,* 46 (Sept. 5, 1996). Note also the comments in Section A of this chapter regarding the uncertainty of bequests until all estate affairs have been settled.

"any manifestation by word or other conduct by one person to another that, under the circumstances amounts to an assertion not in accordance with the facts."[14] However, as described in the section on "Authentications" in Chapter XIII, usually the plaintiff in a misrepresentation suit must show that the defendant acted intentionally or at least that the plaintiff "reasonably relied" on the information given. As a careful reading of the section on "Authentications" will demonstrate, these elements of proof may be difficult to sustain when the object in question is unique and/or very old, since opinions regarding provenance and value may vary substantially. If the tort of misrepresentation does not provide an avenue for relief and if the collection object in question was bought by the museum, relevant sections of the Uniform Commercial Code should be examined.[15]

3. WARRANTIES IN A SALE AND THE UNIFORM COMMERCIAL CODE

When a collection object is purchased and the object itself or its title proves to be faulty, the sales contract may provide a basis for recovery against the seller. Such an action is based on contract, as distinguished from the tort of misrepresentation, and this presents certain advantages. In the contract action, the museum does not need to establish that the seller intended to make false representations or did so negligently. It is sufficient to establish that a warranty existed and that it was not met, even though the seller may have acted in good faith. Several sections of the Uniform Commercial Code (U.C.C.) are mentioned here for purposes of illustration, but numerous other sections of the U.C.C., as well as more specific statutes, can affect the outcome of a dispute over the sale of a unique cultural object.[16]

Section 2–312 of the U.C.C. concerns warranty of title:

(1) Subject to subsection (2) there is in a contract for sale a warranty by the seller that:
 (a) the title conveyed shall be good, and its transfer rightful; and
 (b) the goods shall be delivered free from any security interest or other lien or encumbrance of which the buyer at the time of contracting has no knowledge.
(2) A warranty under subsection (1) will be excluded or modified only by specific language or by circumstances which give the buyer reason to know that the person selling does not claim title in himself or that he is purporting to sell only such right or title as he or a third person may have.
(3) Unless otherwise agreed a seller who is a merchant regularly dealing in goods of the kind warrants that the goods shall be delivered free of the rightful claim of any third person by way of infringement or the like, but a buyer who furnishes specifications to the seller must hold the seller harmless against any such claim which arises out of the compliance with the specifications.

14. *Black's Law Dictionary* (6th ed. 1990). A plaintiff in such an action must also show that he or she suffered damages as a result of the alleged misrepresentation.

15. A tort is a legal wrong committed against the person or the property of another independent of contract.

16. The Uniform Commercial Code (U.C.C.) governs the sale of personal property. The code has been adopted, with occasional modification, by all states except Louisiana and by the District of Columbia. In addition, some states have legislation that specifically addresses the sale of art or unique objects.

Section 2–312 would seem to provide protection for the museum in sale situations, but in reality most cases fall into a "gray" area. For example, what if the object sold is an art piece that has a history that a professional might question? Would this be a circumstance that should give the museum/buyer "reason to know that the person selling . . . is purporting to sell only such right or title as he . . . may have"? What if the seller is a dealer, or what if the object is bought at auction? How does this change the situation for the museum/buyer? Will the law expect the museum/buyer to probe into the actual ownership of the object being offered by the dealer or auctioneer? In other words, must the museum specifically ask the party offering the object for sale if it is a consignee, a joint owner, or some variation thereof and, if so, whether the sale is within the limits of the seller's authority? The following few cases illustrate the complexity of art-sale disputes and how the status of a particular party or the nature of the complained-of defect can be crucial factors in determining who wins and who loses.[17]

In *Menzel v. List,*[18] a relatively simple case, the defendant, List (not an art expert), was forced to return a painting to the plaintiff, who could establish ownership. List, in turn, impleaded (that is, brought in as parties to the case) the art dealers who had sold him the painting, charging breach of implied warranty. List recovered from the art dealers without any need to establish bad faith or negligence on the part of the dealers (a mere showing that title was in fact faulty was sufficient basis for recovery). In another case, *Jeanneret v. Vichey,*[19] the nature of the complaint was the determining factor. The plaintiff, an art dealer, sued the defendant, who had sold her a Matisse painting that had left Italy under questionable circumstances. At the trial level, the plaintiff prevailed. On appeal, the court reversed and remanded the case for a new hearing, stating that the plaintiff, in order to establish a breach of warranty, had to do more than suggest improper export. The fact that the plaintiff, as a reputable dealer, could no longer sell the Matisse with a "cloud" on the title was not deemed an "encumbrance" sufficient to sustain a breach of warranty finding. Suppose the buyer in a similar case today was a museum. Would the fact that the "cloud" constituted a violation of the museum's code of ethics cause a court to find differently? An attorney might find it difficult to advise on this point.

In *Morgold, Inc. v. Keeler,*[20] the issue was the validity of a buyer's title to a piece of art; the

17. F. Feldman and S. Weil, *Art Law* (Boston: Little Brown, 1986, supp. 1993), Chapters 9 and 10, is an excellent resource on the law regarding private and public sales. Also, "Stolen Art Sold at Auction," 5 *Stolen Art Alert* 4 (June 1984), is a series of letters written to a London magazine on the subject of stolen art sold at auction. The letters illustrate the complex issues that can arise and the differing opinions as to how such situations should be handled. In the case of *Autocephalous Greek-Orthodox Church v. Goldberg and Feldman Fine Arts, Inc.,* 717 F. Supp. 1374 (S.D. Ind. 1989), *aff'd,* 917 F.2d 278 (7th Cir. 1990), the court discusses the following question: When can an art dealer qualify as a good-faith purchaser of art?

18. 267 N.Y.S.2d 804, 49 Misc. 2d 300 (1966), modified 28 A.D. 2d 516, 279 N.Y.S.2d 608 (1967), *third party claim rev'd on other grounds,* 24 N.Y.S.2d 91, 298 N.Y.S.2d 979, 246 N.E.2d 742 (1969).

19. 541 F. Supp. 80, *rev'd and remanded for new trial,* 693 F.2d 259 (2d Cir. 1982). This case eventually became moot when Italy decided it would not question the sale.

20. No. C-92-4902-CAL (U.S.D.C. N.D. Cal., April 27, 1995). See also *Cantor v. Anderson,* 639 F. Supp. 364 (S.D.N.Y. 1986), and *Porter v. Wertz,* 416 N.Y.S.2d 254 (N.Y. App. Div. 1979), *aff'd,* 439 N.Y.S.2d 105 (N.Y. 1981).

previous owners were joint venturers, and one of them sold the work in violation of their joint-venture agreement. The facts of the case caused the court to explore the distinction between joint-venture and consignment agreements, the difference between an art expert and a nonexpert, and the definition of "good faith" on the part of an expert who purchases art. In trying to adjudicate the rights of the parties, the court lamented the fact that art is often treated in the law as ordinary chattel and that, thus, the task of the judge is made more difficult. This also, one could add, makes the decision more difficult to predict.

Similar problems arise when the U.C.C. is invoked to remedy the sale of a fake or forgery. Section 2–313 of the U.C.C. addresses warranties made by affirmation, promise, description, or sample:

(1) Express warranties[21] by the seller are created as follows:
 (a) Any affirmation of fact or promise made by the seller to the buyer which relates to the goods and becomes part of the basis of the bargain creates an express warranty that the goods shall conform to the affirmation or promise.
 (b) Any description of the goods which is made part of the basis of the bargain creates an express warranty that the goods shall conform to the description.
 (c) Any sample or model which is made part of the basis of the bargain creates an express warranty that the whole of the goods shall conform to the sample or model.
(2) It is not necessary to the creation of an express warranty that the seller use formal words such as "warrant" or "guarantee" or that he have a specific intention to make a warranty, but an affirmation merely of the value of the goods or a statement purporting to be merely the seller's opinion or commendation of the goods does not create a warranty.

Section 2–313 is modified in part by § 2–316, which concerns the exclusion or modification of warranties:

(3) . . .
 (b) When the buyer before entering into the contract has examined the goods or the sample or model as fully as he desired or has refused to examine the goods, there is no implied warranty with regard to defects which an examination ought in the circumstances to have revealed to him, and
 (c) an implied warranty can also be excluded or modified by course of dealing or course of performance or usage of trade.

These sections raise several qualifications that could negate a claim made by a museum under the U.C.C. for the sale of a fake or forged object. Section 2–313 specifically notes that a seller's "opinion or commendation" does not create a warranty.[22] The value and the provenance of museum-quality objects are frequently matters of opinion.[23] Section 2–316

21. The express warranties need not be recited in the sales contract itself. See Comment 7 on § 2–313 of the U.C.C.

22. See discussion of fact versus opinion in Chapter XIII.

23. In *Weisz v. Parke-Bernet Galleries, Inc.*, 67 Misc. 2d 1077, 325 N.Y.S.2d 576 (1971), *rev'd*, 77 Misc. 2d 80, 351 N.Y.S.2d 911 (1974), a case decided under a statute similar to the U.C.C., the plaintiff failed to prevail in a suit

cautions that there is no implied warranty regarding defects that an inspection ought to have revealed. Similarly, it provides that an implied warranty can be excluded if this is customary in the trade. A museum, if considered an expert that is buying in a speculative market, may well find little relief in these portions of the U.C.C.[24] Also, the U.C.C. tends to have more rigid time periods for bringing actions questioning the quality of title. In other words, the applicable statute of limitations begins from the time of purchase, regardless of whether the buyer is on notice of any cause of action.[25]

4. OTHER STATUTES AND REMEDIES AFFECTING THE SALE OF FAKE COLLECTION OBJECTS

Even a statute written specifically to cover the sale of fine arts may not afford protection to a museum. For example, New York has a law that imposes greater responsibilities on an art merchant who sells fine art[26] to a buyer who is not an art merchant.[27] An "art merchant" is defined to include a person (or an entity) who deals in works of fine art or has knowledge or skill peculiar to works of fine art. To seek the protection afforded by this statute, a museum would have to argue that it had no skill in fine arts—hardly a convincing or attractive position. A similar statute in Michigan makes the same distinction between professional and nonprofessional buyers.[28]

A number of states have statutes dealing with the sale of fine prints.[29] "Fine prints" usually

to recover for the purchase of fake art. But see *Legum v. Harris Auction Galleries,* File No. 81–013 (Md. Consumer Protection Div., Office of the Att. Gen., April 1983). Here the seller was afforded some relief under the Maryland Consumer Protection Law. Since the *Weisz* case, mentioned above, New York has enacted legislation that specifically addresses warranties in the sale of fine art when the seller is an "art merchant" and the buyer is a nonmerchant.

24. On the general issue of the application of the U.C.C. to the sale of art, see Note, "Uniform Commercial Code Warranty Solutions to Art Fraud and Forgery," 14 *Wm. and Mary L. Rev.* 409 (1972), and F. Feldman and S. Weil, *Art Law* (Boston: Little Brown, 1986, supp. 1993). If a cause of action can be maintained under the U.C.C., relief may prove generous. Section 2–714(2) of the code states, "The measure of damages for breach of warranty is the difference at the time and place of acceptance between the value of the goods accepted and the value they would have had as warranted, unless special circumstances show proximate damages of a different amount." Consider the following example. A painting is purchased for $1,000, and a number of years later the purchaser discovers that title is faulty. The painting is now worth $5,000, and the seller is sued successfully under the U.C.C. The plaintiff may be able to recover not merely the $1,000 purchase price but $5,000, the present fair market value. (See *Menzel v. List* discussed in Section D(5), this chapter, regarding the recovery of List against the Perls.)

25. See, for instance, *Firestone & Parson, Inc. v. Union League of Philadelphia,* 672 F. Supp. 819 (E.D. Pa. 1987), and *Wilson v. Hammer Holdings, Inc.,* 850 F.2d 3 (1st Cir. 1988). Both are reproduced in F. Feldman and S. Weil, *Art Law* (Boston: Little Brown, 1986, supp. 1993)

26. "Fine art" is defined to mean a painting, sculpture, drawing, or work of graphic art.

27. New York Arts and Cultural Affairs Law, Art. 13. See, for instance, *Dawson v. G. Maliney, Inc.,* 463 F. Supp. 461 (1978), and *Pritzker v. Krishna Gallery of Asian Arts,* 93 C 4147. The latter, a case decided by a federal judge in Chicago on May 7, 1997, raised the issue of whether one knowledgeable in the arts can seek the protection of the New York statute.

28. Mich. Comp. Laws Ann. §§ 442.321 *et seq.*

29. The following states have legislation governing the sale of fine prints: Arkansas, California, Georgia, Hawaii, Illinois, Maryland, Michigan, Minnesota, New York, Oregon, South Carolina, and Wisconsin.

are defined to include engravings, etchings, woodcuts, lithographs, and serigraphs. The statutes are designed to protect all purchasers and, as a rule, require the publication of all relevant information regarding the identity of the artist, the signature on the work, the process used to create the article offered for sale, and the number and kind of reproductions. Remedies are limited by the terms of the statutes.

As of 1991, New York has had in effect a statute that regulates the sale of sculpture produced and sold in multiples.[30] The statute requires that art merchants have available for the public the following information on each "multiple" that was produced, fabricated, or carved on or after January 1, 1991: artist, title, foundry, medium, dimensions, time produced, number cast, whether the artist was deceased when the sculpture was produced, and specific information concerning the authorization for the production of the sculpture. Art merchants must also provide certain information concerning a piece that qualifies as either of the following: a "limited edition" sculpture produced on or after January 1, 1991; or a copy of sculpture not made from the master and produced on or after the previously mentioned date. The New York law also requires the affixing of identifying marks on sculpture and the maintenance of certain records by those who produce sculpture.[31]

Another avenue of possible relief when misrepresentation is suspected may be state or local consumer-protection laws.[32] In an opinion issued by the Consumer Protection Division of the Office of the Attorney General of Maryland, a painting purchased at auction was held to be a "consumer good" and hence covered by the Maryland Consumer Protection Act.[33]

The Federal Trade Commission is charged with preventing unfair or deceptive acts or practices in or affecting commerce.[34] Its general jurisdiction should be investigated as another possible means of relief. The commission also administers the Hobby Protection Act, which requires the dating of imitation political items and the marking of imitation numismatic items.[35] Covered under the Hobby Protection Act are such objects as coins, tokens, paper money, and commemorative medals, as well as political buttons, posters, literature, stickers, and advertisements produced for use in any political cause. If the mails or interstate wire communications have been used in an alleged deceptive sale, the federal statutes relating to mail fraud should be consulted.[36]

In addition to using the common law and statutory remedies already suggested, a museum may be able to set aside a fraudulent sale contract in an action in equity or in an action for restitution. Professor William L. Prosser in § 85 of Chapter 16 of his *Law on Torts* discusses these forms of actions.[37]

30. New York Arts and Cultural Affairs Law, Art. 15.

31. Ibid., Art. 14.

32. See, for example, New York City Consumer Protection Law, Reg. 30.

33. *Legum v. Harris Auction Galleries,* File No. 81-013 (Md. Consumer Protection Div., Office of the Att. Gen., April 1983).

34. 15 U.S.C. §§ 41 *et seq.*

35. 15 U.S.C. §§ 2101–6.

36. 18 U.S.C. §§ 1341–43.

37. For a general discussion on the problem of fake art, see S. Hodes, "'Fake' Art and the Law," 27 *Fed. B.J.* 73 (winter 1967). See also Committee on Art of the Bar of the City of New York, "Legal Problems in Art

5. STOLEN PROPERTY

If a museum acquires an object for its collection and if the object is subsequently determined to be stolen property, what are the rights of the parties involved? The general rule in the United States is that a thief cannot convey good title. Therefore, if the party transferring the object to the museum is a thief or even if the party innocently passes stolen property, the museum does not receive good title. Title probably still remains with the party who suffered the theft, and on demand, the object, or its value, has to be returned to the true owner.[38]

This rather simple explanation requires modification because of three defenses frequently raised to prevent a party from recovering stolen property: statutes of limitations, adverse possession, and laches.

Statutes of Limitations. The law recognizes that title to property should not remain in an indefinite state for too long.[39] Such extended periods of uncertainty frequently make it more difficult ultimately to determine true ownership because evidence has faded, and long intervals increase the likelihood that innocent parties who acquire the stolen property in the interim may suffer. To prevent such undesirable consequences, statutes have established time periods within which a victim of theft must press his or her claim. These time periods set by law are called statutes of limitation.

Adverse Possession. With the passage of time, a possessor of property can effectively acquire title by certain overt actions. To perfect title, a possessor must show that the possession of the property is hostile (that is, clearly at odds with anyone else's assertion of title), actual, visible, exclusive, and continuous for the period of time required by statute. All jurisdictions establish by law the period during which one must hold property adversely in order to perfect title.

Laches. The defense of laches is based on equity or fairness. It essentially argues that the party seeking relief has negligently delayed taking action to the detriment of the defendant and that allowing that party to prevail would be unjust.

The cases that follow span a period from the mid-1960s until the mid-1990s. They show the difficulties courts have had in balancing the interests of victims of art theft versus the interests of subsequent innocent holders of stolen art. The three "defenses" listed above are interwoven in the decisions, with the most attention being given to statutes of limitations. Considerable space is devoted to these cases because they have important ramifications for museums. Museums can find themselves, on occasion, to be innocent possessors of stolen art and, on occasion, to be victims of art theft. They can also appear to be insensitive to theft

Authentication," 21 *Records of N.Y.C.B.A.* 96–102 (1966), and F. Feldman and S. Weil, *Art Law* (Boston: Little Brown, 1986, supp. 1993). For problems in the print market, see S. Hobart, "A Giant Step Forward: New York Legislation on Sales of Fine Art Multiples," 7 *Art and the Law* 261 (1983). For an article on how a museum reacts when it suspects that one of its works is a fake, see R. Flamini, "Not the Real Thing," 32 *Washingtonian* (No. 2, Nov. 1996).

38. If purchased property turns out to be stolen and has to be returned, the museum-purchaser might have a cause of action against the seller based on the sales contract or some form of misrepresentation (see previous sections).

39. *Wood v. Carpenter,* 101 U.S. 135, 25 L.Ed. 807 (1879).

by unwittingly borrowing objects of doubtful provenance for exhibition or by supporting colleagues that mount such exhibitions.

a. Statutes of Limitations and the Doctrine of Laches

Statutes of limitations vary in length depending on the cause of action at issue and the jurisdiction. If a museum determines that it is in fact holding stolen property, it could find itself a defendant in a suit for conversion or replevin.[40] In looking to its possible defenses, the museum would want to determine the applicable statute of limitations for conversion or replevin and whether the statute had begun to run.[41] This second determination—when such a statute begins to run—can be complex, and here again, the law of the particular jurisdiction must be studied.

The traditional rule is that the statute of limitations begins to run from the time of the theft, but frequently this rule is not invoked if the property is concealed. If unable to identify the wrongdoer, the owner cannot assert his or her remedies. If the thief sells to an innocent purchaser, the statute of limitations may be construed to run from the date of purchase, but at times this rule is not applied if the owner is still unlikely to know the whereabouts of the property. Some construe the statute of limitations as beginning to run only after the victim has identified the holder of the property and made a demand for return. More recent decisions appear to focus on the ability of the victim to press the claim. In other words, the statute of limitations is viewed as beginning when the victim discovers—or, with the exercise of reasonable diligence, should have discovered—the facts that form the basis of the cause of action.[42] And finally, some courts are rejecting the statute of limitations as a proper defense and are looking to the doctrine of laches as the more appropriate vehicle.

Brief discussions follow of a number of cases that illustrate the complexities that can arise in this area and the different approaches that courts can take. In all of these cases, a victim of theft is pitted against an innocent possessor—one who acquired the property in good

40. "Conversion" is a civil action for money damages based on the unlawful withholding of property. If the plaintiff seeks the return of the property itself, rather than its value, the action may be called "replevin."

41. In *State of North Carolina v. West*, 293 N.C. 18, 235 S.E.2d 150 (1977), North Carolina was demanding the return of certain historic documents that were once the property of the state. The court held that in North Carolina, the statute of limitations would not be applied against the state. Individual state law should be checked on this point.

42. This interpretation is frequently referred to as the "discovery rule." See 51 *Am. Jur. 2d*, "Limitation of Actions," § 146, at 716. See also Comment, "The Recovery of Stolen Art: Of Paintings, Statues, and Statutes of Limitations," 27 *U.C.L.A. L. Rev.* 1122 (1980). One state, California, decided to settle this matter by statute. In 1983, it added this amendment to its statutes: "The cause of action in the case of theft, as defined in Section 484 of the Penal Code, of any art or artifact is not deemed to have accrued until the discovery of the whereabouts of the art or artifact by the aggrieved party, his or her agent, or the law enforcement agency which originally investigated the theft." Cal. Civil Code § 338.3 (West Supp. 1985). The amendment, though seeming to favor owners of art, is not without ambiguity. The reference to the law enforcement agency that originally investigated the theft could be construed as imposing on victims at least a duty to report. Two 1996 cases that deal with the 1983 amendment are *Naftzger v. American Numismatic Society*, 96 Daily Journal D.A.R. 1140, 49 Cal. Rptr. 2d 784 (1996), and *Society of California Pioneers v. Baker*, 96 Daily Journal D.A.R. 3079, 50 Cal. Rptr. 2d 865 (1996).

faith. The first two cases, *Menzel v. List*[43] and *O'Keeffe v. Snyder,*[44] highlight a basic dichotomy in approach; the others show how subsequent courts handled this dichotomy. The *Menzel* case was argued in the late 1960s, the *O'Keeffe* case was tried in the late 1970s, and the others are more recent. This same time period also saw in the United States a growing sensitivity to the problem of stolen art. This changing mood was not lost on the courts and may help to explain the refinements in their thinking.

Menzel Case. In *Menzel v. List,* the Menzels purchased a painting by Marc Chagall in 1932 for about $150 at an auction in Brussels, Belgium. In 1941, when the Germans invaded Belgium, the Menzels were forced to flee the country, and the painting was left behind in their apartment. On their return six years later, the painting was gone, having been taken by the Germans. In 1955, Klaus Perls and his wife, proprietors of a New York art gallery, bought the painting from a Parisian art gallery for $2,800. The Perls knew nothing about the history of the painting and did not question the Paris gallery. Klaus Perls testified that it would have been an "insult" to question a reputable dealer as to the title.[45] Several months later, the Perls sold the painting to Albert List for $4,000. In 1962, Mrs. Menzel noticed a reproduction of the painting in a book, which gave List's name as the owner. She requested the return of the painting, but List refused to surrender it. Mrs. Menzel then instituted an action for replevin[46] against List, and he in turn brought the Perls into the suit, alleging that they were liable to him for breach of an implied warranty of title.[47] The defendants argued, among other issues, that they were bona fide purchasers for value and that the statutes of limitations of New York and Belgium barred the action. The court disagreed, stating that the plaintiff's cause of action arose from the defendant's (List's) refusal to return the painting on demand and that, therefore, the statutes of limitations had begun to run from that point. In this case, the date of the original taking and the dates of sales to innocent purchasers were not considered relevant for purposes of initiating the period of limitations. After much litigation, Mrs. Menzel was awarded her painting, and the Perls were ordered to pay List the value of the painting as of the date the painting was surrendered to Mrs. Menzel. The Perls only recourse was to sue the Paris dealer.

O'Keeffe Case. The next case, *O'Keeffe v. Snyder,* further highlights the difficulties involved in cases of this nature, but it illustrates a different solution. In 1946, the artist Georgia O'Keeffe noticed that three of her paintings, valued at about $150 each, had disappeared from her husband's New York City art gallery. She suspected that a man named Estrich may have taken them, but she never investigated. She explained, "It wouldn't have been my way!" She did mention the loss to several acquaintances in the art profession. Sometime

43. 267 N.Y.S.2d 804, 49 Misc. 2d 300 (1966), modified 28 A.D. 2d 516 (1967), 279 N.Y.S.2d 608; *third party case rev'd on other grounds,* 24 N.Y. 2d 91, 298 N.Y.S.2d 979, 246 N.E.2d 742 (1969).

44. 170 N.J. Super. 75, 405 A.2d 840, 416 A.2d 862 (1980). See also P. Amram, "The Georgia O'Keeffe Case: New Questions about Stolen Art," *Museum News* 49 (Jan.–Feb. 1979), and P. Amram, "The Georgia O'Keeffe Case: Act II," *Museum News* 47 (Sept.–Oct. 1979).

45. 24 N.Y. 2d 91.

46. "Replevin" is an action seeking the return of misappropriated property.

47. Note the previous section on warranties in a sale.

before 1955, the paintings came into the possession of a Dr. Frank of Concord, New Hampshire, and in 1965, Dr. Frank gave the paintings to his son Ulrich Frank. Dr. Frank died in 1968, and it is unknown how he had acquired the works. The Franks displayed the pictures in their homes, and for a single day in 1968, the paintings were displayed at a community center in Trenton, New Jersey.

In November 1972, O'Keeffe, through her secretary, reported the paintings missing to the Art Dealers Association of America. In 1973, Ulrich Frank consigned the paintings to a New York City gallery for sale. When they did not sell, they were consigned to the Princeton Gallery of Fine Art, owned by Barry Snyder. In 1975, Snyder bought the pictures for $35,000.

O'Keeffe learned the whereabouts of the paintings in 1976, and she demanded their return. Snyder refused, and O'Keeffe immediately instituted a replevin action against him. Snyder's first defense was that the statute of limitations had run. In New Jersey, an action for replevin is barred if not brought within six years of the time the action accrued. O'Keeffe argued that her cause of action did not accrue until she knew the whereabouts of her property, but the trial court found for Snyder, stating:

> The Court will not countenance the application of a rule of law which will remove the repose granted by the Statute of Limitations to allow this plaintiff to advance a claim based on her recitations of facts not to seek or confront a thief at the time of the alleged theft and to institute suit thirty years later when the defendants are incapable of presenting contrary evidence to either refute the plaintiff's claim or establish the validity of their own title.
>
> The Statute of Limitations . . . bars the plaintiff's recovery. The cause of action accrued in March, 1946.[48]

O'Keeffe appealed the decision, and she was upheld by the appellate court. The members of the court differed in their reasoning, but the majority view stated that the defendant, Snyder, had not proven that the paintings had been held openly and adversely and that such open and adverse possession was necessary to start the statute of limitations running. The appellate court did not stress O'Keeffe's failure to report the theft but instead focused on Snyder's failure to protect himself. "Moreover, defendant Snyder was not without means of self-protection. He was not a novice in dealing with art work. He purchased the paintings without provenance. He was thus aware of the uncertain history of the paintings' ownership. The artist, however, is alive and it was always open to him to check with her as to their authenticity and the legitimacy of his purchase. He elected to take his chance with this result."[49] Essentially, the appellate court put the burden of proving a right to possession on the defendant, Snyder.

The case was appealed to the Supreme Court of New Jersey, and in July 1980, the court

48. The trial court opinion is cited as *O'Keeffe v. Snyder,* Docket No. L-27517-75 (N.J. Super. Ct., Law Div., Mercer County, July 1978). It is printed in *Museum News* 50 (Jan.–Feb. 1979).

49. 405 A.2d 840, 848.

issued a detailed opinion that reversed the appellate court and sent the case back to the trial level for the gathering of additional facts. The supreme court's opinion strongly endorsed the use of the discovery rule in cases of this nature. The discovery rule provides that a cause of action will not accrue "until the injured party discovers, or by exercise of reasonable diligence and intelligence should have discovered, facts which form the basis of a cause of action."[50] The discovery rule places some burden on the owner. It requires that the one seeking the benefit of the rule establish facts that justify deferring the running of the statute of limitations. Applying this to the *O'Keeffe* situation, the supreme court ordered the case back to the trial court[51] to settle issues such as

(1) whether O'Keeffe used due diligence to recover the paintings at the time of the alleged theft and thereafter;
(2) whether at the time of the alleged theft there was an effective method, other than talking to her colleagues, for O'Keeffe to alert the art world; and
(3) whether registering paintings with the Art Dealers Association of America, Inc., or any other organization would put a reasonably prudent purchaser of art on constructive notice that someone other than the possessor was the true owner.[52]

Under this test, if O'Keeffe was not able to convince the court or jury that she had used due diligence in trying to recover her loss (and thus stopped the statute of limitations from running), she would be barred from pursuing her claim. In effect, the court pointed out that, at the end of the statutory period of limitations, title vests in the possessor.[53]

The *Menzel* (New York) rule and the *O'Keeffe* (New Jersey) rule offer different solutions to the same problem. The *Menzel* rule favors the owner because it does not begin the running of a statute of limitations until the owner makes a demand for the return of the property. The *O'Keeffe* rule places a burden on the owner to establish a consistent pattern of efforts to recover the lost property. A careful reading of all opinions in the *Menzel* and *O'Keeffe* matters shows efforts by the courts to weigh the "equities" between relatively innocent parties. In *Menzel*, the plaintiff was a victim of Nazi aggression in World War II; the war and its aftermath violently disrupted her life for an extended period of time. It is easy to understand a court's reluctance to adopt a theory of recovery that would bar such a plaintiff from arguing her claim in court. (If a statute of limitations is found to have run, the case is dismissed at that point.) In contrast, in the *O'Keeffe* case, the theft took place in the United States, and opportunities to advertise the loss and seek relief were readily available. When equities are being weighed, it is not difficult to impose on such a plaintiff some responsibility to take action concerning the loss, and this is what the *O'Keeffe* court did. In subsequent cases, this same issue of fairness always seems to lurk close to the surface, no matter what theory is used to support the result.

50. 416 A.2d 862, 869.
51. O'Keeffe elected not to pursue the case further, and the parties entered into a private settlement.
52. 416 A.2d 862, 870
53. 416 A.2d 862, 874. See also *Desiderio v. D'Ambrosio*, 190 N.J. Super. 424, 463 A.2d 986 (1983).

Elicofon Case. While the *O'Keeffe* matter was wending its way through the New Jersey courts, the New York courts were faced with another situation involving art stolen during World War II. In *Kunstsammlungen zu Weimar v. Elicofon,*[54] title to two Duerer portraits was at issue. The portraits had been stolen in 1945 in Germany and did not come to the attention of the German claimants until 1966. At that time, the portraits were in the possession of Edward Elicofon, a resident of New York. Elicofon had purchased the paintings in 1946 from an American serviceman. The paintings were unsigned, and the serviceman claimed he had purchased them while serving in the armed forces in Germany. Elicofon displayed the paintings in his home, and they were seen over the years by many people knowledgeable about art. In 1966, a friend told Elicofon that the two works were listed in a publication describing stolen art treasures of World War II. The discovery was publicized, and the German parties made a demand for the return of the paintings. The demand was refused, and litigation began. At the trial level, the court adopted the *Menzel* approach and held that the German parties' claim did not accrue until 1966, when they had learned of the whereabouts of the paintings and made their demand. On the merits of the claim of ownership, the court then found for the German parties. Elicofon appealed. On the issue of the running of the statute of limitations, the appeal court reaffirmed the *Menzel* approach. It also noted in a footnote that even if New York took the approach ultimately endorsed in New Jersey in the *O'Keeffe* case (the discovery rule), the German parties would still prevail.

In the *Elicofon* case, extensive testimony described the efforts that the German parties had taken to publicize the loss of the paintings immediately after determining that they were missing in 1946. These efforts included notifying various German cultural organizations, military officials occupying Germany at that time, the U.S. State Department, and art experts in the United States. In effect, the court was saying that these efforts, under the *O'Keeffe* approach, would have stopped the statute of limitations from running. Thus, with the *Elicofon* case, New York maintained its allegiance to the *Menzel* rule but with a situation that would have brought the same result no matter which legal theory was adopted.

DeWeerth Case. The next major case in this sequence involving the statute of limitations was *DeWeerth v. Baldinger.*[55] Ms. DeWeerth, a German citizen, owned a Monet painting. During World War II, she sent the painting and other valuables to her sister's home in southern Germany for safekeeping. At the end of the war, American soldiers were quartered in the sister's home. After they left, the Monet was missing. The sister immediately informed DeWeerth. DeWeerth filed a report with the military government in Germany, listing objects, including the Monet, that she had lost in the war. She inquired of her lawyer if the picture was covered by her insurance. When she received a negative answer, the matter was dropped. In 1955, she sent a picture of the painting to an art expert asking him to investigate into the whereabouts of the painting. When the expert said the picture was insufficient to mount a search, DeWeerth did not pursue the matter further. In 1981, De-

54. 536 F. Supp. 829 (E.D.N.Y. 1981), *aff'd,* 678 F.2d 1150 (2d Cir. 1982). See also F. Feldman, "The Title to a Work of Art Means Much More Than Just Its Name," *Collector-Investor* 38 (Feb. 1982).

55. 658 F. Supp. 688 (S.D.N.Y. 1987), *rev'd,* 836 F.2d 103 (2d Cir. 1987).

Weerth's nephew was told about the painting, and after a brief search, he found, in the library of a local museum, a reference to the painting in a published *catalogue raisonne* of Monet's work. The painting was described as having been sold by a New York dealer in 1957 and exhibited in 1970. Through the dealer, the work was traced to a Ms. Baldinger of New York City. Baldinger had purchased the work in good faith from the New York dealer in 1957. When DeWeerth demanded the return of the work, Baldinger refused, and litigation began. At the trial level, the court found DeWeerth's action to be timely and judged her title to be superior. Baldinger appealed. The appeal court reversed, taking a fresh look at the *Menzel* approach and adding a new consideration.[56] After analyzing New York law, the *DeWeerth* court concluded that although in New York a cause of action does not accrue against an innocent holder of stolen property until a demand is made for the return of the property, a claimant cannot unreasonably delay making that claim. The court found that this interpretation was in accord with other New York decisions that held that when a demand and a refusal are necessary to start a statute of limitations period, the demand may not be unreasonably delayed. Based on this interpretation, DeWeerth had to prove first that she had not delayed bringing her claim. If she could not sustain this burden, her case would be barred. The court then went on to examine the evidence regarding DeWeerth's efforts to locate her painting. It concluded that her efforts were insufficient to support a conclusion that reasonable steps had been taken to find the painting. "[A]lthough an individual, De-Weerth appears to be a wealthy and sophisticated art collector; even if she could not have mounted a more extensive investigation herself, she could have retained someone to do it for her." Accordingly, the statute of limitations had not been held in abeyance. Baldinger won the appeal.[57]

Guggenheim Case. At this point, it appeared that New York was moving to the *O'Keeffe* (discovery rule) approach. However, the next case involved a museum, the Guggenheim located in New York City, and it gave the New York state courts (not the federal courts sitting in New York that had decided the *DeWeerth* case) another opportunity to address the issue of how statutes of limitations are interpreted when the return of stolen art is sought from a good-faith possessor. The facts of the *Guggenheim* case follow.

In the mid-1960s, the Guggenheim noticed that it could not locate a Chagall watercolor

56. Both *DeWeerth* and *Elicofon* were tried in federal court. Federal courts, as appropriate, apply the law of the state that is controlling. If the law of the state is unclear, the federal court "makes an estimate of what the state's highest court would rule to be its law." The federal court sitting in New York also has the option to submit the unresolved state law issue to the New York Court of Appeals (in other words, it can defer to a New York court to bear the burden of interpreting a questionable issue of state law). That option was not elected in *DeWeerth*—a case in which the interpretation of the law would alter the outcome—but in its opinion the court does discuss why it decided not to seek state court clarification of the law.

57. After the decision in the later-decided *Guggenheim* case, which is discussed next, DeWeerth went back to federal court to request a rehearing of her case. The request was granted, and she prevailed: 804 F. Supp. 539 (D.N.Y. 1992). Baldinger then appealed this decision, and she prevailed on a procedural issue. The court held, in effect, that the *Guggenheim* decision amounted to a change in New York law and that subsequent change in state law is not grounds to reopen a federal diversity case decided under prior law of the state. 28 F. R. Serv. 3d 1231 (2d Cir. 1994), *cert. denied*, 130 L.Ed. 2d 419, 115 S. Ct. 512 (1994).

that was part of its collection. There was some suspicion that the work might have been stolen by an employee, but the matter was not pressed. In 1970, after a routine inventory was completed, the museum determined that in fact the watercolor was gone. In 1974, the museum "deaccessioned" the work—removed it from the official list of holdings. At no time did the museum advertise the loss or notify law enforcement officials or professional art-loss registries. In 1985, a slide of the watercolor was brought to a New York auction house for an appraisal. An employee of the auction house, who happened to be a former employee of the Guggenheim, recognized the watercolor, and the Guggenheim was notified. By this time the work was in the possession of a Ms. Lubell. She and her husband had purchased the work in 1967 from a reputable New York dealer. The Guggenheim made a demand for the work. Lubell refused to return the work, and the Guggenheim sued.[58]

At the trial level, the court found for Lubell on a summary judgment. Citing the *DeWeerth* decision, it held that the Guggenheim's claim was barred by the statute of limitations because the museum had not taken reasonable steps to find out where the watercolor was and this had caused an unreasonable delay in making the demand on Lubell. The Guggenheim appealed. The appeal court reviewed New York law and determined that the proper test in a case of this nature should not be whether a statute of limitations had run (the question of whether the plaintiff is barred from court because too much time has elapsed between the cause of action and the actual seeking of redress); rather, the test should be that of laches. A laches defense involves a balancing of the equities, and this requires a full trial on all the issues. To prevail with a laches defense, a defendant must show not only that the plaintiff delayed unreasonably but that this delay prejudiced the defendant. Accordingly, the appeal court reversed the trial court's judgment and sent the case back to the trial level for a full hearing using the laches test. However, before the case went to trial again, the parties settled.[59]

Post-Guggenheim. This sequence of cases, from *Menzel* to *Guggenheim,* contains some interesting lessons. Certainly, the cases show the dilemmas that can arise, especially when there

58. *Solomon R. Guggenheim Foundation v. Lubell,* 77 N.Y. 2d 311, 567 N.Y.S.2d 623, 569 N.E.2d 426 (N.Y. Ct. App. 1991). A somewhat similar case was initiated by a museum against a college. In this case, an artifact mysteriously disappeared from the college's collection (a suspected case of employee theft), and the artifact later surfaced in a museum collection. The college had not pursued its loss, but when it eventually learned of the whereabouts of the object, it demanded a return. The museum refused based on the theory that rewarding the college for its negligence would be unjust. Subsequently, the museum sued "to quiet title"—to seek court confirmation of its title. The case was settled out of court. *Museum of Fine Arts v. Lafayette College,* C.A. #91-10922 Ma., U.S.D.C. Ma. In 1990, the Art Institute of Chicago announced that it was officially listing as "lost" one of Georgia O'Keeffe's works that had been missing for twenty years. The loss was confirmed after a major inventory. The Art Institute then (in 1990) notified law enforcement officials and art-loss registers of the loss. See *Chicago Tribune,* 1 (Aug. 14, 1990).

59. See *New York Times,* metro section (Dec. 29, 1993). A subsequent case that concerns lost art is *Hoelzer v. Stamford,* 933 F.2d 1131 and 972 F.2d 495 (2d Cir. 1991), *cert. denied,* 506 U.S. 1035, 121 L.Ed. 2d 687 (1992). *Hoelzer* is a very convoluted case that involves not theft but a series of highly questionable acts by city and federal employees. See also *The Republic of Turkey v. The Metropolitan Museum of Art,* 762 F. Supp. 44 (S.D.N.Y. 1990), in which the Metropolitan Museum of New York sought to have Turkey's claim for return of antiquities dismissed as time barred under a statute of limitations. The court refused to dismiss and, relying on the *Guggen-*

is growing awareness of the ramifications of court decisions on the trade in stolen art. There are good reasons to protect owners of art and to discourage theft. Rules of law should not encourage mischief or deceit. On the other hand, purchasers of art and the art market need reasonable methods of protection. Also, claims should be heard in a timely manner because life needs to go on and because courts cannot function effectively if cases can be tried after evidence is lost and/or witnesses are dead. In the *Guggenheim* case, the court was struggling with all of this, and its laches solution can be lauded or criticized. On the negative side, a laches test can be more costly in time, money, and anxiety, without justifiable benefits. When laches is the controlling defense, there must be a full trial on the merits, and this in turn translates into long hours of work and great expense.[60] Making a judgment in advance about the probable outcome of litigation is also more difficult, and this can discourage the pursuit of legitimate claims. On the positive side, the laches approach offers two major advantages. It is a test that puts a premium on fairness because all conduct of both the victim and the holder can be examined and weighed. Second, since all conduct is open to review, a strong message is sent to the art market, and to those who can affect the art market, that in the end, prudence and forthrightness are the best protection. The appeal court in the *Guggenheim* case appeared to view its decision as providing these "positive" messages. New York is the center of the art market in the United States, and attempts in the mid-1980s to amend New York law to favor purchasers met with public disapproval.[61] Also, there was a growing sensitivity to the problems facing those countries of origin suffering the loss of illegally excavated cultural property and to the attendant problems of monitoring and proving such losses. The New York court, in its *Guggenheim* decision, was sending a message to the world that New York was not about to become a haven for cultural objects of dubious provenance.

Yet a third opinion of the laches defense, as set forth in *Guggenheim,* argues, with some justification, that in most cases the same result can be reached whether the "discovery rule"

heim reasoning, held that the case would have to be heard on its merits with a weighing of the equities under a "laches" defense. Another case of considerable interest is *Autocephalous Greek-Orthodox Church v. Goldberg and Feldman Fine Arts, Inc.,* 717 F. Supp. 1374 (S.D. Ind. 1989), *aff'd,* 917 F.2d 278 (7th Cir. 1990). Here, Cyprus was seeking the return of four Byzantine mosaics looted from a church in Cyprus in the late 1970s and purchased in Europe by an American dealer many years later. The decision discusses such questions as the following: The law of which country applies? When did the statute of limitations begin? When can a dealer qualify as a "good-faith" purchaser?

60. When a statute of limitations defense is raised, this matter is examined first by the court. If the court finds, on the evidence presented, that the statute has in fact run, the case is dismissed at that point. In other words, the rest of the case is barred from court.

61. Not long before the *Guggenheim* case was decided, there had been a series of efforts in New York to pass legislation that would limit the time during which one could question the title of cultural and scientific objects purchased in good faith by nonprofit organizations. In 1985, one of these bills (S. 3273, "An Act to Amend the General Business Law, in Relation to Actions Against Non-Profit Organizations for Recovery of Objects") actually passed the legislature but was vetoed by the governor because of the fear, expressed by many, that the bill would make New York a haven for art of questionable provenance. In the same year, two similar bills were introduced to the U.S. Congress (S. 605 and S. 1523). Neither bill was favorably acted on when few came forward to endorse either one.

for determining the running of a statute of limitations or the "laches" approach is used. In effect, when the discovery rule is used in art-theft cases, the victim's actions must be weighed in light of all the circumstances, including the actions of the possessor, in order to decide whether the victim has shown sufficient diligence to stop the running of the statute of limitations.[62] This weighing of all the circumstances sounds very close to laches. Holders of this third opinion, then, stress that the discovery rule can often resolve a dispute without the need for a full trial on all the issues.

Despite debate about the proper legal defense that should be used to achieve a fair result when a theft victim seeks return of property from a good-faith possessor, the movement of the law is fairly clear. The trend is definitely toward encouraging prudent conduct by the victim and by the acquirer of art. The lessons for museums are evident.

In acquisitions, whether by purchase or donation, museums should

- question provenance;
- take advantage of art-loss registers to be sure the proposed acquisition is not listed as missing;
- make reasonable efforts to probe for indications of trouble (the level of efforts should be commensurate with the value of the material);
- keep records of all steps taken in the acquisition process; and
- publicize the acquisition of all objects of significance.

When museums are victims of theft, they should

- have sufficient control over their collections so that they can spot a loss in a timely manner;
- have procedures for investigating a loss effectively;
- have policies regarding reporting a loss and seeking appropriate assistance;
- have thorough documentation and descriptions of lost material;
- have procedures for recording a loss; and[63]
- have procedures for the long-term monitoring, if necessary, of a loss.[64]

62. See, for example, *Autocephalous Greek-Orthodox Church v. Goldberg and Feldman Fine Arts, Inc.*, 717 F. Supp. 1374 (S.D. Ind. 1989), *aff'd*, 917 F.2d 278 (7th Cir. 1990), and *Eristoy v. Rizek*, CA #93-6215, U.S.D.C. (E.D. Pa.), Feb. 23, 1995. In the latter stolen art case, the court, citing *O'Keeffe*, "balanced the equities" as the proper exercise of the discovery rule. Several articles discuss some of these cases: I. DeAngelis, "Civil Claims for Recovery of Stolen Property: Developments in the Law and Lessons for Museums," in American Law Institute–American Bar Association (ALI-ABA), *Course of Studies Materials: Legal Problems of Museum Administration* (Philadelphia: ALI-ABA, 1992); P. Gerstenblith, "Guggenheim and Lubell," I *International Journal of Cultural Property* (No. 1, 1992). S. Bibas, "Note: The Case against Statutes of Limitations for Stolen Art," 103 *Yale L.J.* 2437 (1994).

63. See Chapter V, "The Disposal of Objects: Deaccessioning."

64. See Chapter XIV, "Care of Collections," Section B, for more discussion on this topic.

b. Adverse Possession

Closely associated with the statute of limitations defense and the laches defense is the doctrine of adverse possession. Adverse possession is a method used by a possessor of property to establish title to the property. To perfect this title, the possessor must show that the possession of the property is hostile (that is, clearly at odds with anyone else's assertion of title), actual, visible, exclusive, and continuous for the period of time required by statute.[65]

Invariably, the burden is on the person claiming title under adverse possession to prove all of these elements. Thus, if a museum wants to take steps to perfect title to collection objects of uncertain ownership, it has to establish, through convincing evidence, that it held the objects for the required period of time in a manner hostile to the true owner (that is, clearly claiming title in the museum), that this possession was actual, continuous, and exclusively claimed, and that its hostile possession was readily discernible to the general public. This is a hard case to make, especially for personal property. The doctrine of adverse possession is more closely associated with real property, and in the *O'Keeffe* case, the court held that in New Jersey the doctrine of adverse possession henceforth should be confined to real property situations.[66] The doctrine has, however, a substantial history of application in personal property cases.[67]

Interestingly, despite the waning reliance on the doctrine of adverse possession in stolen art (i.e., personal property) cases, a fairly recent federal statute adopts this approach. The Convention on Cultural Property Implementation Act, a federal statute in effect since 1983, was designed to curb the importation of stolen cultural property.[68] The act prohibits, from April 1983 on, the importation into the United States of certain described stolen cultural property and certain designated archaeological and ethnological material removed from foreign countries. However, the act protects from seizure any such material that is imported after April 1983 and that

(A) has been held in the United States for a period of not less than three consecutive years by a recognized museum or religious or secular monument or similar institution, and was purchased by that institution for value, in good faith, and without notice that such material or article was imported in violation of this title but only if—

(i) the acquisition of such material or article has been reported in a publication of such institution, any regularly published newspaper or periodical with a circulation of at least fifty

65. 54 *C.J.S.*, "Limitations of Actions," § 119, at 23 (1948).

66. Refer to footnote 44 and the last decision, 416 A.2d 862. In this regard, the *O'Keeffe* court overruled *Redmond v. New Jersey Historical Soc.*, 132 N.J. Eq. 464, 28 A.2d 189 (1942), a case involving a museum's refusal to return a painting, which had been placed on loan subject to the occurrence of certain events.

67. But see *Wogan v. State of Louisiana*, No. 81-2295 (La. Civ. Dist. Ct. for Parish of Orleans, Jan. 8, 1982). *Wogan* involved a demand for the return of a painting originally placed on loan in a museum and subsequently claimed by the museum as its own. Citing the peculiarities of Louisiana law, the court would not recognize an adverse possession defense. See also discussions in Chapter VII, "Unclaimed Loans," and Chapter X, "Objects Found in the Collections."

68. See Chapter IV, Section D(6).

thousand, or a periodical or exhibition catalog which is concerned with the type of article or materials sought to be exempted from this title,

(ii) such material or article has been exhibited to the public for a period or periods aggregating at least one year during such three-year period, or

(iii) such article or material has been cataloged and the catalog material made available upon request to the public for at least two years during such three-year period;

(B) if subparagraph (A) does not apply, has been within the United States for a period of not less than ten consecutive years and has been exhibited for not less than five years during such period in a recognized museum or religious or secular monument or similar institution in the United States open to the public; or

(C) if subparagraphs (A) and (B) do not apply, has been within the United States for a period of not less than ten consecutive years and the State Party concerned has received or should have received during such period fair notice (through such adequate and accessible publication, or other means, as the Secretary shall by regulation prescribe) of its location within the United States; and

(D) if none of the preceding subparagraphs apply, has been within the United States for a period of not less than twenty consecutive years and the claimant establishes that it purchased the material or article for value without knowledge or reason to believe that it was imported in violation of law.[69]

These enumerated exceptions recognize a form of adverse possession for certain types of personal property and establish time periods for the accrual of a defense based on adverse possession. Yet the exceptions apply only to objects falling under the purview of the Convention on Cultural Property Implementation Act, and as of 1997, fourteen years after the passage of the act, there is little evidence that courts have looked to these exceptions as appropriate models for deciding similar claims that fall outside the coverage of that act.

6. OBJECTS IMPROPERLY REMOVED FROM THEIR COUNTRIES OF ORIGIN

In talking about "stolen art," we need to distinguish between two types of situations. The first concerns objects that have a recorded provenance. In other words, credible records exist of their origin and of at least some of their history of ownership. These will be referred to as "documented objects." The second situation concerns objects that have no credible record of origin or ownership because they were excavated (and often removed) from their countries of origin clandestinely and in violation of the law. These will be referred to as "undocumented objects." In the "Stolen Property" section above, the focus is on documented objects. In this section, undocumented property will be added to the mix because when foreign countries seek the return of cultural property, often that property falls into the undocumented category.[70] This "undocumented" status adds more layers of complexity,

69. Section 312 of Pub. L. 97–446. Property imported for temporary exhibit and protected by a declaration of immunity from seizure under 25 U.S.C. § 2549 is also exempt.

70. Undocumented property claims can also be national rather than international in nature. For example, a clandestine removal of archaeological material from federal or Native American lands in this country would

as will be seen. Foreign laws in this area may not always mesh with those of the United States, and thus U.S. courts can at times appear inhospitable to foreign petitioners. Foreign customs may differ from those in the United States, and this can lead to unsympathetic public reactions to such claims. The objects at issue may have strong nationalistic or cultural significance for the claimants, and this can cause international ripples. Consider, for example, the following news items:

ANKARA, Turkey, Feb. 22—The Minister of Culture has praised the work of archeological teams in Turkey but warned that the activities of some foreign institutes may be curbed if the country's "stolen treasures" are not returned soon.

"If these works are not restored, we could revise excavation permits issued to some foreigners," the Minister, Cihat Baban, cautioned. "We prefer to preserve our cultural assets even under the ground rather than let them slip through our hands."

Mr. Baban's warning was made during a recent week-long symposium on excavation works carried out last year at 56 sites around the country, including 18 being worked by foreign teams.

Addressing the gathering of archeologists and students, Mr. Baban singled out the Byzantine works from the Antalya region that were said to have been smuggled out of the country to "an American museum." . . .

United States officials here expressed concern about Mr. Baban's threats and the possible effect on the work of American archeologists. . . .

The officials also said they feared that any Turkish retaliation might jeopardize attempts to organize the first major showing of Turkish archeological works at the Metropolitan Museum of Art in New York.[71]

Similarly, the July 1982 issue of *Stolen Art Alert* reported that an "Open Letter" from the Egyptian Antiquities Organization was being sent to foreign museums, asking their cooperation in stemming the trade of objects illegally removed from Egypt. The letter stated: "We are obliged to call your attention to a decision already taken by the Egyptian Antiquities Organization that any sort of scientific archeological cooperation between the E.A.O. and any museum proved to be retaining or dealing with such artifacts will be terminated. Such cooperation includes scholarly exchanges, loans, and exhibitions, and archeological excavations and surveys."[72]

In a sense, every museum in the country has an opportunity to affect the international climate regarding the import or export of cultural objects. Two justifications are offered for this statement. First, the problems raised in this area do not lend themselves to simple solutions. They are many-faceted, and they can raise legal and ethical considerations that strain the traditional avenues of redress. As a result, courts and legislatures find it difficult

give rise to a claim on the part of the U.S. government or the appropriate tribe, and it would present many of the difficulties of proof inherent in an "undocumented property" claim brought in a U.S. court by a foreign country.

71. *New York Times*, A.3, Col. 1 (Feb. 23, 1981). Copyright © 1981 by the New York Times Co. Reprinted by permission.

72. *Stolen Art Alert* 1 (July 1982).

to offer comprehensive guidance. Often, practical considerations demand that cases of this type be decided on their individual merits with the assistance of members of the museum profession. This cannot be done effectively unless all in the museum community keep abreast of the issues and, through mutual support, create and sustain an enlightened atmosphere in which these problems can be aired and resolved. Second, the word "international" can touch very close to home. In the area of repatriation or return of cultural objects, a Native American tribe is not unlike a foreign nation in that its claims may be based on tribal law or custom that differs from Anglo-American concepts.[73] Thus, adjusting such claims can be as painful as resolving foreign claims, since important but differing cultural values can be at stake. If all "keepers of culture" in this country can pursue their "internal" repatriation claims with intelligence and mutual respect, the United States could end up offering to the rest of the world procedural models worthy of imitation.[74]

Every museum—whether it is a large natural history museum, a major art gallery, a community-oriented cultural center, or a small historical society—shares this common problem. Each has an obligation to see the whole picture and to weigh its attitudes and actions in light of all relevant considerations. If the museum community fails to step forward with constructive assistance, it can hardly complain when economic and political considerations alone determine the fate of cultural objects.

Problems arise in the international movement of cultural property because of the different perspectives of what might be called the "art rich" nations and the "art poor" nations. Essentially, the former are those countries whose cultural properties are located outside their borders or are in danger of being exported, and the latter are those countries that house or seek these cultural properties.[75] Some of these properties have left their countries of origin because of war or licit or illicit trade, and the countries themselves have varied histories regarding the effectiveness of internal export controls. Today, in the more enlightened atmosphere of the United States, there is a greater sympathy for general proposals to return major cultural properties to their countries of origin or to halt the improper export of such properties. Countries of origin have unique claims, and some works of art have an integrity that transcends conventional concepts of ownership.[76]

73. Historically, the U.S. government has viewed Native American tribes as foreign nations, as evidenced by its negotiation of treaties with individual tribes. To this day, Native American tribes are reserved certain rights of self-government. The issue of Native American repatriation claims is discussed more fully in Section D(6)(f), below.

74. See "Repatriation and the Law" in M. Malaro, *Museum Governance: Mission, Ethics, Policy* (Washington, D.C.: Smithsonian Institution Press, 1994).

75. The term "cultural properties" is generally defined to mean properties that, on religious or secular grounds, are designated by a nation as being of unique importance to the nation for reasons relating to archaeology, prehistory, history, literature, art, or science. The term has been refined further by UNESCO action. See Section D(6)(b), "Post–UNESCO Convention Activity." See also the Convention on Cultural Property Implementation Act, hereinafter described, which defines the term. As highlighted by the implementation of the Native American Graves Protection and Repatriation Act (1990), the use of the term "cultural property" to include human remains is offensive to many.

76. This is a very general statement. The extent of these "unique claims" and how such determinations are made continue to be debated. For differing viewpoints, see G. Burcaw in "A Museological View of the Repatriation of Museums Objects," 1 *Museum Studies Journal* 8 (spring 1983); P. Messenger, *The Ethics of Collecting Cultural*

Closely allied to this problem are the concerns of the scholarly community over the pillage of archaeological sites by organized entrepreneurs or amateur pothunters. For the anthropologist, the archaeologist, and the art historian, the original context of an artifact is as important as the object itself, and an artifact unscientifically removed from its site is, at most, a vapid beauty. "What help are those looted 'floating' artifacts for answering questions about the forces behind the emergence or decay of civilization, social heterogeneity, population pressures on available resources, political or technical intensification? . . . [In this regard,] the artifact with no context or provenance is virtually worthless, despite the irony of a fat price tag."[77]

Frequently, such despoliation is outlawed by the country of origin, but these statutes do little to deter those bent on financial gain and urged on by an ever-growing market for such artifacts. A 1995 publication stated, "The illicit trade in stolen and/or illegally exported cultural objects in particular has grown so large that INTERPOL[78] now believes it to be one of the most prevalent categories of international crime."[79]

Although, in the abstract, there may be much sympathy for claims of countries of origin and although despoliation of archaeological sites may be roundly condemned, the search for acceptable methods of repatriation and control is an arduous one. Central to any discussion on the international movement of cultural property is the Convention on the Means of Prohibiting and Preventing the Illicit Import, Export, and Transfer of Ownership of Cultural Property, which was adopted by the General Conference on the United Nations Educational, Scientific, and Cultural Organization (UNESCO) on November 14, 1970,[80] as well as subsequent U.S. actions to implement the convention. Also of significance are the following: a series of lawsuits concerning the importation into the United States of archaeological or ethnological "undocumented" material from countries of origin; the Treaty of Cooperation between the United States of America and the United Mexican States Providing for the Recovery and Return of Stolen Archeological, Historical, and Cultural Properties; the U.S.

Property: Whose Ethics? Whose Property? (Albuquerque: U. of New Mexico Press, 1989); J. Merryman, "The Nation and the Object," 3 *International Journal of Cultural Property* (1994); J. Greenfield, *The Return of Cultural Treasurers* (New York: Cambridge U. Press, 1989); and E. Green, ed., *Ethics and Values in Archeology* (New York: Free Press, 1984).

77. P. Sheets, "The Pillage of Prehistory," 38 *Am. Antiquity* 317, 319 (1973). See also C. Coggins, "Illicit Traffic of Pre-Columbian Antiquities," 29 *Art J.* 94 (1969); C. Coggins, "Archeology and the Art Market," 175 *Science* 263 (1972); M. Robertson, "Monument Thievery in Mesoamerica," 37 *Am. Antiquity* 147 (1972); "International Protection of Cultural Property," 1 *Art Research News* (No. 2, 1981); I. McBryde, ed., *Who Owns the Past?* (Melbourne: Oxford U. Press, 1985); and O. Acar and M. Kaylan, "The Hoard of the Century," *Connoisseur* 74 (July 1988).

78. INTERPOL (International Criminal Police Organization) is a voluntary organization that promotes and organizes collaboration among national law enforcement agencies. The General Secretariat of INTERPOL is located in Lyons, France. INTERPOL has a network of some 170 member countries, and one of its most important roles is to act as a clearinghouse for information on offenses considered to be of international interest. See the editorial by G. Henley in 46 *ICOM News* (No. 3, 1993), for a description of how INTERPOL assists in circulating information concerning theft of cultural property.

79. R. Thornes, *Protecting Cultural Objects through International Documentation Standards: A Preliminary Survey* (Malibu, Calif.: Getty Art History Information Program, 1995), 7.

80. See Appendix A for a copy of the convention.

statute regulating the importation of certain monumental-type pre-Columbian art; and the Native American Graves Protection and Repatriation Act.[81]

a. The UNESCO Convention and U.S. Implementation

The purpose of the Convention on the Means of Prohibiting and Preventing the Illicit Import, Export, and Transfer of Ownership of Cultural Property (the UNESCO Convention) was to provide a common framework among nations for alleviating abuses in the international trade of cultural property.[82] Nations were asked to join in the convention by ratifying, accepting, or acceding to its terms in accordance with the procedures required by their respective constitutions.

Before the convention could be effected in the United States, it first had to be approved by the U.S. Senate and then had to be implemented by federal legislation that would establish internal methods of enforcement. The State Department, in urging Senate ratification, described the convention as follows:

The convention responds to the growing concern of the world community at the illegal removal of the national art treasures from their countries of origin. In recent years there appears to be an increase in the theft of art objects and the despoliation of national monuments and archeological sites in all parts of the world. Churches and temples are frequently looted and some ceremonial centers of ancient civilizations have been virtually dismantled. One of the most serious problems is the clan-

81. Another federal statute should be kept in mind when American Indian objects are at issue. 18 U.S.C. § 1163 makes it a crime to embezzle or steal property from an Indian tribal organization. The statute reads as follows:

Whoever embezzles, steals, knowingly converts to his use or the use of another, willfully misapplies, or willfully permits to be misapplied, any of the moneys, funds, credits, goods, assets, or other property belonging to any Indian tribal organization or intrusted to the custody or care of any officer, employee, or agent of an Indian tribal organization; or

Whoever, knowing any such moneys, funds, credits, goods, assets, or other property to have been so embezzled, stolen, converted, misapplied or permitted to be misapplied, receives, conceals, or retains the same with intent to convert it to his use or the use of another—

Shall be fined under this title, or imprisoned not more than five years, or both; but if the value of such property does not exceed the sum of $100, he shall be fined under this title, or imprisoned not more than one year, or both.

As used in this section, the term "Indian tribal organization" means any tribe, band, or community of Indians which is subject to the laws of the United States relating to Indian affairs or any corporation, association, or group which is organized under any of such laws.

The statute became law in 1956 and can be invoked only for violations occurring on or after that date. If a museum is considering acquiring Indian material located in Canada, it may want to become familiar with Canada's Cultural Property Export and Import Act of 1977 (Chapter 50.23–24, Elizabeth II, Vol. 1, No. 9, *Canada Gazette,* Part III).

82. For a brief account of the history of the convention and reactions to it, see A. Zelle, "Acquisitions: Saving Whose Heritage?" *Museum News* 19 (April 1971). See also *ICOM News* for Sept. 1969 and for March, June, and Sept. 1970. The most comprehensive study of the history of the UNESCO Convention is found in P. Bator, "An Essay on the International Trade in Art," 34 *Stan. L. Rev.* 275 (1982). This article was then put into book form: P. Bator, *The International Trade in Art* (Chicago: U. of Chicago Press, 1983). The UNESCO Convention does not address the subject of protecting underwater cultural heritage. See, for instance, E. Clement and L. Prott, "UNESCO and the Protection of the Underwater Cultural Heritage," 192 *Museum International* 37 (Vol. 48, No. 4, 1996).

destine excavation of archeological sites which can destroy the scientific value of the objects re-moved and of the site itself.

The situation is a problem for each country to deal with at home, but it is also a matter of inter-national concern and responsibility. Every country has an interest in the preservation of the cultural patrimony of mankind. Moreover, the flourishing international art market provides a major induce-ment of these illegal operations. The appearance in the United States of important foreign art trea-sures of suspicious origin gives rise to problems in our relations with other countries and makes it more difficult for American archeologists and scholars to work in these lands. It also stimulates over-restrictive export controls by the countries concerned which sometimes compound the problem.

The UNESCO convention deals with these issues by recognizing the primary responsibility of each state to protect its own cultural heritage and by establishing a framework for international co-operation that should be of significant assistance in a number of areas.

[T]hree of the most important provisions [are as follows]. First, the states parties undertake in ar-ticle 7(b) to prohibit the import of cultural property stolen from museums, religious or secular pub-lic monuments, or similar institutions in other states parties and to take appropriate steps, upon re-quest, to recover and return such property to the country of origin. This provision, like the other provisions of the convention, is not retroactive.

Second, the parties agree in article 7(a) to take the necessary measures, consistent with national legislation, to prevent museums and similar institutions within their territory from acquiring cul-tural property illegally removed from another state party after entry into force of this convention. In the United States this provision applies primarily to institutions controlled by the Federal Govern-ment; it does not require enactment of new legislation to control the acquisition policy of other in-stitutions. However, it does create a standard for private and local institutions, and it is expected they will develop their own code of ethics in the spirit of this provision.

Third, the convention includes a specific provision relating to materials of archeological and eth-nological importance. Article 9 provides that a state party whose cultural patrimony is in jeopardy from pillage of archeological or ethnological materials may call upon other state parties to partici-pate in a concentrated international effort to determine and to carry out the necessary concrete measures including appropriate controls of imports, exports, and international commerce in these materials. The Congress will be asked to enact appropriate legislation to implement this provision and the import controls required by article 7(a).

These are the highlights of the convention. It is by no means a panacea, but it is a significant effort to deal with a complex problem that does not yield easily to legal solutions.[83]

The convention was ratified by the Senate in 1972 with certain reservations and with the understanding that any federal legislation implementing the agreement would have to con-form to U.S. constitutional and legal standards. Framing and passing such implementing legislation, however, proved to be far more difficult than ratifying the convention itself. For the next ten years, various bills were introduced to effect the objectives of the convention, and each evoked comment from groups and individuals representing museums, private col-

83. Statement by Mark B. Feldman, then Assistant Legal Advisor for Inter-American Affairs, Department of State, before the Senate Committee on Foreign Relations.

lectors, art dealers, anthropologists, and so on.[84] Some argued for very strong, comprehensive legislation to demonstrate that the United States is a "moral nation." Others contended that art objects of ancient and primitive cultures belonged to everyone and that there was no fundamental obligation to return them to countries of origin, which may have done little to preserve them. Archaeologists stressed the irreparable damage done when objects are unscientifically excavated. Some dealers and collectors feared that strong U.S. legislation would only divert treasures to other importing nations that had failed to implement the convention. Practical problems were raised concerning statutes of limitations, methods of enforcement, and compensation of innocent holders. Each new version of the proposed legislation became more complex in order to accommodate the concerns of commentators, and at times, the protracted debate appeared to hinder rather than encourage resolution.

In December 1982, in the waning hours of the 97th Congress, implementing legislation was finally passed, without fanfare. The Convention on Cultural Property Implementation Act[85] contains the following major provisions:

1. Procedures by which the president of the United States can, on request, impose temporary import restrictions in order to deter a serious situation of pillage of archaeological or ethnological materials of a state that has acceded to the convention. As a rule, such action cannot be taken unless the application of import restrictions will be applied in concert with similar restrictions imposed by other nations having signifi-

84. An excellent overview of the divergent views expressed can be found in the legislative histories of the bills proposed to implement the convention: H.R. 5643 of the 95th Cong., H.R. 3403 of the 96th Cong., S. 1723 of the 97th Cong., 1st sess., and H.R. 4566 of the 97th Cong., 2d sess., the bill that eventually became law. See also L. DuBoff et al., "Proceedings of the Panel on the U.S. Enabling Legislation of the UNESCO Convention on the Means of Prohibiting and Preventing the Illicit Import, Export, and Transfer of Ownership of Cultural Property," 4 *Syracuse J. Int'l L. & Com.* 97 (1976), and M. Wisner, "Implementing the Convention on Illicit Traffic in Antiquities: Proposals, Past, and Prospective," 2 *Art Research News* 3 (No. 1, 1983). The definitive work, as noted in footnote 82, is P. Bator, "An Essay on the International Trade in Art," 34 *Stan. L. Rev.* 275 (1982), also published in book form under the title *The International Trade in Art* (Chicago: U. of Chicago Press, 1983).

85. Title II of Pub. L. 97–446 (a copy of the act is included in Appendix B). Interestingly, in Sept. 1977, Canada adopted a Cultural Property Export and Import Act (Chapter 50.23–24, Elizabeth II, Vol. 1, No. 9, *Canada Gazette,* Part III), a portion of which is designed to implement the UNESCO Convention. The Canadian act provides a relatively simple format whereby the attorney general of Canada is charged with instituting the legal proceedings necessary to resolve claims of countries of origin. For a discussion of the Canadian act, see I. Clark, "The Cultural Property Export and Import Act: Legislation to Encourage Co-operation," 2 *Art Research News* 8 (No. 1, 1983). One of the first cases arising under the act attracted international interest. In 1981, the New York art dealer Ben Heller brought into Canada for authentication by the Glenbow Museum in Calgary, and possible for sale, a Nigerian Nok sculpture. While in Canada, Heller and the owner of the sculpture, a Mr. Zango, were arrested by the Canadian government when they could not produce a Nigerian export license. A major issue in the case was what "illegal export" means under the Canadian statute. Does this phrase mean illegal export from the country of origin only after the effective date of the Canadian statute (1977) and/or Canada's acceding to the UNESCO Convention (1978), or does it mean illegal export at any time, even years before these dates? See *Between Her Majesty the Queen and Heller, Zango, and Kassam,* In the Court of Queen's Bench of Alberta, Judicial District of Calgary (Canada), as reported in *Stolen Art Alert* (Jan.–Feb. 1982) and (Oct. 1983). For another point of view on the *Nigerian Nok* case, see E. Eyo, "Repatriation of Cultural Heritage: The African Experience" in F. Kaplan, ed., *Museums and the Making of "Ourselves"* (London: Leicester U. Press, 1994), 339–40.

cant import trade in such materials. There are also procedures for unilateral action in emergency situations.

2. The creation of a Cultural Property Advisory Committee to assist the government in implementing and evaluating the effectiveness of such temporary import restrictions.

3. Restrictions on the importation of cultural property appertaining to the inventory of a museum or public institution of a party to the convention if such property was stolen from the institution after a prescribed date.

4. Procedures for seizing and disposing of cultural property illegally imported into this country.

5. Exemption of certain cultural properties from coverage: those imported for temporary exhibit or display and rendered immune from seizure under 25 U.S.C. § 2459;[86] those purchased in good faith by a museum or similar institution and held by it for at least three consecutive years under certain conditions; those held in the United States for at least ten consecutive years and displayed during that time for at least five years in a museum or similar institution; those held in the United States for at least ten consecutive years with evidence of actual or constructive notice, to the foreign nation concerned, of the location of such cultural properties; and those held for a period of not less than twenty consecutive years with evidence of good-faith purchase.

In the confirmation of the UNESCO Convention, the Senate specifically noted that it was not the intention of Congress to enact legislation to control the acquisition policies of museums generally. This "reservation" was directed to Article 7(a) of the convention:

The State parties to the Convention undertake:

(a) to take the necessary measures, consistent with national legislation, to prevent museums and similar institutions within their territories from acquiring cultural property originating in another State Party which has been illegally exported after entry into force of this Convention, in the States concerned. Whenever possible, to inform a State of origin Party to this Convention of an offer of such cultural property illegally removed from that State after the entry into force of this Convention in both States.

In the opinion of Congress, museums would voluntarily conform their policies to meet the standards expressed in the convention. In fact, professional organizations did begin to issue position papers urging their members to put into practice the principles underlying the convention,[87] and some institutions quickly responded with actual policies. One of the earli-

86. See Chapter VIII, "International Loans," for a description of this statute.

87. See the "Report of the Special Policy Committee of the American Association of Museums," as reported in *Museum News* (May 1971). The committee submitted, to the Council of the American Association of Museums, recommendations on the proposed UNESCO Convention. In 1973, the American Association of Muse-

est to do so was Harvard University, which in 1972—long before federal implementing legislation was enacted—adopted a policy that applied to all university collecting organizations.[88] The policy statement, with its prefatory explanation, is reproduced here because it represents the work of a variety of collecting disciplines (see Figure IV.1).

In May 1973, the Smithsonian Institution promulgated a somewhat similar policy, applicable to all of its collecting organizations. A copy of that policy follows (see Figure IV.2).

The Convention on Cultural Property Implementation Act makes a distinction between "documented objects" (materials that appear on inventories of museum and other public institutions of a country that belongs to the convention) and "undocumented objects" (illegally excavated archaeological or ethnological materials of a country that belongs to the convention). Under U.S. implementing legislation, stolen documented objects are stopped at U.S. borders when they have been reported by a foreign country. Undocumented stolen property of a foreign national, however, is subject to a more complex method of control because of the problem of proving the identity of such objects in a manner that comports with U.S. legal traditions. The method of control requires individual review of reported situations and, where appropriate, the imposition of precise temporary import restrictions. Key to this process is the Cultural Property Advisory Committee, created under the Convention on Cultural Property Implementation Act.

The advisory committee is composed of eleven members, appointed by the president and selected from four distinct groups:

- Experts in archaeology, anthropology, and ethnology
- Experts in the international sale of cultural property
- Representatives of the interests of museums
- Representatives of the interests of the general public

The United States Information Agency provides administrative and technical support to the advisory committee.

ums, the College Art Association, the Archeological Institute of America, the U.S. Committee of the International Council of Museums, the Association of Art Museum Directors, and the American Anthropological Association joined in adopting and promulgating a resolution that stressed the ethical and professional responsibilities of museums to support the principles of the UNESCO Convention. The "Code of Ethics for Art Historians," adopted by the College Art Association as of Jan. 24, 1995, gives more information on this resolution. An area of museum activity, sales in museum shops, also can affect the illegal movement of cultural properties and should be considered by museums when they are establishing internal policies. The "Code of Ethics" promulgated by the Museum Store Association contains the following statement: "Sale of illicitly acquired antiquities is offensive to the affected cultures and destructive to archeological sites. The Museum Store Association fully supports existing laws and recognizes the need for their rigid enforcement in order to preserve and protect our dwindling cultural . . . resources from wanton commercial exploitation." *Museum News* 51 (Jan.–Feb. 1982).

88. Policies adopted before the 1982 enactment of the Convention on Cultural Property Implementation Act were drafted without benefit of this national legislation. Passage of the Act should not materially affect most policies, which generally express a commitment to consider carefully relevant legal and ethical issues. As a practical matter, the Act should assist in implementing such policies by providing guidance on the issue of legality.

Under the Convention on Cultural Property Implementation Act, a country that is a member of the UNESCO Convention and whose cultural patrimony is in jeopardy from pillage of archaeological or ethnological materials may petition the United States for the imposition of temporary import controls designed to prevent the entrance into the United States of such pillaged "undocumented" material. The advisory committee reviews such requests for assistance and makes recommendations to the president. If temporary import controls are put into place, an immediate public notice describes in considerable detail what material is banned from importation and the duration of the ban. The advisory committee monitors the effectiveness of each ban and makes recommendations concerning its duration.

As of 1995, temporary import controls had been established to protect specifically described artifacts from the countries of Bolivia, El Salvador, Guatemala, Mali, and Peru. When such action is taken, both a general notice and precise information on import restrictions are published in the *Federal Register.* At the time of publication, a museum is considered to have notice that it cannot import or assist in the importation or retention of such prohibited material unless the importer can provide proof that the material left the country of origin legally. The U.S. Customs Service is responsible for monitoring materials covered by the import restrictions. Two sample notices follow: one declaring that import protection has been granted and one describing the materials covered (see Figure IV.3).[89]

89. Information brochures on the work of the advisory committee are available from the Cultural Property Advisory Committee staff, located within the Division of Creative Arts, U.S. Information Agency, 301 4th Street, S.W., Room 224, Washington, D.C. 20547. The U.S. Customs Service regulations setting forth its procedures for carrying out its role under the Convention on Cultural Property Implementation Act are found in 19 C.F.R. § 12.104. Lists of objects that have been declared banned under the act are located in 19 C.F.R. § 104g. In 1985, Canada sought protection for certain classes of its archaeological and ethnological artifacts and requested U.S. cooperation. Because of a difference between the countries in defining the scope of material that should be covered under the UNESCO Convention, Canada's petition contained material that fell outside of the U.S. Convention on Cultural Property Implementation Act. See C. Clark, "Illicit Traffic in Cultural Property: Canada Seeks a Bilateral Agreement with the United States," 38 *Museum* (No. 3, 1986). In April 1997 the United States and Canada entered into an agreement resolving this matter.

Figure IV.1

Harvard University Statement on Acquisitions

<div style="text-align: center;">

HARVARD UNIVERSITY
Cambridge, Mass.
617-495-1585

</div>

Release: Immediate University News Office Tuesday, January 18, 1972

The President and Fellows of Harvard College have approved a policy aimed at countering illicit international trade in objects of art.

So far as is known, Harvard is the first university to establish such a policy for an entire university, although institutions within other universities have taken similar measures. The Harvard policy governs not only acquisitions but also loans and exhibitions.

The policy, proposed by a committee that included directors of the major Harvard collections of art and antiquities, requires that officers of the University—curators, directors of libraries and museums or others— responsible for acquisitions should assure themselves that the University can acquire valid title to the object in question. They must assure themselves that the object was not recently exported illegally from the country where it originated or where it was last legally owned.

In any doubtful case, the responsible officer must consult widely with others within, and perhaps outside of, the University.

If Harvard should in the future acquire an object exported in violation of the laws of another country, it should return it if it can legally do so.

The most important part of the policy states:

"The University will not acquire (by purchase, bequest, or gift) objects that do not meet the foregoing tests. If appropriate and feasible, the same tests should be taken into account in determining whether to accept loans for exhibition or other purposes."

The report of the committee, accepted by the Corporation, stated that "no matter how complex, badly framed, or impractical" national legislation might be, "a responsible collecting institution must abide by it."

Prof. Stephen Williams, Director of the Peabody Museum of Archaeology and Ethnology, commented: "The trade in antiquities in recent years, particularly those of Mexico and Central America, has led to great destruction of the heritage of these nations—and of all mankind. The great Maya civilization, which reached its climax about 700–800 A.D., is of particular concern. Very little is known about the language of the Maya, which is recorded in hieroglyphic carvings on stone monuments. So far only the calendar can be read. Yet vandals steal, and mutilate for easy transportation, these magnificent stone documents. Indeed, at least two murders have occurred when gangs of looters were surprised at Mayan sites."

Central America, while perhaps the largest source of illegal objects, is not the only one. The countries of the eastern Mediterranean and India have been plagued with smuggling of treasures and the consequent destruction of their archaeological history.

A UNESCO conference of 1970 proposed an international treaty—so far not yet ratified by many nations, including the United States—to regulate illicit trade. Last year, the State Department proposed to Congress legislation that would have made illegal the import of pre-Columbian objects from Central America.

The Harvard statement called for a "firm, united stand, publicly taken by leading institutional and private collectors" to try to "eliminate or at least diminish the power of the black market."

Figure IV.1 continued

The committee had as members William H. Bond, Librarian of the Houghton Library of rare books and manuscripts, chairman; and Alfred W. Crompton, Director of the Museum of Comparative Zoology; J. David Farmer, Curator of the Busch-Reisinger Museum of Germanic Culture; Agnes Mongan, recently retired director of the Fogg Art Museum; William R. Tyler, Director of the Dumbarton Oaks Library and Research Collection of Byzantine Culture in Washington, D.C.; Stephen Williams, Director of the Peabody Museum of Archaeology and Ethnology; and Paul M. Bator, Professor of Law, who has worked with UNESCO on the problem.

The committee was appointed in the fall of 1970 by President Nathan M. Pusey. It made its report in June, 1971.

The policy statement is attached:

The collections in the museums and libraries of Harvard University have been formed and are augmented and maintained primarily to promote teaching and research. In recent years a flourishing international black market has grown up in the kinds of objects that are the proper concern of our collections, and this threatens the work of the University in various ways. For example, sites have been ravaged by thieves and vandals, to the irreparable damage and even total loss of important objects, while persons involved in this traffic either carelessly lose or deliberately conceal information about the precise origins of objects, often rendering them valueless for scientific study.

In response to this situation many countries have developed legislation designed to regulate the collection and export antiquities, art objects, and natural specimens found within their borders. But without the cooperation of the ultimate consumer—the collecting institution or individual—such legislation has often proved inadequate to control abuses.

More and more countries attempt to regulate these matters. The resulting legislation is far from uniform and has become steadily more complex. But no matter how complex, badly framed, or impractical such legislation may appear to be, a responsible collecting institution must abide by it. The violation, real or apparent, of regulatory legislation by one branch of the University is likely to have adverse effects upon the legitimate interests of all other branches of the University who pursue activities within the countries in question; and a bad reputation, once gained, is difficult to improve.

What is needed is a firm, united stand, publicly taken, by leading institutional and private collectors against illicit commerce in these materials. We believe that Harvard has a generally good record in the policies that have been privately and independently developed by its several collecting agencies. But it is now highly desirable that our informal and private code be formalized and made public, and that Harvard join with other responsible institutions and private collectors in an effort to eliminate or at least diminish the power of the black market. Such an action will serve both the particular interests of various sectors of the University and the more general aims of teaching and research.

Regulatory legislation differs widely from country to country, and the different kinds of objects that are collected also differ widely in their method of production or appearance on the market, the channels through which they are normally procured, and the extent to which their origin and history can be reasonably documented. Certification is no guarantee; if the stakes are high enough, certificates can be bought or forged even more easily than art can be faked. On the other hand, objects from currently restricted areas may have been exported in the period before restrictions were imposed, or have come out through legal means, and they may be legitimately on the market. Because absolute criteria applicable to all cases are difficult

Continued on next page

Figure IV.1 continued

or impossible to formulate, heavy reliance must be placed upon the knowledge and experience of the curatorial staff.

We believe that it is the business of the Curators of the several collections to master as far as possible, these complexities in their individual fields of competence. Curators should be relied upon for judgement in such matters in their special fields, and they must assume responsibility for the decisions that they make. The integrity of Harvard's collecting policy must be firmly maintained. A Curator's basis for decision should be a matter capable of public record; whether it need actually be published will depend upon the circumstances surrounding each individual case. In doubtful cases and in unfamiliar circumstances Curators should have recourse to the advice of the General Counsel to the University, who may in turn call upon other Curators and officers of the University for assistance in reaching a decision. If a difference of opinion arises between branches of the University over a matter of acquisitions policy, and if agreement cannot be reached between the interested parties, a similar mechanism of advice and appeal should be available.

To a great extent the proposed rules reflect practices long observed by the collecting agencies of the University. It will be noted, however, that the rules are largely forward-looking. In view of the tangle of international legislation, the complications arising from trusteeship, the probability of conflicting claims, and the extreme difficulty or impossibility in many cases of establishing a clear and unbroken line of provenance for past acquisitions, something resembling a statute of limitations must apply—as, in fact, it does among museum collections throughout the world. By taking a public stand along the lines we suggest, we hope that the University will play a significant role in the attempt to curb the abuses that have aroused so much public concern.

We therefore recommend that the President and Fellows adopt the following general principles to govern the University with respect to the acquisition (whether by gift, bequest, or purchase, or through the activities of scientific or archaeological expeditions) of works of art and antiquities:

1. The museum director, librarian, curator, or other University officer (hereinafter to be referred to as "Curator") responsible for making an acquisition or who will have custody of the acquisition should assure himself that the University can acquire valid title to the object in question. This means that the circumstances of the transaction and/or his knowledge of the object's provenance must be such as to give him adequate assurance that the seller or donor has valid title to convey.

2. In making the significant acquisition, the Curator should have reasonable assurance under the circumstances that the object has not, within a recent time, been exported from its country of origin (and/or the country where it was last legally owned) in violation of that country's laws.

3. In any event, the Curator should have reasonable assurance under the circumstances that the object was not exported after July 1, 1971 [this is the approximate date on which Harvard adopted its policy], in violation of the laws of the country of origin and/or the country where it was last legally owned.

4. In cases of doubt in making the relevant determinations under paragraphs 1–3, the Curator should consult as widely as possible. Particular care should be taken to consult colleagues in other parts of the University whose collecting, research, or other activities may be affected by a decision to acquire an object. The Curator should also consult the General Counsel to the University where appropriate; and, where helpful, a special panel should be created to help pass on the questions raised.

5. The University will not acquire (by purchase, bequest, or gift) objects that do not meet

Figure IV.1 continued

the foregoing tests. If appropriate and feasible, the same tests should be taken into account in determining whether to accept loans for exhibitions or other purposes.

6. Curators will be responsible to the President and Fellows for the observance of these rules. All information obtained about the provenance of an acquisition must be preserved, and unless in the opinion of the relevant Curator and the General Counsel to the University special circumstances exist in a specific instance, all such information shall be available as a public record. Prospective vendors and donors should be informed of this policy.

7. If the University should in the future come into the possession of an object that can be demonstrated to have been exported in violation of the principles expressed in Rules 1–3 above, the University should, if legally free to do so, seek to return the object to the donor or vendor. Further, if with respect to such an object, a public museum or collection or agency of a foreign country seeks its return and demonstrates that it is a part of that country's national patrimony, the University should, if legally free to do so, take responsible steps to cooperate in the return of the object to that country.

Figure IV.2

Smithsonian Institution Statement on Acquisitions

SMITHSONIAN INSTITUTION

Policy on Museum Acquisitions

The documentary value of a museum collection is a principal criterion of its excellence, and museum accession records should therefore be of the highest order of accuracy and completeness. To this end, each object acquired should have a provenance as completely documented as possible. Objects with incomplete provenance should be acquired only when they are of exceptional rarity, and when it is reasonably certain that their origin, context, and history can be established through scholarly research. An inadequate provenance may give rise to doubt as to the licit quality of an object. Each provenance should be a matter of public record.

The Institution supports the free exchange of information and artifacts which contributes to the advancement of knowledge and promotes international comprehension and goodwill. The legitimate international transfer of natural and cultural material should be facilitated by all available means, including loans and sales, and the Institution encourages such transfers in the same manner as it now fosters international exchanges between museums. At the same time, the Institution undertakes to cooperate fully with local, state, Federal and foreign authorities and institutions in their endeavors to protect their art, antiquities, national treasures and ethnographic material from destructive exploitations. An illicit international market has contributed to the despoliation of museums and monuments, and the irreparable loss to science and humanity of archaeological remains. The Institution repudiates the illicit traffic in art and objects. Objects and specimens which have been stolen, unscientifically gathered or excavated or unethically acquired should not be made part of the Smithsonian museum collections.

In consideration of this policy, the Regents of the Smithsonian Institution adopted the rules

Continued on next page

Figure IV.2 continued

set forth below for the acquisition of art, antiquities, and other specimens. The Director of each Bureau shall be responsible for the application of the rules. Donors, vendors, and correspondents will be notified of this policy.

1. Each Director of a museum collection, before authorizing the acquisition of an object, whether by purchase, transfer, gift or bequest, has the responsibility, in good faith, to ascertain, from the circumstances surrounding the transaction, or his knowledge of the object's provenance, that the object in question was not stolen or wrongfully converted, and is not illegally present in the United States.

2. Each Director also has the responsibility to ascertain that any proposed new acquisition was not unethically acquired from its source, unscientifically excavated or illegally removed from its country of origin after the date of adoption of this policy.

3. (a) In cases of doubt, the Director should consult widely within the Institution, particularly with those scientists or curators whose interests would be affected by acquisition of the object, and with the General Counsel. Where helpful, a special panel should be created to help pass on the questions raised.

(b) In the case of a substantial proposed acquisition of foreign provenance whose acceptability is in question, the Institution will contact the competent authorities or corresponding national museums of the probable countries of origin, or the countries whose laws may be affected by the transaction, in order to determine whether the latter can advise the Institution as to the status of the object. If any such object can be demonstrated to form part of the national patrimony of another country, the Institution will take reasonable steps within its power to aid that country in its efforts to effect the object's return.

4. In case the Institution should hereafter come into possession of an object which can be shown to have been acquired, excavated or exported in violation of Rule 2 above, the Institution should proceed as appropriate in each case, to seek to return the object to the donor or vendor or to contact the competent authorities or corresponding national museum in the probable country of origin, to determine what steps might be taken best to preserve the interests of all parties.

5. The policy set forth here should be applied in determining whether to accept loans for display or other purposes.

6. The provenance of acquired objects shall be a matter of public record.

Figure IV.3

Sample Declarations of Temporary U.S Import Control

SAMPLE 1

UNITED STATES INFORMATION AGENCY

Findings and Determinations by the Deputy Director Under the Convention on Cultural Property Implementation Act (Pub. L. 97–446, as amended)

Pursuant to the authority vested in me under Executive Order 12555, and USIA Delegation Order No. 86-3 of March 18, 1986 (51 FR 10137),

Findings

I hereby find:

(1) That Government of Bolivia made a request to the United States Government of the type and in the form required by section 303(a) of the Act, 19 U.S.C. 2602(a), on May 6, 1988,

Figure IV.3 continued

seeking emergency U.S. import restrictions and has supplied information which supports a determination that an emergency condition exists with respect to certain ethnological material from the community of Coroma, which material was identified as comprising a part of Bolivia's cultural patrimony in danger of being dispersed and fragmented in crisis proportions;

(2) That, pursuant to section 303(f)(1), 19 U.S.C. 2602(f)(1), notification of this request was published in the Federal Register on May 20, 1988 (53 FR 11544);

(3) That, pursuant to section 303(f)(2), 19 U.S.C. 2602(f)(2), this request was submitted to the Cultural Property Advisory Committee on May 19, 1988 for investigation, review and recommendation;

(4) That on August 4, 1988, the Committee transmitted to me its Report within the statutory ninety (90) day period prescribed in section 304(c)(2), 19 U.S.C. 2603(c)(2);

(5) That the Committee, in accordance with the requirements of section 306(f), 19 U.S.C. 2605(f), has thoroughly considered the request of Bolivia and has investigated the situation described in it;

(6) That the Committee recommends that emergency import restrictions be imposed on certain ethnological material from the community of Coroma;

(7) That the ethnological material which is the subject of the request consists of antique ceremonial textiles from the community of Coroma, situated high in the southern Altiplano region of the Andes, in Quijarro Province, Department of Potosi, which for centuries have been kept in bundles called q'epis that the ayllus of Coroma have passed from generation to generation as the collective inheritance from ancestors who lived near sacred areas;

(8) That the antique ceremonial textiles of Coroma are a part of the remains of a particular culture, the record of which is in jeopardy from dispersal and fragmentation which is, or threatens to be, of crisis proportions;

(9) That the imposition of emergency import restrictions on a temporary basis would, in whole or in part, reduce the incentive for dispersal and fragmentation of this ethnological material from the community of Coroma.

Determinations

Now, therefore, in accordance with the aforementioned authority vested in me, I hereby determine:

(1) That, pursuant to section 304(b) of the Act, 19 U.S.C. 2603(b), an emergency condition exists with regard to the antique ceremonial textiles from the community of Coroma;

(2) That the import restrictions set forth in section 307, 19 U.S.C. 2606, be applied to the antique ceremonial textiles of the community of Coroma; and

(3) That in accordance with the provisions of section 304(c)(3), 19 U.S.C. 2603(c)(3), the duration of such restrictions shall extend until May 6, 1993, five years from the date on which the Government of Bolivia's request was made to the United States.

Dated: January 19, 1989.

Marvin L. Stone,
Deputy Director.

Continued on next page

Figure IV.3 continued

SAMPLE 2

Customs Service

Import Restrictions on Cultural Textile Artifacts From Bolivia

AGENCY: U.S. Customs Service, Department of the Treasury.

ACTION: Notice of import restrictions.

SUMMARY: This document advises the public that, in accordance with a request from the Government of Bolivia, restrictions are being placed on the importation of certain culturally and historically significant textile artifacts from Bolivia. This action, which is being taken pursuant to the Convention on Cultural Property Implementation Act and in accordance with the United Nations Educational, Scientific and Cultural Organization (UNESCO) Convention on the Means of Prohibiting and Preventing the Illicit Import, Export and Transfer of Ownership of Cultural Property, and in cooperation with the U.S. Information Agency, will assist Bolivia in protecting its cultural property.

EFFECTIVE DATE: March 14, 1989.
FOR FURTHER INFORMATION CONTACT: Legal Aspects: Samuel Orandle, Commercial Rulings Division (202-566-5765).
Operational Aspects: Phyllis Henry, Trade Operations (202-566-7877). Both are at U.S. Customs Service, 1301 Constitution Avenue, NW., Washington, DC 20229.

SUPPLEMENTARY INFORMATION:

Background

The value of cultural property, whether archaeological or ethnological in nature, is immeasurable. Such items often constitute the very essence of a society and convey important information concerning a people's origin, history, and traditional setting. The importance and popularity of such items regrettably makes them targets of theft, encourages clandestine looting of archaeological sites, and accompanying illegal exporting and importing.

There has been growing concern in the U.S. regarding the need for protecting endangered cultural property. The appearance in the U.S. of stolen or illegally exported artifacts from other countries where there has been recent pillaging has, on occasion, strained our foreign and cultural relations. This situation, combined with the concerns of the museum, archaeological, and scholarly communities, was recognized by the President and Congress. It became apparent that it was in the national interest for the U.S. to join with other countries to control illegal trafficking of such articles in international commerce.

The U.S. joined international efforts and actively participated in deliberations resulting in the 1970 UNESCO Convention on the Means of Prohibiting and Preventing the Illicit

Figure IV.3 continued

Import, Export and Transfer of Ownership of Cultural Property (823 U.N.T.S. 231 (1972). U.S. acceptance of the 1970 UNESCO Convention was codified into U.S. law as the "Convention on Cultural Property Implementation Act" (Pub. L. 97–446, 19 U.S.C. 2601 et seq.). The spirit of the Convention was enacted into law to promote U.S. leadership in achieving greater international cooperation towards preserving cultural treasures that are of importance not only to the nations whence they originate, but also to greater international understanding of mankind's common heritage. In 1983, the U.S. became the first major art importing country to implement the 1970 Convention.

It was with these goals in mind that Customs issued interim regulations to carry out the policies of the act. The interim regulations, which were set forth in §§ 12.104–12.104; Customs Regulations (19 CFR 12.104), were published in the Federal Register as T.D. 85–107 on June 25, 1985 (50 FR 26193), and took effect immediately. After consideration of comments received on the interim regulations, final regulations were issued as T.D. 86–52, published in the Federal Register on February 27, 1986 (51 FR 6905), and took effect on March 31, 1986.

<center>Bolivia</center>

Under section 303(a)(3) of the Cultural Property Implementation Act (19 U.S.C. 2602(a)(3)), the Government of Bolivia, a State Party to the 1970 UNESCO Convention, requested the U.S. Government to impose emergency import restrictions on certain endangered cultural material to assist Bolivia in protecting its cultural patrimony. Notice of receipt of the request was published by the U.S. Information Agency (USIA) in the Federal Register on May 20, 1988 (52 FR 11544).

On May 19, 1988, the request was referred to the Cultural Property Advisory Committee, which conducted a review and investigation, and submitted its report in accordance with the provisions of 19 U.S.C. 2605(f) to the Deputy Director, USIA, on August 4, 1988. The Committee found the situation in Bolivia to be an emergency and recommended that emergency import restrictions be imposed on certain ethnological material from the community of Coroma. The Deputy Director, pursuant to the authority vested in him under Executive Order 12555 and USIA Delegation Order 86-3, considered the Committee's recommendations and made his determination that emergency import restrictions be applied. (See this issue of the Federal Register.)

The Commissioner of Customs, in consultation with the Deputy Director of the USIA, has drawn up a list of covered ethnological material from the community of Coroma in Bolivia. The materials on the list are subject to the 1970 UNESCO Convention and § 12.104a, Customs Regulations. As provided in 19 U.S.C. 2601 et seq., and § 12.104a, Customs Regulations, listed material from this area may not be imported into the U.S. unless accompanied by documentation certifying that the material left Bolivia legally and not in violation of the laws of Bolivia.

Continued on next page

Figure IV.3 continued

In the event an importer cannot produce the certificate, documentation, or evidence required in § 12.104c, Customs Regulations, at the time of making entry, § 12.104d provides that the district director shall take custody of the material until the certificate, documentation, or evidence is presented. Section 12.104e provides that if the importer states in writing that he will not attempt to secure the required certificate, documentation, or evidence, or the importer does not present the required certificate, documentation, or evidence to Customs within the time provided, the material shall be seized and summarily forfeited to the U.S. in accordance with the provisions of Part 162, Customs Regulations (19 CFR Part 162).

Antique Ceremonial Textiles From Coroma, Bolivia

U.S. import restrictions are applied to the antique ceremonial textiles from the community of Coroma, Bolivia. These are woven garments, dating from before 1500 to approximately 1850 A.D., owned communally by the Native people of this small Andean community. For centuries, they have played an integral role in the lives of the people of Coroma who wear them in special ceremonies. When not worn, they are honored and stored in bundles.

Textiles from this community may be identified by their appearance and texture. They are plain, not ornate, with varying widths of vertical stripes or bands. A few textiles display a checkerboard pattern. In color, the textiles are usually red, blue, or purple, or a shade of yellow, tan or brown. Unlike the more modern textiles from this Andean region, Coroma's ceremonial garments are made from high quality yarn from the wool of vicuna, or llama, and feels very soft to the touch, similar to silk.

Coroma's ceremonial garments consist of:

1. Tunic/Poncho: (asku or urku for women; unku or ccahua for men; poncho) A tunic is a woven garment consisting of either one or two pieces of woven cloth with sides stitched together; a poncho is a woven garment resembling a tunic but without the sides stitched together. (Approximate size: women's tunic is 1.2 m. by 90 cm.; Men's tunic is 82 cm. by 78 cm.)

2. Cape/Shawl: (llaqota or manta; llixilla or awayo; isqayo) Woven garment worn either on the back, like a cape, [or] worn over the back and arms, like a shawl. (Approximate size: 80 cm. by 79 cm.)

3. Small Ceremonial Cloth: (tari or inkuna) Woven square cloth small in size used as a woman's head covering for ceremonial purposes.

4. Hat/Headdress (sombrero, pillu) A sombrero is a hat made from vicuna hide; a pillu is a wool headdress made in the shape of a crown with fringe.

Dated: March 7, 1989.

William von Raab,
Commissioner of Customs.

b. Post–UNESCO Convention Activity

By the late 1970s, when it became evident that the UNESCO treaty would not meet with prompt, widespread acceptance, the international community began to explore other alternatives. UNESCO, with the assistance of the International Council of Museums (ICOM),[90] initiated work on a new approach. First, it was acknowledged that traditional legal mechanisms for deciding and adjusting questions of title worked poorly when the return of cultural objects was at issue.[91] The focus, therefore, was on devising a system whereby museums themselves could bilaterally decide issues concerning the fate of cultural objects without directly involving government action. As explained in an ICOM study report,[92] such a system would require the acceptance of certain premises:

(1) The legality of a claim is not necessarily determinative. In order to accept this premise, there must be an acknowledgment that certain important elements of a nation's cultural heritage belong with that nation, whether or not the object in question left the country or its people legally.

(2) The museum community must assist in trying to determine what constitutes an important element of a country's or people's cultural heritage, or a representative portion of that heritage, so that extravagant claims cannot be pressed.

(3) The country of origin, as the requesting nation, must establish that it can protect and preserve objects that are requested, and also that it is doing its utmost at the time to preserve similar objects already within its borders.

(4) Restitution need not always be a one-way street. At times, long-term loans, interchange of exhibits, or exchange of objects are suitable alternatives.

To implement these ideas, the general conference of UNESCO established a new international committee in November 1979, called the Inter-governmental Committee for Promoting the Return of Cultural Property to Its Countries of Origin, or Its Restitution in Case of

90. ICOM (International Council of Museums) is a nongovernmental organization composed of museums and representatives of museums. It was established in 1946 and has its headquarters in Paris. For ICOM's early role in working for international restraints on the illicit international movement of cultural property, see J. Nafziger, "Regulation by the International Council of Museums: An Example of the Role of Non-Governmental Organizations in the Transnational Legal Process," 2 *Denver J. of Int'l L. and Pol'y* 231 (1972). See also S. Ciccotti, "ICOM Celebrates 50 Years of Global Activism," *Museum News* 28 (Nov.–Dec. 1996).

91. The ICOM report cited in this section addressed "cultural properties," defined as follows: (a) objects and documentation of ethnological interest; (b) works of fine art and decorative art; (c) archives and documents; (d) paleontological and archaeological objects; and (e) zoological, botanical, and mineralogical specimens. At its twentieth session in 1978, the General Conference of UNESCO modified this list as follows: "cultural property, shall be taken to denote historical and ethnographic objects and documents including manuscripts, works of the plastic and decorative arts, paleontological and archeological objects and zoological, botanical and mineralogical specimens."

92. "Study on the Principles, Conditions, and Means for the Restitution or Return of Cultural Property in View of Reconstituting Dispersed Heritages," prepared by the Ad Hoc Committee appointed by the Executive Council of ICOM, 1978.

Illicit Appropriation.[93] The group, which has a rotating membership of twenty member states, is essentially an advisory body. Its main function is to facilitate bilateral negotiations based on offers or requests by member nations of UNESCO. The idea is that offers of return or requests will be presented to the committee so that it can use its resources as an impartial third party to assist in negotiations.

The committee also has important auxiliary tasks. It assists in identifying objects that warrant international negotiations. This may entail working with individual nations to define and limit what constitutes an important element of cultural heritage. If an object does not meet established criteria, the committee will not lend its assistance in negotiations. Second, the committee offers technical and, perhaps, financial assistance to a country of origin so that the country can provide facilities to care for and protect objects that are returned. The country of origin would be expected to demonstrate that it has sensible internal measures for taking care of such objects and that it has clear and enforced export laws. Third, the committee promotes the international exchange of important cultural objects. When there is a greater opportunity to borrow such objects, the question of ownership becomes less significant. Finally, the committee is charged with the task of creating a favorable international climate for the acceptance of its mission.

The committee met for the first time in May 1980 at UNESCO headquarters in Paris and adopted a program of work. It has continued to meet regularly to consider requests for return or restitution and to foster more interest in stemming the illicit traffic in cultural property. In the early 1990s, the committee renewed efforts to encourage countries to prepare national inventories of their protected cultural property, and it took part in discussions to make more uniform national laws concerning trade in cultural property.[94] As of 1995, the committee was the only permanent international discussion body dedicated to furthering the struggle against illicit trade.[95]

As of 1997, some eighty-six countries had joined the UNESCO Convention, but most commentators agree that the convention has had only limited success. Until France joined in January 1997, only two member countries, Canada and the United States, could be classified as major art-importing countries. In other words, after twenty-seven years, membership is composed mainly of countries that seek protection for their cultural property; countries that can afford this protection are notably absent. But the convention has served as an important vehicle for drawing into the limelight the problem of illicit traffic in cultural property. It has done so by codifying and giving validity to certain central concerns. It has provided a framework for seminars held throughout the world, professional organizations concerned with cultural property have incorporated convention guidelines into their codes

93. A distinction is sometimes made between "return" and "restitution," the former being applied to a voluntary offer to return and the latter referring to a situation in which a claim for return is based on an alleged legal right in the property. The word "return" is frequently favored when there is no desire to suggest illegal action on the part of the holder.

94. See the following discussion on UNIDROIT.

95. See E. Clement, "Return and Restitution of Cultural Property," 173 *Museum* 32 (Vol. XLIV, No. 1, 1992).

of practice, and courts have turned to the convention to validate the existence of problems worthy of their attention. In the United States, the convention has contributed to greater public awareness and a more informed legal profession.

However, acceptance of the convention has been impeded by differences in internal protections afforded by the legal systems of individual countries. Article 7(b)ii of the convention provides that countries joining the convention agree, at the request of a country of origin that is also a member, to return illegally imported cultural material, "provided, however, that the requesting . . . [country] shall pay just compensation to an innocent purchaser or to a person who has valid title to that property." This particular subsection has raised many problems, as the following example illustrates. As explained earlier, in the United States, as a general rule, a bona fide purchaser of a stolen object gets only the quality of title that the seller had (i.e., defective title). In contrast, in some countries, as a general rule, a bona fide purchaser of a stolen object gets good title. In effect, the stolen object is "cleansed" by selling it. The purpose of such a rule is to promote commerce by putting the purchaser in a favored position, and "market-oriented" countries that have such laws are reluctant to change them. In turn, countries—like the United States—that are more "victim-oriented" see the quoted portion of Article 7 as being unfair. In "victim-oriented" countries, holders of objects that are subject to return need to prove their innocence if they hope to get compensation, whereas holders in "market-oriented" countries need only produce bills of sale.

Recognizing this, and other problems, UNESCO began efforts in the 1980s to enlist the assistance of the International Institute for the Unification of Private Law (UNIDROIT).[96] As its name indicates, the group seeks to propose solutions to international problems that require agreement on legal principles of private (internal to a country) law. With the encouragement of UNESCO and under the auspices of UNIDROIT, a group of legal experts drawn from around the world began meeting in the late 1980s to work out proposed legal principles that balance the interests of "market-oriented" countries and those of "victim-oriented" countries. Two major areas of discussion have been the issues raised by the quoted portion of Article 7 and the equally difficult problem of the return of "illegally exported" (removed contrary to the law of the country of origin) objects. For importing countries, "requests for return" of "illegally exported" objects can raise questions about the proper characterization of the export law of the country of origin and/or the sufficiency of proof offered to support the claim.

In June 1995, the UNIDROIT committee reached agreement on a text and approved it in the form of the Convention on Stolen or Illegally Exported Cultural Objects. This con-

96. For the early history of UNIDROIT involvement, see the explanatory report that accompanies "The International Protection of Cultural Property," a preliminary report issued by UNIDROIT in Aug. 1990. A good source of information on the U.S. participation in the UNIDROIT initiative is the Advisory Committee on Private International Law, U.S. Department of State, Office of the Legal Adviser, Suite 402, 2100 K Street, N.W., Washington, D.C. 20037-7180. See also B. Hoffman, "How UNIDROIT Protects Cultural Property," *N.Y. L.J.* (March 3, 10, 1995); C. Lowenthal, "Stolen Art: A Positive Move toward International Harmony," *Museum News* 22 (No. 5, Sept.–Oct. 1991); and L. Prott, "UNIDROIT Draft Convention Focuses on Purchasers," 172 *Museum* 221 (Vol. XLIII, No. 4, 1991).

vention, like the UNESCO Convention of 1970, affects the law of a country only if the country votes to adopt the convention. It is difficult to predict, as of early 1997, how countries will react to the UNIDROIT proposal and whether this newer attempt to regulate the international movement of cultural property will have more far-reaching effects than the UNESCO Convention. The UNIDROIT proposal is definitely a compromise, since it tries to offer something to both market-oriented and victim-oriented countries. For victim-oriented countries, the proposal requires the return of all stolen cultural property, and unlawfully excavated property is included within the definition of "stolen." For market-oriented countries, statutes of limitations on claims are recognized in most instances, and an innocent possessor of stolen goods can obtain fair compensation for property that must be returned, provided he or she can establish that reasonable inquiries were made before the work was acquired. If the UNIDROIT proposal is adopted by the United States, no great change in U.S. laws will be required. But many observers speculate that the United States has little incentive to rush to adopt it. The United States, among art-importing countries, has so far been in the forefront in striving for international cooperation, and some argue that it is time for other art-importing nations to act before more is expected of the United States.

c. Cases Concerning Archaeological and Ethnological Materials

As mentioned earlier, cases discussed in Section D(5), "Stolen Property," focus on stolen objects that were clearly identifiable—a documented painting or piece of sculpture. The victim could establish former possession, and the alleged wrong clearly fell within what is commonly accepted as theft. Such cases can be complicated enough, but cases involving undocumented archaeological and/or ethnological materials add new dimensions. In this second group of cases, the party seeking relief in a U.S. court has two additional hurdles: Prior ownership of the particular objects in question must be provable by court standards, and the complained-of activity must be established as actual theft as recognized by court standards. Two cases illustrate these added difficulties. *United States v. McClain*[97] (also known as the *Simpson* case) highlights the problem of establishing an actual "theft"; *Government of Peru v. Johnson*[98] demonstrates not only the "theft" problem but also the problem of proving former ownership of the particular material at issue.

Once an object has been exported in contravention of the laws of a country (not necessarily "stolen" in the classic sense), the country of origin normally has limited recourse. The object and its possessor are beyond the country's jurisdiction, and in the absence of a specific international commitment to do otherwise, the importing country is frequently reluctant to take affirmative steps to secure the return of the object.[99] For example, in the United

97. *McClain I*, 545 F.2d 988 (5th Cir. 1977), *McClain II*, 593 F.2d 658 (5th Cir. 1979), *cert. denied*, 444 U.S. 918.

98. 720 F. Supp. 810 (C.D. Cal. 1989).

99. An example of such an international agreement is the "Treaty of Cooperation between the United States of America and the United Mexican States Providing for the Recovery and Return of Stolen Archeological, Historical, and Cultural Properties," 22 U.S.T. 494. The treaty, which is discussed in the following section, provides for the return, through diplomatic channels, of stolen archaeological, historical, and cultural objects that be-

States a foreign country may successfully bring a civil action to recover property stolen from it in the classic sense, but as a rule, a U.S. court will not entertain an action to enforce fines levied by the foreign government for failure to adhere to export procedures or other penalties of a regulatory nature.[100] Some foreign laws addressing the export of cultural material are so vague that U.S. courts hesitate to equate their violation with theft. Rather, the courts view these laws as merely export regulations—laws that do not affect the right to own objects but that simply require the owner to satisfy certain export regulations. This means that historically, once an illegally exported object arrived in the United States and no U.S. statute specifically barred its importation, the possessor rarely worried about legal action. A protracted court proceeding in the late 1970s, *United States v. McClain,*[101] threatened to upset this relatively secure situation.[102]

The *McClain* case concerned a group of U.S. citizens who were engaged in transporting movable pre-Columbian artifacts from Mexico into the United States. After transferring a group of such artifacts from California into Texas in order to offer them for sale, the parties were arrested and indicted for violating and conspiring to violate the National Stolen Property Act.[103] That act makes it a federal crime knowingly to transport in interstate or foreign commerce "any goods . . . of the value of $5,000 or more," which were "stolen, converted or taken by fraud." The prosecution argued that the artifacts were considered stolen under Mexican law and that the court should give full faith and credit to the foreign law. The group was convicted, and an appeal was filed. The American Association of Dealers in

long to the government. In *United States v. McClain,* this treaty was not invoked by Mexico, possibly because the treaty applies to objects of outstanding importance to the national patrimony and the objects at issue in *McClain* were not of this stature. Instead, criminal charges for theft were filed against the defendants by U.S. federal law enforcement officials.

100. J. Story, *Commentaries on the Conflict of Laws,* 8th ed. (Boston: Little Brown, 1883), § 18 ; J. Moore, *A Digest of International Law* (Washington, D.C.: Government Printing Office, 1906), 236; P. Bator, "An Essay on the International Trade in Art," 34 *Stan L. Rev.* 275 (1982), also published in book form under the title *The International Trade in Art* (Chicago: U. of Chicago Press, 1983).

101. See footnote 97, above.

102. An earlier case, *United States v. Hollinshead,* 495 F.2d 1154 (9th Cir. 1974), was similar in nature but did not arouse such interest. Hollinshead, a California art dealer, was arrested for violating the National Stolen Property Act when he was found to possess a pre-Columbian stela allegedly stolen from Guatemala. The prosecution was able to prove that the stela was removed from Guatemala, that the laws of Guatemala vested title to such property in the state, and that Hollinshead was aware of such laws. Hollinshead was convicted, and his conviction was sustained on appeal. Perhaps this case did not create as much controversy as *United States v. McClain* because *Hollinshead* involved a stela, a piece readily identified as a choice cultural object and one commonly known to be subject to control by its country of origin. In addition, the stela in question had been documented *in situ* some years earlier by the noted archaeologist Ian Graham. In *McClain v. United States,* the objects at issue were movable pre-Columbian artifacts, a category not so readily associated with state control. It is easier to imagine the innocent possession of movable pre-Columbian material than it is the innocent possession of stelae. Nevertheless, *Hollinshead* has been subject to legal criticism. See, for example, W. Hughes, "*United States v. Hollinshead:* A New Leap in Extraterritorial Application of Criminal Laws," 1 *Hastings Int'l & Comp. L. Rev.* 149 (1977).

103. 18 U.S.C. §§ 2314, 2315 and, regarding the conspiracy charge, 18 U.S.C. § 371.

Ancient, Oriental, and Primitive Art appeared as amicus curiae[104] in the appeal, arguing that giving full faith and credit to the Mexican law would establish a dangerous precedent.

Mexican statutes on the subject of archaeological monuments date back to 1897, and these laws have been revised on several occasions, with the latest revision occurring in 1972. A good deal of court argument centered on the translation and interpretation of these various statutes. It was important to determine, the court said, whether the laws merely imposed export requirements or whether they vested title to the artifacts in the Mexican government. If they did the latter, then, under Mexican law, a removal of the artifacts from the control of the government would constitute theft.[105] The appeals court did not agree with the trial court's opinion that Mexican law from 1897 vested title to the artifacts in the government, and it remanded the case to the lower court for a new trial on this subject. The group was convicted again, and a second appeal was filed. In the second appeal the court agreed to give full faith and credit to the 1972 Mexican statute, which, in its opinion, clearly claimed state ownership of all pre-Columbian antiquities. On the basis of this, the convictions of the defendants were upheld for conspiring to violate a federal law (the National Stolen Property Act). The appeals court stated that it would not enforce the pre-1972 Mexican statutes because they were not written "with sufficient clarity" to survive translation into terms understandable by and binding on American citizens.[106]

In *Government of Peru v. Johnson,* brought in the late 1980s, the government of Peru sued Johnson, an American citizen, for conversion (stealing) of some eighty-nine artifacts that Peru claimed were illegally removed from its borders. At the time, Peru was experiencing a good deal of plundering of its archaeological sites, and strong evidence indicated that some of this material was finding its way into California, where Johnson resided. Johnson claimed that he had purchased the artifacts in good faith over a number of years. In order to prevail, Peru had to show that the objects in question had actually come from Peru and that Peru had owned the artifacts at the time of the removal.

These objects, pre-Columbian artifacts, were "undocumented." In other words, they had never been described and catalogued as coming from a particular site. Peru produced its foremost expert in pre-Columbian artifacts; he testified that the objects were of Peruvian style and culture, and he gave his opinion that they had come from a particular region of Peru. However, on questioning, he admitted that Peruvian pre-Columbian culture extended into areas within the borders of Bolivia and Ecuador and that the artifacts could have come from these areas. Peru, as the plaintiff in the case, had to prove the provenance of the disputed objects; because of the undocumented nature of the material, this was a very difficult

104. Literally "friend of the court." With this status, one who is not a party to a case is granted permission to advise the court on the merits of the case.

105. If Mexican law merely imposed an export tax, a U.S. court would not normally entertain a suit to enforce such a foreign tax. If the foreign law made export a theft, then, as noted before, a U.S. court might entertain a foreign country's civil suit for the return of the material. Note, however, that *McClain* was a criminal action to enforce a foreign law.

106. 593 F.2d 658, 665–66. The court was saying, in essence, that the pre-1972 Mexican statutes would not be enforced because under U.S. constitutional standards they were "void for vagueness."

task. The court found that Peru's evidence was insufficient to sustain its claim that the objects were from Peru.

On the issue of establishing government ownership of pre-Columbian material, Peru experienced equal difficulty. Peru could not prove exactly when government ownership was established by statute and whether the statutes were consistent and uninterrupted in asserting government ownership. Since Peru could not prove when the objects were removed (because of their undocumented nature), it could not establish that they were removed during a period when there was clear statutory evidence of government ownership. The court also pointed out that despite statutes claiming government ownership, there was no evidence that Peru sought to exercise its ownership rights in pre-Columbian material as long as none of the material was being removed from the country. In other words, objects of this nature remained in private hands and were treated as private property within the country. The court suggested that Peru's statutes could be interpreted to be export restrictions, not assertions of title, and it cited the *McClain* case for support. Accordingly, although the court expressed sympathy for Peru's problem with looting of sites, it could only conclude that Peru was unable to sustain any of the claims in court.

The type of questions that come up in cases like *McClain* and *Government of Peru v. Johnson* had been at the core of the strain between "art rich" nations and "art poor" nations. Many foreign countries have statutes regulating archaeological and/or ethnological materials found within their borders. Some of these statutes cover only selected materials, are carefully administered, and are well-publicized. Others, however, are written in the broadest of terms, are not widely promulgated, and/or present problems of interpretation or administration. Even if knowledge of a statute of the latter type is assumed, it may be difficult for a foreigner to determine what the statute really means, especially if few within the country appear to follow it. Also, if such a statute is written to prohibit the export of all archaeological and/or ethnological material (no matter how minor), this offends many "art poor" nations, which maintain that movement of at least some of this material is important for the advancement of knowledge. It was these kinds of situations that caused "art poor" (i.e., art-importing) nations to effectively close their courts to claims of "art rich" (countries of origin) nations for the return of archaeological and/or ethnological material, either by classifying some of these foreign laws as export regulations or by insisting that promulgation and administration of these laws meet certain standards before relief will be granted. And, as explained earlier, the UNESCO Convention and the U.S. statute implementing the convention—the Convention on Cultural Property Implementation Act—address this core problem by calling for different remedies for documented objects and for undocumented objects.[107]

107. Interestingly, after losing its case in *Government of Peru v. Johnson,* Peru petitioned the United States under the Convention on Cultural Property Implementation Act for imposition of import bans on materials being looted from a sector of its country. The United States responded favorably. On June 9, 1997, the United States and Peru signed a "Memorandum of Understanding" that restricts the importation of pre-Columbian archaeological material and certain ethnological material into the United States unless accompanied by an export per-

More than twenty-five years have passed since the UNESCO Convention was first promulgated. By now, museums in the United States should be very aware of the major goals the convention seeks to achieve and the progress made through legislation and professional codes to move toward those goals in this country. This progress, in turn, should cause museums to review regularly their internal policies on acquisitions and loans to ensure conformance with current professional standards. It should also impress on museums the importance of maintaining complete and accurate records concerning acquisitions and loans. If a museum is ever questioned about the legality of its actions in these areas, a record of thoughtful deliberation and prudent action should weigh heavily in its favor.

d. Treaty of Cooperation between the United States of America and the United Mexican States Providing for the Recovery and Return of Stolen Archeological, Historical, and Cultural Properties

The late 1960s saw more attention focused on the international movement of art. The UNESCO Convention was in the process of development, and increased publicity was being given to the illicit traffic in pre-Columbian artifacts. The climate was right for the United States to take two significant steps. In July 1970, the United States and Mexico signed a treaty to cooperate in the recovery and return of certain cultural properties, and in October 1972, Congress passed Pub. L. 92–587, which regulates the importation of monumental-type pre-Columbian artifacts.

The treaty concerns itself with the recovery and return of "archeological, historical and cultural properties" that belong to either country. Such properties are defined to be

(a) art objects and artifacts of the Pre-Columbian cultures of the United States of America and the United Mexican States of outstanding importance to the national patrimony, including stelae and architectural features such as relief and wall art;
(b) art objects and religious artifacts of the colonial periods of the United States of America and the United Mexican States of outstanding importance to the national patrimony;
(c) documents from official archives for the period up to 1920 that are of outstanding historical importance; that are the property of federal, state, or municipal governments or their instrumentalities, including portions or fragments of such objects, artifacts, and archives.[108]

Under the treaty, both countries undertake to encourage the proper excavation and study of archaeological sites, to deter illicit excavations and the theft of properties covered by the treaty, to encourage the exhibit in both countries of properties covered by the treaty, and to permit legitimate international commerce in art objects. Also, each country agrees to assist in the return from its territory of stolen property covered by the treaty, and if the

mit issued by Peru. In signing the "Memorandum of Understanding," both countries agreed to work more closely using existing law to protect a broader area of Peru's rich cultural heritage.

108. Treaty of Cooperation between the United States of America and the United Mexican States Providing for the Recovery and Return of Stolen Archeological, Historical, and Cultural Properties, July 17, 1970, 22 *U.S.T.* 494.

requesting party cannot otherwise effect recovery, the attorney general of the country where the property is located is authorized to institute civil proceedings on behalf of the requesting party. Expenses incident to a return are borne by the requesting party.[109]

e. U.S. Statute Regulating the Importation of Pre-Columbian Monumental or Architectural Sculpture or Murals

Pub. L. 92–587, enacted in October 1972 (19 U.S.C. §§ 2091 *et seq.*), establishes a method of halting the importation into the United States of certain monumental-type pre-Columbian artifacts. The statute empowers the secretary of the treasury to promulgate a current list of stone carvings and wall artworks that are pre-Columbian monumental or architectural sculpture or murals; objects covered in the list cannot be imported into the United States without proof of a valid export permit from the country of origin. The statute is enforced at U.S. borders by U.S. Customs agents, and contraband objects are subject to forfeiture.

In 1973, the Treasury Department issued regulations detailing the implementation of the statute and defining the phrase "pre-Columbian monumental or architectural sculpture or mural."

(a) The term "pre-Columbian monumental or architectural sculpture or mural" means any stone carving or wall art listed in paragraph (b) of this section which is the product of a pre-Columbian Indian culture of Bolivia, British Honduras, Colombia, Costa Rica, Dominican Republic, Ecuador, El Salvador, Guatemala, Honduras, Mexico, Panama, Peru, or Venezuela.

(b) The term "stone carving or wall art" includes:

(1) Such stone monuments as altars and altar bases, archways, ball court markers, basins, calendars, and calendrical markers, columns, monoliths, obelisks, statues, stelae, sarcophagi, thrones, zoomorphs;

(2) Such architectural structures as aqueducts, ball courts, buildings, bridges, causeways, courts, doorways (including lintels and jambs) forts, observatories, plazas, platforms, facades, reservoirs, retaining walls, roadways, shrines, temples, tombs, walls, walkways, wells;

(3) Architectural masks, decorated capstones, decorative beams of wood, frescoes, friezes, glyphs, graffiti, mosaics, moldings, or any other carving or decoration which has been part of or affixed to any monument or architectural structure including cave paintings or designs;

109. Apparently, the first time Mexico asked for the assistance of the U.S. attorney general in this regard was in July 1978. At issue were pre-Columbian murals bequeathed to the de Young Museum in San Francisco. See B. Braun, "Subtle Diplomacy Solves a Custody Case," *Art News* 100 (summer 1982). Note that in addition to treaties, "executive agreements" and "memorandums of understanding" are used to facilitate cooperation between countries. Footnote 107 mentions the "Memorandum of Understanding" that was signed on June 9, 1997, between the United States and Peru concerning the protection of Peru's cultural heritage. In March 1995 a similar "Memorandum of Understanding" was signed between the United States and El Salvador in order to protect certain categories of pre-Hispanic archaeological material located in El Salvador. Memorandums of understanding and executive agreements do not change existing laws; they are used to facilitate cooperation between the signing parties in utilizing legal and diplomatic means to achieve articulated goals.

(4) Any fragment or part of any stone carving or wall art listed in the preceding
subparagraphs.[110]

Articles forfeited to the United States are first offered for return to the country of origin,
but the country of origin must bear all expenses incident to the return.

f. Native American Graves Protection and Repatriation Act

The Native American Graves Protection and Repatriation Act (NAGPRA) was signed into
law on November 16, 1990.[111] It was the culmination of many years of discussions and nego-
tiations between Native Americans and, in large part, the museum community concerning
the disposition of Native American human remains and the use and disposition of Native
American cultural materials. NAGPRA set the stage for greatly improved communication
between Native Americans and the museum community in the United States, thus offering
opportunities for growth for all concerned. The term "Native American" is defined, for
purposes of NAGPRA, to include tribes, peoples, and cultures indigenous to the United
States (American Indian, Native Alaskan, Native Hawaiian).

Historically, Native Americans had found themselves disconnected from museums in this
country; they were studied and interpreted from a distance, with little opportunity to speak
for themselves. In addition, Native American artifacts and human remains that were part
of museum collections seemed beyond their reach. Museums, in turn, were wary of re-
quests for the return of objects or human remains, insisting that each case had to be consid-
ered individually and in accordance with established legal principles. Native Americans
questioned whose law applied (the law of the "white man" or their law) and raised issues
concerning basic human rights.

A brief discussion of the legal issues regarding Native American claims for the return of
human remains or objects in museum collections follows. An understanding of the prob-
lems that were raised by both sides and that prompted the passage of NAGPRA helps in the
interpretation of the legislation.

A major concern for museums was the question of "standing" to bring a claim. In the
Anglo-American legal tradition, one must have "standing" to bring a claim in court—the
plaintiff must establish a direct, personal stake in the controversy before the court will adju-

110. See 19 C.F.R. §§ 12.105 *et seq.* One author questions whether these regulations accurately reflect the stat-
utory language. See J. McAlee, "From the Boston Raphael to Peruvian Pots: Limitations on the Importation of
Art into the United States," 85 *Dick. L. Rev.* 565 (1981).

111. Pub. L. 101–601, 25 U.S.C. §§ 3001–13. A precursor to NAGPRA was the American Indian Religious
Freedom Act, Pub. L. 95–341 (1978), which reaffirmed American Indians' First Amendment rights. The central
section of the act reads as follows: "[I]t shall be the policy of the United States to protect and preserve for Amer-
ican Indians their inherent right of freedom to believe, express, and exercise the traditional religions of the
American Indian, Eskimo, Aleut, and Native Hawaiians, including but not limited to access to sites, use and pos-
session of sacred objects, and the freedom to worship through ceremonials and traditional rites." Using this as a
guide and after consultation with Native Americans, the American Association of Museums promulgated the
"AAM Policy Regarding the Repatriation of Native American Ceremonial Objects and Human Remains," pub-
lished in *AVISO* (March 1988).

dicate the claim. The very practical reason for this rule is that a court wants to be sure it is dealing with the right party before decisions are made. This same practical reason prompted museums to want to be sure they were dealing with the right parties when Native American claims were made against their collections. If museums returned objects to the wrong parties, they were still liable to those who actually had "standing" to make the claims. The issue of standing was a particularly worrisome one when a claim was made for human remains by individuals or groups that could not prove direct lineal descent. The older the human remains, the more difficult it was to establish a direct blood relationship. Law in the Anglo-American tradition gave no clear direction on the issue of tribal standing to claim human remains of tribal members. "Standing" for representative groups (groups dedicated to pressing Native American concerns generally) was even more tenuous under Anglo-American legal precedent.

Another issue for museums was the type of evidence that could be accepted. Anglo-American legal tradition has rules regarding what kinds of evidence are admissible in court and rules regarding who has the "burden of proof" (the one who has to overcome the assumption that the other party is right). Museums were very conscious of these rules because of their obligation to be able to defend their actions to all their constituents. For Native Americans, however, strict adherence to these rules invariably defeated their claims because culturally they relied far more on oral tradition (not written records, which are favored in court), and as claimants, they usually had the burden of overcoming the presumption that the museum's ownership was valid. Relevant also to the issue of evidence was the Anglo-American legal tradition of enforcing statutes of limitation. Statutes of limitation, as explained in the earlier section on stolen property, are designed to ban from court those controversies that are so old that evidence has faded. The public policy behind these statutes is that justice cannot be done when strong evidence is not available. Although museums were hesitant to raise formal statutes of limitation objections to Native American claims, there remained the underlying problems of trying to reconstruct what had happened generations or centuries ago, with little, if any, written evidence.

The issue of precedent worried museums. They pointed out that if they deviated from their traditional method of handling a claim against their collections, they weakened their ability to defend against all other claims. And, as mentioned in the earlier section on the UNESCO Convention and its ramifications, a museum's response to a Native American claim could be construed as precedent for the handling of a later claim from a foreign country.[112]

While museums struggled with their worries, Native Americans had some strong points

112. Historically, the United States has treated Indian tribes as separate nations. In *Santa Clara Pueblo v. Martinez*, 436 U.S. 49, 56 L.Ed. 2d 106, at 113 (1978), the Supreme Court stated:

Indian tribes are "distinct independent political communities retaining their original natural rights in matters of local self-government. . . ." Although no longer "possessed of the full attributes of sovereignty" they remain "a separate people, with the power of regulating their internal and social relations. . . ." "They have power to make their own substantive law in internal matters . . . and to enforce that law in their own forums."

of their own to make. A major problem was the existence of a conflict in cultural and legal traditions. Native Americans pointed to their tribal methods of resolving disputes and to their interpretations of such issues as admissible testimony and burden of proof. Their rules were often quite different. Whose rules should apply?

Native Americans described their concepts of what was sacred and gave their definition of "sacred objects"—a definition that was far more encompassing than the rigid lines drawn between sacred and secular by the dominant culture.

It is deceptive to compare Western religious standards to Indian concepts of sacredness. In most native languages, there is no word that translates specifically to "religion" because spiritual thoughts, values, and duties are totally integrated into the social, political, cultural, and artistic aspects of daily life. This unity of thought—the combination of individual and community life in expressing thanks to the Creator—is the Indian "religion." In American Society, there has been a clear separation between church and state that is nearly impossible in traditional Indian Society.[113]

Native Americans pointed also to their concepts of community property—concepts that bore on the issue of alienability of property—which were very different from those of the Anglo-American tradition, which enshrined the idea of private property. Whose concepts should prevail when a Native American claim was made for the return of a Native American object?[114]

Native Americans also spoke about basic human rights and the importance of respecting deeply held spiritual beliefs and the cultural traditions of others. This again resonated to principles enunciated in the UNESCO Convention.

After reviewing at least some of the concerns of both sides, we see that the law is a clumsy tool to resolve conflicts based on cultural difference. One law school dean noted: "No issue better illustrates the point we try to make to our first year law students that formal legal institutions such as the courts are often the worst possible places to resolve conflicts. It is hard to explain to litigiously anxious neophytes that those things which we might 'legally' do may not be the things which we ought 'practically' or 'morally' to do."[115]

NAGPRA does not give wholesale answers to disputes. Instead, it sets forth rules, definitions, and procedures that are to be used in resolving problems relating to Native American human remains and cultural materials. More specifically, NAGPRA mandates (a) procedures for the disposition of Native American human remains and cultural objects in museum collections, (b) procedures for the disposition of Native American human remains and cul-

113. R. Hill, "Indians and Museums: A Plea for Cooperation," 4 *Council of Museums Anthropology Newsletter* 22, 23 (No. 2, 1979).

114. The semi-autonomous status of Indian tribes as described in footnote 112 makes the questions raised in this and the preceding two paragraphs all the more interesting. See "Museum Rights v. Indian Rights: Guidelines for Assessing Competing Legal Interests in Native Cultural Resources," 14 *N.Y.U. Rev. of Law and Social Change* (No. 2, 1986).

115. R. Strickland, "Beyond the Legal Dimension: Native American Ceremonial Objects and Human Remains," in American Law Institute–American Bar Association (ALI-ABA), *Course of Studies Materials: Legal Problems of Museum Administration* (Philadelphia: ALI-ABA, 1988).

tural objects found on federal or tribal lands after the passage of the act; (c) establishment of an advisory committee to help accomplish the purposes of the act; and (d) methods for funding projects and enforcing conduct required by the act.

Of immediate importance to museums after the passage of NAGPRA in November 1990 were the requirements that they complete, within stated time periods, "summaries" of certain Native American cultural materials held in their collections and "inventories" of Native American human remains and associated funerary objects held in their collections. Museums covered by these requirements include the following:

- Any department, agency, or instrumentality of the United States[116]
- Any state or local government
- Any institution that receives federal funds

"Receives federal funds" means receipt of funds after November 16, 1990, from a federal agency through any grant, loan, contract (other than a procurement contract), or other arrangement by which a federal agency makes or made available assistance in the form of funds.[117]

The purpose of the summaries and inventories was to provide information to Native American individuals, Indian tribes, and native Hawaiian organizations so that they could identify human remains and cultural objects that were probably culturally affiliated to them. Where there was evidence of cultural affiliation, the appropriate individuals or tribes had, under the legislation, procedural avenues for pursuing repatriation claims.

For the establishment of cultural affiliation, the following criteria were set forth:

- Existence of an identifiable present-day Indian tribe or native Hawaiian organization
- Existence of an identifiable earlier group
- Existence of a shared identity that could be reasonably traced between the present-day Indian tribe or native Hawaiian organization and the earlier group

Many kinds of information could be submitted to establish cultural affiliation: biological, kinship, oral history, archaeological, anthropological, linguistic, folkloric, ethnohistorical, expert opinion, and archival data.

In preparing summaries and inventories, museums were urged to consult with appropriate Native American groups and to provide these groups reasonable access to relevant

116. A federal agency is responsible for ensuring that the requirements of NAGPRA are met for all collections removed from lands under its control even though the collections may now be in the possession of another federal agency or nonfederal repository.

117. Federal funds that are provided for any purpose and that are received by a larger entity of which the museum is a part are considered federal funds. The Smithsonian Institution is expressly exempt from coverage under NAGPRA. This is because Smithsonian activity regarding Native American human remains and cultural objects was addressed in an earlier piece of federal legislation, the National Museum of the American Indian Act (Pub. L. 101–185), enacted in 1989 and later amended by Pub. L. 104–278 in 1996.

records in order to facilitate judgments concerning cultural affiliation. In other words, close communication was strongly encouraged.

Summaries had to give information on unassociated funerary objects, sacred objects, and objects of cultural patrimony held by the museums.[118] They were to give the general scope of the holdings, not item-by-item lists. Summaries were to be completed by November 16, 1993 (three years after the passage of NAGPRA), and copies were to be provided to the National Park Service and all Native American groups likely to be affiliated with the collections described in the summaries.

Inventories had to give information on Native American human remains and associated funerary objects held by the museum.[119] They were to be specific, not general, because the purpose was to give Native Americans sufficient evidence to make judgments about the cultural affiliation of individual remains or funerary objects. The deadline for completing inventories was November 16, 1995 (five years after the passage of NAGPRA), and two documents were to be produced by that date. One was a list of remains and objects that had been identified as affiliated with one or more Native American groups; the other was a list of remains and objects for which such affiliation could not be determined. On completion of the inventories, appropriate Native American groups and the National Park Service were to receive copies.

Using information gleaned in the summary and inventory processes, Native American individuals or groups could come forward to request repatriation of human remains or cultural objects. NAGPRA set forth standards of proof to be used to determine cultural affiliation, the order of preference to be given to claimants, and procedures for resolving disputes.

NAGPRA also set forth procedures to be followed after November 16, 1990, whenever Native American human remains or cultural objects are found on federal or tribal lands. These procedures ensure prompt consultation with appropriate Native American groups and clarify who has the priority to make decisions about the disposition of such remains or objects. The act also provided for the establishment of a committee, the Native American Graves Protection and Repatriation Review Committee, to monitor and review the implementation of repatriation activities, to facilitate resolution of disputes, and to report periodically to Congress on progress made under the act.

In August 1991, the Native American Graves Protection and Repatriation Review Committee was formally chartered.[120] The early work of the committee has focused on assisting in the development of regulations that provide guidance on the implementation of

118. Each of these terms is defined in the statutes and is further amplified in the regulatory process. See, for example, the Jan. 1, 1993, memorandum of the director of the National Park Service titled "Summaries, Inventories, and Notification under the Native American Graves Protection and Repatriation Act of 1990."

119. Each of these terms is defined in the statute and is further amplified in the regulatory process. See, for example, the March 1995 memorandum from the director of the National Park Service titled "Examples of Native American Graves Protection and Repatriation Act (NAGPRA) Inventory."

120. The charter of the Native American Graves Protection and Repatriation Review Committee was signed Aug. 2, 1991, by Manuel Lujan Jr., secretary of the interior.

NAGPRA and giving advice on resolution of disputes. As of 1997, a major task facing the committee was the preparation of recommendations for the disposition of culturally unidentifiable human remains that are not claimed under the provisions of NAGPRA.[121]

It is too early to make judgments on the effectiveness of NAGPRA.[122] Over the initial years, attention focused on the processes of doing summaries and inventories, the logistics of establishing improved lines of communication, and the clarification of numerous administrative questions. Human remains and cultural objects are being repatriated, Native Americans are developing their own concepts of museums, exhibitions that include Native American materials are being mounted with broader collaboration, and many museums are adjusting their collection-management policies to ensure that collection decisions conform to the spirit as well as the letter of NAGPRA.[123] Hopefully the process of implementing NAGPRA is impressing upon all concerned the importance of careful research, thoughtful deliberation, and mutual respect.

121. In June 1995, the review committee published a notice in the *Federal Register* outlining its current position on the disposition of culturally unidentifiable human remains (which can include associated funerary objects), as well as other options under discussion. Public comment was invited at this early stage of development. 60 *Fed. Reg.* 32163–65 (No. 118, June 20, 1995). In Aug. 1996, the review committee published draft recommendations on this subject. 61 *Fed. Reg.* 43071–73. The draft recommendations, influenced by many public comments received after the first "notice" was promulgated, present an approach substantially different from the one first suggested by the review committee. The newer approach seeks to narrow the number of cases of "unidentifiable human remains" by clarifying the definition of "shared group identity" and by establishing a mechanism for nonfederally recognized Native American groups to participate in disposition cases.

122. Proposed regulations for implementing NAGPRA were published in the *Federal Register* on May 28, 1993. Final regulations were promulgated in the *Federal Register* on Dec. 4, 1995 (43 C.F.R. pt. 10). Much has been written about NAGPRA. For an extensive bibliography covering publications before the passage of the act, see American Indian Program, National Museum of American History, *American Indian Sacred Objects, Skeletal Remains, Repatriation, and Reburial: A Resource Guide* (Washington, D.C.: Smithsonian Institution, 1990). For information on the implementation of the act since its passage, the best source would be the federal office directly involved in the administration of the act: Departmental Consulting Archeologist, Archeological Assistance Division, National Park Service, P. O. Box 37127, Washington, D.C. 20013-7127. Also, individual states can have their own statutes that address repatriation and/or burial sites within the state and for trade in human remains. Such statutes can affect human remains and cultural objects that do not fall under the purview of NAGPRA. For a discussion of state laws and other federal laws that relate to Native American remains and funerary objects, see M. Price, *Disputing the Dead* (Columbia: U. of Missouri Press, 1991).

123. Shortly after the passage of NAGPRA, the Field Museum of Natural History (Chicago) issued a "Policy Statement Concerning Requests for Reinternment of Human Remains and Burial Objects." The policy was formulated to address specifically the concerns of Native Americans. It conforms quite closely to NAGPRA requirements and also sets forth internal procedures for handling repatriation requests in an expeditious manner. The policy was published in *Course of Studies Materials: Legal Problems of Museum Administration* (Philadelphia: ALI-ABA, 1992). In 1996, a rare skeleton dating back more than nine thousand years was found in Kennewick, Washington, on land under the control of the U.S. Army Corps of Engineers. The skeleton raised intense interest because it did not have the features typical of those associated with Native Americans. Representatives of local tribes came forward and claimed the remains for immediate burial, citing NAGPRA. As of mid-1997, members of the scientific community were exploring ways to halt reburial, claiming the loss of possibly very significant information on the early settlement of the continent. See "Indian Tribes' Creationists Thwart Archeologists," *New York Times*, C13 (Oct. 22, 1996).

g. Conclusions

The UNESCO Convention and efforts to implement that convention, the *McClain* case, *Government of Peru v. Johnson,* and the Native American Graves Protection and Repatriation Act highlight the sensitive issues that can arise when a museum holds or seeks to obtain culturally significant property that may be claimed by its country or ethnic group of origin. The museum community's heightened awareness of these issues, the use of liberal doses of common sense in handling specific demands, and time should lead to acceptable methods of resolution. More and more examples now exist of successful accommodations whereby museums have returned objects voluntarily, and in turn, countries of origin or indigenous groups have loaned the objects back or have extended other favors to museums. More museum professionals in the United States are now willing to take a proactive position to halt illegal export. U.S. courts are listening more sympathetically to claims brought by foreign countries for the return of culturally significant objects. And a number of member nations of the UNESCO Convention have found the U.S. government to be quite responsive to their petitions for help brought under the U.S. Convention on Cultural Property Implementation Act.

These are all encouraging signs, but the next decade may provide a truer test of how much real progress may be made. The end of the cold war and the dramatic upheavals in Eastern Europe have brought new challenges. What had been suspected for some time was confirmed in 1994 and 1995: For decades, Russian museums have been hiding thousands of works of art and other treasures looted from East German storage areas at the end of World War II. At the time of these disclosures, the Russian government showed little indication that it would seek to return the works to their original owners.[124] If this proves to be the official position, how will the U.S. museum community react? Will there be silence, or will there be strong peer pressure urging a more enlightened solution? While Russia was displaying its war booty, many of the emerging independent nations of Eastern Europe were experiencing a dramatic loss of art and cultural material. Will much of this material find its way into the United States? Interesting times lie ahead. And as these explanations on stolen and illegally exported cultural material have shown, every museum in this country has an opportunity to affect the international climate regarding the import or export of cultural objects.

124. See K. Akinsha et al., "Spoils of War: The Soviet Union's Hidden Art Treasures," *Artnews* (April 1991); J. Lewis, "Art from the Cold War Deep-Freeze," *Washington Post,* Oct. 5, 1994; J. Lewis, "The Fine Art of Saving a Museum in Need," *Washington Post,* Oct. 16, 1994; R. Hughes, "Russia's Secret Spoils of World War II," *Time,* Oct. 17, 1994; C. Lowenthal, "Spoils of War," *Museum News* 42 (May–June 1995); S. Stephens, "The Hermitage and Pushkin Exhibits: An Analysis of the Ownership Rights to Cultural Properties Removed from Occupied Germany," 18 *Hous. J. Int'l Law* 59 (fall 1995). In 1996 the Russian government began considering legislation that would assert Russian ownership of approximately two hundred thousand works of art taken from Germany at the end of World War II. As of mid-1997, such a bill had been passed by the parliament and sent to President Boris Yeltsin for signature. Yeltsin refused to sign and returned the bill to parliament for further review. See VI *Artworld Europe* 1 (No. 6, May/June 1997).

7. LAWS PROTECTING PLANTS AND WILDLIFE (AND PARTS THEREOF)

A consistently expanding range of federal, state, and foreign laws is designed to protect certain types of plants and wildlife, and these laws can have an immediate effect on museum operations. Regarding collecting activity, such laws can come into play when specimens and/or objects cross state or national borders, and they very often are at issue when there is collecting in the field, whether in the United States or abroad. Museum shops can be affected also because the laws can restrict the use of parts of plants and wildlife—parts that may be incorporated into objects that seem appropriate for inclusion in shop inventories. What all this means is that museum personnel need to be aware of these laws and need to explore their ramifications before engaging in certain activities. Many of these laws have exemptions for certain types of educational and scientific uses (uses compatible with museum needs), but permits must be obtained before the activity is undertaken. And, of course, if there is no such exception for the planned activity, it is far better for the museum to know this before liability is incurred.

The laws under discussion regulate the disposition, sale, trade, taking, and transportation of certain fish, wildlife, and plants. Some of the statutes cover live as well as dead specimens, parts of specimens, or products made from parts of specimens.[125] Thus, without a sustained effort to keep abreast of current developments, every museum, zoo, or museum shop could unwittingly run afoul of these laws. This section discusses only the federal protective statutes that are of general interest to the museum community, but the violation of a state or foreign law can amount to a federal violation. For example, a section of the Lacey Act (described below) makes it a federal offense to transport, receive, or acquire in interstate or foreign commerce fish or wildlife, or parts thereof, taken in violation of a state or foreign law.[126] Another section of that act makes it a federal offense to transport, receive, or acquire plants, or parts thereof, in violation of any state law.[127] Therefore, museums need to be familiar with the laws of the jurisdiction in which a specimen or object is obtained so that necessary precautions can be taken not only to satisfy local requirements but also to avoid subsequent federal entanglements. Bear in mind that if the activity is covered by more than one statute, the most restrictive one will usually control.

A number of federal protective laws frequently affect museum activity: the Lacey Act, the Convention on International Trade in Endangered Species of Wild Fauna and Flora (CITES), the Endangered Species Act, the Marine Mammal Protection Act, the Migratory Bird Treaty Act, the Bald and Golden Eagle Protection Act, the Wild Exotic Bird Conservation Act, the African Elephant Conservation Act, and the Antarctic Conservation Act.[128] The essential features of each are described below.

125. Animal and plant parts, for example, can be used in native handicrafts, jewelry, wearing apparel, and decorative objects, as well as for objects of ethnographic and/or religious importance.

126. § 3(a)2A of Pub. L. 97–79, 16 U.S.C. § 3372(a)(2)(A).

127. § 3(a)2B of Pub. L. 97–79, 16 U.S.C. § 3372(a)(2)(B).

128. This list mentions only the statutes more likely to affect museum activity. Not mentioned, for example, are the U.S. Department of Agriculture and the Public Health Service restrictions on the importation of certain

a. Lacey Act

The Lacey Act (16 U.S.C. § 3371, *et seq.*) was originally passed in 1900.[129] It has been amended several times, with a major revision in 1981.[130] It now amounts to an omnibus statute: Numerous activities that are regulated by state or foreign governments are made a federal offense and, thus, subject to federal control once material enters the country or crosses state lines. The act prohibits the importation, exportation, transportation, sale, receipt, acquisition, or purchase of any fish, wildlife, or plant taken or possessed in violation of any law, treaty, or regulation of the United States or in violation of any Indian tribal law. In addition, the act has a provision that prohibits the transportation in interstate or foreign commerce of (1) fish or wildlife taken, possessed, transported, or sold in violation of any law or regulation of any state or in violation of any foreign law, or (2) any plant taken, possessed, transported, or sold in violation of any law or regulation of any state. This particular provision is intended to apply to fish, wildlife, or plants introduced into any state or foreign country in violation of its laws, as well as to fish, wildlife, or plants removed from a state or foreign country in contravention of its laws. The term "fish or wildlife" is defined to include any wild animal, dead or alive, and any part, product, egg, or offspring thereof. It covers mammals, birds, reptiles, amphibians, fish, mollusks, crustacea, anthropoids, coelenterates, or other invertebrates. The term "plant" means any wild member of the plant kingdom, including roots, seeds, or other parts thereof, that is indigenous to any state and that is either (a) listed as protected by the Convention on International Trade in Endangered Species of Wild Fauna and Flora (see next section) or (b) listed pursuant to any state law that provides for the conservation of species threatened with extinction.

To provide a mechanism for enforcement of the law, the secretary of the interior and the secretary of commerce are authorized to promulgate regulations for the marking and labeling of containers or packages containing fish or wildlife. Failure to abide by these regulations amounts to a violation of the act: "It is unlawful for any person to import, export, or transport in interstate commerce any container or package containing any fish or wildlife unless the container or package has previously been plainly marked, labelled, or tagged in accordance with the regulations issued pursuant to [this act]."[131] Also, regulated material can move in or out of this country only through specially designated locations. As a general rule, wildlife material that requires a permit can enter or leave the country only through

plants and animals, or parts thereof, for health and safety reasons. Information on such regulations can be obtained from the U.S. Department of Agriculture (Animal and Plant Health Inspection Service, Hyattsville, MD 20782) and from the U.S. Public Health Service (Center for Disease Control, Atlanta, GA 20222). No attempt is made to cover state or municipal regulation of the movement of wildlife. On the municipal level, regulations usually address live animals that may be dangerous, hazardous to health, or noisy. In addition to the statutes mentioned, zoological parks and aquariums can be subject to other federal laws and regulations that primarily address the care and use of live species. A good source of information on these laws and regulations is the American Association of Zoological Parks and Aquariums, Bethesda, Md. See also D. Kleiman et al., eds., *Wild Mammals in Captivity* (Chicago: U. of Chicago Press, 1994).

129. Regulations implementing the act are found in 50 C.F.R. subchapter B.

130. Lacey Act Amendments of 1981, Pub. L. 97–79, 95 Stat. 1073.

131. Ibid., § 3(b). See also 50 C.F.R. pt. 14.

the following ports: Baltimore, Maryland; Chicago, Illinois; Dallas–Fort Worth, Texas; Honolulu, Hawaii; Los Angeles, California; Miami, Florida; New Orleans, Louisiana; New York, New York; Portland, Oregon; San Francisco, California; and Seattle, Washington. Exceptions to this requirement can be sought from the U.S. Fish and Wildlife Service, Division of Law Enforcement. All protected plant material can enter or leave the country only through the following ports: Brownsville, Texas; El Paso, Texas; Hoboken, New Jersey; Honolulu, Hawaii; Houston, Texas; Jamaica, New York; Laredo, Texas; Los Angeles, California; Miami, Florida; New Orleans, Louisiana; Nogales, Arizona; San Diego, California; San Francisco, California; San Juan, Puerto Rico; and Seattle, Washington.[132]

The Lacey Act carries civil penalties up to $10,000 per violation, and such a penalty can be imposed if a violation occurs because of lack of "due care." Criminal penalties for a felony offense for sale or purchase can go as high as $250,000 for an individual ($500,000 for an organization) and up to five years in prison. Criminal penalties for a misdemeanor (lesser) charge can go as high as $100,000 for an individual ($200,000 for an organization) and up to one year in prison.[133]

b. Convention on International Trade in Endangered Species of Wild Fauna and Flora (CITES)

The Convention on International Trade in Endangered Species of Fauna and Flora (16 U.S.C. § 1538[c]), an international wildlife treaty, is commonly referred to as CITES.[134] Periodically under the treaty, an animal or plant species can be classified as falling into one of the following categories or "appendices": endangered, threatened, or internally protected. Each category imposes limitations. The CITES treaty member nations, of which the United States is one, agree to adhere to these limitations.

Appendix 1 of the CITES treaty lists all species that are in danger of extinction and that may be affected by trade. Species in this category are subject to stringent restrictions on movement. Appendix II of the treaty lists species that are threatened with extinction if their movement is not regulated. Restrictions on movement for this category are not quite as stringent. Appendix III of the treaty lists species for which a member nation of CITES has internal regulations "for the purpose of preventing or restricting exploitation." Countries that have adopted the CITES treaty agree to honor these regulations.

Species covered by CITES include both living and dead specimens, as well as all readily recognizable parts and derivatives thereof. Permit requirements vary depending on which appendix the specimen falls under, but all required permits must be obtained before the specimen is exported or imported. Species that are protected by CITES frequently are protected as well by one of the other federal laws discussed in this section, and such law could impose more stringent requirements.[135]

132. See 50 C.F.R. pt. 14, and § 24.12.
133. 16 U.S.C. § 3372.
134. 16 U.S.C. §§ 1531 *et seq.*
135. See, for example, the description of the Lacey Act, above. For CITES appendices, see 50 C.F.R. pt. 23.

c. Endangered Species Act

The Endangered Species Act of 1973, as amended (16 U.S.C. §§ 1531, *et seq.*), prohibits the importation and exportation, and the sale, trade, or shipment in interstate and foreign commerce, of listed endangered species, their parts, and products made from them.[136] The act also makes it illegal to harass, harm, capture, or kill any such species within the United States. The prohibitions apply to threatened species as well as to endangered species.

The term "endangered species" means "any species which is in danger of extinction throughout all or a significant portion of its range." The term "threatened species" means "any species which is likely to become an endangered species within the foreseeable future throughout all or a significant portion of its range." The term "species" includes any subspecies of fish or wildlife or plants and any distinct population segment of any species of vertebrate fish or wildlife that interbreeds when mature.[137] The current list of endangered and threatened species can be found in 50 *Code of Federal Regulations,* part 17 (50 C.F.R. pt. 17).

Permits may be granted for scientific or propagational purposes or in other limited situations. All wildlife must be imported and exported through certain designated ports, but permits may be obtained for the entry of fish and wildlife other than endangered species through nondesignated ports of entry for scientific purposes.[138]

The Endangered Species Act also implements the earlier mentioned Convention on International Trade in Endangered Species of Wild Fauna and Flora (CITES). Species listed in the CITES appendices are not necessarily the same as those listed under the Endangered Species Act.[139] The requirements of CITES are in addition to, not in lieu of, the requirements of the Endangered Species Act. Penalties under the Endangered Species Act can be substantial. Civil penalties can range up to $10,000; criminal charges may be assessed up to $100,000 and one year in prison for an individual and up to $200,000 for an organization.

d. Marine Mammal Protection Act

The Marine Mammal Protection Act of 1972, as amended (16 U.S.C. §§ 1361, *et seq.*), establishes a moratorium on the taking of marine mammals and bans the importation of such mammals.[140] The term "marine mammal" means "any mammal which (A) is morphologi-

136. The Endangered Species Act Amendments of 1978 (Pub. L. 95–632, 92 Stat. 3751) amended the 1973 act to permit the importation of certain antique articles (other than scrimshaw) that (1) were made before 1830; (2) are composed in whole or in part of any endangered or threatened species; (3) have not been repaired or modified with any part of any endangered or threatened species on or after Dec. 28, 1973; and (4) are entered at a designated port.

137. 16 U.S.C. § 1532.

138. See the discussion of ports of entry and exit in Section D(7)(a), "Lacey Act."

139. The list of endangered and threatened wildlife and plants appears in 50 C.F.R. § 17.11 and § 17.12. The list of wildlife and plants covered by CITES appears in 50 C.F.R. § 23.23.

140. Regulations implementing the act are found in 50 C.F.R. pt. 18. "To improve the operation of the Marine Mammal Protection Act of 1972," Pub. L. 97–58, 95 Stat. 979, signed on Oct. 9, 1981, provides for increased federal-state cooperation in managing marine mammals in ocean waters from three to two hundred miles offshore. State regulations may now be adopted and enforced in federally controlled waters.

cally adapted to the marine environment . . . or (B) primarily inhabits the marine environment . . . , and . . . includes any part of any such marine mammal, including its fur, skin, bones or teeth."[141] Falling within the definition are polar bears, sea lions, porpoises, whales, sea otters, walruses, seals, dugongs, and manatees.[142]

An exception is made for Indians, Aleuts, or Eskimos who dwell on the coast of the North Pacific Ocean or the Arctic Ocean. They are permitted to hunt for subsistence purposes and for obtaining material used in certain traditional native handicrafts to be sold in interstate commerce. Permits can also be granted for research and display and in certain cases of economic hardship. Civil penalties for violating the act can range as high as $25,000; criminal penalties may be assessed up to $100,000 and one year of imprisonment for an individual and up to $200,000 for an organization.

e. Migratory Bird Treaty Act

The Migratory Bird Treaty Act (16 U.S.C. §§ 703, *et seq.*) was originally passed in 1918 and has been amended several times.[143] The act makes it unlawful to kill, capture, collect, possess, buy, sell, ship, import, or export most migratory game and nongame birds, including their parts, nests, or eggs, unless an appropriate federal permit is obtained. Sport hunting of certain migratory game birds is permitted under federal regulation, and certain commercial activities involving captive-reared birds are allowed under permit.

There are only criminal penalties for violation of the act. A criminal felony charge for sale or barter can bring a penalty of up to $250,000 and two years in prison for an individual and up to $500,000 for an organization. A criminal misdemeanor charge can bring a penalty up to $5,000 and six months in prison for an individual and up to $10,000 for an organization.

f. Bald and Golden Eagle Protection Act

The Bald and Golden Eagle Protection Act (16 U.S.C. §§ 668, *et seq.*), originally enacted in 1940 and since amended, makes it illegal to take bald or golden eagles or to sell, purchase, or barter their parts (including feathers) or products made from them.[144] It also prohibits the killing or harassment of any bald or golden eagle. Exceptions may be granted for scientific, exhibition, or Indian religious purposes.

The act has only criminal penalties. A criminal misdemeanor charge can bring up to one year in prison and $100,000 in fines for an individual and up to $200,000 for an organization. For a criminal felony charge (second offense), penalties can go as high as two years in prison and $250,000 in fines for an individual and $500,000 for an organization.

141. 16 U.S.C. § 1362(5).
142. Some of these are also protected by the Endangered Species Act.
143. Regulations implementing the act can be found in 50 C.F.R. pts. 10 and 21.
144. Regulations implementing the act can be found in 50 C.F.R. pt. 22.

g. The Wild Exotic Bird Conservation Act

The Wild Exotic Bird Conservation Act (16 U.S.C. § 4901), passed in 1992, prohibits the importation of any exotic bird in violation of any prohibition, suspension, or quota on importation.[145] The term "exotic bird" means any live or dead member of the class Aves that is not indigenous to the fifty states or the District of Columbia and any egg or offspring thereof; it does not include domestic poultry, dead sport-hunted birds, dead museum specimens, dead scientific specimens, or product manufactures from such birds or any birds in the following families: Phasianidae, Numididae, Cracidae, Mealeagrididae, Megapodiidae, Anatidae, Struthionidae, Rheidae, Dromaiinae, and Gruidae.

Civil penalties of up to $25,000 may be assessed under the act. For a criminal misdemeanor, penalties may be assessed up to $5,000 and six months in prison for an individual and up to $10,000 for an organization. Criminal felony charges may be assessed up to $250,000 and two years in prison for an individual and up to $500,000 for an organization.

h. African Elephant Conservation Act

The African Elephant Conservation Act (16 U.S.C. § 4201) was passed in 1988 to protect the endangered African elephant.[146] The African elephant is currently listed in Appendix I of the CITES treaty (as an endangered species subject to strict protection), and this designation, along with the African Elephant Conservation Act, all but eliminated the import and export of raw ivory into or from the United States. The act also greatly restricts the movement of worked ivory into and out of the United States.

Civil penalties of up to $5,000 can be assessed under the act. Criminal misdemeanor charges may be assessed up to $100,000 and one year in prison for an individual and up to $200,000 for an organization.

i. Antarctic Conservation Act

The purpose of the Antarctic Conservation Act of 1978 (16 U.S.C. §§ 2401, *et seq.*) is to conserve and protect the native mammals, native birds, and native plants of Antarctica and the environment on which they depend. The act makes it unlawful, without permit authority, for any U.S. citizen

1. to take within Antarctica any native mammal or native bird;
2. to collect any native plant within specially protected areas;
3. to introduce into Antarctica any animal or plant that is not indigenous to Antarctica;

145. Regulations appear in 50 C.F.R. § 15.

146. Opinions differ as to whether restricting trade in elephants is the best way to preserve the species. Some argue that policies designed to make elephants valuable for trade will, in the long run, protect the species. See, for example, R. Simmons and U. Kreuter, "Save an Elephant: Buy Ivory," *Washington Post*, Oct. 1, 1989.

4. to enter any specially protected area or site of special scientific interest; or

5. to discharge or dispose of any pollutant within Antarctica.[147]

The act makes it unlawful also for a U.S. citizen to receive, possess, or ship a mammal, bird, or plant improperly taken from Antarctica. Although these prohibitions do not apply to any such mammal, bird, or plant held in captivity on or before October 28, 1978, the effective date of the statute, the burden of proof is on the possessor to prove that this exception applies.[148]

Permits can usually be obtained for the acquisition of native mammals and birds, except for those in specially protected species, for use as specimens in museums, zoological parks, and similar organizations and for approved scientific study.

j. Application to Museums

As noted, the above-described statutes can restrict the acquisition,[149] loan, and disposal of certain collection objects and can limit the kinds of merchandise sold in a museum's shop.[150] Because some of these statutes serve also as a basis for enforcing state and foreign laws that may apply to the objects in question, museums frequently need to do considerable research before acting with any degree of certainty. In addition, a literal reading of some of the statutes can occasionally place obstacles in the way of scientific investigations or can create seemingly impossible dilemmas for those attempting to further the laudatory objectives of the protective legislation.[151] The sensible approach, however, is to meet these statutes in a positive manner, prepared for some inconvenience and with an understanding of the magnitude of the problems the statutes are designed to address. Trading in live animals, plants, and products is a very lucrative business that supplies pet retailers, the clothing and leather industries, manufacturers of decorative objects, and collectors, to name a few. Smuggling wildlife into the United States is in itself a multimillion-dollar business, and this plus the

147. 16 U.S.C. § 2403

148. Pub. L. 95–541, 92 Stat. 2048 (1978). Regulations implementing the act can be found in 45 C.F.R. pt. 670.

149. Even being a consignee may draw a museum within the purview of a statute. Acquisition by gift can also be affected. A prospective donor of an object possibly covered by a protective statute should be cautioned to check carefully the status of the object before any transfer is made. It goes without saying that a museum should never encourage or assist prospective donors in evading laws designed to protect endangered species. See, for example, C. Babington, "Curator Says He Sought Hunter's Gifts," Raleigh News and Observer, Oct. 26, 1989.

150. The "Code of Ethics" promulgated by the Museum Store Association states: "The sale of any object or any merchandise which is manufactured from or incorporates parts of any endangered species is a grievous offense against the moral principles upon which museums are established. . . . The Museum Store Association fully supports existing laws and recognizes the need for their rigid enforcement in order to preserve and protect our dwindling . . . natural resources from wanton commercial exploitation." Museum News 51 (Jan.–Feb. 1982). See, for example, C. Blakeslee, "Art with Feathers Won't Fly with Feds," Art Calendar (Nov. 1994).

151. See C. Hart, "The Burden of Regulations," Museum News 23 (Jan.–Feb. 1978); "The Law Moves In," Nature 1 (March 1977); D. Garfield, "Notes: Butterfly Sting," Museum News 7 (May–June 1994).

illegal domestic takings and the legal trade place unprecedented strains on an ever-growing number of plant and animal species. Although museums are minor consumers, they can play a vital role by educating the public about the objectives of these protective laws and by working with regulators to improve the efficiency and effectiveness of procedures designed to achieve these objectives. The first task is to keep informed.[152]

The U.S. Fish and Wildlife Service of the U.S. Department of the Interior has the major burden of implementing the Lacey Act, CITES, the Endangered Species Act, the Marine Mammal Protection Act, the Migratory Bird Treaty Act, the Bald and Golden Eagle Protection Act, the Wild Exotic Bird Conservation Act, and the African Elephant Conservation Act. The service publishes numerous pamphlets on various aspects of these statutes and on procedures for obtaining permits, and it maintains lists of foreign counterparts who can advise on import/export restrictions within their respective countries.[153] The National Science Foundation administers the Antarctic Conservation Act through the Office of Polar Programs.[154] The National Marine Fisheries Service shares enforcement authority with the U.S. Fish and Wildlife Service regarding the Endangered Species Act.[155] Questions concerning regulatory jurisdiction over specific marine animals or plants should be referred to either agency for clarification. The U.S. Department of Agriculture also can offer assistance if a question pertains to the importation or exportation of terrestrial plants.

For years, most of the wildlife parts, wildlife products, and plants forfeited under the laws described in this section had been stored by the U.S. Fish and Wildlife Service, with no formal procedures for disposal. In April 1982, the U.S. Fish and Wildlife Service remedied this situation by publishing rules for the disposal of such wildlife and plants.[156] Methods of disposal, in order of preference, are

152. In March 1994, the National Research Council sponsored a meeting to discuss the scientific research community's concerns regarding alleged burdensome federal regulations governing the taking of plant and animal specimens. As a result of the meeting, planning was begun for two projects. One would be a National Research Council study of the current permit-granting process and its actual effect on the scientific community. The second would be a forum for a multiyear dialogue involving regulators, enforcement officials, and users of permits that relate to scientific research with the objectives of improving communication and ensuring effective implementation of legislative objectives. The Association of Systematic Collections, Washington, D.C., is involved in this undertaking. See D. Garfield, "Notes: Butterfly Sting," *Museum News* 7 (May–June 1994).

153. Information on permits can be obtained from the special agent in charge of the nearest Division of Law Enforcement, U.S. Fish and Wildlife Service. Local offices are maintained in major cities throughout the country. A current listing of local offices is published in 50 C.F.R. or can be obtained by contacting the U.S. Fish and Wildlife Service, Office of Management Authority, 4401 N. Fairfax Drive, Arlington, VA 22203. See also R. Littell, *Controlled Wildlife,* Vol. 1, *Federal Permit Procedures,* 2d ed. (Washington, D.C.: Assoc. of Systematic Collections, 1993).

154. Office of Polar Programs, National Science Foundation, Arlington, VA; phone: (703) 306-1030.

155. National Marine Fisheries Service, Office of Protected Resources, Permits Division, 1315 East-West Highway, Silver Spring, MD 20910; phone: (301) 713-2289.

156. 47 *Fed. Reg.* 17521 (April 23, 1982). There had been some uncertainty concerning the authority of the U.S. Fish and Wildlife Service to promulgate its own disposal procedures. The authority was clarified in 1978 with the passage of the Fish and Wildlife Improvement Act of 1978. The relevant portion of the act, 16 U.S.C. § 742(c), states: "(c) Disposal of Abandoned or Forfeited Property. Notwithstanding any other provision of law, all

1. return to the wild;
2. use by the U.S. Fish and Wildlife Service or another government agency for official purposes;
3. donation or loan for noncommercial, scientific, educational, or public display purposes; or
4. sale.

These procedures afford another source of collection material for museums, and they should clarify how a museum might lawfully obtain wildlife and plants that it inadvertently collected in contravention of conservation statutes.

8. LAWS PROTECTING ANTIQUITIES AND HISTORIC PROPERTIES

Unlike most other countries, the United States has not sought to exert broad control over artistic, historic, or scientific resources found within its borders.[157] The policy of the federal government has been to leave the development, use, and preservation of these resources in the hands of the private sector, with two exceptions: archaeological material found on federally owned or controlled lands and archaeological resources affected by federally assisted projects.[158] The federal government also has programs that encourage the private sector to take an active role in the preservation of important archaeological and historic sites. This approach is just another manifestation of the U.S. people's historic preference for voluntary cooperative efforts rather than government-controlled programs. Discussed below are the major federal statutes that protect antiquities and historic properties and the impact of these statutes on the collection activity of museums. The statutes are the Antiquities Act of 1906, the Archaeological Resources Protection Act of 1979, and the National Historic Preservation Act of 1966.[159]

fish, wildlife, plants, or any other item abandoned or forfeited to the United States under any laws administered by the Secretary of the Interior or the Secretary of Commerce regulating fish, wildlife, or plants, shall be disposed of by either Secretary in such manner as he deems appropriate (including, but not limited to, loan, gift, sale or destruction)."

157. See the prior sections concerning the international movement of cultural property; these sections describe approaches taken by other countries. See also L. Prott and P. O'Keefe, *Handbook of National Regulations Concerning the Export of Cultural Property* (Paris: UNESCO, 1988).

158. Note also the Native American Graves Protection and Repatriation Act discussed in Section D(6)(f), above. In addition, some U.S. government agencies in their enabling legislation have language that empowers them to exert control over more than just archaeological material located on land under their control.

159. Other federal statutes, such as the Reservoir Salvage Act, as amended, encourage "in federal undertakings" the preservation of historic and cultural properties, and indirectly, these may affect collecting activity. State statutes, which affect resources located on state property, should also be reviewed on this subject. The National Park Service publishes useful booklets such as "Federal Historic Preservation Laws," U.S. Dept. of Interior, National Park Service, Cultural Resources Program, Washington, D.C. (1993) and, in conjunction with the National Trust for Historic Preservation, "A Survey of State Statutes Protecting Archeological Resources," by C. Carnett (1995).

a. Antiquities Act of 1906

The Antiquities Act of 1906[160] was the first federal acknowledgment of a general need to preserve domestic antiquities.[161] The portion of the original statute that most directly affected museum collection activity reads as follows:

Any person who shall appropriate, excavate, injure, or destroy any historic or prehistoric ruin or monument, or any object of antiquity situated on lands owned or controlled by the Government of the United States without the permission of the Secretary of the Department of the Government having jurisdiction over the lands on which said antiquities are situated, shall, upon conviction, be fined in a sum of not more than $500.00 or be imprisoned for a period of not more than ninety days, or shall suffer both fine and imprisonment, in the discretion of the court.[162]

In essence, the statute forbade the harming or unauthorized taking of antiquities that were located on certain government-controlled property. "Examinations, excavations, and gatherings" on such properties by institutions were allowed by permit, however, if these activities were conducted for educational purposes and if the resulting "gatherings" were permanently preserved in museums.

This portion of the act proved at best to be a mild deterrent. Initially, there was scant public support for its enforcement, and decades later, when attention began to focus on the abuses that the act was designed to correct, its penalty structure was woefully outdated. A major blow to enforcement came in 1974 with the decision of *United States v. Diaz,*[163] the first reported federal case interpreting the statute.

Ben Diaz was convicted of taking "objects of antiquity" from government-controlled property, in violation of the Antiquities Act. The objects were Indian ceremonial masks that had been located on an Apache reservation in Arizona. On appeal, Diaz argued that the masks were not "antiquities" because they had been made only four or five years previously. In reply, the government contended that age was not necessarily controlling; the socioreligious importance of an object and its use in the culture could place an object in antiquity status, regardless of age. The conviction was upheld, and Diaz appealed, again questioning the lower court's interpretation of "object of antiquity." The court of appeals reversed the conviction, finding the penalty section of the Antiquities Act unconstitutionally vague because the act did not define, with sufficient clarity, the terms "ruin," "monument," or "object

160. 16 U.S.C. §§ 432 *et seq.*

161. Earlier statutes offered protection to certain national historic properties on a case-by-case basis. See F. McManamon, "The Antiquities Act: Setting Basic Preservation Policies," *CRM* (Cultural Resources Management), National Park Service (Vol. 19, No. 7, 1996). The act has also been interpreted to protect the salvage of certain historic shipwrecks. On this issue, see C. Zander, "The Antiquities Act: Regulating Salvage of Historic Shipwrecks," *CRM* (Vol. 19, No. 7, 1996).

162. 16 U.S.C. § 433. Other sections of the statute permit the president to designate as national monuments "historic landmarks, historic and prehistoric structures, and other objects of historic or scientific interest" located on federal property.

163. 499 F.2d 113 (9th Cir. 1974), *reversing,* 368 F. Supp. 856 (D. Ariz. 1973).

of antiquity."[164] Considerable doubt then existed concerning the government's ability to protect any "object of antiquity" on federal lands and concerning the title status of objects previously removed in apparent violation of the Antiquities Act. Work was begun on new legislation that would provide a more effective means for protecting federally controlled archaeological material.

b. Archaeological Resources Protection Act of 1979

The Archaeological Resources Protection Act of 1979 was enacted to cure major deficiencies in the Antiquities Act.[165] The scope of protection was clarified, and penalty provisions were expanded.[166] Activities prohibited by the 1979 act are as follows:

(a) No person may excavate, remove, damage, or otherwise alter or deface any archeological resource located on public lands or Indian lands unless such activity is pursuant to a [duly authorized] permit.

(b) No person may sell, purchase, exchange, transport, receive or offer to sell, purchase, or exchange any archeological resource if such resource was excavated or removed from public lands or Indian lands in violation of:

(1) the prohibition contained in subsection (a), or

(2) any provision, rule, regulation, ordinance, or permit in effect under any other provisions of Federal law.

(c) No person may sell, purchase, exchange, transport, receive, or offer to sell, purchase, or exchange, in interstate or foreign commerce, any archeological resources excavated, removed, sold, purchased, exchanged, transported, or received in violation of any provision, rule, regulation, ordinance, or permit in effect under State or local law.[167]

The term "archeological resources"[168] is defined to mean

any material remains of past human life or activities which are of archeological interest, as determined under uniform regulations promulgated pursuant to this Act. Such regulations containing such determinations shall include, but not be limited to: pottery, basketry, bottles, weapons,

164. See R. Cooper, "Constitutional Law: Preserving Native American Cultural and Archeological Artifacts," 4 *Am. Indian L. Rev.* 99 (No. 1, 1976). But see *United States v. Smyer*, 596 F.2d 939 (10th Cir. 1979), *cert. denied*, 444 U.S. 843, a later case that held that the Antiquities Act was not unconstitutionally vague when applied to the facts in that case. See also *United States v. Jones*, 607 F.2d 269 (9th Cir. 1979), *cert. denied*, 444 U.S. 1085, where the government chose to sue not under the Antiquities Act for alleged improper removal of archaeological material but rather under more general theft and malicious mischief statutes, 18 U.S.C. §§ 641 and 1361.

165. Pub. L. 96–95, 93 Stat. 721, 16 U.S.C. §§ 470(aa–mm). Department of Interior regulations implementing the act are cited as 43 C.F.R. pt. 7.

166. The act also stresses increased communication and exchange of information among government authorities, the professional archaeological community, Native Americans, collectors, and the general public in order to further the goal of protecting and conserving domestic archaeological resources: §§ 10, 11, 13 of Pub. L. 96–95, 93 Stat. 721 (1979).

167. § 6(a–c) of Pub. L. 96–95, 93 Stat. 721 (1979).

168. This phrase is used instead of the Antiquities Act terminology of "ruin" or "monument" and "object of antiquity."

weapon projectiles, tools, structures or portions of structures, pit houses, rock paintings, rock carvings, entaglios, graves, human skeletal materials, or any portion or piece of any of the foregoing items. Nonfossilized and fossilized paleontological specimens, or any portion or piece thereof, shall not be considered archeological resources, under the regulations under this paragraph, unless found in an archeological context. No item shall be treated as an archeological resource under regulations under this paragraph unless such item is at least 100 years of age.[169]

Criminal penalties for knowingly violating the 1979 act are substantial. If the commercial or archaeological value of the material involved is $5,000 or less, penalties can total up to $10,000 and one year of imprisonment. Violations involving material that exceeds the $5,000 figure carry penalties up to $20,000 and a two-year imprisonment. Repeat violators can be fined up to $100,000 and can be imprisoned for as many as five years. Under another section of the act, civil penalties[170] can be assessed against anyone who is in violation of the act or who does not abide by the terms and conditions of a permit.[171]

Several legal changes made by the 1979 act are of specific interest to museums. Under the Antiquities Act, permits for excavations could be obtained only by qualified institutions; under the Archaeological Resources Protection Act, such permits are available to qualified individuals as well as institutions.[172] Under the Antiquities Act, "gatherings" from such excavations had to be preserved in public museums; under the Archaeological Resources Protection Act, such gatherings and associated data are to be preserved "by a suitable university, museum, or other scientific or educational institution."[173] Also, the Archaeological Resources Protection Act considerably broadens the enforcement power of the federal govern-

169. § 3(1) of Pub. L. 96–95, 93 Stat. 721 (1979). See § 7.3 of 43 C.F.R. for Interior Department regulations that clarify this definition. In 1990, the discovery in South Dakota of a well-preserved and complete tyrannosaur fossil, subsequently called "Sue™," eventually led to a lawsuit that raised the issue of whether paleontological material was covered by preservation statutes. It also caused the introduction of a bill in Congress to protect paleontological resources (S. 3107, "The Vertebrate Paleontological Resources Protection Act," introduced into Congress in 1992). The bill failed to pass. See P. Duffy and L. Lofgren, "Jurassic Farce: A Critical Analysis of the Government's Seizure of Sue™," 39 S.D. L. Rev. 478 (Issue 3, 1994), and L. Grant and M. Malaro, "Disputed Bones: The Case of a Dinosaur Named Sue™," in American Law Institute–American Bar Association (ALI-ABA), Course of Studies Materials: Legal Problems of Museum Administration (Philadelphia: ALI-ABA, 1993). In 1996, H.R. 2943, "The Fossil Preservation Act of 1996," was introduced into Congress by Rep. Tim Johnson of South Dakota. Rather than limit the removal of paleobiological specimens, this proposal sought to set standards regarding the treatment of specimens once they are removed. The proposal never became law. Meanwhile, Sue™ was not resting quietly. The legal battle ultimately returned her to the owner of the land from which she had been excavated. In late 1996, she was placed on the auction block and on October 4, 1997, was sold to the Field Museum for $8.4 million. See "Chicago Museum Gets Bones of T. Rex," Baltimore Sun, Oct. 5, 1997.

170. In a civil matter it is not necessary, as a rule, to prove that one had knowledge of the law that he or she is charged with violating.

171. The act specifically notes that these penalty provisions do not apply to "any person with respect to the removal of arrowheads located on the surface of the ground": § 6(g) of Pub. L. 96–95, 93 Stat. 721 (1979). See, however, 43 C.F.R. pt. 7 and 49 Fed. Reg. 1018 (Jan. 6, 1984) for an explanation of how arrowheads can fall within the definition of "archaeological resource."

172. See the definition of "person" in § 3(6) and § 4 of Pub. L. 96–95, 93 Stat. 721 (1979).

173. § 4(b) of Pub. L. 96–95, 93 Stat. 721 (1979).

ment. Not only can unsanctioned activity on federal and Indian land be prosecuted, but the mere holding of property unlawfully removed from such lands constitutes an offense. Thus, if a museum subsequently acquires such unlawfully removed property, it could be in violation of the Archaeological Resources Protection Act.[174] The act also contains an omnibus provision, similar to that found in the Lacey Act, which makes it a crime to receive or dispose of any archaeological resource in interstate or foreign commerce if the resource was taken in violation of any state or local law.[175] A knowledge of local restrictions is essential, therefore, to judge the provenance of any archaeological resource being considered for acquisition by a museum.

c. National Historic Preservation Act of 1966

The National Historic Preservation Act of 1966 (NHPA), as amended,[176] provides a broad base for federal protection of domestic cultural resources. Whereas earlier legislation focused on federal acquisition of specific properties of national significance,[177] the NHPA recognizes a federal interest in generally encouraging the preservation of culturally significant resources through public and private efforts: "[I]t is . . . appropriate for the Federal Government to accelerate its historic preservation programs and activities, to give maximum encouragement to agencies and individuals undertaking preservation by private means, and to assist state and local governments and the National Trust for Historic Preservation in the United States to expand and accelerate their historic preservation programs and activities."[178]

Central to the accomplishment of the goals of the NHPA is the National Register, which is maintained by the secretary of the interior.[179] The National Register is a current listing of districts, sites, buildings, structures, and objects deemed significant in American history, architecture, archaeology, and culture. National Register status, or in some cases even eligibility for such status, triggers NHPA action. The two major forms of NHPA action are: (1) financial assistance to accomplish preservation projects, and (2) mandatory review of federal undertakings that may affect properties of National Register quality.

174. § 6(b) of Pub. L. 96–95, 93 Stat. 721 (1979); § 6(f), however, states that people who were in lawful possession of archaeological resources before the date of the enactment of Pub. L. 96–95 (Oct. 31, 1979) are not deemed in violation of § 6(b)(1). The legislative history of the act explains that this provision is aimed at protecting individuals and institutions possessing artifacts or collections of archaeological resources that were obtained legally. See 49 *Fed. Reg.* 1024 (Jan. 6, 1984) for additional comments on this subject.

175. § 6(c) of Pub. L. 96–95, 93 Stat. 721 (1979).

176. 16 U.S.C. §§ 470 *et seq.* (Pub. L. 89–665 of Oct. 15, 1966). The National Historic Preservation Act (NHPA) has been amended several times, most recently in the National Historic Preservation Act Amendments of 1992 (Pub. L. 102–575, Oct. 30, 1992).

177. For a comprehensive discussion of early federal historic preservation legislation, see J. Fowler, "Federal Historic Preservation Law," 12 *Wake Forest L. Rev.* 31 (1976).

178. 16 U.S.C. § 470(d).

179. The 1979 amendments to the NHPA afford statutory recognition also to the National Historic Landmark Program, which evolved from the Historic Sites Act of 1935. The National Historic Landmark Program identifies properties that possess exceptional value in commemorating or illustrating the history of the United States.

The majority of NHPA grant money is expended through states that have developed historic preservation programs that meet federal requirements. State programs are designed to promote public and private participation in the preservation of properties of National Register quality. When an approved state program is in place, the state, in turn, may take a significant role in nominating properties for the National Register.[180]

Section 106 of NHPA provides a major source of protection for properties of National Register quality.[181] Under Section 106, no federal agency can approve a federal undertaking or issue a federal license that may affect a district, site, building, structure, or object on, or eligible for, the National Register without first considering the effects of its planned action. The term "federal undertaking" includes

any Federal, federally assisted, or federally licensed action, activity or program or the approval, sanction, assistance or support of any non-Federal action, activity or program. Undertakings include new and continuing projects and program activities (or elements of such activities) not previously considered under Section 106 . . . that are: (1) directly undertaken by Federal agencies; (2) supported in whole or in part through Federal contracts, grants, subsidies, loans, loan guarantees, or other forms of direct and indirect funding assistance; (3) carried out pursuant to a Federal lease, permit, license, certificate, approval or other form of entitlement or permission; or (4) proposed by a Federal agency for Congressional authorization or appropriation.[182]

Thus, quite a bit of federal agency activity requires a Section 106 process. One consideration in such a process is a determination of whether archaeological resources will be disturbed as part of the contemplated activity. If such a disturbance will probably take place and cannot practically be avoided, the Section 106 process invariably requires that the archaeological material be professionally excavated and preserved. Much of this material finds its way into museums.[183]

d. Impact of Antiquities Laws on Collections

Under the Antiquities Act and the Archaeological Resources Protection Act, archaeological material removed from federally owned or controlled land remains the property of the United States.[184] Some archaeological material removed under Section 106 of the NHPA also remains the property of the United States. In all such excavations, the government

180. Subsequent amendments to the original act now permit local governments and Indian tribes to assume state historical preservation officer functions. See, for instance, D. Suagee and K. Funk, "Reconfiguring the Cultural Mission: Tribal Historic Preservation Programs," 13 *Cultural Resources Management* 21 (No. 4, 1990).

181. 16 U.S.C. § 470(f), as amended.

182. "Procedures for the Protection of Historic and Cultural Properties," 36 C.F.R. § 800.2(c).

183. For more information, see S. Henry, *Protecting Archeological Sites on Private Lands* (Washington, D.C.: National Park Service, 1993), and S. Hutt et al., *Archeological Resource Protection* (Washington, D.C.: National Trust for Historic Preservation, Preservation Press, 1992).

184. Since the passage of the Native American Graves Protection and Repatriation Act of 1990, Native Americans can claim control over culturally affiliated human remains and cultural material found on federal or federally controlled property. See Section D(6)(f).

agency in control of the land from which government-controlled archaeological material is removed is responsible for seeing that the material is placed in a repository for permanent curation. This means that since 1906, when the Antiquities Act was first passed, countless archaeological specimens have been taken from federal or federally controlled lands or federally supported projects and have been scattered throughout the country in "repositories." Much of this material remains federal property. Until the late 1980s, little attention was paid to the quality of the curation of this material.

In the 1980s, the federal government became more concerned about its cultural resources. Initial inquiries regarding the status of federally owned archaeological material indicated a serious lack of accountability. To gain a clearer picture of the situation, Congress requested that the Government Accounting Office (GAO) undertake an in-depth study of federal archaeological resources. The area targeted for study comprised the "four corner" states of Arizona, Colorado, New Mexico, and Utah. This area was chosen because of its wealth of important archaeological sites—many of which were on federal or federally controlled land or had been excavated under federal permits. The GAO study took several years to complete, and the report—titled "Cultural Resources: Problems Protecting and Preserving Federal Archeological Resources"—was issued in 1987.[185] The report painted a dismal picture of neglect regarding curation practices. Federal agencies in control of lands in the area could not account for much of the material that had been excavated over the years. If the locations of repositories were known, the repositories had rarely, if ever, been monitored by the government agencies, and those agencies that maintained their own repositories had massive amounts of uncatalogued material. The nonfederal repositories visited by GAO investigators varied greatly in quality. Some had their collections and records in good order, but others were housed in dilapidated warehouses holding deteriorating and uncatalogued material. In many instances, record-keeping from the points of excavation to the delivery to repositories was so poor that government agencies could not identify with certainty those materials removed from lands under their control. If the GAO report gave a valid picture of the overall status of federal archaeological resources—and observers generally conceded that it did—the logical question was, Why mandate retention of this material if over time most of it is lost or so poorly curated that it is rendered useless? Clearly, steps had to be taken to improve the situation.

Under the lead of the National Park Service, curation standards for federally owned and administered archaeological collections—essentially those collections that resulted from surveys, excavations, or other studies conducted under the previously described federal preservation statutes—were promulgated in 1990.[186] These standards cover not only objects but also the records associated with the objects. The regulations require that the federal agency that oversaw the original removal of any "material remains" do the following:

185. GAO/RCED-88-3, issued Dec. 1987.

186. 36 C.F.R. pt. 79, "Curation of Federally-Owned and Administered Archeological Collections": 55 *Fed. Reg.* 37670 (Sept. 12, 1990).

- Identify the repositories holding the material remains.
- Review and evaluate the curatorial services being provided by the repositories. (Detailed standards for evaluation were set forth in the regulations.)
- If standards are not being met,
 —enter into a new agreement with the repository to upgrade curation, or
 —remove the collection and deposit the material with a repository that meets the regulatory standards.
- Carry out periodic reevaluations.

Material remains excavated after the effective date of these regulations and destined for curation are to be placed in repositories that meet the curation standards set forth in the regulations.

The described regulations have a broad impact. They affect repositories maintained by federal agencies and many nonfederal museums and collecting organizations that serve as repositories for federal archaeological collections. The nonfederal repositories may experience problems with the identification of materials owned by the federal government, with control over the quality and quantity of new federal material destined for a repository, with the reconciliation of differing collection management practices, and of course, with the ever-present questions of cost.

Both the GAO report of 1987 and the curation standards promulgated in 1990 brought to the fore several issues that need to be addressed by the museum community and by professional archaeologists:

- Many field archaeologists do not give adequate attention to long-term curation needs when planning and carrying out their work. From the very beginning, curation needs should be factored into budgets, and field practices should ensure that properly prepared and fully documented specimens are transferred to repositories.
- Long-term curation is costly. Good curation requires expert personnel and high-quality facilities. Accordingly, attention must be given to what is worthy of long-term curation. Archaeologists, many of whom have been woefully unconcerned about the quality of curation practices, cannot continue to insist that everything be saved. Thoughtful decisions need to be made in collaboration with those expert in curation.[187]
- The museum profession accepts the fact that deaccessioning (the permanent removal of material from a collection) is an integral part of prudent collection management. More discussion is needed between archaeologists and curation experts regarding deaccession practices for archaeological collections.[188]

187. On the issue of what should be saved, see L. Sullivan, "Managing Archeological Resources from the Museum Perspective," *Technical Brief No. 13* (April 1992), National Park Service, ISSN 1057-1574.

188. The curation standards, published in 1990, for federal archaeological material do not contain any provisions concerning deaccessioning. However, a proposed rule on deaccessioning was published in the *Federal Reg-*

A copy of the curation standards for federally owned and administered archaeological collections is contained in Appendix C of this text. The collection management standards set forth in these regulations for repositories of federal archaeological material are closely patterned after standards developed by the museum community. Within the federal government, their application is spreading to all types of government-controlled collections.[189]

E. Circumstances That Can Affect the Completeness of Title

1. RESTRICTED GIFTS

Every museum is confronted with the problem of the restricted gift, whether an object has already been given or is presently being offered. If experience is the best teacher, few museums would need to be cautioned about the perils of accepting collection objects with strings attached. Unfortunately, even among those who should know better, the offer of an attractive gift, though tightly bound, can bring on a sudden case of myopia. Although there can be defensible exceptions, a good general rule is for a museum to accept only unrestricted gifts. Another good general rule is for a museum, if it accepts a restricted gift, to manage that gift with integrity and to seek court relief only when circumstances clearly make adherence to the restriction impossible or impractical. Both rules (the reluctance to accept restrictions, yet the faithful adherence to accepted restrictions) have as their goal the maintenance of public confidence.

a. The Offer of Restricted Gifts

A reluctance to accede to the offer of a restricted gift should not be viewed as a sign of ingratitude. Rather, it is an acknowledgment by the museum of the importance of the contribution of the donor and evidence of a desire to make the best use of that contribution. As John Stuart Mill pointed out over one hundred years ago: "No reasonable man, who gave . . . when living, for the benefit of the community, would have desired that his mode of benefiting the community should be adhered to when a better could be found."[190]

Ideally, the offer and the acceptance of an object for the collections represent the best contemporary judgments as to the suitability of the object and its potential for museum use, and both donor and curator naturally hope that time will prove them right. But if time is not so accommodating, who would refuse another opportunity to reevaluate the situation? The acceptance of the restricted gift denies the donor the opportunity for reevaluation.

ister on the same day (Sept. 12, 1990) that the curation standards were promulgated. The proposed rule asked for public comment. Little comment was forthcoming, and the proposal still languishes as of 1997. For an article on this subject, see R. Sonderman, "Primal Fear: Deaccessioning Collections," 1 *Common Ground* (No. 2, summer 1996).

189. See National Park Service, *Museum Handbook, Part I, Museum Collections* (revised 1990) and *Museum Handbook, Part II, Museum Records* (revised 1992).

190. 1 *Dissertations* 36 (1864).

A paragraph from *Central University of Kentucky v. Walters' Executors* states the point rather well:

The very nature of the enterprise, on the contrary, looked to improvement. It contemplated, by every reasonable implication, that new methods, new people, even new ideas, would be employed, when approved by the governing body of the Institution. A [museum] means, or ought to mean, growth; the elimination of the fake; the fostering of the true. As it is expected to be perpetual in its service, it must conform to the changed condition of each new generation, possessing an elasticity of scope and work commensurate with the changing requirements of the times which it serves. For the past to bind it to unchangeableness would be to prevent growth, applying the treatment to the head that the Chinese do to the feet.[191]

There is an additional consideration. The beneficiaries of the material held by a museum are the members of the general public; therefore, the museum must use its best efforts to mold and use its collections for the good of the public. It is difficult to reconcile prudent trusteeship with the acceptance of restrictive conditions that can limit the future usefulness of collection objects or limit the exercise of good judgment by subsequent museum administrators. Consider the following: If a prospective donor offers to give a university a valuable book collection with the condition that those books always be part of the university curriculum, the conflict with academic freedom and the pursuit of excellence would be recognized immediately.[192] That the gift must be declined would be a foregone conclusion. Is there not an analogy to be drawn when a museum is offered a valuable collection of objects on the condition that the collection always be displayed as a unit? If there is no similarity, how can a museum represent itself as an educational organization? On reflection, the natural desire to acquire choice objects should be tempered by an awareness of the possible needs of

191. 122 Ky. 65, 83, 90 S.W. 1066 (1906).

192. In *In re Estate of Rood,* 41 Mich. App. 405, 200 N.W.2d 728 (1972), the testator established a fund so that colleges could teach certain political theories. When the validity of the trust purpose was questioned, the court stated: "No legitimate institution of higher learning could permit this kind of control of the classroom from the grave" (736). See also *Chapin v. Benwood Foundation, Inc.,* 402 A.2d 1205, *aff'd,* 415 A.2d 1068 (Del. 1980). In *Chapin,* at issue was whether trustees of a charitable corporation could bind themselves in advance regarding the filling of vacancies on their board. The court said: "To commit themselves in advance, perhaps years in advance, to fill a particular board vacancy with a certain named person, regardless of the circumstances that may exist at the time that the vacancy occurs, is not the type of agreement that this Court should enforce, particularly when it is an agreement made between persons who . . . owe a duty to those intended to be benefitted by the charitable corporation they are charged with managing." In March 1995, Yale University returned to a donor a gift of $20 million. The gift was to have endowed faculty positions for a new program. When the donor added a new condition in which the donor retained the authority to approve the appointment of faculty, the gift was returned. In a public letter of explanation, the president of the university said: "The University must continue to use its own judgment of excellence in scholarship and teaching as the sole basis for faculty appointments. We simply could not delegate authority over faculty appointments to a donor, even one as generous as . . . [this donor]." Richard C. Levin, president of Yale University, letter of March 23, 1995. See also M. Zaretsky, "$20 Million Gift to Yale Returned," *New Haven Register,* March 15, 1995. Some commentators appear to lose sight of the educational function of a museum. See, for example, P. Gerstenblith, "The Fiduciary Duties of Museum Trustees," 8 *Art and the Law* 175 (No. 2, 1983).

generations to come. A donor given the opportunity to ponder these points often is amenable to suggestions.

It is wise for a museum to have a general policy that prohibits the acceptance of restricted gifts. It also is wise to have a procedure for considering exceptions to the rule. At a minimum, the procedure should state who has the authority to approve exceptions and what written records are to be maintained to explain each decision. As a safeguard, museum policy should require that a deed of gift for a restricted gift be countersigned by a museum official authorized to approve exceptions and that evidence of the restriction always be on file with the accession records.[193]

Whether a museum should accept an object with restrictions depends on the facts. What is the object? What is the limitation? A promise never to dispose of an object (unless it is a national treasure) may be unacceptable, but a promise to dispose of the object only to another educational organization may, considering the nature of the item, be within reason. Requiring that an object always be displayed usually is an anathema, but requiring that the museum use its best efforts to have the object on display (whether on its premises or on loan) for two months each year may merit consideration if the item is unusually significant. A promise to return an object to the donor if the museum ever decides to dispose of it can be fraught with problems. If the donor is long since dead when the disposal occurs, is the museum charged with finding the proper heirs? If the museum wants to exchange the object with another museum, is this a "disposal" according to the donor's definition? What is meant by "return"? Does this mean an offer to return that must be accepted within a set time? Does this give the donor a right to meet the museum's best price if the object is put up for sale? If the museum decides to accept some restrictions of this nature, it is prudent to have the restrictions binding only for a set period of time[194] and to spell out when and how the return is to be effected. It is difficult to be more specific regarding when a restriction should be accepted, but these procedural suggestions are offered: (1) before each case is considered, review the reasons for the general prohibition against restricted gifts; (2) consider the precedent that will be set—the terms of a gift can never be kept secret; (3) if you are willing to make a concession, carefully consider the wording of the restriction; (4) when in serious doubt about the advisability of accepting a restricted gift, do not accept it.[195]

193. One of the first considerations in deaccessioning is whether any restriction prohibits removal. Record-keeping practices should be such that all relevant information on restrictions is maintained in the master accession file.

194. For example, the museum might agree to a return if the object is sold within twenty years of its acceptance. The twenty years assures the donor that the acceptance is not frivolous, and it is a manageable period of time if a return must be made. See also discussion of the "rule against perpetuities" in Section B(2)(e) of Chapter V.

195. Sometimes a restriction harms the gift itself. In 1963, Mark Rothko gave to Harvard University a series of huge murals he had created for a meeting room in a newly constructed university building. The gift stipulated that the canvases should always be shown as an ensemble and in a given configuration. Also, once installed, they were not to be moved without the approval of the artist or his representative. After a few years, the murals appeared to be fading, and despite measures to limit the light in the room, the deterioration continued at an alarming rate. Tests showed that Rothko had used unstable paint. By 1970, Rothko had died, and

Sometimes, when a donor feels strongly about limiting his or her largesse, alternative techniques can be discussed. The use of precatory rather than mandatory language is one such technique. If the donor states a wish but not a command that an object be used in a particular way (or uses language of similar import), this can be interpreted as imposing a moral but not a legal obligation on the museum to administer the gift accordingly.[196] In other words, the museum agrees in good faith to follow the restriction, deviating from it only when such a course is dictated by good judgment in light of current circumstances.[197] Such a moral obligation should not be assumed lightly. Before the good faith of the museum is pledged, the museum should carefully assess its probable ability to carry out the wish within its overall responsibilities to the public.

A somewhat similar technique is to draft a gift document with a mandatory restriction but to state that the restriction can be lifted and an alternative course of action approved by a stipulated percent of the vote of the museum's board of trustees. This procedural requirement may offer the donor needed assurance that changes in his or her instructions will not be made in an arbitrary manner. Here again, this type of gift should not be accepted lightly, and the museum should demonstrate over the years to come that any internal decisions to alter such gifts are made only after a thoughtful weighing of all relevant facts. Public confidence is at stake.

A situation with less options presents itself when the museum is faced with a restricted

who could speak for him regarding the restriction was unclear. The university took it upon itself to remove the works, for their own safety, and stored them in darkness in a basement. Eventually, the Rothko Foundation approved the removal. It was finally determined that the paint used on the murals was so unstable that the huge works must hang indefinitely in darkness in a storage room. According to conservators, modern works are frequently less stable because of the variety of products used. See J. Bethell, "Damaged Goods," *Harvard Magazine* 25 (July–Aug. 1988). A restriction might also harm the donor monetarily. The restriction might be such that the IRS could limit the amount of the charitable deduction to be claimed. See "IRS Technical Advice Memorandum," 9443004.

196. Such gifts are not without peril, as illustrated by the de Groot affair at the Metropolitan Museum of Art. De Groot left a sizable collection of art to the Metropolitan with the "wish," stated in her will, that the Metropolitan give to other museums those works it did not want. Some years later, thirty-two of the paintings were sold by the Metropolitan. Unfavorable publicity and an investigation by the attorney general of New York followed. The museum's position, affirmed by legal counsel, was that de Groot's bequest was absolute and that her request not to sell was not binding but was merely precatory. After having considered the request and also the benefit to the museum of acquiring finer works that would bear the de Groot name, the trustees of the museum chose to sell. Many questioned not the legality but the wisdom of the decision. The attorney general took no formal action. Shortly thereafter, the trustees of the museum published a deaccession policy that requires considerable internal review of each deaccession proposal. One self-imposed restriction states that no work of art valued at more than $10,000 and held for less than twenty-five years will be disposed of if the donor or the donor's heirs object. Metropolitan Museum of Art, "Procedures for Deaccessioning and Disposal of Works of Art" (June 20, 1973), reprinted in P. Wald, "Museum Sales and Trades Provisions and Safeguards," in American Law Institute–American Bar Association (ALI-ABA), *Course of Studies Materials: Legal Problems of Museum Administration* (Philadelphia: ALI-ABA, 1974).

197. Relief from a legally binding restriction can usually be obtained only with court approval. (See later sections of this chapter.) Such a process can be time-consuming and costly. A decision concerning precatory language may be made internally.

bequest.[198] With the donor deceased, there is no one with whom to negotiate, and the museum must judge the advisability of accepting the bequest as it is written in the will. Executors[199] and heirs cannot change the terms of a will, but they may prove helpful in shedding light on the interpretation of bequests. For example, if a bequest reads that an object "must be exhibited," several interpretations can be given to this language. Must the object always be on exhibit? Need the object be exhibited only in accordance with the museum's internal policy, which places the responsibility on a certain individual or group to determine when and where objects are exhibited? Can the object be placed on loan for exhibit? In a situation of this nature, the museum may want to explore with the executor and heirs whether there is mutual agreement regarding the interpretation of the restriction. If all agree that the deceased benefactor meant to give the museum flexibility, a written record should be made of this understanding. The museum can then accept the bequest with some confidence that these contemporaneous inquiries may put to rest any later questions that could arise concerning the donor's intent. However, if the museum cannot prudently accept the restricted bequest, a refusal may not mean that all is lost. If heirs are informed that the museum would welcome the object without the restrictions and if the heirs are alternative beneficiaries, they may in time decide to make an unrestricted gift of the object to the museum.[200]

b. Is the Gift Restricted?

A question can arise as to whether conditions were actually imposed when the gift was made. Frequently, a gift comes to a museum after a long series of communications with the donor. Various proposals may have been discussed, and more than one staff or board member may have been involved in the exchanges. A formal deed of gift may or may not have

198. See Section A of this chapter as it relates to the merits of discussing in advance with owners the wording of proposed bequests.

199. Executors, or administrators, are parties appointed by the courts to see that estates are properly administered. In *In re Estate of Charles Clegg*, an issue was whether the executor (as distinct from the testator) can impose limitations on a bequest. #P-18202, 1st Judicial District Ct. of Nevada (July 18, 1986). See B. Wolff, "Processing Bequests: From Notice of Probate to Receipt and Beyond," in American Law Institute–American Bar Association (ALI-ABA), *Course of Studies Materials: Legal Problems of Museum Administration* (Philadelphia: ALI-ABA, 1996), Section III, which deals with the role of the executor.

200. Another possible alternative is for the museum to ask the estate to seek court instructions concerning the interpretation of the gift language, as was done in the case of *Morgan Guaranty Trust Co. of New York v. The President and Fellows of Harvard College* (see footnote 207, below). In this procedure, the issue is clarified before the museum makes its decision as to whether the gift will be accepted. For an extensive discussion of restricted gifts, see M. Malaro, "Restricted Gifts and Museum Responsibilities," *Museum Governance: Mission, Ethics, Policy* (Washington, D.C.: Smithsonian Institution Press, 1994). See also J. Sare, "Art for Whose Sake? An Analysis of Restricted Gifts to Museums," 13 *Columbia V.L.A.J.L. and Arts* 377 (1989); S. Cott, "Mega Gifts to Museums," in American Law Institute–American Bar Association (ALI-ABA), *Course of Studies Materials: Legal Problems of Museum Administration* (Philadelphia: ALI-ABA, 1995); I. DeAngelis, "A Practical Guide to Dealing with Restricted Bequests," in American Law Institute–American Bar Association (ALI-ABA), *Course of Studies Materials: Legal Problems of Museum Administration* (Philadelphia: ALI-ABA, 1996).

passed.[201] Years later, a misunderstanding can arise as to whether the gift was in fact restricted. How are such matters decided?

Normally, a properly executed deed of gift will control, but if such an instrument does not expressly state that the gift is unrestricted or if there is no formal gift instrument, the donor, or the heirs of the donor, have a greater opportunity to place in doubt the completeness of the gift. A case of this nature was brought before a Maryland court in 1979.[202] The defendant historical society had received, some years earlier, a valuable desk from a patron, but no deed of gift had been executed. When the society decided to sell the desk at auction in order to obtain a much-desired native-made piece for its collections, the heirs of the donor sued, claiming the donor and the museum had "understood" that the donor's gifts would always be retained for display by the society. The society, in turn, argued that there was no clear restriction on the gift. In deciding for the historical society, the court stated: "Gifts cannot be presumed to be conditional. Their conditions must be clearly set forth, as the memories of men do fade with time."[203]

In another Maryland case, several museums and an art school found themselves in court because of differing interpretations of a gift known as the "Lucas Collection."[204] Mr. Lucas had died in December 1909. His will left his collection of art to his friend, Henry Walters, with the stipulation that if Walters predeceased him, the collection was to go to the Maryland Institute College of Art (MICA). Walters was alive when Lucas died, and on receiving the bequest, Walters gave the collection to MICA in a letter written by his attorney. The letter read:

Mr. Henry Walters has the pleasure to present to the Institute the collection of Art Works of the late George A. Lucas. . . .

By the will of Mr. Lucas, the collection was bequeathed to Mr. Walters, who, in accordance with the testator's desire, delivers it to your institution, in order that it may serve as a continuing example and incentive to earnest ambitious effort of Art Students in your care.

The collection . . . Mr. Lucas . . . desired to have placed in your charge to be dedicated to sincere art education in his native city.

The collection was later placed on long-term loan to the Baltimore Museum of Art and the Walters Art Gallery. In the early 1990s, MICA, having determined that the collection would

201. A firm practice of requiring formal deeds of gift is highly desirable. See Section F, "Acquisition Procedures."

202. *Abrams v. Maryland Historical Society*, Equity No. A-58791 A-513/1979 (Md. Cir. Ct. for Baltimore City, June 20, 1979). See also *Trustees of Dartmouth College v. Quincy*, 357 Mass. 521, 533–34, 258 N.E.2d 745 (1970).

203. In *Taussig v. Historic Annapolis*, Case #6-93-4451 (Cir. Ct. for Anne Arundel County, Feb. 15, 1995), another donor sued a historical society, questioning the society's right to deaccession objects given earlier by the donor. The donor had signed a deed of gift, and there was no express restriction on disposal in the deed of gift. The society prevailed.

204. *Maryland Institute College of Art v. The Baltimore Museum of Art and the Walters Art Gallery*, Civil No. 95030001/CL191657 (Cir. Ct. for Baltimore City, Sept. 28, 1995). The quotations that follow are from the cited case.

no longer be used for student instruction, decided to sell the collection to strengthen the school's endowment. The museums challenged the school's right to sell, arguing that Walters' gift letter created a restriction on disposal and citing the following words from the letter: "in order that it may serve as a continuing example and incentive to earnest ambitious effort of Art Students in your care [and] . . . to be dedicated to sincere art education in his native city." MICA asked the court to construe the language. The court found for MICA, saying:

It is perhaps the most fundamental principle of property law that restrictions on alienation of property are highly disfavored. In keeping with this policy, it is the rule in Maryland that restrictions upon alienation will not be enforced in the absence of express language in the donative instrument which provides that the gift will terminate if the condition is not complied with. . . .

Although [the donative] letter contains references to how Mr. Lucas desired the gift to be used, those references alone are not sufficient to create a restriction on the MICA's right to sell the collection. The references to Mr. Lucas' intentions are more appropriately categorized as precatory language.

c. Interpretation of Restrictive Language

A related question is the interpretation of an acknowledged restriction. A museum may concede that a gift is restricted, but there may be a difference of opinion as to the actual restraints placed on the use of the gift. Court advice can be sought in a petition for instruction, or what is sometimes called a "declaratory judgment."

In the case *In re Trust of the Samuel Bancroft, Jr., Art Collection,*[205] the Delaware Art Museum petitioned for instructions concerning a valuable collection of English pre-Raphaelite paintings left to the museum by Bancroft. The terms of the gift stated that the museum

(1) shall not sell, transfer, or in any manner part with the possession of the objects in said collection . . . unless said objects, or any of them, shall so irreparably deteriorate in condition, because of the passage of time, or otherwise, as to substantially impair their value as works of art. . . .

(6) shall exhibit, or make available to the public said art collection at an appropriate place in the City of Wilmington. It is the desire of the Estate of Samuel Bancroft, Jr., Incorporated, but the [museum] shall not be absolutely bound thereby, that said art collection shall be so exhibited, or made available, at least five days each week during at least 10 months annually.

The Delaware Art Museum wanted to lend the collection to an exhibition traveling throughout the country for two years, and it also wanted to accommodate the request of an out-of-state museum for a loan of the collection for a three-month exhibition. The issue was whether the terms of the restriction permitted such loans. A contingent beneficiary, the City of Wilmington, took the position that such loans violated the terms of the gift because, in the city's view, the works were to be held and maintained within city limits.

205. An unreported opinion of the Court of Chancery of the State of Delaware, New Castle County, Civil Action No. 6601 (Oct. 28, 1981). The quotations that follow are from the cited case.

The court construed the gift liberally in deciding for the museum. In its view, the word "possession" does not necessarily mean physical possession but also can mean control over the property.[206] Looking at the intent of the donor as expressed in the entire donative instrument, the court concluded that his primary purpose was to ensure the ongoing public exhibition of the collection and that thus the proposed loans, with control remaining in the Delaware Art Museum, were consistent with the restrictive language.

In *Morgan Guaranty Trust Co. of New York v. The President and Fellows of Harvard College,*[207] the court was called on to interpret the phrase "permanent exhibition." The executor of the estate of Scofield Thayer petitioned the court for instructions in connection with the distribution of certain works of art to the Fogg Art Museum and to the Metropolitan Museum of Art. Thayer's will contained the following provisions:

I give and bequeath to the Fogg Art Museum of Cambridge, Massachusetts, all drawings of Aubrey Beardsley of which I may die possessed, the gift of which said Museum shall accept for permanent exhibition.

I give and bequeath to the Metropolitan Museum of Art in the City of New York, all sculpture, paintings, drawings, etchings and other works of plastic or graphic art of which I may die possessed (other than those mentioned [above]) the gift of which said Museum shall accept for permanent exhibition.

At the trial, testimony was introduced regarding routine museum practices of changing exhibitions and lending works for exhibition. Especially noted were the facts that the Thayer collections contained many works on paper and some erotic art. Under current museum practices, the former, in order to be preserved, were stored most of the time in acid-free boxes; the latter were held available for study on request. The court's conclusions were as follows:

"Permanent exhibition" as used in this will means readily accessible to anyone desiring to examine the art objects under such reasonable rules as the museum may make in respect thereto and not that they shall be continuously exposed to the public view on the walls or in cases in the museum.

The word "exhibition" as used in this will includes display of the art objects in public galleries, study-display areas or in other facilities available to the public upon reasonable request.

The term "permanent exhibition" does not prohibit loans to other museums as the decedent did not require the permanent exhibition of his collection "solely" or "only" at the Metropolitan and/or Fogg Art Museum.

The term "permanent exhibition" does not prohibit the removal of art objects for gallery renovation, photography, preservation, cleaning, or scholarly examination.

206. Citing *Restatement (Second) of Trusts* § 175 and *Scott on Trusts* § 175 (3d ed.).

207. No. E 1855 (Mass. Probate Ct. for Worcester, Dec. 20, 1983). The quotations that follow are from the cited case.

Frick Collection v. Goldstein[208] also was a petition for instructions regarding a gift to a museum. In this instance, the donor had left his art collection to the public with instructions to his trustees to incorporate an art gallery at his residence, to be known as "The Frick Collection." The donor also left a substantial endowment fund, the income from which was to be used "for the maintenance, care, protection and support of said gallery of art . . . and any surplus of such income to be expended from time to time as the director, trustees or managers of said corporation may determine in the purchase of other suitable works of art to form part of such gallery."[209] Subsequently, a third party offered to the trustees of the museum additional money and valuable works of art, both to be used to add to the donor's collection. The question was whether the terms of the gift permitted such outside additions or whether additions could be purchased only with endowment fund income. The *Frick* court also took a liberal approach in interpreting the gift instrument. Lacking clear evidence in the donative instrument of the donor's intention to impose a restriction on the acceptance of outside gifts to augment the collection, the court was not inclined to read such a restriction into the terms of the gift. The court refused to give weight to the donor's daughter's testimony that the donor intended a restrictive reading. This same reluctance to read conditions constrictively was reiterated by the Massachusetts Court in *Trustees of Dartmouth College v. Quincy:*[210] "A donor who brings into existence a charitable institution must recognize that most institutions are likely to change with time, that they will become sterile if they remain static, and that they must be adaptable to new public considerations and unpredictable economic circumstances. For this reason, the intention to make mandatory even detailed restrictions on the conduct of such institutions is not lightly to be inferred."[211]

d. Relief from Restrictions

As a general rule, a legal restriction imposed by a donor (distinct from a moral restriction founded on precatory language) and accepted by the museum subsequently cannot be waived by the museum of its own accord. If the museum wants relief, it must seek court approval either in a *cy pres* action or in an action based on the doctrine of equitable deviation.[212]

208. 83 N.Y.S.2d 142 (1948), *aff'd*, 86 N.Y.S.2d 464 (1949).

209. Ibid., 144.

210. 357 Mass. 521, 258 N.E.2d 745 (1970).

211. Ibid., 533–34. Other cases dealing with interpretation of restrictions are *Attorney General v. President and Fellows of Harvard College*, 350 Mass. 125, 213 N.E.2d 840 (1966); *Harvard College v. Attorney General*, 228 Mass. 396, 117 N.E. 903 (1917); *Wilstach Estate*, 1 Pa. D&C2d 197 (1954); *Parkinson v. Murdock*, 183 Kan. 706, 332 P.2d 273 (1958). In *Ranken-Jordan Home v. Drury College*, 449 S.W.2d 161 (Mo. 1970), the court treated as an interpretation what other courts might consider a deviation (see next section). Peculiarities of Missouri law may explain this. See also *Taylor v. Baldwin*, 247 S.W.2d 741 (Mo. 1952).

212. See *O'Hara v. Grand Lodge Independent Order of Good Templars*, 213 Cal. 131, 2 P.2d 21 (1931), and *Gordon v. Baltimore*, 258 Md. 682, 267 A.2d 98 (1970), concerning the ability of a court to confirm *cy pres*–type action already taken by a charity. Regarding the question of whether a restricted gift designed to benefit a particular

Cy pres,[213] literally translated to mean "as near as may be," "designates that powers which courts of equity have evolved to correct the lack of wisdom and foresight of the benevolently inclined, permitting them to mold the charitable trust to meet the vicissitudes of a changing world."[214] In a *cy pres* action, the petitioner usually needs to demonstrate (1) that the donor's described purpose is impossible, impractical, or illegal to carry out, and (2) that the donor had a general charitable intent when making the gift. An alternative course of action, which conforms to the donor's general charitable intention, then is offered to the court for its approval.

Cy pres is unique to charitable trusts and charitable corporations, and it was developed to prevent the "dead hand" from thwarting common sense and decisions of the living.[215] The *Restatement of Trusts* explains *cy pres* as follows: "If property is given in trust to be applied to a particular charitable purpose, and it is or becomes impossible or impracticable or illegal to carry out the particular purpose, and if the settlor [creator of the trust] manifested a more general intention to devote the property to charitable purposes, the trust will not fail but the court will direct the application of the property to some charitable purpose which falls within the general purpose of the settlor."[216]

Court interpretations of the *cy pres* doctrine vary, in part because some states have statutes that specifically address situations of this nature[217] and in part because a particular state may have case law that limits the application of the doctrine to narrow circumstances.[218] As a rule, however, as long as the donor evidenced a general charitable intention when making the original gift, a court may approve an alternative purpose that appears to be in accord

group falls under a state Uniform Management of Institutional Funds Act (and that act's procedures for relief from restrictions), see *Yale University v. Blumenthal,* A.G., Conn. L. J., March 16, 1993, 225 Conn. 32, 621 A.2d 1304 (1993).

213. For a detailed discussion of the doctrines of *cy pres* and deviation, see S. Urice, "Some Issues Raised by the Case(s) of the Barnes Foundation: Enforcing a Donor's Restrictions, *Cy pres,* and Deviation (Or How Long Is Forever?)," in American Law Institute–American Bar Association (ALI-ABA), *Course of Studies Materials: Legal Problems of Museum Administration* (Philadelphia: ALI-ABA, 1993). Some courts refer to either doctrine as "approximation." See, for example, *Britton v. Killian,* 27 Conn. Supp. 483, 245 A.2d 289 (1968).

214. T. Blackwell, "The Charitable Corporation and the Charitable Trust," 24 *Wash. U. L.Q.* 1 (1938).

215. A much-quoted treatise on the subject is A. Scott's "Education and the Dead Hand," 34 *Harv. L. Rev.* 1 (Nov. 1920). On the first page of the article, Scott explains why an organization should have a legal mechanism to review restricted gifts to charity:

If a testator chooses to leave his property to definite beneficiaries, he cannot control its disposition for more than a generation or two (i.e., the Rule Against Perpetuities). But a trust for charitable purposes may last forever. By the creation of such a trust, a specific property or the beneficial interest in specific property or in a shifting fund or mass may be rendered forever inalienable, may be forever "taken out of commerce," may be devoted in perpetuity to the accomplishment of the purposes for which the trust was created. One who happens to acquire property during the short span of his lifetime may by giving it for charitable purposes control its disposition throughout the ages.

216. *Restatement (Second) of Trusts* § 399.

217. See, for example, § 8–1.1(c) of the New York Estates, Powers and Trust Law.

218. These reasons frequently explain why the lines between *cy pres* actions, actions for equitable deviation, and petitions for declaratory judgments tend at times to blur. When issues arise concerning restrictive gift language, applicable state law should be reviewed carefully.

with what the settlor would have wanted had he or she had knowledge of present-day circumstances.[219]

The doctrine of equitable deviation differs from *cy pres*. *Cy pres* is invoked when the purpose of a charitable trust cannot be carried out. If only a method of accomplishing the purpose is at issue, the doctrine of equitable deviation is invoked. In other words, in an action for equitable deviation, there is no request to change the purpose of the trust but only a request for permission to alter the prescribed method of accomplishing that purpose.[220] The petitioner does not need to demonstrate impossibility or impracticability of purpose—only that the prescribed method is thwarting the accomplishment of the trust purpose. Similarly, because the donor's specific purpose is not being questioned, the petitioner does not need to demonstrate that the donor had a general charitable intent—a necessary element in a *cy pres* action. In effect, an action for equitable deviation usually presents less hurdles for the petitioning donee.

Defining the difference in the two doctrines is easier than applying the correct doctrine to a particular situation. For instance, a donor leaves his art collection to a museum to establish a room in his honor, with all his paintings to be kept together and to be displayed as a unit. In time, the museum finds it burdensome to display everything together and seeks relief from the court. Is this properly a *cy pres* action or an action for equitable deviation? If the purpose of the donor is perceived to be the maintenance of an example of a typical turn-of-the-century art collection, a *cy pres* petition would seem to be in order. If, however, the donor's purpose is interpreted to be the making of his art available to the public, all that is at issue in court is the method of accomplishing this purpose, and equitable deviation is the proper vehicle.[221] Courts can be less than precise in their interpretation and application of these two forms of action.[222]

An example of lack of precision is found in *Cleveland Museum of Art v. O'Neill*.[223] In this case, the museum petitioned the court to apply the doctrine of equitable deviation. The relief sought was permission to use certain trust funds, restricted by their donors for the purchase of art, for the costs of building construction. The court's analysis appears to be along *cy pres* lines: "In passing upon a request such as that prayed for . . . the Court has two general duties: to determine (1) what was the basic purpose of the settlors in establishing

219. But see the discussion later in this section about situations in which the donor specifies an alternative donee in case the first gift fails.

220. *Restatement (Second) of Trusts* § 381.

221. In *Sendak v. Trustees of Purdue University*, 279 N.E.2d 840 (Indiana 1972), and the *Toledo Museum of Art v. Bissell*, Case No. 83-2229 (Ohio C.P. Ct. of Lucas County, 1984), the courts were faced with donative language that presented similar problems of interpretation. See also *Burr v. Brooks*, 83 Ill. 2d 488, 416 N.E.2d 231 (1981).

222. See *Trustees of Dartmouth College v. Quincy*, 357 Mass. 521, 258 N.E.2d 745 (1970); *Ranken-Jordon Home v. Drury College*, 449 S.W.2d 161 (Mo. 1970); *Britton v. Killian*, 27 Conn. Supp. 483, 245 A.2d 289 (1968); Note, "Cy Pres and Deviation: Current Trends in Application," 8 *Real Prop. Prob. and Tr. J.* 391 (fall 1973).

223. 57 Ohio Op. 250, 129 N.E.2d 669 (1955). See also: *Harris v. Attorney General*, 31 Conn. Supp. 93, 324 A.2d 279 (1974); *Moore v. City and County of Denver*, 292 P.2d 986 (Colo. 1956); *Hinkley Home Corp. v. Bracken*, 21 Conn. Supp. 222, 152 A.2d 325 (1959); *In re Stuart's Estate*, 183 Misc. 20, 46 N.Y.S.2d 911 (1944); *City Bank Farmers Trust Co. v. Arnold*, 283 N.Y. 184, 27 N.E.2d 984 (1940); *Olds v. Rollins College*, 173 F.2d 639 (N.C. 1949).

the respective trusts, and (2) what would the settlors now direct in view of the changed conditions which have resulted with the passing of time."[224] The court determined that the donors (in creating trusts for the purchase of art) had a broad purpose—to help create and maintain an art museum that would endure indefinitely—and that when the gifts were made, the need was for art for the collections. Hence, in this court's interpretation, the direction that funds were to be used to purchase art was viewed as merely a means to achieve the desired end, and under the doctrine of deviation, this means could be changed to accommodate current circumstances. Applying this reasoning, the court approved the use of the funds for building construction even though one of the funds at issue provided that failure to abide by its terms voided the fund. The court specifically ruled that regarding that particular fund, the exercise of the power of deviation did not constitute a failure to abide by the terms of the trust.

A case involving the Isabella Stewart Gardner Museum also illustrates the less-than-precise line between *cy pres* and the doctrine of equitable deviation.[225] Under her will, Gardner gave explicit and detailed instructions regarding the conversion of her home and art collection into a museum. One paragraph of her will set the salary of the director of the museum and specified that the fourth story of the house "be appropriated, rent free, to his use, so long as he shall continue to be director." The will then went on to say that this same space "shall be appropriated to the use of every succeeding director for the time of his directorship, rent free."[226]

In 1989, the trustees of the museum petitioned the court in the form of an action for deviation to renovate the residence area into badly needed conservation laboratories and administrative offices. The trustees' position was that the use of the fourth floor as a residence for the director was only a means designated to achieve the donor's purpose—the maintenance of a museum. However, in court the opposition argued that Gardner had created the museum to preserve an exact example of late-nineteenth-century taste and that this was her role in creating and organizing her home and art collection. Thus, it was central to her purpose that the fourth-floor living quarters remain, especially since this is where Gardner had lived for the last twenty-five years of her life as she formed her collection and its setting.[227] In this case, the court accepted the position of the trustees, finding that the dominant intent of the donor was to have her art collection (which occupied the first three floors) maintained according to her instructions. Hence, instructions regarding the fourth floor were means to achieving the purpose but were not the central purpose, and an action for deviation was proper. The court approved the request for equitable deviation.[228]

224. *Cleveland Museum of Art v. O'Neill,* 57 Ohio Op. 250, 129 N.E.2d 669, 670 (1955).

225. *The Isabella Stewart Gardner Museum v. Shannon,* Docket #89E-0047 (Probate/Family Ct., Suffolk County, Mass., May 18, 1989), Memorandum and Order, July 19, 1989.

226. Ibid.

227. See A. Higonnet, "Where There's a Will," *Art in America* 65 (May 1989).

228. See S. Urice, "Some Issues Raised by the Case(s) of the Barnes Foundation: Enforcing a Donor's Restrictions, *Cy pres,* and Deviation (or, How Long Is Forever?)," in American Law Institute–American Bar Association

As illustrated by the above cases, the mere fact that a donor has stated that property can be used "only" for a certain purpose or that it is given "on condition" that it be applied to a certain purpose or that trustees are "directed" to do a certain thing does not necessarily prevent the application of the doctrines of *cy pres* or equitable deviation. Courts tend to favor the perpetuation of charities.

But what happens if the donor has named an alternative donee in the event that the first gift fails? Does this factor inhibit the application of the doctrines of *cy pres* or equitable deviation? The alternative donee could be another named charity or a residuary legatee. Consider the following examples, in which the alternative donees were residuary legatees.

In *In re Stuart's Estate,*[229] the New York Public Library petitioned the court for relief from various restrictions imposed on a gift. Under the terms of the donor's will, the books, manuscripts, paintings, and other works of art were left to the Lenox Library in 1891. These articles were to be housed separately from other library holdings and were to be exhibited to the public at all reasonable times but never "on the Lord's Day." The will further stated that the library had ninety days in which to accept or refuse the gift, and if it did not accept, the gift would pass to residuary legatees. The library accepted. Years later, the Lenox Library merged with and became part of the New York Public Library. By 1944, because of changed conditions, the New York Public Library found the restrictions burdensome, and it proposed to the court that permission be granted under *cy pres* to transfer the material to the New York Historical Society with the provision that the material could be displayed on Sunday, the day when many people visit museums. At issue was whether the gift would be forfeited on failure to abide by the conditions and, thus, would have to pass to the residuary legatees. The court ruled that under the terms of the will, the residuary heirs could receive the gift only if the library had refused to accept it within the stated ninety-day period. When the library accepted, a charitable trust was created to benefit the general public, and any interest held by the heirs terminated.[230] Once the charitable trust was created, any questions about the adherence to restrictions were enforced subject to rules applicable to charities.[231] (In other words, the doctrines of *cy pres* and equitable deviation could be considered.) The

(ALI-ABA), *Course of Studies Materials: Legal Problems of Museum Administration* (Philadelphia: ALI-ABA, 1993), 500–501.

229. 183 Misc. 20, 46 N.Y.S.2d 911 (1944).

230. Comment (e) of § 351 of the *Restatement (Second) of Trusts* states:

A charitable trust may be created although the settlor uses words of condition. If the owner of property transfers it *inter vivos* or by will "upon condition" that it be applied for a charitable purpose, a charitable trust is created if the transferor manifested an intention that the transferee should be subject to a duty so to apply it, rather than that he should be divested of his interest if he should fail so to apply it. In the absence of other evidence, a transfer of property "upon condition" that it be applied for a charitable purpose indicates an intention to create a charitable trust rather than an intention to make a transfer "upon condition."

231. An additional reason for holding void such a gift over to individuals would be the "rule against perpetuities." See § 1.6 of *Restatement (Second) of Property*, "Donative Transfers." In general terms, the "rule against perpetuities" states that a gift made to an individual must vest within twenty-one years after a life or lives in being at

court then went on to find a general charitable intention on the part of the donor and, applying *cy pres*, approved the library's proposed disposition of the material.

A situation with a similar twist was presented in *Amato v. Metropolitan Museum of Art.*[232] Here, the daughter of a donor sued the Metropolitan Museum of Art in 1975 for the return of two paintings bequeathed in 1959. Under the donor's will, the paintings were to be displayed as gifts of the donor in memory of her parents. The museum had six months in which to accept the gift with the stipulated conditions; otherwise the paintings were to go to the daughter. The gift was accepted by the museum. Over the years, the paintings were placed on loan for display to other cultural institutions, properly labeled, but they were not displayed at the Metropolitan. The plaintiff was informed of this practice and initiated legal action to have the paintings removed from the museum and turned over to her as alternative legatee. The court rejected the plaintiff's request for return on two grounds, one being that acceptance by the museum of the gift under the specified terms eliminated the possibility that title to the paintings might vest in the daughter at a later date. The court ruled that here, as in *In re Stuart's Estate,* once the gift was accepted by the charity, a charitable trust was created and the heirs lost standing to sue. Thereafter, if questions arose about adherence to restrictions, they were to be addressed by the appropriate authorities and decided under trust law.

As a general rule, the reasoning of *In re Stuart's Estate* and the *Amato* case is followed by courts when there is a "non-charity" alternative legatee and when the charity in question has accepted the restricted gift and made reasonable efforts to adhere to its terms. Thus, even here, the tendency of courts to favor charities continues. But if the alternative legatee is another charity, the question of which should prevail becomes more complex. If in the "gift over" sequence, the alternative charity is to adhere to the same restrictions and that charity is inclined to accept that responsibility, it is difficult for the charity currently holding the gift to prove elements necessary to support a *cy pres* petition (seeking relief because the purpose of the gift is now impractical, impossible, or illegal). If the alternative charity is to take the gift without any restrictions, even this form of "gift over" can weaken the position of the charity seeking relief. It infers that the donor had a narrow charitable purpose regard-

the time of the gift's creation. (A "life in being" means the remaining duration of the life of a person who is alive at the time the gift first takes effect.) If a gift to a charity fails many years after it is made and if the residuary legatee is an individual, this rule could defeat the gift. If the residuary legatee is another charity, the rule may not be a problem. As the above-noted section of the *Restatement (Second) of Property* further explains:

A non-vested interest in an individual is subject to the rule against perpetuities, even though it will vest, if it ever vests, by divesting a valid gift to a charity. The combination of interest in a charity followed by an interest in an individual does not justify excepting from the operation of the rule against perpetuities the non-vested interest in the individual.

[Excluded] from the operation of the rule against perpetuities [is] a charitable interest that divests a charitable interest if the interest divested is valid so far as the rule against perpetuities is concerned.

Legal advice is invariably needed for the proper application of the "rule against perpetuities." See also J. Dukeminier, "A Modern Guide to Perpetuities," 74 *Cal. L. Rev.* 1867 (1986).

232. Index. No. 15122/79 (N.Y. Sup. C. N.Y. County, Special Term, Sept. 1979). The case is also mentioned in Chapter II, "Museums Are Accountable to Whom?"

ing the first donee, and thus there is no room for the court to restructure that gift and yet remain faithful to the donor's intent.

In a situation with an alternative charitable legatee, the charity seeking relief tends to argue, if possible, that the proper cause of action is equitable deviation, not *cy pres*. In other words, the charity argues that it is not seeking to alter the purpose of the restricted gift but merely a means specified by the donor to achieve the purpose. This approach is easier to explain by example. In the earlier mentioned case of *The Isabella Stewart Gardner Museum v. Shannon*,[233] the donor had set forth in her gift instrument explicit and detailed instructions regarding the conversion of her home and art collection into a museum. She had also provided that if her instructions regarding the museum were not followed, everything was to be sold and the proceeds given to Harvard University. After many years, the museum decided to seek relief from a few of the donor's instructions but carefully classified the petition as one for equitable deviation, not *cy pres*. Scholars divided over whether the requested change did in fact alter the donor's vision of the museum—and thus trigger the "gift over." The museum was successful in convincing the court that the requested change was not an integral part of the museum but was merely a means of achieving the donor's vision. Under this interpretation, the issue of the "gift over" did not have to be addressed because even if the relief requested was granted, this would not constitute a failure to adhere to the purpose of the gift.

The above discussion is general and serves merely to sketch out some broad considerations on the subject of court relief from gift restrictions. Jurisdictions vary in their approaches to these questions, and a museum should always make a careful review of applicable law before initiating court action in this area.[234]

2. COPYRIGHT CONSIDERATIONS

Within the last decade, copyright concerns arising from collections not only have multiplied but also have become far more complex as museums have expanded uses of their images into merchandising and other less familiar arenas.[235] For museum staff, a workable knowledge of copyright law has become a necessity. Those who have faced the task of unraveling copyright issues years after works were acquired would agree that clarifying copyright issues at the time of acquisition is the best, and possibly the only, chance to ensure that the museum is free to make expanded uses of the object in the future.

Copyright concerns for museums are also driven by the current technology-induced information revolution. As with all revolutions, the existing laws based on the old order have

233. See footnote 225.

234. For other viewpoints, see, for example, *Hartford National Bank and Trust Co. v. Oak Bluffs First Baptist Church*, 116 Conn. 347, 164 A. 910 (1933), and *Burr v. Brooks*, 83 Ill. 2d 488, 416 N.E.2d 231 (1981). In J. DiClerico, "Cy Pres: A Proposal for Change," 47 *B.U. L. Rev.* 153 (1967), the author discusses the weight to be given to the intent of the testator versus current public need and policy.

235. This section, "Copyright Considerations," is the work of Ildiko Pogany DeAngelis, Assistant General Counsel of the Smithsonian Institution. Opinions expressed are those of the author and not of the Smithsonian.

failed to keep up with rapid changes. The ability to copy images into heretofore unknown formats and to transmit them and other information instantaneously worldwide has out-paced the traditional protections afforded by existing U.S. copyright laws. Understandably, the vacuum has caused confusion and insecurity for museums, as both creators and consumers of creative works. On the positive side, the present uncertainties have focused attention on the existing laws. New legislative initiatives to fill the gaps will seek to strike a balance, traditionally sought under copyright law, between two conflicting interests. On one side is society's interest in the unfettered public access to creative works, and on the other is creators' proprietary interest in reaping commercial benefit from their work. The museum profession has an important stake in making sure that the new balance struck will not unduly hamper museums' educational missions. An understanding of the current scope of copyright laws will allow museums to join the ongoing dialogue for proposed changes. This discussion will begin with copyright basics and will end with the challenges presented by newly emerging "electronic uses."

a. What Is Copyright?

Copyright is the legal recognition of special property rights that a creator may have in his or her work.[236] The rights are distinct from the right to possess the work. For the nonlawyer, it may be easier to visualize copyright as a bundle of rights carried on the back of certain objects. The object may be acquired with or without the bundle or with one or some of the rights in the bundle. When a museum obtains an object that may carry such a bundle, it is important for the museum to know if the ability to use any or all of the rights in that bundle passes to the museum with the object itself.

Copyright protection exists for original works of authorship that are fixed in a tangible medium of expression.[237] Copyright protects the tangible expression of the idea, not the idea itself. In other words, the idea to create a statue called "Supermom" is not eligible for copyright, but once the statue has been created, the owner of the copyright can control certain specific uses of the statue. Examples of types of works that may be protected by copyright are literary works, musical and dramatic compositions, paintings, drawings, sculpture, photographs, motion pictures, stage presentations, television programs, computer programs, and cartographic works. Artistic craftsmanship such as jewelry, toys, fabric designs, and even the embellishments of furniture, architectural drawings, and architecture

236. Art. 1, § 8, cl. 8, of the U.S. Constitution empowers Congress to enact legislation "to promote the progress of science and useful arts, by securing for limited times to authors and inventors the exclusive right to their respective writings and discoveries."

237. 17 U.S.C. § 102; see *Wallace Computer Servs., Inc. v. Adams Business Forms,* 837 F. Supp. 1413 (N.D. Ill. 1993); *Arthur v. American Broadcasting Cos.,* 633 F. Supp. 146 (S.D. N.Y. 1985); *Original Appalachian Artworks, Inc. v. Toy Loft, Inc.,* 684 F.2d. 821 (11th Cir. 1982); and *Gracen v. Bradford Exchange,* 698 F.2d 300 (7th Cir. 1983). On the issue of copyright protection for oral histories, see J. Neuenschwander, *Oral History and the Law* (Albuquerque: Oral History Association, 1993) and "Oral History and Copyright: An Uncertain Relationship," 10 *J.C. & U.L.* (No. 2, 1983–84), reprinted in American Law Institute–American Bar Association (ALI-ABA), *Course of Studies Materials: Legal Problems of Museum Administration* (Philadelphia: ALI-ABA, 1984), 527.

may be protected, but only to the extent that they are not utilitarian. For the balance of this discussion, we will assume that the work in question is eligible for copyright protection.

The owner of a copyright controls five distinct uses of the work:

1. the right of reproduction (the right to make copies of the work);
2. the right of adaptation (the right to produce derivative works based on the work itself);
3. the right of distribution (the right to distribute copies of the work for sale, rental, loan, and so on);
4. if the work is of such nature, the right of performance (the right to perform the work publicly); and
5. if the work is of such nature, the right of display (the right to display the work publicly).[238]

Under current law, if a museum acquires a work that could have copyright protection without clear evidence of the museum's ability or inability to exercise the enumerated rights, there is a serious potential for copyright infringement.[239]

In determining whether a particular work is protected by copyright, a museum should keep in mind the following. The U.S. Constitution provides that copyright exists "for limited times."[240] In other words, all copyright protections afforded to creators will eventually expire. In addition, copyright may be lost or waived before expiration under certain circumstances described below. All works for which copyright has expired or was lost, together

238. 17 U.S.C. § 106. Regarding the right to display, it is important to note that the copyright statute specifically provides that the owner of an object, or any person authorized by such owner, can, without the authority of the copyright owner, display the work publicly. 17 U.S.C. § 109(b). See note 284 below. For a general outline of copyright law as of 1992, see C. Wilson, "Museum Operations and Copyright Law," in American Law Institute–American Bar Association (ALI-ABA), *Course of Studies Materials: Legal Problems of Museum Administration* (Philadelphia: ALI-ABA, 1992), 107–13.

239. For example, if copyright is ignored, a museum may find itself in the unenviable position of having museum shop merchandise seized or prohibited from sale pursuant to a court-ordered injunction pending final decision in a lawsuit claiming copyright infringement. 17 U.S.C. §§ 501–4. If the museum loses the suit, the value of that merchandise will be lost and the museum will face substantial legal fees for its defense. Some argue that the actual threat of legal action for copyright infringement against museums is small, noting that instituting a lawsuit is costly and that rights holders usually have little economic incentive to sue because they cannot show sufficient monetary damages to make it worthwhile. The copyright law provides no automatic or statutory damages unless a work was "registered" with the copyright office at the time of infringement. Works of contemporary art, for example, are rarely registered in this way. Nevertheless, the threat of a suit is there. Moreover, violating legal rights of another because there is little chance of getting sued is not an appropriate standard for an educational institution that depends on public confidence for its effectiveness. Recent Congresses have proposed legislation that would eliminate the need to have the work registered before statutory damages were due. See H.R. 897 and S. 373 "Copyright Reform Act of 1993" (introduced in the House and Senate on Feb. 16, 1993). Such a change would expose violators to far greater potential liability for copyright infringement. Statutory damages may amount to as much as $100,000 for each willful infringement. 17 U.S.C. § 504. Note, however, that statutory damages are not available in the event of good-faith reliance on the doctrine of "fair use" by an employee of a nonprofit organization for an allegedly infringing reproduction.

240. Art. 1, § 8, cl. 8.

with works that may never have been subject to any copyright protection (such as works of U.S. government employees),[241] are said to be in the "public domain." Works that are in the public domain may be reproduced, adapted, distributed, performed, or displayed freely by anyone without risking any liability to anyone else, including the original creator.[242]

b. Has Copyright Expired?

The rules to determine whether copyrights have expired in a particular work are unavoidably technical. When the object was created and when it was published become important because of revisions of the federal copyright law, the most significant of which became effective on January 1, 1978.[243] The tables at the end of this section provide the rules of duration. However, for any work *created* on or after January 1, 1978, the ordinary copyright term is measured by

- the life of the creator plus 50 years; or
- for joint works with more than one creator, the life of the last surviving creator, plus 50 years; or
- for "works-made-for-hire"[244] or anonymous works, the shorter of 75 years from the date of first publication or 100 years from the date of creation.[245]

Note that all copyrights expire on December 31 of the last calendar year of protection.

241. 17 U.S.C. § 105 states, "Copyright protection under this title is not available for any work of the United States Government."

242. But see the discussion below in Section E(2)(c) on copyright restoration for certain foreign works as of Jan. 1, 1996, that were previously in the public domain. In investigating the copyright status of a work, the museum should begin by carefully examining the work, looking for such elements as a copyright notice (the familiar © or "copr.," name of the artist, and date). Any investigation should also include a search of the Copyright Office catalogs and other records. If a work was registered for copyright or for renewal of copyright, which was important before 1978, records should exist in the Copyright Office catalog. The Copyright Office is located in Washington, D.C., and is open for anyone wanting to conduct a search, but staff members are also available to make searches, at the rate of $20 for each hour or fraction of an hour. Requests for searches may be sent to Research and Bibliography Section, Copyright Office, Library of Congress, Washington, D.C. 20559; phone (202) 707–6850. It is important to note that a lack of registration in the Copyright Office *does not* mean the work may not be covered by copyright. However, lack of registration may indicate that no statutory damages for infringement would be available. See the discussion in footnote 239, above. See also Circular 22, "How to Investigate the Copyright Status of a Work," published by the U.S. Copyright Office; Copyright Office records are also available for on-line search for any work registered after 1978 via LOCIS (Library of Congress Information Service). For further information, see the Library of Congress website at http://www.loc.gov. F. Smallson, "Searching for the Right Stuff," *Legal Times* 55–60, special issue, "Expanding the Boundaries of Intellectual Property" (May 15, 1995), discusses the complexity of copyright searches and lists professional search firms that offer multimedia licensing services.

243. Pub. L. 94–553 was a major revision of the federal copyright law that was passed in 1976, but in most respects it was not effective until Jan. 1, 1978. It now appears, as amended, in Title 17 of the U.S. Code.

244. See the discussion of "work-made-for-hire" below in Section E(2)(d).

245. 17 U.S.C. § 302. The copyright duration rules are found in 17 U.S.C. §§ 301–5. In 1996 a bill was introduced in the Senate (S. 483) to extend the term of copyright protection for an additional twenty years. The bill

Rules for copyright duration become more complicated for any work created before January 1, 1978. For such works, it becomes important to determine the year that federal copyright protection was first secured. Once the starting date for federal copyright protection has been established, the tables at the end of this section should be consulted to determine whether copyrights still exist or whether the applicable term of years of copyright protection has since expired. Before 1978, federal copyright protection was secured in one of two ways: (1) as of the date the work was first published (as distinct from created); or (2) as of the date a work was registered at the U.S. Copyright Office in unpublished form.

Because unpublished works of art were rarely registered,[246] federal copyright protection began for most works in museum collections in the year the work was first "published." In the ideal case, the date of publication will appear on the work itself because the law in effect before 1978 required a copyright notice to be affixed to a work at the time of publication. A full notice included the familiar symbol "©" or "Copr." or "Copyright," the name of the copyright owner, and the date of publication. However, certain types of works were specifically exempted from this notice format. For works of art, photographs, drawings, prints, and maps, the law required only the symbol © and the initials or symbol of the artist. Specifically, the date of publication on the work was *not* required. In addition, as discussed in the next section, many works of foreign origin have been exempted from any pre-1978 copyright notice requirements. Therefore, publication dates that trigger copyright duration will generally not be found on works in museum collections. Without a date on the work, establishing a date of publication is not always a simple matter because the term "publication" has its own history in copyright law. Before 1978, the term was not defined uniformly

met with opposition, and as of mid-1997, it had not passed into law. (See the minority views reported in *S. Report 104–315*, 104th Cong., 2d sess.) However, the reader is cautioned to check for recent amendments to the duration rules, as well as to any other area of copyright law, which is especially subject to change.

246. Registration for federal copyright protection of unpublished works required an application, the payment of a fee, and the deposit of a photograph or other identifying reproduction of the unpublished work with the U.S. Copyright Office in Washington, D.C. Aside from the disincentives caused by these registration procedures, registering an unpublished work for federal copyright protection was often viewed as unnecessary and perhaps even detrimental. Before 1978, an unpublished work enjoyed protection under a patchwork of state common copyright laws until the time of "publication." Such state law protections could continue indefinitely until a work was "published," at which time federal copyright law governed. However, if a work was originally registered with the U.S. Copyright Office in unpublished form, state law protections ceased and federal copyright duration began to run as of the date of registration. Therefore, registration of an unpublished work shortened the potential period of copyright protection for the work. As a practical matter, most artists were probably not even aware of these federal registration possibilities. For these reasons, most works found in museum collections were rarely registered in unpublished form. Although a search of the records of the U.S. Copyright Office may not uncover a date of registration triggering duration, such a search should be conducted nevertheless. If no registration is found, a work unpublished and unregistered as of Jan. 1, 1978, is now protected by federal copyright and is subject to separate duration rules as noted in Figure IV.4. For works created after 1978, federal copyright protection attaches as soon as the work is created (i.e., as soon as it is "fixed" in a tangible medium of expression), and all state copyright law protections for unpublished works were preempted by the 1976 federal copyright law (effective in 1978). See 17 U.S.C. § 301.

but rather depended on often inconsistent court interpretations. Although it was accepted that reproducing an image in a magazine or book that was then sold or widely distributed to the public constituted a "publication," there were more varied interpretations of the term, especially when it was applied to a work that existed in a single copy. A safe course is to assume that before 1978, a publication occurred (1) in the year when the work was reproduced (such as in a magazine or other publication) and when such reproductions were distributed to the public or (2) in the year when the work was either sold or offered for sale to the public (such as by a gallery, dealer, or public auction).[247]

Included in the tables at the end of this section are rules, given in a simplified format, for works created before and after 1978. However, one shorthand rule, which permits an easy determination of public domain status for certain older works, is well worth remembering. In all cases, the *maximum* length of federal copyright protection secured before 1978 is 75 years. Therefore, anything published or registered in unpublished form more than 75 years before the current date is no longer subject to copyright protection. For example, if provenance records indicate that a work was first sold to the public by the artist in 1920, the museum may safely assume that copyright in the work has expired because the date of publication by sale was more than 75 years ago. If the work was published less than 75 years before the date of inquiry, the duration tables that follow should be consulted (see Figure IV.4).

If after applying these rules, the museum determines that copyright has probably not yet expired, the possibility remains that copyright was lost sometime before 1978 for failure of the creator to comply with certain technical requirements then in effect.

c. Was Copyright Lost?

Before January 1, 1978, U.S. copyright law was defined by a 1909 law, which was unforgiving in its technical requirements.[248] For example, if, before 1978, a creator "published" a work

247. The definition of "publication" given in the 1976 Copyright Act (effective 1978) is as follows: "[T]he dissemination of copies or phonorecords of a work to the public by sale or other transfer of ownership, or by rental, lease, or lending. The offering to distribute copies or phonorecords to a group of persons for purposes of further distribution, public performance, or public display, constitutes publication. A public performance or display of a work does not of itself constitute publication." 17 U.S.C. § 101. As noted, before 1978, the copyright law did not define publication. Rather, the meaning was developed by judicial interpretation found in court cases, resulting in conflicting definitions. Often courts were reluctant to find that a publication had occurred because if a work had been published without the requisite copyright notice (at a minimum for works of art, the familiar © and the initials or symbol of the artist), the work fell into the public domain.

248. For a comparison of the two laws, it may be useful to imagine a balancing scale, with the goals of free public access to creative works on one side and with the need to protect the proprietary interests of the creator on the other. The 1909 law, by being unforgiving in its technical requirements for obtaining protection, favored free public access over the proprietary rights of the creator. Beginning in 1978, there has been a marked tipping of the scale in the other direction as many of these technical requirements have been eliminated. In fact, copyright to some foreign works that lost protection as a result of failure to abide by the 1909 law's technical requirements has been reinstated. See the discussion below later in this section.

Figure IV.4

Copyright Duration Tables

TABLE I: COPYRIGHT DURATION TABLES FOR WORKS CREATED BEFORE JANUARY 1, 1978

A. Works That Were "Published" or Registered with the U.S. Copyright Office in Unpublished Form before January 1, 1978

Date Federal Copyright Protection Was Secured (Date of First Publication or Date of Registration with Copyright Office in Unpublished Form)	Status
75 years ago or more	Public domain
From January 1, 1964, to December 31, 1977	Protected for 75 years from date of publication or date of registration in unpublished form
Before January 1, 1964, but less than 75 years ago	Protected only for 28 years from date of first publication or date of registration, if no timely renewal application was filed with the Copyright Office. If there was no timely renewal, the work is now in the public domain. (Exception: Copyright to certain works of foreign origin was reinstated. The term of restored copyrights is 75 years from the date of first publication.) For all other works, if a timely renewal application was filed with the Copyright Office, the work is protected for 75 years from date of first publication or date of registration in unpublished form.

B. Works That Remained "Unpublished" and Unregistered with the U.S. Copyright Office as of January 1, 1978

Works by a single creator	Protected for the life of the creator plus 50 years*
Joint works, works created by two or more creators	Protected for the life of the last surviving creator plus 50 years*
Works-made-for-hire or anonymous works	Protected 100 years from creation or, if published for the first time after January 1, 1978, the shorter of 75 years from date of publication or 100 years from creation*

Continued on next page

Figure IV.4 continued

ALL WORKS THAT REMAINED UNPUBLISHED AND UNREGISTERED AS OF JANUARY 1, 1978	*UNDER NO CIRCUMSTANCES WILL COPYRIGHT TO A WORK EXPIRE BEFORE DECEMBER 31, 2002. IF THE WORK WAS PUBLISHED ON OR AFTER JANUARY 1, 1978, THEN COPYRIGHT WILL NOT EXPIRE BEFORE DECEMBER 31, 2027.

TABLE II: COPYRIGHT DURATION TABLE FOR WORKS CREATED ON OR AFTER JANUARY 1, 1978

Works by a single creator	Protected for the life of the creator plus 50 years
Joint works of two or more	Protected for the life of the last surviving creator plus 50 years
Works-made-for-hire or anonymous work	Protected for the shorter of 100 years from creation or 75 years from first publication

Author's Note: Users of these tables are cautioned to check for any amendments to the law on copyright duration that may have passed after mid-1997. For instance, as of mid-1997, Congress was considering a bill that would extend copyright protection by twenty additional years. See footnote 245, Chapter IV.

without notice of a claim of copyright (at minimum, the initials or symbol of the artist and the familiar "©"),[249] copyright was deemed to be waived and the work fell into the public domain.[250] For works of art, this meant that if the work was sold or offered for sale to the public or was reproduced in a gallery brochure or other publication distributed to the public without a copyright notice, the artist lost all copyright protection. The new law effective

249. As discussed in the previous section, before 1978, copyright notices may have taken two forms. The full copyright notice included the name of the copyright owner, the date of publication, and the symbol © or "copr." or "copyright." Certain works, such as works of art, were exempted from the full notice requirement. The initials or symbol of the artist and the symbol © were sufficient. Under current law, a copyright notice is no longer required. However, if a notice is affixed, the full format as under the older law applies to all works: the name of the copyright owner or an abbreviation by which the name can be recognized or a generally known alternative designation of the copyright owner, the date of publication, and the symbol © or the abbreviation "copr." or the word "copyright." See 17 U.S.C. §§ 401(b)–(c).

250. The 1909 law required a notice of copyright for all "published" works. The problem courts faced was that a finding that a work was published without notice brought harsh consequences, namely, that the creator would lose all copyright protection. However, this was true only if the publication was authorized by the creator. If a work was published without such authority, the lack of notice on such works would not have divested copyrights in the work. Sometimes, especially with multiples and photographic prints, it is difficult to establish

January 1, 1978, relaxed many of these formal notice requirements. However, for an interim period between 1978 and 1989, the law still required notice of copyright to be affixed to works at the time of publication. A work publicly sold or reproduced and distributed without such notice lost copyright protection and fell into the public domain unless (1) the notice was omitted from a "relatively few number of copies" distributed to the public,[251] or

whether the museum possesses an authorized copy. Certainly, if the work was signed by the creator, the museum may assume the work was an authorized copy. If such a work lacked notice and was published before 1978, then the work potentially lost all copyright protection. See *Grandma Moses Properties, Inc. v. This Week Magazine,* 117 F. Supp. 348, 352 (D.N.Y. 1953) (unrestricted sale of a work of art existing in a single copy without copyright notice was found to have forfeited all copyright protection for that work). However, to avoid this harsh result, courts invented the concept of "limited publication," which would not divest the creator's copyright. A limited publication takes place when the work is distributed only to a select group for a limited purpose, with the recipients restricted expressly or implicitly from further distribution of the work. Although there is very little case-law guidance on "limited publication" involving transfers of works of art, it may be argued that if a work was donated or bequeathed or sold privately by an artist rather than made available generally to the public (without the requisite notice), then *no* publication would have occurred that resulted in eliminating all copyright protection for that work. This argument would have significantly greater validity if the artist expressly restricted further distribution or copying of the work at the time of the original transfer. See *Burke v. National Broadcasting Co.,* 598 F.2d 688 (1979) (distinguishing between general and limited publication of a film to prevent a forfeiture of copyright stating that prohibition against copying can be "tacitly understood" or implied). See also *American Vitagraph, Inc. v. Levy,* 659 F.2d 1023, 1027 (9th Cir. 1981). A safe course for purposes of analysis is to assume that a publication divesting copyright protection occurred before 1978 if (1) the work bearing no notice was sold or offered for sale publicly, or (2) reproductions of the work appeared in publications that bore no copyright notice. In addition, there is limited case-law authority that in certain circumstances, the public display of a work of art where viewers were free to photograph the work constituted a "publication." If notice was not affixed, copyright was waived. See *Letter Edged in Black Press, Inc. v. Public Bldg. Com.,* 320 F. Supp. 1303 (N.D. Ill. 1970) (public display of Picasso model—during which viewers were encouraged to take photographs, and photographic prints of the work were distributed without copyright notice—constituted a divesting publication of the copyrights in the sculpture); *American Tobacco Co. v. Werckmeister,* 207 U.S. 284 (1907) (Supreme Court held that no publication took place if the public was admitted to view the painting with the express or implied understanding that no copying should take place, provided that further measures were taken to prevent such copying). However, because the case law on publication through public display is far from clear and because display history is often difficult to reconstruct, it is a safer course not to draw any firm conclusions on loss of copyright through public display unless viewers were clearly invited to freely photograph or otherwise copy the work while it was on display and, in fact, did so. Copyright experts argue that courts today would take a narrow approach in applying pre-1978 case law (which they would be bound to do for transfers of the work that occurred before 1978), given how copyright laws have changed to free copyright holders from such technical traps. The law, as of 1978, specifically states that public display is not a publication. 17 U.S.C. § 101. See 1 *Nimmer on Copyright* §§ 4.09 and 4.13A (Matthew Bender 1994).

251. 17 U.S.C. § 405. The question presented is whether omission of a notice on a work that exists in a single copy, such as a painting, is omission of a "relatively few number." This depends on how the term "relatively" is defined. Is one out of a possible one a relatively few number? Logically, one out of one should not qualify as a relatively small number. However, there is no case law on this point. Cases interpreting "relatively few number" have all involved multiple copies. See *Kakizaki v. Riedel,* 811 F. Supp. 129 (S.D.N.Y. 1992) (which held that 50 percent of two hundred copies of a photograph was not a "relatively few" number; therefore, the exception excusing notice did not apply). Until there is further judicial guidance on this issue, a safer course is not to draw any firm conclusions on loss of copyright based on the omission of a notice on a work existing in a single copy that was first published on or after Jan. 1, 1978, and before March 1, 1989.

(2) the copyright owner took advantage of a grace period in which to cure the error.[252] As of an amendment to the copyright law effective March 1, 1989, the requirement for the copyright notice on works was completely abolished.[253] Clearly, for works created on or after that date, neither registration with the U.S. Copyright Office nor use of the copyright notice is essential to secure copyright, and any subsequent sale, publication, or distribution will not divest such rights. In light of this March 1, 1989, act and the prior, less demanding registration rule in effect since January 1, 1978, a museum acquiring a work that was created on or after January 1, 1978, and that lacks any copyright notice should assume that the work is subject to copyright interests held by another. In other words, the mere lack of a copyright notice on such works is no assurance that copyright has been waived, and a museum acquiring such a work without an expressed conveyance of copyright interests acts at its peril if it does more than display the work or if it engages in uses outside the boundaries of traditional "fair use."[254]

To complicate matters further, as of 1996, a special rule applicable to foreign works can revive copyright. Although for works first "published" in the United States before 1978, the absence of copyright notice at time of publication is an indication that the work fell into the public domain, the same is not now true for foreign works that were not first "published" here.[255] The mere lack of notice no longer can be used as an indicator of copyright status for pre-1978 works of foreign origin as a result of the Uruguay Round Agreements Act, implementing the General Agreement on Tariffs and Trade (GATT).[256] Copyright protec-

252. The cure provision reads: "The omission of the copyright notice . . . does not invalidate the copyright in a work if— . . . (2) registration for the work has been made before or is made within five years after the publication without notice, and a reasonable effort is made to add notice to all copies or photorecords that are distributed to the public in the United States after the omission has been discovered." 17 U.S.C. § 405(a)(2).

253. The Berne Convention Implementation Act, Pub. L. 100–568, Oct. 31, 1988, 102 Stat. 2855, was passed by Congress to bring U.S. copyright law in line with the Berne Convention (the Berne Convention for the Protection of Literary and Artistic Works, signed at Berne, Switzerland, on Sept. 9, 1886, and all acts, protocols and revisions thereto). The Berne Convention did not enter into force in the United States until March 1, 1989. The fact that the notice provision was removed did not itself serve to recapture copyright for those works that had already fallen into the public domain because of a failure to include notice at the time of publication except for certain works of foreign origin that were restored as of Jan. 1, 1996, as explained below in this section.

254. See Section E(2)(f), below, which describes "fair use."

255. If a work was first published abroad and then published in the United States within thirty days of its first publication abroad, the work will be deemed to have been first published in the United States, and the special restoration rules for foreign works will not apply. 17 U.S.C. § 104A(h)(6)(D). For a discussion of the restoration rules for foreign works, see B. Wolff, "Copyright," in American Law Institute–American Bar Association (ALI-ABA), *Course of Studies Materials: Legal Problems of Museum Administration* (Philadelphia: ALI-ABA, 1995), 29–33; M. Klipper and C. Meyer, "The U.S. Public Domain: It's Not What It Used to Be," *Museum News* 31 (July–Aug. 1996); Gayton-Sleiman "GATT and NAFTA: Look at What Your Country Has Done for You Lately," *PORTFOLIO* (Washington, D.C.: Washington Area Lawyers for the Arts, 1995), 1–3.

256. Under the GATT-generated Uruguay Round Agreements Act of 1994 (Pub. L. 103–465, 108 Stat. 4809, signed Dec. 8, 1994), copyrights in thousands of foreign literary and artistic works that were previously in the "public domain" were restored as of Jan. 1, 1996, under the General Agreement on Tariffs and Trade (GATT). The provision, codified in 17 U.S.C. § 104A, is expected to have a significant impact on museums holding works by modern masters such as Picasso and Matisse. For example, the U.S. Copyright Office has received notice

tion in the United States for foreign artists' works first published in certain foreign coun-
tries[257] has been reinstated as of January 1, 1996. This new law permits thousand of works
to move back into copyright protection even though they were in the public domain for
many decades. This is significant and unprecedented under U.S. law. Except for very minor
earlier exceptions,[258] works moved only one way—from copyright protection into the pub-
lic domain—and not in the reverse.[259]

This special "reverse" rule has several practical effects. If a museum acquires a work by
a foreign artist, the museum cannot assume that the work is in the public domain even if
the work lacks any notice and even if the image was freely reproduced before the effective
date of GATT restoration (January 1, 1996) by all previous owners. Moreover, even if the
museum acquired the work years ago and has used the image for many years, relying on a
conclusion that the work was in the public domain, it may no longer use that image without
permission, subject only to a limited exception applicable to "reliance parties." Reliance
parties are defined as those who, relying on the work's public domain status before Decem-
ber 8, 1994, had incorporated the image into their products and publications. Reliance par-
ties may continue to sell their products for one year after the owner of the reinstated rights

from the Picasso estate for restoration of over two hundred works. Restoration applies to those works that are
still copyrighted in the "source country." The "source country" is the country where the work was first pub-
lished (other than the United States) if that country is a member of the World Trade Organization or the Berne
Convention. To qualify for restoration, the work must still have been covered under copyrights in the source
country as of Jan. 1, 1996. This, of course, requires reference to duration rules of foreign copyright laws. In addi-
tion, the restoration will apply to works that entered the public domain in the United States because of a fail-
ure to comply with the copyright notice, registration, and renewal requirements under the 1909 U.S. law or to
works from a source country with which the United States did not have copyright relations at the time that
U.S. copyright protection was sought. For example, this last provision would apply to any Chinese work of art
that pre-dated the commencement of copyright relations between China and the United States in 1990. The du-
ration of the restored copyrights, however, will follow the current rules of U.S. law. For pre-1978 works, the
maximum term of copyright protection is 75 years from date of first publication. Therefore, restoration may ex-
tend copyright protection in some cases well into the next century. Museums that want to make any uses of for-
eign works that were first published less than 75 years from the date of inquiry should consider that such uses
may infringe the rights of those artists or their heirs. The copyright status of each such work should be reas-
sessed before there are any further uses beyond the "fair use" safe harbor. Library of Congress, "Copyright Res-
toration of Certain Berne and WTO Works," 60 *Fed. Reg.* 7793 (Feb. 9, 1995); M. Klipper and C. Meyer, "The
U.S. Public Domain: It's Not What It Used to Be," *Museum News* 31 (July–Aug. 1996), 31.

257. The law also requires that at least one of the authors was a citizen or permanent resident of the eligible
country at the time the work was created. Eligible countries include all major European countries and many
others. As of Feb. 1996, 144 countries were eligible. M. Klipper and C. Meyer, "The U.S. Public Domain: It's
Not What It Used to Be," *Museum News* 31 (July–Aug. 1996), 31. A list of Berne and World Trade Organization
member nations may be found in 6 *Nimmer on Copyright,* Appendix 20, "International Copyright Relations of
the United States," App. 20–1.

258. The North American Free Trade Act (NAFTA) first restored copyright to a certain group of "North
American" motion pictures pursuant to a 1993 amendment of the Copyright Act.

259. U.S. artists have recently begun a lobbying effort in Congress seeking to have copyrights to their works
lost under the 1909 rules reinstated as well, arguing that restoring copyright protection to foreign works with-
out doing the same for U.S. works is unfair. The impact on museums of the further draining of the "public do-
main" pool should be considered as a part of the fact-finding before any such law is passed.

notifies them to cease doing so.[260] However, no new uses except fair use are permitted as of January 1, 1996, without the permission of the copyright holder. Because of the complexity of this new law, museums should seek legal advice on the status of any collection objects that were first published outside the United States less than 75 years before the date of inquiry. (As noted earlier, copyright protection for any work first published more than 75 years before the date of inquiry would have expired under the general rules of copyright duration.)

Clearly, the question "Was copyright lost?" can be a difficult one to answer because of changing U.S. rules regarding the use of the copyright notice. In this area in particular, museums should consult with legal counsel before drawing any definitive conclusions on the loss of copyright, especially when uses outside the boundaries of fair use are contemplated. However, the general guidelines that follow may be helpful to museums in resolving situations in which this question arises.

- "Unpublished" works, no matter when created, require no copyright notice. The absence of copyright notice on unpublished material has no legal consequence regarding copyright status.
- If a work of U.S. origin was first "published" before 1978 without a copyright notice, it fell into the public domain.
- If the work was first "published" on or after January 1, 1978, and before March 1, 1989, the law required a copyright notice to be affixed at the time of publication, but omission did not necessarily mean that the artist lost copyright protection. Therefore, no firm conclusions may be drawn from the mere lack of notice for works first published during the 1978–89 period.
- If the work was first "published" on or after March 1, 1989, omission of a copyright notice no longer has any legal effect.
- The lack of any notice on a foreign work may have no legal consequence depending on when and where the work was first "published."

For all such works that could be protected by copyright, inquiry should be made to ascertain who owns the copyright, and the museum should adjust its records and practices as needed.

260. A notice to enforce copyrights against a reliance party may be given directly or by notice published in the *Federal Register* within twenty-four months of the date of restoration of copyright. The Copyright Office has published such notices on May 1, 1996 (61 *Fed. Reg.* 19371–88) and Aug. 30, 1996 (61 *Fed. Reg.* 46133–59). However, these published notices are often wholly inadequate because rather than listing the name of the artist, the notice lists only the current owner of the restored copyrights; these owners may be third parties with whom the artist cannot be easily associated. Museums must proceed with great care in selling any potentially infringing product one year after the date of any published notice that may relate to any work in their collections. This one-year grace period is given to reliance parties for liquidating such inventory. The *Federal Register* is accessible on-line at http://www.access.gpo.gov; e-mail: gpoaccess@.gov.

d. Who Owns the Copyright?

As of now, when a museum is in the process of acquiring an object that appears to be protected by copyright, it needs to establish, if possible, who holds copyright and to clarify whether any of the existing copyright interests will pass to the museum.[261] If the work is offered by the creator, copyright usually resides in the creator.[262] If the work is offered by others and if copyright still exists or appears to exist, the museum should attempt to determine who holds the copyright interests. Even if the museum does not currently want to acquire such interests, copyright status may become important at a later date, especially if the museum wants to transfer the object. As a part of the acquisition procedure, the museum should inquire whether the owner offering the work to the museum claims to hold copyright interests as well, and if so, the museum should request supporting documentation of copyright ownership. If the owner makes no claim of copyright ownership, the museum should collect as much provenance history as possible to determine who may currently own copyright.

If there is a copyright notice on the work, normally the owner of the copyright is the person identified on the notice.[263] If the work bears no copyright notice, the prior section on loss of copyright should be reviewed. If after reviewing the guidelines given there, the museum decides that copyright interests still exist, it can begin by assuming that the artist still holds copyright.[264]

What if the artist is deceased? Copyright interests may pass through a will or by inheritance, so records on the estate of the artist must be investigated.

What if there was more than one artist? Creators of a joint work are co-owners of the copyrights, and hence the history of each artist must be investigated to determine whether each is alive (or whether his or her interests have passed to heirs) and whether each has transferred any rights.[265]

What if the work was prepared by an employee in the course of his or her employment? In such a case, copyright vests in the employer.[266] The definition of work prepared in the

261. Photographs can present even more complex problems. For example, if the photograph is a picture of an original work, one can hold the copyright in the photograph but, in using the photograph, can infringe the copyright of the creator of the original work. With photographs, the subject of the photograph must also be considered. Consider also the question of whether the photograph itself is an "original work" and hence subject to protection. B. Wolff, "Copyright," in American Law Institute–American Bar Association (ALI-ABA), *Course of Studies Materials: Legal Problems of Museum Administration* (Philadelphia: ALI-ABA, 1995), 42–50. For a discussion of potential multilayered copyright protection for digital images, see the discussion below in Section E(2)(h).

262. Note, however, the exception regarding a "work made for hire," that is, a commissioned work or a work of an employee.

263. There may have been a transfer of copyright by the owner, as discussed in the following section.

264. Again, a museum should search to determine if there was a transfer of copyright, as discussed in the following section.

265. 17 U.S.C. §§ 101, 201(a). 1 *Nimmer on Copyright* § 6.10. One owner of the copyright in a joint work may grant a license, subject only to the duty to account for any profits to the other owner(s).

266. 17 U.S.C. § 201(b) and 17 U.S.C. § 101 (for definition of "work made for hire").

course of employment is not always completely clear,[267] and professional advice is often needed to make a determination. A good rule to remember regarding creative works by an employee is that it is always preferable to have a written agreement between the employee-creator and the employer to spell out their understanding about who will own the copyright to the final product.[268] Such an agreement is especially helpful in the case of a museum that is researching the ownership of copyright for a work created in an employer/employee situation.

What if the work was commissioned from someone who was not an employee? Here again, professional advice is usually needed, especially because of the major changes in the copyright law effective January 1, 1978. Before that date, the law (developed by court decisions) usually favored the commissioning party. As indicated earlier, the law in the relevant jurisdiction needs to be reviewed as such questions arise. Regarding works commissioned on or after January 1, 1978, the statutory law is more definitive and offers the creator more protection. As of January 1, 1978, if a work is commissioned in writing from someone who is clearly not an employee of the hiring party and with the express use of the term "work-made-for-hire," the person or organization commissioning the work may be deemed to own all copyright interests provided that the work commissioned fits the legal definition of "a work specially ordered and commissioned for use as a contribution to a collective work, a part of a motion picture or other audiovisual work, as a translation, as a supplementary work, as a compilation, as an instructional text, test, as answer material for a test or as an atlas."[269]

The definition is restrictive in order to grant creators more bargaining power regarding work that falls outside the definition. For works commissioned on or after January 1, 1978, a museum investigating copyright status must be guided by this statutory language. Similarly, if a museum itself has occasion to commission works or hire photographers or contributing authors, expert advice may be needed to ensure clear resolution of copyright issues before contracts are signed. If the intent is to commission a work that falls outside the statutory definition of "specially ordered or commissioned," the museum must negotiate for a direct license or assignment if it hopes to exercise all or some copyrights. If the intent

267. See *Community for Creative Non-Violence v. Reid*, 490 U.S. 730, 109 S. Ct. 2166 (1989). In this leading case on the work-made-for-hire doctrine, the Supreme Court considered the following factors in determining when a person may be considered an employee for purposes of determining whether copyright belongs to the employer: the hiring party's right to control the manner and means of production; the skill required; the source of instruments and tools used; the location of the work; the duration of the relationship of the parties; whether the hiring party had the right to assign additional projects to the hired party; whether the hired party had the right to hire assistants; whether the hired party was in the business of providing such service to others; and the tax treatment of the hired party. In this case, a nonprofit organization hired a sculptor to create a work depicting a homeless family. After considering these factors, the Court concluded that the sculptor was not an employee and that copyright to the work did not automatically rest with the nonprofit organization. For a general discussion of the work-made-for-hire doctrine, see Circular 9, "Works-Made-for-Hire under the 1976 Copyright Act," available from the Copyright Office, Library of Congress.

268. This matter frequently arises for a museum regarding writings or photographs produced by museum employees.

269. 17 U.S.C. § 101.

is to commission a work that falls within the statutory definition, the contract should clearly state the creator and the museum's intention that the museum will hold copyright, and some experts suggest an added assignment to the museum of any and all copyrights.[270]

One other caution is in order on the issue of who owns copyright. Beginning in the late 1970s, most deed of gift forms included some copyright transfer language, as do current forms.[271] At times, however, donors sign these forms without accurate knowledge of what rights they may possess. There can be no valid transfer of copyrights by signing such a form if the donor does not hold the described rights. Museums need to bear this in mind regarding both executed deeds of gift and those deeds presented to current donors. If copyright could be an issue because of the nature of a gift, a museum should now, more than ever before, be on the alert to ask informed questions so that accurate information guides the execution of the deed of gift form.

e. How Is Copyright Transferred?

Copyright interests in a collection object may be transferred to a museum in one of two ways. First, in a limited number of cases, copyright may have automatically accompanied a work that was acquired by the museum before 1978. Second, copyright may be transferred, in whole or in part, to the museum by agreement.

Automatic Transfers of Copyright before January 1, 1978. Before January 1, 1978, if a museum acquired an unpublished work bearing no copyright notice and if there was no mention of copyright interests in the conveyance, the museum *may* have obtained "the bundle of rights" along with the right to possess the object itself. This result is based on a rule referred to as the "Pushman presumption," enunciated in *Pushman v. New York Graphics Society, Inc.*[272] The rule presumes an intent to transfer copyright along with the ownership of the work unless such rights are specifically reserved by the transferor.[273] However, the Pushman presumption will be applicable in only a limited number of cases for works acquired before 1978

270. For agreements commissioning works that may fall into the law's narrow definition of "works specially ordered or commissioned" (for example, a contribution to a collective work, such as an introductory essay for a museum catalog), the agreement should designate the work as a "work-made-for-hire," and in addition, the agreement should also contain an assignment to the museum of all copyrights by the creator in the event the work is later adjudged not to fit the definition.

271. See the sample deed of gift forms at the end of the chapter.

272. 287 N.Y. 302, 39 N.E.2d 249 (1942). Note, as later explained, that the Pushman presumption was reversed as of Jan. 1, 1978, when the 1976 copyright revision went into effect. The *Pushman* decision is also somewhat perplexing because the facts involved a sale and a public display of a work of art bearing no copyright notice. Under existing law, this should have resulted in the loss of all copyright protection. However, the court did not address that issue, stating that the court was "not entering into a separate discussion as to whether by this sale and public exhibition the artist is to be held to have 'published' the work so that its common law right is lost." Nevertheless, under the Pushman presumption, if nothing was said about copyrights at the time of transfer of an unpublished work of art, copyright to the work was transferred automatically to the recipient.

273. A presumption is a rule of law by which the finding of a basic fact gives rise to the existence of presumed fact, until the presumption is rebutted. *Black's Law Dictionary* (1990). Thus, if sufficient evidence indicates that copyrights were not meant to be transferred with the object, then the presumption that they were transferred will not apply.

because *all* of the following four conditions must have been met at the time of the transfer of ownership of the work to the museum.

1. The work was acquired by the museum from someone who was also the owner of the copyrights in the work. For example, if an artist transferred the work directly to the museum, it is usually safe to assume that the artist, as the creator, was also the owner of the copyright in the work. However, if the work was given to the museum by someone other than the creator, ownership of the copyright by the transferor cannot be assumed. Rather, direct evidence of copyright ownership by the transferor at the time of transfer has to be established before the Pushman presumption can be applied. Often, however, uncovering such evidence years after the work was acquired is a difficult if not impossible task. In practice, copyright was not in the forefront of most parties' minds when objects were being transferred to museums before 1978; hence, accession records during these earlier years often lack information on points of current interest now that copyright is of greater importance.

2. The work was "unpublished" at the time it was acquired by the museum, and the transfer to the museum did not constitute a "publication." The rules on what constitutes "publication"—as discussed in the earlier section "Was Copyright Lost?"—should be consulted. Generally, if a work bearing no copyright notice was purchased by the museum at a public sale, such a sale constituted "publication," resulting in the loss of all copyright protection for that work.[274] In such a case, the Pushman presumption would not apply because no copyright interest survived the transfer. By contrast, if the work was bequeathed (or possibly donated) to the museum by an artist, the museum may argue that the transfer of ownership was only a "limited publication" that did not divest copyright protection for the work.[275] It then may presume that all copyrights passed to the museum along with the work.

3. The work bears no copyright notice, and there is no other indication of any written or oral reservation of copyright by the transferor of the work.[276]

4. The transfer of the work did not occur in states that reversed the Pushman presumption by statute (such as New York in 1966 and California in 1977).[277]

274. Similarly, if there was a public sale in the chain of title before the museum's acquisition of the work, the work would have been in the public domain at the time of its acquisition.

275. A "limited publication" takes place when a work is distributed to a limited number of people for a limited purpose rather than being made available generally to the public. The "limited publication" rule was invented by courts to avoid the harsh result (namely, loss of all copyright protection) that followed a failure to affix a copyright notice on a work before publication. See footnote 249, above.

276. The Pushman presumption should not apply to a work bearing a copyright notice because by affixing notice, the artist indicated that he or she wanted to retain copyright interests in the work. The Pushman presumption assumes, because of the lack of any facts to the contrary, that the artist intended to transfer the copyrights to the recipient.

277. E. Johnston, "Determining the Copyright Status of Museum Collections," Smithsonian Institution OGC Copyright Workshop, Nov. 5, 1996. Since Sept. 1, 1966, New York State reversed the Pushman presumption by

Provided that these four conditions were met for works acquired before 1978, the museum would have acquired the copyright along with the work itself. Here again, because of the complexity of the law, museums are advised to seek competent legal advice in drawing any conclusions on copyright status based on the Pushman presumption. In many cases, museums will simply lack sufficient provenance information to take advantage of the Pushman presumption rule. For works acquired by the museum after 1978, the Pushman presumption has no application, since the federal copyright law effective as of that date reversed this rule.

No Automatic Transfers of Copyright as of January 1, 1978. If copyright interests in the object exist, or appear to exist, and if the object is conveyed to the museum after January 1, 1978, without reference to copyright interests, the museum has acquired no copyright interests. The relevant section of the copyright law, 17 U.S.C. § 202, reads as follows:

Ownership of a copyright, or of any of the exclusive rights under a copyright, is distinct from ownership of any material object in which the work is embodied. Transfer of ownership of any material object, including the copy or phonorecord in which the work is first fixed, does not of itself convey any rights in the copyrighted work embodied in the object; nor, in the absence of an agreement, does transfer of ownership of a copyright or of any exclusive rights under a copyright convey property rights in any material object.

As a precaution, lack of passage of such interests should be noted on the accession records along with any information on the actual copyright holder. If copyright interests exist and the museum wants to obtain them, or the right to exercise some or all of them, this must be negotiated with the copyright holder and expressly noted on the conveying instrument.[278]

Transfers of Copyright by Agreement. A transfer of the entire "bundle of rights" from one party to another is generally referred to as an assignment of copyright. If an artist assigns

establishing a different rule governing the sale of works of fine art. Section 224 of Article 12-E of the New York General Business Law reads:

Whenever a work of fine art is sold or otherwise transferred by or on behalf of the artist who created it, or his heirs or personal representatives, the right of reproduction thereof is reserved to the grantor until it passes into the public domain by act or operation of law unless such right is sooner expressly transferred by an instrument, note or memorandum in writing signed by the owner of the rights conveyed or his duly authorized agent. Nothing herein contained, however, shall be construed to prohibit the fair use of such work of art.

The term "fine art" was defined to mean "a painting, sculpture, drawing or work of graphic art," and the term "artist" meant "the creator of a work of fine art" (§ 223). Note also that § 301(a) of the new federal copyright law preempts all common-law and states' rights that are equivalent to copyright protection. Therefore, as of Jan. 1, 1978, reproduction rights in the sale of works of fine art in New York are governed by the federal act, but the New York special statute is still applicable to works sold in New York after Sept. 1, 1966, but not created after Jan. 1, 1978. California had a similar law, which became effective on Jan. 1, 1976. CA Civ. § 982. Therefore, no automatic transfer of copyright was effective in California from 1976 until Jan. 1, 1978, when the federal copyright law preempted it.

278. 17 U.S.C. § 204(a) states: "A transfer of copyright ownership, other than by operation of law, is not valid unless an instrument of conveyance, or a note or memorandum of transfer, is in writing and signed by the owner of the rights conveyed or such owner's duly authorized agent."

all copyright interests to the museum, then the museum becomes the new owner of the copyright to the work. Although all existing copyright may have been assigned to the museum on paper, the law provides that an assignment, or indeed any transfer of copyright interests (including licenses), may be revoked under certain circumstances by the creator or the creator's heirs. However, this termination right is not automatic and requires a certain passage of time and prior notice.[279]

A transfer of some but not all rights is commonly called a license. A license may be exclusive or nonexclusive. An exclusive license[280] gives the museum the power to prevent others from exercising the *specific* right (that is, the museum can sue for infringement if there is an improper use). For example, assume the museum was granted an exclusive right to use an image for a poster. If anyone else makes a poster of that image, the museum, as the holder of the exclusive right, may sue for infringement. A nonexclusive license permits the museum to exercise a right, but the copyright holder reserves the right to grant others a similar nonexclusive right. Licenses also may be limited for use in certain geographic areas and/or may be limited as to duration. Assignments and exclusive licenses must be in writing, signed by the owner, to be effective because they are considered transfers of copyright ownership. Although a written agreement is not required under the law for a nonexclusive license, museums are advised to require written transfers for all copyright interests as a matter of policy to avoid any uncertainties regarding the extent of the rights acquired.

Other Considerations. When an object is acquired by a museum but existing copyrights are not also acquired, there are long-term ramifications for the museum. Therefore, museums should have a method for focusing staff attention on copyright matters before collection acquisitions are consummated. This can be done by including the copyright issue in the museum's collection management policy and by requiring that informed decisions be made

279. As of Jan. 1, 1978, the copyright law allows statutory termination of any assignment or license by the creator of the work or his or her heirs even if full copyrights were transferred or even if the duration specified in the agreement has not yet expired, as follows. If the transfer of copyright (assignment or license) dates from 1978 or later, to qualify for termination, (1) the transfer must have been from the creator (as opposed to his or her heirs); (2) the transfer must not have been by bequest; (3) the creator or his or her heirs (defined as either a surviving spouse or surviving children and grandchildren, in case of a deceased child) must serve advance notice in writing to the holder of the terminable transfer, stating the effective date of the termination; (4) the termination may be effected at any time during the period of five years beginning at the end of thirty-five years (or in some cases involving unpublished material, forty years) from the date of transfer; and (5) the notice cannot be given less than two or more than ten years before the termination date. For transfers that date anytime before 1978, transfers made not only by the creators but also by his or her heirs may be terminated generally during a five-year period anytime after fifty-six years from the date copyright was secured. The notice provisions are the same as those for post-1978 transfers. For all statutory terminations, a derivative work created under the authority granted earlier may continue to be utilized after the termination. 17 U.S.C. §§ 203 and 304(c). In practice, museums have had little experience with termination of copyright transfers. This may be explained in part by the fact that transfers granted in 1978 or thereafter are not eligible for termination notice until 2003.

280. An exclusive license can also be called a "transfer of copyright ownership." 17 U.S.C. § 101. All transfers of copyright ownership must be in writing. 17 U.S.C. § 204(a) quoted in footnote 278, above. A nonexclusive license is not considered a transfer of copyright ownership.

by staff before acquisitions.[281] Some museums treat works offered without the requisite copyright interests under the more exacting procedures required for restricted gifts to ensure adequate consideration of the limitations presented by the lack of copyright interests. Deed of gift and sale contract forms, and/or instructions on their use, should call staff attention to the fact that express language concerning transfer of copyright interests must be used if such interests are desired.[282] A donor-proposed modification of a museum's acquisition form should be referred to counsel for review if there is any uncertainty about its impact on the museum.

Should the museum strive to obtain all existing copyrights in an object acquired for its collections? There is no simple answer to this question, which involves many variables:

- The availability of such interests (photographers, for example, frequently do not want to part with copyright interests)
- The cost of acquiring the interests
- The perceived need for such interests

In situations where the transferor is willing and able to convey copyright interest at little or no cost, there is no problem, and a transfer of all the "bundle of rights" (that is, an assignment) can be made a part of the conveyance.[283] However, if the transfer is a matter for negotiation, the museum may find that even a reluctant copyright owner is willing to consider a carefully drafted license that grants the museum limited rights frequently associated with routine museum functions. Such rights might include the following: the right to reproduce the work in sale catalogs, both the museum's and those of museums that borrow the work; the right to create marketable slides designed for classroom use; the right to print postcards or inexpensive posters for the museum's use in its gift shop; the right to grant

281. The collection policy should require that the museum consider whether the proposed acquisition is encumbered by copyright or other restrictions. The following questions may be useful to ask in dealing with copyright concerns at the acquisition stage: (1) Is the work covered by copyright? (2) What uses are intended for the work, and will these uses require a transfer of copyrights? (3) Who owns the copyrights? (4) Is the owner willing to transfer the needed rights? (5) If the owner seeks to modify the museum's standard copyright transfer language, has the modification been reviewed by counsel? (6) If copyrights exist but will not be transferred, has the work been accepted under the museum's more rigorous procedures established for restricted donations? (7) If the work has been accepted, have the copyright status and all provenance history for the work been documented in the accession records?

282. Note the sample deed of gift in Section F, "Acquisition Procedures."

283. In such instances, some museum professionals (especially those holding large archival collections) argue that it is better to ask the copyright holder to dedicate the work to the public. It is reasoned that once the work is in the public domain, the overall benefits outweigh any loss to the museum. Also, the work is no longer subject to a termination of assigned rights. Another practical consideration is that if a living artist transfers copyright to the museum, as distinct from dedicating the work to the public, the artist may expect the museum to take action if there is possible infringement. This is a burden that a museum may not want to assume. However, if the museum wants to gain economic benefit from licensing the work to others, owning the copyrights is essential.

permission to scholars to reproduce in educational publications, such as university press publications and limited electronic uses. Frequently, it is to the benefit of the copyright holder to have the work promulgated by the museum in these ways. Such educational endeavors can increase the commercial value of the rights retained by the copyright holder. Part of the negotiations could involve a payment of royalties to the copyright holder if the requested use involves major commercial considerations. If it is uncertain whether the individuals in question have or still retain copyright interests, the museum may want to request a conveyance of any such rights they "may be deemed to have." Such a quitclaim document can be helpful in putting to rest shadow claims, which may lessen the value of the object to the museum over the years.

f. What If the Museum Owns No Copyright Interests? Fair Use

What can a museum do with an object it owns when someone else holds the copyright in the object? There is much debate as to the scope of the museum's power over such an object. As previously mentioned, a copyright holder has the right to reproduce the work, the right to adapt it, the right to distribute copies of it, the right of performance, and the right to display the work publicly.[284] However, the law provides certain exceptions to these exclusive rights of the owner of the copyrights, recognizing that the proprietary rights of copyright holders must, in certain cases, give way to society's interest in the free dissemination of ideas. The mechanism provided is called the "fair use doctrine."[285] Under the fair use doctrine, copying or photographing a work for internal registrarial or archival purposes is permissible.[286] Fair use also permits copying for such purposes as criticism, comment, news reporting, teaching, scholarship, or research. For determining whether a particular use is fair, the copyright statute lists the following criteria for consideration:

284. Regarding the right to display, the copyright statute specifically provides that the owner of an object, or any person authorized by such owner, can, without the authority of the copyright owner, display the object publicly. 17 U.S.C. § 109(b) reads: "Notwithstanding the provisions of § 106(5), the owner of a particular copy lawfully made under this title, or any person authorized by such owner, is entitled, without the authority of the copyright owner, to display the copy publicly, either directly or by the projection of no more than one image at a time, to viewers present at the place where the copy is located." Thus, even without copyright, if a museum owns the object, the museum can display it and lend it for display elsewhere. If a museum has an object on loan, it would normally not reloan it to someone else without the express approval of the owner. (See Chapter VI, "Loans: Incoming and Outgoing.") This express approval (usually in the loan agreement) should constitute a license to display.

285. 17 U.S.C. § 107. For recent developments in the doctrine of fair use, see B. Wolff, "Copyright," in American Law Institute–American Bar Association (ALI-ABA), *Course of Studies Materials: Legal Problems of Museum Administration* (Philadelphia: ALI-ABA, 1995), 34–41; K. Spelman, "The Copyright Defense of Fair Use," in American Law Institute–American Bar Association (ALI-ABA), *Course of Studies Materials: Legal Problems of Museum Administration* (Philadelphia: ALI-ABA, 1995), 3–26; Michael Scott, "Transforming the Fair Use Doctrine," in American Law Institute–American Bar Association (ALI-ABA), *Course of Studies Materials: Legal Problems of Museum Administration* (Philadelphia: ALI-ABA, 1995), 51–68. For an excellent on-line resource on fair use, see: http://fairuse.stanford.edu.

286. See 17 U.S.C. § 107 and 17 U.S.C. § 108(b).

(1) the purpose and character of the use, including whether such use is of a commercial nature or is for nonprofit educational purposes;[287]

(2) the nature of the copyrighted work;[288]

(3) the amount and substantiality of the portion used in relation to the copyrighted work as a whole;[289] and

(4) the effect of the use upon the potential market for or value of the copyrighted work.[290]

Fair use determinations require a case-by-case analysis of the facts presented for any proposed use in light of these four factors. Note that the purpose and the character of the use are the controlling factors, not the identity of the user. Any museum reproduction that falls outside the generally accepted interpretation of fair use would be in a gray area, with possible liability for infringement.[291] However, there are no court decisions interpreting fair use in the museum context to give meaningful guidance. Few would dispute that a reproduction of a work on a T-shirt or coffee mug for sale in a museum shop would not fare as well

287. In a recent case involving Roy Orbison's song "Pretty Woman," the Supreme Court held that a commercial distribution of 2 Live Crew's parody was "fair use." *Campbell v. Acuff-Rose*, 510 U.S. 569 (1994). Traditionally, purely commercial uses are rarely deemed "fair." In cases where the use is sufficiently "transformative," such as in this parody, commercial use is not per se disqualifying.

288. Generally, the more creative the work is, the more copyright protection it enjoys and the less likely that unauthorized copying will be deemed "fair use." In other words, a telephone directory will enjoy less protection than a work of poetry. In addition, courts are generally more reticent to find reproduction of unpublished material to be "fair," although the mere fact that the work is unpublished will not preclude a finding of fair use. See S. Weil, "Copyrights and Wrongs," *Museum News* 40 (July–Aug. 1993).

289. This factor involves a quantitative analysis of how much was copied and a qualitative analysis of whether the copying was substantial, looking at the work as a whole. For example, in *Campbell v. Acuff-Rose Music, Inc.*, 510 U.S. 569, 588 (1994), a small portion of a song was found substantial because the court found that the "heart" of the song was copied. Although there is no case law on this issue, an expert on "fair use" in the museum context argues that because a postcard-sized reproduction of a painting lacks the original painting's scale, supporting canvas, paint surface, and color, the reproduction is more akin to a quotation of a brief passage from a literary work than to a substantial use of the work in relation to the whole. S. Weil, "Fair Use/Museum Use: How Close Is the Overlap?" 3 *Visual Resources* 355–56 (Amsterdam, Overseas Publishers Association, 1977). However, even if an entire work is copied, such as in *Sony Corp. of America v. Universal City Studios, Inc.*, 464 U.S. 417 (1984), this does not preclude a finding of fair use. No one factor is determinative of "fair use." All four factors need to be considered.

290. 17 U.S.C. § 107. Courts may consider the effect on the "potential" market. *Salinger v. Random House, Inc.*, 811 F.2d. 90 (2d Cir.), *cert. denied*, 484 U.S. 890 (1987). In other words, the copyright holder need not have current intention to exploit the work. In addition, courts will also look to emerging markets. For example, in *American Geophysical Union v. Texaco, Inc.*, 37 F. 3d 881 (2d Cir. 1994), the court's finding that copying by Texaco scientists of scholarly journal articles for use in their laboratories was not "fair," relying in part on the existence of a new Copyright Clearance Center that, for a fee, licenses the making of photocopies of articles in scholarly journals on behalf of publishers that have contracted for the services. Note, however, that public libraries and archives enjoy a special exception that permits limited photocopying for private use under defined circumstances. 17 U.S.C. § 108. Museums should become familiar with these provisions as they may apply to museum libraries and archives open to the public. See also "Reproduction of Copyrighted Works by Educators and Librarians," Circular R21, Copyright Office, Library of Congress.

291. However, no statutory damages will be due for good-faith reliance on the doctrine of fair use by an employee of a nonprofit organization for an allegedly infringing reproduction. 17 U.S.C. § 504(c)(2). See footnote 239, above, discussing statutory damages.

under a fair use analysis as would a reproduction of that same image in a scholarly catalog publication. How would reproduction for slides, transparencies, CD-ROMS, or Internet Web-sites be judged?[292] At this point, there is little guidance available. The extent of distribution and the mode of pricing may become relevant factors in a fair use analysis. In gray areas, it is safer to contact the holder of the copyright and secure a written understanding concerning the exercise of the desired uses.

In recent years reliance on the doctrine of fair use for museums has been shrinking.[293] Both domestic and foreign licensing agencies representing visual artists have been very aggressively pursuing licensing fees from museums for all uses, even those that previously may have been considered "fair," such as images used in museum catalogs.[294] These agencies are being joined by some very successful artists who believe that museums should not reproduce their works without payment.[295] As of early 1997, several major art museums have acceded to such artists' demands, choosing to regard the payment of such fees as a cost of doing business rather than as a matter that should be decided on the merits.

292. See the discussion of "fair use" in the electronic environment in Section E(2)(i) below.

293. Some commentators argue that "fair use" should be expanded. They regard "fair use" not as being an exception to the copyright's objective but rather as being consistent with that objective. Pursuant to the U.S. Constitution, copyright is designed to "promote the useful arts," and therefore they urge that the question should be whether a particular use serves this objective without diminishing the economic incentives afforded for creativity. Thus if a new work is "transformative" in that it uses the original work in a different manner or for a different purpose than did the original, then it should be deemed fair. Something that merely repackages the original should not qualify. See a discussion of federal Judge Pierre N. Leval's approach in S. Weil, "Fair Use/Museum Use: How Close Is the Overlap?" 3 *Visual Resources* 357–58 (Amsterdam, Overseas Publishers Association, 1977), and D. Demac, *Is Any Use "Fair" in a Digital World? Toward New Guidelines for Fair Use in the Educational Context* (New York: Freedom Forum Media Studies Center, 1996), 28. See also P. Jaszi, "Goodbye to All That: A Reluctant (and Perhaps Premature) Adieu to A Constitutionally-Grounded Disclosure of Public Interest in Copyright Law," 29 *Vand. J. Transnat'l L.* 595 (May 1996); F. Nevins, "Availability: The Hidden Value in Copyright Law," 15 *Colum.-VLA J.L. & Arts* 285 (No. 3, spring 1991) (arguing for the expansion of fair use accessibility to creative works).

294. A New York–based artist rights' organization argues that the quantity of the reproduction should be considered in determining whether a use is nonprofit or commercial in nature. The group suggests that use of a work in a catalog published in an edition of 1,000 copies might be "fair use" but that an exhibition catalog produced in an edition of 100,000 is not. Weil points out that this argument has been undercut by the Supreme Court's decision in *Campbell v. Acuff-Rose Music, Inc.,* 510 U.S. 569 (1994), where a purely commercial distribution of a parody was not too commercial to be fair use, and that thus "the sale of 100,000 Matisse catalogues ought to present a court with no worse case." S. Weil, "Fair Use/Museum Use: How Close Is the Overlap?" 3 *Visual Resources* 357–58 (Amsterdam, Overseas Publishers Association, 1977), 355. The largest licensing groups include SPADEM (Societe de la Propriete Artistique, des Dessins et Models), ADAGP (Association pour la Diffusion des Arts Graphiques et Plastiques), VAGA (Visual Artists and Gallery Association), and ARS (Artists Rights Society/Art Research Service).

295. Their requests for reproduction fees also may pertain to works already in the public domain. Domestic artists, in particular, strongly argue that the restoration of copyrights granted to foreign works by the GATT agreement should also be made applicable to works by domestic artists. See footnote 259, above. Museums faced with demands for "voluntary" royalties may succumb in order to maintain good donor relations or to evoke artists' cooperation when exhibitions are mounted. Also, there is worry about museum publications sold abroad that may contain images for which museums refused to pay requested royalties. Such publications could be subject to seizure in foreign countries, since many foreign copyright laws have no similar "fair use"

g. Requests for Permission to Reproduce Museum Holdings

As matters become more complex, any museum, especially one with large archival or photograph collections, may find it prudent to review periodically, with legal counsel, its acquisition policies and practices pertaining to copyright. At the same time, the museum should carefully review its responsibilities when third parties request permission to reproduce material in its collections. Can the museum give such permission? What, if any, cautions must be given to the requestors? Establishing internal procedures that recognize and respect intellectual property rights associated with creative works, as well as the terms of any preexisting agreements with donors or others, is a necessity.[296]

Usually, a museum has a form for those requesting permission to reproduce, for publication, objects that the museum fully controls. Similarly, a form is frequently used to process requests for permission to use museum archival material for which rights may reside in others. If the form regarding archival material contains a general caution that the burden of obtaining all necessary reproduction permissions rests with the requesting party, the requesting party is clearly on notice that he or she may be required to go beyond the museum to resolve copyright issues. As individual requests are processed, the museum can then ascertain whether it has any definitive information on record to offer to the requestor regarding the copyright status of the material in question.

Two examples of cautionary clauses (used in request forms for material to which ownership rights may be uncertain) follow:

Photographs.

The Museum can grant the permission requested only to the extent of its ownership of the rights relating to the request. Certain works of art as well as the photographs of those works of art may be protected by copyright, trademark, or related interests not owned by the Museum. The responsibility for ascertaining whether any such rights exist, and for obtaining all other necessary permissions, remains with the applicant.

protections. Others, however, fear that the payment of such "voluntary" royalties will set a pattern that all museums will be forced to follow. Already some are proposing a compulsory licensing arrangement for visual arts (similar to the one in place in the music industry) whereby all museums would pay for the rights to use copyrighted visual images.

296. Charging fees for photographic usage is common practice, especially in art, history, and general museums. Some museums have contracted with commercial firms to handle requests for images that will be utilized in commercial or profit-making ventures, mostly in commercial publications. Great care must be given that all images made available have been cleared through someone who is knowledgeable about copyright and who can confirm that either the museum owns the copyright or that the work is in the public domain. For commercial uses, the museum is advised to control the use of its name by the party using the image. The museum may prefer not to allow identification of the museum as the source of the image if the image will be used in commercial products or advertising. (Otherwise it may appear that the museum is endorsing the product or service.) Care also should be taken so that the museum reproduction policies reflect a fee schedule that distinguishes between different types of uses, thus not inhibiting the publication of images, especially in the noncommercial scholarly publications.

Archival Material.

I understand (a) that the Museum makes no representation that it is the owner of any copyright or other literary property in the materials contained in its archives, (b) that, in providing access to or permitting the reproduction of any such materials, the Museum does not assume any responsibility for obtaining or granting any permission to publish or use the same, and (c) that the responsibility (i) for determining the nature of any rights, and the ownership or interest therein, and for obtaining the appropriate permissions to publish or use and (ii) for determining the nature of any liabilities (including liabilities for defamation and invasion of privacy or publicity) that may arise from any publication or use, rests entirely with the researcher.

h. Electronic Uses

Within the last few years, advances in computer technology have spawned an expanding multimedia industry hungry for what is known as "existing content."[297] To many in the business, museum collections are veritable cookie jars of desirable images and textual material. It is no surprise, then, that museums are facing increasing demands to make their collections accessible by computer in digital format.[298] At the same time, museums that want to reach broader audiences are publishing their collections in new multimedia products[299] and are establishing their presence on-line on the Internet through World Wide Web home-page sites featuring highlights of their collections.[300] In addition to educational out-

297. M. Radcliffe, "New Money for Old Property," *Legal Times,* special supplement, "Intellectual Property: Soaring into the Next Century," 39 (Dec. 11, 1995).

298. For a comprehensive discussion of the technological issues involved in digitizing museum images, see H. Bresser, *Introduction to Imagery: Issues in Constructing an Image Database* (Santa Monica, Calif.: Getty Art History Information Program, 1995). This pamphlet is a useful primer on the technology and vocabulary of digital imagery for museums considering establishing digital databases of their collections. See also A. Newman, "Electronic Imaging in the Museum," in American Law Institute–American Bar Association (ALI-ABA), *Course of Studies Materials: Legal Problems of Museum Administration* (Philadelphia: ALI-ABA, 1992), 345–60, for a discussion of the technical aspect of electronic uses from a museum's point of view, including a dictionary of technical terms. In recognition of the importance of the "existing content" available in museum collections, for-profit companies are courting leading museums in the United States and abroad to digitize, market, and distribute electronic reproductions of their collections. J. Lusaka, S. O'Donnell, and J. Strand, "Whose 800-lb Gorilla Is It? Corbis Corporation Pursues Museums," *Museum News* 34 (May–June 1996).

299. Many museums now offer interactive computer kiosks, allowing visitors to browse through their collections by viewing digital images. Among these are the Seattle Museum's "Viewpoint" and the National Gallery of Art's "Micro Gallery." See "The Rights Stuff," *Scientific American* 30 (Jan. 1995), and J. Strand, "High Art, High Tech: The National Gallery of Art's New Micro Gallery," *Museum News* 34 (July–Aug. 1995). Similarly, CD-ROMs of collections have enjoyed commercial success, such as the "Passion for Art," which features the Barnes Collection. See W. Mossberg, "Personal Technology: A Great CD-ROM That Does Justice to Viewing Great Art," *Wall Street Journal,* Feb. 16, 1995.

300. The Internet or, particularly, the World Wide Web is a rapidly expanding computer network and permits users to navigate from one computer station to another throughout the world. A "home page" is a Web electronic location that contains basic information about its creator in the form of text and graphics and that also includes links to other information on the Web. Commentators, noting the benefits of the Internet to museums, point to a practical result of Internet access, namely, that small museums can be just as effective as larger ones in displaying their educational programs and collections. The Internet also is described as "democratizing," in that any user can tap into on-line information at a small expense. G. Singer et al., "The Legal Con-

reach, digital images are increasingly used by museums for record-keeping and preservation purposes.[301] The rights needed to use works subject to copyright protection in these ways are loosely referred to as "electronic rights." This term has no clear legal definition, and it may be used as shorthand for a broad spectrum of uses, from the Internet and commercial on-line services to CD-ROM and disk purposes.[302]

Digitizing museum collections is an expensive proposition;[303] hence, a growing number of museums are joining with for-profit companies in agreements wherein the for-profits bear such expense in return for the right to license the digital images commercially for a set period of time. But often these companies will select from a museum's collections only the most commercially desirable images, leaving the remainder, and in addition, they may seek to claim copyright in the digital format they produce, thus limiting what the museum will be able to do with the digital images.[304] Such an arrangement will leave the museum with an incomplete digital record of its collections for internal purposes as well as limitations on its ability to exploit, to the museum's best advantage, commercial opportunities open to its most popular images. Accordingly, other museums are exploring the option of paying for digitizing their collections and recouping their costs by entering into site licensing arrangements with other educational organizations such as colleges, universities, and school systems. For site licensing, the museum itself selects and creates a database of digital images of objects in its collections. Through a licensing agreement, it then grants the right for a school's computer network to access the museum's database for teaching and other research purposes. In return, the school pays a fee, which is used by the museum to offset the costs of creating and maintaining the database.[305] Whichever road a museum decides to follow (and there are more under discussion), the decision should be made by a well-informed board of trustees, keeping at all times the educational mission of the museum in focus.

cerns of Museums in an On-line Environment," in American Law Institute–American Bar Association (ALI-ABA), *Course of Studies Materials: Legal Problems of Museum Administration* (Philadelphia: ALI-ABA, 1996), 515, 518. See also M. Anderson et al., "Museums on the World Wide Web," *Museum News* 34–40 (Jan.–Feb. 1997); L. Johnston and K. Jones-Garmil, "So You Want to Build a Web Site?" *Museum News* 41–44 (Jan.–Feb. 1997).

301. J. Lusaka, S. O'Donnell, and J. Strand, "Whose 800-lb Gorilla Is It? Corbis Corporation Pursues Museums," *Museum News* 36 (May–June 1996).

302. M. Radcliffe, "New Money for Old Property," *Legal Times,* special supplement, "Intellectual Property: Soaring into the Next Century," 39 (Dec. 11, 1995). See also M. Levine, "Electronic Publishing: A Legal and Practical Primer," 18 *CRM* 23 (No. 9, 1995), for a summary of the legal issues involved in electronic publication.

303. The cost of producing one digitized image in 1996 was reported to be around $20.00 to $22.00. The cost may be significantly higher if first a photo transparency is required of the object. J. Lusaka, S. O'Donnell, and J. Strand, "Whose 800-lb Gorilla Is It? Corbis Corporation Pursues Museums," *Museum News* 34 (May–June 1996).

304. See the discussion below on ownership of copyright in a digital image as a derivative work.

305. G. Samuels, "CyberMuse: The Site Licensing Solution," *Museum News* 54 (May–June 1996). In mid-1997 the Association of Art Museum Directors (AAMD) announced the founding of the Art Museum Image Consortium (AMICO), a new not-for-profit organization. The mission of the new organization is to build a shared library of digital images from the collections of member museums for licensing to the educational community. Over seventy art museums from the United States and Canada were invited to participate. See http://www.amn.org/AMICO.

The decision about which objects to digitize will often turn not only on the importance of the object to the collections but also on the nature and scope of the copyrights held in the object by the museum. Often, even those well-versed in copyright law must perform intellectual somersaults to apply existing legal concepts crafted for the print medium to electronic uses.[306] As a rule, the copyrights held by a museum in its collection objects were granted in copyright provisions in deeds of gift or purchase agreements that did not anticipate the new electronic media explosion. However, if a museum was assigned *all* copyrights in an object rather than simply granted a license for limited uses, the museum generally need not worry whether it holds rights for new technological uses. An assignment of "all rights" without a reservation usually may be interpreted to include the right to exploit the work in new media made possible by technological advancements.[307] This is not the case if the museum holds only limited rights defined in a license.

Many museums are faced with deciding whether the new uses are permissible under older licensing language or whether further permissions from the copyright holders are required. Unfortunately, the law gives no clear guidance on this issue. One reason is that the courts simply have not decided enough cases on electronic uses to serve as guiding precedents.[308] But cases have grappled with the underlying problem of trying to fit new technologies into preexisting licensing provisions (such as whether television rights were covered by licenses granting motion picture rights). In such earlier cases, the courts have taken two conflicting approaches, with differing results.[309] In the first approach, a holder of a license may properly pursue any uses that may reasonably be said to fall into the media described in the license. The second approach limits the license to rights that were expressly

306. R. Coleman, "Copycats on the Superhighway," 81 *A.B.A. J.* 68 (July 1995).

307. See *Burnett v. Warner Bros. Pictures, Inc.*, 493 N.Y.S.2d 326 (S. Ct. App. Div. 1985), *aff'd*, 501 N.Y.S.2d 815 (1986) (an assignment of "all rights" to a dramatic work in 1942 was held to include the right to use the work much later in a television production). However, at least one court interpreting the phrase "all rights" implied that any subsequent technological advances that made new uses possible must have been at least foreseeable at the time the original assignment was made in order to fall within the assignment. *ABKCO Music Inc. v. Westmister Music Ltd.*, 838 F. Supp. 153 (S.D.N.Y. 1993), *aff'd*, 41 F.3d 1502 (2d Cir. 1994). The court, however, rejected the plaintiff's argument that an assignment of "all rights" signed in the 1960s could not have conveyed rights to use music in videotapes, leaving the "natural implications of the language" in the agreement as a question of fact for the jury to decide. See also *Maljack Productions v. Goodtime Home Video Corp.*, 30 U.S.P.Q.2d 1959 (C.D. Cal. 1994).

308. At least one case has been filed by members of the National Writers Union (NWU) on the issue of whether a grant of a license by authors to magazine publishers to publish their articles includes the right for the magazine publisher to republish the contents of the magazine electronically without additional compensation to the authors. See *Tasini v. New York Times*, No. 93-CV-8678 (S.D.N.Y. filed Dec. 16, 1993). This case is still pending. However, the NWU and other unions have been very vocal in advocating that the interpretation of "all rights" clauses should be limited to rights for media in existence at the time of the agreement. M. Radcliffe, "New Money for Old Property," *Legal Times*, special supplement, "Intellectual Property: Soaring into the Next Century," 39 (Dec. 11, 1995).

309. 3 *Nimmer on Copyright* § 10.10[B] (1996).

granted and reserves the remainder to the holder of the copyrights.[310] Given this split of opinion, as of early 1997, reliable general guidance based on court precedents is not possible.

To further complicate matters, as of early 1997 the law is still unclear on such basic issues as which rights in the bundle of copyrights are implicated in digitizing images. In addition to the expected reproduction right (the digital image being a copy of the original), some—most notably, for-profit corporations in the business of digitizing images—argue that the digital image is suitable for separate copyright protection as a derivative work (thus implicating the rights of adaptation). In other words, they maintain that there is sufficient "originality"[311] in digitizing (such as fine-tuning of patterns, brightness, contrast, and colors) so that the final product is entitled to separate copyright protection apart from the underlying image.[312]

If this second interpretation prevails, there can be as many as three layers of copyright protection in a digital image. For example, an original work of art is first photographed with film, and the photo transparency is then used to scan the image into a computer.[313] The artist may hold copyrights in the work itself, the photographer may hold copyrights in the photo transparency, and the party responsible for the digital image may hold copyrights in that image. Like peeling the skin of an onion, removing one layer of rights may reveal another. This debate over the copyright ramifications of digital images must be kept in mind whenever electronic rights are granted or acquired.

Once the digital image is created, a whole other set of rights in the bundle of copyrights

310. In addition, if a license is not clear on its face, a court may look to "industry practice" at the time to help interpret what was intended in the license. For example, in *Playboy Enterprises v. Dumas*, 831 F. Supp. 295 (S.D.N.Y. 1993), the court was convinced that at the time, industry practice between magazine publishers and illustrators was to acquire one-time rights unless explicitly stated otherwise. In interpreting the scope of a museum's license, a court may look to the rights that museums generally acquired in the past for works in their collections.

311. According to court interpretation, copyright law requires only that there be some modicum of creativity in order to create a product entitled to its own protection. In effect, the level required to be original is low.

312. J. Lusaka, S. O'Donnell, and J. Strand, "Whose 800-lb Gorilla Is It? Corbis Corporation Pursues Museums," *Museum News* 76 (May–June 1996). If the museum enters into an agreement with an outside entity for digitizing its collections, ownership of the copyrights in this potential derivative work should be settled in advance. It is important to note that if indeed the digital image is eligible for separate copyright protection, museum-held works that are in the public domain may be subject to copyright control once they are in digital form. The issue of who has the right to control access to such digital images is an important one. See the discussion later in this section. The federal government's Working Group on Intellectual Property Rights compiled a report on recommended changes in the copyright laws for the development of the National Information Infrastructure (NII); *Intellectual Property and the National Informational Infrastructure,* called the "White Paper" (1995), fails to address whether digitizing a photograph constitutes a derivative work or merely a reproduction. B. Rich and E. Weiswasser, "Intellectual Property and the National Information Infrastructure: The Report of the Working Group on Intellectual Property Rights," 7 *Journal of Proprietary Rights* 7 (No. 12, Dec. 1995). For a fuller discussion of the "White Paper," see the text below.

313. Depending on the digitizing equipment used, the object may be directly scanned using a digital camera without the need for a separate photo transparency. See H. Bresser, *Introduction to Imagery: Issues in Constructing an Image Database,* (Santa Monica, Calif.: Getty Art History Information Program, 1995), 27.

may be implicated when that image is made available on-line. Here again, as of early 1997, there is an ongoing debate. Some argue that copyright law should have little application in the electronic environment, thus allowing for the free flow of information unfettered by proprietary concerns. Others maintain that copyright law should apply, perhaps even more stringently, to on-line transmissions because the technology facilitates the copying and transmitting of proprietary information. In 1993, the federal government established the Working Group on Intellectual Property Rights to explore the application and effectiveness of existing copyright laws to the National Information Infrastructure (NII). The working group released its findings in September 1995 in *Intellectual Property and the National Informational Infrastructure,* a publication known as the "White Paper." Generally, the "White Paper" sides with the proponents of strong copyright controls on-line. The "White Paper" takes the position that current copyright laws, interpreted broadly, are adequate to protect the interests of copyright owners in the electronic environment. Accordingly, the "White Paper" offers only a handful of recommendations for amending the 1976 Copyright Act. Late in 1995, the legislative amendments and recommendations were introduced in Congress as the NII Copyright Protection Act of 1995 (S. 1284 and H.R. 2441).[314] These recommended amendments had not been passed as of 1997. As noted above, the recommended ground rules concerning the use and transmission of information on the Internet proposed by the "White Paper" are based on the view that current copyright law gives, for the most part, adequate direction in the on-line environment.[315] For example, the "White Paper" maintains that, under current copyright law, the exclusive right of reproduction is implicated in each of the following instances:

314. The amendments to the Copyright Act proposed in the "White Paper" would, *inter alia,* (1) extend copyright protection for a distribution by transmission, (2) expand the definition of "transmit" to include a "transmission of a reproduction," and (3) amend the definition of "publication" to include distribution of copies by transmission. On the international front, on December 20, 1996, members of the World Intellectual Property Organization (WIPO), an agency of the United Nations, concluded a treaty in Geneva called the "WIPO Copyright Treaty," which is intended to extend the Berne Convention copyright protections to the digital age. The treaty, which must be adopted by thirty countries before it becomes effective, extends copyright protection to computer programs, adds the right of communication to the list of exclusive rights of authors (including ondemand interactive communications through the Internet), and provides remedies against the circumvention of technological measures (e.g., encryption). The WIPO Copyright Treaty, for the first time, also extends the term of protection for photographic works to the author's life plus fifty years. Each contracting party is required to pass laws to ensure the application of the treaty in its jurisdiction. In the United States, most of the treaty's protections are already recognized under existing law. For the remainder, the WIPO Copyright Treaty implementation bill (H.R. 2281) was introduced on July 29, 1997. The WIPO Copyright Treaty, in addition to the recommendations of the "White Paper," is expected to set the course for domestic legislation in this area. S. Chartrand, "The Ins and Outs of On-Line Copyright," *New York Times,* April 14, 1996; "International Protection of Copyright and Neighboring Rights," at http://www.wipo.org./general/copyrght/wet.htm.

315. For a discussion of the "White Paper" and court cases involving copyright infringement for on-line uses, see G. Singer et al., "The Legal Concerns of Museums in an On-line Environment," in American Law Institute–American Bar Association (ALI-ABA), *Course of Studies Materials: Legal Problems of Museum Administration* (Philadelphia: ALI-ABA, 1996).

- When a work is placed into a computer's memory
- When a printed work is scanned into a digital file
- When other works such as photographs or movies are digitized
- When a digitized file is uploaded from a user's computer to a bulletin board system or other server
- When a digital file is downloaded to users
- When an end user's computer is used as a "dumb" terminal to access a file resident on another computer, and a copy of at least the portion viewed is placed in the temporary memory of the user's computer[316]

However, critics of the "White Paper" argue that in an effort to protect the economic interests of copyright holders, the "White Paper" at times relies on scanty precedents in current case law and on incomplete analyses to draw such conclusions, conclusions that will have a chilling effect on the accessibility of on-line information essential for research and education.[317] As an example, critics point to the assertion of the "White Paper" that it is "clear," under U.S. law, that a "reproduction" is made when an image is placed into computer memory.[318] Critics argue that this broad assertion fails to account for differences between temporary and permanent computer-storage memories and for the expressed legislative intent of the 1976 Copyright Act to offer no copyright protection for certain ephemeral copies made by a computer for temporary storage purposes. Although case law supports the conclusion that the uploading or downloading of a digital work into permanent computer-storage devices constitutes a "reproduction," critics argue that the same should not be true when a digital work is transferred temporarily to random access memory (RAM) for reading on the computer user's screen (for example, while the user is browsing the World Wide Web for information). Proponents of freer on-line access maintain that the temporary RAM-stored material is too transitory to qualify as a "reproduction" for copyright purposes. They rely on support found in the legislative history of the 1976 Copyright Act, which indicates that works are not considered "fixed" (and therefore are not a copy in relation to the exclusive right to reproduce) if captured momentarily in the "memory" of a computer.[319] The copyright implications of the two approaches are far-reaching. If, as the pro–"White Paper" advo-

316. "White Paper," 64–66.

317. See P. Jaszi, "Taking the White Paper Seriously," *Copyright and the NII: Resources for the Library and Education Community* (Washington, D.C.: Association of Research Libraries, 1996), 97–99; J. Yates and M. Greenlee, "Intellectual Property on the Internet: Balancing of Interests between the Cybernauts and the Bureaucrats," 8 *Journal of Proprietary Rights* 8 (July 1996).

318. In fact, commentators point out that the case law of only one jurisdiction supports this assertion. See J. Yates and M. Greenlee, "Intellectual Property on the Internet: Balancing of Interests between the Cybernauts and the Bureaucrats," 8 *Journal of Proprietary Rights* 9 n. 5 (July 1996), citing *MAI Systems Corp. v. Peak Computer, Inc.,* 991 F.2d 511, 519 (9th Cir. 1993), *cert. denied,* 114 S. Ct. 671 (1994); *Triad Systems Corp. v. Southeastern Express Co.,* No. 94-15818 (9th Cir. 1995).

319. J. Yates and M. Greenlee, "Intellectual Property on the Internet: Balancing of Interests between the Cybernauts and the Bureaucrats," 8 *Journal of Proprietary Rights* 9 n. 8 (July 1996), citing H.R. 1476, 94th Cong., 2d sess. 53 (1976).

cates suggest, a RAM copy constitutes a reproduction, without fair use, such a reproduction (made without the authority of the copyright holder) would constitute copyright infringement. As a result, access to on-line information would become subject to user fees, greatly limiting the pursuit of research and education. Anti–"White Paper" advocates, on the other hand, insist that Web browsing should be considered more akin to paging through a book at a bookstand than to copying the book. In general terms, those favoring the "White Paper" are viewed as advocating the economic rights of creators, whereas those criticizing the "White Paper" are labeled champions of educators and students.[320] As of early 1997, the debate continued as the copyright map for on-line uses remains to be drawn.[321]

Given the complexity of and lack of clarity on rights clearances for electronic uses, museums are advised to establish carefully developed procedures for screening requests for the digitization of their images and for the use of such digital images. The procedures should include all aspects of copyright clearance raised by such requests (including who will own copyright in the digital version), as well as possible issues concerning the transmission of "indecent" and "obscene" images or images that may infringe on rights of privacy and publicity.[322] Rights clearances should be handled centrally by knowledgeable staff, since this area

320. Another recommendation criticized for the same reason relates to the "first sale" doctrine. This doctrine now allows a purchaser of a book to sell or lend a book to another without violating the copyright law. The recommendation of the "White Paper" would not allow the same for digital works because sending a copy of a digital work to someone via the Internet would require an unauthorized copy to be made, even if the original on the sender's computer is erased. J. Yates and M. Greenlee, "Intellectual Property on the Internet: Balancing of Interests between the Cybernauts and the Bureaucrats," 8 *Journal of Proprietary Rights* 11 (July 1996). Generally, the "White Paper" is criticized for treating copyrights as physical packages of information to be sold rather than as a means for balancing proprietary interests and the public interest in the free and open dissemination of ideas. P. Wallich, "The Chilling Wind of Copyright Law?" *Scientific American* 30 (Feb. 1995). P. Jaszi, "Taking the White Paper Seriously," *Copyright and the NII: Resources for the Library and Education Community* (Washington, D.C.: Association of Research Libraries, 1996), states, "The ironic result is that in the regime of intellectual property law envisioned in the *White Paper,* the digital information consumer actually has less assured access and fewer use privileges than does the consumer of works in 'hard copy' form" (97). Jaszi adds, "Put it another way, the *White Paper* struggles to put the genie of digital information technology back in the bottle of a copyright system originally devised to regulate the traffic of printed books—something which can be achieved, if at all, only by enlarging and strengthening the bottle" (ibid.).

321. In addition to the rights of reproduction, the exclusive rights of distribution and display are also involved in the on-line environment. For example, a federal district court held that making an image available on-line to a number of people infringed a copyright holder's exclusive right to distribute and his or her exclusive right to publicly display the work. *Playboy Enterprises v. Frena,* 839 F. Supp. 1552 (M.D. Fla. 1993) (holding that *Playboy's* distribution and display rights were infringed by the owner of an electronic bulletin board service when *Playboy's* photographs were placed on the bulletin board system by a subscriber and were downloaded by another subscriber, when it was clear that the defendant knew about the activity). However, compare *Religious Technology Center v. Netcom On-line Communication Servs.,* 907 F. Supp. 1361 (N.D. Cal. 1995), where the court found that the Internet access provider did not violate the copyright holder's exclusive right to publicly display his or her work by simply maintaining an infringing copy on its server for eleven days when the provider did not create or control the content of the information on the computer bulletin board. According to the "White Paper," if users visually "browse" through copies of works, a public display occurs. "White Paper," 70–72.

322. See the discussion of the rights to privacy and publicity in Section E(3)(c). In addition, on Feb. 1, 1996, Congress passed the Communications Decency Act (CDA), Title V., Pub. L. 104–104, 110 Stat. 133, which makes it a crime to transmit "indecent" or "obscene" images or comments through telecommunications de-

is a potential minefield.[323] Many museums are taking the safe road regarding copyright in the underlying work. They have chosen to limit images posted on-line to three categories: (1) works for which they clearly own all copyrights; (2) works for which the museum holds an explicit license for on-line uses; or (3) works that are in the public domain. Until the law settles out, this may be the most advisable route. Finally, for each image the museum decides to make available on-line, the museum should be sure that proper copyright notices appear as well.[324]

Since this area of the law is still evolving, little can be said with assurance. Nevertheless, the following general points are worth noting. These are grouped by whether the museum consumes electronic rights (the copyrights are not held by the museum) or provides electronic rights (the museum is the holder of the copyrights or otherwise controls the underlying works).

The Museum Consumes Electronic Rights: The Copyrights Are Not Held by the Museum.

- The language in the original license granting the museum limited rights is key to determining whether electronic rights are covered. Museums should request counsel's advice in interpreting the standard licensing language used in past museum forms.
- In cases of doubt as to whether the museum holds sufficient rights, the museum should contact the copyright holder to avoid problems. Some museums may be hesitant to ask for permission because they do not want to acknowledge any uncertainty or they fear they will be refused clear additional rights. This approach begs trouble. If there is uncertainty, the copyright holder can be asked to grant the requested rights "if such permission is necessary." This language does not seek to resolve the issue of who holds the rights but merely confirms that this particular use will not be contested. If the copyright holder refuses this compromise language, the museum has clear warning that legal action will possibly result if it goes forward without reaching an agreement with the copyright holder.
- Museums should ask counsel to update existing licensing language in deeds of gift and other licensing forms so that these instruments clarify, as much as possible, what is passing to the museum. If a broad transfer is sought, often favored by a museum,

vices, including a computer modem. Shortly after its passage, key provisions of the CDA were held unconstitutional. See the discussion below on content-related issues on obscenity in Section E(3)(c).

323. See F. Smallson, "Searching for the Right Stuff," *Legal Times* 55–60, special issue, "Expanding the Boundaries of Intellectual Property," May 15, 1995, for a general road map for locating rights holders. The Copyright Office charges $20 per hour for copyright searches, but such searches will reveal only those works that have been registered in the United States. Moreover, works that are not registered may be protected by U.S. copyright laws. Various on-line services are now being developed to help with multimedia licensing. In addition, there are companies that will research and negotiate all appropriate clearances for a fee.

324. Until there is further guidance to the contrary, a museum should assume that a digital image is capable of separate copyright protection as a derivative work and should claim copyright by placing a copyright notice (© date, name of museum) on the image. In addition, because on-line transmissions will reach countries that may not be members of the Berne Convention, museums should place copyright notices on their Websites, along with "all rights reserved" language intended to protect against international copyright infringement.

the following language is suggested: "for use in all media by any means or method now known or hereafter invented." If the grantor is willing to give the museum such rights, this language may prevent the need to return for additional permissions for uses in emerging technologies.

- If a party wants to alter a museum's language regarding passage of rights or wants to use its own licensing form, the museum should request legal counsel's advice before accepting the license offered.

The Museum Provides Electronic Rights: The Museum Is the Holder of the Copyrights or Otherwise Controls the Underlying Works.

- As providers of copyrights, many museums refuse to grant exclusive electronic rights to any outside entity. A grant of exclusive rights would prevent a museum from allowing others to use that same content electronically, thereby tying the museum's hands from disseminating its educational assets in the broadest way possible in keeping with its mission. A nonexclusive license is preferred, specifying, as appropriate, the medium, the scope of distribution, and the time limits.
- If the museum enters into an agreement for digitizing its collections with an outside entity, ownership of the copyrights in this potential derivative work should be settled in advance. The issue of who has the right to control such digital images is important. For example, works that are in the public domain before they are digitized may be subject to copyright control once they are in digital form by the owner of the digital copyright (assuming that indeed a digital image is capable of separate copyright protection). Preferably, the museum should require the assignment of all copyrights in the digital image, allowing the company to keep a nonexclusive license for defined uses.
- In licensing content for digital imaging products, such as CD-ROMs, museums should be aware that the resulting product may be eligible for separate copyright protection as a compilation. The question of ownership of these new copyrights, as well as rights to any software created for the product, should be settled in advance.[325]
- If the museum's rights to an object or image are murky, an outside user should be obligated to investigate whether additional permissions from third parties may be required and to obtain such rights before the image is used. Such cautionary language in user forms is provided in the general discussion in Section E(2)(g) above.

i. Fair Use in the Electronic Environment

Whether a museum is the consumer or the provider of electronic rights, the potential application of the doctrine of fair use is an important consideration. Fair use is often described

325. A compilation is "a work formed by the collection and assembling of preexisting materials or of data that are selected, coordinated, or arranged in such a way that the resulting work as a whole constitutes an original work of authorship." 17 U.S.C. § 101. C. Steiner, "Controlling Your Images," *Museum News* 62 (July–Aug. 1992).

as the most significant yet the most poorly defined limitation on the exclusive rights held by the copyright owner. In the electronic environment, the doctrine becomes even murkier. For example, without express permission from the copyright holder, museums have traditionally relied on fair use to place images of copyrighted works in exhibition brochures distributed free to the visiting public. However, what if that same brochure is scanned and posted on the museum's Web-site? Is that fair use? In both cases, the museum is using the work for essentially educational, noncommercial purposes. However, when applying the fair use factors enumerated in Section E(2)(f) above, especially the factor concerning the effect of use on the potential market for or value of the copyrighted work, one could argue that these two uses produce substantially different results. In the brochure case, there is relatively limited exposure, whereas in the on-line case, technology permits worldwide display, distribution, and reproduction of the work to and by anyone signing onto the museum's Web-site. Questions of this nature are unresolved as of 1997.[326]

Notably, the previously mentioned "White Paper" did *not* address issues relating to fair use. Instead, it deferred to the Conference on Fair Use (CONFU) to promulgate fair use guidelines. But as of 1997, CONFU had yet to accomplish this task.[327] The work of CONFU has attracted greater attention from fair use advocates such as universities, libraries, and museums because of what they see as the restrictive economic focus of the "White Paper."[328]

326. See D. Demac, *Is Any Use "Fair" in a Digital World? Toward New Guidelines for Fair Use in the Educational Context* (New York: Freedom Forum Media Studies Center, 1996). Demac argues that crafting "fair use" guidelines is "a daunting task, but a necessary one," quoting federal Judge Pierre Leval's comment: "Fair use should not be considered a bizarre, occasionally tolerated departure from the grand conception of the copyright monopoly. To the contrary, it is a necessary part of the overall design. Although no simple definition of fair use can be fashioned, and inevitably disagreements will arise over individual applications, recognition of the function of fair use as integral to copyright's objectives leads to a coherent and useful set of principles" (28).

327. CONFU has several working subgroups, including the digital image discussion group, in which both consumers and providers of images were asked to participate. The groups represented in the digital image discussion group include the American Association of Museums, several major museums, members of the library and research community, professional associations representing creators, and companies from the multimedia industry. The digital image discussion group is preparing a report for submission to CONFU. In turn, CONFU is expected to take the recommendations of its subgroups and to publish a consolidated report.

328. For example, see the press release issued by the Society of American Archivists (SAA), dated Nov. 12, 1996, and entitled "The Society of American Archivists Issues Six Objections to Draft Educational Fair Use Guidelines for Digital Images." This press release responds to draft CONFU guidelines that the SAA finds needlessly restrictive. See also "CONFU Guidelines for Digital Images: VRA Position Statement," published by the Visual Resources Association in the winter of 1996. A key objective to these guidelines is that they ignore the fundamental nature of the "fair use" doctrine. By definition, "fair use" means that use is authorized, by law, without permission from the copyright owner or the payment of any licensing fee. However, through the proposed "fair use" guidelines for digital images circulated in late 1996, an educational institution must try to obtain permission from copyright holders. For example, an educational institution would be allowed to digitize images from legally acquired slide collections provided that a digital version of the image is not already available for purchase or by license for a reasonable price. Thumbnail versions of such digital images may then by transmitted on secure internal networks for educational purposes for limited periods, provided that the educational institution seeks permission to continue the use from the copyright holder of the image after the specified grace period expires. By mid-1997, major museums had joined other educational organizations in expressing their dissatisfaction with CONFU's proposed approach.

Many within these educational groups believe that maintaining the survival of fair use should be among the first objectives of any attempts to clarify and/or revise the copyright laws. As a result, CONFU's recommendations will be closely scrutinized and are expected to engender a heated debate. It is important that the interests of museums be heard.

Although there are arguments to support expanding fair use in the electronic age, technological advances are threatening to erode fair use in another manner. The ability to track license transactions is becoming easier with new technology, and as a result, more copyright clearance organizations are being formed to track and collect royalties on behalf of copyright holders. This affords rights holders an ability to demonstrate more effectively their economic loss when fair use is used to justify copying without permission. And as it becomes easier for users to pay royalties, courts may be less likely to find a reason why the rights holder should forfeit such payment under the rubric of "fair use."[329]

j. Special Considerations with Internet Uses

Aside from copyright concerns, should a museum post its images on the Internet?[330] The opinions on this issue vary. One school of thought is that making the museum's "existing content" available to the widest possible audience is in keeping with its mission. Others fear that once an image is on the Internet, the museum can no longer effectively control its use. Thus there is the basic problem of access versus control. As of 1997, these additional considerations should be factored into the balancing process. Those who favor caution present the following arguments:

1. Currently, many think that anything on the "net" is fair game.[331]
2. The opportunity for misuse is far greater because of the sheer number of people who have easy access to the image.
3. The ability to misuse is greater because it is becoming easier to manipulate images electronically—and often in ways that are difficult to detect and stop.
4. Some images may prove inappropriate for on-line use because they are culturally sen-

329. See, for instance, *American Geophysical Union v. Texaco, Inc.*, 37 F. 3d. 881 (2d. Cir. 1994). The case held that scientists' photocopying of journals was not "fair use"—relying, in part, on the availability of a centralized copyright clearance organization that tracked and collected royalties on behalf of the publishers. P. Jaszi, "Taking the White Paper Seriously," *Copyright and the NII: Resources for the Library and Education Community* (Washington, D.C.: Association of Research Libraries, 1996), 101.

330. For a discussion of museums and the Internet, see B. Wallace and K. Jones-Garmil, "Museums and the Internet: A Guide for the Intrepid Traveler," *Museum News* 32 (July–Aug. 1994); G. Singer et al., "The Legal Concerns of Museums in an On-line Environment," in American Law Institute–American Bar Association (ALI-ABA), *Course of Studies Materials: Legal Problems of Museum Administration* (Philadelphia: ALI-ABA, 1996), 515. M. Anderson et al., "Museums on the World Wide Web," *Museum News* 34 (Jan.–Feb. 1997); L. Johnston and K. Jones-Garmil, "So You Want to Build a Web Site?" *Museum News* 41 (Jan.–Feb. 1997).

331. "Internet ethics" and existing copyright laws seem to be at odds. G. Singer et al., "The Legal Concerns of Museums in an On-line Environment," in American Law Institute–American Bar Association (ALI-ABA), *Course of Studies Materials: Legal Problems of Museum Administration* (Philadelphia: ALI-ABA, 1996), 515, 526.

sitive,[332] may raise concerns about rights of privacy and publicity, or may test obscenity standards. In these areas, a museum must consider not only U.S. laws and sensibilities but also possible worldwide reactions.[333]

5. With rapid technological advances, it may be easier to monitor Internet uses and, perhaps, capture user fees.[334] Thus, it is more prudent to wait until both legal and technological protection measures are more fully developed.

In contrast, others offer the following arguments:

1. Technology already offers ways to control images on-line, such as using limited resolution that inhibits commercial reuse or by adding "watermarks" that enable tracking of unauthorized uses.[335]
2. There is little evidence so far that exploitation of electronic rights will bring substantial economic gain; thus, museums that wait, for economic reasons, to make their collections available on-line are most likely to be disappointed.[336]

In summary, the only advice that can be offered—as of 1997—on this general topic is that since the road is uncharted, museums should carefully investigate before making commitments.

k. Additional Information on Copyright Issues

The Copyright Office of the Library of Congress, the federal office primarily concerned with the administration of the copyright law, cannot give legal opinions on particular problems. It does, however, offer numerous informative booklets. Of particular interest to museums might be the following publications:

332. For an interesting discussion of culturally sensitive Native American images, see N. Holman, "Sensitive Native American Photographic Images: Stepping Back to Look at the Big Picture," 3 *Smithsonian Institution Center for Museum Studies Bulletin* 1 (No. 2, Sept. 1995).

333. The worldwide reach of the Internet presents potential liability under foreign laws of defamation, privacy, obscenity, moral rights, or copyrights, among others. If a museum has assets in a foreign country, these assets may be seized to satisfy the judgment of a foreign court.

334. Various fee structures are under discussion, such as a pay-as-you-go system, digital cash, and some compulsory licensing arrangements similar to those in existence in the music industry. R. Coleman, "Copycats on the Superhighway," 81 *A.B.A. J.* 68 (July 1995). The "White Paper" concluded that compulsory licensing is "neither necessary or desirable," taking the position that licensing should be left to the marketplace. "White Paper," 52.

335. The "White Paper" notes that systems are being developed to track and monitor uses of copyrighted works as well as licensing of rights and indicating attribution, creation, and ownership interests. Among these systems are encryption technologies, digital signatures, and steganography. "White Paper," 191. The report further recommends a Copyright Act amendment that will prohibit the importation, manufacture, or distribution of any device or product that will circumvent or deactivate the detection of copyright infringement. "White Paper," 230–34.

336. For a discussion of the application of the NII in the cultural arena, see the report of the Information Infrastructure Committee on Applications and Technology, "The Information Infrastructure: Reaching Society's Goals," published by the U.S. Department of Commerce, Technology Administration, in draft form in 1996.

- Circular 1: *Copyright Basics*
- Circular 9: *Works-Made-for-Hire under the 1976 Copyright Act*
- Circular 22: *How to Investigate the Copyright Status of a Work*
- Circular 38b: *Highlights of Copyright Amendments Contained in the Uruguay Round Agreements Act (URAA)*
- Circular 40: *Copyright Registration for Works of Visual Arts*
- Circular 40a: *Deposit Requirements for Registration of Claims to Copyright in Visual Arts Material*

To obtain any of these publications, write to Information and Publications Section, Information and Reference Division, U.S. Copyright Office, Library of Congress, Washington, D.C. 20559. These publications are also available on-line at http://lcweb.loc.gov/copyright/circs.html.

The Copyright Office site may be accessed through the Library of Congress home page at http://www.loc.gov. This site also includes information on CORDS (Copyright Office Electronic Registration, Recordation, and Deposit System), allowing on-line digital registration and deposit of works for copyright purposes. On-line copyright and related information is available on-line at many sites including the following:

- Basic patent, copyright, and trademark information: http://www.fplc.edu
- Electronic Frontier Foundation: http://www.eff.org
- Copyright Clearance Center On-line: http.//www.copyright.com
- Fair Use: http://fairuse.stanford.edu

3. OTHER RESTRICTIONS ON USE: ARTISTS' RIGHTS AND CONTENT-RELATED RIGHTS[337]

a. Artists' Rights: *Droit Moral*—the Visual Artists Rights Act of 1990

For many years, the "moral right" or *droit moral* of visual artists was recognized and protected in many foreign countries,[338] but the concept struggled for acceptance in the United States. *Droit moral* assumes that every work of art carries with it the distinctive imprint of its creator; hence, the fate of the work and the reputation of the artist are inextricably bound.[339] This being assumed, it follows that the artist should have a right to prevent misuse

337. This section is the work of Ildiko Pogany DeAngelis, Assistant General Counsel of the Smithsonian Institution. Opinions expressed are those of the author and not of the Smithsonian.

338. For an international survey and comparison of moral rights statutes, see the final report of the Register of Copyrights, *Waiver of Moral Rights in Visual Artworks* 29 (March 1, 1996) (hereafter cited as *Waiver Report*). This publication (ISBN 0-16-048570-3) is available for sale from the U.S. Government Printing Office, Superintendent of Documents, Mail Stop: SSOP, Washington, D.C. 20402-9328.

339. By contrast, *droit de suite* acknowledges a property right in the artist to benefit for a certain period from the resale of his or her work, based on the theory that artists should share in the success of their creations. For a discussion of U.S. law on resale royalties for artists, see Section E(3)(b), below.

of his or her work even after ownership of the work may have passed to another. Except for a handful of state statutes that addressed aspects of moral rights, most notably statutes from California and New York,[340] U.S. law traditionally focused (mainly through copyright protection) on limited economic rights for artists. At least, this was the case until Congress passed the landmark Visual Artists Rights Act of 1990 (VARA), which took effect on June 1, 1991.[341] VARA, for the first time, provides federal protection for the moral rights of visual artists (see Figure IV.5 at the end of this section).[342] This new law, written as an amendment to federal copyright law, explicitly preempts the "equivalent rights" that may have been provided in the patchwork of earlier state statutes that addressed moral rights.[343]

340. Cal. Civ. Code § 987; N.Y. Arts & Cult. Af. Law §§ 14.01 *et seq.* For an analysis of state moral rights laws, see *Waiver Report,* 11–20. The *Waiver Report* classifies the ten existing state laws on moral rights into three general models: (1) the preservation model, which protects works from destruction, as well as protects rights of attribution and integrity; (2) the moral rights model, which protects rights of attribution and integrity; and (3) the public works model, which uses a state's police power to protect works from vandalism. *Waiver Report,* 11. The laws of California, Connecticut (Conn. Gen. Stat. Ann. §§ 42–116s to 42–116t [West 1995]), Massachusetts (Mass. Gen. Laws Ann. ch. 231 § 855 [West Supp. 1995]), and Pennsylvania (Pa. Stat. Ann. tit. 73 §§ 2101–10 [Purdon Supp. 1995]) are classified as preservation laws. Louisiana (La. Rev. Stat. Ann. §§ 51:2151–56 [Purdon West 1995]), Maine (Me. Rev. Stat. tit. 27, § 303 [West 1995]), New Jersey (N.J. Stat. Ann. §§ 2A:24A-1 to 2A:24A-8 [West 1995]), New York, and Rhode Island (R.I. Gen. Laws, §§ 5–62-2 to 5–62-6 [Michie 1994]) follow the moral rights model. New Mexico's law (N.M. Stat Ann. §§ 13–4B-2 to 13–4B-3 [Lexis, States Library, NMCODE file 1995]) follows the public works model. *Waiver Report,* 11–17.

341. The Visual Artists Rights Act (VARA), Pub. L. 101–650, 104 Stat. 5132, Dec. 1, 1990, codified in part at 17 U.S.C. §§ 106A *et seq.* For a discussion of VARA, see D. Nimmer, "The Visual Artists Rights Act of 1990," in American Law Institute–American Bar Association (ALI-ABA), *Course of Studies Materials: Legal Problems of Museum Administration* (Philadelphia: ALI-ABA, 1991), 149–90; C. Wilson, "The Moral and Economic Rights of Artists," in American Law Institute–American Bar Association (ALI-ABA), *Course of Studies Materials: Legal Problems of Museum Administration* (Philadelphia: ALI-ABA, 1992), 115–31; and B. Sirota, "The Visual Artists Rights Act: Federal versus State Moral Rights," 21 *Hofstra L. Rev.* 461 (1992).

342. Congress passed VARA to bring U.S. law into compliance with the protections for moral rights found in the international Berne Convention for the Protection of Literary and Artistic Works. Specifically, U.S. law was to be brought into conformity with the Paris Act of the Berne Convention adopted in 1971. See footnote 253, above. But see R. Kaufman, "The Berne Convention and American Protection of Artists' Moral Rights: Requirements, Limits, and Misconceptions," 15 *Colum.-VLA J.L. & Arts* 417 (1991), in which the author argues that through existing laws and doctrines of unfair competition, defamation, contract, and copyright, the United States had adequate protection for moral rights to meet the Berne Convention requirements and that, in fact, VARA's preemption of some of those protections may raise the issue of whether U.S. law is now in compliance.

343. 17 U.S.C. § 301(f)(1). The question remains whether any of the state statutes continue to have validity because VARA preempts any "equivalent rights" in state statutes. Answering this question is difficult because it involves examining whether the state right is the same as the right granted by the federal law. It is sufficient to note that these state statutes may continue to have validity for any work created and transferred by the artist before June 1, 1991 (the effective date of VARA), or any claims arising before the effective date. For example, for any work of visual art that was altered before June 1, 1991, its continued display after that date does not give rise to a claim under VARA. The sole remedy of the artist is under state law. *Pavia v. 1120 Avenue of the Americas Associates,* 901 F. Supp. 620 (S.D.N.Y. 1995) (holding that because a mutilated work was improperly displayed before the effective date of VARA, VARA does not preempt New York state moral rights claim). In addition, the state statutes may continue to have validity for works that do not fall into the narrow definition of "work of visual art" found in VARA, as well as for claims based on rights extending beyond the life of the artist. For a discussion of the preemption issues, see J. Zuber, "Do Artists Have Moral Rights?" 21 *J. Arts Mgmt. & L.* 284 (No. 4, winter 1992); *Waiver Report,* 17–20.

VARA's protections apply only to an object that qualifies as "a work of visual art." The definition is narrow, including only

- original paintings;
- drawings;
- prints that exist in single copies or in a signed and consecutively numbered edition of no more than 200 copies;
- sculptures that are carved or fabricated in multiple cast of 200 or fewer and that are consecutively numbered by the artist and bear the signature or other identifying mark of the artist; and
- still photographs produced for exhibition, provided these exist in signed single copies or in a signed and consecutively numbered edition of no more than 200 copies. Although photographs must be produced for exhibition, they will not lose their protection if they are used later for nonexhibition purposes.[344]

VARA applies to works of visual art created on or after June 1, 1991 (the effective date of VARA) and to works that may have been created before that date if title was not transferred by the creator to another as of June 1, 1991.[345] In addition, works-made-for-hire do not qualify under the act.[346]

Rights granted by VARA fall into two major categories: rights of attribution and rights of integrity.[347] Basically, the former addresses the association of the artist's name with the work; the latter concerns the artist's right to protect his or her vision of the work or to prevent destruction of the work.

Under the rights of attribution, the artist can claim authorship to a work (i.e., insist that his or her name be associated with the work) or can insist that his or her name not be used with a work that the artist did not create. The artist can also insist that his or her name no longer be used in association with a work that was distorted, mutilated, or otherwise modified in a way that is prejudicial to the artist's honor and reputation.[348]

344. 17 U.S.C. § 101: definition of "work of visual art." This definition specifically excludes a poster, map, globe, chart, technical drawing, diagram, model, applied art, motion picture or other audiovisual work, book, magazine, newspaper, periodical, database, electronic information service, electronic publication or similar publication, merchandising item, or advertising, promotional, descriptive, covering, or packaging material or container. For a discussion of nonexhibition uses of photographs created for exhibition purposes, see H.R. 101–514, 101st Cong., 2d sess. 11 (1990), cited by D. Nimmer, "The Visual Artists Rights Act of 1990," in American Law Institute–American Bar Association (ALI-ABA), *Course of Studies Materials: Legal Problems of Museum Administration* (Philadelphia: ALI-ABA, 1991), 24. Although VARA extends protection to certain signed multiples, it does not cover any reproduction or depiction of the work in print or other media. See 17 U.S.C. § 106A(c)(3).

345. 17 U.S.C. § 106A(d)(1)–(2).

346. 17 U.S.C. § 101. For a discussion of "work-made-for-hire," see Section E(2)(d), above.

347. 17 U.S.C. § 106A(a).

348. By law, museum labels accompanying an original work of visual art must conform to these rights of attribution. For example, if an artist claims that his or her work has been distorted, perhaps through grossly negligent conservation, the artist may direct the museum to cease identifying his or her name with that work in all exhibition signage. But the museum may continue to attribute the same work in a catalog containing a repro-

Rights of integrity give the artist the right to prevent *intentional* distortion, mutilation, or other modification of a work that would be prejudicial to the artist's honor or reputation. The rights allow the artist to seek damages if, in fact, such intentional alteration took place.[349] As for what constitutes actionable modification under VARA, two points must be borne in mind: (1) Modification that is a result of the passage of time or the inherent nature of the object is not actionable; and (2) modification that is caused by conservation or mode of exhibition, including lighting and placement, is not actionable unless gross negligence can be established.[350]

As distinct from alteration of a work, VARA also addresses the artist's rights regarding destruction of a work. Destruction must be viewed in two contexts: freestanding visual art and visual art incorporated into a building. For a freestanding object, under rights of integrity the artist can prevent *any* type of threatened destruction of a work of "recognized stature" and can sue for damages if the artist can establish that the work was destroyed intentionally or through gross negligence.[351] Destruction is just one of several possibilities, however, when the issue is removal of visual art incorporated into a building. A separate section of VARA addresses this topic and, in general terms, provides as follows:

- Only visual art installed in a building on or after June 1, 1991, falls under the purview of VARA.
- If the artist and the owner of the building sign a written agreement that the artist understands that the work he or she plans to install, or has installed, could be subject to destruction or damage due to removal, this constitutes a waiver of the artist's right under VARA.
- If there is no such waiver, the owner cannot remove the work without risking a VARA claim unless the owner takes a series of procedural steps designed to notify the artist of the planned removal.
- If the artist responds to the owner's notice in a timely manner, the artist may remove the work installed or pay for its removal.

duction of the "mutilated" work because VARA's rights of attribution and integrity apply only to originals, not to "any reproduction, depiction, portrayal, or other use" of the work in a book, magazine, or other media specifically listed as excluded from coverage. 17 U.S.C. § 106A(c)(3).

349. 17 U.S.C. § 106A(a)(3)(A).

350. 17 U.S.C. § 106A(c)(1)–(2).

351. 17 U.S.C. § 106A(a)(3)(B). Suppose a museum fails to follow an artist's instruction for assembly or disassembly of a work used for an exhibition. The museum may find itself the target of claims for intentional or grossly negligent destruction. In fact, such a case was brought against the Denver Art Museum in *Pfaff v. Denver Art Museum,* in which the artist claimed that the Denver Art Museum had dismantled her work without reference to her instructions and that, as a result, the work was "permanently and irreparably destroyed." Complaint at 2, *Pfaff v. Denver Art Museum* (94 Civ. 9271) cited in *Waiver Report,* 104. A museum is advised to adopt a policy that all handling instructions given by an artist are to be meticulously followed. Indeed, for particularly difficult installations, the museum should consider asking the artist to sign a waiver protecting the museum from a later claim under VARA. A sample general VARA waiver appears at the end of this section. (See Figure IV.7.)

- If the artist does not respond in a timely manner, or if the artist cannot be located by means of the described statutory procedure, the owner can proceed with the removal because the artist's rights are deemed to be waived.[352]

From a practical point of view, a museum contemplating the acquisition of visual art (as defined by VARA) that will be incorporated into its building (or a museum already having such art that was installed on or after the effective date of VARA) should seek legal advice concerning the merits of negotiating with the artist a written agreement that could constitute a waiver of the artist's rights regarding any later removal of the art.[353] An example of such a waiver appears at the end of this section (see Figure IV.6).[354]

Rights of attribution and integrity granted by VARA exist, as a general rule, for the life of the artist. The exception to the rule concerns works in existence before June 1, 1991, and not yet transferred by the artist to another as of that date. For this class of works, protection lasts for the life of the artist plus fifty years.[355] Rights of attribution and integrity may not be transferred, although as indicated already, an artist may waive these rights in writing.[356] Such a waiver must be signed by the artist and should refer to the specific work and to the

352. 17 U.S.C. § 113(d). Federal regulations implementing VARA's requirement to create a registry of addresses for artists whose works of visual art are incorporated into buildings appear in 37 C.F.R. § 201.25. What if the work is destroyed, distorted, or mutilated in the process of removal by an owner who has unsuccessfully attempted to notify an artist? By its terms, the notification provision applies only if the owner, in the first instance, believed that the work could be removed without causing any destruction, mutilation, or other modification of the work. Later, the artist may insist that the notice provision should never have been triggered, and consequently, his moral rights should not be deemed to be waived. A further problem is that the artist may have a completely different view on what constitutes destruction. An artist may argue (as the artists did in the *Carter v. Helmsley-Spear* case, discussed in the text below) that the work is an integral part of its setting and that removal from the setting (even if the work itself may be unharmed) caused its destruction. Without more court cases interpreting these terms, the owner must ultimately act at his or her peril if removal is done without a signed waiver from the artist.

353. 17 U.S.C. §§ 106A(e) and 113(d)(1)(B).

354. Although VARA specifically states that the "fair use" provision of the copyright laws applies, the usefulness of the doctrine to moral rights is difficult to foresee except in the parody context. See 17 U.S.C. § 107. The following scenario has been cited as an example of "fair use" of moral rights in original works of visual art. Assume that a modern-day Leonardo da Vinci creates a portrait of Mona Lisa in lithograph form of two hundred copies, then signs and numbers each. Then, suppose that a modern-day Marcel Duchamp buys one of the prints and paints a mustache on the print and exhibits it. Leonardo then may sue Duchamp for an infringement of his moral rights of integrity under VARA. A museum that exhibits the Duchamp piece could not attribute the underlying work to da Vinci in its label without risking a VARA claim of illegal attribution, to which "fair use" would be the museum's only defense. G. Yonover, "The Precarious Balance: Moral Rights, Parody, and Fair Use," 14 *Cardozo Arts & Ent. L. J.* 79 (1996); G. Yonover, "The 'Dissing' of Da Vinci: The Imaginary Case of *Leonardo v. Duchamp*—Moral Rights, Parody, and Fair Use," 29 *Val. U. L. Rev.* 935 (1995).

355. 17 U.S.C. § 106A(d)(2). This difference in duration is due to a late Senate amendment. The extension of moral rights past the life of the author may invite a court challenge in the future. Under VARA, "[o]nly the author of a work of visual art has the rights" of attribution and integrity; thus if these rights are indeed personal, it can be argued that they should not survive the death of the artist. 17 U.S.C. § 106A(b). Generally, rights that protect the reputation of an individual, such as those rights protected by the laws of defamation and rights to privacy, are held to be personal rights that do not survive the death of the individual. This issue, along with many others presented by VARA, will have to be addressed by the courts.

356. 17 U.S.C. §§ 106A(e), 113(d)(1)(B).

uses for which the rights are waived. An example of such a waiver appears at the end of this section (see Figure IV.7). For joint works, one artist may waive the moral rights for the other creators without their consent.[357]

It is important to remember that moral rights are separate from the work itself and from the copyrights to the work. In other words, the artist may have the moral rights to one of his or her works, but another person may own the work itself, and yet a third party may hold the copyrights to the work.

To enforce the rights granted by VARA, an artist may seek injunction relief or money damages.[358] Criminal penalties are not available for violations of the act.[359] However, a court may direct payment of attorneys' fees to the prevailing party and may award statutory damages even if the work in question was not registered with the copyright office, relief that is not available for traditional copyright claims.[360]

As of 1997, VARA is too new a statute to have the benefit of extensive court interpretation. The first major case brought under the act, however, immediately highlighted provisions that are bound to spawn many more controversies. The case, *Carter v. Helmsley-Spear, Inc.*,[361] involved three artists known as "Three-Js" or "J x 3." The artists were seeking to prevent the removal of their joint artwork installed in the lobby of a commercial building in Queens, New York.[362] On the trial level, the court granted a permanent injunction to the artists, preventing removal of their work from the building. On appeal, the higher court reversed the lower court on the finding that the Three-Js were employees of the defendant and thus their work was a work-made-for-hire and was not covered by VARA. This greatly weakens the precedential value of the lower court's opinion, but it is instructive to review the lower court's reasoning, since the court struggled with VARA language that is subject to multiple interpretations.

The first issue before the trial court was whether the work that filled the lobby of the building was a single work. Having found that the elements of the work were interrelated and thematically consistent, the court decided that the artists had made a strong showing that the piece was a single work entitled to protection as a whole. Next, the court addressed whether "intentional distortion, mutilation, or modification" of the work would be "preju-

357. 17 U.S.C. § 106A(e)(1); H.R. 101–514, 101st Cong., 2d sess., 7, 19 (1990), cited in D. Nimmer, "The Visual Artists Rights Act of 1990," in American Law Institute–American Bar Association (ALI-ABA), *Course of Studies Materials: Legal Problems of Museum Administration* (Philadelphia: ALI-ABA, 1991), 16 n. 160.

358. VARA provides injunctive relief to allow an artist to seek court protection before a threatened violation of VARA rights and/or to seek money damages after such violation occurs. 17 U.S.C. §§ 501(a), 502, 504.

359. 17 U.S.C. § 506(f).

360. A violation of the artist's moral rights is a copyright infringement, and the artist may recover actual or statutory damages. 17 U.S.C. § 504(a)–(c). In a case brought for injunctive relief, no actual or statutory damages may be due because no harm has been done yet. However, the court may in its discretion award the cost of attorney's fees to the prevailing party.

361. "Opinion & Order" in C94 Civ. 2922 (DNE) (S.D.N.Y dated Aug. 31, 1994), unpublished; "Opinion & Order" was later revised and published as a "Memorandum and Order" in 861 F. Supp. 303 (S.D.N.Y. 1994), *rev'd and vacated in part and aff'd in part*, 71 F. 3d 77 (2d Cir. 1995), *cert. denied*, 116 S. Ct. 1824 (1996).

362. The work at issue was described in press accounts as "recycled glass and discarded objects" such as "soda machines, two safes, bathroom fixtures, some sinks. There is a school bus along one wall." "Obiter Dicta: Sculpture Squabble" *A.B.A. J.* 42 (Nov. 1994).

dicial to the artists' honor or reputations." Finding no definitions in the text of the law, the court was forced to turn to the *Webster's Dictionary* to define "prejudicial," "honor," and "reputation." Relying on the expert testimony of a well-known New York art critic, the building owners argued that these artists were not recognized and that therefore they had no reputations to protect in the artistic community. In turn, the artists called their own experts, including a professor of art history, who disagreed and stated that the destruction of the works would be damaging to their reputations. Faced with the contradictory testimony, the court eventually chose to side with the artists' experts. The court then turned its attention to the VARA section that prevents destruction of works of "recognized stature." For this term, the court established a two-prong test: (1) The work must have stature, that is, must be "viewed as meritorious," and (2) the stature must be "'recognized' by art experts, or other members of the artistic community, or by some cross-section of society."[363] The court found that at the pretrial hearing, the artists' experts presented sufficient evidence that met this test (which, most agree, is less than exacting) to entitle them to injunctive relief. The owners were prohibited from removing the work from the lobby because "elements of the Work must be destroyed in order to be removed."[364] Although this case was eventually reversed and vacated on other grounds, the opinion demonstrates how courts struggle with applying what are in essence aesthetic criteria. In effect, the trial court's test for "recognized stature" would allow just about any work to find protection from intentional destruction under VARA. This, in turn, raises the question of whether VARA will continue to withstand future constitutional attacks for being vague and overbroad.

363. "Opinion & Order" in C94 Civ. 2922 (DNE) (S.D.N.Y dated Aug. 31, 1994), 39, unpublished.
364. Ibid., 50.

Figure IV.5
Visual Artists Rights Act (VARA)

	VISUAL ARTISTS RIGHTS
(Public Law 101–650, 104 Stat. 5128, December 1, 1990)	SEC. 601. SHORT TITLE. This title may be cited as the "Visual Artists Rights Act of 1990". SEC. 602. WORK OF VISUAL ART DEFINED. Section 101 of title 17, United States Code, is amended by inserting after the paragraph defining "widow" the following: "A 'work of visual art' is— "(1) a painting, drawing, print, or sculpture, existing in a single copy, in a limited edition of 200 copies or fewer that are signed and consecutively numbered by the author, or, in the case of a sculpture in multiple cast, carved, or fabricated sculptures of 200 or fewer that are consecutively numbered by the author and bear the signature or other identifying mark of the author; or

Figure IV.5 continued

"(2) a still photographic image produced for exhibition purposes only, existing in a single copy that is signed by the author, or in a limited edition of 200 copies or fewer that are signed and consecutively numbered by the author.

"A work of visual art does not include—

"(A)(i) any poster, map, globe, chart, technical drawing, diagram, model, applied art, motion picture or other audio-visual work, book, magazine, newspaper, periodical, data base, electronic information service, electronic publication, or similar publication;

"(ii) any merchandising item or advertising, promotional, descriptive, covering, or packaging material or container;

"(iii) any portion or part of any item described in clause (i) or (ii);

"(B) any work made for hire; or

"(C) any work not subject to copyright protection under this title".

SEC. 603. RIGHTS OF ATTRIBUTION AND INTEGRITY.

(a) RIGHTS OF ATTRIBUTION AND INTEGRITY.— Chapter 1 of title 17, United States Code, is amended by inserting after section 106, the following new section:

"§ 106A. Rights of Certain Authors to Attribution and Integrity

"(a) RIGHTS OF ATTRIBUTION AND INTEGRITY.— Subject to section 107 and independent of the exclusive rights provided in section 106, the author of a work of visual art—

"(1) shall have the right—

"(A) to claim authorship of that work, and

"(B) to prevent the use of his or her name as the author of any work of visual art which he or she did not create;

"(2) shall have the right to prevent the use of his or her name as the author of the work of visual art in the event of a distortion, mutilation, or other modification of the work which would be prejudicial to his or her honor or reputation; and

"(3) subject to the limitations set forth in section 113(d), shall have the right—

"(A) to prevent any intentional distortion, mutilation, or other modification of that work which would be prejudicial to his or her honor or reputation, and any intentional distortion, mutilation, or modification of that work is a violation of that right, and

"(B) to prevent any destruction of a work of recognized stature, and any intentional or grossly negligent destruction of that work is a violation of that right.

"(b) SCOPE AND EXERCISE OF RIGHTS.— Only the author of a work of visual art has the rights conferred by subsection (a) in that work whether or not the author is the copyright owner. The authors of a joint work of visual art are co-owners of the rights conferred by subsection (a) in that work.

"(c) EXCEPTIONS.— (1) The modification of a work of visual art which is

Continued on next page

Figure IV.5 continued

a result of the passage of time or the inherent nature of the materials is not a distortion, mutilation, or other modification described in subsection (a)(3)(A).

"(2) The modifications of a work of visual art which is the result of conservation, or of the public presentation, including lighting and placement of the work is not a destruction, distortion, mutilation, or other modification described in subsection (a)(3) unless the modification is caused by gross negligence.

"(3) The rights described in paragraphs (1) and (2) of subsection (a) shall not apply to any reproduction, depiction, portrayal, or other use of a work in, upon, or in any connection with any item described in subparagraph (A) or (B) of the definition of 'work of visual art' in section 101, and any such reproduction, depiction, portrayal, or other use of a work is not a destruction, distortion, mutilation or other modification described in paragraph (3) of subsection (a).

"(d) DURATION OF RIGHTS.— (1) With respect to works of visual art created on or after the effective date set forth in section 610(a) of the Visual Artists Rights Act of 1990, the rights conferred by subsection (a) shall endure for a term consisting of the life of the author.

"(2) With respect to works of visual art created before the effective date set forth in section 610(a) of the Visual Artists Rights Act of 1990, but title to which has not, as of such effective date, been transferred from the author, the rights conferred by subsection (a) shall be coextensive with, and shall expire at the same time as, the rights conferred by section 106.

"(3) In case of a joint work prepared by two or more authors, the rights conferred by subsection (a) shall endure for a term consisting of the life of the last surviving author.

"(4) All terms of the rights conferred by subsection (a) run to the end of the calendar year in which they would otherwise expire.

"(e) TRANSFER AND WAIVER.— (1) The rights conferred by subsection (a) may not be transferred, but those rights may be waived if the author expressly agrees to such waiver in a written instrument signed by the author. Such an instrument shall specifically identify the work, and uses of that work, to which the waiver applies, and the waiver shall apply only to the work and uses so identified. In the case of a joint work prepared by two or more authors, a waiver of rights under this paragraph made by one such author waivers such rights for all such authors.

"(2) Ownership of the rights conferred by subsection (a) with respect to a work of visual art is distinct from ownership of any copy of that work, or of a copyright or any exclusive right under a copyright in that work. Transfer of ownership of any copy of a work of visual art, or of a copyright or any exclusive right under a copyright, shall not constitute a waiver of the rights conferred by subsection (a). Except as may otherwise be agreed by the author in a written instrument signed by the author, a waiver of the rights conferred by subsection (a) with respect to a work of visual art shall not constitute a transfer of ownership of any copy of that work, or of ownership of a copyright or of any exclusive right under a copyright in that work."

Figure IV.5 continued

(b) CONFORMING AMENDMENT.— The table of sections at the beginning of chapter 1 of title 17, United States Code, is amended by inserting after the item relating to section 106 the following new item:

SEC. 604. REMOVAL OF WORKS OF VISUAL ART FROM BUILDINGS.

Section 113 of title 17, United States Code, is amended by adding at the end thereof the following:

"(d)(1) In a case in which—

"(A) a work of visual art has been incorporated in or made part of a building in such a way that removing the work from the building will cause the destruction, distortion, mutilation, or other modification of the work described in section 106A(a)(3), and

"(B) the author consented to the installation of the work in the building either before the effective date set forth in section 610(a) of the Visual Artists Rights Act of 1990, or in a written instrument executed on or after such effective date that is signed by the owner of the building and the author and that specifies that installation of the work may subject the work to destruction, distortion, mutilation, or other modification, by reason of its removal,

then the rights conferred by paragraphs (2) and (3) of section 106A(a) shall not apply.

"(2) If the owner of a building wishes to remove a work of visual art which is a part of such building and which can be removed from the building without the destruction, distortion, mutilation, or other modification of the work as described in section 106A(a)(3), the author's rights under paragraphs (2) and (3) of section 106A(a) shall apply unless—

"(A) the owner has made a diligent, good faith attempt without success to notify the author of the owner's intended action affecting the work of visual art, or

"(B) the owner did provide such notice in writing and the person so notified failed within 90 days after receiving such notice either to remove the work or to pay for its removal.

For purposes of subparagraph (A), an owner shall be presumed to have made a diligent, good faith attempt to send notice if the owner sent such notice by registered mail to the author at the most recent address of the author that was recorded with the Register of Copyrights pursuant to paragraph (3). If the work is removed at the expense of the author, title to that copy of the work shall be deemed to be in the author.

"(3) The Register of Copyrights shall establish a system of records whereby any author of a work of visual art that has been incorporated in or made part of a building, may record his or her identity and address with the Copyright Office. The Register shall also establish procedures under which any such author may update the information so recorded, and procedures under which owners of buildings may record with the Copyright Office evidence of their efforts to comply with this subsection".

Continued on next page

Figure IV.5 continued

SEC. 605. PREEMPTION.

Section 301 of title 17, United States Code, is amended by adding at the end the following:

"(f)(1) On or after the effective date set forth in section 610(a) of the Visual Artists Rights Act of 1990, all legal or equitable rights that are equivalent to any of the rights conferred by section 106A with respect to works of visual art to which the rights conferred by section 106A apply are governed exclusively by section 106A and section 113(d) and the provisions of this title relating to such sections. Thereafter, no person is entitled to any such right or equivalent right in any work of visual art under the common law or statutes of any State.

"(2) Nothing in paragraph (1) annuls or limits any rights or remedies under the common law or statutes of any State with respect to—

"(A) any cause of action from undertakings commenced before the effective date set forth in section 610(a) of the Visual Artists Rights Act of 1990;

"(B) activities violating legal or equitable rights that are not equivalent to any of the rights conferred by section 106A with respect to works of visual art; or

"(C) activities violating legal or equitable rights which extend beyond the life of the author."

SEC. 606. INFRINGEMENT ACTIONS.

(a) IN GENERAL.— Section 501(a) of title 17, United States Code, is amended—

(1) by inserting after "118" the following: "or of the author as provided in section 106A(a)"; and

(2) by striking out "copyright." and inserting in lieu thereof "copyright or right of the author, as the case may be. For purposes of this chapter (other than section 506), any reference to copyright shall be deemed to include the rights conferred by section 106A(a)."

(b) EXCLUSION OF CRIMINAL PENALTIES.— Section 506 of title 17, United States Code, is amended by adding at the end thereof the following:

"(f) RIGHTS OF ATTRIBUTION AND INTEGRITY.— Nothing in this section applies to infringement of the rights conferred by section 106A(a)."

(c) REGISTRATION NOT A PREREQUISITE TO SUIT AND CERTAIN REMEDIES.— (1) Section 411(a) of title 17, United States Code, is amended in the first sentence by inserting after "United States" the following: "and an action brought for a violation of the rights of the author under section 106A(a)".

(2) Section 412 of title 17, United States Code, is amended by inserting "an action brought for a violation of the rights of the author under section 106A(a) or" after "other than".

Figure IV.5 continued

SEC. 607. FAIR USE.

Section 107 of title 17, United States Code, is amended by striking out "section 106" and inserting in lieu thereof "sections 106 and 106A".

SEC. 608. STUDIES BY COPYRIGHT OFFICE.

(a) STUDY ON WAIVER OF RIGHTS PROVISION.—

(1) STUDY.— The Register of Copyrights shall conduct a study on the extent to which rights conferred by subsection (a) of section 106A of title 17, United States Code, have been waived under subsection (e)(1) of such section.

(2) REPORT TO CONGRESS.— Not later than 2 years after the date of the enactment of this Act, the Register of Copyrights shall submit to the Congress a report on the progress of the study conducted under paragraph (1). Not later than 5 years after the date of enactment, the Register of Copyrights shall submit to Congress a final report on the results of the study conducted under paragraph (1), and any recommendations that the Register may have as a result of the study.

(b) STUDY ON RESALE ROYALTIES.—

(1) NATURE OF STUDY.— The Register of Copyrights, in consultation with the Chair of the National Endowment for the Arts, shall conduct a study on the feasibility of implementing—

(A) a requirement that, after the first sale of a work of art, a royalty on any resale of the work, consisting of a percentage of the price, be paid to the author of the work; and

(B) other possible requirements that would achieve the objective of allowing an author of a work of art to share monetarily in the enhanced value of that work.

(2) GROUPS TO BE CONSULTED.— The study under paragraph (1) shall be conducted in consultation with other appropriate departments and agencies of the United States, foreign governments, and groups involved in the creation, exhibition, dissemination, and preservation of works of art, including artists, art dealers, collectors of fine art, and curators of art museums.

(3) REPORT TO CONGRESS.— Not later than 18 months after the date of the enactment of this Act, the Register of Copyrights shall submit to the Congress a report containing the results of the study conducted under this subsection.

SEC. 609. FIRST AMENDMENT APPLICATION.

This title does not authorize any governmental entity to take any action or enforce restrictions prohibited by the First Amendment to the United States Constitution.

SEC. 610. EFFECTIVE DATE.

(a) IN GENERAL.— Subject to subsection (b) and except as provided in subsection (c), this title and the amendments made by this title take effect 6 months after the date of enactment of this Act.

Continued on next page

Figure IV.5 continued

(b) APPLICABILITY.— The rights created by section 106A of title 17, United States Code, shall apply to—

(1) works created before the effective date set forth in subsection (a) but title to which has not, as of such effective date, been transferred from the author, and

(2) works created on or after such effective date, but shall not apply to any destruction, mutilation, or other modification (as described in section 106A(a)(3) of such title) of any work which occurred before such effective date.

(c) SECTION 608.— Section 608 shall take effect on the date of enactment of this Act.

Author's Note: The federal regulations implementing VARA's requirements to create a registry for artists whose works of visual art are incorporated into buildings appear in 37 C.F.R. § 201.25.

Figure IV.6

VARA Waiver for Removal of Visual Art Incorporated into a Building

VARA WAIVER FOR REMOVAL OF A WORK OF VISUAL ART INCORPORATED INTO A BUILDING

The Artist hereby consents to the installation of [name of work] ("the Work") in [XYZ] Museum's building located at [address]. The Artist further acknowledges that installation of the Work may subject the Work to possible destruction, distortion, mutilation, or other modification by reason of its removal. The Artist hereby agrees that the rights conferred on the Artist by paragraphs (2) and (3) of Section 106A(a) of Title 17 of the United States Code shall not apply to the removal of the Work, and the Artist hereby expressly waives such rights pursuant to Section 113(d)(i) of Title 17 and any other rights of the same nature granted in U.S. federal, state, or foreign laws.

Date: _____ _____

Signature of the Artist

Author's Note: Such language should be included in the agreement commissioning the artist to create a work that is to be incorporated into the museum's building, in addition to provisions regarding copyright ownership of the commissioned work.

Figure IV.7

General VARA Waiver

GENERAL VARA WAIVER FOR WORKS OF VISUAL ART

The Artist hereby acknowledges the rights of attribution and integrity conferred by Section 106A(a), paragraphs (2) and (3) of Title 17 of the U.S. Code, and any other rights of the same nature granted by U.S. federal, state, or foreign laws, and of his/her own free act hereby waives such rights with respect to the uses specified below by the [XYZ] Museum (or anyone duly authorized by the [XYZ] Museum) for the following work of visual art:

Name of work: _____

Specified uses: [Examples: exhibition, installation, conservation, and any other standard museum activities in which the attribution right and/or the integrity rights of the artist might be implicated.]

Date: _____ _____
 Signature of Artist

b. Artists' Rights: *Droit de Suite*

In the initial version of the bill introduced in Congress, VARA also included a resale royalty provision. Known abroad as *droit de suite,* this provision acknowledges a property right in the artist to benefit for a certain period of time from resale of his or her work. The concept has been embodied in statutory protections in numerous foreign countries, but it remains the subject of much debate in the United States. By far, the resale royalty provision in the VARA bill created the most controversy.[365] As a result, Congress dropped it from the version that ultimately became law but directed the register of copyrights (in consultation with the chair of the National Endowment for the Arts) to study the concept.[366] The VARA-mandated study was to determine the feasibility of implementing a system of resale royalties under U.S. federal law. The study resulted in a report, *DROIT DE SUITE: The Artist's Resale Royalty, a Report of the Register of Copyrights* (2 vols., December 1992, ISBN 0-16-038232-7), for sale by the U.S. Government Printing Office. Known as the "Resale Royalty Report," it concluded, "[T]he Copyright Office is not persuaded that sufficient economic and copyright policy implications exist to establish *Droit de Suite* in the United States." In reaching this

365. S. Weil, "Perspective: Resale Royalties—Boon or Boondoggle?" *ARTNews* 172 (May 1991).

366. See § 608 of VARA, duplicated at the end of Section E(3)(a). Congress may have been willing to drop this provision from VARA because, unlike *droit moral,* a recognition of rights of resale was not mandated by the Berne Convention (Paris text) in art. 14ter(2), which states that *droit de suite* is recognized "only if legislation in the country in which the author belongs so permits." This was the second piece of legislation before Congress on the concept of *droit de suite.* In 1978, a proposal was introduced into Congress to create a federal resale royalty, but when it became apparent that the art community was deeply divided on the merits of the legislation, the bill never reached a vote. H.R. 11403, 95th Cong., 2d sess. (introduced March 8, 1978), "The Visual Artists' Residual Rights Act of 1978," 137.

conclusion, the study weighed the potential economic incentives for artists in a resale roy-alty system against potential adverse effects on the art market due to less frequent ex-changes of art and fewer purchases of works by unknown artists, as well as the administra-tive and privacy burdens of tracking sales of visual artworks. As an alternative, the "Resale Royalty Report" suggested that Congress should consider granting broader public display rights or compulsory licensing fees for public display of works of art and stated, "Museums and public art galleries [should] pay a fee to display a work of art publicly."[367] Although *droit de suite* seems, as of 1997, to be a dead issue under federal law, one state, California, initiated state law protection in 1977.[368] Generally, under the California law (which applies to sales of works of fine art[369] in California), 5 percent of the sale price is withheld for the artist from any sale (other than from the artist himself or herself) or any resale (subject to certain exceptions).[370] The right survives only twenty years after the death of the artist. However, the continued viability of the California Resale Royalty Act has been questioned based on the preemption provisions of the federal copyright law effective as of 1978.[371] Moreover, studies show that in practice, California's Resale Royalty Act has generated very little mone-tary reward for artists and, in fact, has caused the state to be at a disadvantaged position in the U.S. art market.[372]

c. Content-Related Rights: Privacy, Publicity, First Amendment

In addition to copyright and possible artists' moral rights and *droit de suite* rights are other, somewhat similar issues that must be considered at the time of acquisition. For example, if the work includes an image of an individual, the subject depicted may have rights to privacy or publicity regarding his or her image. These rights are distinct from the copyright, but they may also affect whether the work may be publicly displayed, published, or otherwise distributed. Another example is a work that may be viewed as obscene or indecent. Here again, before acquisition, the museum should review potential problems surrounding public display, publication, or other methods of distribution.

Rights to Privacy. A patchwork of state laws defines an individual's right to privacy.[373] Be-cause these laws differ from state to state, each museum should check the law in the applica-

367. See a report of the Register of Copyrights: *Droit De Suite: The Artist's Resale Royalty* (Washington, D.C.: Government Printing Office, 1992), 150 (hereafter cited as *Resale Royalty Report*). This publication (ISBN 0-16-03832-7) is available from the U.S. Government Printing Office. See the discussion of compulsory licensing in footnote 295, above.

368. See California Resale Royalty Act (Cal. Civil Code § 986), as amended, and California's Art in Public Buildings Act (Cal. Gov't Code §§ 15813–15813.8).

369. "Fine art" is defined to mean an original painting, sculpture, or drawing or an original work of art in glass.

370. For example, the resale royalty provision does not apply to fine art selling for under $1,000 or to works sold for less than what the seller paid or to certain sales between and by art dealers. Cal. Civ. Code § 986 (b).

371. *Resale Royalty Report*, 77–86.

372. Ibid., 69–76.

373. This discussion concerns state privacy laws that have been developed in the branch of the law dealing with torts. In addition, the term *privacy* appears in many other legal contexts that are not considered here. For

ble jurisdiction. Generally, the protections for the rights to privacy fall within four catego-
ries: intrusion on seclusion; misappropriation of name or likeness; disclosure of intimate
private facts; and false light. Museum collections, especially photographic collections, pres-
ent possible liability situations regarding the last three categories.[374]

Invasion of privacy based on the misappropriation of someone's name or likeness should
present little concern for museums if some basic rules are followed. Museums that want to
use an image of an individual on museum merchandise, advertisements, or promotions
should not do so without a release signed by the subject.[375] Consent is a defense to claims
for invasion of privacy. With children, special care should be taken to ensure that a guardian
is aware of the museum's use of the child's image and has signed a release permitting such
use. Courts generally are more protective of the rights to privacy of children or those who
cannot make informed decisions for themselves.

The third type of invasion of privacy, disclosure of intimate private facts, may occur if
highly embarrassing facts about an individual are made known that are not of legitimate
concern to the public. In this regard, a public figure has less rights to privacy than a private
citizen because the public is deemed to have a legitimate broader interest in the public
figure. With collection objects, this type of invasion may arise if the subject of the work
appears unclothed or engaged in compromising activity that is not a matter of general
knowledge. For example, assume that a museum is offered a collage that includes photo-
graphs, taken decades ago, in a private setting, of students smoking what appears to be

example, federal and state laws deal with the kinds of information that may be maintained on individuals by
the government. (See Privacy Act, 5 U.S.C. § 552a, and Section C of Chapter XVI.) In addition, there are consti-
tutionally recognized privacy interests of individuals, such as those interests protecting against illegal searches
and seizures by governmental action. The privacy protected under state tort law is concerned with invasions of
privacy by people or private entities. The rights to privacy are judicially created and are rather recent. The
rights to privacy began with a famous *Harvard Law Review* article written by Samuel Warren and Louis Bran-
deis in 1890 in which the authors argued that the law should protect individuals from truthful but intrusive and
embarrassing disclosures by the press. S. Warren and L. Brandeis, "The Right to Privacy," 4 *Harv. L. Rev.* 193
(1890). The law of defamation, which protected only against the publication of false information, was argued to
be insufficient in the emerging age of "yellow journalism." By 1960, the rights to privacy were grouped by Pro-
fessor W. Prosser, a leading expert in the law of torts, into four categories based on his reading of relevant
court decisions throughout the country as of that time. In 1975, the rights to privacy were included in the *Re-
statement (Second) of Torts,* a publication often cited by courts because it restates legal principles extracted from
similarly decided cases from around the country.

374. The first, namely intrusion on seclusion, is not applicable in the museum collection context because it
involves a physical intrusion on the seclusion of someone, such as unauthorized entry on private property or
eavesdropping. See a discussion of the rights to privacy in N. Ward, "Photography: Art Form or Legal Forum,"
in American Law Institute–American Bar Association (ALI-ABA), *Course of Studies Materials: Legal Problems of Mu-
seum Administration* (Philadelphia: ALI-ABA, 1985), 75; for a comprehensive treatise on the law of rights to pri-
vacy and publicity, see J. McCarthy, *The Rights of Publicity and Privacy* (Deerfield, Ill.: Clark Boardman Callaghan,
1996).

375. The misappropriation branch of the rights to privacy protects against the hurt feelings or embarrass-
ment of the subject. See *Cohen v. Herbal Concepts, Inc.,* 100 A.D. 2d 175, 473 N.Y.S.2d 426 (1st Dep't 1984) (unau-
thorized use of a photograph of mother and child in defendant's advertisement). In contrast, the right of public-
ity, discussed below at Section E(3)(c), which grew out of the misappropriation branch of the rights to privacy,
protects the economic value of a person's identity.

marijuana. It would not be far-fetched for the museum to consider that some of these students may now be prominent members of society who would find revelations about their youthful activities highly embarrassing. If the work is displayed, reproduced, or otherwise distributed, anyone who is identifiable on that photograph may have a potential claim for invasion of privacy asserting that their involvement many years ago in this allegedly illegal activity is no longer of any legitimate concern to the public. Another example reported in the press involved nude "posture photos" of college students; these were taken as part of a scientific study and were then placed in a museum's archives. Cases of this nature are not frequent, and when they do arise, they usually involve photographic images taken under circumstances in which the subject was not on notice or could expect privacy. In contrast, if a photograph is taken of an individual in a public place, where his or her actions are open to public scrutiny, and no protest is made, there is considerably less chance of liability when the photograph is then exhibited or distributed. Generally, an individual should hold no expectation of privacy while in a public place.[376] Nevertheless, a museum is advised to seek a written release from a living subject of a photograph that it intends to exhibit, especially if the individual is readily identifiable and if the photograph could be viewed as embarrassing.[377]

The last potential invasion of privacy may arise if an individual is placed in a "false light" before the public. False light is similar to defamation in that something untrue is alleged or appears to be alleged about the subject and causes embarrassment or hurt feelings.[378] Consider this example. In a museum exhibition featuring works of local artists is a collage on the subject of rape. Unknown to the museum, photographs used by the artist in the collage came from a publication on the subject of battered women. Each woman depicted on the collage could argue that she was placed in a false light as having been a victim of rape.[379] This is a problem for the museum as well as the artist. The accepted rule is that anyone who makes the offending work public by publishing it, distributing it, or publicly displaying it can be held liable as well. If such a suit is brought, the museum would probably explore as a defense the argument that the offending image was of legitimate concern to the public under First Amendment principles because of either its historical or its aesthetic value.

376. By contrast, if a photograph was taken in a private home or in a place where privacy is expected, such as in a hospital room, invasion of rights to privacy will be found.

377. Courts seem to be convinced that photographic invasions of privacy are usually more painful than narrative ones, and even partial nudity is an aggravating factor. Although there are no reported cases involving museums, a considerable number involve photographic images. For example, damages were awarded in cases involving the following situations: photographs of a naked woman when the photographs were taken by her husband and then stolen by a neighbor and published in a magazine, *Wood v. Hustler Magazine, Inc.,* 736 F.2d. 1084 (5th Cir. 1984); before-and-after shots of a plastic surgery patient when the photographs were used by a doctor in a public lecture and on a television program, *Vassiliades v. Garfinckel's, Brooks Brothers,* 492 A.2d 580 (D.C. 1985); and a photograph, published in a magazine, of a woman whose skirt was lifted by the wind on exiting a funny house at a fair, *Daily Times Democrat v. Graham,* 276 Ala. 380, 162 So.2d. 474 (1964).

378. See the discussion of defamation in Chapter XIII, Section B(3).

379. See W. Grimes, "On Display in a Show at the Whitney: A Question of Ownership of Image," *New York Times,* Aug. 20, 1993, discussing the copyright issues involved with the unauthorized use of the images.

The last important point to remember is that the right to privacy generally dies with the individual. Heirs cannot sue for invasion of the deceased relative's right to privacy because rights to privacy are intended to protect the feelings of the person whose rights are invaded. By contrast, the right of publicity, discussed below, protects the economic value of someone's likeness or identity. The right of publicity, like any other property of value, may be inherited.

Right of Publicity. The legal right of publicity protects the economic interests that people, usually famous people, have in their name, likeness, voice, and other aspects of their identity.[380] The right protects any commercial exploitation of a persona without obtaining permission or paying compensation. The right of publicity is relatively new, dating from 1953,[381] and is recognized in only about half of the states. In addition, what is protected may vary considerably from state to state. For example, some states may require plaintiffs to show that they had economically exploited their fame before the offending use, thus, apparently, establishing the economic value of the image. Other states find that even private individuals have rights of publicity that require compensation for the use of their image for commercial purposes. The use of such a protected economic interest in a museum exhibition normally could not be actionable because the First Amendment protects such educational uses. However, the same may not be true for use on items produced for sale in museum shops. Although such products are generally regarded as educational, if the intended primary use is commercial in nature, most laws will require the museum to seek permission and perhaps pay a fee to the protected subject or the estate of the protected subject. Thus, if a museum is contemplating an essentially commercial venture that may infringe on a right of publicity, it should check the law regarding potential liability in all jurisdictions where the venture may be carried out.

First Amendment Rights. Another central question for museums is whether the First Amendment of the U.S. Constitution will protect the display of works that may be viewed as obscene by segments of the public. Most states have obscenity laws that are generally criminal statutes used against those who distribute pornography. In addition, federal laws make it a crime to transport or to sell obscene material in interstate commerce.[382] When these laws are invoked, the issue before the court is whether the contested expression satisfies the legal definition of "obscenity." The First Amendment does not offer absolute freedom for all types of expression.[383] Obscene expression is not protected, and the U.S. Su-

380. "Famous" people can include entertainers, sports stars, composers, and even Albert Einstein, whose image is actively licensed for compensation.

381. L. Grant, "Restricted Images: Who Owns Einstein? The Emerging Right of Publicity and the Conversion of Public Image to Private Property," in American Law Institute–American Bar Association (ALI-ABA), *Course of Studies Materials: Legal Problems of Museum Administration* (Philadelphia: ALI-ABA, 1990), 669; M. Levine and L. Grant, "Law: Copyrights of the Rich and Famous," *Museum News* 48 (Nov.–Dec. 1994).

382. For a brief review of federal and state obscenity laws, see B. Wolff, "Restricted Images: What Can Museums Exhibit? Nudity and the New Reach of the Law," in American Law Institute–American Bar Association (ALI-ABA), *Course of Studies Materials: Legal Problems of Museum Administration* (Philadelphia: ALI-ABA, 1990), 633–34.

383. *Miller v. California,* 413 U.S. 15, 23 (1973).

preme Court has adopted a three-prong test to determine obscenity. The test looks to (1) whether the average person, applying contemporary community standards, would find that the work, taken as a whole, appeals to prurient interests; (2) whether the work depicts or describes, in a potentially offensive way, sexual conduct specifically defined by the applicable state law; and (3) whether the work, taken as a whole, lacks serious literary, artistic, political, or scientific value. This test, called the Miller test after the name of the case in which it was established, was applied in a criminal obscenity case involving a traveling museum exhibition of Robert Mapplethorpe's photographs on display at the Contemporary Art Center in Cincinnati, Ohio. In this, the first case that attempted to prosecute an art museum under an obscenity statute, criminal indictments were brought against the museum director and the museum under Ohio law for possession and display of obscene material, including photographs of nude minors. Evidence of serious artistic value, under the third prong of the Miller test, was admitted by the defense through the testimonies of curators and educators. Press reports indicate that the failure of the prosecution to provide rebuttal evidence of a lack of artistic merit played a decisive role in the jury's decision to acquit the defendants.[384]

The Supreme Court, in *Miller*, specifically rejected a national standard of obscenity. Therefore, museums must look to standards in their communities for guidance. However, in this age of the Internet, the question presented may well be the following: Which community's standards will apply—New York's, Alabama's, or Oregon's? In 1996, Congress attempted to prohibit the transmission of "indecent" material on the Internet by passing the Communications Decency Act, the key portions of which were immediately declared unconstitutional.[385] The problem becomes more complex if children are involved. There is specific federal criminal law on the sexual exploitation of children.[386] Anyone who knowingly transports, ships, receives, or distributes a visual depiction of a child in "sexually explicit conduct," which is defined to include "lascivious exhibition of the genitals or pubic area," is subject to a fine of up to $100,000 and imprisonment of up to ten years.[387] Although the law does not contain a specific exception for legitimate scientific or artistic works, the Department of Justice assumed, in statements to a congressional committee, that such a

384. The indictment and supporting facts are described in the court's decision on pretrial motions reported in *Cincinnati v. Contemporary Arts Center*, 566 N.E.2d 207 (1990). See also J. Darraby, *Art, Artifact, and Architecture Law* (Deerfield: Clark Boardman Callaghan, 1995), Sec. 10.02(7)(f). For a discussion of the Miller test, see B. Wolff, "Restricted Images: What Can Museums Exhibit? Nudity and the New Reach of the Law," in American Law Institute–American Bar Association (ALI-ABA), *Course of Studies Materials: Legal Problems of Museum Administration* (Philadelphia: ALI-ABA, 1990), 628, citing *Miller v. California*, 24.

385. *Shea ex rel. American Reporter v. Reno*, 930 F. Supp. 916 (S.D.N.Y. 1996), *petition for cert. filed* (Oct. 15, 1996). The Communications Decency Act, Pub. L. 104–104, 110 Stat. 56, would have criminalized the transmission by computer of indecent material, although the law offered on-line service providers and transmission companies some "safe harbors" that protected them from liability. Soon after passing in 1996, the law was declared unconstitutional on First Amendment grounds in the *Shea* case, but many experts believe that Congress will seek to pass further legislation to regulate pornographic or obscene material on the Internet.

386. 18 U.S.C. §§ 2251, 2252, 2253.

387. N. Ward, "Can There Be a Constitutional Right for the Sexual Exploitation of Children?" in American Law Institute–American Bar Association (ALI-ABA), *Course of Studies Materials: Legal Problems of Museum Administration* (Philadelphia: ALI-ABA, 1990), 641–68.

defense existed based on the First Amendment.[388] However, with no defined exception in the statute, coverage "has functionally been made to depend so much on prosecutorial discretion."[389] The law in this area is very uncertain. A museum that exhibits material that could raise obscenity questions should have competent legal advice and should have a clear vision of its mission. Both are necessary if prudent decisions are to be made regarding activity that best serves that museum's public.

F. Acquisition Procedures

1. ROLE OF THE COLLECTION MANAGEMENT POLICY

A museum should have established procedures for processing proposed acquisitions. This aids in ensuring that important decisions are made in a timely manner and that the necessary documentation is acquired promptly and is placed on file. A museum's collection management policy can be an excellent vehicle for establishing such procedures, for delegating responsibilities for acquisition decisions, and for promulgating general acquisition guidelines.[390]

The initial work in most acquisitions usually falls on the curator or staff member most knowledgeable in the area represented by the object in question. Depending on the type of material, museum procedures should set forth the kind of justification that is needed to support the acquisition, as well as the level of internal review required before the object can be officially accepted or rejected. If the object is an insect specimen to be added to the extensive collection of a natural history museum, the justification required may appropriately be minimal, with no need for review beyond curatorial level. However, if the object is a valuable piece of art or an item requiring extensive conservation work, the level of justification and review would be expected to rise accordingly.

All important issues that must be addressed in any internal review process should be listed in the collection management policy. Some such issues are as follows: the relevance of the object to the collections; the ability and the intention of the museum to use and care for the object effectively;[391] provenance concerns; and if restrictions are imposed, whether

388. Comments of Mark M. Richard, Deputy Assistant Attorney General, Criminal Division, Department of Justice, before the Committee on the Judiciary, 1984 *U.S. Code Congressional and Administrative News* 492, 503–4, as cited in N. Ward, "Can There Be a Constitutional Right for the Sexual Exploitation of Children?" in American Law Institute–American Bar Association (ALI-ABA), *Course of Studies Materials: Legal Problems of Museum Administration* (Philadelphia: ALI-ABA, 1990), 653.

389. N. Ward, "Can There Be a Constitutional Right for the Sexual Exploitation of Children?" in American Law Institute–American Bar Association (ALI-ABA), *Course of Studies Materials: Legal Problems of Museum Administration* (Philadelphia: ALI-ABA, 1990), 661.

390. See Chapter III, "Collection Management Policies."

391. Museums are becoming more aware of the cost of caring for collection objects, with the realization that such costs can be a significant factor when making acquisition decisions. See Chapter VII, "Unclaimed Loans," footnote 22, for additional information. Also, the media used by the artist may raise questions about the advisability of acquisition. See, for example, P. Cannon-Brookes, "Impermanence: A Curator's Viewpoint,"

their acceptance is justifiable. If the acquisition is to be by purchase or exchange, instructions should be given as to when independent appraisals or outside consultations are to be sought. The decision-making process itself should be a matter of written record. Museum policy should establish who has the responsibility for seeing that all necessary documentation of title has been obtained and promptly recorded and who has the responsibility for maintaining such records.

If a museum collects archaeological material, its collection management policy should clearly address the importance of obtaining and maintaining not only the artifacts themselves but also complete "archaeological records" associated with the artifacts. These archaeological records "include, but are not limited to, survey forms, provenance catalogues, architectural drawings, cartographic records, photographs, inventories, and the like. They also include oral histories and related ethnographic materials, cultural resource management and preservation records, and lab reports (including computer software)."[392] Field archaeologists frequently overlook the importance of keeping artifacts and all associated records together. The museum that is looked to for curation of the artifacts can play a vital role in insisting on complete documentation as a condition for curation.[393]

2. DEEDS OF GIFT

When objects are donated to a museum for the collections, the routine use of a formal deed of gift is a wise measure. Such a deed of gift should be drafted so that it is clear that the gift is without restrictions or, if restrictions have been agreed to, that these are stated expressly on the deed. Also, the deed should contain language confirming the donor's belief that the donor owns the object and has the ability to pass title.[394] The deed form should require the signature of the donor and the date, and if the gift is restricted, the form should be countersigned by a museum official with the authority to approve restricted gifts.[395]

Lawyers sometimes tend to be overcautious when asked to prepare a deed of gift form. In the desire to ward off a host of possible problems, the form can grow to be long and complicated. The average donor may feel intimidated when presented with such a document or, in good conscience, may be reluctant to sign it for fear he or she cannot conclusively prove every representation. Common sense favors the use of a simple, straightforward form that is adequate for the museum's average transaction. If an offered gift raises

International Journal of Museum Management and Curatorship 283 (No. 3, Sept. 1983). See also H. Fox, "The Thorny Issues of Temporary Art," *Museum News* 42 (July–Aug. 1979), and J. Bethell, "Damaged Goods," *Harvard Magazine* 24 (July–Aug. 1988).

392. J. Fowler et al., "Wealth Concealed," 1 *Common Ground* 31 (No. 2, 1996), 32.

393. Note that for federally owned and administered archaeological collections, the curation standards that appear in 36 C.F.R. pt. 79 insist on the linkage of artifact with archaeological record. See also S. Silverman and N. Parezo, eds., *Preserving the Anthropological Record* (New York: Wenner-Gren Foundation for Anthropological Research, 1992).

394. As mentioned in Section D(1), "The Status of the Transferor," such a statement by the donor does not cure bad title, but it may help rebut a challenge to the museum's title many years hence.

395. Some states require that deeds of gift be notarized. A museum should check the law of the controlling state.

questions that are not covered in the museum's standard gift form or seeks deviation from standard museum policy, this is a situation that invariably needs high-level review. If there is a decision to go forward with the gift, the wording of a gift instrument can then be crafted to meet that particular situation.

Four examples of relatively simple deed of gift forms appear at the end of this chapter (see Figure IV.8). Before any form is adopted by a museum, however, the form should be carefully reviewed in light of the museum's needs and procedures, and every word should be understood by the museum staff involved in the acquisition process.[396]

Although a formal deed of gift is usually the easiest way to document an inter vivos (during life) gift, it is by no means the only way. Letters and other forms of communication between a donor and a museum may provide adequate evidence of a gift, but each such case must be evaluated individually. In other words, the mere fact that a deed of gift is not on record does not mean there was not a valid gift. It is not uncommon for a museum, especially one in the process of upgrading its documentation practices, to become concerned about its failure in the past to have formal deeds of gift. Museums in this situation frequently ask, "Should we go back to donors who are still living and get them to sign deeds of gift?" Here, common sense should be the guide. If the museum had a routine way of noting gifts (in other words, gifts were distinguished from loans), it may be more sensible to leave that system in place and note in the museum records that before such and such a date, this was the system of record.[397] Thereafter, the practice of using a deed of gift can begin. If, however, when reviewing earlier records, the museum finds only scattered instances in which known gifts lack clear documentation, it should consider "confirming" these gifts if the donors are still available. A gift "confirmation" is different from a deed of gift. A confirmation merely asks the donor to sign a statement verifying that X period of time ago he or she did in fact give an object (describe object) to the museum and that the gift was unrestricted, that all rights passed, etc. (refer to the museum's current deed of gift for language regarding representations made by the donor). If a deed of gift was used in this situation rather than a confirmation, the ownership of the object in the interim period is left in limbo, as is also the time when the charitable contribution took place for income tax purposes.

3. HIGH-RISK ACQUISITIONS

Museums that normally acquire objects of considerable value, especially objects that usually have long and sometimes clouded histories, have, as explained earlier in this chapter, come to recognize that extra cautions should be taken regarding these high-risk acquisitions. In such acquisitions, the museum wants to establish that commensurate with the importance

396. As a rule, legal counsel should review any contemplated museum form that concerns collection activity. Different approaches can be discussed and decisions made regarding what will best meet the needs of that particular organization.

397. If the museum has no evidence of whether an object was a gift or a loan, see Chapter X, "Objects Found in the Collections."

of the object involved, it has taken prudent steps to check the provenance of the object, that countries with a possible interest in the object are aware of the pending transfer, and if the acquisition is by purchase, that the vendor is reputable and ready to warrant his or her role in the transaction.

Regarding provenance, the museum will want to gather from the donor, seller, or in the case of a bequest, the estate as much information as it can on the history of the object. As appropriate, it will check art-loss registries and other established sources of information regarding theft. It will consult scholars and, if necessary, probable countries of origin regarding provenance and quality of title. If the object is acquired by purchase, the reputation of any dealer involved will be checked, and the museum should decide whether it will require a warranty from the vendor and, if so, the nature of the warranty. If the object is acquired, the museum will want to publicize the event widely and, as soon as practical, exhibit the object.

At the end of this chapter, two samples of seller's warranties are offered (see Figure IV.9). One merely states the enforceable representations made by the seller; the other, in addition to stating the enforceable representations, contains a commitment by the seller to reimburse the museum for legal fees growing out of any title challenges and a commitment to refund the sale price if the museum is forced to surrender the work to a party with better title. Also included at the end of this chapter is the Acquisition Policy for Classical Antiquities of the J. Paul Getty Museum, adopted in 1987 and revised in 1995 (see Figure IV.10). This is an example of the increasing sensitivity within the museum community to the problems of stolen or improperly exported cultural material.[398]

4. SPECIAL TAX CONSIDERATIONS

In addition to clarifying questions concerning the quality and completeness of title conveyed to a museum, accession procedures should also be structured so that important tax information is readily available. Two issues deserve specific mention: documentation concerning the completion of the gift for tax purposes, and documentation concerning the intended use of the gift.

Completion of the Gift. Museum records concerning inter vivos donations should note the date on which each gift is actually placed under the control of the museum, the date on which the deed of gift (or other appropriate written evidence of donative intent) is signed, and the date on which the gift is accepted by the museum. Questions can arise between the donor and the Internal Revenue Service concerning the year in which a charitable gift was made, and copies of museum records may be requested for evidence. In the eyes of the Internal Revenue Service, a gift to a charity is not eligible for a tax deduction until title has

398. Refer also to the earlier adopted acquisition policies of Harvard University and the Smithsonian Institution (Figures IV.1 and IV.2), published in Section D(6) of this chapter. Regarding the interpretation of the phrase "well-documented provenance," as used in the Getty policy, see R. Elia, "Getty Gets Fleischman Collection," *Archeology* (Sept.–Oct. 1996).

passed to the charity (usually evidenced by a deed of gift or other donative evidence and evidence that the museum accepted the gift) and the donor has relinquished control over the object. Thus, evidence that the museum had a deed of gift in hand on December 31 and has accepted the gift does not secure a tax deduction for the donor for that year unless the museum can also verify that the donor effectively relinquished control of the gift before the end of the year.[399] (And vice versa, if there is evidence that the gift was in hand on December 31, the museum can be asked to document that there was in fact a deed of gift and an acceptance in that year.) A museum should keep and, if necessary, disclose these records meticulously.[400] Also, a museum should go through existing records in about October of each year, looking for incomplete gift transactions. Donors can then be put on notice that if a tax deduction is to be sought for that year, immediate action is necessary to complete Internal Revenue Service requirements.

The insistence on "donor relinquishment of control" as a requisite for a tax deduction stems from earlier abuses when donors gave paper evidence of gifts to charitable organizations but delayed delivery indefinitely in order to have continued enjoyment of the objects in question. In effect, these "donors" had the benefit of a charitable deduction on their income tax with no concurrent benefit to the public. To prevent the continuance of such abuses, the Internal Revenue Code was amended so that a charitable contribution deduction is not permitted for a "future interest" in personal property. "The term 'future' interest includes situations in which a donor purports to give tangible personal property to a charitable organization, but has an understanding, arrangement, agreement, etc., whether written or oral, with the charitable organization which has the effect of reserving to, or retaining in, such donor a right to the use, possession, or enjoyment of the property."[401]

Exactly when possession of a gift passes depends on when it is established that the donor relinquished control. In other words, "donor relinquishment of control" is the key issue. To date, some general observations can be offered on this question. Ordinarily, the mailing of a check or an endorsed stock certificate is deemed relinquishment of control if the check or certificate clears in due course. Stock certificates forwarded through the donor's broker or the issuing corporation are not deemed "relinquished" until the stock is transferred on the

399. The tax laws do not permit a charitable contribution deduction for a "future interest" in personal property of this type. See the following discussion of "donor relinquishment of control."

400. The folly of backdating museum records to assist in tax fraud is illustrated by the experience of several California museums in 1982. According to affidavits filed by the IRS in Los Angeles federal court, museum personnel in several prestigious local museums collaborated with an art dealer to produce false museum documents to support tax-evasion schemes. The documents included backdated deeds of gift. In addition to receiving extremely poor publicity, the museum officials named in the affidavits exposed themselves to criminal charges for violating or conspiring to violate 26 U.S.C. § 7206(2) (providing or aiding in the providing of false statements, documents, etc.). A "future interest" differs from a fractional gift situation, in which the donor retains ownership rights proportional to the interest not yet donated to the charity. In the fractional gift situation, the donor can take a charitable contribution for the fractional interest that actually passes to the charity in a particular year. See Chapter XII, Section D.

401. IRS Regulation § 1.170A-5(a)(4).

books of the corporation.[402] For museums, "donor relinquishment of control" is usually evidenced by the physical transfer of the object to the museum (or the museum's agent) with "no strings attached." This relatively simple test has been further refined by the following IRS rulings.

In *Winokur v. Commissioner,* a donor gave a museum a partial interest in a collection of art (a fractional gift).[403] The museum had the right, therefore, to possess the collection for a certain period of the year that conformed to its fractional interest. The question posed was this: If the museum failed to take possession of the collection for the time allotted to it in a year, did this nullify the donor's right to declare a fractional gift for the year? The court held that the right to current possession was real (i.e., the museum could have demanded possession), and this was all that was required to validate the fractional gift. In other words, the donor had in fact relinquished control over that fraction of the art collection. In another situation, "IRS Private Letter Ruling 9218067,"[404] donors planned to execute a deed of gift transferring art objects to a museum that was then under construction. The museum was not expected to open for a year after the deed of gift was signed. It was anticipated that the donors would retain and display the art objects in their home until the museum opened. The question for the Internal Revenue Service was whether this arrangement invalidated a tax-deductible gift for the donors for the year in which they signed the deed of gift. The ruling of the Internal Revenue Service was that the understanding and expectation of the parties did not result in "a tacit reservation by the donors of a present right of possession." Accordingly, the donors in this situation would, on the execution of the deed of gift, "relinquish control," and the contribution of the art objects would qualify as a charitable contribution.

Even though the Internal Revenue Service has demonstrated a willingness to be somewhat flexible in interpreting "donor relinquishment of control," museums evaluating similar situations should remember why this requirement was first inserted into the IRS Code. Museums should also remember this provision of the tax code, and its interpretation, when a donor requests to borrow back an object that has been donated.[405]

Intended Use of the Gift. As explained in Section A on the meaning of the word *accession,* and in Chapter XII, Section C, the Internal Revenue Code draws a distinction between gifts donated to a charity for the organization's "related use" and those donated for an unrelated use. The former affords a donor more favorable tax advantages. A museum's acquisition procedures, therefore, should recognize this distinction. For example, raising money through the sale of objects is not considered a related use for a museum. Thus, if an object is being accepted by a museum so that it can be sold, the proposed use should be a matter of record and should be understood by the donor. The acknowledgment to the donor

402. IRS Regulation § 1.170A-1(b).

403. 90 T.C. 733 (1988). See Chapter XII, Section D, for discussion of fractional gifts.

404. Dated May 1, 1992.

405. See Chapter VI, Section B(1), for more discussion.

should be worded accordingly. Also, as previously explained, such an object is not "accessioned." The museum's goal should be to avoid even the appearance of collusion to circumvent tax code requirements.[406]

406. Occasionally mentioned is a "three-year rule": after objects are held in the collections for three years, it is then "safe" to dispose of them. The origin of the rule is uncertain, but it may stem from the standard three-year time period (beyond the date of filing) within which the IRS can question the validity of a tax return. The use of the rule is not recommended. Under IRS Regulations § 1.170A-4(b)(3)(ii), a gift of tangible personal property to a charitable organization may be treated as put to a related use if (1) the taxpayer establishes that the property is not in fact put to an unrelated use by the donee; or (2) at the time of the contribution or at the time the contribution is treated as being made, it is reasonable for the donor to anticipate that the property will not be put to an unrelated use by the donee. If a museum (as a donee) creates a situation where alternative (2) appears to be reasonable to donors but then establishes a pattern of holding such material for a set period of time before disposing of it, the museum's true motivation becomes apparent. It is by far more prudent to observe the spirit as well as the letter of the law. Section 155 of the Tax Reform Act of 1984 contains a provision that could adversely affect the museum that is not careful in its acquisition policies. Under this provision, if a museum disposes of certain donated property (property requiring a "qualified appraisal" when donated) within two years of receipt, the disposal must be reported to the IRS and the donor. As a rule of thumb, if a museum accepts an object for its collections, only after making a good-faith judgment that it intends to keep the object indefinitely, and in addition, if the museum has a prudent deaccession policy, it should have no cause to fear IRS scrutiny.

Figure IV.8

Deed of Gift Samples

SAMPLE 1: DEED OF GIFT (DEVELOPED BY AN ART MUSEUM)

XYZ MUSEUM DEED OF GIFT

Please complete this deed of gift and return this form to _____
_____. Upon acceptance of your gift by the Trustees, a copy certifying the fact will be returned to you.

I/We, _____ hereby give to the Trustees of the XYZ Museum absolute and unconditional ownership of the following, together with all copyright (in all media by any means or method now known or hereafter invented) and associated rights which I/we have:

(ARTIST) (WORK) (MEDIUM)

I/We wish that the gift be identified to the public and in the records of the Museum as:

Gift of _____

Continued on next page

Figure IV.8 continued

To the best of my/our belief, the subject of this gift is free and clear of all encumbrances and restrictions and since _____ has not been imported or exported into or from any country contrary to its laws.

Date: _____ Signature of Donor: _____

Date: _____ Signature of Donor: _____

Address of Donor: _____

Telephone No.: _____

.

Delivery: Works of Art offered to the Trustees should be physically present in the Museum for consideration at their next meeting. Please write or call _____ to obtain information on the dates of scheduled meetings of the Trustees and to make arrangements for transportation and insurance of your gift.

Provenance: For many reasons it is important that the Museum have as complete as possible a history of the subject of a gift. To that end, it will be helpful if you will forward any information or documentation which you may have with respect to your ownership, display and restoration, and all prior ownership, display and restoration, of the subject of your gift.

Valuation: The Museum may accept your valuation of your gift for insurance purposes but may not determine value for any purpose.

I certify that a deed of gift and the subject thereof were physically present in the XYZ Museum prior to the meeting of the Trustees of the Museum on _____ at which meeting the Trustees accepted the gift as described above.

(signed by the director of the museum)

SAMPLE 2: DEED OF GIFT (DEVELOPED BY A HISTORY MUSEUM)

DEED OF GIFT TO THE _____ MUSEUM

By these presents I(we) irrevocably and unconditionally give, transfer, and assign to the _____ Museum by way of gift, all right, title, and interests (including all copyright, trademark, related interests* in all media by any means or method now known or hereafter invented), in, to, and associated with the object(s) described below. I(we) affirm that I(we) own said object(s) and that to the best of my(our) knowledge I(we) have good and complete right, title, and interests (including all transferred copyright, trademark and related interests) to give.

Figure IV.8 continued

1. Dated _____ _____
 (month)(day)(year) (signature of donor)

2. Dated _____ _____
 (month)(day)(year) (signature of donor)

The _____ Museum hereby acknowledges receipt of the above
Deed of Gift.

Dated _____ _____
 (month)(day)(year) (signature of curator)

*If less than all copyright, trademark, and related interest are given, specify above.

Author's Note: Notice that on this form the museum is acknowledging receipt of the deed of gift, not of the gift itself. A separate record is maintained for the date of actual receipt of the gift.

SAMPLE 3: DEED OF GIFT (FOR THE TRANSFER OF A VARIETY OF TYPES OF OBJECTS, ASKING FOR A NONEXCLUSIVE LICENSE, NOT FULL COPYRIGHT)

DEED OF GIFT TO THE _____ MUSEUM

By these presents I(we) hereby irrevocably and unconditionally give, transfer and assign to the _____ Museum by way of gift, all right and title (including the nonexclusive license described below), in, to and associated with the object(s) described below. I(we) affirm that I(we) own said object(s) and that to the best of my(our) knowledge I(we) have good and complete right and title (including the right to convey said nonexclusive license) to give.

I(we) give permission to use said object(s) and/or photograph(s) or other reproductions of it(them) for all standard museum purposes including, but not limited to, exhibition, publicity, outgoing loans and educational endeavors in all media by any means or method now known or hereafter invented.

Description:

1. Dated _____ _____
 (month)(day)(year) (signature of donor)

2. Dated _____ _____
 (month)(day)(year) (signature of donor)

The _____ Museum hereby acknowledges receipt of the above
Deed of Gift.

Dated _____ _____
 (month)(day)(year) (signature of curator)

Attachments _____

Author's Note: Notice that on this form the museum is acknowledging receipt of the deed of gift, not of the gift itself. A separate record is maintained for the date of actual receipt of the gift. See also Section E(2), "Copyright Considerations."

Continued on next page

Figure IV.8 continued

NONEXCLUSIVE LICENSE

I, _____, being the (owner) (holder) of all in the following work(s) of art:

in consideration of the acquisition of the work(s) by the _____ Museum, do hereby authorize the _____ Museum, and other parties duly authorized by the _____ Museum, to use the work(s) for all standard museum purposes including, but not limited to, displaying work(s), lending the work(s), reproducing or preparing derivatives of the work(s), and displaying, distributing, selling, and transmitting such reproductions or images to the general public. Such reproductions and transmissions may be distributed through media such as catalogues, books, brochures, postcards, posters, invitations, magazines, newspapers, journals, films, television, slides, negatives, prints and electronic media, computerized retrieval systems, and by all means or methods now known or hereafter invented in connection with standard museum activities. All reproductions shall bear a copyright notice, as prescribed by the Copyright Law of the United States, which shall read as follows (please complete blanks):

© Date: _____

Name: _____

The effective date of this nonexclusive irrevocable and royalty-free license shall coincide with the date ownership of the work(s) of art itself (themselves) is acquired by the _____ Museum. This nonexclusive license, which does not transfer ownership of the copyright to the _____ Museum, shall survive all assignments of copyright.

Date: _____

Signature of Copyright Holder: _____

Typed or Printed Name of Above: _____

Author's Note: A separate deed of gift is used for the object itself. See also Section E(2), "Copyright Considerations."

Figure IV.9

Seller's Warranty Samples

<div style="border:1px solid">

Seller's Warranty

I hereby warrant that the work(s) of art described hereon and sold to the _____
Museum is(are) free of all liens and encumbrances, that *(use clause a. or b. as appropriate)*
a. I am the authorized agent of the owner, who is

_____,

b. I am the actual owner of said work(s) of art,
and am competent to make said sale; and that, in so doing, I hereby transfer to the said
Museum legal title to said work(s) of art and all other property rights or interests therein of
whatever kind and wheresoever situation including, without limiting the generality of the
foregoing, the copyright and all associated rights belonging to the owner.

I further warrant that said work(s) of art has(have) not been exported from nor imported
into any country contrary to the laws thereof or to the provisions of the UNESCO convention
on the means of prohibiting and preventing the illicit import, export, and transfer of ownership
of cultural property.

Description:

Agreed to by: _____ (seller)

Address: _____

Date: _____

</div>

<div style="border:1px solid">

Seller's Warranty and Indemnification

I hereby affirm that the work of art described as follows:

and in the attached bill of sale dated _____ is being sold by me to the _____
Museum ("the Museum"). I warrant that such work of art is authentic and of the period
indicated above and on the bill of sale. I further warrant that such work of art is free and clear
of all liens, claims and encumbrances, that its exportation from any foreign country has been
in conformity with the laws of such country, that its importation to the United States has been
or will be in conformity with the laws of the United States, that I have the right and title to sell
such work of art and that in so doing I hereby transfer to the Museum full legal and equitable
title to such work of art. I understand that these warranties shall survive the sale
contemplated hereby.

Continued on next page

</div>

Figure IV.9 continued

I agree to indemnify the Museum for any legal fees incurred by it which arise, result from or relate to any breach of the above warranties or a good faith challenge of the Museum's title to all or any part of said work of art or its right to the free use and enjoyment of said work.

I further agree that the Museum shall be entitled to receive a full refund for the work of art in the event of any breach of the above warranties which results in the surrender of said work of art by the Museum.

Agreed by: _____
(seller)

Address: _____

Date: _____

Figure IV.10

J. Paul Getty Museum Acquisition Policy

J. Paul Getty Museum "Acquisition Policy
for Classical Antiquities"
Adopted by the Board of Trustees, November 13, 1987
Revised November 10, 1995

It is the policy of the J. Paul Getty Museum to acquire Classical antiquities of great artistic merit that become available in the United States and abroad, provided that these acquisitions are made in accordance with the 1970 UNESCO Convention Agreement and with certain procedures enumerated here.

1. **Vendors of substance.** All transactions shall be conducted only with vendors of substance and established reputation in order that such transactions shall be covered by enforceable warranties.

2. **Documented provenance.** Proposed acquisitions must come from established, well-documented (i.e., published) collections. Publication must precede the date of adoption of these revisions, November, 1995. The only category of material that may be excluded from this requirement are fragments of ancient vases that join vases in the Museum's collection.

3. **Warranties.** The standard Museum warranties apply to any Antiquities acquisition.

4. **Exhibition and publication.** New acquisitions will be placed on exhibition as soon as they can be safely installed; an illustrated entry for the object will be included in the next Acquisitions Supplement to the *J. Paul Getty Museum Journal*.

5. **Claims.** In the case of acquisitions made after adoption of this Policy:

Figure IV.10 continued

a) If the Museum becomes aware of a patrimony claim by a foreign government which claim would be valid but for the bar of the statute of limitations or the three-year exemption period in Section 312 of the 1970 UNESCO Convention, the Museum normally will offer to return the object to the aggrieved country upon payment of just compensation.

b) If the Museum becomes aware of a patrimony claim by a foreign government before the expiration of the statute of limitations at the Museum's option, the vendor will be required by warranty to defend the claim at the vendor's expense. Should the vendor be unable or unwilling to do so, the Museum will consider the validity of the claim and will determine accordingly whether to contest the claim or surrender the object.

c) If the vendor defends such a claim which ultimately is adjudged valid, the vendor will be required by the sales agreement to be responsible for all damages, costs and expenses imposed by judgment upon the Museum; if the object is ordered to be returned to the aggrieved country by the judgment, the vendor in addition shall refund to the Museum the purchase price thereof, interest thereon, and all expenses borne by the Museum in connection with the transaction.

Author's Note: Printed with permission.

The Disposal of Objects

Deaccessioning

A. The Practice of Deaccessioning

The word *deaccession* is now beginning to appear in dictionaries, and this can be viewed as a sign of progress. Little more than a decade ago there were many who did not accept the practice of deaccessioning. They viewed museums essentially as mausoleums dedicated to preserving, intact, the accumulations of successive generations. Collecting, however, is not a mechanical process. It is a combination of intelligent selection and thoughtful pruning. Periodic reevaluation is as important as acquisition, and deaccessioning, if properly used, can be a means toward true growth.[1]

1. "A . . . museum, if it is to serve the cultural and educational needs of the community, cannot remain static. It must keep abreast of the advances of the times, like every other institution whose purpose is to edu-

Deaccessioning, for the purposes of this text, is the process used to remove permanently an object from a museum's collection or to document the reasons for an involuntary removal (one required by law or due to circumstances not controlled by the museum). The definition presupposes that the object in question was once *accessioned,* that it was formally accepted and recorded as an object worthy of collection status. Even if an object was inadvertently accessioned (years ago some museums accessioned everything on the premises), a deaccession process should be followed in order to document why that object is being removed from the accession records. Transfers from permanent collections to study or "school" collections should be considered deaccessions, with full documentation made. Also, involuntary removals should be treated as deaccessions so that records are complete. Broadly defining *deaccession* ensures that the museum will carefully consider and fully record all actions that remove objects from official accession records.

The practice of deaccessioning is not new, but increasingly, more is heard about it. What makes the topic so newsworthy? In part, this awareness may be the price of success. With increased public use of museums generally, there is a growing interest in every facet of museum operations, and quite understandably, people tend to take a more proprietary view of collection objects. The removal of an object from a collection can cause more apprehension than an acquisition. Any decision to deaccession, therefore, is a potential subject of public concern.

Coupled with this increased public interest is a growing need on the part of many museums to consider deaccessioning. Several reasons can be given.

Museums Are Becoming More Selective. They recognize a responsibility to prune collections in order to adhere to defined goals. Many museums grew unchecked in their early days. Areas of interest were broad, or perhaps more accurately, areas of interest were undefined, and almost anything offered was accepted. With the growing professionalism among museum personnel, most now acknowledge that there must be some order and purpose in collecting. Frequently, this cannot be achieved without a judicious weeding of existing holdings.

The Costs of Storage and Conservation May No Longer Permit the Retention of Excess Objects. Few museums have excess storage space, and acquiring additional space is a major investment. Storage does not mean just space; the area should be secure, should have proper atmospheric controls, and should be designed for efficient access to material. All of this costs money.[2] In addition, a greater awareness of conservation needs has led to an acknowledged

cate and enlighten the community." *Wilstach Estate,* 1 D&C 2d 197, 207 (Penn. 1954). For articles written for international audiences, see S. Weil, "Deaccession Practices in American Museums" and "Deaccessioning Modern and Contemporary Art," *Rethinking the Museum* (Washington, D.C.: Smithsonian Institution Press, 1990); M. Malaro, "Deaccessioning: The American Perspective," 10 *Museum Management and Curatorship* 273 (No. 3, Sept. 1991). For information on deaccession practices in zoological parks and aquariums, see K. Vehrs, "Disposition of Wild Animals from Zoological Parks and Aquariums," in American Law Institute–American Bar Association (ALI-ABA), *Course of Studies Materials: Legal Problems of Museum Administration* (Philadelphia: ALI-ABA, 1993). For an article regarding the deaccessioning of archaeological collections, see R. Sonderman, "Primal Fear: Deaccessioning Collections," 1 *Common Ground* (National Park Service, Washington, D.C.) (No. 2, summer 1996).

2. See Chapter VII, "Unclaimed Loans," footnote 22, for additional information on the cost of caring for a collection object.

obligation to use reasonable efforts to maintain the stability of museum objects by practicing preventive conservation techniques and, as appropriate, by providing conservation treatment. All of this can be very costly.[3] These practical considerations may make it difficult for a museum to justify the retention of surplus objects.[4]

Growth May Be Possible Only through Exchange. As resources become limited (a common contemporary problem), priorities must be established. A museum may decide that it can best serve its purpose by focusing attention on its central collections, even if this means sacrificing auxiliary holdings. The deaccessioning and exchange of secondary holdings in order to acquire additions for core collections may present the only viable means for growth for a museum on a strict budget. Similarly, a decision to sacrifice lesser pieces in the core collections in order to substitute particularly choice objects could be justified by the facts of a particular situation.

The Mission of the Museum May Require Change. Museums whose missions are to focus on aspects of contemporary art or culture have a mandate to adjust to changing times. Their chief purpose is to communicate the present, not to maintain objects indefinitely. Such museums, if they are true to their purposes, need to have policies that ensure that their collections change to reflect what is truly contemporary. Museums devoted to a wide variety of objects can fall into this category: art museums, children's museums, and technology museums, for example.

Financial Difficulties May Force Consolidation. Financial distress in a museum can certainly raise the issue of deaccessioning. This can be the most troublesome reason because deaccessioning is then being viewed not as a way to enhance collections but as a source of funds for capital improvements or operating expenses. The sale of a few collection objects is indeed a temptingly efficient way to solve a financial emergency. But this is all the more reason to exercise extreme caution because such a solution allows the museum to dispose of part of its very purpose for being. For the thoughtful person, deaccessioning for a goal other than to improve collections raises not just legal questions but serious ethical questions. More is said about this in Section B(2)(f), "Use of Proceeds Derived from Deaccessions."

Deaccessioning can legitimately be viewed quite differently from discipline to discipline and from collection to collection. For example, within an art museum, the art historian may argue for the retention of a fake, whereas more curatorial-oriented colleagues press for its disposal. The ethnologist may find value in any object, regardless of its condition, for the bit of information it might add about a culture. In the local historical society, the third example of a weskit may be considered surplus; to the botanist in the natural history museum next door, the one hundredth example of a grass may be viewed as hardly adequate. Because of the variables that arise, there can be considerable tension within the profession itself on the subject of deaccessioning if standard procedures are thought to apply to all

3. See Chapter XIV, "Care of Collections," Section D, "Conservation."

4. See *Johnson Trust,* 51 Pa. D&C 2d 147 (1970), wherein the court approved the deaccession of certain objects from the John G. Johnson Collection because they were not deemed of sufficient quality to warrant museum storage expense.

collection objects or specimens. On the contrary, there are few constants. Deaccessioning is essentially an acknowledgment that museums cannot collect everything and that, therefore, those charged with the administration of a museum must establish procedures for periodically reviewing and, if necessary, culling collections. Those procedures should be geared to the peculiarities of a collection, should permit the expression of a range of views, should clearly place responsibility for final decision making, and should require the maintenance of complete records of actions taken. The remarks contained in this chapter should be considered accordingly.

B. The Process

1. LEGALITY OF DEACCESSIONING

The general authority of a museum to deaccession can be questioned even though there is no specific prohibition in the museum's charter limiting such activity. Without doubt, such a challenge reflects a natural cautiousness against disturbing the status quo. Courts, however, appear to be reluctant to inhibit the discretion of trustees in this area, regardless of whether the museum is a charitable trust or a charitable corporation.[5] For example, in *Wilstach Estate*,[6] a case involving a charitable trust, Mrs. Wilstach gave a collection of art to the city of Philadelphia. The collection was "to be preserved . . . and taken care of and kept in good order, as the nucleus or foundation of an Art Gallery for the use and enjoyment of the people. The collection [was] to be kept together, and known and designated by the name of 'the W. P. Wilstach Collection.'"[7]

Years later, the trustees of the collection sought court advice as to whether they had the authority to dispose of certain works from the original collection as well as some works acquired later. In deciding the question, the court quoted the *Restatement of the Law of Trusts:* "The trustee of a charitable trust can properly exercise such powers . . . as . . . are necessary or appropriate to carry out the purposes of the trust and are not forbidden by the terms of the trust."[8] In interpreting the "terms of the trust," in this case Wilstach's will, the court concluded that her primary purpose was to furnish the people of Philadelphia with a public art gallery; reading her will as a whole, the court decided there was evidence that she had contemplated changes in the collection. Deaccessioning was found to be a "necessary or appropriate" power for those charged with the operation of a public art gallery, and hence,

5. If a museum was established under the terms of someone's trust instrument, it would normally be a charitable trust. If the museum was incorporated under the not-for-profit incorporation laws of the state, it would normally be classified as a charitable corporation. A third category of museums, those that are part of government, must look to their particular statutory authority to determine whether they have the power to deaccession. On the federal level, on Sept. 12, 1990, a proposed deaccession regulation that was published in the *Federal Register* was to apply to federally owned and administered archaeological collections. As of mid-1997, no further action has been taken on the proposal.

6. 1 D&C 2d 197 (Penn. 1954).

7. Ibid., 201.

8. *Restatement (Second) of Trusts* § 380.

the court concluded that the trustees had the authority to buy and sell paintings at their discretion.[9]

In *Rowan v. Pasadena Art Museum,*[10] a case involving a charitable corporation, the plaintiffs challenged the power of the trustees to change the focus of the museum collections by deaccessioning various pieces of contemporary art in order to acquire more traditional works. They argued that although the charter of the museum did not limit the focus of the museum, past practice had permanently set the direction of the museum. The court rejected this argument about past practice and affirmed the power of the board, as the governing authority of the charitable corporation, to change the makeup of the collection.[11]

2. PROCEDURE FOR DEACCESSIONING

Museums contemplating deaccession should keep one thought in the forefront: A museum exists to serve its public, and to be truly effective, it must maintain the confidence of these beneficiaries. A decision to deaccession, therefore, should be weighed not just in light of what the museum perceives to be best for the people but also in light of what the people may perceive to be their best interests. In the eyes of experts, a decision to sell a particular work may be well-justified, but if the public feels otherwise, or is unsure, caution should be exercised. This is not to say that every proposed deaccession should be submitted to public

9. *Frick Collection v. Goldstein,* 83 N.Y.S.2d 142 (1948), *aff'd,* 86 N.Y.S.2d 464 (1949), questioned the authority of trustees to add to the museum's collection. The court was reluctant to read into the will any such restriction and confirmed the power of the trustees to accession material. See also *Parkinson v. Murdock,* 183 Kan. 706, 332 P.2d 273 (1958); *Taylor v. Baldwin,* 362 Mo. 1224, 247 S.W.2d 741 (1952); *Ranken-Jordan Home for Convalescent Crippled Children v. Drury College,* 449 S.W.2d 161 (Mo. 1970); *Gordon v. Baltimore,* 258 Md. 682, 267 A.2d 98 (1970). *Trustees of the Peabody Institute Library v. James M. Shannon,* Attorney General of Massachusetts, No. 84-EO137-GL, Mass. Probate and Family Court, Essex Div. (Consent Decree dated Oct. 6, 1989), conceded that the board of trustees had the authority to sell collection objects, but the attorney general questioned the degree of care used by the board in arriving at its proposed plan to dispose of certain objects. But see P. Gerstenblith, "The Fiduciary Duties of Museum Trustees," 8 *Colum.-VLA J.L. & Arts* 175 (No. 2, 1983), for a different perspective. Gerstenblith argues that under the "public trust" concept, objects donated to museums cannot later be returned to private hands. This seems a very strained extension of a "public trust" doctrine that is usually applied to unique natural resources. For example, courts frequently use such a "public trust" argument to invalidate any attempts to give exclusive control of navigable waters to a private party. To argue that any object donated to a museum is as essential to the public welfare as the ability to use navigable waters does not comport with common sense. No state has a statute that expressly addresses the general issue of museum deaccessions. In New York, two such bills were introduced into the state legislature but were never passed: the Brodsky/Pillittere bill (June 1991), No. 8531, and the Grannis bill (1989–1990), A. 3835. Both attempted to regulate the practice, not ban it. Other states have legislation that addresses deaccessioning by a particular museum or group of museums. This legislation usually grants to government-run museums powers normally held by nonprofit museums. For a list of states with this type of legislation, see L. Wise and B. Wolff, "Deaccessioning, Disposition, and the Pledge of Museum Collections: The Legal Parameters," in American Law Institute–American Bar Association (ALI-ABA), *Course of Studies Materials: Legal Problems of Museum Administration* (Philadelphia: ALI-ABA, 1991).

10. No. C 322817 (Cal. Super. Ct., L.A. County, Sept. 22, 1981).

11. Every state has laws that regulate the formation of not-for-profit corporations. These laws vest broad discretionary powers in governing boards to do what is necessary to carry out the purposes of these organizations.

vote, since a museum cannot delegate its responsibilities in this area, but it should be pre-
pared to explain its plans and give due consideration to public reaction.[12] Because of this
added dimension, a museum's deaccession process should be flexible; it should consider not
just purely legal issues but also what might be called the "human factors."

In the spring of 1979, the Corcoran Gallery of Art deaccessioned and sold at auction some
one hundred European paintings from its collections. Apparently, much thought was given
to all aspects of the proposed removal. The following statement by the director of the gal-
lery[13] appeared in the front of the auction catalog. The statement illustrates the museum's
concern for its constituency:

Director's Statement

De-accessioning is a bold move which no museum would undertake lightly. After prolonged deliber-
ation, the Corcoran Gallery of Art has decided to sell at public auction approximately 100 works
from its European collection. Funds generated by this sale will be placed in a separate, restricted ac-
count designated solely for the purchase of American art of historical importance.

As Director of the Corcoran, I look upon this action as a means of keeping the museum's identity
clear and focused, as a way of defining its mission and planning for its future, as well as a method of
improving its collections. From its establishment in 1869, the Corcoran has enjoyed a preeminence
in the field of American Art. This sale will permit the Gallery—a private institute with very limited
funds for acquisition—to fill some of the major lacunae in its outstanding American collection with-
out diminishing the effectiveness of the institution.

Conscious of its responsibility to donors and mindful of its obligation to the public, the Corcoran
followed rigorous procedures in selecting the objects for this sale. From curatorial recommendation
to final Board approval, each work was carefully scrutinized and its relevance to the Gallery's pres-
ent and future programs weighed. It was decided that the works should be sold at auction to insure
that they were offered to the largest possible audience. Trustees and staff of the Gallery, and mem-
bers of their immediate families are restricted from bidding on these paintings.

Several of the works offered for sale were given to the Corcoran with the expressed purpose that
they be sold and American works purchased with the resultant funds. In the case of the European
paintings owned by William Wilson Corcoran, the donor himself, in what is an extraordinary ex-
ample of farsighted museum philanthropy, stipulated in his deed of gift that their disposition was at
the discretion of the Trustees. Donors of works sold will be acknowledged in future publications
and on labels for art purchased through their generous gifts.

It is hoped that this sale will help make a great museum of American art even greater, and it is in
this spirit and with this intention that we have taken this important step.

12. An example might be the Carnegie Institute's experience in 1979–80 regarding its proposal to deacces-
sion its stamp and coin collections. Rather than engage in protracted legal proceedings to counter opposition to
its court-approved deaccession plan, the institute decided that the public would be better served by a compro-
mise solution. See a more detailed discussion in Chapter II, "Museums Are Accountable to Whom?" in Section
C, "Expanding Concept of Standing to Sue."

13. At this time, Dr. Peter C. Marzio was director of the Corcoran Gallery of Art.

Certainly, the deaccession process should not be left to chance; written procedures are a prudent safeguard. Guidance to staff on at least the following issues should be offered in a museum's deaccession procedures.

a. The Need to Establish the Museum's Clear and Unrestricted Title to the Object under Discussion

If title is uncertain, problems could be compounded by attempting to dispose of an object. For instance, if an object is sold, and years later the museum determines that it did not pass good title, the museum could find itself subject to a breach-of-warranty action with potentially dire consequences. Under section 2–714(2) of the Uniform Commercial Code, a disappointed purchaser who did not acquire good title and who is forced to return an object to its rightful owner can claim damages from the seller equal to the present value of the object.[14] Thus, if an object had been sold by a museum for $5,000 and had appreciated to $10,000 by the time the purchaser became aware that he did not have good title, the museum, as the seller, could be assessed damages of $10,000 in order to give the purchaser "the benefit of the bargain."

The museum wants to be sure not only that it has "good" title before thinking of disposal but also that there are no legally binding restrictions that prevent disposal.[15] Aside from express conditions (those articulated by the transferor), there is an added caution if the object in question was donated and the proposed deaccession is not intended to be used for improving the collection (but for funding capital improvements or operating expenses). Some, in an effort to halt what is perceived to be the "slippery slope" of deaccessioning for building or operating funds, argue that there is an implied restriction when an object is donated to a museum: The object, or proceeds acquired from the sale of the object, can be used only to replenish collections. This argument is put forth in the code of ethics promul-

14. Under 2–714(2): "The measure of damages for breach of warranty is the difference at the time and place of acceptance between the value of the goods accepted and the value they would have had as warranted, unless special circumstances show proximate damages of a different amount." Under the reasoning of *Menzel v. List*, 267 N.Y.S.2d 804, 49 Misc. 2d 300 (1966), modified 28 A.D. 2d 516, 279 N.Y.S.2d 608 (1967), third-party claim reversed on other grounds, 24 N.Y. 2d 91, 298 N.Y.S.2d 979, 246 N.E.2d 742 (1969), the disappointed buyer is entitled to the value of the object as warranted as of the date that the true owner recovered the object. (If the Uniform Commercial Code is being used as a basis for such a claim, the code should be checked for any relevant statute of limitations.) A museum could possibly sell an object subject to unknown third-party claims, thus disavowing a warranty of clear title, but the sales price would have to be reduced accordingly. Another alternative could be for the museum to limit the liability in the sale contract to an amount not exceeding the sale price. Note also *Jeanneret v. Vichey*, 541 F. Supp. 80, (S.D.N.Y. 1982), *rev'd and remanded*, 693 F.2d 259 (2d Cir. 1982), in which the plaintiff, an art dealer, sued the defendant for breach of implied warranty. The defendant had sold the plaintiff a painting that, subsequently, the plaintiff learned had been exported from Italy without a permit. The plaintiff claimed the method of export created a cloud on the title and sued for the present-day value of the painting, as warranted. The plaintiff prevailed in the trial court, even though there was no clear determination of the precise nature of the "cloud," but on appeal the case was remanded for a new trial. In the opinion of the appeals court, the plaintiff had to come forward with better proof than that required by the trial court to establish an actual breach of warranty.

15. Refer to Section E(1), "Restricted Gifts," in Chapter IV.

gated by the Association of Art Museum Directors.[16] At least one court appears to have given some credence to this argument when enjoining a deaccession sale in Pennsylvania,[17] but most courts wisely hesitate to infer restrictions on charitable gifts. This subject is discussed more fully in Section B(2)(f), "Use of Proceeds Derived from Deaccessions," but here it is noted as an issue that might possibly arise when the question is whether an object is encumbered with a restriction that inhibits a proposed disposal.

The difference between a self-imposed policy and a legal requirement should also be borne in mind when the issue is disposal of the work of a living artist. Many museums that collect the work of contemporary artists have a policy of not disposing of an artist's work during his or her lifetime without the consent of the artist. The law does not impose such a practice; it is a courtesy. In other words, a museum can decide what policy it will have in this regard.[18]

Without doubt, one of the most troublesome problems for many museums is the management of objects of uncertain ownership. A museum that has been in existence for a good length of time invariably finds in its possession objects lacking any documentation and/or objects placed with it long ago "on deposit" or on loan but never claimed. As described in Chapter X, "Objects Found in the Collections," and Chapter VII, "Unclaimed Loans," the law often offers no clear solutions if a museum wants to dispose of such objects. Those chapters should be read carefully if an object proposed for deaccessioning appears to fall into either of these categories.

What constitutes good title or unrestricted title, or what is legally required versus what is optional, can at times be difficult to determine. If a museum is at all uncertain of the title status of an object being considered for disposal, it should seek professional help.[19]

b. The Proper Authority to Approve a Decision to Deaccession

A safe rule is that the level of authority needed to remove an object from the collection should be equal to or higher than the level of authority needed to accession such an object. What that level should be in individual cases depends on various factors such as the monetary value of the object, its value as a research specimen, and the extent of the proposed deaccession. For example, a museum may delegate to the director the authority to approve the deaccessioning of objects of relatively modest value, reserving to the board of trustees

16. See Association of Art Museum Directors, *Professional Practices in Art Museums* (New York: Association of Art Museum Directors, 1991, amended 1992), Section 24.

17. *In re Commonwealth of Pennsylvania v. Reading Public Museum and Art Gallery,* No. 72430, Pa. Ct. of Common Pleas of Berks County, Orphans Court Div. (August 1991). See also M. Malaro, "Deaccessioning in Hard Times," in American Law Institute–American Bar Association (ALI-ABA), *Course of Studies Materials: Legal Problems of Museum Administration* (Philadelphia: ALI-ABA, 1992).

18. For more comment on the practices of contemporary art museums, see S. Weil, "Deaccessioning Modern and Contemporary Art," *Rethinking the Museum* (Washington, D.C.: Smithsonian Institution Press 1990).

19. If the object of doubtful title is of little, if any, value, common sense is often a good guide. After carefully documenting lack of value, professionals might well recommend giving such objects to a nonprofit organization that can use them. Of course, the museum will then retain indefinitely complete records of the deaccession. See also footnote 32, below.

the authority to pass on all other removals. However, in a large natural history museum, even this division of authority may prove too cumbersome and unnecessarily restrictive. If there are frequent exchanges with other educational organizations of duplicate scientific specimens that have little if any market or scientific value, such deaccessions could appropriately be delegated to the curatorial level.[20] Similarly, if there are bottles and bottles of duplicate specimens of minimal value, the removal of several specimens because they are flawed should be within the discretion of the department. Any system for deaccessioning, however, should have effective controls for monitoring adherence to museum policy and should require the maintenance of complete records. The museum goal is twofold: to have prudent deaccessioning procedures and to have the ability to demonstrate that, in fact, the procedures are followed.

If the object under consideration is of major significance or if a substantial portion of a museum's holdings are being considered for deaccessioning, some thought should be given to the advisability of discussing the matter with the state attorney general's office. In New York, for instance, court approval is needed for a proposed sale of substantially all the assets of a not-for-profit corporation. This is to ensure that the terms of such a sale are fair and reasonable and that the purpose of the organization will be promoted by the sale.[21] Notice of the sale must also be given to the attorney general so that his or her views can be made known to the court. Somewhat similar precedents can be found in other states, and a museum should determine whether state law treats both charitable trusts and charitable corporations in the same manner regarding disposal of assets or whether different rules apply for each. There is no hard-and-fast rule as to what is a "significant" or "substantial" sale that might trigger a need for court review, but in doubtful cases, early consultation with the attorney general can prove helpful, especially if the museum suspects that a proposed sale may provoke public debate.[22] The views of the attorney general, as the representative of the

20. An exchange essentially involves a deaccession and then an accession, and it should be treated as such, with all relevant procedural safeguards. Whereas it is important for those who govern to delegate responsibility for deaccession decisions, it is equally important for them to carry out their oversight obligations. A museum could find itself bound by unfortunate staff decisions to remove objects from the collections if those with oversight authority regarding deaccessions fail to pay proper attention to what is going on. See, for example, *In the Matter of the Arbitration between the State of Connecticut and the Administrative and Residual Employees Union (P-5) Bargaining Unit*, OLR File #16021730076 87, State of Conn., August 8, 1987, and Memorandum of the Attorney General, Joseph Lieberman, to the Governor of Connecticut, dated February 24, 1988. This case involved deaccessions from the Raymond E. Baldwin Museum of Connecticut History and Heritage.

21. Section 511 of the New York Not-for-Profit Corporation Law. See *Matter of Horticultural Society of New York* (N.Y. Sup. Ct., N.Y. County, as reported in the *New York Law Journal* on April 1, 1980), wherein the society sought to sell its McKenzie Collection of rare books. See also *In re Conrad Poppenhusen Assoc. for an Order Approving the Sale of Assets*, Index No. 74-7/80 (N.Y. Sup. Ct., Queens County, Sept. 1980).

22. In *Wilstach Estate*, 1 D&C 2d 197 (Penn. 1954), the court noted that trustees of a museum did not need court approval for each sale of an unrestricted collection object, but see *Trustees of the Everhart Museum v. Commonwealth of Pennsylvania*, No. 1043, Pa. Court of Common Pleas of Lackawanna County (1992). Also, attorneys general differ from state to state in their policies regarding oversight of charitable organizations. Some have active education programs and favor early consultation. Others give their attention only to situations that show evidence of serious abuse.

people, afford an outside perspective that can be of great assistance to the museum in making its final decision. If cases of this nature (deaccessions not complicated by donor restrictions) need to be pursued in court, court review is limited to the issue of whether the museum's proposed action falls within the bounds of sound discretion. The role of the court is not to substitute its discretion for that of the museum.[23]

c. Documentation Needed to Support Proposed Deaccessions

The range of issues that should be addressed in reviewing a proposed deaccession and the extent of documentation required are necessarily governed by the quality and/or quantity of the objects at issue. A museum's collection management policy should establish minimum criteria for reviewing proposed deaccessions of various classes of material. Acceptable reasons for removal should be listed, and guidance should be given as to when outside opinions or appraisals should be sought.[24] The actions of those authorized to advise on or approve proposed deaccessions should be a matter of written record. In the case of *Lefkowitz v. Kan*,[25] at issue was the legality of a curator's role in certain deaccessions conducted at a museum. The case was settled in January 1983 by a compromise agreement between the attorney general of New York and the defendant curator. The agreement contains this statement: "Good museum practice requires the complete and candid discussion of each step used in determining how an object from the collection was chosen for deaccession, and how the value of such an object was determined." Deaccession records should be kept by the museum indefinitely.

23. *Conway v. Emeny*, 139 Conn. 612, 96 A.2d 221 (1953), involved proposed action to close the Hill-Stead Museum in Connecticut. Regarding the trustees' decision, the court said: "[T]o the extent to which the trustees had discretion, the court will not attempt to control their exercise of it as long as they have not abused it. But the law will not tolerate its abuse, however great the creator of the trust intended the grant of discretion to be" (224). See also *Ranken-Jordan Home for Convalescent Crippled Children v. Drury College*, 449 S.W.2d 161 (Mo. 1970); *Attorney General v. President and Fellows of Harvard College*, 350 Mass. 125, 213 N.E.2d 840 (1966); and *Scott on Trusts* § 187 (3d ed.), which states: "In other words, although there is a field, often a wide field, within which the trustee may determine whether to act or not and when and how to act, yet beyond that field the court will control him. How wide the field is depends upon the terms of the trust, the nature of the power, and all the circumstances." *Zehner v. Alexander*, 89 (Penn. 39th Jud. Dist., Franklin County, Ct. of C.P., Orphans' Ct. Div.) 262 (May 25, 1979), concerns an attempt by trustees of a college to close the school. A similar incident concerning the Mannes College of Music (New York) was reported in *Chronicle of Higher Education* 9 (Nov. 5, 1979). In 1982, the Detroit Zoo was sued by a citizens' group protesting the planned euthanasia of several tigers. After protracted hearings, the court ruled that the deaccession decision had been made by the zoo after careful consideration and that the decision was not capricious; hence the court would not intervene. *Doppelberger v. City of Detroit*, No. 82-234592-CZ (Mich. Cir. Ct., Wayne County, December 10, 1982), *aff'd*, Mich. Ct. of Appeals, Nov. 14, 1984. See also *Taussig v. Historic Annapolis*, Case #C-93-4451, Md. Cir. Ct. for Anne Arundel County (Feb. 15, 1995); *Maryland Institute College of Art v. The Baltimore Museum of Art and the Walters Art Gallery*, Civ. No. 95030001-CL191657, Md. Cir. Ct. for Baltimore City (Sept. 18, 1995); *Hammond Museum, Inc. v. Scott Harshbarger*, Att. Gen. of Mass., No. 92E-0067-G1, Mass. Probate and Family Ct., Essex (Oct. 8, 1992).

24. If an object of substantial value is to be sold (but not at public auction) or exchanged, a museum may want to obtain one or two outside appraisals for additional assurance that the price received or the exchange is fair.

25. Index No. 40082/78 (N.Y. Sup. Ct., N.Y. County, Jan. 3, 1978).

d. The Appropriate Method of Disposal

A decision concerning the method of disposal can be intrinsically tied to the decision concerning whether to deaccession, but neither should be allowed to overshadow the merits of the other. For example, the fact that a museum desperately needs money should not dictate that collection objects must be sold, nor should a whimsical decision to sell a collection object gain an aura of legitimacy because sale proceeds will be used for a worthwhile cause. Those people charged with making deaccession decisions should carefully and separately weigh the merits of the removal itself and the merits of the mode of disposition.

Conway v. Emeny[26] illustrates the pitfalls when this distinction is not made. In *Conway,* a testatrix left property to establish a museum for the citizens of the locality. Her will provided that if after a certain period of time the trustees of the museum "in their absolute discretion" determined there was not sufficient public interest in the museum to warrant its maintenance, the trustees could terminate the museum and transfer all its assets to a school specified by the testatrix. The museum was established, and some years later the trustees learned that the school was in grave financial difficulty. Some of them argued that if the museum stayed open, the school would have to close. The trustees voted to close the museum, but this decision was challenged by the attorney general of the state. The court concluded that the trustees were in error. The essential question they had to decide in exercising their discretion was whether there was sufficient public interest in the museum to warrant its maintenance. In failing to focus on this issue, the trustees were not loyal to their trust. "In his dealings with his beneficiary [a trustee] must not be influenced by the interest of a third party."[27]

Assuming that a museum has made an independent decision that an object can be deaccessioned, care should be given to selecting an appropriate method of disposition. The museum's collection management policy should state what methods are acceptable and, perhaps, what circumstances may favor one method over the other. Here again, the nature of the object in question greatly influences the available options. In natural history museums, policies often favor or even require exchanges with other educational associations. This is based on a conviction that the museum's audience as well as the general public will benefit by keeping certain archaeological artifacts and scientific specimens in the public domain. As a rule, such methods of disposal are not stressed in art museums because, frequently, the marketplace offers the most realistic route for acquiring or disposing of art objects. There is no uniformly correct method of disposal. Based on its particular circumstances and the nature of its holdings, a museum, however, should be able to arrive at general guidelines

26. 139 Conn. 612, 96 A.2d 221 (1953).

27. G. Bogert, *The Law of Trusts and Trustees,* rev. 2d ed., § 543 (St. Paul, Minn.: West Pub. Co., 1977). See also *Henley v. Birmingham Trust National Bank,* 295 Ala. 38, 322 So.2d 688 (1975); *Attorney General v. President and Fellows of Harvard College,* 350 Mass. 125, 213 N.E.2d 840 (1966). This falls under the duty of loyalty imposed as well on those who govern charitable corporations. See D. Kurtz, *Board Liability: Guide for Nonprofit Directors,* (Mt. Kisco, N.Y.: Moyer Bills Ltd., 1988). See 75 A.L.R.2d 449, supp. sec. 3, for cases dealing with the removal of trustees of charitable trusts for cause.

regarding methods of disposal for its various classes of objects.[28] In establishing these guidelines, a museum should consider first the interests of the beneficiaries of the museum (the public it serves)[29] and, thereafter, the interests of the general public,[30] the need to retain public confidence in the management of the museum,[31] and any unusual considerations that may influence the selection of a particular method of disposal.[32]

28. As a rule, a museum should have a procedure for granting special exceptions to these general guidelines. If exceptions are a matter of written record and require high-level approval, there is less chance for abuse.

29. As a general rule, a trustee has a duty to make trust property productive. *Scott on Trusts* §§ 181, 386 (3d ed.). See also D. Kurtz, *Board Liability: Guide for Nonprofit Directors* (Mt. Kisco, N.Y.: Moyer Bills Ltd., 1988).

30. It is not uncommon for a museum to be faced with a dilemma as to whether an object or collection should be sold at the best possible price in order to increase trust assets or whether a sacrifice should be made in order to retain the material in the public domain or within a certain locality. In a sense, this is a tug-of-war between favoring one's own beneficiaries and favoring the general public. There is no easy answer, but if the trustees of a museum have weighed the merits of all arguments in good faith, their decision, if within reason, should stand as within the limits of their discretionary powers. *Scott on Trusts* §§ 187, 382 (3d ed.). See also *In re Carnegie Institute,* No. 208 of 1979 (Penn. Ct. of C.P., Allegheny County, Orphans' Ct. Div., May 14, 1980); *The New Bedford Glass Society, Inc. v. Scott Harshbarger,* Supreme Judicial Ct., Suffolk County, Ma., Civil Action No. 91-546 (1991), and the case of the deaccession sale of the New York Historical Society as reported in the following: M. Kimmelman, "Is This the End for New York's Attic?" *New York Times,* Feb. 21, 1993; L. Rosenbaum, "New York Historical Society Sells New York Heritage," *Wall Street Journal,* Jan. 19, 1995; P. Zimmerman, "Financial Stabilization and Deaccessioning at the New York Historical Society," *Sourcebook,* AAM Annual Meeting, May 1995; and the most comprehensive treatment to date, K. Guthrie, *The New York Historical Society: Lessons from One Nonprofit's Long Struggle for Survival* (San Francisco: Jossey-Bass, 1996). In both the New Bedford and New York cases, the deaccession disposal plans were approved by the Attorney General's Office of the respective state. But see footnote 51 below, which notes that the New York plan was criticized for not fairly balancing the needs of the historical society and the interests of other collecting organizations. For an opinion that museums should favor intermuseum deaccessioning—transferring collections from one museum to another—see S. Miller, "Guilt-Free Deaccessioning," *Museum News* (Sept.–Oct. 1996).

31. Private sales, although not wrong per se, are more vulnerable to accusations of favoritism or inept bargaining by the museum. See, for instance, the complaint in *Lefkowitz v. Kan,* Index No. 40082/78 (N.Y. Sup. Ct., N.Y. County, Jan. 3, 1978). (Kan, a museum curator, deaccessioned and sold certain museum objects to a dealer. Kan also collected personally and did business with the same dealer. The attorney general charged Kan with violating his fiduciary duties by not obtaining the best price for museum objects so that Kan could benefit in his personal transactions with the dealer. The case was settled in January 1983.) See M. Brenson, "Auctions: The Museum Connection," *New York Times* C17 (Jan. 6, 1984), for a discussion of disposal routes used by New York City art museums. Private sales to employees and trustees should be avoided because they raise ethical, if not legal, problems. Also on the issue of sales to trustees, see *Lefkowitz v. The Museum of the American Indian, Heye Foundation,* Index No. 41416/75 (N.Y. Sup. Ct., N.Y. County, June 27, 1975). On the issue of whether deaccessioned material should be sold in museum stores, the "Code of Ethics" of the Museum Store Association Inc. contains the following statement: "The sale of any deaccessioned material through the museum shop is unacceptable. Even though the item may have been properly deaccessioned, the public may perceive the transaction as the museum store participating in the liquidation of the museum's collection. Therefore, no deaccessioned items should be ever [*sic*] sold through the museum store." *Museum News* 50, 51 (Jan.–Feb. 1982).

32. If deaccessioned objects have little, if any, monetary value, a museum well may be justified in donating them to worthy causes. Schools and universities often welcome gifts that can be used for teaching purposesor for theatrical props, for example. Such donations would not violate the trust responsibility to preserve trust assets if, on balance, the museum gains by acquiring storage space and by being relieved of routine maintenance expenses. In this regard, see *Scott on Trusts* §§ 227.17, 389 (3d ed.), which discusses the ability of trustees to invest or make gifts of trust assets based on moral or social considerations. A museum tht is part of a governmental entity may be subject to limitations regarding methods of disposal. See, for instance, *Board of Supervisors*

e. Notification to Donor of Deaccession

If an object is given to a museum without restriction, the donor retains no legal interest in it. The gift becomes the museum's property, to be administered for the benefit of the public.[33] If that object subsequently is deaccessioned, there is no legal requirement to seek the approval of the donor.[34] On their own accord, however, some museums have a "goodwill" policy of notifying donors of pending deaccession actions, and frequently, objects obtained for the collections as a result of the deaccessions are noted on museum records as having been acquired through the original donor's generosity. Whether such a voluntary practice is feasible for a particular museum depends on the circumstances, and even with a general practice in force, cases often need to be weighed on their own merits. The desire of the museum to retain the goodwill of donors should be balanced with its obligation to carry out its functions in a reasonably efficient manner.[35]

If an object has been given with precatory (nonbinding) language that bears on deaccessioning, the museum will want to proceed with thoughtful caution.[36] The decision to deaccession still rests with the museum, but such cases may present situations in which consultation with the donor or the donor's heirs strengthens confidence in the fairness of the museum's ultimate decision. An example is the de Groot incident mentioned in Chapter IV.[37] Here the Metropolitan Museum of Art decided that it would not donate certain deaccessioned paintings to other museums, a course of action the donor expressly favored in her will but did not require. Instead, the trustees of the museum determined that the museum's interests would be better served by selling the paintings. The museum's decision was legal (it fell within the discretion of the museum trustees), but there was much adverse public

v. Dolan, 45 Cal. App. 3d 237, 119 Cal. Rptr. 347 (1st Dist. 1975). If an object is being removed from the collection because it has been judged a fake, additional considerations arise concerning proper disposition. See "Report on Disposition of Fake Art," 26 Record 591 (Assoc. of the Bar of the City of N.Y., 1971), and State v. Wright Hepburn Webster Gallery, Ltd., 64 Misc. 2d 423, 314 N.Y.S.2d 661 (1970), aff'd, 323 N.Y.S.2d 389 (1971). See also the "Code of Ethics for Art Historians" (revised as of January 1995), Section VI, and also the companion document "Guidelines for Professional Practice." If an animal is being removed from a zoo collection because of overpopulation, emotional issues can create major problems. See J. Luoma, "Prison or Ark?" 84 Audubon 102 (No. 6, Nov. 1982), and K. Vehrs, "Disposition of Wild Animals from Zoological Parks and Aquariums," in American Law Institute–American Bar Association (ALI-ABA), Course of Studies Materials: Legal Problems of Museum Administration (Philadelphia: ALI-ABA, 1993).

33. Scott on Trusts § 391 (3d ed.); Abrams v. Maryland Historical Society, Equity No. A-58791/A513/1979 (Md. Cir. Ct., Baltimore City, June 20, 1979). Even if there are restrictions, the donor or the donor's heirs may not have residuary interests. See, for example, Amato v. The Metropolitan Museum of Art, No. 15122/79 (N.Y. Sup. Ct., N.Y. County, Sept. 24, 1979); Gifford v. First Nat'l Bank, 285 Mich. 58, 280 N.W. 108 (1938); In re Estate of Rood, 41 Mich. App. 405, 200 N.W.2d 728 (1972).

34. See the later comments in this section on possible IRS notification requirements.

35. For example, if heirs of a deceased donor cannot be located readily, or if the object to be deaccessioned was donated generations ago, or if the object is of modest value, practical considerations may dictate against searching for donors and their heirs.

36. Precatory language places a moral rather than a legal obligation on the museum. For example, "It is my hope but not my command that . . ." Court approval is not needed to deviate from precatory language.

37. See Section E(1), "Restricted Gifts," in Chapter IV.

criticism. Shortly after the de Groot sales, the museum voluntarily imposed the following policy restrictions on its deaccession activity:

(a) The Museum will, as in the past, consistently honor restrictions attaching to the gift or be-
 quest of any work of art. In addition, requests which do not impose any legal obligation ac-
 companying the bequest or gift of any work of art will be respected to the extent feasible, un-
 less modified by the donor or, if the donor is not living, the donor's heirs or legal
 representatives, on notice to the Attorney General of the State of New York.
(b) No work of art valued by the Museum at $10,000 or more will be disposed of within 25 years
 following its receipt if objected to, after appropriate notice, by the donor or the donor's heirs
 or legal representatives. This policy will apply to any work of art, including gifts or bequests
 which are not subject to any legal obligation or accompanied by any nonbinding request.[38]

If an object is given with legally binding restrictions that affect the museum's ability to deaccession, the museum should not take any removal action without first consulting legal counsel. As a general rule, court approval is required to alter a legally binding restriction, and whether the donor is an appropriate party in such an action depends on the particular circumstances.[39] Who may need to be notified becomes even more complex if the restriction in question has a "gift over"—that is, the donor has named an alternative donee in case the first gift fails. Here, legal counsel will want to check the "rule against perpetuities" as interpreted in the relevant jurisdiction. The "rule against perpetuities" states, in most general terms, that a gift must vest within twenty-one years after a life or lives in being at the time of the creation of the gift. To the layperson, all of this may sound very confusing, but it can bear on the question of whether a "gift over" is valid. This question is discussed in greater detail in footnote 231 of Chapter IV, Section E(1), "Restricted Gifts."

The above comments address the issue of whether the approval of the donor is needed in order to deaccession. With the passage of the Tax Reform Act of 1984,[40] the Internal Revenue Code now requires, in some situations, that a museum notify the donor and the Internal Revenue Service if certain donated property is sold, exchanged, or otherwise transferred within two years of the date of the gift. The information-reporting requirement applies if the amount of the charitable contribution for the property claimed by the donor under Section 170 of the Internal Revenue Code exceeds $5,000 for any single item of such property or exceeds $5,000 in the aggregate for similar items of such property donated to one or more charitable donees within the tax year. As explained in Section A of Chapter XIII, such donations to a museum must, as of 1985, be accompanied by a copy of Section B of IRS form 8283, a form the donee museum must sign to acknowledge receipt of the gift. With certain limited exceptions, if the donee museum disposes of such a gift, or any part thereof, within two years of receipt, it must file an information notice (IRS form 8282) with

38. Metropolitan Museum of Art, "Procedures for Deaccessioning and Disposal of Works of Art" (June 20, 1973).

39. See Section E(1) "Restricted Gifts," in Chapter IV; see also Chapter II, "Museums Are Accountable to Whom?"

40. See discussion in Chapter XIII, Section A.

both the donor and the IRS. The information notice is precisely what its name implies: It gives the donor and the Internal Revenue Service information on the deaccession practices of the museum.[41] The requirement for an information notice, of itself, in no way alters the museum's ability to deaccession and pass title to the property in question.

f. Use of Proceeds Derived from Deaccessions

The common museum practice is to use proceeds from deaccessions for the acquisition of new collection material. Such a practice usually serves the best interests of the public because it lessens the temptation to drain collections in order to meet support expenses. After all, the purpose of the average museum is to collect, and thus, the prime concern should be the enhancement and protection of the collection. Here, we need to distinguish between the purpose of a nonprofit and the purpose of a for-profit organization. The ultimate purpose of any for-profit organization is to make enough profit to satisfy those who have invested time or money in its operation. The ultimate purpose of a nonprofit is to carry out its particular mission for the public it serves. (For a museum, the mission invariably centers on the maintenance and effective use of a collection.) When a for-profit organization faces a financial crisis, the sale of part of its assets is essentially a matter of business judgment: Will this allow the organization to keep going, with the hope that it can come up with another way to turn a profit? For the nonprofit, the sale of assets can mean (as in the case of a museum) the disposal of part of its very reason for being. When this is the situation, there has to be very strong justification—not just a business gamble—that a sale for other than collection improvement is in the best interests of the public served.

This common practice—to use proceeds from deaccessions only for the acquisition of new collection material—has been and continues to be the subject of intense debate as museums experience the difficult financial climate of the late 1980s and the 1990s. In analyzing the debate, we should make a distinction between law and ethics.

Law can be enforced, whereas ethical codes (at least in the museum field) depend on voluntary compliance. Professional codes of ethics set standards that are deemed important in order to uphold the integrity of the profession. The goal of such codes is to encourage conduct that warrants the confidence of the public. Legal standards are more mundane. They set minimum standards below which one is liable for civil or criminal sanctions. As one would expect, ethical standards invariably are more demanding than legal standards.

The museum profession is split on an ethical standard for the use of deaccession proceeds. The Association of Art Museum Directors, in its code of professional standards, has consistently taken the position that funds obtained through disposals must be used to replenish the collection.[42] It vigorously reaffirmed this stance in a review of its code in 1992. In the

41. In this regard, consider the discussion in Chapter IV, Section A, on the meaning of the word "accession" and the concept of "related use," and also Chapter XII, Section C.

42. Association of Art Museum Directors, *Professional Practices in Art Museums* (New York: Association of Art Museum Directors, 1991, amended 1992), Paragraph 24 and Appendix B. This association is composed of chief executive officers of art museums that have substantial budgets. Its headquarters is in New York City.

early 1990s the American Association of Museums[43] revised its code of ethics. The first revision, adopted in 1991, contained the following provision: "[D]isposal of collections through sale, trade or research activities is solely for the advancement of the museum's mission, and use of proceeds from the sale of collection materials is restricted to the acquisition of collections." There was immediate protest from a sizable segment of the organization's membership. Most of those protesting argued that the quality of care given to a collection was as important as the size and makeup of the collection and that, in certain circumstances, it is more sensible to devote deaccession proceeds to collection care. The American Association of Museums set aside a year or two to study this issue, and during this time, the New York Historical Society and a number of smaller museums provided graphic examples of what the protestors were talking about.

The New York Historical Society, one of the oldest and largest historical societies in the country, was on the verge of bankruptcy after decades of poor management.[44] The society was literally stuffed with objects, many of great value and importance, and it had scant funds to organize, care for, and utilize its collection. When reports of its plight failed to produce any solutions, the society began negotiations with the attorney general of New York. The result was a plan to refocus the society's mission, pare its collections, and put up for auction some $20 million worth of objects. Clearly, the money raised was not going to be used to buy more collection objects. Meanwhile, other smaller collecting organizations were also engaged in efforts to implement deaccession plans to raise money for operating expenses; each argued that it could not continue to function, or function effectively, unless money was drawn from collections.[45]

In 1994, the American Association of Museums promulgated a slightly revised code of ethics, which contained the following statement regarding the use of proceeds from deaccessions: "[D]isposal of collections through sale, trade, or research activities is solely for the advancement of the museum's mission. Proceeds from the sale of nonliving collections are to be used consistent with the established standards of the museum's discipline, but in no event shall they be used for anything other than acquisition or direct care of collections."[46]

43. The American Association of Museums is the largest museum professional organization in the country. Its members are drawn from all sizes and types of collecting organizations. Its headquarters is in Washington, D.C.

44. See footnote 30, above.

45. See, for example, *Commonwealth of Pennsylvania v. The Reading Public Museum and Art Gallery*, No. 72430, Pa. Ct. of Commons Pleas of Berks County, Orphans Ct. Div. (Aug. 1991) (eventually settled out of court when the people of the community rallied to the support of the museum; the deaccessioning did not take place); *Trustees of the Everhart Museum v. Commonwealth of Pennsylvania*, No. 1043, Pa. Ct. of Common Pleas of Lackawanna County, Orphans' Ct. Div. (1992) (the court allowed the sale, but the piece did not sell); *Hammond Museum, Inc. v. Scott Harshbarger, Attorney General of Mass.*, No. 92E-0067-G1, Mass. Essex Probate and Family Ct (1992) (the deaccession was allowed by the court in order to raise operating expenses); *In re the Barnes Foundation*, No. 58,788, Pa. Ct. of Common Pleas of Montgomery County, Orphans Ct. Div. (1991) (this petition to sell part of the Barnes art collection to raise operating expenses was withdrawn after significant public outcry; the objects at issue were also subject to donor-imposed restrictions).

46. American Association of Museums, "Code of Ethics for Museums" (1994).

In this revised wording, the code recognizes that some collection disciplines may want to impose more stringent rules, but it sets as the minimum ethical standard for the use of deaccession proceeds the "acquisition or direct care of collections." Just how "direct care" is interpreted remains to be seen, but at least one example has been provided so far, the interpretation approved by the New York Attorney General's Office in the deaccession plan for the New York Historical Society, as described below.

A third professional organization, the American Association for State and Local History, was also writing its code of ethics at this time.[47] Its code, published in 1992, offers the following guidance on the use of proceeds from deaccessions: "Collections shall not be deaccessioned or disposed of in order to provide financial support for institutional operations, facilities maintenance, or any reason other than the preservation or acquisition of collections."[48] This language appears to restrict the use of proceeds, other than when used to replenish collections, to direct preventive conservation measures and conservation treatment.

On the whole, the law has been more receptive to broader uses of deaccession proceeds. In good part, this is because when cases of this nature reach the attention of an attorney general or a court, the museum in question is usually in serious financial difficulty. The options at this point, barring a windfall, are either to allow the use requested or to shut down the museum. *The New York Historical Society* case is a classic example. In this case, when faced with these alternatives, the New York Attorney General's Office elected to go along with a plan to deaccession in order to raise money for other than collection-replenishment purposes because this was the lesser of two evils.[49] Two provisions of the plan approved by the New York Attorney General's Office are noted here: the limitations on the use of proceeds, and the incentive plan to encourage New York collecting organizations to purchase some of the deaccessioned pieces.

Use of Proceeds. In the negotiations between the society and the attorney general, the permitted uses for deaccession proceeds were expressly limited as follows:

47. The American Association for State and Local History is an organization comprising individuals, agencies, and organizations engaged in the practice of history. Its headquarters is in Nashville, Tenn.

48. American Association for State and Local History, "Statement of Professional Ethics" (1992).

49. Part of the survival plan allowed the society to borrow $1.5 million from Sotheby's. In return, the society put up as collateral close to $3 million worth of objects from its collection. See W. Honan, "Historical Society Puts Up Artworks as Loan Collateral," *New York Times*, Jan. 27, 1993; W. Honan, "The Historical Society Is Criticized for Using Artworks as Collateral," *New York Times*, Jan. 28, 1993; and "N.Y. Historical Society Closing," *Washington Post*, Feb. 4, 1993. The subject of putting up collections as collateral for loans is another hotly debated issue for museums. For an analysis of the law regarding the pledging of museum collections, see L. Wise and B. Wolff, "Deaccessioning, Disposition, and the Pledge of Museum Collections: The Legal Parameters," in American Law Institute–American Bar Association (ALI-ABA), *Course of Studies Materials: Legal Problems of Museum Administration* (Philadelphia: ALI-ABA, 1991). In 1989, the Triton Museum of Art (Santa Clara, California) was severely criticized for mortgaging its permanent collection to secure a loan to pay off a construction debt. See M. Malaro, "Current Problems in Collection Management," in American Law Institute–American Bar Association (ALI-ABA), *Course of Studies Materials: Legal Problems of Museum Administration* (Philadelphia: ALI-ABA, 1990).

Proceeds from the sale of deaccessioned objects or collections may be used for acquisitions, direct care of the collection (e.g., curatorial staff salaries and other expenses incurred in conservation and preservation; rehousing or storage), and collections management. Examples of expenditures which shall not be made from the proceeds from deaccessioning include, but are not limited to, costs of general building operations, including utilities, guard service and janitorial services; costs of public programs; salaries of administrative personnel; construction or maintenance of facilities or equipment not directly related to the care of the collections, such as coatrooms, kitchens, or administrative offices; and maintenance and repairs not directly related to the physical security of the collections, such as painting or air conditioning of administrative offices.[50]

Purchase Incentive. Regarding incentives to encourage New York collecting organizations to purchase some of the deaccessioned objects, the agreement set up a mechanism whereby qualified New York collecting organizations could preempt a winning bid on objects auctioned, obtain a discount on the auctioned price, and take advantage of a long-term payment plan.[51]

So far, the law offers no serious impediments to the use of deaccession proceeds for operating expenses if the museum planning the deaccession demonstrates serious financial distress and presents a plan to stabilize its condition. But this is because, as explained, courts usually consider these cases when museums are on the brink of disaster and when the time for "good" solutions has long passed.

In my opinion, museum codes of ethics, at least as of mid-1997, do little to alleviate the underlying problem. When museums seek to deaccession for reasons other than collection improvement, the underlying problem is invariably a history of board failure to exercise prudence in fiscal management. The lack of prudence can take many forms, such as collecting without considering the cost of maintenance, failing to maintain reasonable reserves, or depending too much on unstable sources of funding. These are situations that are truly the antithesis of "prudence governance" when one considers that a major purpose of museums is the long-term care and utilization of large collections for the benefit of the public. To be effective on this subject, codes of ethics should address the key issue. They should warn that any museum planning to deaccession for other than collection-improvement purposes raises the presumption of fiscal mismanagement and that, consequently, a burden is placed on the museum to rebut this presumption publicly before it proceeds with its deaccession plans. This approach would encourage museums and their boards to give far more attention to disciplined growth and careful fiscal management or bear the stigma of poor

50. P. Zimmerman, "Financial Stabilization and Deaccessioning at the New York Historical Society," *Sourcebook,* AAM Annual Meeting, May 1995.

51. The special conditions imposed by the New York attorney general on the deaccession sale of the New York Historical Society objects did not go uncriticized. See B. Schreiber-Jacoby, "Forum: Caveat Pre-Emptor," *Museum News* 54 (Jan.–Feb. 1996). The article claims that the right of qualified New York collecting organizations to preempt winning bids seriously depressed competition for choice objects—to the detriment of the ailing New York Historical Society.

performance. The result should be fewer crisis situations. At the same time, for museums that can rebut the presumption raised in such a code provision, there is an acceptable avenue of relief, one that does not label them as unethical.[52] Hopefully, ethical codes of professional organizations will move toward an approach that highlights the importance of early attention to fiscal stability.

As of the late 1990s, a museum planning to use deaccession proceeds for operating expenses should expect considerable opposition, and rightfully so. At a minimum, such a museum should be prepared to explain to its public

- why the use is necessary (i.e., all other avenues have been exhausted);
- why the crisis could not have been avoided with the exercise of reasonable diligence; and
- how the proposed use of deaccession proceeds will enable the museum to continue to operate effectively for the indefinite future.[53]

C. Requests for the Return of Collection Objects

Occasionally a museum is faced with a request to return a collection object. Such requests can take various forms, and each has its particular problems. Experience rather quickly demonstrates that a museum must have basic guidelines to follow when handling requests for the return of objects. Today, a museum may be asked for a very minor item, one deemed not worth much thought; tomorrow, the request may be for a choice item. It is difficult to pick and choose battles and still retain credibility. If a museum's records on deaccessions are complete and open for inspection (a prudent policy), they should reflect consistency in handling all requests for returns.

In the first chapter of this book, the nature of a museum was discussed. The chapter pointed out that a museum holds it collections in trust for the public it serves (the benefici-

52. In *Board of Trustees of the Malden Public Library v. Scott Harshbarger,* Attorney General, No. 93EO187G1, Mass. Probate and Family Ct., Middlesex County (Dec. 10, 1993), the townspeople did not object to a plan (subsequently approved by the court) whereby a portion of the art collection owned by the town library (a nonprofit organization) was to be sold to provide funds to renovate the library building. In this case, a serious financial depression in the area affected all public services, and the townspeople, the beneficiaries of the services, expressed their preferences.

53. For a case in which a museum decided it could not survive and ended up disposing of all collections and other assets, with the consent of the attorney general, see *The New Bedford Glass Society, Inc. v. Scott Harshbarger,* Civil Action No. 91-546, Mass. Sup. Judicial Ct., Suffolk County (Dec. 1991). For a case in which an art school sought to dispose of a donated art collection in order to increase its general endowment fund, see *Maryland Institute College of Art v. The Baltimore Museum of Art and the Walters Art Gallery,* Civil No. 95030001/CL191657, Md. Cir. Ct. for Baltimore City (Sept. 28, 1995). For another approach to resolving the controversy over the use of deaccession proceeds, see J. White, "When It's OK to Sell the Monet: A Trustee-Fiduciary-Duty Framework for Analyzing the Deaccessioning of Art to Meet Museum Operating Expenses," 94 *Mich. L. Rev.* 1041 (No. 4, Feb. 1996).

aries of the trust) and that the museum has a duty to preserve and protect these assets and to use them for the good of that public. All of this is relevant when a museum is faced with a request for a return of an object. If there is no question of the validity of the museum's title to the object,[54] the museum is not free to return the object without carefully weighing its obligations. Bursts of generosity or expedient solutions are avenues normally closed to a trustee. As *Scott on Trusts* states: "It is the duty of the trustee to use care and skill to preserve the trust property. . . . Where the loss to the trust is the result of his failure to use proper care or skill, where it is due to his negligence, he is liable to the beneficiaries for the loss."[55]

Requests for the return of collection objects can present complex legal and/or practical problems. This does not mean that to fulfill its responsibilities, a museum must pursue to the bitter end every possible argument for retention. Trustees do have the power to compromise a claim if this seems prudent or to make a judgment that a claim should not be contested because of unusual circumstances.[56] The important points are that when a museum is faced with a request, it should (1) ascertain the facts, (2) sift them carefully in light of trust responsibilities, and (3) be prepared to defend its action as prudent and taken in good faith. Consider, for example, the following hypothetical situations. Each presents a variety of issues that must be weighed before prudent decisions can be made.

Hypothetical Example 1. In 1970, Mr. X donated to the local historical society his grandfather's diary and scrapbooks. He signed a deed of gift stating that he was giving all rights and interest to the society. The society placed the materials in its archives but never displayed them. In 1980, Mr. X asked that the diary and scrapbooks be returned. He explained that his family had become very interested in genealogy and that this material had assumed a new importance for them. He indicated that he had been misled into making the gift because he thought the items were of importance and would be placed on display. Mr. X's grandfather, a local carpenter, had never achieved prominence in the community. Consider the following questions:

1. Was there a valid gift? Was there any question of fraud?
2. Because of the nature of the material, should the family's request be given special consideration?

54. If title is in doubt, this issue must be resolved first. If the requestor can establish that the object does in fact belong to the requestor and that the museum has not acquired good title (and has no valid defense to an action for conversion), the museum is bound by law to return the object on demand. See Section D(5), "Stolen Property," in Chapter IV, and see Chapter X, "Objects Found in the Collections."

55. *Scott on Trusts* § 176 (3d ed.). Chapter I explains the difference between a traditional trustee and a trustee (or director) of a charitable (nonprofit) organization. Although their roles can vary because of the nature of their respective responsibilities, it is difficult to argue that the museum trustee should be held to a less demanding standard regarding the organization's collections. At the very least, museum trustees have a responsibility to see that the museum has prudent policies and procedures on deaccessioning and that the board exercises reasonable oversight in this area.

56. See *Scott on Trusts* § 192 (3d ed.).

3. Would the public be served if copies of the diary and the scrapbook were made and the originals returned, or should the society consider only an offer to make copies for Mr. X?

4. What if the society no longer wants the diary and scrapbook? Should they be returned to Mr. X, or should they be offered to other educational institutions so that they remain available to the public?

Hypothetical Example 2. In 1940, Mrs. B brings to the museum a doll, a family heirloom. She explains that it belongs to her seventeen-year-old daughter, who is abroad at school; the family is selling their large home and moving into an apartment, and the daughter wants the doll placed in the museum. The museum gratefully accepts the doll and writes the daughter, at her family's address, an acknowledgment for her generous gift. The doll is accessioned into the collections. On one or two occasions it is displayed briefly, but most of the time it is in storage and available to researchers. In 1979, the daughter requests the return of the doll. The museum refuses, stating its belief that there was a valid gift. The daughter then explains that she never gave her mother permission to give the doll away, only permission to loan it.[57] Consider the following questions:

1. If the daughter was a minor when the gift was made, was the gift void or voidable? (State law must be checked. In some jurisdictions, the gift would be void unless confirmed after majority. In others, a gift can be declared void within a set period of time after the minor reaches majority.)

2. Even if the original gift was void, has the daughter, since reaching majority, delayed too long in bringing her claim? (See the discussions on "Statutes of Limitations," "Laches," and "Adverse Possession" in Chapter VII, "Unclaimed Loans.")

Hypothetical Example 3. The state historical society has a collection of Indian artifacts that were obtained in the late 1800s. Several are objects associated with a Canadian tribe. Representatives of the tribe now ask for the return of these objects, claiming that the historical society could never have acquired good title because under tribal law such objects are communally owned and can never be conveyed by an individual regardless of whether the individual is a member of the tribe. In researching the objects, the historical society finds evidence that the objects are copies made by a tribal member for a person who was not a member of the tribe. When this information is conveyed to the tribe, the response is that the tribe also asserts ownership over all copies under tribal law. Consider the following questions:

1. The Native American Graves Protection and Repatriation Act of 1990 establishes procedures regarding the repatriation of culturally important material to Native Ameri-

57. See *Magruder v. Smithsonian Institution*, Case No. 83-693-Civ.-Ca. (U.S.D.C. So. Fla., Sept. 15, 1983).

can tribes. The law specifically states that it applies only to peoples indigenous to the United States. What precedent is established if the historical society looks to this statute for direction in handling the Canadian claim?[58]

2. What are the ramifications of agreeing to return copies? What if the tribe also wants all pictures of the objects?

3. How can the museum be sure it is dealing with the proper representatives of the tribe?

Hypothetical Example 4. In 1900, Mr. C placed on loan with the museum four mineral specimens, with the notation that he would call for them in a year or two. The specimens are still with the museum, and museum records shed no additional light on whether there was further communication with the owner. The specimens have apparently borne an accession number for some time, but when or why this was done is not documented. Heirs of Mr. C are now inquiring about the status of these specimens, which have increased greatly in value over the years. Consider the following questions:

1. Have the heirs established their status to make the claim? Before any material is returned, a museum must assure itself that the return is made to the proper party. Otherwise, the museum remains liable to the true owner. Heirs should be required to prove that they are the sole and rightful claimants.

2. What facts would be necessary to establish that the heirs have lost any right to claim the specimens?[59]

3. Can any weight be given to the fact that the items were accessioned? Is there other evidence that there was a subsequent donation?[60]

Hypothetical Example 5. The local historical society must move into new quarters, and an inventory is being conducted of its holdings. Many objects are found to have no documentation. All that is known is that the items have been stored in the attic of the society for years. Someone in the organization suggests a white elephant sale to dispose of unwanted items. Another suggests displaying the items and asking the townspeople to take back what might belong to them. Consider the following questions:

1. It is important to verify the status of each article. Is an article placed on indefinite loan and never claimed more vulnerable to question than an article with no documentation?

2. The value of articles (monetary and/or historical value) can be an important consideration in determining prudent disposition. Can criteria be established for identi-

58. Refer to Section D(6)(f), "Native American Graves Protection and Repatriation Act," in Chapter IV.

59. See Chapter VII, "Unclaimed Loans." From the fact that the owner said he would call for the objects "in a year or so," can a reasonable term for the loan be inferred?

60. See Chapter VII, "Unclaimed Loans," and Chapter X, "Objects Found in the Collections."

fying objects of negligible value that can be disposed of in a more expeditious manner?

3. Is it safer to give away rather than sell objects that have clouded title?
4. If objects are offered back to townspeople, how will claims be processed, and how might this method of disposition be interpreted by some?[61]

Each of these hypothetical situations places a museum in an uncomfortable situation. The temptation may be to put off a decision or to give a noncommittal response, hoping the problem will go away. Yet delay rarely works in a museum's favor. If the museum, after investigation, really believes it should acquiesce, then it maintains its credibility by doing so in a timely manner. If, on the other hand, investigation convinces the museum that it should deny the claim, a prompt, clear, written refusal is the most efficient way to resolve the matter. The refusal starts a statute of limitations running so that if the requestor fails to press the claim in court within the time allowed by the relevant statute, the claim is thereafter barred.[62]

61. See Chapter X, "Objects Found in the Collections," for issues raised in this hypothetical situation.
62. See Section D(5)(a) in Chapter IV. See also the *Magruder* case cited in footnote 57, above.

Loans

Incoming and Outgoing

Loans, both incoming and outgoing, present distinct problems, and invariably these prob-
lems are best managed by preplanning. A museum's collection management policy should
establish rules and procedures that are designed to encourage thoughtful attention to all
aspects of loan procedure, whether objects are being borrowed or loaned. Issues that may
be addressed in the policy are listed in Chapter III, "Collection Management Policies," in
Section B, "Guidelines for Preparing a Collection Management Policy." In this chapter, some
of these issues will be explored in more detail.[1]

A. Incoming Loans

1. LIABILITY EXPOSURE

In everyday legal parlance, a loan creates a bailment. The term *bailment* is derived from the
French word *bailier* meaning "to deliver": "[It imports] a delivery of personal property by
one person to another in trust for a specific purpose, with a contract, expressed or implied,
that the trust shall be faithfully executed and the property returned or duly accounted for
when the specific purpose is accomplished or kept until bailor claims it."[2]

When a loan is made to a museum, the lender is the bailor (the one giving), and the
museum is the bailee (the one receiving). The law recognizes innumerable forms of bail-
ments; some are classified for the benefit of the bailor, some for the benefit of the bailee,
and others for mutual benefit. The classifications are relevant when determining the rights
and liabilities of the parties. For example, if the bailment is viewed primarily as a benefit to
the bailor, the standard of care imposed on the bailee is more relaxed. The bailee may be
held liable only for gross negligence.[3] If, on the other hand, the arrangement also is for the
benefit of the bailee, the law requires the bailee to exercise at least due care in managing
the entrusted property.

Although the law establishes general categories of bailments and sets forth duties im-
posed by each, these become of major importance only when there is no expressed contract
governing the arrangements.[4] If there is an expressed contract, its terms prevail.[5] A museum
is advised, therefore, never to accept a loan unless there is a written contract (that is, an

1. In 1991, the Registrars Committee of the American Association of Museums issued "Statement of Prac-
tice for Borrowing and Lending." The statement, which summarizes common loan practices of art, history, and
natural history museums, was published to offer guidance to museums as they review their own current loan
procedures. The Registrars Committee is a standing professional committee of the American Association of
Museums.

2. *Commonwealth v. Polk*, 256 Ky. 100, 75 S.W.2d 761, 764 (1934).

3. "Gross negligence" is subject to different definitions. In the California Art Preservation Act (Cal. Civil
Code § 987), the term is defined to mean "the exercise of so slight a degree of care as to justify the belief that
there was an indifference to the particular work of fine art."

4. See *Prince v. Alabama State Fair*, 106 Ala. 340, 17 So. 449 (1895); *Colburn v. Washington State Art Ass'n.*, 80
Wash. 662, 141 P. 1153 (1914).

5. Assuming the contract does not violate public policy. See also the following footnote.

incoming loan agreement) spelling out the rights and responsibilities of each party. Leaving the situation up to the common law could result in some unhappy surprises.

The museum's incoming loan agreement (the bailment contract) should recite the standard of care that will be accorded the object while on loan.[6] The most frequently used statement is that the museum will exercise the same care as it does in the safekeeping of its own objects of a similar type.[7] Some loan forms speak of "ordinary care and supervision" or "reasonable care."[8] Other museums seem to impose a slightly higher standard on themselves when they promise to take "every possible care of the object."

2. INSURANCE

Invariably, the incoming loan form addresses the subject of insurance for the objects. The museum should insure borrowed objects. If an object is lost or damaged while on loan, the museum, as bailee, has the burden of proving that it was not negligent.[9] In many instances, this is a difficult burden to sustain because the museum must come forward and prove due care. If there is uncertainty as to how an accident occurred, the party that must prove due care frequently suffers. Insurance offers a practical method for resolving lenders' claims, and it protects the museum from possible catastrophic liability.

The incoming loan agreement usually offers the lender several options regarding insurance. The insurance can be carried by the borrowing museum, the lender can maintain its own insurance at the borrowing museum's expense, or insurance can be waived. To enable the lender to make an informed decision, the loan agreement should briefly describe the insurance offered by the museum. Is it the "all risk" wall-to-wall policy subject to standard exclusions? (Be certain to list exclusions.) Also, the loan agreement form should have a provision stating that the amount payable by the insurance is the sole recovery available to the lender in case of loss or damage. And experience has shown that even this last simple statement merits further refinement in the loan agreement. In some situations, an insured object suffered damage while on loan, and the owner then claimed that because the object

6. Whether a museum can release itself from any and all negligence as bailee is questionable. Sometimes, a release is held to excuse simple negligence but not gross negligence. There is also the issue of whether the bailor was sufficiently informed of the release. See *Picker v. Searcher's Detective Agency, Inc.,* 515 F.2d 1316 (D.C. Cir. 1975); *Smith v. Library Board of Minneapolis,* 58 Minn. 108, 59 N.W. 979 (1894); *Kay County Free Fair Ass'n v. Martin,* 190 Okla. 225, 122 P.2d 393 (1942).

7. In *Gardini v. Museum of New York,* 173 Misc. 791, 19 N.Y.S.2d 96 (1940), the loan contract read, "[T]he museum is not responsible for the safekeeping of articles entrusted to it for exhibition beyond the exercise of such precautions as are now in force, or may hereafter be put in force, for the safekeeping and preservation of the property of the museum itself." The court held that this language entitled the lender to believe that its property would receive the care given by a reasonably prudent museum and that this language did not absolve the museum from the responsibility of exercising reasonable care in safeguarding the property.

8. "The degree of care which a man may reasonably be required to take of anything (loaned) must . . . essentially depend upon the quality and value of the thing, and the temptation thereby afforded to theft. The bailee, therefore, ought to proportion his care to the injury or loss which is likely to be sustained by any improvidence on his part." J. Story, *Bailments* (Littleton, Colo.: F. B. Rothman, 1986), § 15. See also *Perera v. Panama-Pacific International Exposition Co.,* 179 Cal. 63, 175 P. 454 (1918).

9. *Colburn v. Washington State Art Ass'n,* 80 Wash. 662, 141 P. 1153 (1914).

had appreciated in value while on loan, the partial loss now equaled the maximum value originally placed on the object. In other words, it has been argued that the loan agreement does not mandate that the stated insured value should always be considered the total loss value. To avoid confusion on this point, the museum should add to the loan form a sentence such as the following: "Any recovery for depreciation or loss of value shall be calculated on a percentage of the insured value specified by the lender in the agreement."

If the lender elects to maintain insurance at the borrowing museum's expense,[10] several points should be spelled out in the loan agreement. The museum should require that it be listed as an additional insured on the policy or that rights of subrogation be waived. This is to prevent a possible later rude awakening for the museum in the event of a loss. Suppose the lender provides insurance for a valuable piece lent to the museum. Through negligence on the part of a museum employee, the object is damaged, and restoration costs are high. The lender's insurance company reimburses the lender for these expenses, and in so doing, the lender's rights arising out of the accident are subrogated (passed on) to the insurance company. The insurance company turns around and sues the museum for the restoration expenses caused by the museum's negligence. Certainly, the museum has not been protected by the lender's insurance. This can be avoided with some certainty by having the museum listed as an additional insured on the policy (the insurance company cannot seek reimbursement from the insured) or by having the lender waive the subrogation of rights against the museum.[11]

Additional issues should be clarified in the loan agreement when the lender insures. Some museums prefer to have in hand, before an object is shipped, a certificate of insurance verifying that the required insurance has been procured by the lender. Other museums look on this requirement to monitor a commitment made by the lender as placing an undue burden on the receiving museums. They prefer to rely on a statement saying that failure of the lender to provide the agreed-upon insurance constitutes a complete release of the receiving museum from any liability for damage to or loss of the property placed on loan. Even if a museum elects to request certificates of insurance, it may want to include the added precaution that failure of a lender to secure insurance constitutes a complete release of the borrower from any liability. The loan agreement should also provide that the museum will not be responsible for any error or deficiency in information provided by the lender to the insurer or for any lapse by the lender in coverage.

Situations may possibly arise in which, for practical reasons, a lender may want to waive

10. The loan form should ask the lender to estimate premium costs so that possible problems in this area can be resolved before presentation of the bill.

11. If the museum carries legal liability insurance, a common clause in most collection insurance policies, its own insurance company will defend if such a claim is brought against it. With legal liability insurance, the museum may not need to request a waiver of subrogation or be named as an additional insured. See also *Housing Investment Corp. v. Carris*, 389 So.2d 689 (Fla. Dist. Ct. App. 5th Dist. 1980), and *Fortin v. Nebel Heating Corp.*, 12 Mass. App. Ct. 1006, 429 N.E.2d 363 (1981). These cases discuss the proposition that when parties to a contract agree that one party will obtain insurance as part of the bargain, the risk of loss from both of them is shifted to the insurance carrier. In other words, in such instances the implication is that subrogation is not allowed.

insurance coverage. Unless it is clear in the loan agreement that this waiver constitutes a release of the museum from any liability arising out of the loan, the museum can still be sued by the lender, exposing it to legal fees and possible damages. A release of liability, therefore, should go hand in glove with a waiver of insurance. Even a release of liability might not protect a museum if loss is caused by the museum's gross negligence.[12] One additional caution is that if a lender elects to waive insurance coverage and signs a release because the lender is relying on protection from a blanket insurance policy, the lender should inform its insurer in advance. Execution of the release by the lender without concurrence by the insurer could inhibit the lender's ability to pursue a later claim under the policy. (In other words, the insurer might claim that the lender signed away the insurer's right of subrogation without the insurer's permission.)

The valuation of the lender's objects for insurance purposes can be troublesome. As a rule, the valuation should reflect fair market value, and this caution can be printed on the loan form.[13] Some lenders still, innocently or through design, grossly overvalue their objects. This issue is important whether the museum is insuring or whether it is paying the premiums for the lender's own insurance. In either event, there are obvious financial considerations and sometimes also ethical considerations, which are subtle and more difficult to deal with. If a claim is filed on an article that has been grossly overvalued, the insurer is bound to have questions. Did the museum, by accepting the valuation, tacitly endorse it? Can the museum honestly say "It is not my problem" and yet retain the goodwill of the insurer and/or the lender? Even if no claim is ever presented on the overvalued object, did the museum nevertheless assist in "hyping" the object? The owner can always demonstrate that the object was valued at that figure when loaned to the museum. The museum bears some responsibility for monitoring gross overvaluation, as well as gross undervaluation. Frequently, this can be one of the more difficult tasks for museum staff, but it should not be skirted or left for someone to resolve frantically at the last minute. Curators or even the insurer may be able to suggest where valuations of comparable objects can be checked by the lender. If all else fails, the museum should reconsider, at a very high level, whether the loan should be pursued.

Sometimes lenders fail to give valuations. They do not want to be bothered, or they do not know where to begin. To cover these situations, the loan agreement can provide that if a valuation is not given, the lender agrees to accept an insurance value set by the museum and that this value is not to be considered an appraisal. Museums are placed in an awkward position when they have the burden of setting an insurance figure on property owned by others, and it should be understood that under the circumstances, all the museum will provide is a figure within reasonable limits.

12. *Smith v. Library Board of Minneapolis*, 58 Minn. 108, 59 N.W. 979 (1894).

13. The cost of restoring a damaged object may exceed its fair market value, and the lender may request coverage of the greater figure because of the unique nature of the object. A museum is advised not to accept an arrangement containing unlimited liability for restoration. Some compromise should be reached and a maximum figure set.

In the case of long-term loans,[14] the loan form should clearly state who has the responsibility for updating insurance valuations. Most loan forms have a statement notifying the lender that it is the lender's responsibility to notify the museum if it wants adjustments on insurance values.

Some museums that borrow fabricated works of art have limited insurance recovery in their loan agreements in certain instances. A well-known museum administrator gives two favorite examples that illustrate the problem. One concerns the sculptor who worked in fabricated steel; he lent his work, with an insurance value of $25,000, to a museum. The work was damaged while on loan, and the museum quickly reported the accident to the sculptor and assured him that it would pay the $4,000 necessary to have the damaged portion replaced by the steel fabricator. (The plans were still with the fabricator.) The sculptor demanded $25,000. After much wrangling, there was a substantial settlement.

The other example concerns a temporary exhibition of light works designed for a museum by an artist using neon tubes. After the artist prepared the specifications, the museum bought the parts and provided the labor to assemble the display. The total cost was $800. On the loan form, the exhibition was valued at $25,000 for insurance purposes. If some neon tubes are broken during the course of the loan, what is the recovery? This type of situation has prompted the inclusion in some loan agreements of a provision stating that in the case of works that have been industrially fabricated and that can be replaced, the museum's liability, regardless of insurance valuation, is limited to the cost of such replacement.

3. AUTHORITY TO ACCEPT LOANS

Since the acceptance of loans brings with it a considerable liability exposure for the museum, it is only prudent to establish clearly who in the museum has the authority to approve an incoming loan.[15] In a large, complex museum with considerable loan activity, approval authority may have to be delegated and redelegated depending, for example, on the value and kind of objects involved. Such delegations are frequently accompanied with a caveat that unusual situations should be reserved for at least the director's attention. A clarification of approval authority and appropriate lines of delegation can be accomplished quite neatly by means of the collection management policy. Once adopted by a museum's governing board, a collection management policy that spells out incoming loan procedures and approval authorities should constitute a valid delegation of power.

4. LOAN POLICY

Setting out in writing the purposes for which loans can be accepted is a useful exercise and can prevent embarrassment. Some people look on museums as convenient warehouses, and

14. See Section A(6), "Duration of Loans."

15. On the issue of whether a museum has an implied power to accept objects on loan, see *Smith v. Library Board of Minneapolis*, 58 Minn. 108, 59 N.W. 979 (1894). Museums that are nonprofit organizations usually have broad implied powers. The museum that is part of government does not fall within this category, and it needs to verify its statutory authority to accept loans and to provide insurance coverage.

with no clear policy direction, it can be difficult for the individual staff member tactfully to refuse friends of the museum who want to store family treasures. For example, if a museum has an established policy that, unless written permission is obtained from the director (or board of trustees), loans will be accepted only for special exhibits or for approved research, a ready answer is available.

An exception procedure to the general rule is a sensible precaution. Delicate situations can arise in which potential donors are looking for receptive homes for their collections. Museums have been known to offer free storage and other considerations.[16] In New York, the attorney general publicly questioned the legality of one museum's decision to offer long-term housing to a prospective donor's collection. At issue was whether funds dedicated to a public purpose were being ill-used in this instance. No legal action was taken, perhaps because these situations are rarely all black or all white. Much can be said on both sides, and invariably, some very hard decisions have to be made by the museum.

There are additional matters that are worth considering when setting incoming loan policy. The fact that an object has been exhibited in a museum invariably enhances its monetary worth. Lenders have been known to whisk their objects from the exhibit floor to the auction block, touting recent exposure at a museum. Or the local museum of design might borrow for exhibit exemplary samples of contemporary crafts only to have the museum director later open the newspaper and read advertisements describing the crafts as "museum quality" or "selected by" the museum. Such potential problems should be brought to the attention of the staff. The first example is more difficult to control. The best protection is a perceptive staff that recognizes the pitfalls and selects lenders carefully. A simple precaution can control instances like the second example. If there is a possibility that the lender may use the loan for commercial advantage, he or she can be asked to sign a statement (or such a statement may be incorporated into the loan agreement) promising that no commercial exploitation will be made of the fact that the object was exhibited by the museum. If the lender objects to this provision, the museum may want to look for another lender. A museum that gives even the appearance that favoritism or commercialism rather than scholarship dictates loan selections is courting trouble.

Closely allied is the subject of borrowing objects from board members or employees. Such loans are particularly vulnerable to accusations of self-dealing. A museum should have very stringent rules about this practice.[17]

Provenance issues should be considered regarding incoming loans. If, for example, an article is stolen property, was imported illegally, or was taken in violation of certain endangered species laws, the party that has custody of the article may be embroiled in legal proceedings. A certain amount of caution is necessary. If staff members are well-instructed

16. Museums are becoming increasingly aware of the fact that "storage" is costly. See Chapter VII, "Unclaimed Loans," footnote 22.

17. See Chapter I regarding the standard of care imposed on museum trustees. See also A. Ullberg and P. Ullberg, *Museum Trusteeship* (Washington, D.C.: AAM, 1981), Chapter V. Any instructions in a museum's collection management policy on the subject of borrowing objects owned by trustees or employees should be coordinated with the museum's code of ethics section on personal collecting.

regarding the provenance criteria applicable to museum acquisitions, these same criteria can serve as guides in reviewing proposed incoming loans. Also, if a museum has publicly committed itself to an acquisition policy consonant with the goals of the UNESCO Convention on the Means of Prohibiting and Preventing the Illicit Import, Export, and Transfer of Ownership of Cultural Property,[18] the display of borrowed material acquired by its owners in contravention of those goals can be an embarrassment.

A prudent provision in any incoming loan form is an affirmation by the signer of the form that he or she either is the owner of the object or is a duly authorized agent of the owner with full authority to enter into the loan agreement. This affirmation is not a cure-all, but it does demonstrate, if this point later becomes important, that the museum asked for and received assurance of authority to lend. Also, the very presence of the statement on the form might cause the uncertain lender to pause and to resolve in advance any problems in this area.[19]

5. HANDLING AND USE OF OBJECTS ON LOAN

It should not be assumed that lenders are familiar with what a museum may consider the routine use of borrowed objects. To avoid misunderstanding, the museum should spell out these uses in the loan agreement. If the lender objects to specific provisions, these can be discussed before entering into a loan contract.

If a museum does not restrict the use of cameras by the general public in exhibition areas, this may be worth noting on the loan agreement. If the museum expects to be able to photograph or otherwise reproduce borrowed objects for catalog, educational, or publicity purposes, this should be stated in the loan agreement. Such a statement can resolve copyright issues that could arise later on. Frequently, the subject of exhibit labels is important to the lender. The museum may want to clarify its policy in this regard and reach written agreement on the wording or placement of any credit line. If the museum reserves the right to fumigate objects and/or to examine them by photographic techniques, the loan form should so indicate. Most museums will not repair, restore, or in any way alter an object without the lender's written permission. This is a sensible rule and one worth noting on the loan agreement. Even though a museum may reserve the right to cancel a loan at will, it might want to state on the loan form that an object may be withdrawn from display at any time.[20] Occasionally lenders have considered it a breach of contract for a museum not to display continuously objects on loan.

18. See Chapter IV, "The Acquisition of Objects: Accessioning," Section D(6), "Objects Improperly Removed from Their Countries of Origin."

19. Consider, for example, this not uncommon occurrence. A museum eager to obtain the loan of a particular object for a special exhibition permits the loan form to be signed by someone with questionable authority or even permits two loan forms to be signed, each by a party claiming ownership. When the exhibition is over and it is time to return the object, the museum is faced with conflicting claims of ownership. The museum acts at its peril if it returns the object to the wrong party. The loan may end up costing the museum a sizable legal fee to unravel a situation it could have avoided.

20. See Section A(6), "Duration of Loans."

Lenders should receive notice of the museum's expectations concerning the condition and handling of borrowed objects. The average insurance policy covers a borrowed object "wall to wall" (from the time the object leaves the owner's wall, or custody, until it is returned). The borrowing museum, therefore, has a definite interest in protecting its liability from the very inception of object movement. Where appropriate, several contract requirements can be imposed that lessen liability exposure. Some museums insert in their loan form a statement that the lender certifies that objects lent can withstand ordinary strains of packing, transportation, and handling. Museums may also request that the lender send a written condition report prior to shipment of objects. These two devices are designed to focus the lender's attention on its role in risk management. If for some reason the objects in question should not travel or should travel only with special handling, the owner has the opportunity to give notice. The borrowing museum may also want to reserve some control over packing and transportation methods. It may reserve the right to prescribe such methods or to approve the owner's methods. Much depends on the nature of the objects and the expertise of the lender.

A museum should have definite in-house procedures for monitoring the condition of loans. Immediately on receipt, borrowed material should be inspected and photographed, if appropriate, and written notations should be made of findings. Damage or suspected damage should be investigated immediately and appropriate action taken to notify the owner and the insurer. As a rule, none of this will happen unless there is clear definition of responsibility. Who is responsible for receiving and opening packages? Who must inspect? Who within the museum must be notified if there is damage, and who is responsible, for example, for compiling a record of findings and notifying the owner and the insurer? Who handles any claim negotiations? So often a museum's claim payments increase in direct proportion to its degree of disorganization.

Similar instruction should be in force regarding the responsibility for monitoring loans and for promptly returning borrowed objects. The same attention should be given to inspection, packing, and transportation when returning objects as is given on receipt. This is the museum's last opportunity to verify in writing, and/or through photographs, the exact objects being returned and their condition.

The following example illustrates the value of extra care. Museum X had on loan an exhibition of artwork done on transparent acrylic material. On the owner's instructions, Museum X was to pack the exhibition and forward it to Museum Z for a subsequent showing. Museum X carefully packed the artwork in specially constructed cartons and listed, photographed, and described each piece inserted. Three cartons were forwarded to Museum Z, and under separate cover, duplicate lists of the shipped material were mailed to Museum Z. Several months later, a very agitated owner called Museum X. He had just visited the opening of his show in Museum Z, and two of his works were missing. Museum Z claimed it had never seen them. The owner valued the works at $10,000. On investigation, Museum X was able to produce descriptions and photographs of the objects it claimed it had forwarded. It could also produce duplicates of the lists sent to Museum Z. Museum Z, in turn, could not explain why it had not noted the discrepancy between the shipping list

and what it claimed it had received. In addition, Museum Z had to admit to destroying all the specially constructed transportation crates and the packing materials. With the suggestion that the two pieces of lost art had probably gone out with Museum Z's trash, Museum Z's insurer quietly paid the owner's claim.

6. DURATION OF LOANS

Lawyers who have museums as regular clients eventually meet their nemesis in the form of either the indefinite or the permanent loan. Loans that are not monitored only invite trouble. Lenders move away or die, records become obsolete or disappear, and before long the museum finds itself saddled with objects over which it has little effective control. Can such objects be disposed of? If they need conservation or repair, does the museum have the authority to initiate such work? Is it obliged to do so? Can heirs of lenders claim these objects generations later? As a rule, the law offers no quick solutions for the museum that is trying to clean house or assert title over objects left in its care for generations.[21] The only advice a lawyer may want to give with confidence is how to avoid these situations in the future.

Regarding prevention, a museum should adopt a general policy that all incoming loans must be for a set period that cannot exceed a certain length of time. For example, a museum's rule might be that all loans must be for a definite term but that no term can exceed five years. This restraint forces regular evaluation of each loan situation.[22] If mutually desired, the loan can be renewed and insurance valuations updated. If the material is ready for return, the likelihood is good that the lender is available or easily traced. If the museum would welcome the material as part of its own collections, this is a convenient opportunity to discuss the possibility with the lender. On the whole, this procedure is simply good management for the modern museum.

Regarding the duration of incoming loans, a museum may want to reserve to itself the ability to terminate a loan at any time before its expiration with reasonable notice to the owner. Consider this instance. A museum is planning a major special exhibition that will consist mainly of objects borrowed from private individuals, and loan agreements are executed. Shortly before the exhibition date, the museum loses most of the funding for the show, and the exhibit is canceled or drastically curtailed. Some of the lenders are enraged. They have touted the fact that these objects will be on exhibit, and they demand full execution of the loan agreement. Another unpleasant situation can arise when a museum has entered into a loan agreement only to find that the object it intends to borrow has serious provenance or ownership problems. If the museum goes through with the loan, it will be enmeshed in legal wrangling or professional criticism. Both situations can easily be solved if the loan agreement expressly warns that the museum may terminate the loan at will.

21. See Chapter VII, "Unclaimed Loans."

22. Today, museums are assumed to have in place adequate registrarial facilities and personnel for such a task or to be working toward that goal.

7. "PERMANENT" LOANS

By definition, loans are temporary arrangements, but regardless of what *Webster's* says, many museums are the possessors of permanent loans. And what is a permanent loan? The definitions are as varied as a roomful of museum professionals: "the opposite of a short-term loan"; "longer than an indefinite loan"; "a loan that ultimately will be given to the museum."[23] A lawyer turning to case law does not get much help, unless it is useful to know that in 1924 an English court stated, "I do not think 'permanent' [loan] means everlasting or perpetual and they are right in treating the word 'permanent' in the sense that it is contra-distinguished from something that is temporary."[24] *Corpus Juris Secundum* is closer to the mark. It notes, "The significance of the term ["permanent"] depends on the subject matter in connection with which it is employed, and its meaning is to be construed according to its nature and in its relation to the subject matter of the instrument in which it is used."[25]

In reality, therefore, the term "permanent loan" in itself tells little, and unless the parties spell out in detail precisely what is meant, uncertainty reigns. At best, some permanent loans are in written agreement form describing rights and obligations of the recipient museum. Most are bereft of such instructions, and questions constantly arise. Must the object be insured even if the museum does not insure its own collections? If the object is damaged, is the museum liable to the owner, and if so, how are damages measured? Can the object be lent to other museums? What if the museum can no longer justify the expense of retaining the object? If the owner is available, answers can be sought, but the museum may find that it has limited bargaining power.

Many permanent loan situations probably came about because the lender wanted to defer a hard decision and because the recipient museum, eager for the object, thought mainly in terms of present needs. Situations of this kind rarely improve with age, since there is even less incentive for the lender to make that "hard decision" after the museum has com-

23. See Chapter XI, "Promised Gifts." However, the term "permanent loan" as used in zoos is interpreted to mean a loan for the life of the specimen. In this sense, the loan is for a definite period and is not subject to many of the perils associated with the permanent loan of inanimate objects.

24. *Yorkshire Railway Wagon Co. v. Inland Revenue Commissioners*, 94 L.J.K.B. 134, 137 (1924).

25. 70 *C.J.S.* § 94, at 560. See also *Massachusetts Mutual Life Insurance Co. v. Montague*, 63 Ga. App. 137, 10 S.E.2d 279 (1940) and *Morgan Guaranty Trust Co. of New York v. The President and Fellows of Harvard College*, No. E 1855 (Mass. Probate Ct. of Worcester, Dec. 20, 1983). The question "What is a permanent loan?" also caused many problems for the Los Angeles County Museum of Art regarding a loan of the collection of the late Hal Wallis, a well-known movie producer. At his death, Wallis left written instructions that a group of his paintings were to be left indefinitely on loan to the museum. Accordingly, a loan "on a permanent basis" was negotiated with the museum by the Wallis Foundation. Later, the foundation recalled the paintings and put them up for auction. The museum sued for damages. The matter was settled by agreement. See *Museum Associates d/b/a/ Los Angeles County Museum of Art v. The Hal B. Wallis Foundation*, Supreme Court of the State of New York, County of New York, Filed May 17, 1989, and Superior Court of the State of California for the County of Los Angeles, Filed July 6, 1989, No. 729716, and *In the Matter of the Amended and Restated Declaration of Trust of the Hal B. Wallis Trust*, Superior Court of the State of California for the County of Los Angeles, Filed June 1, 1989, No. P734703.

mitted itself to caring for the object. As time goes on, the attractiveness of the loan to the museum may begin to dull because the upkeep has become expensive or because similar objects have since been acquired for the museum's collections. If the lender is not readily accessible,[26] much time and money can be spent trying to locate heirs or successors in interest to request renegotiation or termination. Even if the lender is known, the museum can only hope that it is sympathetic to changing the arrangements so that confrontation in court is unnecessary.

Consider this rather typical example. Organization X has acquired as a gift an extensive collection of books on the history of textiles. Under the terms of the gift, the organization can never dispose of the collection and must always keep it together in one room labeled as the collection of Donor Z. Before long, Organization X realizes that it has made a mistake; it has no urgent need for the collection and cannot justify the expense of upkeep. It turns to the local museum and offers to place the material on "permanent loan."[27] The museum quickly accepts. As years go by, the museum takes a closer look at its coup. Many of the books need expensive conservation work. The collection is of uneven quality, and if it was owned outright by the museum, it could be greatly improved by pruning and judicious exchange. In addition, the requirement that the collection be kept together in one room prevents its full utilization. The museum approaches Organization X, which is very reluctant to discuss the matter. Any relief will require that Organization X initiate a *cy pres* or similar petition in court, and the organization has no incentive to incur this expense.[28] In hindsight, the museum realizes that it should have taken a firmer stand when the loan was initially offered. The museum could have agreed to support the organization's petition for court relief if the petition requested permission to make an unrestricted gift of the collection to the museum. Or the museum could have accepted a loan of the collection for a limited period of time. At the termination date of the loan, the museum would have possessed an unquestioned right to return the collection if a more suitable arrangement could not be

26. For example, the museum may need to locate heirs of a long-deceased lender or locate successors in interest to a defunct organization.

27. In loaning the material, Organization X is arguably not "disposing" of it, since the organization retains title to the material. Thus, Organization X is acting within the terms of the donor's restrictions.

28. See Section E(1), "Restricted Gifts," in Chapter IV, "The Acquisition of Objects: Accessioning." In a situation somewhat similar to the hypothetical case, an additional issue was raised in *Maryland Institute College of Art v. Baltimore Museum of Art*, Civil No. 9503001/Cb191657 (Cir. Ct. for Baltimore City, Md., Opinion and Order dated 9/28/95), a museum accepted a long-term indefinite loan of artworks. When the organization owning the objects sought to recall them because it had decided to sell the works, the museum challenged the organization's right to sell the art (claiming that the art had been donated with restrictions) and, in the alternative, claimed that if the museum was required to return the art, the museum was due reimbursement for the years of care it had given the art. In effect, the museum was arguing that the organization that owned the works would be "unjustly enriched" if it was able to recall the art without compensating the museum for the conservation and other work done while the artworks were on long-term loan. Fortunately, the museum did not press this claim. This was a situation in which the borrowing museum wanted the loan to continue, and it could readily have contacted the lender if it had wanted to return the objects or could have negotiated a payment for certain costs of upkeep. Pressing a claim for unjust enrichment in such a situation can have unfortunate effects on lending practices for museums.

negotiated. Faced with the imminent return of the collection, Organization X might have had more incentive to resolve the matter.

It is difficult to imagine a situation where an indefinite loan is a more suitable arrangement than a series of term loans. In this day and age, entering into an indefinite loan situation usually marks a museum as sorely lacking in professionalism. However, a permanent loan between organizations or institutions might be justified in rare circumstances. For instance, one organization may have a very strong moral and/or cultural claim to material but may not be able to support with certainty a legal claim. The possessor organization might conclude, with good reason, that the public will generally benefit if the material is in the custody of the claiming organization, but it may be reluctant to pass title because of the possibility that someday the material could be transferred to a third party. A permanent loan, with the rights of each party carefully spelled out in an agreement, might be a legitimate solution.[29]

8. CHANGE IN OWNERSHIP

The incoming loan form should require the lender or the lender's representative to give prompt notice to the museum if there is a change in ownership of the material on loan. Loan agreements impose obligations requiring that a museum periodically consult with the owner, and of course, the museum should be able to reach the owner at the termination of the loan or sooner if an early termination is sought. If the present owner cannot be ascertained conveniently and with certainty, the museum is at a grave disadvantage. Therefore, the museum should clearly indicate that as part of the loan agreement, the owner or the owner's representative has a responsibility to keep in touch with the museum. This provision is especially helpful if the owner dies during the loan period. Notice to the museum by the estate at the owner's death permits consultation regarding oversight of the loan during probate proceedings and verification of who will succeed to the owner's rights. If mutually agreeable, a new loan agreement can be entered into with the party succeeding in interest, or the museum, with the assurance that it is dealing with the right party, can return the material. The notice provision also may help in those cases in which the museum is unable to locate an owner and, years later, heirs appear to claim the property. If in fact no notice was given to the museum of the change in ownership, the failure to abide by the terms of the loan agreement would work to the heirs' detriment.

9. RETURN PROVISIONS

Through experience, most museums have learned that not all owners can be relied on to retrieve their property. Too often, museums have found themselves holding, indefinitely, property of owners who cannot be located, and the law affords them no clear guidance on

29. Another, and perhaps better, solution might be for a museum to make a gift of the material to the claiming organization, with the stipulation that before the material can be retransferred, it must first be offered back as a gift to the museum. See also M. Malaro, "How to Protect Yourself from Not-So-Permanent Loans," *Museum News* 22 (Sept.–Oct. 1989).

how to resolve these matters.[30] Increasingly, museums are trying to prevent such situations by spelling out in their incoming loan agreements exactly what will happen if property is not claimed in a reasonable time. The technique is still relatively new, and there has been little practical experience in enforcing such a provision, but a museum would do well to consider the merits of the provision.

According to such a clause, if material cannot be returned at the termination of a loan, it will be maintained at the owner's expense and risk for a set number of years.[31] At the expiration of this final period, if the material is still unclaimed, the owner, in consideration of the museum's care, is deemed to have made an unconditional gift of the property to the museum. In drafting and implementing such a provision, a museum should observe several cautions. First, the loan agreement should be clear as to the date the loan terminates. This sets the precise time when the owner should come forward. If this element is missing, the museum will have difficulty establishing when the holding period began. Without a certain time, the owner or the owner's heirs can always argue that the loan was meant to last until they saw fit to demand the return of the property. Second, the museum should clarify which party has to initiate the return. Some loan forms provide alternative arrangements from which to select. The owner can request the museum to mail the object to a specified address, or the owner can elect to retrieve the object. If options are offered, the museum should be sure that a selection has been made. Finally, the museum should provide some form of written notice to the owner when the loan terminates, stating that the material is being mailed or that it is time to retrieve the object. If cautions such as these are observed and the museum maintains meticulous records documenting its efforts to return the property, the "gift provision" should withstand challenge.

When borrowed objects are returned, the museum should have some form of a written receipt as part of its loan record. In the case of objects retrieved in person by the owner or agent, proper identification should be requested and the receipt immediately signed. Objects returned by mail should include a return receipt, or preferably, the receipt can be sent separately by certified mail. Experience has demonstrated that the lender should be required to return the receipt within a certain time period or else forfeit any claim for damage or loss. The purpose of the requirement is to encourage claim resolution while evidence is fresh, a fair procedure for all concerned.

10. SAMPLE INCOMING LOAN AGREEMENT

Like all other sample forms, the model incoming loan agreements that follow should not be adopted by a museum without independent review by competent professionals. If the lender is another museum, quite possibly the lender may insist on using its outgoing loan form. This is understandable because its objects are at issue. In such cases, each party should

30. See Chapter VII, "Unclaimed Loans."

31. Often this period is the local statute of limitations for bringing actions to recover wrongfully held property.

carefully review the other's form, and differences should be resolved in advance. It is not unusual (assuming no major differences are apparent) for both forms to be signed with the expressed understanding that the terms of one (usually the lending museum's form) will prevail in case a conflict develops.

The first model form is patterned on one used by a large history museum and is suitable for a range of loan purposes (see Figure VI.1). The second model is based on one that a large art museum uses specifically to borrow artwork for a discrete exhibition (see Figure VI.2).

Figure VI.1
Agreement for Incoming Loan (History Museum)

Museum Control No. _____

NAME OF MUSEUM (hereafter "Museum")
ADDRESS OF MUSEUM
TELEPHONE NUMBER OF MUSEUM
FAX NUMBER OF MUSEUM

AGREEMENT FOR INCOMING LOAN Date: _____

From: _____ Telephone:_____
 (name of lender) Fax:_____

Address: _____

In accordance with the conditions printed on the reverse, the objects listed below are borrowed for the following purpose(s): (give name of exhibition when applicable)

for the period* _____ to _____
(*from estimated time objects leave lender's custody until their return and receipt by lender; see "Shipping" below.)

Objects	Description (Please include size, weight, and brief report of condition; and attach a recent photo if possible.)	Insurance Value (please itemize)

Continued on next page

Figure VI.1 continued

(If additional space is necessary, attach extra sheet.)

Initiated by

 (museum curator) (museum department)

INSURANCE: (see conditions on reverse)

[] to be carried by Museum
[] to be carried by Lender: estimated premium charge
$_____

[] insurance waived

PACKING and SHIPPING: The following packing and shipping arrangements are proposed subject to review and approval by the Museum's Registrar's Office in consultation with the Lender.

Objects to be packed by: _____ Lender _____ Museum
Other: _____

To be shipped from (address and contact):

To arrive no later than (date): _____
Via: _____

To be returned to above address (unless otherwise notified)
Via: _____

COSTS: Borrower will pay all costs of packing, shipping, insurance, unless otherwise noted here: _____

CREDIT LINE (for exhibition label and catalog):

SPECIAL REQUIREMENTS for handling, installation, etc. (attach continuation sheet if necessary): _____

(Loan Agreement continued on reverse side.)

.

CONDITIONS GOVERNING LOANS

Care, Preservation & Exhibition
1. The Museum will give to objects borrowed the same care as it does comparable property of its own. Precautions will be taken to protect objects from fire, theft, mishandling, dirt and insects, and extremes of light,

Figure VI.1 continued

temperature and humidity while in the Museum's custody. It is understood by the Lender and the Museum that all tangible objects are subject to gradual inherent deterioration for which neither party is responsible.

2. Evidence of damage at the time of receipt or while in the Museum's custody will be reported immediately to the Lender. It is understood that objects, which in the opinion of the Museum show evidence of infestation, may be fumigated at the discretion of the Museum.

3. The Lender will be requested to provide written authorization for any alteration, restoration or repair. The Museum may examine objects by all modern scientific methods.

4. The Museum retains the right to determine when, if and for how long objects borrowed will be exhibited. The Museum retains the right to cancel the loan upon reasonable notice to the Lender.

Transportation and Packing

1. The Lender certifies that the objects lent are in such condition as to withstand ordinary strains of packing and transportation and handling. A written report of condition of objects prior to shipment must be sent by the Lender to the Museum. Otherwise, it will be assumed that objects are received in the same condition as when leaving the Lender's possession. Condition records which may include photographs will be made at the Museum on arrival and departure.

2. Costs of transportation and packing will be borne by the Museum unless the loan is at the Lender's request. The method of shipment must be agreed upon by both parties.

3. Government regulations will be adhered to in international shipments. As a rule, the Lender is responsible for adhering to its country's import/export requirements and the borrower is responsible for adhering to its country's import/export requirements.

4. The Lender will assure that said objects are adequately and securely packed for the type of shipment agreed upon, including any special instructions for unpacking and repacking. Objects will be returned packed in the same or similar materials as received unless otherwise authorized by the Lender.

Insurance

1. Objects will be insured for the amount specified herein by the Museum under its "all risk" wall-to-wall policy subject to the following standard exclusions: wear and tear, gradual deterioration, insects, vermin or inherent vice; repairing, restoration or retouching process; hostile or warlike action, insurrection, rebellion, etc.; nuclear reaction, nuclear radiation or radioactive contamination. Insurance will be placed in the amount specified by the Lender herein which must reflect fair market value. If the Lender fails to indicate an amount, the Museum, with the implied concurrence of the Lender, will set a value only for purposes of insurance for the period of the loan. Said value is not to be considered an appraisal.

2. If the Lender elects to maintain his own insurance coverage, then prior to shipping the Museum must be supplied with a certificate of insurance naming the Museum as an additional insured or waiving rights of subrogation. If the Lender fails to provide said certificate, this failure shall constitute a waiver of insurance by the Lender (see No. 4 below). The Museum shall not be responsible for any error or deficiency in information furnished by the Lender to the insurer or for any lapses in such coverage.

3. In the case of long-term loans, it is the responsibility of the Lender to notify the Museum of updated insurance valuations.

4. If insurance is waived by the Lender, this waiver shall constitute the agreement of the Lender to release and hold harmless the Museum from any liability for damages to or loss of the loan property.

5. The amount payable by insurance secured in accordance with this loan agreement is the sole recovery available to the Lender from the Museum in the event of loss or damage. Any recovery for depreciation or loss of value shall be calculated as a percentage of the insured value specified by the Lender in the agreement.

Reproduction and Credit

Unless otherwise notified in writing by the Lender, the Museum may photograph or reproduce the objects lent for educational, catalog and publicity purposes. It is understood that objects on exhibit may be photographed by the general public. Unless otherwise instructed in writing, the Museum will give credit to the Lender as specified on the face of this agreement in any publications. Whether individual labels are provided for objects on display is at the discretion of the Museum.

Continued on next page

Figure VI.1 continued

Change in Ownership and/or Address

It is the responsibility of the Lender or his agent to notify the Museum promptly in writing if there is any change in ownership of the objects (whether through *inter vivos* transfer or death) or if there is a change in the identity or address of the Lender. The Museum assumes no responsibility to search for a Lender (or owner) who cannot be reached at the address of record.

Return of Loans

1. Unless otherwise agreed in writing, a loan terminates on the date specified on the face of this agreement. If no date is specified, the loan shall be for a reasonable period of time, but in no event to exceed three years. Upon termination of a loan, the Lender is on notice that a return or renewal must be effected, or else an unrestricted gift of the objects will be inferred.

2. Objects will be returned only to the Lender of record or to a location mutually agreed upon in writing by the Museum and the Lender of record. In case of uncertainty, the Museum reserves the right to require a Lender/claimant to establish title by proof satisfactory to the Museum.

3. When the loan is returned, the Museum will send the Lender a receipt form. If this form is not signed and returned within thirty days after mailing, the Museum will not be responsible for any damage or loss.

4. If the Museum's efforts to return objects within a reasonable period following the termination of the loan are unsuccessful, then the objects will be maintained at the Lender's risk and expense for a maximum of _____ years. If after _____ years the objects have not been claimed, then and in consideration for maintenance and safeguarding, the Lender/Owner shall be deemed to have made the objects an unrestricted gift to the Museum.

Applicable Law

This agreement shall be construed in accordance with the law of the _____ (name of the applicable jurisdiction).

I have read and agree to the above conditions and certify that I have full authority to enter into this agreement.

Signed: _____ Date: _____
 (Lender*)

Title: _____

*If Lender is not the owner, complete the following two lines:
Name of owner: _____
Address of owner: _____

APPROVED FOR MUSEUM:

Signed: _____ Date: _____
Title: _____

(Please sign and return both copies.)

Figure VI.2

Agreement for Incoming Loan (Art Museum)

NAME OF MUSEUM (hereafter "Museum")
ADDRESS OF MUSEUM
TELEPHONE NUMBER OF MUSEUM
FAX NUMBER OF MUSEUM

LOAN AGREEMENT

Return this agreement to: _____

Exhibition Title: _____

Venues (Borrowers) and Dates: _____

Lender: _____

Address: _____

Telephone: _____ Fax: _____

Name, Address, and Telephone (if different from above) for collection & return: _____

Exact form of Lender's Name or Credit Line for exhibition label, catalogue, and other publications: _____

Artist Name or Attribution: _____

Title of Work: _____

Medium or Materials: _____

Support: _____

Date of Work: _____ Inventory Number: _____

Signature, Other Inscriptions, and Their Location on Work: _____

CIRCLE ONE:
Dimensions Height: _____ Width: _____
(Without Mat, Frame, or Base) Depth: _____ Weight: _____

Continued on next page

Figure VI.2 continued

Dimensions Height: _____ Width: _____
(With Mat, Frame, or Base) Depth: _____ Weight: _____

(Loan Agreement Continued on Reverse Side)

· ·

INSURANCE

The Borrowers will exercise the same care with respect to the Work as they do in the safekeeping of their own works. The [NAME OF MUSEUM] will arrange for the insurance of the Work on a nail-to-nail basis for the value stipulated below, using standard fine arts commercial insurance and/or Untied States Government indemnity.

Insurance Value of the Work (U.S. Dollars):

$_____

The Lender agrees that in the event that the Work is lost or damaged, recovery, if any, will be limited to such amount as may be paid by the insurer plus any deductible, hereby releasing the Borrowers from any further liability for claims arising out of such loss or damage. If the Lender elects to maintain his own insurance, the Borrowers must be supplied with a certificate of insurance naming the Borrowers as additional insureds under the Lender's policy or waiving subrogation against the Borrowers. If the Lender elects to maintain his own insurance, this shall constitute a release of the Borrowers from any liability in connection with the Work. The Borrowers will accept no responsibility for any error or deficiency in information furnished to the Lender's insurers or for lapses in coverage.

PHOTOGRAPHY AND REPRODUCTION

Unless permission to do so has been specifically denied in writing by the Lender at or prior to the time this agreement is executed, the Lender authorizes the Borrowers to photograph, reproduce, and publish the Work in any medium for archival, educational, and publicity purposes.

Please send one black-and-white photograph of the work. If a photograph is not available, where can the Borrowers obtain one?

SHIPPING

Date Work due at first venue:

(Month/Day/Year)

The [NAME OF MUSEUM] assumes all costs of packing and transportation of the work, and will contact the Lender approximately three months before the opening of the exhibition to make necessary shipping arrangements.

SIGNATURES

The Lender declares that he has full authority to make this loan, that the information listed above is correct, and that he has read and accepts the conditions of this agreement.

SIGNED: _____ Date: _____
Name: _____ Title: _____
(Lender or Authorized Agent)

Figure VI.2 continued

SIGNED: _____ Date: _____

Name: _____ Title: _____

(For the [NAME OF MUSEUM] and other Borrowers*)

*Reference to "other Borrowers" is used when the exhibition will travel to other venues.

B. Outgoing Loans

1. TO WHOM WILL LOANS BE MADE?

When a museum assumes the role of lender, several new considerations arise that have legal implications. A very basic decision that should be made early is the museum's general policy regarding eligibility to borrow collection objects.

Most museums do not lend to individuals. There are sound reasons for this rule. Of paramount importance is the fact that museum collections are maintained for the benefit of the public; rarely can a museum justify their exclusive use by any individual. And there are additional reasons:

- Adjustments made in the tax laws many years ago require donors to relinquish control over property donated to a museum if full charitable-contribution tax deductions are to be taken. If museum policy permits donated property to be returned temporarily to the donor under a loan agreement, the validity of the donor's tax deduction could be called into question. (But see the fine points of this as discussed in Section F[4] of Chapter IV.)
- Museum trustees and officers have a duty not to self-deal when managing museum assets, and their acceptance of loans of collection objects for personal benefit could amount to a violation of this responsibility.[32] A museum policy that generally forbids loans to individuals serves as a useful reminder of this particular standard of conduct.
- When museum objects are on loan, they should be afforded the care and protection normally expected in a museum environment. As a rule, such requirements can be met more readily by institutional borrowers.[33]

Frequently, museums limit borrower eligibility even further by lending only to educational and/or nonprofit organizations. The purposes of this limitation are to focus loan activity on educational and research projects and to avoid entanglement in commercial ven-

32. See Chapter I, "What Is a Museum? What Is Required of Its Board Members?"

33. When objects are lent for scholarly research carried out primarily by an individual, the loan is usually made to the educational organization with which the individual is affiliated. That organization assumes the responsibility for the proper administration of the loan.

tures.[34] The latter purpose warrants special attention by government-run or government-associated museums.[35] Such museums could find their loan policies challenged on constitutional grounds if loan policies are drawn without reference to equal-protection guarantees. Consider the following example.

The X Historical Society, run under the auspices of the county government, is asked to mount a small exhibit in the lobby of the local bank. The exhibition will be part of the bank's fiftieth birthday celebration and will depict life in the county fifty years ago. The historical society eagerly agrees to the loan because the exhibit will have prominent exposure and the bank promises to meet all temperature, humidity, and security requirements. The exhibit is a popular success. Some months later, the historical society is approached by the local department store, which asks if it can borrow material for an exhibit on the local textile industry. The material will be used in an "educational" window display. Once again the society agrees. When the local liquor store comes forward with a similar request, it is rejected because "the loan wouldn't be suitable." The owner of the liquor store protests and threatens legal action.

There is a good possibility that the liquor store will get its exhibit. Both federal and state constitutional safeguards generally guarantee equal access to government-offered benefits, and exceptions are narrowly construed. Once the X Historical Society, a part of the local government, extended a benefit to the bank and the department store, both commercial entities, it established a practice, one that the law may well require it to administer even-handedly to all commercial entities in the area. The lesson, therefore, is simple, especially for government-run or government-associated museums: Have a thoughtfully prepared loan-eligibility policy, and understand all its implications. Once certain actions have been taken, selection criteria may be severely limited.

2. WHAT WILL BE LOANED?

If proper handling is to be afforded all objects in a museum's care, some distinctions must invariably be made regarding what can be placed on loan. A primary consideration is whether the museum has the authority to loan a particular object. If the object is on loan to the museum and is not part of its own collections, no outgoing loan should be considered without evidence of written approval from the owner.[36] A normal use of an incoming loan does not include a reloaning of the object. If such is contemplated, the permission of the owner should be expressly sought, usually in the loan agreement. Another consideration relating to authority to loan is whether the object is encumbered by restrictions that inhibit

34. In the 1990s, many museums set aside those purposes in order to pursue new sources of income. See Section C, "Nontraditional Loans."

35. The classification of a museum as "government-associated" frequently amounts to a determination of whether the museum is engaged in "government action." This determination depends on the circumstances of the particular case.

36. A possible copyright infringement problem could arise if objects on loan, which are subject to copyright, are reloaned for display without the permission of the owner of copyright.

a loan. Accession records should be reviewed carefully to see if any such restrictions exist. When there is doubt regarding the existence or interpretation of restrictive language, professional advice should be sought.[37]

The value, rarity, and/or condition of an object may dictate loan restrictions. No object should be exposed to loan conditions that may seriously threaten its safety, and the museum is obligated to use due care in this regard.[38] What constitutes due care depends on the facts of each situation. Possibly, some objects should never be placed on loan because of fragility. If there is a serious question concerning the ability of an object to travel, the museum should seek the opinion of a conservator.

To ensure that sufficient regard is given to the question of what should be loaned, a museum is advised to have written guidelines on hand for staff instruction. The guidelines also should be clear on the issue of who has the authority to approve loans.[39]

3. LOAN APPROVAL

As a rule, the basic authority to make loans resides in a museum's board of trustees.[40] The board may retain the exercise of this authority or, barring specific legal restrictions to the contrary, may delegate and redelegate its exercise. Complete delegation, however, without guidance and oversight, is not in accord with normally accepted trust responsibility,[41] and a museum's board will want to assure itself that policies and review procedures clarify who has the authority to make certain loans and what records must be maintained. If delegations are clear and adequate records are kept, effective oversight is possible.

When and how much loan-approval authority should be delegated are largely matters of common sense. In a large, complex museum, many routine outgoing loans can be left to the discretion of designated members of the professional staff. As a rule, such delegations are limited to loans not exceeding certain values or certain amounts or are limited to objects in certain classes. The rule of thumb for the museum's board is whether the delegation is a reasonable one in light of the museum's overall size and activities.

37. In a case discussed in Chapter IV, Section E(1), "Restricted Gifts"—*In re Trust of the Samuel Bancroft, Jr., Art Collection,* Civil Action No. 6601 (Del. Ct. of Ch., New Castle County, Oct. 28, 1981)—the Delaware Art Museum petitioned the court for instructions regarding the museum's ability to lend certain art objects. The objects had been given with the restriction that the museum "shall not . . . in any manner part with the possession of the objects." The court interpreted the restriction to permit loans.

38. As noted in Chapter I, a trustee has an affirmative obligation to preserve trust assets.

39. See *Johnson Estate,* 51 Pa. D&C 2d 147 (1970), in which the court approved a specific outgoing loan policy for the John G. Johnson Collection held in custody by the Philadelphia Museum of Art. See also "Guidelines for Lending Works of Art on Paper" (Print Council of America, 1995) for a discussion of loan policy regarding art on paper.

40. *Smith v. Library Board of Minneapolis,* 58 Minn. 108, 59 N.W. 979 (1894), held that a museum has an implied power to accept objects on loan. Each museum, however, must examine its own situation to determine whether express restrictions override any implied powers. See also footnote 15, above.

41. See Chapter I on the duties of trustees.

4. CARE OF OBJECTS

The lending museum has an obligation to take reasonable precautions to ensure that museum objects placed on loan receive proper care. If the borrowing institution is not known to the museum, a facilities report may be in order or even an inspection visit by museum staff so that such matters as physical conditions and security standards can be judged. Also, the museum's loan agreement should specify the care that should be afforded the borrowed objects so that there are no misunderstandings. If a museum has a history of poor experience with a borrower, prudence would dictate a stringent review before any new loans are negotiated.

A loan agreement usually contains a standard clause requiring the borrower to give prompt, written notice to the museum of any damage or loss to loaned objects. Also included is a general caution that objects cannot be altered, cleaned, or repaired without the written permission of the lending museum. If, in addition, a condition report is required of the borrower on receipt of a loan, not only is delivery confirmed, but any problems associated with transportation can also be handled in a timely manner. Requiring a similar condition report before objects are packed and shipped for return helps to pinpoint responsibility if the objects are received back in damaged condition.

Packing and transportation methods should not be left to chance.[42] The borrowing institution should be on notice that certain requirements must be met when the objects are in transit. If special cases have been prepared for sending the material, the borrower is usually instructed to retain the cases for use in return shipment. In any event, the lending museum should clearly communicate to the borrower any special care needed in unpacking the loan item or in returning it. The loan agreement should also specify who is responsible for the packing and transportation costs.

The cautions against indefinite and permanent loans mentioned in the Section "Incoming Loans" apply also to the museum as a lender. There are few situations in which it would be prudent for a lending museum to lend objects on an indefinite basis. Museums are obligated to use due care in overseeing collection assets, and if objects are loaned, the museum's responsibilities do not disappear. "Due care" can be interpreted to mean that loan situations should be checked periodically to see that objects are safe, that they are being used for the agreed-upon purpose, and that insurance valuations are current. A practice of lending only for a stated term, subject to renewal, encourages adherence to the due care standard.[43]

5. INSURANCE

Invariably, the lending museum insists on insurance coverage for all objects sent out on loan. Insurance offers the added measure of security that claims will be processed objectively and that resources will be available for payment of damages or replacement of the loaned object.

42. As noted in Chapter XV, "Insurance," one insurance expert cites accidents during transportation as the leading cause of museum collection claims.

43. See also Section C, "Nontraditional Loans."

As a rule, the borrower absorbs insurance costs by either providing insurance satisfactory to the lender or by reimbursing the lending museum for providing its own insurance.

If the borrower is to provide insurance, the lending museum will want evidence that adequate coverage has been obtained before objects are released. As a rule, a certificate of insurance or a copy of the policy is requested before shipment. The borrower should also be warned that any cancellation or meaningful change in insurance coverage must be immediately communicated to the lender. A wise precaution is to add to the loan agreement a statement that failure of the borrower to have in effect the agreed-upon insurance will in no way release the borrower from liability for loss or damage. The purpose of such a statement is to rebut any inference that the lending museum may have waived its rights by any inaction on its part in monitoring the borrower's insurance. Even if there is no insurance coverage, the lending museum still wants to preserve all legal rights it may have arising out of loss of or damage to its property.

Occasionally, a borrower is not able to provide standard insurance coverage. It may, for example, be a governmental entity that self-insures.[44] In such instances, the lending museum will want to assure itself that the borrower will respond to any loss or damage claim. If the borrower has an established method for processing claims and can demonstrate a history of fair and timely attention to such matters, the lending museum may well decide that there is no undue risk in negotiating a loan. However, a clear statement in the loan agreement to the effect that the borrower agrees to indemnify the museum for any loss or damage occurring during the course of the loan is an added protection. Such a statement establishes that the borrower was fully aware of potential liability when it undertook the loan.

Setting a value on objects for insurance can raise problems for the lending museum. For example, some natural history specimens may have no readily ascertainable market value, but their loss to the collections would be significant. Some objects may be irreplaceable, and some, if damaged, may need restoration work that could be more costly than their market value. The insurance value of an object does not always equal fair market value, and in those cases where insurance estimates significantly exceed the traditional fair market value test, the lending museum should be prepared to defend its position. If the borrower does not question the valuation before entering into the loan, the insurer may well do so when a claim arises. During negotiations for a loan, if there are serious differences of opinion between lender and borrower over insurance valuations, the advisability of going forward with the loan should be weighed. The costs of pursuing any claim that might arise and the potential for aggravating already strained relations may far exceed the perceived benefits from the loan.

44. Sometimes there can be great confusion regarding the ability of a governmental entity to buy insurance. A possible solution might be for the lending museum to impose a modest "service fee" for such loans and then use this fee to cover the loaned material under its own insurance policy.

6. DURATION, CANCELLATION, AND RETURN

As explained earlier, in Section A(7), indefinite loans are avoided today by the prudent museum, and a permanent loan should never be considered unless there are extraordinary circumstances and a carefully crafted agreement describing in detail the rights and obligations of both parties. When the museum is the lender (i.e., the situation is an outgoing loan), the reasoning behind this rule becomes even more evident. A museum that sends its objects off for indefinite or very long periods with no mechanism in place for regular monitoring of their use and care hardly presents a picture of prudent stewardship. Today museums lend objects only for stated, relatively short periods of time, subject to possible loan renewal.

When an object is loaned for a definite term, there is a presumption that the borrower, as long as it does not breach the terms of the loan agreement, will have the right to use the object for the stated time. If the lending museum wants to have the flexibility of canceling the loan before the termination date or of recalling the object for a period of time, these conditions should be made an express part of the loan agreement. Without the benefit of such contract provisions, the lender who attempts to recall objects before the stated termination date may get a firm refusal or, accompanying the returned material, a bill for damages.

If objects have been loaned on an indefinite basis, the normal assumption is that either borrower or lender may request termination. However, the facts of each situation must be reviewed to see if there is evidence that both parties may have intended otherwise when the loan was negotiated. Any museum that finds itself with objects out on indefinite or poorly documented permanent loan should consider the advantages of seeking to renegotiate each such loan for a stated term. As noted previously, indefinite or permanent loan situations tend to produce problems that grow worse with time. A museum may find it prudent to take the initiative in clarifying such loans with the borrower before conflicts arise that make amicable resolution much more difficult.

Once a loan has ended, the lending museum should promptly retrieve its property. Unclaimed property is likely to become lost or mislaid. Also, the borrowing organization could take the position that it owes a lesser standard of care to property left beyond the term of the loan agreement[45] or, if the property is unclaimed for a long period of time, that there is an inferred gift, as described in Section A(9) of this chapter. Therefore, a museum is advised to have in place a system for monitoring loan terminations, giving clear guidance to staff regarding responsibility for seeing that loans are actually returned.

7. SAMPLE OUTGOING LOAN AGREEMENT

Like all other sample forms, the outgoing loan agreements that follow should not be adopted by a museum without independent review by competent professionals. If in a particular transaction the borrower wants to use its incoming loan form as a supplement to

45. On expiration of a loan agreement and failure of the owner to retrieve, the argument can be made that the bailee now holds the property strictly for the benefit of the owner and, hence, is liable only for gross negligence. See the general discussion on bailment in Section A, "Incoming Loans."

the lender's outgoing form, both documents should be reviewed in advance for compatibility. Even where there appears to be no substantial conflict, the lender may still want to specify that its form will be the controlling one.

The first sample outgoing loan form is modeled on one used by a large history museum and is suitable for a range of loan activities (see Figure VI.3). The second sample outgoing loan form is one that several large art museums use specifically to lend artwork for exhibition (see Figure VI.4). For the sake of efficiency, the museums collaborated to produce a form that is acceptable to all of them.

Figure VI.3
Agreement for Outgoing Loan (History Museum)

Registrar's No. _____

NAME OF MUSEUM (hereafter "Museum")
ADDRESS
TELEPHONE & FAX NUMBERS OF MUSEUM
Date: _____

AGREEMENT FOR OUTGOING LOAN

To: _____ Address: _____
 (Borrower's name) _____
Telephone: _____ Fax: _____
From: _____ Telephone: _____
 (Curatorial unit) Fax: _____

In accordance with the conditions printed on the reverse, the objects listed below are lent for the following purpose(s) only (give name of exhibition, when appropriate): _____

For the period* _____ to _____
(*approximate time objects leave Museum until their return receipt)

Locations of object(s) while on loan (attached itinerary, if applicable):

Initiated by:

(Curator's signature)

Accession or Index Number	Description of Objects (include size, materials, catalog numbers, etc.)	Insurance Value

(Attach continuation sheet if necessary.)

Continued on next page

Figure VI.3 continued

INSURANCE: (Please see conditions on reverse.)
 [] to be carried by Museum and premium billed to borrower
 [] to be carried by borrower
 [] insurance waived

PACKING AND SHIPPING:
 Object(s) packed by

 Object(s) shipped to

 from Museum ———————————————— or other ————————————————
 Outgoing shipment via

 Return via (Contact Museum Registrar prior to return)

COSTS: (Please see conditions on reverse.)
 Borrower will pay all costs, unless otherwise noted here:

CREDIT LINE (for exhibition label and catalog):

SPECIAL REQUIREMENTS for handling, installation, etc. (attach continuation sheet if necessary):

(Loan Agreement continued on reverse side.)

· ·

THE BORROWER AGREES TO THE FOLLOWING CONDITIONS OF THE LOAN:

Object Care and Protection: Objects borrowed shall be given special care at all times to insure against loss, damage, or deterioration. The Borrower agrees to meet the special requirements for installation and handling as noted on the face of this agreement form. Furthermore, the Museum may require an inspection and approval of the actual installation by a member of its staff as a condition of the loan at the expense of the Borrower. Upon receipt and prior to return of the objects, the Borrower must make a written record of condition. The Museum is to be notified immediately, followed by a full written report, including photographs, if damage or loss is discovered. No object may be altered, cleaned, or repaired without the written permission of the Museum. Objects must be maintained in a building equipped to protect objects from fire, smoke, or flood damage; under 24-hour physical and/or electronic security; and protected from extreme temperatures and humidity, excessive light, and from insects, vermin, dirt, or other environmental hazards. Objects must be handled only by experienced personnel and be secured from damage and theft by appropriate brackets, railings, display cases, or other responsible means.

Insurance: Objects shall be insured during the period of this loan for the value stated on the face of this agreement under an all-risk, wall-to-wall policy subject to the following standard exclusions: wear and tear, gradual deterioration, insects, vermin or inherent vice, repairing, restoration, or retouching process; hostile or warlike action, insurrection, rebellion, nuclear reaction, nuclear radiation, or radioactive contamination.

If the insurance is to be carried by the Museum, with premium billed to Borrower, this agreement will act as proof of, or as a certificate of, "all-risk," wall-to-wall insurance coverage subject to the above-listed standard exclusions.

Figure VI.3 continued

If the Borrower carries insurance, then the Borrower hereby warrants that the required coverage as described above will be secured and maintained and that the Museum will be named as additional insured. The Museum may request documentary evidence of coverage such as a copy of the policy or a certificate of insurance. If the Borrower fails to secure and maintain said insurance, the Borrower will, nevertheless, be required to respond financially in case of loss or damage as if said insurance were in effect.

Any inaction by the Museum regarding evidence of coverage shall not be deemed a waiver.

Insurance value may be reviewed periodically and the Museum reserves the right to increase coverage if reasonably justified. In the event of loss or damage, the Borrower's maximum liability will be limited to the insurance value then in effect.

If insurance is waived, the Borrower agrees to indemnify the Museum for any and all loss or damage to the objects occurring during the course of the loan, as if it were insured as stated above.

Packing and Transportation: Packing and transportation shall be by safe methods approved in advance by the Museum. Unpacking and repacking must be done by experienced personnel under competent supervision. Repacking must be done with the same or similar material and boxes, and by the same methods as the objects were received. Any additional instructions will be followed.

Government regulations will be adhered to in international shipments. As a rule, the Borrower is responsible for adhering to its country's import/export requirements and the Lender is responsible for adhering to its country's import/export requirements.

Reproduction and Credit: Each object shall be labeled and credited to the Museum. Unless otherwise agreed to in writing, the visiting public may take impromptu photographs, but no other reproduction is permitted except photographic copies for catalog and publicity uses related to the stated purpose of the loan.

Costs: Unless otherwise noted, all packing, transportation, customs, insurance, and other loan-related costs shall be borne by the Borrower.

Return/Extension/Cancellation: Objects lent must be returned to the Museum in satisfactory condition by the stated termination date. Any extension of the loan period must be approved in writing by the Museum Director or his designate and covered by parallel extension of the insurance coverage. The Museum reserves the right to recall the object from loan on short notice, if necessary. Furthermore, the Museum reserves the right to cancel this loan for good cause at any time, and will make every effort to give reasonable notice thereof.

Interpretation: In the event of any conflict between this agreement and any forms of the Borrower, the terms of this agreement shall be controlling. This agreement shall be construed in accordance with the law of

(name applicable jurisdiction)

I have read and agree to the above conditions and certify that I am authorized to agree thereto.

Signed: _____ Date: _____
 (Borrower or authorized agent)

Title: _____

APPROVED FOR MUSEUM:

Signed: _____ Date: _____

Title: _____

(Please sign and return both copies.)

Figure VI.4

Agreement for Outgoing Loan (Art Museum)

NAME OF MUSEUM
ADDRESS OF MUSEUM
TELEPHONE AND FAX NUMBERS OF MUSEUM

BORROWER'S AGREEMENT

Borrower: _____

Exhibition: _____

Exhibition sites and dates: _____

Objects requested (accession number, artist, title, medium, credit line): _____

The Borrower agrees to observe all conditions and obligations contained herein including the following conditions and obligations, which are not the Borrower's stated practice:

All loans of works of art are subject to the Borrower's signed agreement to the conditions and obligations listed in this document. After agreement is received from the Borrower, the Borrower will be notified whether or not the loan has been approved. (Such determination may take several months.) Any change in venue or additional venues for a loan will be subject to each new or additional Borrower's agreeing to these conditions and obligations, and to loan approval by the [NAME OF MUSEUM], hereafter "MUSEUM."

(Loan Agreement continued on reverse side)

. .

**Security, Staffing, and Environmental
Conditions at Borrowing Institutions**

The Borrower will exercise the highest professional degree of care in the safeguarding of MUSEUM works on loan, including but not limited to the following:

Security

1. A sufficient number of guards for adequate security will be present in the building 24 hours per day, or an interior electronic sensing device will be functioning at all times when guards are not present during non-public hours. A guard will always be posted at each public entrance/exit to the building during public hours.

Figure VI.4 continued

2. All exterior openings, including accessible windows, roof doors, and air ducts, will be secured by alarm at all times. Alarms will be monitored at a central control station within the Museum, at a local police department, or at a reputable alarm company 24 hours per day. There will be written alarm response procedures that employees are trained to follow, and a designated Museum official will be available at all times to respond to emergency situations.

3. Storage areas where MUSEUM objects are located will be locked with alarms on windows, doors, and any other openings. Access to these storage areas will be restricted.

4. Exhibition galleries where MUSEUM objects are located will be checked by security personnel on an established basis of frequency during hours of closing. Exterior checks of the building are desirable but not mandatory when a 24-hour guard is posted in the building. If a 24-hour guard is not posted in the building, local police or private security personnel will perform exterior checks of the premises on a periodic basis during hours of closing. Access to the facility will be controlled during hours of closing.

5. Exhibition galleries where MUSEUM objects are located will be under guard during exhibition installation and deinstallation, with access to the area limited to those staff immediately involved; and the area will be locked and secured when staff are not working.

6. All MUSEUM objects on exhibition will be within continuous sight of a trained guard, employee, or volunteer at all times during public hours with at least one stationary guard or other trained security employee for every two galleries. However, if objects are framed by MUSEUM under plexiglas and attached to the wall with security mounting, camera surveillance in the exhibition area is sufficient with prior MUSEUM approval, but only when cameras are monitored in-house by someone who has this as his/her sole responsibility, and only when there is a satisfactory method of communication (alarm, radio, or telephone) from the camera monitoring station to the exhibition area to alert security personnel in that area during an emergency situation.

7. Records will be maintained on all movement of MUSEUM loans, including internal relocations, and only the registrar's staff or a limited number of higher-level officials will sign for the removal of works of art.

Fire Control

1. Exhibition buildings will be equipped with early-warning smoke detection and fire alarm equipment connected to and monitored at an internal security monitoring system, a local fire department, or a reputable alarm company 24 hours per day. There will be written alarm response procedures and a designated official available at all times to respond to emergency situations.

2. No wet or dry pipe automatic water sprinkler systems will be present or used in exhibition, storage, or packing areas where MUSEUM loans are located. If a pre-action sprinkler system is in use in these areas, MUSEUM works will be glazed or placed in vitrines.

3. No water or CO_2 hand-extinguishers will be present or used in exhibition, storage, or packing areas where MUSEUM loans are located. Only Halon or ABC dry chemical hand-extinguishers will be present and used in these areas. Staff will be trained in the proper use of hand-extinguishers.

Relative Humidity and Temperature Controls

1. There will be facilities for control of relative humidity and temperature in gallery, storage, and packing areas where MUSEUM objects are located. Relative humidity will be maintained at 50% \pm 5% with no more than 5% fluctuation within that range during a 24-hour period. Temperature will be maintained between 67°F and 77°F (19°C to 25°C).

2. There will be a system for monitoring and recording temperature and relative humidity; relative humidity will be monitored and documented using a psychrometer or a recording hygrothermograph, which will be calibrated monthly, or using an electronic system that monitors and records the temperature and relative humidity. Hygrothermograph and electronic charts will be checked on a daily basis.

Light Levels

1. Natural, quartz, tungsten-halogen, and fluorescent light will be filtered for ultraviolet radiation.

Continued on next page

Figure VI.4 continued

2. Works of art on paper will be stored and exhibited only in incandescent light or other light that has been filtered to remove at least 97% of the ultra-violet radiation.

3. Exhibition lights in galleries where MUSEUM objects are located will be turned off when those galleries are closed to the public.

4. Light levels will be measured with a calibrated footcandle / lux meter and will not exceed the following levels:

Paintings	35 footcandles (377 lux)
Graphics	
Watercolors, pastels, color or hand-colored prints, drawings, color photographs, platinum photographs, and other light-sensitive black and white photographs	5 footcandles (54 lux)
Black-and-white prints, archivally processed black and white photographs	10 footcandles (108 lux)
Objects	
Light-sensitive materials (ivory, textiles)	5 footcandles (54 lux)
Other materials	35 footcandles (377 lux)

Display Conditions

1. No MUSEUM loan will be displayed in close proximity to sources of heat or cold air, or in cases or vitrines in which the internal temperature exceeds 77°F (25°C).

2. No food or beverages will be present in areas where MUSEUM works of art are located, nor will smoking be permitted in those areas.

3. The MUSEUM may require that its small objects and sculpture be secured by alarm, or exhibited in locked cases that are fitted with alarms; and that some type of security mounting be used in the installation of framed objects.

Staff

1. MUSEUM loans will be handled by packers and staff specially trained to handle works of art. If the Borrower employs a commercial packing firm, that firm's employees will be supervised by the Borrower's trained curatorial, conservation, or registrarial staff.

2. The Borrower will employ, or have access to, a conservator (restaurateur) who is professionally trained to examine and restore works of art.

Shipping

1. All shipping arrangements will be made by the MUSEUM Office of the Registrar in consultation with the Borrower. MUSEUM will pack the works for outgoing loan.

2. The Borrower will keep the MUSEUM crates and packing materials for return shipment, and works will be repacked using the same protective methods and materials. Packing crates will be stored in appropriate environmental conditions to ensure that the crate interior is in equilibrium at 50% RH prior to repacking.

3. Condition reports accompanying MUSEUM loans will be annotated and signed upon receipt of loan and upon repacking for outgoing shipment by a qualified representative of the Borrower and by a MUSEUM representative if one is present.

4. The MUSEUM reserves the right to determine at any time prior to or during the loan period that courier accompaniment is required and to designate the courier.

Figure VI.4 continued

Care and Handling

1. Objects lent by the MUSEUM will remain in the condition in which they are received. The Borrower will exercise the highest professional degree of care in the handling of MUSEUM works in its possession. MUSEUM loans will not be unframed, unglazed, or removed from mats, mounts, vitrines, or bases without the prior written consent of the MUSEUM. Unless it is necessary in an emergency situation to protect an object from further damage, loans will not be cleaned, repaired, retouched, or altered in any way without the prior written consent of the MUSEUM. Loans will not be subjected to technical or scientific examination of any type without the prior written consent of the MUSEUM.

2. In the event of an emergency, the Borrower will take all steps prudent and necessary to halt or minimize damage to loans. The Borrower will immediately report any loss or damage to the MUSEUM Office of the Registrar by telephone and confirm in writing by telefax.

Photography and Reproduction

1. Photographic materials of MUSEUM works on loan provided by the MUSEUM may be used only for the exhibition catalogue and for educational, archival, and publicity purposes related to the exhibition unless the MUSEUM has given specific written authorization for additional uses, including commercial uses.

2. MUSEUM works on loan may be photographed individually by the Borrower as necessary for condition reports, and in general installation views by professional photographers authorized by the Borrower. Such general installation photography may be made in any medium and may be used only for educational, archival, and publicity purposes. Works will not be unframed, unglazed, unmatted, or removed from mounts, vitrines, or pedestals for photography without the prior written consent of the MUSEUM. Any such professional photography will be in accordance with the following guidelines:

A) All personnel authorized by the Borrower to photograph MUSEUM works on loan will be accompanied and supervised by one or more members of the exhibiting institution's staff, who will halt proceedings at any time that they determine that the safety of MUSEUM works on loan may be in jeopardy.

B) No photographers will handle MUSEUM works on loan, including frames, mats, mounts, vitrines, and pedestals.

C) No supplemental lights of any kind will be permitted for photographing graphic objects (prints, drawings, books, photographs) and textiles.

D) Supplemental lighting may be used for other MUSEUM works on loan, but only if the following conditions are observed:

(1) Lights will be at least ten feet from any MUSEUM work.

(2) Lights and light stands will be placed so that heat generated will not endanger any MUSEUM work on loan and so that falling light stands cannot hit any such work.

(3) Total wattage of all lights will not exceed 1200 watts.

(4) Lights will not be left on unnecessarily and never for more than five minutes at a time without a cooling period. Lights will be turned off immediately if the temperature on the surface of a MUSEUM work on loan increases appreciably of if the temperature in the room increases toward the limit of an additional 5°F (2°C).

3. Exhibition photography of MUSEUM works on loan by the general public for their private, non-commercial use is permitted, provided that no flash units are used when photographing graphic objects (prints, drawings, books, photographs) and textiles.

4. Except as authorized above, reproduction of MUSEUM works is strictly prohibited in any form, product, or publication unless prior written permission for the specific use, whether for commercial distribution or otherwise, has been obtained from the MUSEUM.

Continued on next page

Figure VI.4 continued

Catalogues

Two copies of any published exhibition catalogue or brochure will be sent to [INSERT APPROPRIATE MUSEUM OFFICE].

Credit Line

Information about MUSEUM loans used for the catalogue and for labels and publicity will conform to the catalogue data provided by the MUSEUM, and will always include the official credit line provided by the MUSEUM.

INSURANCE

The MUSEUM will insure (at the Borrower's expense) all outgoing loans under its regular policy, which waives subrogation by the insurance company against the borrowing and exhibiting institutions. The MUSEUM will consider coverage under government indemnities, but such requests must be received well in advance of the opening date of the exhibition.

LOAN COSTS

The Borrower will be responsible for all costs associated with loans from the MUSEUM including, but not limited to, packing, shipping, insurance, photography, courier accompaniment, and any special crating or framing requirements. The MUSEUM will invoice the Borrower for these costs and may require advance payment. The Borrower agrees to pay all such costs promptly on receipt of invoice. If an institution other than the Borrower is serving as Exhibition Organizer for a tour to several museums, the Exhibition Organizer will be billed for all costs. However, if the Exhibition Organizer fails to pay the MUSEUM promptly on receipt of invoice, the Borrower will be held responsible for all costs associated with the loan to that particular museum.

BORROWER RESPONSIBILITY AND LOAN AGREEMENT FORMS

The Borrower agrees to the conditions of loan stated above.

In the case of any difference between this agreement and the Borrower's own loan agreement forms, which the MUSEUM will complete upon request, the conditions in this document will control.

(Name of institution)

By:

Signature _____

Name _____

Title _____

Date _____

LOAN APPROVED:

[NAME OF MUSEUM]

Figure VI.4 continued

By:

Signature _____

Name _____

Title _____

Date _____

C. Nontraditional Loans

1. COLLECTION SHARING

The term "collection sharing" is relatively new, and it is used here to describe formal programs designed to establish networks that encourage museums to identify underutilized objects in their collections and then facilitate the lending of these objects to appropriate museums. Carefully designed and well-managed programs of this nature have much to offer. Ideally, such a program is structured so that it

- provides no inducement to participate for a profit motive;
- requires adherence to professional standards for the care and handling of objects;
- prohibits indefinite loans; and
- does not provide a convenient way to avoid the issue of prudent deaccessioning.

With the support of two major foundations, a national collection sharing program was initiated in 1995. Called the "Museum Loan Network" and operated by the Office of the Arts at the Massachusetts Institute of Technology, the program focuses on art objects, and participating organizations must be art museums or must have a significant art collection. Also, participating organizations must be located in the United States, or its territories, and have federal tax-exempt status. The articulated goals of the Museum Loan Network are

- to encourage audience appreciation and understanding of works of art by supporting and facilitating the exchange of art between collecting institutions, and thereby making a greater range of objects available for public view;
- to strengthen existing museum networks, to build new ones, and to provide a vehicle for the compilation and exchange of information about art objects or collections available and needed for sharing.[46]

46. See "Guidelines for the Museum Loan Network" (1995), published by Museum Loan Network, MIT, 265 Massachusetts Avenue, N.52–439, Cambridge, MA 01239. See also D. Garfield, "Museum Loan Network," *Museum News* 8 (Jan.–Feb. 1996).

To achieve the above-noted goals, the network has a series of grant programs that offer modest amounts (based on actual costs) to accomplish the following kinds of activities:

- *Surveying Grants.* These grants are awarded to potential lending organizations to allow them to identify objects they are willing to loan and to have placed on the Museum Loan Network directory. The directory includes sufficient information about an object so that potential borrowing organizations can target objects of probable interest to them.
- *Planning Grants.* These grants can go to either potential lending organizations or potential borrowing organizations and allow an on-site visit to the other party's location to facilitate decision making regarding a loan.
- *Implementation Grants.* These grants are awarded to support the costs associated with actual loans of objects. The grants are usually made to borrowing organizations, which are then responsible for reimbursing their lending organizations. Loans cover only direct, "clearly delineated" costs.

2. LENDING FOR PROFIT

Traditionally, museums in the United States have looked on the lending and the borrowing of objects as integral parts of a museum's educational mission and have conducted these activities "at cost" in recognition of their importance. The "at cost" standard ensures that a request to borrow is judged on the merits of the proposed use, on how the loan may affect the lending organization's ability to serve its own constituency, and on the ability of the objects in question to withstand the strains of travel. And, very important, the standard treats all museums equally regardless of their size or wealth. Although there were some deviations from the "at cost" standards during the 1980s, museums in this country did not openly discuss the issue of "lending for profit"—lending with the objective of making a profit—until the early 1990s.[47]

What triggered more open discussion was a case involving not a museum but an educational organization known as the Barnes Foundation of Merion, Pennsylvania. The Barnes Foundation is a nonprofit organization created by a trust agreement of the late Dr. Albert C. Barnes. Under the terms of the trust agreement, the foundation oversees the Barnes Collection, some one thousand works of art collected by the donor. This collection must remain "on site" at the Merion location so that it can serve as the means for teaching art appreciation in a manner fostered by Dr. Barnes. In the early 1990s, the trustees of the Barnes Foundation needed funds to undertake major building renovations. They first decided to seek court permission to deaccession and sell some of the objects from the collec-

47. The Phillips Collection of Washington, D.C., created a minor stir in the 1980s when it lent abroad for high fees in order to obtain funds for capital improvements. During the same decade, many foreign countries, especially in the Far East, were offering to pay high fees to U.S. museums to tour their paintings abroad. Some U.S. museums also began to initiate general loan fees (undocumented costs) applicable to all borrowers. Although the general loan fee was a new device and troublesome to many, it tended to be relatively modest and hence was not aggressively challenged.

tion (court permission was necessary because the trust agreement forbade deaccession-ing),[48] but this idea was abandoned when the museum community voiced strong disapproval of selling collection objects in order to raise money for renovations.[49] Then, with the active cooperation of some major U.S. museums, the Barnes trustees devised a plan whereby a group of pictures from the collection would be exhibited in Paris and Tokyo for loan fees amounting to some $7 million, with additional millions expected from auxiliary activities associated with the foreign tour. The plan was presented to the court for approval because, once again, the activity violated restrictions imposed by the donor. The court granted a one-time deviation to allow the tour and later granted permission to extend the tour to include additional stops, with loan fees in the millions, in the United States and Canada. In all, the tour was said to have grossed over $15 million.[50] Clearly, this event, which could not have happened without the active participation of several large U.S. museums and which generated much media attention, placed the issue of lending for profit squarely before the museum profession.[51] There were few strong criticisms voiced by the profession, and in fact, several other large museums were busily pursuing lending-for-profit projects of their own.

In 1992 the Whitney Museum of American Art in New York entered into an eight-year arrangement with the San Jose Museum of Art in California to install in San Jose four sequential exhibits, each lasting eighteen months, drawn from the permanent collections of the Whitney. The San Jose Museum committed to pay the Whitney $1.4 million for its services, and the Redevelopment Agency of the City of San Jose added a $3 million bonus for the Whitney.[52] The Whitney is reported as stating that it will dedicate its sizable income from the loans to caring for its collection and to strengthening its endowment fund. The city of San Jose sees the exhibit arrangement as an "economic catalyst" that will generate millions of dollars in local economic activity.[53]

At the same time that the Whitney Museum was negotiating its lending-for-profit arrangement, the Boston Museum of Fine Arts was entering into an agreement with the city of Nagoya, Japan, whereby the Boston Museum would provide Nagoya, over a twenty-year period, with exhibits drawn from the breadth of the museum's collections. When queried,

48. See the discussion of *cy pres* in Chapter IV, Section E(1), "Restricted Gifts."

49. See Chapter V, Section B(2)(f), "Use of Proceeds Derived from Deaccessions."

50. See, for example, L. Rosenbaum, "Art for Rent: Museums Hire Out Their Collections," *Wall Street Journal*, Sec. A, p. 13 (July 21, 1994); R. Graham, "Barnes or Bust," *Toronto Life*, 62–67 (Sept. 1994); J. Lewis, "Broadsides at the Barnes," *Washington Post*, Sec. G, p. 4 (Dec. 17, 1995).

51. From the inception of its plans to raise money from activities that contravene donor restrictions, the Barnes Foundation has been involved in a series of legal actions brought by the Violette de Mazia Trust, a supporting trust of the Barnes Foundation, by students of the Barnes art school, and by the township of Merion itself.

52. See L. Rosenbaum, "Art for Rent: Museums Hire Out Their Collections," *Wall Street Journal* (July 21, 1994).

53. See J. Callan, "Loans: Standard Forms, Mega Loans, and Branch Museums," in American Law Institute–American Bar Association (ALI-ABA), *Course of Studies Materials: Legal Problems of Museum Administration* (Philadelphia: ALI-ABA, 1995).

the museum merely affirmed that it would be "compensated" for its services.[54] In other words, for a fee, the Boston Museum of Fine Arts was pledging to place portions of its collections on loan to Nagoya for varying periods of time over the next twenty years.

Japan has been a popular destination for a number of "loans for profit" from the United States. In Japan, department stores and other commercial venues commonly house cultural exhibitions, and Japanese entrepreneurs have had considerable success in convincing a number of American museums that this is the thing to do—for a substantial fee, of course.

Lending for profit does raise some profound issues for American museums:

- The practice commercializes the use of collections and thus clearly contradicts the museum community's statements that collections are not assets to be placed on a balance sheet.[55]
- The practice shifts the focus away from a museum's own public. When there is money to be made by sending collections out on loan, there is pressure to devote more time and attention to this activity than to the core work of the museum.
- If revenue is consistently drawn from loans made to locations away from a museum's tax base, local authorities may have reason to examine more closely the tax exemptions customarily provided to such museums.
- When loans are a source of substantial income, the museum has difficulty being objective on the issue of wear and tear on objects.
- When individuals are asked to lend objects for museum exhibition, will they expect fees also?
- Practically every museum that lends also borrows. This means that the museum that charges lending fees has realized little because it, in turn, must pay fees when it borrows.
- There is no incentive to lend to a museum that cannot afford to pay fees; so the practice widens the gulf between the more powerful museums and the more modest ones.
- The practice discourages restraint in collecting by the more powerful museums because excess collections are seen as sources of revenue.[56]

54. The agreement required both parties to maintain confidentiality about the arrangements unless mutually agreed otherwise. See M. Pierce, "Loans: Standard Forms, Mega Loans, and Branch Museums," in American Law Institute–American Bar Association (ALI-ABA), *Course of Studies Materials: Legal Problems of Museum Administration* (Philadelphia: ALI-ABA, 1995). Under the arrangement, however, Nagoya sources have pledged $1 million annually for operating costs and $15 million (in three payments) to feed the Boston Museum of Fine Arts endowment fund. See H. Selby, "BMA to Launch Debut in Japan," *Baltimore Sun*, Sept. 29, 1996.

55. During the early part of 1990, museums were locked in combat with the accounting profession over the issue of capitalization of collections. The accounting profession, through its Financial Accounting Standards Board, was seeking to require museums to put a dollar figure on their collections and show the collections as assets on balance sheets. The museum community won major changes in this proposal by arguing that collections are not true assets because they are not used for financial gain.

56. When there is possible profit to be made, acquisition decisions can more easily be rationalized. For example, in 1988, when the Toledo Zoo imported two pandas from China, the World Wildlife Fund and the American Association of Zoological Parks and Aquariums sued to prevent the exhibition of the animals. They claimed that the zoo's acquisition was primarily for commercial exploitation (pandas draw huge crowds) and

Museums concerned about the long-range consequences of their actions are advised to think carefully about the ramifications of lending for profit.[57]

3. TEMPORARY ART AND SITE-SPECIFIC INSTALLATIONS

When a museum commissions an artist to create a piece of temporary art for on-site exhibition, this involves elements of a loan in that the museum has the right to exhibit for a set period of time a work it does not own. But this situation also involves complex issues that do not arise in the traditional loan situation.

One such issue is balancing the artist's freedom to conceive and produce the work and the museum's legitimate interest in having some control over what it exhibits. When the project is still only an idea or a sketch and a contract has to be written before work begins, how should these possibly conflicting interests be framed? Other issues include the following:

- *Deadlines.* Museums have set schedules for opening and closing exhibits. When the readiness of an exhibit depends on the ability of an artist to start the creative process and complete it within a set time period, much can go wrong.
- *Access.* The project invariably requires that the artist have access to the museum, to support services, and perhaps to members of the museum staff. How is this covered in a contract when no one can predict the flow of the creative process?
- *Rights.* Is the installation to be photographed and, if so, by whom? Who controls the photographs, and who has rights to the photographs—photographs that will eventually be the only record of the work of art? Who controls diagrams and models produced in the creative process? Who owns the components of the work after its removal?
- *Costs.* How is the artist paid, and exactly what costs are covered by the payment? (In other words, what additional expenses should the museum anticipate during the course of the project?) Who repairs or adjusts the work during the exhibition period if this becomes necessary (and who decides this), and how are such costs handled?
- *Removal.* When the exhibition is over, who is responsible for removing the artwork, and what are the options if removal does not take place in a timely manner?
 Tied into many of these questions is the issue of the artist's precise relationship with the museum during the process. Is he or she an independent contractor or an employee? How the process actually unfolds should support the desired relationship.

Arrangements for a site-specific installation should be a matter of contract, and the contract should seek to address all reasonably foreseen issues. It is far easier to sort out rights

was detrimental to the protection of endangered species. The professional community knew that other zoos, seeing dollar bills, were seeking similar imports.

57. See M. Malaro, "Lending for Profit," *Museum Governance: Mission, Ethics, Policy* (Washington, D.C.: Smithsonian Institution Press, 1994).

and obligations in the calm before work begins. Museums that are part of government and, thus, are subject to state and/or federal constitutional protections regarding interference with free expression need special guidance in these areas. They should recognize also that since tax dollars are involved, they are more vulnerable to public opinion regarding the final product itself.

The following sample agreement for a site-specific installation is used by a major non-profit (not government-controlled) museum (see Figure VI.5). Like all other sample agreements, it should not be adopted in whole or in part by a museum without careful review and professional advice.[58]

58. For more detailed information, see, for example, F. Feldman and S. Weil, *Art Law* (Boston: Little Brown, 1986, and supplements), especially Chapter 4; S. Weil, "Selected Materials on Site Installation and Other Temporary Art Projects," in American Law Institute–American Bar Association (ALI-ABA), *Course of Studies Materials: Legal Problems of Museum Administration* (Philadelphia: ALI-ABA, 1989); E. Cameron et al., "Art in Public Spaces: Rights and Responsibilities Relating to Display and Care: Special Problems of Public Entities," in American Law Institute–American Bar Association (ALI-ABA), *Course of Studies Materials: Legal Problems of Museum Administration* (Philadelphia: ALI-ABA, 1986).

Figure VI.5

Agreement for Site-Specific Installation

Agreement for Site-Specific Installation

Exhibition Title: _____

Dates of Showing: _____

This Agreement is made the _____ day of _____, 199___, by and between the *(name and address of museum)* (hereinafter referred to as "MUSEUM") and _____ _____ (hereinafter referred to as "ARTIST"), for the purpose of defining the ARTIST's preparation of a site-specific installation titled _____ at the MUSEUM.

For valuable consideration MUSEUM and the ARTIST agrees as follows:

1. The ARTIST shall conceive, research, produce, and participate in the installation of his/her work which shall be completed by _____.

2. As full compensation to the ARTIST for performance of services and provision of his/her supplies pursuant to this Agreement MUSEUM shall pay to the ARTIST the following: _____.

The payment of _____ referred to above is not an outright grant and may be utilized only to cover expenses specifically incurred for the _____ TITLE _____ installation at MUSEUM.

Figure VI.5 continued

A partial advance can be made available to the ARTIST following his/her submission of a description of the installation and an accompanying itemized budget estimate. The initial advance will be no more than 50% of the estimated cost of the installation or _____, whichever is less. The ARTIST will provide MUSEUM with back-up receipts to justify the expenditure of the initial advance. Subsequent payments will be made, up to the maximum of _____, upon submission of invoices and back-up receipts from the ARTIST. MUSEUM is not obligated to the ARTIST or any other Parties for installation costs in excess of the maximum amount of _____ as stipulated in this Agreement.

3. MUSEUM shall provide and pay directly for services and expenses required for the preparation of the _____ [LOCATION OF WORK] _____ area (carpentry, painting, electrical, and installation labor and materials), insurance, exhibition graphics (titling, vitrine posters, etc.), a brochure, invitations, a preview party, and promotion; and MUSEUM will photograph the installation, etc.

4. The ARTIST agrees to permit MUSEUM to photograph his/her work (the "WORK") for archival, promotional, educational, and such other purposes as MUSEUM shall determine. Such photographs shall be the property of MUSEUM.

5. Any plans, diagrams, drawings, and models received from the ARTIST for the purpose of planning and/or exhibition shall remain the property of the ARTIST.

6. The ARTIST shall receive from MUSEUM at no cost copies of the brochure and the following photographic documentation of the WORK: five color slides of the completed WORK; five black-and-white 8" x 10" photographs of the completed WORK. Duplicate slides and photographs will be provided to the ARTIST at the standard MUSEUM photographic service fee.

7. The WORK shall remain on its site, in the MUSEUM from the date of completion until _____, subject to earlier removal at the sole discretion and expense of MUSEUM. At such time, MUSEUM will dismantle and remove the WORK (with the ARTIST's participation and with his/her assistance as required) and shall deliver it to his/her premises unless other arrangements have been made between MUSEUM and the ARTIST. Should the ARTIST fail to provide instructions for the dismantling and removal of the WORK on _____, it shall become the property of the MUSEUM which may utilize or dispose of the WORK.[a]

8. MUSEUM will provide periodic on-site inspection of the WORK and will maintain security coverage during public hours. MUSEUM agents and employees shall not be responsible for or liable for any damage to or destruction of any equipment supplied by the ARTIST. MUSEUM will insure the WORK at the value declared by the ARTIST, which will generally be assumed to be its replacement value.

Continued on next page

Figure VI.5 continued

9. The ARTIST shall be an independent contractor during the period of performance under this Agreement and not an employee of MUSEUM. The ARTIST shall be required to carry whatever insurance is deemed necessary for the purpose of performance hereunder. The ARTIST agrees to defend, indemnify, and hold harmless MUSEUM from any and all claims and liabilities arising directly or indirectly out of the ARTIST's or his assistant(s)' activities hereunder.

10. MUSEUM may conduct reviews as desired during the production of the WORK. Final acceptance will be made upon completion of the WORK and upon the recommendation of the MUSEUM curator responsible for the installation.

11. Any reproduction or exhibition of the WORK produced as a result of this Agreement shall be credited as follows:

Installation, _____, the _____(name and address of museum)_____.

12. This Agreement is intended to secure the personal services of the ARTIST and shall not be transferred or assigned in any manner whatsoever without the prior written consent of MUSEUM.

13. This Agreement is the entire understanding between the ARTIST and MUSEUM and supersedes and replaces any previous documents, correspondence, conversations and other written or oral understandings related to this Agreement which are not consistent with or are not contained herein.

IN WITNESS WHEREOF, the parties hereto have executed this Agreement as of the day and year first written above.

(ARTIST's name)

(MUSEUM Representative's name and title)

Author's Note:
*The Visual Artists Rights Act of 1990, a federal statute, affords artists some protection regarding the removal of their works from buildings (17 U.S.C. § 113). Possibly an applicable state statute could expand artists' rights in this area (17 U.S.C. § 301). Before contracting for site-specific installations, a museum should seek professional advice regarding current developments in this area in federal or state law.

D. Corporate Sponsorship

The evolution of corporate sponsorship of museum exhibitions may be viewed as a success story for all concerned or as an example of serious erosion of principle on the part of museums. There is room for differences of opinion on aspects of this evolution, but certain developments are a matter of record.

In the 1970s, museum exhibitions grew grander and more costly. Turning to the business community for financial support seemed like an excellent idea. Museums had a very visible product to present to these potential donors, and what business would not be attracted by the public attention that would be focused on the product? During these early days of cultivating corporate support, the museum community engaged in considerable talk about the importance of protecting the independence of the scholarly endeavors of museums and of avoiding any real or perceived commercialization of exhibitions. In effect, corporate support at that time was viewed by museums as a form of corporate largess, generous gifts from corporate citizens for the purpose of funding educational projects for the benefit of the public. Museums dealt with corporate agents responsible for philanthropic outreach, and the legal aspects of negotiating such gifts were relatively simple. A corporation, like any other generous donor, could expect in return for its largess a sincere "thank-you," a discrete acknowledgment of the gift in the exhibition program, and an invitation to the opening of the exhibition. Not much paper was required to set forth the agreement.

But the 1970s also saw the rise of "image" advertising. Businesses were encouraged to advertise not their product but an image, because the image could be more seductive in attracting buyers. Focusing on image became very popular, and in due time members of the marketing departments of corporations pointed out to their colleagues that what might have been viewed as philanthropic outreach in the past was now just another facet of image-making. A senior vice-president of a major U.S. corporation, a corporation with a tradition of giving to the arts, noted, "In the 1990s, there is less paternal benevolence and more corporate giving focused on furthering broad company objectives."[59] She then explained the two "faces" to corporate giving: contributions and sponsorships. The first, contributions, are usually cash gifts and donations of products or services, and her company makes such contributions "[w]hen a worthwhile request in some way is relevant to our business agenda and has the potential of enhancing our corporate reputation."[60] She added: "A sponsorship is different. Sponsorships are much more focused on marketing and sales. When someone comes to us with a request to sponsor an event, we're looking for heavy exposure of our logo. We want to build our brand. We want to enhance our market position. We are seeking to help build earnings. Often, we want to use sponsorships for customer entertainment, so the sponsorship has to be relevant and attractive to our customers."[61]

Corporate sponsorship today is not viewed by the company as philanthropy. Corporate sponsorship is not giving to benefit society but is contracting for marketing opportunities. The dangers for museums in this change of emphasis are substantial. There is the obvious problem of the tail wagging the dog—with sponsors determining what exhibitions are mounted. This is not to say that sponsors necessarily state what they want; more often the pressure comes from within the museum itself, where curators know that if their exhibitions hope to see the light of day, their ideas must appeal to sponsors and to the audiences that

59. M. Laurie, "Corporate Funding for the Arts," in O. Robinson et al., eds., *The Arts in the World Economy* (Hanover, N.H.: U. Press of New England, 1994), 69.

60. Ibid.

61. Ibid., 69–70.

sponsors hope to reach. In effect, the choice of exhibitions is governed by the marketplace. But is not one of the reasons the United States fosters a nonprofit sector to protect certain activities from the pressures of the marketplace?[62] Another equally worrisome problem is the overall effect of these arrangements on the spirit of philanthropy. Museums in this country depend heavily on donations of objects, money, and time from the general public. Why do museums afford corporate sponsors special treatment? Should individual donors or lenders also now expect some quid pro quo? Many museums either deny the real problems involved in corporate sponsorships or view such problems as circumstances they cannot control. With museums as a group unwilling to speak up, corporations each year ask for a bit more for their dollars.[63]

Today's corporate sponsorship agreement can be a very detailed document, and it should be. A museum should settle as many things as possible during the negotiation period and commit them to writing. Also, a museum should not even attempt negotiations until it has acquainted itself with the realities of corporate sponsorship and has come to some internal agreement as to what it will accept and what it will not accept. If this preliminary soul-searching does not take place, the museum will be totally unprepared to hold its own during the deliberations. The following is a list of questions that frequently must be answered during contract negotiations.[64]

- Who are the real parties to the agreement?
 —Does the museum see any problem with this type of sponsor underwriting the exhibition in question?[65]
 —Is the exhibition sufficiently defined so that both parties know what to expect?
- What is the time frame?
- What support is the corporation giving?
 —What is the payment schedule?
 —How will payments be made?
- Will there be or can there be other sponsors?
 —Who makes decisions regarding other sponsors?
 —When must these decisions be made?

62. See M. Malaro, "On Trusteeship," *Museum Governance: Mission, Ethics, Policy* (Washington, D.C.: Smithsonian Institution Press, 1994).

63. *Museum News* (Jan.–Feb. 1988) featured a series of articles on the topic "The Museum and the Corporation: New Realities." See also O. Robinson et al., eds., *The Arts in the World Economy*, (Hanover, N.H.: U. Press of New England, 1994), and M. Feldstein, ed., *The Economics of Art Museums* (Chicago, Ill.: U. of Chicago Press, 1991).

64. For more information, see P. Jessup., "Corporate Sponsorship of Museum Activities," in American Law Institute–American Bar Association (ALI-ABA), *Course of Studies Materials: Legal Problems of Museum Administration* (Philadelphia: ALI-ABA, 1989), and M. Shaines, "Corporate Sponsorship Agreements," in American Law Institute–American Bar Association (ALI-ABA), *Course of Studies Materials: Legal Problems of Museum Administration* (Philadelphia: ALI-ABA, 1994).

65. As corporate sponsors demand more and more exposure for their logos and products, what they sell has to become a concern for museums. After all, these are marketing-focused agreements. This development draws museums into the quicksand of deciding who are "appropriate" and who are "inappropriate" sponsors.

- How is the sponsor credited?
 —If there are other sponsors, are there limitations concerning their credits?
- Is the museum required to contribute a certain level of funding?
- Under what terms can a party withdraw from its commitment?
- What happens if it becomes impossible or not practical to do the exhibition?
 —Who makes this decision?
 —How will finances be handled?
- Are there limitations on the museum's ability to change the focus, scope, or size of the exhibition?
- What rights, if any, does the sponsor have to comment on the development of the exhibition?
- What does the sponsor expect in return for its contribution?
 —Credit lines:
 —Where?
 —Size?
 —Other publicity:
 —Who controls?
 —Who pays?
- Are there limitations on the right of the sponsor to use the name and/or logo of the museum?
 —Exhibition catalog:
 —Who produces?
 —Who pays?
 —What credit lines are to be used?
 —Opening events:
 —Who controls?
 —Who pays?
 —Other events or products that may affect the sponsor:
 —How are these negotiated?
- Does the sponsor have the right to develop exhibition-related products on its own?
 —If so, under what conditions?
- Will the museum and the sponsor agree to indemnify each other and hold each other harmless from claims arising from the actions of either under the contract?
- Can the agreement be assigned?
- Who are the contact people for each party with regard to contract issues?
 —How is notice given?
 —What law governs the contract?
 —Who signs for each party?

Unclaimed Loans

A. The Problem

When museum professionals meet to discuss common problems, invariably someone asks what can be done about unclaimed loans. Many of these objects have been held in a state of limbo for generations. The owners are unknown or cannot be located with relative ease, and lacking clear title, museums feel compelled to store and care for the objects. This places a considerable drain on a museum's resources, yet the alternatives are even less attractive. If the objects are disposed of, a museum may be vulnerable to claims by individuals who later appear and assert ownership. If extensive searches are mounted to locate owners, a museum faces substantial expenses with little assurance of remuneration or even success. The earnest museum administrator is often shocked to discover that the law and, frequently, even the public offer him little solace.[1]

1. See Section A, "Incoming Loans," in Chapter VI, "Loans: Incoming and Outgoing," for suggestions on ways to avoid future unclaimed loans. The museum should remember that a distinguishing feature of the unclaimed loan is the inability of the museum to identify and/or locate a lender with relative ease. This is not a situation in which the museum knows where to reach a lender but chooses to retain a loan on an indefinite basis. In this later case, the museum has little basis for arguing that it is being unjustly imposed on by the lender.

As explained in the preceding chapter, a loan produces a relationship known in the law as a bailment. The bailor, the owner, places property in the care of the bailee for a particular purpose. The bailee is responsible for holding the property for that purpose until the owner comes forward to claim it. What happens, however, when the owner fails to retrieve the property?

Assuming that there is a loan agreement stipulating that the loan is to terminate at a certain time, the argument can be made that after the termination date, the relationship of the parties is somewhat altered. While the loan agreement is in effect, the bailee is obliged to use and care for the property under the terms of the agreement, but after the expiration date, the "benefits" of the arrangement accrue only to the owner. This is because when the bailor fails to retrieve the property, the bailee is left with the responsibility of care but with no express rights to use the property. A new form of bailment then exists, one essentially for the benefit of the bailor, and the bailee usually is held to a lesser standard of care. Also, if the bailee can demonstrate that expenses were incurred in caring for the property beyond the stipulated loan period, these usually can be recovered from the owner. This "involuntary bailment" situation is of little comfort to the bailee/museum, however, if the owner cannot be located or if, on notice, the bailor fails to retrieve the property. Are there steps a museum can take to resolve these situations? There are three doctrines in the law that may possibly afford relief if they can be set in motion. One is the relief afforded by statutes of limitations, another is a defense called laches, and the third is the doctrine of adverse possession.[2]

B. Statutes of Limitations

Statutes of limitations[3] require that claims be brought within a certain stated period of time or else the right to claim is barred. The purpose of such statutes is to urge plaintiffs to action in a timely manner so that claims do not become stale.[4] In *Wood v. Carpenter*,[5] the Supreme Court of the United States gave the following description:

2. Specifically excluded from this list is the doctrine of abandonment. For establishing abandonment, the law requires proof of the owner's intention to abandon the property, as well as some affirmative act or omission demonstrating that intention. The burden of proof rests with the party claiming ownership by default. See trial court decision of *Hoelzer v. Stamford*, 933 F.2d 1131 (1991), 972 F.2d 495, *cert. denied*, 506 U.S. 1035, 121 L.Ed. 2d 687, 113 S. Ct. 815 (1992). When an object has been lent to a museum, inferring an intention to abandon title when the owner has merely not been heard from for a long time is extremely difficult. Accordingly, the doctrine of abandonment has rarely, if ever, been used effectively in cases of this nature.

3. See also discussion of statutes of limitations in Section D(5), "Stolen Property," in Chapter IV, "The Acquisition of Objects: Accessioning."

4. "After all, statutes of limitations are statutes of repose and the principal consideration underlying their enactment is one of fairness to the defendant," *Lopez v. Swyer*, 62 N.J. 267, 300 A.2d 563, 567 (1973). See also Note, "Developments in the Law: Statutes of Limitations," 63 *Harv. L. Rev.* 1177, 1185 (1950). But see *State v. West*, 293 N.C. 18, 235 S.E.2d 150 (1977), in which the court held that in North Carolina, a statute of limitations could not be applied against the state.

5. 101 U.S. 135, 25 L.Ed. 807 (1879).

Statutes of limitations are vital to the welfare of society and are favored in the law. They are found and approved in all systems of enlightened jurisprudence. They promote repose by giving security and stability to human affairs. An important public policy lies at their foundation. They stimulate to activity and punish negligence. While time is constantly destroying the evidence of rights, they supply its place by a presumption which renders proof unnecessary. Mere delay in extending to the limit prescribed, is itself a conclusive bar. The bane and antidote go together.[6]

The difficulty arises in trying to determine when a statute of limitations might begin to run in an "involuntary bailment" situation. The general rule is that the statute of limitations does not begin to run until the bailor has made a demand for the return of the property and has been refused or until the bailee has acted in a manner inconsistent with the bailment.[7] When an owner is known, therefore, a museum can take certain steps that may trigger the running of a statute of limitations. A written warning, best delivered by certified mail, can be sent to the owner; this should state that the museum, as of such-and-such a date, is asserting title to the property in question unless the property is retrieved by that date.[8] "Where the names and post office addresses of those affected by a proceeding are at hand, the reasons disappear for resort to means less likely than the mails to apprise them of its pendency."[9] The purpose of the written communication is to establish evidence that the owner is on notice that the museum is "converting" (claiming as its own) the property in question. The owner should then be aware that he or she has a cause of action for conversion and that, if the owner fails to press this claim within the applicable statute of limitations, he or she may be forever barred from doing so.[10] All of this, of course, assumes that the owner is easily located and that delivery of notice can be established.

If the owner of a loan is unknown or cannot be located, the museum is faced with a dilemma. Extensive searches for an owner or heirs are costly, and even if searches produce claimants, the museum acts at its peril if it returns objects to those having less than full ownership rights. How, practically, can effective notice be given to unknown owners?

6. Ibid., 139.

7. *Irvine v. Gradoville*, 221 F.2d 544 (D.C. Cir. 1955); *Schupp v. Taendler*, 154 F.2d 849 (D.C. Cir. 1946).

8. Even if the loan in question was for a term and the expiration date has long passed, a museum cannot assume that the courts will impose a duty on the lender to come forward, and it is safer to send such a notice. For example, in *Houser v. Ohio Historical Society*, 62 Ohio St. 2d 77, 403 N.E.2d 965 (1980), a loan made to a museum "for a term of one year or more" went unclaimed for over twenty years after the death of the owner. The court refused to apply the statute of limitations. In museum cases, the courts appear unwilling to concede that at some point lenders, or their heirs should be on notice that loans cannot go on forever. In other situations, ignorance or lack of diligence has been held not to bar the statute of limitations from running: *Wood v. Carpenter*, 101 U.S. 135, 25 L.Ed. 807 (1879); *Fernandi v. Strully*, 35 N.J. 434, 173 A.2d 277 (1961); *Federal Insurance Co. v. Fries*, 78 Misc. 2d 805, 355 N.Y.S.2d 741, 747 (1974), "But ignorance does not stop the clock, unless the defendant engages in fraudulent or misleading conduct."

9. *Mullane v. Central Hanover Bank and Trust Co.*, 339 U.S. 306, 70 S. Ct. 652, 94 L.Ed. 865, 875 (1950). See also *Mennonite Board of Missions v. Adams*, 462 U.S. 791, 77 L.Ed. 2d 180, 103 S. Ct. 2706 (1983).

10. *Magruder v. Smithsonian Institution*, Case No. 83-693-Civ CA (U.S.D.C. So. Fla., Sept. 15, 1983). But see *De-Blanc v. State of Louisiana*, No. 79-13404 (La. Civ. D. Ct. for Parish of Orleans, Div. C, April 1980), and *Wogan v. State of Louisiana*, No. 81-2295 (La. Civ. D. Ct. for Parish of Orleans, Div. D, Jan. 1982), in which, under the peculiarities of Louisiana law, a museum was not permitted to "convert" a loan.

Should a museum place a notice in the newspaper? Perhaps, but this involves an element of uncertainty. The advisability of taking such action depends on whether this method is deemed sufficient by a court later called on to make the determination.[11] Regarding establishing proper notice for judicial proceedings, the Supreme Court has said: "This Court has not hesitated to approve of resort to publication as a customary substitute in another class of cases where it is not reasonably possible or practicable to give more adequate warning. Thus, it has been recognized that in the case of persons missing or unknown employment of an indirect and even a probably futile means of notification is all that the situation permits and creates no constitutional bar to a final decree foreclosing their rights."[12]

This language leads to the reasoning that if a museum has no record of names and addresses of the depositors of objects, or if named depositors cannot be located with reasonable effort,[13] then some form of general notice may be sufficient to begin the running of applicable statutes of limitations. The customary way of giving general notice is a posting in the local newspaper, but any other method or combination of methods just as likely to produce the desired end should be considered. Common sense, not mere custom, should be the guide.[14] For example, if an object has been displayed publicly in a museum for fifty years with a label identifying it as "on loan from John Smith," such a display could be construed an effective notice to John Smith's heirs that a claim should be made immediately to the museum. Similarly, circumstances may be such that a notice in the museum's newsletter

11. In *In re Estate of McCagg*, 450 A.2d 414 (D.C. 1982), the court suggests that if a museum is unable to locate heirs through reasonably diligent efforts, "then constructive notice by publication might suffice." There is no elaboration on the nature of the "publication." By statute in California, notice to unknown or unlocatable owners of unclaimed property left with museums is deemed sufficient if published at least once a week for three successive weeks in a newspaper of general circulation in both the county in which the museum is located and the county of the lender's address, if any. Other statutes on the same subject have different procedures (see Section F, "Legislative Solutions"). The Revised Uniform Disposition of Unclaimed Property Act (1981) does not cover property generally loaned to museums, but its notification provisions may be a useful point of reference if a museum (in a state that does not have an "old loan" statute) is faced with determining what might constitute adequate notice in an unclaimed loan situation.

12. *Mullane v. Central Hanover Bank and Trust Co.*, 339 U.S. 306, 70 S. Ct. 652, 94 L.Ed. 865, 875 (1950). See also *Mennonite Board of Missions v. Adams*, 462 U.S. 791, 103 S. Ct. 2706, 77 L.Ed. 2d 180 (1983); *Cunnius v. Reading School District*, 198 U.S. 458, 25 S. Ct. 721, 49 L.Ed. 1125 (1905); *Blinn v. Nelson*, 222 U.S. 1 (1911).

13. *Jacob v. Roberts*, 223 U.S. 261, 32 S. Ct. 303, 56 L.Ed. 429 (1912), discusses what constitutes diligent search. Here various local residents were questioned and inquiries were made to local officials in an effort to trace a former resident. This search was considered adequate. In *Schroeder v. New York*, 371 U.S. 208, 83 S. Ct. 279, 9 L.Ed. 2d 255 (1962), another case involving "due process," the court held that newspaper notice was not sufficient if, with a good-faith effort, the names and addresses of interested parties could have been obtained from city records. See also *Walker v. Hutchinson*, 352 U.S. 112, 1 L.Ed. 2d 178, 77 S. Ct. 200 (1956). These cases indicate that at a minimum, a museum should document that it conducted a systematic search of items such as public records, telephone directories, and probate court records before it decided that obtaining actual addresses was "not reasonably possible or practicable." For those faced with the task of tracing long-lost lenders, the U.S. Department of Health and Human Services publishes a pamphlet entitled "Where to Write for Vital Records," DHHS Publication No. (PHS) 82-1142. The pamphlet gives such information as the addresses of all state records offices, the scope of their records, and fees for the duplication of records.

14. See *Milliken v. Meyer*, 311 U.S. 457, 61 S. Ct. 339, 85 L.Ed. 278 (1940). *Grannis v. Ordean*, 234 U.S. 385, 34 S. Ct. 779, 58 L.Ed. 1363 (1914).

and posters in the museum itself may be deemed more likely to reach interested parties than a notice in the city newspaper.[15]

The situation regarding effective notice becomes even more tenuous when the original loan was for an indefinite period. When do such arrangements terminate? Normally, if there is no express evidence to the contrary, either party to such a loan can terminate the arrangement on notice to the other. If the owner is known, therefore, a museum could give written notice that it is terminating an indefinite loan. Assuming that the notice is reasonable and the owner fails to collect the property, the museum can then attempt to force action by giving notice of intent to convert.[16] The more common situation, however, involves an unknown or unlocatable owner. This poses two problems for the museum: giving effective notice of termination and giving effective notice of intent to convert if the owner fails to retrieve. A museum could attempt to do both by using a form of general notice that it believes is defensible in light of all the circumstances.[17] Having given such notice, it could then prudently determine that the appropriate statute of limitations has begun to run, hoping that, if challenged, its actions will be upheld by the courts. At the present time this may be the safest, though arduous, course. However, a museum should also consider several other theories, which do not place all the burden on the museum to establish adequate notice in order to begin a statute of limitations. Rather, these theories infer an obligation on the depositor or the depositor's heirs to come forward.

Some cases lend support to the argument that an owner should not be allowed to delay beyond a reasonable time in making a request for the return of property left on indefinite loan. In *Nyhus v. Travel Management Corporation*,[18] for example, the court reasoned as follows: "Where a demand is necessary to perfect a cause of action, the statute of limitations does not commence to run until the demand is made. . . . [But] a party is not at liberty to stave off operation of the statute inordinately by failing to make demand; when statutorily unstipulated, the time for demand is ordinarily a reasonable time. That, however, is a matter of the parties' expectations, and a different result follows when an indefinite delay in making demand was within their contemplation."[19]

If the language of *Nyhus* is followed, a museum might find relief from a long overdue,

15. Of course, when claimants come forward, difficulties may be encountered in determining who are the true parties at interest, and legal advice will be necessary.

16. In *Bufano v. San Francisco*, 233 Cal. App. 2d 61, 43 Cal. Rptr. 223 (1965), an artist sued the city for two of his sculptures that had been held by the city for seventeen years. The court held that a statute of limitations would not begin to run until the owner was on notice that the city claimed the sculptures as its own.

17. See footnote 11, above, and see Section F, "Legislative Solutions," for examples of statutory requirements concerning notice. A notice should contain at least the following information: a brief description of the reason for the notice and the property involved; the approximate date of the loan, if known; the name of any unlocatable owner; when a claimant must come forward and what happens if he or she does not; the name of a person at the museum to contact for more information; and the address for mailing claims.

18. 466 F.2d 440 (D.C. Cir. 1972). See also *Heide v. Glidden Buick Corp.*, 188 Misc. 198, 67 N.Y.S.2d 905 (1947); *Southward v. Foy*, 65 Nev. 694, 201 P.2d 302 (1948); *Slack v. Bryan*, 299 Ky. 132, 184 S.W.2d 873 (1945); *Campbell v. Whoriskey*, 170 Mass. 63, 48 N.E. 1070 (1898); *Wright v. Paine*, 62 Ala. 340 (1878).

19. 466 F.2d 452–53 (D.C. Cir. 1972).

indefinite loan by proving that the owner failed to demand return of property within a reasonable time[20] and that this failure triggered the applicable statute of limitations, which has since run. However, a practical problem may be encountered in trying to convince a court that a "reasonable time" has elapsed for the owner to terminate the loan.[21] Many people unfamiliar with the problems of running a museum think it perfectly reasonable for a museum to be charged with holding indefinitely the property of some unknown party. It matters not whether the "indefinite" loan has been for ten years, forty years, or one hundred years. The average museum administrator can only view such an attitude in complete disbelief, but it is an attitude that must be reckoned with.

If the facts reveal that the lender of an indefinite loan has long since died and that the estate or heirs failed to come forward to notify the museum, additional evidence may be available to support a loan-termination date and a failure to make a demand in a reasonable time. Normally, when people enter into indefinite loans with museums, they are not contemplating an arrangement that will survive death but rather a temporary disposition that will be subject to later review. Indefinite loans are not viewed as testamentary instruments (instruments for determining the disposition of property after death), nor do they have the requisites established by law to be so classified. It is fair to infer, then, that lenders, when entering into indefinite loans, do not intend to have the loan last longer than their life. Rather, lenders expect that if they should die before recalling the loan, the property will become part of their estate, to be administered accordingly. In other words, from the nature of the agreement and the probable intent of the lender, the indefinite loan should be considered terminated at the death of the lender unless evidence clearly indicates that a contrary result was intended. It is equally fair to infer that a museum, in entering into such a loan as bailee, never intends to have the loan last beyond the life of the owner. Otherwise, the museum would be willingly committing itself to a situation in which it may face years of maintenance costs for objects over which it has no definitive control.[22] In addition, common

20. What is a reasonable time must be determined from the nature of the agreement and the probable intention of the parties. *Campbell v. Whoriskey,* 170 Mass. 63, 48 N.E. 1070 (1898); *Warren v. Ball,* 341 Mass. 350, 170 N.E.2d 341 (1960). In *Desiderio v. D'Ambrosio,* 190 N. J. Super. 424, 463 A.2d 986 (1983), the court applied the statute of limitations period from the date the bailment began.

21. See *Houser v. Ohio Historical Society,* 62 Ohio St. 2d 77, 403 N.E.2d 965 (1980). In *Houser,* objects were placed on loan in 1931. In 1948, on demand, one object was returned. In 1952, the lender died, and in 1975 an administratrix was appointed for the lender's estate. The administratrix retrieved loan receipts from the lender's safe-deposit box and requested the property from the historical society. The historical society claimed that the statute of limitations had run. The court quoted the rule stating that a demand must be made in a reasonable time, but it refused to invoke the rule for this "special circumstance." See also *In re Estate of McCagg,* 450 A.2d 414 (D.C. 1982), where the court refused to find "an implied finite time for demand" in an indefinite loan that went unclaimed for almost fifty years after the death of the lender. It is difficult to reconcile these cases with *Desiderio v. D'Ambrosio,* 190 N. J. Super. 424, 463 A.2d 986 (1983), an unclaimed indefinite bailment situation that did not involve a museum. In *Desiderio,* the court held that a bailor was barred from reclaiming property left unclaimed for six and one-half years, even though the address of the bailor was known to the bailee.

22. One subject that deserves more attention by the museum profession is the cost of maintaining a collection object. All too frequently, museums assume that care or "storage" is a minor budgetary item that is of little significance in weighing the relative duties of lender and borrower. Some preliminary work in this area dem-

practice supports the view that museums actually treat indefinite loans as terminating at the death of lenders. In most of these situations, the estate or heirs come forward in a timely manner, and without hesitation, the museum returns the borrowed objects or, if mutually desired, a new loan agreement is entered into between the museum and the current owner. With the death of a lender, therefore, frequently there is persuasive evidence that an indefinite loan situation terminates. If the loan terminates, should not the estate or the heirs have the responsibility to come forward and demand the property? Undue delay, then, may be grounds for arguing that the claim is now barred because the applicable statute of limitations began to run on failure of the estate to make timely demand.[23] So far, this argument has not been successfully made by a museum, but as explained in Section E, developments in the law indicate that courts are growing more receptive to the idea that owners should bear some of the burden of protecting their rights in property.

C. Laches

The second legal doctrine that should be considered when trying to resolve unclaimed property situations is the defense of laches. "Laches" is (1) delay that makes it inequitable to give the relief sought or (2) delay that warrants a presumption that the party requesting relief

onstrates that storage and/or exhibition of art objects and curation of scientific specimens involve substantial costs and that loans or "deposits" to museums should be judged accordingly. With facts and figures on the cost of care available, a judge may pause before finding an indefinite loan of fifty years "reasonable." On the subject of the care of scientific specimens, see W. Marquardt et al., "Resolving the Crisis in Archaeological Collections Curation," 47 *American Antiquity* 409 (No. 2, 1982); *The Curation and Management of Archaeological Collections: A Pilot Study,* Cultural Resources Management Series (Washington, D.C.: U.S. Department of Interior, 1980); T. Nicholson, "The Obligation of Collecting," *Museum News* 29 (Oct. 1983). The North Idaho Regional Laboratory of Anthropology at the University of Idaho and the Institute of Archaeology and Anthropology at the University of South Carolina have developed fee schedules that reflect the actual costs of curation and storage. At the 1983 ALI-ABA conference on "Legal Problems of Museum Administration," a presentation discussed the cost of maintaining a museum object as this relates to "indefinite loans." It was pointed out that a true analysis of cost should include such factors as recording, periodic inventory, maintaining accessible records, environmental pest control, storage equipment, security, conservation, insurance, and general overhead including management and building expense. Display can add considerably more to cost, especially if one realistically calculates total space used to create the ambience necessary for effective presentation. For more specific figures, see W. Washburn, "Collecting Information, Not Objects," *Museum News* 5 (Feb. 1984). The cost of caring for museum collections has become of even greater concern as each year passes. In a 1996 presentation, Willard Boyd, director of the Field Museum of Natural History and an articulate member of the Institute of Museum Services' National Museum Services Board, listed one of the major challenges facing the museum community in the new century: "[M]useums need to be more specific and focused in their collecting. Furthermore, whatever is collected must be conserved and protected. Dollars for collecting must be matched by dollars for conservation." W. Boyd, "The Institute for Museum Services," *AAM Sourcebook 1996* (Washington, D.C.: AAM, 1996).

23. But see *In re Estate of McCagg,* 450 A.2d 414 (D.C. 1982), where the court refused to find that the death of a lender triggered a duty to demand delivery. The root of the problem appears to be an unwillingness to impose any obligation on lenders or their heirs to inquire after property left with a museum. See also footnote 8, above. Note also that a state may have an escheat law providing that unclaimed property left in a dead person's estate passes to the state. In such an instance, the state could attempt to assert a right to property that has not been claimed by the heirs of a deceased lender.

has waived his or her rights.[24] The defense usually is available if there is evidence that a party negligently delayed making a claim or enforcing a right and that this delay actually prejudiced the other party. In such cases, the law may infer a waiver of all claims by the negligent party in order to avoid injustice to the prejudiced party:

The doctrine of laches is based upon grounds of public policy which requires the discouragement of stale demands for the peace of society. Where there is difficulty in doing complete justice by reason of the death of the principal witness or witnesses, or where the original transaction has become obscured by time because of gross negligence or deliberate delay, a court of equity will not aid the party whose application thus lacks good faith and reasonable diligence. Equity takes the view that such manifest neglect constitutes an implied waiver arising from a knowledge of the conditions and an acquiescence in them.[25]

What is an unreasonable time depends on the facts,[26] but the defense of laches does require evidence of negligence on the part of the party asserting a right. In other words, in an unclaimed property situation, the bailee/museum would have to show that the claimant knew or should have known that the claimant was sleeping on his or her rights.[27] Establishing the negligence aspect of laches carries with it the same or similar problems one encounters when trying to establish that a statute of limitations has begun to run.

If negligent delay can be established, the party asserting laches must also show that it has been prejudiced by the delay. A bailee/museum might be able to prove such prejudice if, for example, it can demonstrate that the undue delay has blurred evidence by which it could have shown that a deceased lender intended to make a gift of the property, or that the object in question has become very important to the collections and, if removed now, could not be replaced, or that timely notice would have put the bailee/museum in a better position to negotiate a gift or purchase of the property, or that timely notice would have saved it the expense and frustration of years as an involuntary bailee. If the museum has actually disposed of the property in good faith, it may well have a basis for proving prejudice when a long overdue claim is presented. As explained in Section E, a more recent New York court decision places greater emphasis on the doctrine of laches in situations in which two parties are arguing over title to an object.

24. *Thorpe v. Wm. Filene's Sons Co.,* 40 F.2d 269 (D. Mass. 1930); *Harrison v. Miller,* 124 W. Va. 550, 21 S.E.2d 674 (1942). The distinction is sometimes made that statutes of limitations apply to actions at law, whereas laches is the analogous rule applied to equitable proceedings; see *Desiderio v. D'Ambrosio,* 190 N.J. Super. 424, 463 A.2d 986 (1983). See also discussion in Section E.

25. *Kaufman v. Plitt,* 191 Md. 24, 59 A.2d 634, 635 (1948). See also *Hoffa v. Hough,* 181 Md. 472, 30 A.2d 761 (1943), and *Brady v. Garrett,* 66 S.W.2d 502 (Tex. Civ. App. 1933).

26. *Kaufman v. Plitt,* 191 Md. 24, 59 A.2d 634, 635 (1948).

27. "Laches cannot be imputed to a party who has been justifiably ignorant of the facts creating his right or cause of action, and has consequently failed to assert it." *Berman v. Leckner,* 193 Md. 117, 66 A.2d 392, 395 (1949). In *Brady v. Garrett,* 66 S.W.2d 502 (Tex. Civ. App. 1933), the loan of an object for exhibit for fourteen years and the bailee's belief that a gift had been made by the owner's husband did not support a defense of laches, and the owner was allowed to recover.

D. Adverse Possession

A third legal doctrine that may come into play in an unclaimed property situation is adverse possession.[28] Adverse possession is a method of acquiring title by possessing something for a statutory period of time under certain conditions.[29] The conditions are that the possession must be hostile (adverse to the owner), actual, visible, exclusive, and continuous. The doctrine is associated, as a rule, with real property. For example, if Mr. X allowed, without express permission, Mr. Z to build on and occupy a piece of Mr. X's property for years, Mr. Z may well develop a right to the real estate by adverse possession. The doctrine has also been applied to personal (movable) property, but with less success. Whether or not possession of an object, as distinct from land, has been hostile, actual, visible, exclusive, and continuous often defies conclusive proof, and in addition, confusion can arise as to whether the proper doctrine to apply is adverse possession or the running of a statute of limitations.[30] Consider, for example, the case of *Redmond v. New Jersey Historical Society*[31] and the previously discussed case of *O'Keeffe v. Snyder*.[32]

In *Redmond*, a portrait by Gilbert Stuart was bequeathed by its owner to her son on the condition that if the son died leaving no descendants, the portrait would go to the New Jersey Historical Society. The owner died in 1887, when her son was only fourteen. The portrait was delivered to the historical society. Fifty years later, the son died, leaving children, and these children requested the return of the painting because, under the terms of their grandmother's will, title now vested in them. The historical society refused, claiming it had acquired title to the portrait. The children sued. In deciding the case, the appeals court applied the doctrine of adverse possession and found that during the loan period,[33] the historical society did nothing to establish that its possession of the paintings was "adverse" or "hostile."

This application of the adverse possession concept to personal property gave the New

28. This doctrine is also discussed in Section D(5), "Stolen Property," in Chapter IV.

29. *Black's Law Dictionary* (6th ed. 1990).

30. Two Louisiana cases demonstrate the difficulty that a bailee may have in establishing a defense of adverse possession. *DeBlanc v. Louisiana State Museum*, No. 79-13404 (La. Civ. D. Ct. for Parish of Orleans, Div. C, April 1980), and *Wogan v. Louisiana State Museum*, No. 81-2295 (La. Civ. D. Ct. for Parish of Orleans, Div. D, Jan. 1982), involved claims against the Louisiana State Museum for loans allegedly converted by the museum. In both instances, the plaintiffs prevailed because, under Louisiana law, bailees "cannot prescribe whatever may be the time of possession." These cases also suggest that the public, rightfully, may not look too kindly on museums that silently change old loans to gifts in an effort to resolve title uncertainty through adverse possession.

31. 132 N.J. Eq. 464, 28 A.2d 189 (1942).

32. 170 N.J. Super. 75, 405 A.2d 840 (1979), *rev'd*, 83 N.J. 478, 416 A.2d 862 (1980). See also *Naftzger v. American Numismatic Society*, 42 Cal. App. 4th 421 (1996). See also Section D(5), "Stolen Property," in Chapter IV.

33. The historical society knew or was presumed to have known that under the terms of the owner's will, its claim to the painting could not be resolved until the son's death. Hence, it held the painting on loan as a bailee until this time. In effect, it held the painting on a loan for a definite term, the life of the son. In this regard, the *Redmond* case is quite different from the situation of an indefinite loan for which the lender or heirs cannot be located.

Jersey Supreme Court trouble in *O'Keeffe v. Snyder*. *O'Keeffe* involved paintings allegedly stolen from the artist Georgia O'Keeffe and later found in the possession of an innocent purchaser. When O'Keeffe sued for the return of the paintings some thirty years later after learning of their whereabouts, the question arose as to whether the doctrine of adverse possession should be applied. If adverse possession was the true test, the innocent purchaser could not prevail because the paintings had been displayed almost exclusively in private homes and, hence, "hostile" and "visible" possession could not be proven. The court found that the doctrine of adverse possession did not provide a fair and reasonable means of resolving disputes involving personal property and overruled *Redmond* to the extent that an earlier court decision had held that the doctrine did apply in New Jersey to personal property.

E. Current State of the Law

From what has been said so far, it is evident that unclaimed loans present particularly difficult problems for museums and that, in the relatively few times these matters have been litigated, museums have not succeeded in convincing the courts that they deserve relief. Some blame may be placed on the museums themselves for failure, during litigation, to document the scope of the problem so that the courts were better prepared to weigh the public policy aspects of the decisions. The value of such education has since been demonstrated by the success that many state museum organizations have recently had in convincing their state legislatures that enactment of statutory relief is good public policy. These relatively new unclaimed loan statutes are discussed in Section F, but some observations can be made here about developing legal theories that are worth considering if a museum does have to confront an unclaimed loan situation and if no state statute specifically addresses unclaimed loans. Developments in the law regarding the triggering of statutes of limitations and the application of the doctrine of laches are both worth noting.

In the description of statutes of limitations in Section B, it was explained that these statutes have not, to date, been successfully used by museums in unclaimed loan situations because of the problem of triggering the beginning of such a statute. Since courts refused to infer any obligation on the part of lenders (or heirs) to stay in touch with museums, the burden has always fallen on museums to somehow get actual or constructive notice to delinquent lenders in order to start a running of a statute of limitations. The development of what is called the "discovery rule" could possibly offer museums some relief in this regard. The discovery rule was adopted in the before-mentioned case of *O'Keeffe v. Snyder*,[34] in which the court had to weigh two relatively innocent parties' claims involving alleged stolen property. "The discovery rule provides that, in an appropriate case, a cause of action will not accrue until the injured party discovers, or by exercise of reasonable diligence and intelligence should have discovered, facts which form the basis of a cause of action. . . . The rule

34. See note 32, above.

is essentially a principle of equity, the purpose of which is to mitigate unjust results that otherwise might flow from strict adherence to a rule of law."[35]

As explained in Chapter IV, in the *O'Keeffe* case the artist, Georgia O'Keeffe, sued in the late 1970s to recover paintings she had lost in 1946. At the time of the loss, she had taken little action to advertise that her works were missing and to notify law enforcement authorities. Only in 1976, when she happened by chance to learn that the paintings were in the hands of an innocent purchaser, did she come forward to demand their return. The major issue in this case was whether O'Keeffe should be barred from suing the innocent purchaser because of the running of a statute of limitations. The case went all the way to the final court of appeals in New Jersey, with the court reasoning as follows. O'Keeffe's cause of action would normally have accrued in 1946, when she had discovered that her paintings were stolen. New Jersey has a six-year statute of limitations for bringing an action to recover stolen property; thus, barring unusual circumstances, O'Keeffe had to sue by 1952 or lose her right to claim the property. But this instance involved unusual circumstances because O'Keeffe said that she did not know where the paintings were until 1976 and hence could not make her demand until that time. Under the discovery rule, however, the running of the statute of limitations would not be postponed unless O'Keeffe could establish that she had exercised reasonable diligence in discovering the facts that formed the basis of her cause of action. In other words, the discovery rule placed a burden on O'Keeffe to justify her lack of action for so many years.[36] Accordingly, the Supreme Court of New Jersey ordered the case to be returned to the trial court so that further evidence could be introduced by O'Keeffe to establish reasonable diligence in pursuing her property.[37]

The discovery rule is an attempt to balance the repose that is essential to stability in human affairs (that is, the reason for statutes of limitations) with the desire to afford plaintiffs generous opportunities to press claims in court. In the *O'Keeffe* case, the court considered it an unacceptable imbalance to permit owners of stolen property an indefinite period of time in which to claim their property, and by use of the discovery rule, it required such owners to justify long delays. In unclaimed museum loan situations, it is frequently an unacceptable imbalance to allow owners indefinite periods of time in which to claim their property, and here again, the discovery rule could be used to correct the imbalance. Its use, however, would be predicated on a court's willingness to place a time limit on the duration of an indefinite loan.[38]

Consider, for instance, the following set of facts. In 1920, Mr. X loaned an antique clock to Museum Y. No time period was set on the loan, but the loan was acknowledged in writing

35. *O'Keeffe v. Snyder*, 416 A.2d 862, 869 (N.J. 1980).

36. In *Poffenberger v. Risser*, 290 Md. 631, 431 A.2d 677 (1981), the court discusses the type of knowledge that is necessary under the discovery rule to start the running of the limitations period.

37. At this point, the parties entered into a private settlement, and the case went no further in the courts.

38. An unwillingness by a court to place a time limit on the duration of an indefinite loan is, in effect, a disregard for the public policy behind statutes of limitations. If a court does not pinpoint some time at which a lender, or heirs, must come forward, then there is no point at which the statute of limitations can begin to run and no possible period of repose. The case of *In re Estate of McCagg*, 450 A.2d 414 (D.C. 1982), illustrates this.

by the museum, and a loan receipt was given. Years passed, and no further correspondence between the lender and the museum is shown in the museum files, but museum records do indicate that in the 1940s, some attempt was made by the museum to locate Mr. X or his family. During all this time, the clock remained on exhibit and was cared for by the museum. Museum records, which are open to the public, continued to record the clock as a 1920 loan from Mr. X. Some sixty years after the loan was made, heirs of Mr. X came forward and demanded the clock, which now had a substantial resale value. Does Museum Y have any basis for contesting the heirs' demand? If the adverse possession test is applied, the museum cannot prevail because it cannot demonstrate the necessary "hostile" possession. The museum never attempted to hide or change its records regarding the origin of the clock. But if the discovery rule is applied, possibly, in balancing the equities, the museum could prevail. The museum can argue that the 1920 indefinite loan must be examined in light of what the parties had probably intended. From the known facts, the museum might be able to establish that it is reasonable to infer that the indefinite loan terminated at the death of Mr. X[39] or that, under the reasoning of the *Nyhus* case, the court should determine a reasonable time within which a demand should have been made.[40] At termination of the loan, or at expiration of a reasonable time for making a demand, Mr. X's estate or heirs would then be obligated to come forward and take action, and with this obligation, the appropriate statute of limitations would begin to run.[41] Under the discovery rule, if the heirs hoped to postpone the running of the statute of limitations, the burden would be on them to show due diligence in pursuing their rights. A mere statement that they did not know of the clock until recently would not do. The discovery rule places a responsibility on owners to use reasonable care in looking after their property.[42] If Mr. X lost his loan receipt and never left evidence among his papers that the clock was on loan to the museum, he may well have violated the due care requirement and his heirs must suffer thereby. If evidence of the loan was left among his papers, his executor (and heirs) may well be unable to show due care in gathering all estate assets in a timely manner. If the existence of the clock had been known generally to the family members, some explanation would have to be given as to why they

39. See Section B, "Statutes of Limitations."

40. Ibid., and see footnote 18, above.

41. In *Desiderio v. D'Ambrosio*, 190 N.J. Super. 424, 463 A.2d 986 (1983), the court applied the statute of limitations from the date the bailment began and thus did not consider the value of the discovery rule. The approach of first determining a reasonable time for the indefinite loan and then applying the statute of limitations appears to offer an equitable solution in a greater variety of cases.

42. In the case of *The Mary*, 13 U.S. 126, 9 Cranch 126, 3 L.Ed. 678, 684 (1815), the Court commented, "[I]t is part of common prudence for all those who have any interest in . . . [an object], to guard that interest by persons who are in a situation to protect it." Also, California recognizes an obligation on the part of lenders to keep in touch with museums. The California statute described in Section F of this chapter states: "It is the responsibility of the owner of property on loan to a museum to notify the museum promptly in writing of any change of address or change in ownership of the property. Failure to notify the museum of these changes may result in the owner's loss of rights in the property." This California statute was enacted on the basis of extensive fact-finding on the totality of the "old loan" situation in California museums. See J. Teichman, "Museum Collections Care Problems and California's 'Old Loan' Legislation," 12 *Hastings Comm. & Ent. L. J.* 423 (spring 1990).

made no attempt to locate it. The fact that the clock was on public display at all times as a loan from Mr. X may cause some doubt as to whether any diligence was used by the family in searching for the property.

From a museum's standpoint, a court's willingness to find a reasonable time for the running of an indefinite loan and then to permit the application of the discovery rule affords a fairer test and, arguably, one that is in accord with public policy. Such a test discourages carelessness on the part of owners and, at the same time, encourages museums to act in a forthright manner. Under the discovery rule approach, museums are not pressured to hide or change their records or to convert in order to ward off stale claims. The maintenance of accurate and open records actually works to a museum's advantage because it creates a situation in which forgetful owners cannot later claim that they used due diligence in looking for their property. On the other hand, evidence of deceit or lack of good faith on the part of a museum may well be used to justify a claimant's long delay in demanding property. The discovery rule also recognizes that no museum alone can bear the burden and expense of keeping track of the current status of all its lenders, or their heirs, and that justice is better served when obligations are imposed on the lender as well as the borrower.

Developments in the doctrine of laches should also be noted. In recent years, more attention has been given to the doctrine of laches by the museum community because of New York State court decisions concerning litigation between victims of theft and innocent purchasers, situations similar to the one in the *O'Keeffe* case. The central case in New York is *Solomon R. Guggenheim Foundation v. Lubell,* a case mentioned in Chapter IV.[43] As explained earlier, the Guggenheim Museum first noticed one of its paintings was missing in the mid-1960s but failed to advertise the loss or to notify law enforcement officials. In 1985, purely by chance, the museum learned that the painting was in the possession of a person who had innocently purchased it from a reputable dealer many years earlier. When the possessor refused to give up the painting, arguing that a statute of limitations had run, the Guggenheim sued. The trial court, relying on the discovery rule approach, found for the innocent purchaser on the grounds that the statute of limitations had run because the museum was not sufficiently diligent in pursuing recovery to stop the statute from tolling. The museum appealed. In the final appeal the court refused to accept the statute of limitations as the proper defense but held instead that the correct doctrine to apply was laches because laches required a full hearing on all the issues and a balancing of the equities.[44] Hence, in New York as long as the *Guggenheim* decision prevails, courts will examine the conduct of both parties in cases of this nature and will not limit their inquiry to the procedural issue of whether the plaintiff pursued the claim with due diligence.

In truth, it is difficult to draw a clear line between the "discovery rule" as it is applied to a statute of limitations issue, and the doctrine of laches, because in determining the

43. 567 N.Y.S.2d 623, 569 N.E.2d 426 (1991). See Chapter IV, Section D(5). See also *Society of California Pioneers v. Baker,* 43 Cal. App. 4th 774 (1996), and *Naftzger v. American Numismatic Society,* 42 Cal. App. 4th 421 (1996).

44. At this point, the case was sent back to the trial court for a new hearing based on the defense of laches. The case was ultimately settled out of court.

reasonableness of the plaintiff's conduct, a court tends to consider, consciously or uncon-sciously, the overall conduct of the defendant. But as a procedural matter, a statute of limita-tions defense can offer a more efficient way to dispose of a case. A statute of limitations articulates a public policy (cases should be heard while evidence is fresh), and with this goes the recognition that an occasional harsh result is a legitimate price for the stability of a good general rule.[45] The doctrine of laches, on the other hand, is an equitable test that responds to the facts of the particular case with a focus on fairness. It forces a full trial on all the issues but can offer a court an opportunity to avoid the distasteful result that may be mandated by the operation of the more mechanical statute of limitations defense. In any event, when considering possible defenses to litigation based on unclaimed loan situations, museums are advised to argue both the application of the discovery rule for purposes of triggering a statute of limitations and the doctrine of laches.[46]

F. Legislative Solutions

Because traditional legal doctrines were offering museums little practical relief for their unclaimed loan problems, some museums decided to look to their state legislatures for the enactment of statutes that set forth procedures specifically designed to resolve these mat-ters.[47] Most of these statutes were passed in the 1980s, and they range from a relatively simple Maine statute to a very detailed California statute.[48] Some, by definition, cover only true unclaimed loans (situations in which there is evidence that the objects were placed as loans), whereas others, unfortunately, define the property covered as both unclaimed loans and undocumented property.[49] All statutes require some type of actual or constructive no-

45. See quotation at footnote 4, above.

46. See I. DeAngelis, "Old Loans: Laches to the Rescue?" in American Law Institute–American Bar Associa-tion (ALI-ABA), *Course of Studies Materials: Legal Problems of Museum Administration* (Philadelphia: ALI-ABA, 1992); L. Wise, "Old Loans: A Collections Management Problem," in American Law Institute–American Bar As-sociation (ALI-ABA), *Course of Studies Materials: Legal Problems of Museum Administration* (Philadelphia: ALI-ABA, 1990).

47. For years, most states have had statutes that address abandoned property: property left unclaimed in safe-deposit boxes, in commercial warehouses, or with government agencies, for example. As pointed out in footnote 2, above, classifying an unclaimed loan to a museum as "abandoned property" is very difficult. Also, most statutes regulating abandoned property require that the property be turned over to the state. Accordingly, a state "abandoned property" statute is rarely helpful to a museum. When writing a state statute that specifi-cally addresses unclaimed loans, however, any state abandoned-property statute should be cross-referenced and any ambiguities regarding the application of each should be clarified.

48. The genesis and implementation of the California statute is well-documented. See J. Teichman, "Mu-seum Collections Care Problems and California's 'Old Loan' Legislation," 12 *Hastings Comm. & Ent. L. J.* 423 (spring 1990), and J. Teichman, "Common Collections Management Questions: Who Owns Old Loans and Un-documented Property, and Are We in Compliance with Our Old Loan Legislation?" in American Law Institute–American Bar Association (ALI-ABA), *Course of Studies Materials: Legal Problems of Museum Administration* (Phila-delphia: ALI-ABA, 1995).

49. Undocumented property or "objects found in the collections" (see Chapter X) normally carry a presump-tion that they belong to the museum. Subjecting this type of object to the same procedures as required for un-claimed loans actually works to the detriment of the museum because the burden of proof is shifted.

tice to lenders, but some statutes, such as that of California,[50] automatically cut off a lender's right to recovery if at least twenty-five years have passed without any written contact between the lender and the museum. Those cases in which termination occurs after constructive notice (e.g., notice by publication in newspapers) or occurs automatically after the passage of a set period of time with no contact involve possible constitutional issues.[51] As one commentator wrote, if the constitutionality of such unclaimed loan legislation provisions is questioned, "courts ultimately will consider the need for the particular provision, the importance of the rights affected, and whether the legislative solution is fair and reasonable in light of the circumstances and problems addressed."[52] Because of this potential problem, those initiating the California statute undertook extensive fact-finding regarding the unclaimed loan problem within the state, and on the basis of this information, the state legislature prefaced its legislation with a series of "findings" to support the procedures adopted.[53]

As of 1997, twenty-eight states have some form of unclaimed loan legislation (see Figure VII.1).

Surprisingly, in the early 1990s, no state in the Mid-Atlantic American Association of Museums (MAAM) had legislation specifically addressing unclaimed loans—despite considerable local interest in the topic.[54] The Registrars Committee of MAAM, a group directly concerned with collection management, decided it was time to act more aggressively and, in 1992, established a task force to investigate old loan issues within the region. The task force, after documenting substantial unclaimed loan problems within the region, decided to produce a model unclaimed property law for museums—a model that could be used by interested parties within each state in the region as a starting point to draft legislative proposals tailored to the peculiarities of their particular states.

The model law was promulgated in 1994. It had been written after a review of all state unclaimed loan statutes then in existence and with these objectives in mind:

1) to encourage museums and lenders to use due diligence in monitoring all outstanding loans;
2) to allocate fairly the responsibilities between lenders and borrowers; and
3) to resolve expeditiously the issue of title to unclaimed loans currently in the custody of the museum.[55]

Those using the model are urged to view it as a beginning step in the process of educating themselves and their professional colleagues about the essential problems. Users are urged

50. See § 1899.10 of Cal. Civil Code.

51. The two issues usually mentioned are Fourteenth Amendment due process considerations (U.S. Constitution) and impairment of contractual obligations (U.S. Const., art. I, sec. X, cl. 1).

52. J. Teichman, "Museum Collections Care Problems and California's 'Old Loan' Legislation," 12 *Hastings Comm. & Ent. L. J.* 423 (spring 1990).

53. See § 1899 of Cal. Civil Code.

54. States within MAAM are Delaware, District of Columbia, Maryland, New Jersey, New York, and Pennsylvania.

55. I. DeAngelis, "Model Museum Unclaimed Property Law for the Mid-Atlantic Region and Citations to Existing State 'Old Loan' Legislation," in American Law Institute–American Bar Association (ALI-ABA), *Course of Studies Materials: Legal Problems of Museum Administration* (Philadelphia: ALI-ABA, 1995), 299, 303.

Figure VII.1

List of State Unclaimed Loan Legislation

Alabama Code §§ 41-6-72 to 41-6-75[a]

Arizona Revised Statutes Annotated §§ 44-351 to 44-356

California Civil Code §§ 1899 to 1899.11

Colorado Revised Statutes §§ 38-14-101 to 38-14-112

1997 Florida Laws chapter 267

Indiana Code Annotated §§ 32-9-10-1 to 32-9-10-16

Iowa Code Annotated §§ 305B.1 to 305B.13

Kansas Statutes Annotated §§ 58-4001 to 58-4013

Kentucky Revised Statutes Annotated §§ 171.830 to 171.849

Louisiana Revised Statutes Annotated §§ 25:345[b]

Maine Revised Statutes Annotated title 27, § 601

Michigan Statutes Annotated §§ 15.1817(601) to 15.1817(613)

1997 Mississippi Laws chapter 464 (House Bill No. 1031)

Missouri Annotated Statutes §§ 184.101 to 184.122

Montana Code Annotated §§ 22-3-501 to 22-3-523

Nevada Revised Statutes Annotated § 381.009[c]

New Hampshire Revised Statutes Annotated §§ 201-E:1 to 201-E:7

New Mexico Statutes Annotated §§ 18-10-1 to 18-10-5

North Carolina General Statutes §§ 121-7(c) and 121-7(d)[b]

North Dakota Century Code §§ 47-07-14

Oregon Revised Statutes §§ 358.415 to 358.440

South Carolina Code Annotated §§ 27-45-10 to 27-45-100

South Dakota Codified Laws §§ 43-41C-1 to 43-41C-4

Tennessee Code Annotated §§ 66-29-201 to 66-29-204

Texas Property Code Annotated §§ 80.001 to 80.008

Washington Revised Code Annotated §§ 63.26.010 to 63.26.050

Wisconsin Statutes Annotated §§ 171.30 to 171.77

Wyoming Statutes §§ 34-23-101 to 34-23-108

[a]Applies only to the Alabama Department of Archives and History.

[b]Applies to the state museum in this state.

[c]Applies only to certain enumerated Nevada museums and historical societies.

Author's Note: Oklahoma is not on this list, but as of 1991, there is a section of the Oklahoma statutes, 60.683.2(c), that exempts museums from the provisions of the state's Uniform Unclaimed Property Act. The legislative history of this provision should be researched to determine whether the provision was adopted specifically to assist museums in resolving unclaimed loan problems.

to review existing legislation in other states and then to assess the unique needs within their own state. At this point, they can begin with some confidence to draft their own proposed legislation, using the model as a guide. A copy of the model follows (see Figure VII.2).[56]

56. Cochairs of the task force were Jeanne Benas, Office of the Registrar, National Museum of American History, Smithsonian Institution, Washington, D.C., and Jean Gilmore, Registrar, Brandywine River Museum, Chadds Ford, Pa. Legal adviser was Ildiko DeAngelis, Office of the General Counsel, Smithsonian Institution, Washington, D.C. As of mid-1997 no state in the MAAM region had yet adopted unclaimed loan legislation.

Figure VII.2

Model Museum Unclaimed Property Law

<div style="border">

MODEL
MUSEUM UNCLAIMED PROPERTY LAW

Section I: Purpose

The people of this state have an interest in the growth and maintenance of museum collections and in the preservation and protection of unclaimed tangible property of artistic, historic, cultural and/or scientific value left in the custody of museums within this state. Loans of such property are made to these museums in furtherance of their educational purposes. When lenders fail to stay in contact, museums routinely store and care for loaned property long after the loan periods have expired or should reasonably be deemed expired. But, museums have limited rights to the use and treatment of such unclaimed loaned property, all the while bearing substantial costs related to storage, record keeping, climate control, security, periodic inspection, insurance, general overhead, and conservation. It is in the public interest to:

(a) encourage both museums and their lenders to use due diligence in monitoring loans;

(b) allocate fairly responsibilities between lenders and borrowers; and

(c) resolve expeditiously the issue of title of unclaimed loans left in the custody of museums.

The purpose of this Act is to establish uniform rules to govern the disposition of unclaimed property on loan to museums and this act should be interpreted with these goals in mind.

Section II: Citation of Law

This law shall be known and may be cited as the Museum Unclaimed Property Act.

Section III: Effective Date

The effective date of this Act is [date].

Section IV: Definitions

(a) "Lender"—an individual, corporation, partnership, trust, estate, or similar organization, whose name appears on the records of the museum as the entity legally entitled to control property on loan to the museum;

(b) "Loan," "on loan," or "loaned"—property in the possession of the museum, accompanied by evidence that the lender intended to retain title to the property and to return to take physical possession of the property in the future;

(c) "Museum"—a public or private non-profit agency or institution located in this state and organized on a permanent basis for essentially educational or aesthetic purposes, which utilizes a professional staff, owns or utilizes tangible objects, cares for them, and exhibits them to the public on a regular basis;

(d) "Museum records"—documents created and/or held by the museum in its regular course of business;

(e) "Property,"—a tangible object, in the custody of a museum, that has intrinsic historical, artistic, scientific, or cultural value;

</div>

Figure VII.2 continued

(f) "Restricted certified mail"—certified mail that carries on its face, in a conspicuous place where it will not be obliterated, the endorsement "deliver to addressee only" and for which the post office provides the mailer with a return receipt showing the date of delivery, the place of delivery and the person to whom delivered;

(g) "Unclaimed property"—property meeting the following two conditions: (1) property is on loan to the museum; (2) the original lender, or anyone acting legitimately on the lender's behalf, has not contacted the museum for at least 25 years from the date of the beginning of the loan, if the loan was for an indefinite or undetermined period, or for at least 5 years after the date upon which the loan for a definite period expired.

Section V: Museums' Obligations to Lenders

1. *Record Keeping for New Loans:* For property loaned to a museum on or after the effective date of this Act, the museum shall do all of the following at the time of the loan:

(a) Make and retain a written record containing at least all of the following:

(i) The lender's name, address, and telephone number;
(ii) A description of the property loaned in sufficient detail for ready identification;
(iii) The beginning date of the loan;
(iv) The expiration date of the loan.

(b) Provide the lender with a signed receipt or loan agreement containing at least the record set forth in subsection (a), above.

(c) Inform the lender of the existence of this Act and provide the lender with a copy of this Act upon the lender's request.

2. *Record Keeping for Existing Loans:* Regardless of the date of a loan of property, the museum shall do the following:

(a) Update its records if a lender informs the museum of a change of address or change in ownership of property loaned, or if the lender and museum negotiate a change in the duration of the loan.

(b) Inform the lender of the existence of this Act when renewing or updating the records of an existing loan and provide the lender with a copy of this Act upon the lender's request.

Section VI: Lenders' Obligations to Museums

1. *Notices Required of Lenders:* As of the date of this Act, the lender, or any successor of such lender, shall, regardless of the date of a loan of property in the custody of a museum, promptly notify the museum in writing:

(a) of a change in lender's address; and/or
(b) of a change in ownership in the property on loan to the museum.

2. *Documentation Establishing Ownership:* It is the responsibility of a successor of a lender to document passage of rights of control to the property in the custody of the museum.

(a) Unless there is evidence of bad faith or gross negligence, no museum shall be prejudiced by reason of any failure to deal with the true owner of any loaned property.

(b) In cases of disputed ownership of loaned property, a museum shall not be held liable for its refusal to surrender loaned property in its possession except in reliance upon a court order or judgment.

Continued on next page

Figure VII.2 continued

Section VII: Notice by Museums to Lenders to Terminate Loans for Unclaimed Property

A museum may terminate a loan for unclaimed property in its possession as follows:

1. *Good Faith Search:* The museum shall make a good faith and reasonable search for the identity and last known address of the lender from the museum records and other records reasonably available to museum staff. If the museum identifies the lender and the lender's last known address, the museum shall give actual notice to the lender that the loan is terminated pursuant to subsection 2(a), below. If the identity or the last known address of the lender remains unknown after the above-described search, the museum shall give notice by publication pursuant to subsection 2(b), below.

2. *Notice:*

(a) *Actual Notice:* Actual notice of termination of a loan of unclaimed property shall take substantially the following form. The museum shall send a letter by restricted certified mail to the lender at the lender's last known address giving a notice of termination of the loan, which shall include the following information:

(i) Date of notice of termination;
(ii) Name of the lender;
(iii) Description of property in sufficient detail for ready identification;
(iv) Approximate initiating date of the loan (and termination date, if applicable), if known;
(v) The name and address of the appropriate museum official to be contacted regarding the loan;
(vi) Statement that within 90 days of the date of the notice of termination, the lender is required to remove the property from the museum or contact the designated official in the museum to preserve the lender's interests in the property and that failure to do so will result in the loss of all rights in the property pursuant to Section VIII of this Act.

(b) *Notice by Publication:* If the museum is unable to identify sufficient information to send actual notice pursuant to section (a), above, or if a signed return receipt of a notice sent by restricted certified mail under subsection (a), above, is not received by the museum within 30 days after the notice is mailed, the museum shall publish the notice of termination of loan containing all the information available to the museum provided in subsection (a) (i-v), above at least twice, 60 or more days apart, in a publication of general circulation in the county in which the museum is located, and the county of the lender's last known address, if known.

Section VIII: Museum Gaining Title to Property; Conditions

As of the effective date of this Act, a museum acquires title to unclaimed property, under any of the following circumstances:

(a) For property for which a museum provides actual notice to a lender in accordance to Section VII 3(a), above, and a signed receipt is received, if a lender of that property does not contact the museum, within 90 days after the date notice was received.

(b) For property for which notice by publication is made pursuant to Section VII 3(b), above, if a lender or anyone claiming a legal interest in that property does not contact the museum within 90 days after the date of the second publication.

Section IX: Contractual Obligations

Despite this Act, a lender and museum can bind themselves to different loan provisions by written contract.

Figure VII.2 continued

Section X: Effect on Other Rights

(a) Property on loan to a museum shall not escheat to the state under any state escheat law but shall pass to the museum under the provision of Section VIII, above.

(b) Property interests other than those specifically addressed in this Act are not altered by this Act.

Section XI: Title to Property Acquired from a Museum

A museum which acquires title to property under this Act passes good title to another when transferring such property with the intent to pass title.

Section XII: Museum Lien for Expenses of Expired Loans

As of the effective date of this Act, a museum shall have a lien for expenses for reasonable care of loaned property unclaimed after the expiration date of the loan.

G. Researching Unclaimed Loans

Every museum faced with real or suspected unclaimed loan situations needs to do considerable investigatory work, starting with a careful review of internal records and progressing to outside inquiry. This is a daunting project because one never knows how much work will be required or what the results may be. But as has been explained, waiting will not make unclaimed loan problems disappear; so, a systematic investigation is the preferred route. "Systematic" is a key word here because a carefully plotted course of action will avoid the need to retrace steps and should produce the quality of documentation that is so important to the ultimate success of the undertaking.

The following "practical guidelines" for organizing a systematic plan of action (see Figure VII.3) were developed by Agnes Tabah in the course of tracing unclaimed loans in a large history museum situated in a jurisdiction that had no statute specifically addressing museum unclaimed loans.[57]

57. Agnes Tabah was then a student in the graduate program in museum studies at the George Washington University, Washington, D.C. Tabah, who also holds a law degree, gained practical experience in tracing unclaimed loans while serving an internship at the National Museum of American History, Smithsonian Institution, Washington, D.C. She made a presentation of these guidelines at the 1992 American Law Institute–American Bar Association seminar "Legal Problems of Museum Administration," Copyright 1992. The substantial reprinting of these guidelines is with the concurrence of Tabah and the American Law Institute–American Bar Association Committee on Continuing Professional Education.

Figure VII.3

Practical Guidelines for Resolving Unclaimed Loans

PRACTICAL GUIDELINES

The key to resolving unclaimed loans is to notify the lender, whether by actual or constructive notice, that the museum is terminating the loan and intends to take title to the object if the lender does not claim it. This paper outlines the steps that the museum might take to reach this goal. The guidelines suggested below for giving notice of the museum's intent to terminate the loan and take title to loaned material were to a large extent developed from a review of mechanisms set forth in various state unclaimed loan statutes. (The guidelines were developed for situations not covered by such a state statute.) Other practical steps were developed over the course of a four- month project during which the author attempted to resolve some unclaimed loans.

A. *Preliminary Steps.* Before undertaking the search for the lender, the museum should take a few preliminary steps designed to collect all of the available information relating to unclaimed loans in question and to determine what the museum wants to do with the loaned objects.

1. *Determine which objects are "unclaimed loans".* As a first step, the museum must determine which of the objects in its possession qualify as unclaimed loans. This may involve an inventory of the museum's records. During this process, the museum should classify the object as either an unclaimed loan or an undocumented object:

 • An unclaimed loan—an object that museum records show was placed on loan for a fixed period or indefinite period, and which has not been retrieved by its owner in a timely fashion.

 • An undocumented object (sometimes called "an object found in the collection")—an object in the possession of the museum for some time but with no identifiable record of the manner of acquisition.

The distinction is important, since, as a general rule, the museum is in a stronger legal position when there is a challenge to its right to possess an undocumented object. In the "unclaimed loan" situation, the records show, by virtue of the "loan" language, that there was no intention to pass title to the museum, and the burden is on the museum to prove that it somehow acquired title to the object. With respect to the undocumented object, there is no evidence that the museum did not acquire title upon transfer of the object, and the burden is on the person challenging the museum's title to prove otherwise.[a]

These guidelines are intended for "unclaimed loans" only, and are not recommended for "undocumented objects." If after a careful search of museum records, objects remain for which no documentation can be found, it may be prudent for the museum to exhibit or in some way represent these objects as belonging to the museum. The purpose is to demonstrate to all that the museum claims these objects as its own. This public representation, if of sufficient duration, could provide a valid defense if someone later challenges the museum's title.[b]

In reviewing its records, the museum may come across objects ambiguously identified as "permanent loans" or "deposits." Many "permanent loans" come about because the lender wanted to defer a decision to make a gift of the object. Although initially reflected as a "loan" in the museum records, the lender may have later decided to give the museum the object, but the museum records may not have been revised to reflect the changed circumstances. For a

Figure VII.3 continued

time, the term "deposit" seemed to have been popular, although it indicates nothing as to whether the depositor intended to make a loan or a gift of the item.

In these situations, the museum should review the existing documentation, such as any loan forms and correspondence to and from the lender and the museum, and make a determination as to whether a loan or a gift was intended. In some cases, the museum records may contain documents that clearly show that the original loan was subsequently made into a gift. The museum should revise its records to reflect that title passed to the museum. In other situations, the records will favor an interpretation that a loan was intended, in which case the museum should follow the guidelines for resolving unclaimed loans.

2. *Compile all information relating to the object.* Remember that your objective is to find the lender. Once a list of unclaimed loans is compiled, the museum should gather all of the written records as well as any other information relating to the object. Often, the person who was directly involved in arranging the loan (such as the curator) will have information not reflected in the official loan file. A museum staff member may have physically received the loan from the lender, and may have spoken with the lender. In order to gather all the disparate information, the museum should:

a. Designate a contact person to whom all information shall be given.

b. Hold an initial meeting with the curatorial and registrarial staff and any other staff who may have knowledge about the loan. The purpose of the meeting is:

- to review the old loan list to determine any recent contact with the lender by any of the staff;

- to determine the location and condition of the object.

In this meeting, the staff should be instructed to search their records and relay the information to the contact person, preferably in writing. If the information is transmitted orally, the contact person should make a written record of that information. This ensures that information is retained in the event of staff changes.

c. Determine the location and condition of the object before making contact with the lender.

3. *Determine what the museum wants to do with the loaned object.* In consultation with appropriate staff, the museum should decide whether it wants to (1) return the object to the lender, (2) renew the loan, (3) acquire the loaned object, or (4) dispose of the object, whether by donation, sale or destruction.

On occasion, the museum may find that it has an object of no value. If after making a careful determination that the object is indeed valueless, the museum may decide that, given the substantial time and expense involved in undertaking the procedures to find the lender of the object, a preferable course of action is to dispose of the material by donating it to another charitable institution. Before giving the object away, the museum should carefully document the disposal of the object, by written record or photograph, to establish clearly that the object had no value.

It is important to note that in this situation, the museum is disposing of an object to which it does not have clear title, and is potentially opening itself to liability if ever the original lender

Continued on next page

Figure VII.3 continued

comes forward to claim the object. Therefore, it should only forgo completing all unclaimed loan procedures when it is satisfied that the object has no value.

Once the preliminary steps outlined above are taken, the museum is ready to begin its search for the lender.

B. *The Search for the Lender*

1. *General advice.* A few words of caution are in order regarding the museum's diligence in making the search and the importance of keeping good written records of the search.

a. *Diligent and good faith search.* It is very important that the museum undertake its search for the lender with the utmost good faith and diligence. The museum cannot be perceived to be grasping for objects that were clearly loaned, not given, to it.^c

b. *Proper documentation of the search.* The museum should document every step taken to find the lender or heir. [A sample worksheet (Figure VII.4) is given at the end of these guidelines; this can be used by staff to record their various efforts in locating the lender.] If a lender comes forward to claim an object years after an unfruitful search for a lender has been completed, the museum, in arguing that it now has title to the object, will use its records as the evidence to demonstrate to the court that it made reasonable and diligent efforts to find the lender.

c. *Legal advice.* Legal advice should be sought regarding the adequacy of procedures to be followed. Advice should also be sought on the applicable statute of limitations which may apply after notice (or constructive notice) has been given.

2. *Steps to find the lender where the museum records indicate the lender's address:*

a. Send a letter addressed to the lender at that address. The letter should be sent via certified mail, with return receipt requested to prove delivery or non-delivery. The museum should include the following items to ensure that the letter will be deemed legally effective notice:

• describe the object and the date of the loan;

• notify the lender that the museum is terminating the loan and request the lender to contact the museum within 45 days. The letter should also caution that if the lender fails to come forward to claim the loaned object, the museum will infer that the lender intends to make a gift of the loaned object.

• indicate the address of the museum and the name and phone number of the person the lender should contact about the loan.

[A letter with suggested language (Figure VII.5) is given at the end of these guidelines.] Clearly, the letter's contents and tone need to be tailored to the situation at hand.

b. If the museum has proof of receipt and the lender does not respond within 45 days, send out a second letter, reiterating the contents of the first letter and requesting the lender to respond within 45 days. Again, the letter should be sent via certified mail with return receipt requested.

c. If at the end of a total of 90 days, the lender still has not responded, send a third letter stating that because the lender has failed to respond to the museum's request, the museum

Figure VII.3 continued

deems that the lender has donated the object as of the date of the third letter, and has asserted title to the object. The letter should also be sent via certified mail with return receipt requested.

Note: At this point, the statute of limitations on conversion (the lender's probable cause of action) should begin to run (since the museum has now taken an action inconsistent with the bailment, i.e., claimed title to the object). The museum's records should now be amended to reflect that it owns the material. It would be prudent, however, for the museum to wait until the expiration of the limitations period before considering any disposal of the object from the collection.

3. *Steps to find the lender where the initial letter is returned undelivered or where the museum records show no address for the lender.*

If the letter is returned to the museum (for example, with the stamp "Addressee Unknown" or "Not Deliverable,") or if the museum has no record of the lender's address, the museum should begin a "reasonable search" for the lender. The purpose of the reasonable search is to establish whether actual notice is reasonably possible or practicable. If the lender is not found through a reasonable search, then the museum must resort to the final step of "constructive" notice by publication.

To conduct a reasonable search, the following sources should be investigated:

a. *Probate records* in the county of the lender's last known address, or in the county in which the museum believes a lender may have died. In many states, the probate office contains a listing of every person whose estate was probated, indexed by name.

b. *Telephone directories* and directory assistance in the area of the lender's last known address.

c. *Real estate tax records.* Some cities have a listing of individuals paying real estate taxes and will give the address of the property on which the taxes are being paid.

d. *Vital (death) records.* Most cities have a department which keeps records of births and deaths. These records can give you a person's date of death. They can be difficult to search, however, because they are usually indexed by date of death.

The above steps are the minimum that should be taken. Depending on the circumstances (and the imagination of the staff), other avenues of information can be explored. For example, a social register might be searched; a cemetery might be contacted to check whether the person was buried there. If you are aware of any professional or personal associations of the lender, these sources can be contacted.

4. *Constructive Notice: publication of notice where the reasonable search has produced no results.* After the museum has completed its reasonable search and still has no indication of the lender's whereabouts, the museum should consider publishing "constructive notice"—the publication of a notice in an appropriate newspaper.

a. *What to publish.* The contents of the notice should indicate:

- the name of the lender

- the lender's last known address

- a description of the item loaned

Continued on next page

Figure VII.3 continued

- the date of the loan

- the name of the person at the museum to contact

- that the museum is terminating the loan and intends to take title to the object if it is not claimed

- the address where to send claims for the object.

The notice may contain a statement with the following information:

Records at [name of the museum] indicate that you have property on loan to the museum. The museum wishes to terminate the loan. If you desire to claim the property, you must contact the museum, establish your ownership of the property, and make arrangements to collect the property. If you do not contact the museum within 45 days of this notice, you will be deemed to have donated the property to the museum as of the date of this notice, [date of notice.]

b. *When to publish.* The museum should publish the notice once a week for three consecutive weeks.

<u>Note:</u> *The guidelines given above on what and when to publish are recommendations based upon a review of "old loan" statutes. Local legal counsel should be consulted for advice on the type of notice (e.g., on the proper response time allowed) that may be appropriate under applicable local law.*

c. *Where to publish.* Generally, the museum should publish in a newspaper of general circulation in the county of the lender's last known address and in the county where the museum is located. If, however, the museum has information which leads it to believe that publication in an area other than the two noted above would most likely reach the lender, then it should publish in that area.

d. *The statue of limitations* should begin to run on the date of the last publication.

C. *Contact with the Lender.* If the museum locates the lender, various issues may come up in the museum's discussions with the lender.

1. *Proper identity of lender.* The museum should assure itself that the person is in fact who he/she claims to be. If the initial contact is made by telephone, the museum should ask the lender for his or her address and send a follow-up letter to that address describing the loaned material, and should take this opportunity to tell the lender whether the museum wishes to obtain title to the object through the lender's donation, return the object, or renew the loan.

2. *Documentation.* The museum should ask the lender to forward to the museum any documentation relating to the loan, preferably the original loan receipt, or any correspondence with the museum relating to the loan. Remember that a return to the wrong individual may subject the museum to a claim from the true owner. Museums should be especially careful to document the lender's rightful ownership when the object at issue is very valuable, and the lender would like the object back.[d]

3. *Donation.* If upon further discussion, the lender wishes to donate the material, the museum should prepare a deed of gift for the lender's signature.

4. *Renewal.* If the lender wishes to renew the loan, the museum should send the lender a new loan form for the lender's signature.

Figure VII.3 continued

5. *Return to lender.* If the lender wishes to retrieve the material, arrangements should be made in coordination with the curator and registrar for either pick-up by or shipment to the lender. In either event, the museum should request the lender to sign a receipt and release form acknowledging receipt of the material, attesting to the lender's rightful ownership of the material, and releasing the museum from any further liability in connection with the material. [See the sample receipt form (Figure VII.6.) at the end of these guidelines.]

D. *Contact with Heirs of Lenders.* A museum should consider itself fortunate if it is able to locate the original lender. If it is determined that the lender has died, the search for the lender's heirs is time-consuming, as is the ultimate resolution of the old loan once the heir (usually multiple heirs) may be located.

1. *Identification of all heirs with an interest in the loaned material.* A search of probate records may reveal that the lender has died, and the records may contain documents (a will or letters of administration) that will indicate the names and addresses of all known heirs of the lender. The museum should contact those heirs using the procedures outlined in Sections B.2, B.3 and/or B.5 above.

In a case where an heir responds to a letter or a published notice, the museum should request the heir to produce the lender's will, if one exists. The museum should contact all of the heirs listed in the will by mail (return receipt requested) telling them about the old loan.

If no will exists, the museum should ask the heir for any information relating to other possible heirs of the lender. The museum will have to consult a lawyer to determine to whom the lender's property passes under that state's intestacy laws (laws of descent). For example, if the spouse of a deceased lender comes forward to claim an object, the museum should ask whether the lender had any children. Depending on the jurisdiction, children may be entitled to an interest in the deceased lender's estate even though the lender has a surviving spouse.

In some cases (especially very old loans), the heir of a lender may also have died. Technically, his or her interest in the lender's object will rest in the heir's heir. One can imagine how time-consuming it can become to try to track down all of the persons who have an interest in an object.

2. *Proof of claim.* In the case of an extremely old "old loan," a claimant who is the heir of the original lender is unlikely to have the loan receipt. In this situation, the museum will have to rely on the identity of the claimant as the rightful heir of the lender. The museum may simply request some form of identification from the heir, or any other document that demonstrates that the person claiming the object is who he claims to be.[e]

3. *After-discovered property.* Under the estate and tax law, all of the assets of an estate should be probated. This is done for the purpose of determining the proper heirs and distributing the assets of the estate accordingly. In the process, inheritance and estate taxes are collected by the government. If the lender has died, and an heir comes forward to claim the lender's property, the question arises whether there is an obligation to submit the loaned material (which is considered an asset of the estate) to the probate court or to reopen the lender's estate. Although this is unlikely to be an issue with loaned material of little value, the same is not true of objects of great value, such as the two Frederick Church paintings at issue in the earlier mentioned *McCagg* case.[f] Although this problem is not the museum's responsibility, the museum should alert the heirs to this issue.

Continued on next page

Figure VII.3 continued

4. *Appraisal.* An issue that often comes up in the first discussion with heirs of a deceased lender is "How much is the material on loan worth?" Heirs are particularly likely to ask this question if the museum would like the material donated, and often request the museum to give them an appraisal. Prudent museum policy prohibits museum staff from providing appraisals. There are various reasons for this, and these can be used to justify to an heir why the museum is not in a position to provide an appraisal:

> • museum curators are not in the business of providing professional appraisals of the market value of objects;

> • under federal tax law, in order for a donor to be able to take a tax deduction for a charitable contribution worth more than $5000, a "qualified appraisal" must justify the amount deducted. A "qualified appraisal" is one performed by a disinterested party. As the party directly benefitting from the contribution, the museum is not a "disinterested party."

A museum may suggest the names of several professional and independent appraisers to the lender/heir, and may also offer to send the lender or heir photographs of the items in question to facilitate appraisal in the event that the lender does not live in the area.[g]

5. *Disposition.* Once the heirs have been identified and contacted, a decision must be made with respect to the disposition of the material. The museum should follow the steps outlined above in C.3–5.

E. *Museum Recordkeeping.* Once the procedures outlined above have been followed, the museum may have located some of the lenders or heirs, and may have returned or been given certain objects. There may be a fair number of objects for which no lender was found, or for which no claim will have been made. With respect to the loans that were not claimed after actual or constructive notice was given to the lender, the museum should now clearly indicate in its records that the material previously on loan has now become the property of the museum.

Specifically, the museum should amend its records to reflect the ownership change.

> • In the case where a certified letter was received by a lender who failed to respond (see B.3), the museum should amend its records upon expiration of the response period after it sent out the third and last letter to the lender. The records should show that the museum claims title as of the date that the third and last letter was sent.

> • In the case of constructive notice by publication, the museum should amend its records upon the expiration of the response period after it has published the last required notice under B.5. The records should show that the museum claims title as of the date of publication of the last notice.

At this time, the museum should also make a note of the date of expiration of claims under the applicable statutes of limitations, and note that prior to this date, the material should not be disposed of.

> Example: The museum published its third notice on January 1, 1996, and received no response after 45 days. On February 15, 1996, the museum should amend its records to reflect that it has title to the object as of January 1. Upon advice of counsel, the museum determines that the statute of limitations for conversion is three years. Therefore, it should note in its records that the object should not be disposed of until January 1, 1999.

Figure VII.3 continued

F. *Disposal of Unclaimed and Unwanted Objects.* What is the museum to do with objects which remain unclaimed and which the museum does not want to keep? In this case, the museum should wait for the limitations period to run. In the meantime, it should assure itself that it has made a diligent search for the lender, and has followed its own procedures for finding the lender. When the limitations period expires, the museum may dispose of the material as it sees fit.

G. *Final Words of Caution.* Museums should be aware that the recommendations outlined above do not guarantee that no claims will be brought against the museum for conversion or wrongful disposition of a loaned object. No guidelines can do that, especially in an area of the law which has not been fully tested. Nevertheless, a museum will certainly be in a better position to defend against claims if prudent guidelines are implemented and followed.

Author's Notes:

[a]Some state statutes do not distinguish between unclaimed loans and undocumented objects, in which case the museum will have to apply the statutory provisions to both types of objects.

[b]For further discussion and guidelines on how to treat objects found in the collections, see M. Malaro, "Practical Steps toward Resolving Ownership Questions," in American Law Institute–American Bar Association (ALI-ABA), *Course of Studies Materials: Legal Problems of Museum Administration* (Philadelphia: ALI-ABA, 1984), 556–58.

[c]As illustrated by *In re Estate of McCagg,* 450 A.2d 414 (D.C. 1982), a case discussed in Section B, a museum that is deemed not to have made a diligent attempt to find the lender may not prevail in an action to take title to objects on loan. One may wonder, at least in cases in which the loan in question is decades old, whether the court has set a standard of conduct that is impossible for most museums to reach. Many years ago, collections management procedures and registrarial record-keeping standards were not what they are today, and it may be unrealistic for courts to expect museums to have made systematic searches for all lenders given the prevailing standards of practice at that time.

[d]Two or more people may come forward to claim the object. If so, the museum should encourage the claimants to settle among themselves the question of who owns the object. If they fail to do so, the museum, as a last resort, may deposit the object with a court in an interpleader action and let the court decide to whom the object legally belongs.

[e]As already noted, two or more heirs may claim title to an object. In that case, follow the recommendations in footnote d.

[f]*In re Estate of McCagg,* 450 A.2d 414 (D.C. 1982).

[g]See Chapter XIII, Section A, for more discussion of appraisals.

Figure VII.4

Sample Worksheet for Resolving Unclaimed Loans

For resolving expired or indefinite loans Loan number:

Lender name:

Last known address:

Title and artist of loaned object:

Date of last contact:

ACTIONS	DATE DONE

Initial meeting with staff:

Review loan file and other
 in-house documents:

If lender's address is known:

 * Send termination to lender at last known address (certified mail, return receipt requested)

If letter is received, and no response:
 * Send second termination letter:
 * Send third letter after 45 days claiming title to item

If letter is returned undelivered or lender's address unknown:
 * Check telephone directory, social register
 * Check probate records/register of wills, obituaries in local papers
 * Check tax records
 * Check Department of Vital Statistics (death records)
 * Check other sources

If lender/heirs are still unknown:
 * Publish notice in newspaper in county of lender's last known address and where museum is located
 * Publish second notice
 * Publish third notice

Update records

Figure VII.5

Sample Letter of Notice to Terminate Loan

Date

VIA CERTIFIED MAIL
RETURN RECEIPT REQUESTED

[Inside Address]

Dear Mrs. Smith:

The Clearwater Textile Museum is currently reviewing its loan records and has noted that on April 1, 1975, you loaned the Museum an Eighteenth Century embroidered English tablecloth. Many years have passed since we have heard from you, and the Museum would like to terminate the loan and update its records.

Kindly contact us at your earliest convenience to indicate what you would like the Museum to do with the tablecloth. We would like to caution you that if you do not respond to our inquiry within 45 days, the Museum will assume that you intend to donate the tablecloth to the Museum.

Please feel free to call or write me at the Museum, 1000 Main Street, Clearwater, Idaho. I can be reached during business hours at 387-1000.

We look forward to hearing from you, and thank you for your past support of our Museum.

Sincerely,

Lauren Brown
Registrar

Figure VII.6

Sample Receipt and Waiver by Lender on Return of a Loaned Item

CLEARWATER TEXTILE MUSEUM
1000 Main Street
Clearwater, Idaho 10001

OUTGOING RECEIPT OF LOANED PROPERTY AND RELEASE

Loan number:

Date of loan:

Name of lender:

Description of loaned item:

Name of recipient:

I, the undersigned, accept receipt from the [name of museum] of the following property:

One Eighteenth Century Embroidered English Tablecloth

I affirm that to the best of my knowledge I have good and complete right, title, and interest in the above-described property. I hereby release the Museum from all further association with the property.

[Name of lender or heir]

Date

International Loans

A. Types of Loans

International loans can take various forms: the importation of a single object from a foreign lender, the receipt of a prepackaged exhibition from a foreign museum, a U.S. exhibition assembled for a foreign tour, or a cooperative effort by a U.S. museum and a foreign museum to assemble from different sources an exhibition to tour both in the United States and abroad. International loans range from the relatively simple to the unbelievably complex. Any museum contemplating initiating or receiving an international loan of any magnitude should first be sure that it has adequate staff expertise and ample time to devote to careful planning and resourceful execution.

It is beyond the scope of this text to detail the numerous legal problems that can arise when a museum is involved in an international loan. Rather, this chapter will address selected topics that generally affect international loan situations: providing for immunity from seizure of the imported or exported objects; the U.S. indemnity program; and the doctrine of force majeure. In addition, three checklists enumerate the various points that may have to be considered when planning, organizing, and implementing international exhibitions.

B. Immunity from Seizure

1. IMPORTED OBJECTS

When a foreign lender transports valuable cultural objects into this country, certain legal risks are assumed, risks that are quite distinct from those normally contemplated in a loan agreement. One is the possibility of seizure of the imported cultural objects by court order because of unrelated litigation initiated against the lender in this country. For example, if individuals or organizations in the United States believe they have a claim against a foreign lender, they cannot, as a rule, obtain jurisdiction over that lender in order to sue in the United States unless the lender is actually present in this country. If the lender is not actually present, an alternative is to attach any of the lender's property that may be in the United States and to use this property as a basis for litigating and/or satisfying the alleged claim. A foreign lender, therefore, might well be reluctant to allow cultural property to enter the United States for exhibition if a possibility exists that those objects might be used as a means to embroil the lender in legal controversy in this country.

To control this deterrent to international cultural exchange, Congress in 1965 passed an "immunity statute," which provides an immunity from seizure in certain instances.[1] The statute (a copy of which is included in Appendix D of this text) states that if an object of cultural significance is being imported into the United States for temporary exhibition, without profit, by a U.S. cultural organization and if the president of the United States, or the president's designee, determines that the object is of cultural significance and that the temporary exhibition is in the national interest, then that object may be declared immune from court seizure while it is within the confines of the United States.[2] By executive order,[3] the president's responsibilities in this regard have been delegated to the U.S. Information Agency (USIA).[4]

Any museum that is assuming responsibility for bringing in cultural artifacts from abroad should consider, in consultation with the lender, the advisability of seeking a declaration of immunity.[5] The process should be initiated several months before the date of entry, usually

1. 22 U.S.C. § 2459. New York also has an immunity statute. See N.Y. Arts and Cultural Affairs Law, 12.03 (Kenney 1987).

2. The immunity statute has also been coordinated with Title III of Pub. L. 97–446, the "Convention on Cultural Property Implementation Act," 96 Stat. 2350 (1983), codified at 19 U.S.C. § 2601 *et seq*. See Chapter IV, "The Acquisition of Objects: Accessioning," Section D(6). The terms of the Convention on Cultural Property Implementation Act do not apply to any archaeological or ethnological material or any article of cultural property that is imported into the United States for temporary exhibition or display if such material or article has been declared immune from seizure under the above-described immunity statute.

3. E.O. 12047 of March 27, 1978.

4. For a period of time, the name of the USIA was changed to the International Communications Agency (ICA), but it was changed back to the former name in 1982 (Pub L. 97–241, § 303, 96 Stat. 291).

5. If the lender is a governmental entity of a foreign country, Chapter 97 of Title 28 of the U.S. Code should be consulted also. The chapter concerns the jurisdictional immunities of foreign states.

by the sponsoring U.S. museum.[6] The application is filed with the general counsel of the USIA and should contain the following:

1. A schedule of all the items being imported for exhibition (including description and value)
2. A copy of the agreement entered into between the foreign owner or custodian and the U.S. sponsoring cultural organization(s), and a copy of any agreements with U.S. participating museums
3. Copies of any related commercial agreements between any or all of the U.S. institutions and the lender or other parties
4. A list of the places and dates of exhibition, especially the date the objects will arrive in the United States
5. A statement that the exhibition is being administered without profit (admission and similar fees that merely cover costs usually do not disqualify the exhibition for the immunity declaration, but a description of all charges or preferences in admission should be included in the application)[7]
6. A statement giving information as to why anyone might want to attach the property in the United States and an evaluation of the threat
7. A statement establishing the cultural significance of the objects
8. Evidence that the U.S. participants are cultural or educational organizations—a citation to the organization's Internal Revenue Code § 501(c)(3) determination letter from the Internal Revenue Service usually satisfies this requirement.

On receipt of the application, the USIA consults with the U.S. Department of State to determine national interest[8] and, as necessary, with other experts to determine cultural significance. If all criteria are met to the satisfaction of the USIA, a notice to this effect is published in the *Federal Register*. Immunity from seizure is then in effect for the enumerated objects for the time period they are to be in the United States for purposes of the temporary exhibition.[9]

6. If time is running short and all information requested on the application is not yet available, check with the USIA. There may be at least sufficient information to start the application process.

7. As a rule, sale of books and other products associated with the exhibition and ripple effects to local merchants are not factored into any determination of "profit." In addition, benefits to lenders—such as conservation work on objects to be lent, or a share in the profits made on auxiliary materials—are also not yet factored into any determination of "profit." However, if a foreign lender demands a substantial sum, over and above costs, as a loan fee, it would be questionable, at least as of 1997, whether the USIA has the authority under the statute to guarantee immunity.

8. For example, in May 1980, a major exhibition from the Hermitage Museum of Leningrad was planned for viewing in the United States. An application for declaration of immunity was filed by the U.S. sponsoring museum, but the request was denied when the ICA (now the USIA) found the exhibition "not to be in the national interest." Just before the application, Russia had invaded Afghanistan, severely straining Soviet-U.S. relations.

9. In 1979, when a number of U.S. citizens were held hostage in Iran, the president of the United States ordered a freeze on all Iranian assets in the United States. The question arose whether such an order took prece-

2. EXPORTED OBJECTS

An exported object, whether owned by the museum or by a lender contributing to the museum's exhibition, could be subject to seizure in a foreign country for the reasons just described. In this regard, consider the situation raised in Canada by the *Heller* case (as described in footnote 85 of Chapter IV). In that case, an antiquity brought into Canada from the United States by a U.S. citizen was seized on suspicion of violating Canada's Cultural Property Export and Import Act. Therefore, an antiquity that is not vulnerable to seizure in the United States under the Convention on Cultural Property Implementation Act may become subject to seizure by the country of origin when brought into a foreign jurisdiction where the law implementing the UNESCO Convention permits the country of origin to sue. If the nature of the material to be exported in an international loan falls within the types addressed by the UNESCO Convention (described in Chapter IV) even though the material is legally possessed in the United States, its status in the importing country should be verified before the loan is made.

Because most foreign countries do not have an immunity statute like the one in the United States, some commentators suggest that the loan agreement should specifically address the potential problem of seizure. A loan agreement could impose the following requirement on the foreign borrower: "Borrower hereby guarantees the return of the work of art to Lender, or, in the event that return should be impossible, Borrower agrees to compensate Lender for the full value of the works. Borrower also agrees to indemnify Lender for all legal expenses Lender may incur in connection with any seizure of the work or other legal action preventing its return."[10] When the lending museum imposes such a requirement because the foreign country has no immunity statute, the borrowers usually must look for some sort of insurance coverage to protect against a possible catastrophic loss. Such coverage can be costly. The lending museum may also want to discuss this risk with its insurance company to determine whether coverage can be obtained in this country (with the borrower paying the fee) or whether the borrower should not only warrant safe return but also provide a bond to ensure fulfillment of this commitment.

dence over a declaration of immunity. S. Weil, in a chapter entitled "No Museum Is an Island" in *Beauty and the Beasts: On Museums, Art, the Law, and the Market* (Washington, D.C.: Smithsonian Institution Press, 1983), discusses these international incidents. For more information on the immunity process, see R. Stuart, "Exemption from Judicial Seizure of Cultural Objects Imported for Temporary Exhibition," and E. Croog, "Immunity from Judicial Seizure for Cultural Objects Imported from Abroad for Temporary Exhibition: The Museum's Perspective," both in American Law Institute–American Bar Association (ALI-ABA), *Course of Studies Materials: Legal Problems of Museum Administration* (Philadelphia: ALI-ABA, 1989).

10. L. Wise and B. Wolff, "Lending across International Boundaries," in American Law Institute, American Bar Association (ALI-ABA), *Course of Studies Materials: Legal Problems of Museum Administration* (Philadelphia: ALI-ABA, 1987), 79.

C. The U.S. Indemnity Program

The cost of insurance for a major international exhibition frequently accounts for a substantial portion of the exhibition budget. By the mid-1970s, as some international shows assumed grand proportions and insurance premiums rose accordingly, even well-endowed museums were not able to afford participation in certain international exhibitions without substantial outside funding or the assistance of special legislation.[11] General legislation was then sought for a government indemnity program,[12] on the basis that the country as a whole would benefit through increased international goodwill and understanding if cultural exchanges were fostered in this manner.[13] In 1975, Congress enacted the Arts and Artifacts Indemnity Act, which established an indemnity program administered by the Federal Council on the Arts and Humanities.[14] (A copy of that act, current as of 1997, is given in Appendix E of this text.) Under the program, the U.S. government guarantees to pay loss or damage claims, subject to certain limitations, arising out of international exhibitions that have been previously certified for indemnity coverage.

To qualify for coverage, eligible items must come from outside the United States for exhibition in the United States or from the United States for exhibition outside the country, preferably when they are part of an exchange of exhibitions. In the mid-1990s, this coverage was expanded slightly by adding eligible items from the United States while on tour in the United States if they were part of an exhibition of eligible items from outside the United States.[15] The following are eligible items:

1. Works of art, including tapestries, paintings, sculpture, folk art, graphics, and craft arts
2. Manuscripts, rare documents, books, and other printed or published materials

11. In 1974, the U.S. government, by special legislation (Pub. L. 93–287, 88 Stat. 141, and Pub. L. 93–476, 88 Stat. 1439), provided indemnification for a Chinese archaeological exhibition that traveled to the National Gallery of Art and for the U.S. portion of a major exchange of exhibitions between the Metropolitan Museum of New York and the Soviet Union.

12. In 1981, Florida became the first state to pass an indemnity law to benefit state cultural organizations. The program insures works of art or exhibitions borrowed within the United States for display in Florida. Particulars on the indemnity program can be obtained from Florida's Cultural Affairs Division: Fla. Stat. Ann. 265.51. In 1984, Iowa passed a similar statute; the Iowa Arts Council administers the statute: Iowa Code Ann. 304 A. 21–30. In 1989, Texas enacted an indemnity statute: Tex. Gov't Code Ann. 481.271 *et seq.* (Vernon 1990). As of the mid-1990s, there had been relatively little use of these state statutes. See N. Morris, "State Art and Artifacts Indemnity: A Solution without a Problem?" 12 *Hastings Comm. & Ent. L.J.* 413 (No. 3, spring 1990).

13. Government indemnity programs have been in operation in other countries for some years. England is a notable example.

14. Pub. L. 94–158, 89 Stat. 826 (Dec. 20, 1975), found in 20 U.S.C. §§ 971 *et seq.* For a general discussion of the indemnity program, see A. Martin, "The Arts and Indemnity Program," in American Law Institute–American Bar Association (ALI-ABA), *Course of Studies Materials: Legal Problems of Museum Administration* (Philadelphia: ALI-ABA, 1989). See also 45 C.F.R. pt. 1160.

15. See 60 *Fed. Reg.* 35162 *et seq.* (July 6, 1995) and 42464 *et seq.* (Aug. 16, 1995).

3. Other artifacts or objects
4. Photographs, motion pictures, and audio and video tapes that are (a) of educational, cultural, historical, or scientific value, and (b) certified for exhibition by the director of the USIA, or the director's designee, as being in the national interest.[16]

Since the total amount that can be "insured" at one time by the government indemnity program is subject to a monetary limit, an applicant should apply in a timely manner, before all available coverage is apportioned.[17] A museum planning quite far in advance can give written notice of its intent to apply at a future specified date, and the Federal Council, in turn, after reviewing its known schedule, will state the likelihood that coverage will be available at that time. However, an opinion on the availability of coverage does not ensure approval. When formally filed, each application for an indemnity must stand on its own merits.[18] Other indemnity limits as of 1997 are as follows:

- No indemnity agreement for a single exhibition can cover loss or damage in excess of $300,000,000.
- There is a deductible per exhibition (see Figure VIII.1), and coverage comes into play after cumulative loss or damage exceeds the deductible regardless of the number of exhibiting museums. The deductible varies depending on the value of the items covered by the indemnity agreement. (Over the years, new layers of deductibles have been added to protect the U.S. Treasury because of the growing magnitude of international exhibitions.)

Some museums seek to self-insure the deductible, at least at the lower levels, because insurance on a first-dollar loss of this type is more costly. At the higher levels, however, most museums need to turn to private insurance to cover the deductible. For amounts in excess of the top limit of indemnity coverage, private insurance is usually available at reasonable rates.[19]

Valuations for purposes of indemnity coverage must be quoted in U.S. dollars, and any claim payments are made in U.S. dollars. These provisions sometimes cause concern because of the fluctuations in currency rates. Also, once valuations are approved by the Federal

16. As a matter of policy, certain very fragile media are usually excluded from coverage. Examples are oil on wood panel, oil on copper paintings, pastels, lacquer objects, certain types of glass, marquetry, and works on velum. Very large works (such as paintings exceeding ten feet by ten feet) that are very difficult to ship are reviewed individually.

17. As of 1997, the aggregate amount that can be insured by the program at any one time is set at $3 billion.

18. Applications are first reviewed by an Indemnity Advisory Panel (composed of museum professionals), with the panel making its recommendations to the Federal Council on the Arts and Humanities, the final approval authority. This process is conducted twice a year.

19. Coverage under the indemnity is cumulative. In other words, individual items in the exhibition are not covered at full value until the limit is reached; rather, all losses are paid (after the deductible is met) until the limit is reached. This means that any excess private insurance that is needed is never costly "first dollar" insurance.

Figure VIII.1

Deductible Chart, U.S. Indemnity Program

Value of Items Covered	Aggregate Deductible
$2,000,000 or less	$15,000
More than $2,000,000 but less than $10,000,000	$25,000
$10,000,000 or more but less than $125,000,000	$50,000
$125,000,000 or more but less than $200,000,000	$100,000
$200,000,000 or above	$200,000

Council for purposes of indemnity, these amounts, as a rule, cannot be changed. This means that care should be taken at the onset to encourage knowledgeable valuations. In the application process, each item that is part of the planned exhibition must be described and given a value. Current application guidelines require that a second, disinterested expert opinion for each such value also be included. As a precaution, applicants can add on a small percentage increase to valuations to protect against currency fluctuations. If this is done, an explanatory note should be given in the application. Gaps or limitations in indemnity coverage are usually filled by private insurance.

Applications for indemnification require the following information:

1. Name and address of applicant
2. Title and nature of proposed exhibition
3. Time period of indemnification
4. Place(s) and dates of exhibition
5. Total value and number of items to be indemnified and the amount of premium if privately insured
6. Total value of entire exhibition
7. A copy of an applying organization's federal tax-exemption letter or evidence that the organization is part of a state or local government
8. Affirmation that those applying for the indemnity have read the required "certification" and will abide by its terms
9. Statement of the exhibition's significance
10. A detailed description of packing, shipping, and security arrangements covering all locations involved in the exhibition
11. A description of any insurance arrangements to supplement indemnity coverage
12. A list of ensured or anticipated financial support for the exhibition and a description of any loan fees or other contractual arrangements (in excess of $10,000 for the entire exhibition), including retail agreements, with lenders to the exhibition or with foreign governments representing lenders
13. A description of all losses over $5,000 experienced by the applicant and each exhibiting institution during the three prior years

14. A statement as to whether the applicant and participating institutions are accredited by the American Association of Museums (a lack of accreditation does not automatically disqualify an organization for an indemnity)
15. Special information required for exhibitions held outside the United States and relating to the policy to give preference to reciprocal exhibitions
16. A detailed description of foreign-owned exhibition objects for which indemnity is sought, their valuations, and the source of the valuations
17. A detailed description of U.S.-owned exhibition objects for which indemnity is sought, their valuations, and the source of the valuations
18. A description of exhibition objects for which indemnification is not sought (this is needed to evaluate the significance of the exhibition as a whole)
19. A set of slides, photographs, or color photocopies of each object for which indemnity is sought

Information on the application process can be obtained from Indemnity Administrator, National Endowment for the Arts, 1100 Pennsylvania Avenue, N.W., Washington, D.C. 20506.

As of early 1997, the indemnity program has been remarkably successful, covering hundreds of exhibitions with a minuscule amount of losses.[20] In good measure, this success can be attributed to the careful administration of the program and the insistence on thorough planning and attention to detail. The indemnity program has also won the confidence of most foreign lenders, but as more foreign countries develop their own indemnity programs, each with its own particular twists, the loan negotiations are becoming extraordinarily complex. An international traveling exhibition may be covered by a variety of national indemnity programs as the show moves from country to country, and at each transition point, arrangements that respond to the peculiarities of that particular locale must fall into place. As one U.S. commentator noted at the 1996 "Museums in the Global Enterprise Society" seminar, "Museum lawyers will clearly be in business for many years to come."[21]

The following is a sample "Certificate of Indemnity," the notice that the U.S. Federal Council on the Arts and Humanities sends to an applicant when an exhibition has been approved for indemnity coverage (see Figure VIII.2). The certificate outlines the commitment of the United States, the obligations of covered parties, and the claim procedures.

20. As of 1997, over five hundred exhibitions have been indemnified, with only two claims paid. The two claims amounted to $104,700.

21. Comment of L. Croog, of the National Gallery of Art (Washington, D.C.), in the panel "Museums as International Borrowers and Lenders" at the "Museums in the Global Enterprise Society" seminar, International Bar Association, London, England (Feb. 15–16, 1996).

Figure VIII.2

Sample Certificate of Indemnity, U.S. Indemnity Program

CERTIFICATE OF INDEMNITY

FOR

AN EXHIBITION KNOWN AS

(NAME)

Under authority of the Arts and Artifacts Indemnity Act (P.L. 94–158) as amended, and in accordance with the provisions thereof, the Federal Council on the Arts and the Humanities (hereinafter "Council"), on behalf of the United States of America agrees to indemnify _____, the participating institution(s), _____, and the owners named on the attached list, as appropriate, against loss or damage to items while on exhibition as set forth below, and described in the attached list. The total amount of indemnity shall not exceed $_____ (United States dollars), each item being insured at the agreed value stated on the attached list. Losses and damages payable in United States dollars only.

Time Period of Indemnification:

This Certificate is effective from 12:01 a.m. Greenwich Time (all references to time herein refer to Greenwich Time) on the earlier date specified until the termination date described in Section 1160.3(j) of Regulations under the Arts and Artifacts Indemnity Act (P.L. 94–158) published in the Federal Register on October 2, 1991, as part of Title 45 of the Code of Federal Regulations, which are hereinafter referred to as "the Regulations." Section 1160.3(j) of the Regulations reads as follows:

"Termination date" means the date thirty (30) calendar days after the date specified in the indemnity Certificate by which an indemnified item is to be returned to the place designated by the lender or the date on which the item is actually so returned, whichever date is earlier. (In museum terms this means wall-to-wall coverage.) After 11:59 p.m. on the termination date, the item is no longer covered by the indemnity agreement unless an extension has theretofore been requested by the indemnitee and granted in writing by the Council.

This Certificate indemnifies against all risks of physical loss or damage from any external cause except normal wear and tear, inherent vice, or damage sustained due to or resulting from any repairing, restoration or retouching process.

1. CLAIM PAYMENT:

If, while on exhibition, as defined in S 1160.3(e) and described in the application for indemnification, any indemnified item(s) is lost, destroyed, stolen or suffers damage from any external cause excepting normal wear and tear, the indemnitee, on behalf of the owner(s), shall file a claim (including agreement to Federal indemnity and to the U.S. dollar values assigned to the item in the Certificate of Indemnity), with the Council under the terms of the Arts and Artifacts Indemnity Act for compensation (United States dollars) to be paid to the indemnitee on behalf

Continued on next page

Figure VIII.2 continued

of the owner or owners (hereinafter called the "owner"), who are identified on the attached list as follows:

(a) In the case of total loss or destruction of the item(s), payment of the agreed valuation specified in the attached list of objects subject to the $___ deductible amount provided by law.

(b) In the case of partial loss or damage to the item(s), payment of:

(i) such reasonable costs or repairs to the item(s) as agreed upon by the owner and the indemnitee, or in default of agreement, as determined by an appraiser mutually acceptable to the owner and the indemnitee, subject to the $___ deductible amount provided by law; and

(ii) an amount equal to any reduction in the fair market value of the item(s) after repair, as agreed upon by the owner and the indemnitee or, in default of agreement, as determined by an appraiser mutually acceptable to the owner and the indemnitee, subject to the $___ deductible amount provided by law.

The indemnitee, before receiving such compensation, will be required to obtain a document from the owner releasing the Council from liability, and to agree to pay such compensation over to the owner who is entitled thereto.

2. APPRAISAL PROCEDURES:

In the event of a disagreement between the Council and the indemnitee regarding claims relating to a partial loss, damage or reduction in fair market value as a result thereof, the arbitration and appraisal procedures described in Section 1160.10 of the Regulations shall apply.

3. CLAIM CERTIFICATION:

In the event of total loss or claims in which the Council is in agreement, or which have been resolved through arbitration proceedings with respect to the amount of partial loss, damage or reduction in fair market value as a result thereof, the Council shall certify the validity of the claim and the amount of such loss, damage, or reduction in fair market value as a result thereof, to the Speaker of the House of Representatives and the President pro tempore of the Senate, in accordance with the provisions of the Arts and Artifacts Indemnity Act.

4. INDEMNITEE RESPONSIBILITIES:

The indemnitee agrees to follow the policies, procedures, techniques and methods with respect to packing, shipping, etc., as described in the Application for Indemnification, unless modified by the Council.

5. CONDITION REPORTS:

No item shall be considered indemnified under this agreement until a condition report has been prepared prior to the initial packing, during the period of indemnification for the exhibition. The indemnitee further agrees to make condition reports upon each occasion of packing and unpacking the items covered during the period of indemnification.

Figure VIII.2 continued

6. SUBROGATION AND LOSS BUY BACK PROVISION:

(Note: See alternate, "*6," for Subrogation for Sovereigns)

In the event of any payment under this Certificate of Indemnity, the Council shall be subrogated to all the indemnitee's and owner's right of recovery therefor against any person or organization other than an indemnitee, participating institution(s) (as listed above), their trustees, officers, employees and agents, all of whom shall be liable only for willful misconduct and gross negligence; and the indemnitee and owner shall execute and deliver instruments and papers and do whatever else is necessary to secure such rights. If the rights secured result in the recovery of property other than money, such property shall be sold at public auction. The owner shall have the right to repurchase from the Council property of the owner that is recovered for the amount paid to the owner for the loss, plus an amount which represents loss adjustment and recovery expenses. Any money recovered under this subrogation provision shall be apportioned as follows:

(a) The Council shall be reimbursed to the extent of its actual payment hereunder;

(b) Payment shall next be made out of amounts remaining from said sale to any interest having paid any portion of the $_____ deductible amount provided by law in an amount not to exceed such interest's actual payment;

(c) If any balance then remains unpaid, it shall be applied to reimburse the indemnitee.

The expenses of all such recovery and sale proceedings shall be apportioned in the ratio of respective recoveries, except that the United States of America shall not be reimbursed its expenses as sovereign in conducting its general police, judicial, and diplomatic business. If there is no recovery in proceedings conducted solely by the Council, it shall bear the expenses thereof.

*6. SUBROGATION AND LOSS BUY BACK PROVISION FOR SOVEREIGNS:

If payment under this Certificate of Indemnity is made to the owner of an insured work which owner is a sovereign or the agent of a sovereign, said owner can elect to be covered either by clause 6 "Subrogation" of the Certificate of Indemnity, or by the following clause:

In the event of a payment under this Certificate of Indemnity, the Council shall be subrogated to all the indemnitee's and owner's right of recovery therefor against any person or organization other than the indemnitee, participating institutions (as listed above), their trustees, officers, employees and agents, all of whom shall be liable only for willful misconduct and gross negligence; and the indemnitee and owner shall execute and deliver instruments and papers and do whatever else is necessary to secure such rights. If the rights secured result in the recovery of property other than money, such property shall be returned to the owner and the owner shall pay to the Council:

(a) the amount previously paid by the Council to the owner;

(b) any amounts paid by the Council, the indemnitee or others as part of the $_____ deductible amount provided by law under the Arts and Artifacts Indemnity Act.

Continued on next page

Figure VIII.2 continued

The costs of recovering the property shall be paid by the indemnitee (or participating institution, as appropriate) as part of the $_____ deductible amount provided by law under the Arts and Artifacts Indemnity Act.

The expenses of such recovery shall be apportioned in the ratio of respective recoveries, except that the United States of America shall not be reimbursed its expenses as sovereign in conducting its general police, judicial, and diplomatic business. If there is no recovery in proceedings conducted solely by the Council, it shall bear the expenses thereof.

7. PAIR AND SET:

It is understood that, in the event of loss of, or damage to, any articles which are a part of a set, the measure of loss of or damage to such articles shall be a reasonable and fair proportion of the total value of the set, giving consideration to the importance of said article or articles, but in no event shall such loss or damage be construed to mean total loss of set.

8. MISREPRESENTATION AND FRAUD:

This agreement shall be void if the indemnitee or owner has concealed or misrepresented any material fact or circumstance concerning this insurance or the subject thereof or in case of any fraud, attempted fraud or false swearing by the indemnitee or owner touching any matter relating to this insurance or the subject thereof, whether before or after a loss.

9. EXAMINATION UNDER OATH:

The indemnitee and the owner shall submit, and so far as is within his or their power shall cause all other persons connected in any way with the indemnified exhibition and members of the household and employees to submit to examinations under oath by any persons named by the Council, relative to any and all matter in connection with a claim and subscribe the same; and produce for examination all books of account, bills, invoices, and other vouchers or certified copies thereof, if originals be lost, at such reasonable time and place as may be designated by the Council or its representatives, and shall permit extracts and copies thereof to be made.

10. NO BENEFIT TO BAILEE:

This agreement shall in no way inure directly or indirectly to the benefit of any carrier or other bailee.

11. SUE AND LABOR:

In case of loss or damage, it shall be lawful and necessary for the indemnitee or owner, his or their factors, servants and assigns, to sue, labor, and travel for, in and about the defense, safeguard and recovery of the property insured hereunder, or any part thereof without prejudice to this indemnification agreement; nor shall the acts of the indemnitee or owner or the Council, in recovering, saving and preserving the property insured in case of loss or damage, be considered a waiver or an acceptance of abandonment to the charge whereof the Council will contribute according to the rate and quantity of the sum herein insured.

Figure VIII.2 continued

12. COLLECTION FROM OTHERS:

No loss shall be paid hereunder if the indemnitee or owner has collected the same from others.

13. THE FOLLOWING CONDITIONS SHALL APPLY TO THE INSURED PROPERTY WHILE IN WATERBORNE OR AIRBORNE TRANSIT OVERSEES:

(a) Including transit by craft and lighter to and from the vessel. Each craft and lighter to be deemed a separate insurance. The indemnitee and owner are not to be prejudiced by any agreement exempting lightermen from liability;

(b) This insurance shall not be vitiated by an unintentional error in description of vessel, voyage or interest, or by deviation, over-carriage, change of voyage, transshipment, or any other interruption of the ordinary course of transit, from causes beyond the control of the indemnitee and owner. It is agreed, however, that any such error, deviation, or other occurrence mentioned above shall be reported to the Council as soon as known to the indemnitee and owner;

(c) General average and salvage charges payable according to United States laws and usage and as per foreign statement and as per York Antwerp rules (as prescribed in whole or in part) if in accordance with the contract of affreightment;

(d) Warranted free of claim for loss of market or for loss, damage or deterioration arising from delay, whether caused by peril insured against or otherwise, unless expressly assumed in writing hereon;

(e) Where goods are shipped under a Bill of Lading containing the so-called "both to blame collision" clause, the Council agrees as to all losses covered by this agreement's proportion of any amount (not exceeding the amount insured) which the indemnitee and owner may be legally bound to pay to the shipowners under such clause. In the event that such liability is asserted, the indemnitee and owner agree to notify the Council who shall have the right at its own cost and expense to defend the indemnitee and owner against such claim;

(f) Marine extension clause: Notwithstanding anything to the contrary contained in or endorsed on this agreement, it is understood and agreed that the following terms and conditions shall apply to all shipments which become a risk hereunder:

(i) This insurance specially to cover the goods during:

(aa) Deviation, delay, forced discharged, reshipment and transshipment; and

(bb) Any other variation of the adventure arising from the exercise of a liberty granted to the shipowner or charterer under the contract of affreightment.

(ii) In the event of the exercise of any liberty granted to the shipowner or charterer under the contract of affreightment whereby such contract is terminated at a port or place other than

Continued on next page

Figure VIII.2 continued

the original insured destination, the insurance continues until the goods are delivered at such port or place; or, if the goods are forwarded to the original insured destination or to any other destination, this insurance continues until the goods have arrived at the place designated by the owner.

(iii) Held covered in case of change of voyage or of any omission or error in the description of the interest, vessel or voyage.

(iv) This agreement shall in no case be deemed to extend to cover loss, damage, or expense proximately caused by decay or inherent vice or nature of the subject matter insured.

(v) It is a condition of this agreement that there shall be no interruption or suspension of transit unless due to circumstances beyond the control of owner and indemnitee.

14. SECURITY PROVISIONS:

The security provisions shall be as stated in the approved indemnity application. Within thirty days preceding the opening of an indemnified exhibition to the public, the Chief of Security, or corresponding official, of the exhibiting museum must submit to the Federal Council on the Arts and the Humanities, c/o Indemnity Administrator, Museum Program, National Endowment for the Arts, Washington, D.C. 20506, a letter certifying that the security arrangements are still as stated in the application on which this Certificate was issued, and the Director or corresponding official of the exhibiting museum shall endorse said letter by signing it.

Failure to comply with the arrangements for security as stated will be deemed "wilful misconduct" or "gross negligence" as those terms are used in Clause 6 "Subrogation and Loss Buy Back Provision."

All other terms and conditions of the agreement not in conflict with the foregoing remain unchanged.

This Certificate of Indemnity is issued under and is subject to the provisions of the Arts and Artifacts Indemnity Act and the Regulations.

This agreement, under authority of Section 4(c) of the Arts and Artifacts Indemnity Act, pledges the full faith and credit of the United States to pay any amount (United States dollars) for which it becomes liable in accordance with the above provisions.

In witness whereof, the Federal Council on the Arts and the Humanities has caused this Certificate to be signed on the date written below.

Chairman Date
National Endowment for the Arts
and
Member
Federal Council on the Arts
 and the Humanities

Attachment: List of Indemnified Items

D. Force Majeure

When negotiating an international loan, museums may, understandably, be more concerned about events that cannot be controlled, such as natural disasters, wars, and political unrest. In a standard commercial contract governing the transport of commodities, such events may or may not be construed to relieve the parties of a duty to perform.[22] However, when the subject of the contract is unique, cultural property safety is a prime objective, and the normal preference is to excuse performance if events outside the control of the parties make performance hazardous. For this reason, the doctrine of force majeure (that is, superior or irresistible force) is frequently incorporated into an international loan agreement. By definition, "force majeure" is a term used in contracts "to protect the parties in the event that a part of the contract cannot be performed due to causes which are outside the control of the parties and could not be avoided by exercise of due care."[23] By way of example, suppose a loan agreement states, "The provisions of this agreement are subject to the doctrine of force majeure." This means that the parties intend that performance will be excused in the case of those unavoidable occurrences that make performance hazardous for the objects.

Some contract provisions of this nature are quite simple, such as the example given above. Others go into much detail. The following rather formidable paragraph was used in a contract for a major foreign exhibition shown in the United States:

Anything herein contained to the contrary notwithstanding, neither party hereto shall be liable or be deemed to be in default to the other by reason of any act, delay or omission caused by epidemic, fire, action of the elements, strikes, lockouts, labor disputes, regulations, ordinances, or order of a court of competent jurisdiction, act of government, act of God, or of a public enemy, war, riot, civil commotion, earthquake, flood, accident, explosions, casualty, embargo, delay of a common carrier, inability to obtain labor, material facilities, transportation, power or any other cause beyond the reasonable control of the party hereto, or for any act, delay or omission not due to the negligence or default of that party hereto; provided, however, that the party whose performance shall have been so prevented shall give prompt written notice to the other of the nature thereof and the date when such condition commenced and give further notice to the other of when such conditions shall have ended. Upon receipt of such notice by either party, both parties shall confer with each other and with appropriate representatives of the . . . Government who shall determine whether the nature of the occurrence warrants cancellation of the Exhibition or its transfer to another location.

Another aspect of the force majeure problem is the allocation of costs if there is a premature termination of the contract. Consider, for instance, a situation in which an exhibition is held successfully in Countries X and Y. Just before delivery to Country Z for the last showing,

22. H. Berman, "Excuse for Nonperformance in Light of Contract Practices in International Trade," 63 *Colum. L. Rev.* 1413 (1963). See also *Restatement (Second) of Contracts,* Chapter 14, and *Williston on Contracts,* 3d ed. (Mt. Kisco, N.Y.: Baker, Voorhis, 1957), § 1936.

23. *Black's Law Dictionary* (6th ed. 1990).

the exhibition is terminated because of civil unrest. Must the museum of Country Z bear its full cosponsorship cost even though it never had the benefit of the exhibition? A clause in a loan agreement can establish an equitable method for resolving such an issue. The clause could state: "In the event of premature termination, the parties will agree on a just settlement of costs incurred prior to the date of termination. Such settlement will take into account any benefits already enjoyed by one or more of the participating museums."

E. Checklists for Organizing and Implementing International Exhibitions

International exhibitions demand careful and thorough planning if legal problems are to be avoided. In addition to the normal exhibition activities and challenges are possible language and cultural difficulties, distance problems, political tensions, and variations in laws, customs, and currencies, to name a few. The sensible approach is to start early, listing all anticipated steps and sketching out a program of action. Where possible, the plans and schedules should allow leeway for ongoing revision as well as for the inevitable emergencies.

As planning guides, museums can refer to the following three checklists for organizing and implementing a sizable international exhibition. Checklist 1 (see Figure VIII.3) deals with the overall planning required of the organizers. Checklist 2 (see Figure VIII.4) concerns the loan contract between the individual lender and the borrower/organizer. Checklist 3 (see Figure VIII.5) outlines points to be considered in drafting a contract between the lender/organizer and the participating museum. The checklists were developed by Martha Morris Shannon, Deputy Director, and Catherine Perge, Program Manager, of the National Museum of American History, Smithsonian Institution.

Figure VIII.3
Checklist 1: Organizing International Exhibitions

I. INITIAL ORGANIZATION

 A. When should negotiations and planning begin?

 As soon as possible, but at least two years in advance; however, be prepared for longer time-frame depending on size and complexity of project.

 B. Who is involved?

 1. Assignment of project director.

 2. Coordination of input from key museum staff: registrar, designer, conservator, curators, public affairs officer, educators, development officer, other administrators.

 3. Is sufficient professional staff available? Will additional staff be needed? Is there a need for short- or long-term contractual support?

 4. Additional support: legal counsel, risk manager/insurance broker, import/export agents, interpreters/translators, guest curators/researchers, and/or designers, participating museum, co-organizers.

Figure VIII.3 continued

 C. Development of projected budget.

 Be sure all costs are realistically high enough to cover contingencies, currency fluctuations, etc. Be prepared to justify all anticipated costs.

 D. Approval of concept and budget by Director (and by Trustees, if required).

 E. Negotiations with funding source(s), e.g., application for Federal Indemnity or other grants. May need to alert granting agencies or foundations prior to formal submissions.

 F. Develop and be prepared to revise schedules and timetables. Develop and revise milestones as needed.

 G. Delineate staff and contractor roles and responsibilities for each participating organization to cover the entire life cycle of the exhibition.

II. NEGOTIATIONS WITH LENDERS (FOREIGN AND DOMESTIC)

 A. Will foreign loans be negotiated with individual lenders or through one source, e.g., foreign government cultural office or co-organizing foreign museum or corporation?

 B. Organizer may be primary borrower and in turn lend exhibit to participant museums—when does each party take responsibility?

 C. How many countries are involved? Are domestic and foreign lenders involved?

 D. If corporate sponsors are involved, do they have domestic and foreign branch offices that will be involved?

 E. Possible assistance from Embassies and Consulates in both U.S. and lender's country?

 F. Final selection of objects/artwork—firm listings required by specific date; avoid last-minute changes. Begin extensive research and documentation on objects/artwork composition, materials, and provenance for import/export documentation, identification of hazardous materials, and permits/licenses.

 G. Formalization of contract or loan agreement with co-organizing foreign museum/organization and/or individual lenders covering all relevant points; budgets and cost sharing; roles and responsibilities; applications for import/export permits/licenses or other documentation required by governments; application for declaration of immunity from seizure. Review terms with legal, risk manager, public relations, fiscal, import/export, and cultural/language, governmental advisors. Recommend English as language of contract; however, both sides will need experienced translators and interpreters for all written and oral negotiations and discussions.

 H. Long before importation, make application for all relevant import/export permits or licenses and declaration of immunity from seizure. Be acutely aware of international political considerations and possible impact on negotiations and contracts (e.g., trade disputes, student protests, or civil strife in adjacent countries). Be sensitive to cultures for whom detailed written contracts are not a standard way of doing business.

Continued on next page

Figure VIII.3 continued

III. OBJECT CONSIDERATIONS: LEGAL AND LOGISTICAL

 A. Documentation

 1. Loan Contract

 a. All lenders must sign a loan contract. [See Checklist 2, which addresses the terms of a loan agreement between organizer/museum(s) or individual lender.]

 b. Is organizer or co-organizer a lender, too?

 c. Lender's forms for your signature? Professional translation required? Be sure conditions are clearly understood and acceptable.

 d. Loan fees charged? Are there other fees?

 e. Identify all anticipated expenses and contingencies, e.g., staff or contractor travel expenses, emergencies, etc.

 f. Keep all correspondence: written, telephone messages with summary of conversations, faxes, and electronic mail.

 2. Receipts

 a. Issued to lenders initially.

 b. Required as objects enter and leave custody of organizer and participant museums.

 3. Condition Reports

 a. Lender must document in writing with photographs, drawings and/or video, the initial outgoing condition, and, ideally, the organizer would be present to verify.

 b. Separate reports for each object are confirmed by organizer and participant museums as objects/works enter and leave custody. May need to provide translations; or use visuals such as photographs, drawings, or video.

 c. Require conservator, registrar, collections manager, and/or curatorial review.

 d. Photographs, drawings, and/or video should be made and accompany written reports. Determine who will provide this documentation.

 e. Borrowers should be prepared to photograph objects if change in condition occurs. Determine who will notify lender if damage/loss occurs and how to receive permission for emergency conservation.

 f. Lender verifies final condition upon receipt.

 4. Photographs

 a. These may serve as exhibit design tools, use by import/export brokers for custom declarations, packing/crating design and fabrication, installation/dismantling logistics, condition records, publicity, catalog reproduction.

Figure VIII.3 continued

 b. Determine who will provide, what type of photographs (e.g., black and white, color, print, or transparency), and costs.

 c. Does lender give permission? Ensure permission covers appropriate uses. Be aware of any restrictions.

 5. Publications

 a. Whose responsibility for preparation and verification of listings either in printed catalog or via electronic publications?

 b. Whose responsibility to negotiate, pay, and acquire all use rights for multi-media publications?

B. Logistics

 1. Packing

 a. Lender's option with organizer's approval. Review all techniques in advance and be on hand to supervise. Use and selection of a contract packer/crater and final packing techniques may require negotiation and approval.

 b. Preservation and environmental concerns.

 c. Making containers for handling and identification.

 d. Crate lists and unpacking and repacking instructions. Augment lists with photo documentation or drawings. If databases are used for tracking, ensure the database can be used outside its country of origin.

 2. Transit

 a. Via consolidated or individual shipments arranged by commercial forwarder or by organizers?

 b. Via lender's chosen shipper?

 c. Via experienced courier? Consider reasonable travel expenses.

 d. Via air transport, either containerized or palletized: in cargo plane or in passenger cargo? Or, will object accompany courier in passenger cabin? Will air transport be chartered or regularly scheduled?

 e. Via ship or barge transport: will shipment ride above or below deck? Will this be a charter or regularly scheduled shipment? If needed, is courier allowed on freighter?

 f. Via ground transportation: exclusive use transport or regularly scheduled shipment?

 g. Security escorts?

 h. Multiple shipments required by insurance/indemnity contracts, or weather or environmental considerations, or the significance of the collection/objects to the lender or museum?

Continued on next page

Figure VIII.3 continued

 i. Will all exhibition components be included with shipments, e.g., exhibit cases, graphics, brackets, photographs, audio-visual equipment, interactive software, etc.? Will any of these materials be perceived as or classified as hazardous cargo and appropriate documentation secured to allow for transit?

 3. Customs

 a. Allow ample time to prepare all required documentation. This can be extremely complicated and it is preferable to hire reputable customs brokers familiar with import/export regulations. Identify who will have the "customs power of attorney." Ensure experienced staff are available to assist throughout all phases of customs review.

 b. Have all import/export regulations been met? Have all permits been acquired and provided to the appropriate authorities allowing adequate time to review?

 c. Require a through waybill to museum or site and on-site inspection to reduce or eliminate inspections at dockside or airport hanger or warehouse. Customs may require detailed photographs, accurate object dimensions, and detailed description of objects' composition in addition to provenance, to facilitate inspection and potentially eliminate or reduce the need to unpack the artifacts.

 d. In rare instances, diplomatic clearance may be arranged. This, however, may not afford the appropriate museum control over the shipment or care for the objects.

 4. Receiving loans

 a. Anticipate object and container flow at museum or site.

 b. Review temporary holding area—adequate space? Convenient to other museum or site services? Acceptable environmental conditions? Clean space?

 c. Security (alarms, guards, staff, contractors) (who has access?).

 d. Unpacking, customs inspection, condition reports; use identifying tags (indicating exhibit or tracking catalog number) or other checks for objects and exhibit components or structures.

 e. Secure, clean, and environmentally stable storage of packing materials and crates or containers during exhibition. Provide graphical or photographic instructions for repacking.

C. Preservation

 1. What are objects' conservation needs?

 a. Lender's requirements?

 b. Amount of conservation prior to travel? Whose cost?

 c. Permissions to reframe, mat, clean, repair, dismantling/reinstall, etc.?

Figure VIII.3 continued

 d. Environmental history and conditions? How and who will monitor? Try to anticipate and monitor environmental fluctuations (i.e., temperature and relative humidity).

 e. Pest management. Note past, current, and potential infestations. Identify means to control and monitor, if possible.

 f. Lighting. Identify light levels, types of lighting available both within exhibit case and throughout exhibition, and who will monitor and record light levels throughout exhibition.

 g. Exhibit case design and fabrication: dust filters in cases, need for environmental monitoring equipment, ability to access case or light fixtures without disturbing or endangering the objects/artwork.

 h. Access to professional conservator?

 2. Handling instructions

 a. Who is authorized to handle?

 b. Require special equipment/manpower?

 c. Provide detailed instructions, photographic documentation, or drawings, for handling or dismantling/reinstalling objects.

 3. Installation/Dismantling

 a. Provide detailed written documentation and illustrations prior to shipping to ensure all participants are familiar with methods and techniques and sequence of installation/dismantling.

 b. Identify staff and communicate clear roles and responsibilities.

 4. Security

 a. Physical guarding—current capability b. additional needs?

 b. Electronic—wiring objects/cases; TV monitors; central station alarms; current capability v. additional needs and complement to physical requirements?

 c. Perimeter alarms for exhibition galleries?

 d. Regular inventory of exhibition spaces and individual objects/artwork.

 e. Confidentiality of all information.

 f. Allow adequate time for inspections by security officials prior to exhibition opening.

D. Insurance/Indemnity

 1. Contracted for in agreements with lenders.

 2. Point of liability at leaving lender's custody or elsewhere?

Continued on next page

Figure VIII.3 continued

3. Who insures? Lender's choice.

 a. Lender's policy—factors to consider:

 (1) Ask for translation?

 (2) Type of coverage; transit limits?

 (3) Exclusions?

 (4) Require certificate waiving subrogation (also for participant museums, but not carrier)?

 (5) How would claims be handled?

 (6) Premium cost?

 b. Your own policy. Advantage in familiarity with coverage and personnel would lead to ease in claim settlement.

 c. Split coverage. More than one company covering loan creates potential problems—who is ultimately responsible when claim occurs?

 d. Federal Indemnity (Federal Council on the Arts/NEA). See Pub. L. 94–158; application, key provisions.

 (1) Regulations require considerable documentation of exhibition details—well in advance of the application and importation.

 (2) Deadlines for coverage require application April 1 for projects beginning July 1 and October 1 for projects beginning January 1.

 (3) Criteria for acceptance.

 (4) May require organizer travel to foreign lender's premises to oversee packing (expense factor).

 (5) Valuations are fixed at time of application in U.S. currency—problem with devaluation of dollar against certain foreign currencies.

 (6) How are deductibles covered (additional expense)?

 (7) Coverage in excess of limit per show (additional expense)?

 (8) With competition from other museums, can you be guaranteed indemnification (total $ limit restrictions)?

 (9) Should you accept partial indemnity?

 (10) Foreign lenders agree to U.S. government indemnity? (Must be in loan agreement.)

 (11) How will claims be settled?

 (12) Changes in plans after indemnity granted may require resubmission of application.

Figure VIII.3 continued

 e. General consideration for insurance or indemnity:

 (1) Valuation—must be fair market value; currency fluctuations need to be considered in coverage as well as value fluctuations in the art market.

 (2) Deductibles—how to cover.

 (3) Excess coverage needed?

 (4) Claims—what is procedure for reporting, adjusting, arbitrating disputes?—settle per values agreed upon; depreciation is allowed in partial losses.

 (5) Subrogation—whose right to waive?

 (6) Insurance or indemnity—must be the sole monetary recovery available to the lender in the event of loss or damage.

 (7) Consider exclusions—limited to standard . . . add war risk.

 (8) What is the most cost effective decision? Compare all costs of commercial v. indemnity (how much premium will be saved with indemnity v. costs to obtain indemnity?).

 (9) Maintain close contact with insurance broker or agent throughout and may have to cover cost of possible site visit.

 (10) Develop disaster plans in consultation with insurance broker/risk manager and exhibition site and other responsible officials.

IV. CIRCULATION OF EXHIBITION

 A. Negotiation with participant museums via specified contract.

 B. Use of facilities reports in gathering information on participant's physical capability, professional staffing, and potential hazard to objects/artwork.

 C. Can entire show travel? Will other objects be added? Or removed?

 D. Scheduling showing to include preparation, travel time, and contingencies.

 E. Preparation of traveling exhibition instructions for object handling, packing, unpacking, crate lists, press kits, catalog, multimedia products and stations, condition report books, graphic and exhibition components.

 F. Who will insure? Waiver of subrogation?

 G. Who will pack? In-house or outside firm? What carrier(s) will be used? Shipment consolidation and insurance requirements (security escorts, split shipments). Lender's courier required?

 H. Who will oversee installations, etc.? Organizer send qualified staff with appropriate authority and skill.

Continued on next page

Figure VIII.3 continued

 I. Cost allocations—problems of *force majeure.*

 J. Sharing of revenue from catalog, multimedia products, or other museum shop sales (e.g., t-shirts, posters, postcards, CD roms, etc.)? Will this require separate agreements and outside audits? Royalty payments to other parties or lenders?

V. DISPERSAL

 A. Will show be extended (try to anticipate this possibility as early in the planning as possible as this could be a significant cost and logistical challenge)? Have all lenders and participants agreed to extension in writing? Insurance extended? (May be difficult to extend indemnity and declaration of immunity.)

 B. Disperse from last exhibitor or return to organizer? Organizer's responsibility to lenders is paramount.

 C. Ongoing condition check, photos, packaging. Keep detailed documentation.

 D. Scheduling returns with lenders, coordinating with couriers.

 E. How to be returned? To one foreign point for distribution or direct to lenders?

 F. Who covers costs? Where do liabilities begin or end? Timely follow-up.

 G. Are customs formalities in line? Return to country of origin to avoid problem of reentry. All permits and licenses prepared and correct with any changes communicated and documented well in advance of return shipment. Avoid surprises during customs formalities.

 H. Obtain timely final receipts from lenders (time limit—insurance requirement).

 I. Write timely thank you letters to lenders and other participants, staff, and officials.

VI. OTHER CONCERNS

 A. In-house or outside designers, graphic artists, photo researchers, computer specialists? Work for hire issues?

 B. Public relations

 1. Opening, other events, receptions, VIPs.

 2. Press, TV, radio coverage (local, national, international), electronic access via internet. Needs may impact schedule for shipping, exhibition fabrication, installation, etc., prior to opening. Who controls information and its quality?

 C. Credit to individual lenders (per loan agreement). Be sensitive to "crediting" individuals as this may or may not be a problem in some cultures.

 D. Acknowledgement of sponsors, e.g., government, corporate, private. There may be sponsorship expectations in advertising, use of corporate logos, special events in the exhibition, private tours, shop sales, use of "in-kind donations" of equipment or supplies, invitations to opening, courtesy catalogs, etc.

 E. Who is allowed to photograph (per loan agreement)? The public? media? And for what purposes (e.g., print, publicity, internet web site, etc.)?

Figure VIII.3 continued

 F. Educational

 1. Lectures and symposia?

 2. Audio or other forms of interactive tours?

 3. Films or other audio visuals, computer interactives?

 4. Visitor interpretation? Visitor experience evaluation?

 5. School outreach?

 6. Curriculum kits?

 7. Tours? Multi-lingual tours? Descriptive tours for visually disabled?

 G. Publications

 1. Multi-language and/or multimedia publications? Import/export problems? Audit and other business concerns?

 2. Who produces, writes, edits, designs, publishes? Who approves? Who sets production deadlines? Number ordered? Selling price? Who reviews quality?

 3. Distribution of complimentary copies?

 4. For on-line publications, who maintains, approves and implements changes? Who monitors quality?

 H. Products, such as posters, postcards, reproduction of artifacts, shop sales.

 1. Who reviews and monitors quality control?

 2. Who has authority to allow reproduction or replication? Who manufactures? Amount of order? Who sells? Cost to exhibitors? Sales revenue to whom? Royalty payments? Corporate sponsorship expectations?

 I. Secure reproduction rights, trademarks (in loan agreement)?

 J. Graphics and banners? Printing forms, invitations, etc. Import/export requirements and problems when materials travel with exhibition?

 K. Are admission fees charged? Disposition of revenue?

 L. Accommodation of increased number of visitors? Contingency plans for visitors not accommodated?

 M. Competition from other exhibitions or events.

 N. Are there accessibility requirements? Are organizers committed to providing full and dignified access to all programs, exhibit, and site, for people with disabilities? (In the U.S. note the Architectural Barriers Act of 1968, the Rehabilitation Act of 1973, and the Americans with Disabilities Act of 1990. Other foreign governments are following with similar regulations.) Will the foreign exhibit traveling to the U.S. need to be adapted to ensure compliance?

Continued on next page

Figure VIII.3 continued

O. Cultural differences. Consider the importance/impact on schedules of national holidays/feast-days, methods of conducting business, timely communication and understanding, etc.

VII. MAJOR BUDGETARY CONSIDERATIONS

A. Drain on daily operations/resources? Overhead? Negotiations may take more time than realized.

B. Staff travel and research.

C. Escort travel.

D. Shipments, customs brokers, import/export fees or duty, and production of all documentation for customs clearances.

E. Packing/unpacking, crate/container design and fabrication.

F. Exhibition design, protyping, fabrication. Major reconstruction of exhibition areas?

G. Insurance premiums, covering deductibles.

H. Catalog, brochures, posters, multimedia products.

I. Conservation and preparation costs.

J. Publicity photography, advertising, opening reception.

K. Audience testing and pre-opening evaluations.

L. Security: guards and hardware.

M. Audio visual, computer hardware and software (new and upgrades and maintenance).

N. Telephone, fax, telex, and electronic mail bills.

O. How are costs shared with participants?

P. How are costs shared with co-organizers?

Q. Is revenue to be shared? Tax and audit preparation costs.

R. Billing, bookkeeping, financial report preparation and reporting, audits, legal advice.

S. Accessibility accommodations.

T. Rights and reproductions fees.

U. Production of detailed installation/dismantling instruction manuals/notebooks as well as condition report notebooks.

V. VIP travel and gifts.

Figure VIII.4

Checklist 2: Loan Agreement between Organizer/Museum and Individual Lender

A. Factual Information

1. Parties to the agreement: individual Lender & Borrower (organizer) for each: name, address, postal code, phone numbers, fax numbers, electronic mail address.

2. Purpose of the loan: name of exhibition.

3. Dates of the exhibit; dates of loan period (wall-to-wall) (if circulating, name participant museums, their addresses and dates of showing).

4. Object(s) description (be consistent with all descriptions):

 Type of object

 Title (if applicable)

 Artist or maker

 Date of execution

 Medium and/or materials

 Size: height, width, depth (include metric and American)

 Weight (metric and pounds)

 Number of parts or pieces

 Museum of collection number(s)

 Inscriptions or identifying marks and locations

 Provenance, bibliographic references, etc.

 Insurance value

5. Design and installation considerations: permission to reframe, remat, clean or alter works for display? (must be reversible process) special requirements for installation?

6. Reproduction and Credit

 Request for photographs (black and white, color, digital images, etc.).

 Request for permission to photograph for:

 —publicity

 —condition reports

 —catalog illustration

 —exhibit graphics

 —internet

 —commercial venture

Continued on next page

Figure VIII.4 continued

Request permission to reproduce for:

—publicity

—catalogs

—slides

—postcards

—internet

—commercial venture

Copyright restrictions? Trademark?

Indicate credit line for publication and label?

7. Insurance

By lender? If so, need certificate waiving subrogation against borrowers. Premium costs? By borrower(s)? Insurance value must be fair market. Will you accept U.S. Federal Indemnity or other government's indemnity?

8. Packing and Transportation
 a. Preferred method of packing?
 Pack by lender or outside firm? (including packing instructions)

 Permission to repack by borrower for consolidated tour?

 Address object to be returned to, if different from above. (Different return address will impact import/export documentation.)

 b. Preferred method of transportation
 Preferred carrier? (If lender has no preference all arrangements will be made by borrower or agent)

 Date due at borrowing museum?

9. Handling & Preservation

 —any handling restrictions?

 —any special requirements for lighting, temperature, humidity?

 —need to reassemble objects?

 —special instructions for brackets, matting, and/or framing?

 Do we have permission to perform emergency conservation measures if necessary?

 Will there be any special preparation or restoration costs?

 Please prepare a written condition report at time of packing the objects for loan and forward to the borrower.

B. Loan Conditions

Loans are made subject to the following conditions; participant museums (as named above) have contracted with borrower (name) and will also comply with these conditions:

Figure VIII.4 continued

1. Care and Preservation

 a. Borrower promises to devote to all objects lent the same care as afforded similar objects in its own collection. Objects will be displayed out of reach, under 24-hour security, with guards during public hours. Efforts will be made to maintain conditions necessary to the conservation of objects such as lighting, climate control, and dust filtering.

 b. Lender certifies objects are in such condition as to withstand normal stress of packing and unpacking, handling, and transits. Any potential problem will be discussed with the Borrower and/or knowledgeable conservator prior to loan. The Borrower will not be liable for normal wear and tear or for damage or loss due to conditions inherent or previously existing in the objects.

 c. Condition reports will be made by the Lender prior to shipment and by Borrower and participating museums at packing, unpacking and regular intervals while on display. Photographs, illustrations, and written reports will be made to document condition and travel with exhibition.

 d. Evidence of damage or loss to an object will be promptly communicated to the Lender. No cleaning, repair or restoration will be undertaken by the Borrower without written authorization, except in an obvious emergency situation to curtail further deterioration.

2. Insurance

 a. If the borrower is insuring, objects will be insured at the Lender's herein stated value against all risks from wall-to-wall subject to standard exclusions (listed). Insurance will be placed with the Borrower's insurance company (named) or under a U.S. Government Indemnity (if applicable) for the entire period of the loan, as stated herein. The amount payable by this insurance or indemnity is the sole recovery available to the lender in event of loss or damage. Valuations should reflect fair market value. If U.S. indemnity is secured, objects will be insured in U.S. dollars at their value as of the application date. Currency fluctuations affecting value of claims at a later date are not recognized under indemnity.

 b. The above insurance/indemnity will reimburse loss or damage occurring during the loan period. Restoration costs and depreciation in value will be covered, but are subject to mutual agreement. Total losses are reimbursed at the value as agreed herein, and are subject to salvage.

 c. If the Lender prefers to maintain his/her own insurance, then the Borrower and participating museums must be named as additional insureds on the policy. Otherwise, they are to be released from all liability and held harmless for any loss or damage to the loaned objects.

3. Shipping and Packing

 a. Unless other arrangements are herein stated, foreign loans will be consolidated for packing and/or shipping to and from the United States at a mutually

Continued on next page

Figure VIII.4 continued

agreeable location and time. Shipments will be by (chosen method) and will be accompanied by the Borrower's authorized agent(s). Packing must be of highest professional quality and done under the supervision of the Lender and/or Borrower. Packing should be of a quality to withstand shocks of handling and changes in climate. Unpacking and repacking instructions should be included. Borrower will provide security protection during packing, transit and storage periods.

b. Lenders and Borrower will adhere to their respective government customs regulations in exporting and importing loans and will protect objects from possible damage during inspections.

c. Lenders who accompany their own loans will provide qualified couriers. Arrangements will be subject to advance agreement with the Borrower.

4. Reproduction, Photography and Credit

a. Unless expressly denied herein, the Lender gives permission to the Borrower and participants to photograph, film, and reproduce by current technology objects for publicity, condition record, catalog illustration, and other educational uses. Credit will be given as stated herein for publication and labels. Copies of the catalog will be furnished to each lender. (English or foreign language edition)

b. Photography will be done under supervision of curators, and excessive lighting will be prohibited.

c. It is understood that the general public may photograph objects for personal use.

d. Lender must inform Borrower of any existing copyright.

5. Possession and Return

a. Objects will remain in the Borrower's possession for the period indicated herein and be displayed at the Borrower's discretion.

b. In case of change in legal ownership, Borrower must be given satisfactory proof before objects will be released.

c. Objects will be returned to the Lender or his authorized agent at the address given herein. If efforts to return the objects within a reasonable time are unsuccessful, the Borrower may place the objects in storage at the Lender's risk and expense. Failure of the Lender to sign and return the official return receipt within 30 days of final shipment will absolve the Borrower of any further liability for the loaned objects.

6. Costs

All reasonable costs of effecting the loan, *e.g.,* insurance, transit, packing, will be covered by the Borrower. Lender must inform Borrower of all known costs incidental to the loan herein.

Figure VIII.4 continued

> C. Certification and Signature (example below)
>
> I have read and agree to the above conditions and certify I am authorized to agree thereto:
>
>
>
> Signed: _____ Date: _____
> Lender (owner or
> authorized agent)
>
>
>
>
>
> _____ Date: _____
> Borrower
>
>
>
> Note: Usually preferable to have agreement written in English. Factor into negotiation period time needed for translation and interpretation.

Figure VIII.5
Checklist 3: Contract between Organizer/Museum and Borrower/Museum

> 1. Name and address of Borrower and Lender as parties to the Contract. Lender is organizer, Borrower is co-organizer, or participant.
>
> 2. Purpose—exhibition title and description.
>
> 3. Time frame and location—exact location of exhibition showings and approximate dates for the loan, including sufficient time to cover shipment, receipt, unpacking, installation, public exhibit, dismantling, repacking, and return shipment.
>
> 4. Objects or artworks included in the exhibit should be referenced by an attachment (catalog listing) or a statement in the contract that the listing will be provided by Lender on a specific date.
>
> 5. Name(s) of curatorial individual(s) (or duly appointed successors) responsible for the exhibition, acting on behalf of the borrowing and lending institutions.
>
> 6. Division of responsibility between organizers and participant museums regarding:
>
> a. Loan selection and negotiation with other lenders.
>
> b. Design and printing of any special loan agreement forms, receipts, condition report forms or stationery.
>
> c. Period of responsibility/liability for objects.
>
> *Continued on next page*

Figure VIII.5 continued

 d. Signing individual Lender's agreements, which should not differ materially from the standard terms agreed upon for borrowing (if Organizers are Lenders, agreement to the same standard terms).

 e. Acceptance and payment of loan fees.

 f. Responsibility for collection, packing, shipping, courier arrangements, security, etc.

 g. Applications for immunity from seizure; Federal indemnity.

7. Description of packing methods and materials:

 a. In accordance with the most advanced techniques in order to assure rapid, safe, and secure transport.

 b. Provision for borrower to review packing technique, especially where insurance liability in effect.

 c. Crate lists, packing and unpacking instructions, install/dismantle notebooks.

8. Condition reports:

 a. Organizing curators (with conservator) to prepare master report and photographs. Condition checked at time of preparation and packing for transport to borrowing organization.

 b. Responsible individual to check condition of objects at packing and repacking points along the tour.

 c. Requirement for receipts.

 d. Notice that damage or loss will be recorded and reported promptly to Organizer and Lenders.

9. Transportation arrangements:

 a. Selection of carrier for each leg of journey.

 b. Transit via mutually agreeable carrier and scheduled time.

 c. Security arrangements for transit.

 d. How shipment(s) will be moved from museum to port for overseas flight/ocean voyage.

 e. Indicate necessity to split shipment on more than one conveyance to meet insurance or indemnity requirements.

 f. Provision for curatorial escort of main shipments.

 g. Provision for reasonable travel expenses for lender escort (as required by loan agreements).

10. Customs responsibility for lending organization or individual Lenders:

 a. Clearance of customs in foreign countries (export licenses?)

 b. Arrangement for U.S. customs clearance and outside inspection on Borrower premises.

 c. Assignment of customs broker.

Figure VIII.5 continued

11. Insurance/Indemnity:

 a. Statement regarding who will arrange for insurance under indemnity or through commercial carrier.

 b. Approximate total value and specific period of coverage.

 c. Indication if there will be a split coverage situation.

 d. Notice that insurance/indemnity is sole recovery available in the event of loss or damage.

 e. Requirement that lending organization(s) should cooperate fully in providing necessary information for completing indemnity application.

 f. Note that U.S. Federal Indemnity requires coverage in U.S. dollars at a set value with no provision for fluctuation in market valuation or currency devaluation. Other government's indemnity programs may differ in this regard.

 g. Provision for covering insurance of the deductibles and any excess.

 h. Description of commercial coverage to be sought in lieu of indemnity.

 i. Provision for sending insurance certificate to Lenders.

 j. Indication that Lenders preferring their own insurance will have borrowers as additional insured or waive subrogation against borrowing institution(s) as referenced in the loan agreements.

 k. Indication of how Lender insurance premium will be paid.

12. Preservation/installation/dismantling:

 a. Borrowers promise to use best efforts to protect exhibition from damage and loss while in custody.

 b. No conservation treatment will be undertaken without approval of lenders.

 c. Request special instruction for handling, care, and installation be provided in loan agreements.

 d. Installation of the exhibit; design concept and selected site will be organizer's and participants' full responsibility and privilege.

 e. Participant exhibitors may omit objects from showings for good cause with prior knowledge of Lender.

 f. Allowance for couriers or Lender representatives to be present at unpacking and installation.

 g. Provision for security alarms and guards for exhibit areas.

13. Catalog:

 a. Designation of curatorial staff or outside contractor responsible for editing, designing, writing, and/or translating catalog.

 b. Indication of where catalog will be produced.

Continued on next page

Figure VIII.5 continued

 c. Number of catalogs in order and suggested price.

 d. Foreign language editions and provisions for translation.

 e. Banner, poster, cards, and artifact reproductions.

 f. Reproduction permission: provision for resolving copyright problems and paying royalties or reproduction fees.

14. Publicity (may need interim agreement on this point to cover negotiation period):

 a. Control of the labelling, press release, promotion, public service TV film, photographs, etc.

 b. Credit lines for sponsors (corporate and/or government).

 c. Allowance for review of press release(s) in advance by organizer and borrower.

 d. Opening invitation and reception.

 e. Obtain and retain copies of all publicity.

15. Provision for who, how, and when photography to be allowed.

16. Statement on admission fees.

17. Indication of any extra material to travel with exhibit such as exhibit cases, graphics, panels, other hardware and responsibility for returning. Require careful documentation of all such material throughout exhibition.

18. Dispersal—primary borrower (organizer) will be responsible?

19. Sharing of costs and revenues.

20. Timetable for completion of various portions of project.

21. Agreement to cooperate and resolve mutual problems—modifications of agreement can be made in writing.

22. Provision for sharing cost should exhibit be subject to early cancellation.

23. Flow-chart or similar diagram showing major decision-makers and lines of authority.

24. Both parties sign.

Objects Left in the Temporary Custody of the Museum

A. Objects in Temporary Custody as Distinguished from Loans

Valid distinctions can be made between those objects loaned to a museum for exhibition and/or for research and those objects deposited with a museum for identification, authentication, examination for purchase, and the like. The first type of objects are invariably sought out by the museum, and subsequent loans benefit both museum and lender. The second classification covers objects left with the museum on the initiative of the owner in order to accomplish an objective of particular interest to the owner. Both situations result in bailments, but the form of the bailment can vary. As explained in the chapter on loans, when a bailment is for the mutual benefit of the parties, the bailee (museum) is held to a higher standard of care than when the bailment is for the benefit of the owner only. A museum, therefore, can justify having a different liability agreement with those who leave objects for their own benefit. Frequently, such an agreement is called "a temporary custody receipt," to be distinguished from the traditional loan.[1]

1. In some instances, questions can arise as to whether a temporary custody receipt or an incoming loan agreement is in order. For example, if someone offers to donate an object to the museum and the museum wants to have the object in hand for a period of time in order to make a decision on whether to accept, then a short-term, incoming loan agreement may be more appropriate. The justification would be that the museum is requesting a period of custody for its own purposes and that, hence, it should provide the owner with insurance coverage. Common sense should be the guide.

The temporary custody receipt may state that the bailment is for the benefit of the owner and that the museum is responsible only for gross negligence, or the receipt may notify the owner that although reasonable care will be used, safety is not guaranteed and no insurance will be carried. Either statement, or variations thereof, should put the owner on notice that the museum, with cause, is limiting its liability regarding the deposited material. Such statements probably will not absolve a museum from liability if there is clear-cut evidence of obvious negligence, but they should afford some protection against weak claims or situations in which misfortune rather than negligence is the cause of damage to or loss of the deposited material.[2] A museum may prudently decide that it will not individually insure objects left for the benefit of owners because of the more limited risk exposure. However, such a decision should be made only after it is clear whether other insurance carried by the museum may come into play in cases of obvious negligence and/or whether the museum, within limits, can self-insure.

Another distinction that can be made between true loans and objects left for the benefit of owners is that frequently the second category of objects should be processed expeditiously in order to limit expense and liability exposure. Experience demonstrates that unsolicited objects have a greater chance of becoming lost or forgotten if they are not given immediate attention. Time spent searching for such objects and their owners, or trying to recall promises made, is costly. Therefore, a museum should devise and follow a system designed to monitor the flow of such material.

B. Temporary Custody Procedures

Every collection-type object that comes into a museum should be a matter of record. Accessioning procedures provide a system of immediate notation of objects known to be destined for the collections, and a similar recording system is invariably in place for incoming loans. The use of a temporary custody receipt provides the catchall for recording those objects that, when received, fall into neither the "to be accessioned" nor the true incoming loan category. To be effective, the temporary custody receipt system needs central coordination with established procedures for the issuance of receipts and for the filing and timely follow-up of all such receipts.

A museum can find itself overwhelmed with material deposited for identification and other assorted purposes unless the museum's collection management policy contains guidelines regarding what and when objects can be taken into custody for the benefit of owners. For example, a museum may find that its liability exposure is greatly reduced if instead of accepting objects on deposit for identification, it sets aside certain times when objects can be brought in for immediate viewing by museum staff. These articles never leave the cus-

2. See Chapter VI, Section A, "Incoming Loans," regarding the ability to limit liability, and Chapter VI, footnote 3, regarding the definition of "gross negligence."

tody of their owners, and only oral opinions are given.[3] This, then, may become the general rule, with exceptions made only for unusual situations. If, on the other hand, a museum generally permits objects to be placed in custody, its collection management policy should have a system for alleviating backlogs. If too many objects are accumulating, perhaps the museum should establish a mechanism for instituting a moratorium on the acceptance of additional objects until the backlog is reduced to a manageable level. The museum should not encourage problems by taking in objects when prompt attention cannot be given to them. The museum's collection management policy also should stipulate who has the authority to approve the issuance of temporary custody receipts.

How an object is received should be a matter of record. For example, if an unsolicited object is mailed to a museum, its method of delivery may be an important piece of information in weighing museum liability if the owner later claims negligence.[4] If the temporary custody receipt form has a space for describing mode of delivery, this information is captured. Ideally, unsolicited objects mailed to a museum should be returned immediately with or without the requested information, or a temporary deposit receipt should be mailed for signature. By definition, the ideal is not the reality.

Another important consideration is the establishment of a maximum duration period for the temporary custody receipt. Every such receipt, when issued, should have a clearly specified termination date so that owner and museum staff are aware that a return date must be met. This encourages prompt processing by the museum, and it establishes a time for the bailment to end, which can be important if the owner fails to retrieve the property. Although staff may be given some discretion in setting the term of a custody receipt, a museum-wide maximum term should be established, one that cannot be exceeded without special permission. Ninety days is the maximum period used by some museums, but each museum can tailor the period to suit its own capabilities and needs.

The temporary custody receipt form may also address certain other topics that can prove troublesome if not explained in advance. Some museums have found, to their dismay, that owners who have temporarily deposited objects have then misused museum custody for personal gain. For instance, a temporary custody receipt usually requires the owner to describe briefly the object and its value. Owners have been known later to tout the attribution and/or valuation as "museum endorsed," merely because the information was accepted by the museum without comment. Another example is the owner who drops off an object at Museum X for possible sale. If there is no sale, the object is then offered elsewhere, with the owner noting that it was once on loan to Museum X. Cautions against such misuse can

3. See Chapter XIII, "Appraisals and Authentications," for other problems pertaining to an authentication service.

4. It may legitimately be argued that when a museum receives, through the mail, unsolicited objects for identification or similar reasons, a constructive bailment is created. In a constructive bailment, the law implies a bailment even though there is no mutual consent between the parties, but the unconsenting bailee is usually held to a low standard of care. If the museum consents to the bailment by issuing a temporary custody receipt, a slightly higher standard of care is generally expected.

be included in the list of conditions that frequently appear on the back of the temporary custody receipt form.

If the museum wants to have the right to photograph such objects or to examine them by generally accepted methods, this should be noted on the form. The form can also explain how this information will be used. As with incoming loans, a museum avoids restoring, treating, or otherwise altering objects left in its temporary custody unless the written permission of owners has been obtained. It may be prudent for a museum to note this particular policy on the receipt form.

If the temporary custody receipt is used occasionally for objects that are being offered to the museum for donation or sale, the museum may want to have the owner warrant, at this stage, his or her ability to pass good title. By including such a provision in the custody receipt, the owner is put on early notice that proof of title is important, and possible difficulties in this area can then be resolved before internal museum review procedures are set in motion.

C. Return Provisions

Two major purposes in establishing a temporary custody receipt procedure are to ensure the prompt return of objects to their owners and, if return cannot be made, to prevent museum storage areas from becoming cluttered with unclaimed objects. As with incoming loans, these purposes cannot be accomplished effectively unless certain precautions are taken when the objects are received. The temporary custody receipt form should require the owner to specify exactly what method should be used to return the object when the period of custody ends. It should also describe the steps the museum will take if the object cannot be returned after reasonable efforts are made. Finally, the form can provide that an unrestricted gift of the object to the museum will be inferred if the object is not claimed after a specified holding period. Both Chapter VII and Section A(9) ("Return Provisions") in Chapter VI should be reviewed for an understanding of why these provisions may prove important to the museum. Section A(8) ("Change in Ownership") in Chapter VI also is relevant when a museum is designing its temporary custody receipt form.

D. Sample Temporary Custody Receipt Form

The sample temporary custody receipt form (see Figure IX.1), like any other form, should not be adopted without question by a museum. Before any form is used, every provision should be understood by staff and judged appropriate. If there is uncertainty, professional advice should be sought.

Figure IX.1

Sample Temporary Custody Receipt Form

Registrar's No. _____

<div align="center">

NAME OF MUSEUM

ADDRESS

TEMPORARY CUSTODY RECEIPT

</div>

The object(s) listed below are received subject to the CONDITIONS printed on the reverse.

Received from: _____
<div align="center">*(name and address of depositor)*</div>

_____ Phone: (_____) _____

For the following purpose:

Removal date is: _____ (Unless otherwise mutually agreed on, the object(s) shall not remain in custody for a period to exceed _____ days. See CONDITIONS on reverse.)

Return of Object(s)
[] will be picked up by depositor
[] Museum will send by _____ to this address: _____

Packing and shipping to be paid by [] Depositor [] Museum.

Description of Object(s): Depositor's Valuation
(include condition)

Curatorial Unit: _____
Date received: _____ Signed: _____
<div align="center">(over)</div>

Museum Control No. _____

<div align="center">COPY DESIGNATION</div>

Continued on next page

Figure IX.1 continued

<div align="center">CONDITIONS</div>

(1) The objects are accepted by the Museum for the benefit of the depositor and the Museum assumes no responsibility except the avoidance of gross negligence. The depositor hereby agrees to release and hold harmless the Museum, its employees, officers, and agents from any liability in connection with the objects while on deposit or in transit except for clear gross negligence.

(2) Insurance of the objects is the responsibility of the depositor.

(3) Attributions, dates, and other information shown on the face are as given by the depositor. They are not to be construed as endorsed by the Museum. The fact that objects have been in the Museum's custody shall not be misused to indicate Museum endorsement.

(4) Objects may be photographed and examined by modern scientific methods by the Museum for its own purposes, but will not be restored, treated, or otherwise altered without written permission of the depositor.

(5) In forwarding imported objects for deposit, the depositor is required to comply with all government regulations.

(6) If there is a change in the identity and/or address of the depositor or the owner, the Museum must be notified promptly in writing. Objects must be claimed on or before the removal date noted on the face of the Receipt. If one other than the original depositor claims objects, the Museum reserves the right to request proof of legal authority to receive the material before objects will be released.

(7) If objects are to be returned to the depositor by mail or other carrier, the depositor will be sent an Outgoing Receipt at time of shipment. Failure to sign and return said Receipt within 30 days of shipment of said objects shall release the Museum from any further liability for the deposited property.

(8) If the depositor of record fails to collect the objects or if delivery cannot be effected after the removal date, the Museum will mail the depositor at its address of record a warning to remove. The Museum assumes no responsibility to search for a depositor (or listed owner) not located at the address of record. If after _____ years from the removal date noted on the face of this Receipt objects have not been claimed, then, and in consideration for their maintenance and safekeeping during such period, the objects shall be considered unrestricted gifts to the Museum.

(9) In the event the objects are being offered for sale or donation to the Museum, the depositor, warrants that he/she upon request is prepared to establish that full and clear title to the objects can be passed to the Museum.

(10) This agreement shall be construed in accordance with the laws of _____ [name of applicable jurisdiction].

I have read and agree to the above CONDITIONS, and I certify that I have full authority to agree thereto.

Date: _____ Signed: _____ [Depositor*]

*If Depositor is not the owner, complete the following:

Name of owner: _____
Address of owner: _____

Objects Found in the Collections

A. The Problem
B. When Claims Are Made
C. When the Museum Wants to Dispose of Objects Found in the Collections

A. The Problem

The phrase "objects found in the collections" is frequently used in the museum profession to describe items that lack any significant documentation as to how they were added to the collections. In other words, the museum knows that these objects have been in its possession for some time, yet if called on, it cannot prove ownership with certainty because it does not have definitive records. For the purposes of this discussion, the phrase does not include unclaimed loans, a subject discussed in Chapter VII. As a general rule, objects found in the collections are distinguishable from unclaimed loans. There is no evidence that objects found in the collections entered as loans, and their continued undisturbed possession by the museum usually supports a presumption of a valid initial transfer of ownership. This means that anyone disputing this presumption has the "burden of proof." (In simple language, the claimant must come forward with better proof of ownership than the museum.)[1] In the case of unclaimed loans, however, there was clearly no initial transfer of ownership to the museum, and if the museum hopes to retain the material, it has the burden of proving why the lender has lost the right to claim the property. In this latter case, the museum now has the more difficult task, and this makes a crucial difference.

 The fact that undocumented objects are fairly common in museum collections should come as no great surprise to anyone familiar with the history of museums. Many museums

1. If the objects at issue could be Native American, note especially the last paragraph of Section B, below.

were begun by public-spirited individuals operating with limited funds and/or without the help of well-trained support staff. (The museum registrar or the museum collection manager of today is a fairly recent addition to the professional ranks of the museum community.) If funds and staff for record-keeping were available, these systems were often quite personalized and hence lacked continuity. Also, the orderly preservation of records and the periodic checking of records against museum inventory are costly tasks that, realistically, do not gain priority if funds are short. We can easily understand, therefore, why museums, particularly those that were founded generations ago or that had very informal beginnings, now have undocumented objects in their collections. The problem is a cause of general concern, but it becomes more acute when a museum wants to dispose of such objects or when someone comes forward to claim one of the objects. What is the position of the museum?

B. When Claims Are Made

First, the museum should consider the status of the claimant. Normally, as previously explained, the burden of proving ownership rests on the claimant. In other words, to prevail, the claimant must show that only he or she has the right to bring the claim and then must prove the claim. Until this is done, the museum need not budge. To decide whether the claimant has the right to pursue the claim (i.e., has standing to bring the claim), the museum usually requires certain information from the claimant:

1. A clear explanation of why the claimant believes he or she holds title, with copies of supporting evidence
2. A statement from the claimant that he or she either is the sole party at interest or is authorized to represent all parties at interest, with supporting proof

Sometimes the second request can be a stumbling block for the claimant. If, for example, the claim is based on the allegation that the object in question was lent to the museum years ago by an ancestor, the claimant must show, by family records, relevant testamentary instruments, or other evidence, that he or she is the sole heir of that ancestor. If not the sole heir, the claimant must produce satisfactory proof that all other heirs have given him or her permission to represent them in the matter. Technically, if a claimant cannot produce satisfactory evidence of the sole right to make the claim (or evidence of the power to represent all claimants), the museum need not go further. However, it should (and, as appropriate, after seeking legal advice) inform the claimant in writing why it disputes his or her right to bring the claim.

When the precise nature of the claim is known and the claimant appears to have the right to make the demand, the museum will want to review its records with great care to see whether it can find evidence that supports or contradicts the claim and whether it has evi-

dence that will support a valid defense. The defenses that are most often used are the running of a statute of limitations, laches, and adverse possession. Each of these has been discussed in some detail in Chapter VII, "Unclaimed Loans." Essentially, to support a defense in claims of this nature, the museum looks for several kinds of evidence:

1. Evidence that the claimant knew, or should have known, the museum thought it owned the object and that the claimant delayed in bringing the action, to the detriment of the museum
2. Evidence that the claimant "slept on his or her rights," that is, failed to use due diligence in seeking out the property
3. Evidence that the museum has publicly displayed the object as its own or has otherwise publicized it as such (this type of evidence can affect items 1 and 2)

After relevant information has been gathered, the evaluation of a claim frequently should be done with professional advice. The museum also will want to review its general trust responsibilities regarding protection of trust assets, as described in Section C, "Requests for Return of Collection Objects," in Chapter V. It is to the museum's advantage to resolve a claim as soon as possible. If the claim is determined to be valid, a timely response creates goodwill. If the claim is determined to be unproven, a clear letter to this effect puts the claimant on notice and starts a statute of limitations running—a statute that limits the time in which the claimant can challenge in court the museum's rejection of the claim.

If there is legitimate doubt as to the validity of a claim or if the claim appears to be valid but there are several claimants and some are reluctant to see the object removed from public use, the museum might suggest an alternative. If the claimant or claimants are willing to give to the museum in writing every right, title, and interest they may have in the object, possibly there may be legitimate tax advantages for the claimants. In either case, the claimants relinquish a chance to win a judgment in court, and in effect, this chance to win is being donated to the museum. The value that can be placed on such a gift is a matter for resolution between the donor and the Internal Revenue Service. If such a quitclaim-type deed of gift is executed, the museum's title to the object should then be secure.

As explained in Chapter IV,[2] the Native American Graves Protection and Repatriation Act of 1990 (NAGPRA) addresses, as one of its concerns, the return to Native Americans of human remains and certain cultural objects from museum collections. If a museum receives a claim for the return of an undocumented object or human remains that could fall under the purview of NAGPRA, the first order of business is to determine whether NAGPRA applies. If it does, the claim should be processed under the procedures and presumptions set forth in that statute.

2. See Section D(6)(f) of Chapter IV.

C. When the Museum Wants to Dispose of Objects Found in the Collections

The disposal of objects of unconfirmed ownership presents risks. These risks should be understood so that informed decisions can be made when there is pressure to prune such objects from the collections. As explained in earlier chapters,[3] as a general rule, if a museum cannot successfully refute a third party's assertion and proof of ownership to an object, that object must be returned on demand. If the object is no longer in the possession of the museum because the object has been given away or sold and if the claimant pursues his or her interest against the present holder, the museum can expect repercussions.

If the museum sold the object to the present holder without reservations about title and if the holder subsequently must return the object to the true owner, the museum may be forced to pay the holder the value of the object as of the date of its return. This is because the Uniform Commercial Code[4] includes a general implied warranty that a seller conveys good title and because the code also provides that if a purchaser does not acquire good title, he or she can elect to claim against the seller damages equal to the present value of the object.[5]

A museum could attempt to protect itself from suit by a disappointed purchaser by selling an object and expressly not warranting title. Naturally, it then can expect that the purchase price will reflect this limitation. Another alternative is to state in the sale agreement that any recovery by the purchaser is limited to the sale price. Here again this provision may affect what the purchaser is willing to pay.

If the museum gives away an object of unconfirmed ownership, the Uniform Commercial Code should not be applicable (there was no sale), and if the present holder is ultimately forced to return the object, the holder may have no recourse against the donor-museum.[6] To sue the museum successfully, the holder, as a rule, would have to demonstrate that the holder was damaged because of the donation. However, if the true owner cannot retrieve the object from the present holder or if the object has been damaged, the museum may well find itself subject to suit.

When considering the disposal of objects of unconfirmed ownership, a museum can rarely deal in generalities. The facts of each particular case must be researched and weighed so that informed judgments can be made about the strength of the museum's position if there is a challenge, as well as about the potential risks. Additional factors that might be considered in such an analysis are as follows:

3. See Section D, "Circumstances That Can Affect the Quality of Title" in Chapter IV, "The Acquisition of Objects: Accessioning," and see Chapter VII, "Unclaimed Loans."

4. Section 2–231. See the discussion on the Uniform Commercial Code in Section D(3) of Chapter IV, "The Acquisition of Objects: Accessioning."

5. Section 2–714(2) of the Uniform Commercial Code. Consider also that in such a sale, there need not be an intervening third party. If the purchaser subsequently learns that title is faulty, he or she may elect to return the object to the seller and seek present-day value.

6. An exchange of objects would normally constitute a sale, not a gift.

- What is the value of the object in question? This bears on the extent of the potential liability. Value also may indicate whether a third party will ever seriously search out the item.[7]
- Is the object quite distinctive, so that it is readily identifiable? The more common the object, the more difficult it might be to establish ownership.
- Has the object ever been displayed publicly as property of the museum? In other words, if the museum has consistently and publicly held the object as its own, the museum has a greater chance of a valid defense if a third party later comes forward to claim it.[8]
- What is the proposed method of disposal, sale, or donation, and how urgent is the need? For instance, donating several large, relatively worthless objects to a charitable organization in order to gain desperately needed space should be easier to justify than selling small, costly objects in order to feed the museum's general acquisition fund.

All in all, there are no quick, easy answers to the problems raised by "objects found in the collections." However, if a museum can afford the time and the money required to research records carefully and to obtain the necessary professional advice, some ameliorating steps may be worth consideration.

7. However, certain objects have been known to increase in value dramatically because of changes in public taste. But in some situations, the objects will clearly never be of museum quality, and continued storage is a waste of resources. Here, after carefully documenting the nature of the objects and their determined value, the museum can dispose of the objects. If anyone should come forward to make a claim, the museum, because of its documentation (which, of course, it retains indefinitely), should be able to easily establish that nothing of value is at issue.

8. See prior discussions in Chapter VII, "Unclaimed Loans," on the defenses of statutes of limitations, laches, and adverse possession. But if NAGPRA applies (see Section B, above), these defenses may not be relevant.

Promised Gifts

A. Obstacles to Enforcement

If an object (or money) has been promised to a museum and if the gift is not completed, does the museum have any recourse? Enforcing such promises is usually difficult because of a lack of what is called "consideration." If all the elements of a valid gift (donative intent, delivery, and acceptance) cannot be established, then a promise, to be enforceable, must be shown to have the requisites for a valid contract. Contracts require a demonstration of "consideration" on the part of both parties:

To make a valid gift inter vivos [during life], there must be a clear intention to transfer title to the property, and also a delivery by the donor and an acceptance by the donee. It is essential to the validity of such a gift that the transfer of both possession and title shall be absolute and shall go into immediate effect. In other words, the donor must intend not only to deliver possession, but also to relinquish the right of dominion. If a gift has reference to future time when it is to operate as a transfer, it is only a promise without consideration, and cannot be enforced either at law or in equity.[1]

1. *Berman v. Leckner,* 193 Md. 117, 66 A.2d 392, 393 (1949). For court interpretations of these requirements, see *Hebrew University Assoc. v. Nye,* 26 Conn. Supp. 342, 223 A.2d 397 (1966), and *Gruen v. Gruen,* N.Y.L.J. (July 23, 1986).

To put this another way, for a valid gift one must have

1. evidence of intent to make a gift,
2. delivery by the donor with intent to pass title, and
3. acceptance by the donee (the museum).

If these elements have not taken place and if the donor is unwilling or unable (because of death or change of fortune, for example) to complete the gift, the donee (museum) has no legal cause of action unless it can prove that the issue is not just an incomplete gift but rather an unfulfilled contract. (A contract is enforceable; a promise of a simple gift, one without consideration, is not.)

To prove a contract, the donee (museum) must show

1. a definite promise,
2. an agreement between the parties as to what the promise is (a "meeting of the minds"), and
3. consideration on the part of both parties.

Consideration is "an act or forbearance or the promise thereof done or given by one party in return for the act or promise of another."[2] Both parties to a contract must proffer consideration. In the typical promised-gift situation, the prospective donor has already made a promise to act (the donor's consideration). So to argue that the gift situation is actually a contract, the donee (the museum) must show some form of consideration. Demonstrating this donee consideration is the most common challenge facing a museum that wants to enforce a promised gift.

Another frequent obstacle to enforcement of a promised gift is the statute of frauds. Most states have a statute requiring that certain kinds of understandings be in writing and be signed before a cause of action can be brought. These statutes are patterned on the old English statute of frauds—hence the common use of that name when referring to laws of this type. If the promise to donate to a museum has not been put in writing and signed, the promise may, quite possibly, run afoul of an applicable statute of frauds and thus may not be enforceable in court.[3]

B. Arguments for Enforcement

The enumerated obstacles are not insurmountable. Each case, however, must stand on its own merits, and the peculiarities of applicable state law must be researched. Two avenues frequently taken by the courts to uphold promised gifts are (1) finding consideration as demonstrated by the subsequent conduct of the promisee and (2) the doctrine of promissory

2. *Webster's Dictionary*, 3d ed.

3. See *Restatement (Second) of Contracts*, Chapter 4, for a listing of state statutes that qualify as statutes of frauds.

estoppel. Examples of these approaches are described below, but when these situations arise, the museum must research the law of the applicable jurisdiction. State courts can vary in the way they interpret these situations, with some giving the benefit of the doubt to the charity and others demanding more evidence to show donee consideration.[4]

A classic situation of the first type—finding consideration as demonstrated by the subsequent conduct of the promisee—was presented to a New York court in 1978.[5] A donor, a Mrs. Payson, had promised a large sum of money to a museum for the construction of an addition to the museum building. The museum understood that the pledge would be paid over a period of five years, but there was no written pledge agreement. Several substantial payments were made to the museum through the donor's bank, acting as agent. The donor died before all payments were due, and when the museum requested the balance of the pledged sum, the matter was taken to court by the donor's estate. The museum prevailed. In this particular case, the evidence demonstrated that on receiving the pledge, the museum initiated building construction. The court found that this liability incurred by the museums in reliance on the pledge constituted adequate consideration. In other words, when the museum took action to its detriment relying on the pledge, this reliance constituted consideration on the part of the donee. In other cases, courts have found reliance that constituted consideration when the donee promised to memorialize the gift with a plaque or borrowed money on the basis of the gift or agreed to comply with conditions placed on the gift.[6]

As mentioned, another reason given by some courts for enforcing charitable contributions is the doctrine of promissory estoppel. In such instances, there usually is evidence that the promisee took action as a result of a promise, that the action was known or should have been expected by the promisor, that the promisor failed to take reasonable steps to warn the promisee there would be no performance, and that under the existing circumstances, it would be an injustice to the promisee if the promise was not enforced. When these facts are present, a court may hold that as a matter of fairness, the promisor is estopped from raising such defenses as the statute of frauds or lack of consideration.[7]

Some experts argue that the use of the doctrine of promissory estoppel in such cases amounts to the application of the previously described "reliance" approach. In other words, there is only one theory, that of reliance.[8] A defense phrased as promissory estoppel may be particularly compelling, however, if the conduct of the promisor appears to be less than honorable. Consider, for example, the following situation. A frequent donor to the XYZ Museum of Technology lends the museum a very rare, recently acquired printing press,

4. Compare, for example, *Salsbury v. Northwestern Bell Telephone,* 221 N.W.2d 609 (Iowa 1974,) and *Floyd v. Christian Church Widows and Orphans Home,* 296 Ky. 196, 176 S.W.2d 125 (1943).

5. *In re Charles S. Payson,* File No. 177095 (N.Y. Sur. Ct., Nassau County, July 11, 1978).

6. See *Tioga County General Hospital v. Tidd,* 164 Misc. 273, 298 N.Y.S. 460 (1937); *In re Estate of Lipsky,* 45 Misc. 2d 320, 256 N.Y.S.2d 429 (1965); and *In re Estate of Couch,* 170 Neb. 518, 103 N.W.2d 274 (1960).

7. See W. Seavey, "Reliance upon Gratuitous Promises or Other Conduct," 64 *Harv. L. Rev.* 913 (1951); *Allegheny College v. National Chautauqua County Bank of Jamestown,* 246 N.Y. 369, 159 N.E. 173 (1927); *In re Field's Estate,* 11 Misc. 2d 427, 172 N.Y.S.2d 740 (1958); and *Restatement (Second) of Contracts* § 90.

8. See Corbin, *Contracts* § 204, and *Restatement (Second) of Contracts* § 90. See also *Greiner v. Greiner,* 131 Kan. 760, 293 P. 759 (1930).

saying that as soon as it is financially advantageous for him to do so, he will make a gift of the press. Museum staff spend much time, money, and effort in restoring, researching, and publicizing the piece.[9] The lender knows about these activities, and he never indicates that he may have changed his mind about the promised gift. As a result of the museum's efforts, the value of the press increases greatly. The lender then announces that he wants the press returned so that it can be sold. Because of the element of unjust enrichment to the promisor if a return is made, the defense of promissory estoppel may be quite effective. Also, this defense may entirely avoid the issue of the statute of frauds.[10]

Another situation that is not uncommon for a museum also may call into play the doctrine of promissory estoppel. A choice item is offered to the Hillandale Historical Society by Mrs. A, an elderly lady of limited means. Mrs. A offers to sell the item to the museum for a modest sum, explaining that she cannot afford to give it outright. Acquisition funds for the historical society are very low, and the director approaches Mr. Z, who has expressed an interest in helping the society. Mr. Z says he will be delighted to buy the piece from Mrs. A at the quoted price, place it on loan to the society, and then, when tax consequences are favorable, donate it to the society. Mr. Z buys the object and lends it, but he later demands its return, informing the society that no gift will be forthcoming. Possibly, the society can successfully refuse to return the piece, arguing that Mr. Z is estopped from enforcing a demand for its return.[11]

A case involving the papers of the poet W. H. Auden illustrates another situation, the "ambiguous delivery," which may have to be resolved when the issue is whether an enforceable gift has been made.[12] Auden bequeathed his entire estate to his friend, Chester Kallman. While Auden's estate was still in the process of being settled, Kallman arranged to have Auden's manuscripts and papers delivered from London to the New York Public Library. Several months after the delivery, Kallman died. When Kallman's estate requested the return of the manuscripts and papers, the New York Public Library refused, contending that a gift of the material had been made by Kallman to the library. As previously noted, the requirements for a completed inter vivos gift are intent of the donor to make such a gift, delivery of the property involved, and acceptance by the donee.[13] The burden of establishing each of these elements rests on the donee.[14] In the *Kallman* case, Kallman's estate conceded that the poet's papers had been delivered to the library but claimed that the papers had been transferred only for safekeeping and not with the intent to make an immediate gift. The library, not without difficulty, was able to convince the court otherwise.

9. The wisdom of such action might be questioned, but in some circumstances, such reliance by a museum is understandable.

10. See *Illinois Railway Museum v. Hansen*, No. 80, Ch. 229 (Ill. 19th Jud. Cir., McHenry County, Woodstock, Oct. 1980).

11. If it can be established that Mrs. A sold to Mr. Z at the reduced rate expressly so that the museum would ultimately benefit, possibly the museum also could sue as the third party beneficiary to enforce the contract between Mrs. A and Mr. Z.

12. *In re Estate of Kallman*, 103 Misc. 2d 339, 425 N.Y.S.2d 938 (1980).

13. Ibid., 940.

14. *In re Moffett's Estate*, 49 Misc. 2d 225, 266 N.Y.S.2d 989 (1966).

The "ambiguous delivery" can be a problem for museums because frequently objects are placed on loan and then later donated. The mere fact that an object is delivered to a museum does not, then, necessarily imply a contemporaneous intent to transfer title. Museums must promptly record the status of each object delivered, with appropriate documentation forwarded to the transferor. If objects are delivered on loan status with the understanding that the owner intends to make a gift at a later date,[15] this should be clarified in writing. If the promise is meant to be enforceable, this should be stated also, with mention of how the museum is relying on the promise.[16] In any event, the loan agreement should be specified for a relatively short period of time so that the situation can be monitored.[17]

Finally, there is the question of the statute of frauds—the requirement, in some states, that certain types of agreements be in writing in order to be enforceable. Here again, state courts can differ in how rigidly they enforce any such requirement. The earlier mentioned *Payson* case illustrates a liberal interpretation. New York, the state at issue, had a statute of frauds, but the promised gift had not been committed to writing. There was evidence, however, that the donor had signed papers that referred to the gift, and the court held this to be sufficient to satisfy the statute of frauds.

C. Determining the Strength of a Claim

If a museum finds itself with an unfulfilled promised gift and if the question is whether it can (not should) sue to enforce the gift, the following information on the law would have to be gathered before an informed opinion could be offered:

- Within the applicable jurisdiction, what is the law regarding what constitutes reasonable reliance on the part of a charitable donee?
- Within the applicable jurisdiction, what is the law regarding the doctrine of promissory estoppel?
- Within the applicable jurisdiction, what is the law regarding the statute of frauds?

The museum must also gather the following facts:

- What evidence is there of the promise?
 —written pledge or oral pledge?
 —witnesses?

15. Tax considerations frequently influence the timing of a gift.

16. For example, the museum may be giving up other gift opportunities in reliance on the promise, or it may be making certain commitments in expectation of the gift.

17. Fractional gifts, as described in Chapter XII, "Tax Considerations Relevant to Gifts," raise pledge-type problems. What happens if the donor dies or changes his or her mind before all portions of the gift pass? Such eventualities should be addressed in the initial agreement between the donor and the museum, with the inclusion of a binding pledge (the museum's consideration being reliance on the pledge) on the part of the donor to fulfill all segments of the gift agreement.

　　—publicity about the promise?

　　—donor's actions that support the promise?

• How has the museum relied on the promise?

　　—undertaken a costly project?

　　—used the promise to attract other donations?

　　—deferred taking action that would have benefited the museum?

　　—honored the promisor in a substantial manner?

　　—took action that benefited the promisor?

　　—took action reasonably related to the promise?

• What about the issue of fairness?

　　—Was the promisor aware of the reliance of the museum, or should he or she have been aware?

　　—Would it be clearly unfair to the museum if the promise was not enforced?

As a general rule, the estate of a promisor usually honors a promise if, under state law, the promise would be considered enforceable if the promisor had lived. Also, as a general rule, the Internal Revenue Service allows the estate to deduct such a donation when it is established that the law of the state in question would consider the promise enforceable.[18]

D. Should a Museum Sue to Enforce a Gift?

Assuming a museum has substantial evidence to support court action to enforce a promised gift, there is a second question: Should the museum sue? There are strong differences of opinion here. On one side are the arguments that such action frightens away other donors, that it can poison relations with a family that long supported the museum, and that such a lawsuit could generate all types of publicity over which the museum would have little control. On the other side are the arguments that the museum has an obligation to its own beneficiaries to pursue a legitimate claim, that being hesitant to sue only encourages less altruistic relatives to look for ways to thwart promised gifts, and that often such a suit benefits the promisor, who may be no longer capable, because of illness or death, to insist on the execution of his or her wishes.[19] There is no simple answer. If faced with this question, a

18. For more detailed discussions, see C. Clark, "Promised Gifts and Partial Gifts: Guidelines for Negotiation and Administration," in American Law Institute–American Bar Association (ALI-ABA), *Course of Studies Materials: Legal Problems of Museum Administration* (Philadelphia: ALI-ABA, 1989); J. Teichman, "The Enforceability of Pledges and Other Pitfalls of Fundraising," in American Law Institute–American Bar Association (ALI-ABA), *Course of Studies Materials: Legal Problems of Museum Administration* (Philadelphia: ALI-ABA, 1992); M. Budig et al., "Pledges to Non-Profit Organizations: Are They Enforceable and Must They Be Enforced?" *Program on Philanthropy and the Law* (New York: N.Y.U. School of Law, 1993). Also worth investigating is the current position of the Financial Accounting Standards Board (FASB) on the issue of how charitable organizations such as museums should report promised gifts on their financial statements. Standards promulgated by the FASB are followed by the American Institute of Certified Public Accountants.

19. The March 9, 1995, issue of *Chronicle of Philanthropy* featured a series of articles on the topic of charities that were suing to enforce gifts. See also "Is Suing for Unfulfilled Pledges Worth the Cost and Publicity?" 10

museum should give it serious thought and be able to document that proper authorities within the museum informed themselves on the issues, discussed the matter, and came to a decision. Even though not everyone may agree with the final determination, evidence that care was taken in arriving at the decision preserves the integrity of the organization.

As a general rule, courts in this country tend to favor the enforcement of charitable gifts. "American courts have traditionally favored charitable subscription . . . and have found consideration in many cases where the element of exchange was doubtful or nonexistent. Where recovery is rested on reliance in such cases, a probability of reliance is enough, and no effort is made to sort out mixed motives or to consider whether partial enforcement would be appropriate."[20]

Over the last decade or so, some signs, at least in the popular press, indicate more skepticism on the part of the public about the fund-raising approaches used by some nonprofits. This skepticism could be attributed to a variety of things: the increased use of professional fund-raisers, with far less direct involvement of board members and staff; the use of highly sophisticated methods to target and research potential donors; the wide media coverage of news stories that reflect unfavorably on the activities of some charitable organizations; and the general proliferation of charitable appeals—just to name a few possible causes. If this trend of skepticism persists, it may soon be felt in the courts, and charities seeking to have their gifts enforced may not enjoy the benefit of the doubt. They will face judges and juries that demand more convincing levels of proof.

E. Pledge Forms

Years ago, after deciding in favor of a museum in an action seeking to enforce an unwritten promised gift, the court made this observation: "The loss of litigation by donors' estates should be of no solace to charitable donees for such litigation, caused by inexcusable casualness, may cause less charitable gift-giving by others. These proceedings would not have been necessary if the Museum had followed reasonably prudent business methods and had the decedent sign a simple pledge form."[21]

Today, with the public even more skeptical, this warning cannot be ignored. Properly executed, written memoranda of gift arrangements can save time, tempers, and needless expenditures on legal fees. A museum is advised to prepare a pledge form with professional assistance and to use, whether the gift is money or objects, appropriate pledge forms that spell out the intentions of all parties.[22] Forms can be drafted for both nonbinding pledges

Tax Exempt News (No. 11, Nov. 1988) and "Pledges to Nonprofit Organizations: Are They Enforceable and Must They Be Enforced?" (a symposium), 27 *U.S.F. L. Rev.* 47 (1991).

20. *Restatement (Second) of Contracts* § 90.

21. See *In re Charles S. Payson*, File No. 177095, at 11 (N.Y. Sur. Ct., Nassau County, July 11, 1978).

22. State laws can vary not only on the interpretation of pledge language but also on the form (witnesses? notary used?) for a valid pledge instrument.

and binding pledges, so a first consideration for a museum is to determine its policies regarding the use of either or both types of arrangements.

Examples of pledge forms follow (see Figure XI.1). Like all other such examples, these should not be adopted for use by a museum without careful, professional review.

Figure XI.1

Pledge Forms

EXAMPLE OF A PLEDGE INTENDED TO BE BINDING

I hereby pledge to give to the _____
(hereinafter "the Museum") at or prior to my death, absolute and unconditional ownership of the following objects, together with all copyright and associated rights which I have:

I wish that the gift be identified in the permanent records of the Museum as:

Gift of _____

This pledge shall extend to and be binding upon my executor, administrator, heirs, and assigns. Should this gift not be completed during my lifetime, my failure to include a specific bequest of the objects to the Museum in my Will shall not release the executor or administrator of such Will from the obligation of delivering the objects to the Museum in accordance herewith.

As I believe that a definite commitment to make this gift will be of great value to the Museum, I agree that the Museum may publicly refer to this gift prior to its delivery, as a gift promised by me, that the Museum may act in reliance on this pledge, and that the pledge may be made known to the public in the course of soliciting gifts from others.

To the best of my belief, the subject of this pledge is free and clear of all encumbrances and restrictions and since _____ has not been imported or exported into or from any country contrary to its laws.[a]

This agreement shall be governed by the laws of the state of _____.

Date: _____ Signature of Donor: _____
Address of Donor: _____

I certify that this pledge agreement was accepted by the proper authority of the Museum and that it correctly states the agreement between us.

Signature of Museum Official: _____

Author's Note:

[a]Optional paragraph to be used when subject of the gift may fall within the museum's policy on illegally excavated or exported objects.

Continued on next page

Figure XI.1 continued

EXAMPLE OF A PLEDGE INTENDED TO BE NONBINDING

I hereby pledge to give to the _____
(hereinafter "the Museum") at or before _____
absolute and unconditional ownership of the following objects, together with all copyrights and associated rights which I have:

I wish that the gift be identified in the permanent records of the Museum as _____
_____.

To the best of my belief, the subject of the pledge is free and clear of all encumbrances and restrictions and since _____ has not been imported or exported into or from any country contrary to its laws.[a]

It is mutually understood that this pledge is not binding, that it may be revoked at any time by the pledgor, and that it is not enforceable on and after the death of the pledgor.

This agreement shall be governed by the laws of the state of _____.

Date: _____ Signature of Donor: _____
Address of Donor: _____

I certify that this pledge agreement was accepted by the proper authority of the Museum and that it correctly states the agreement between us.

Signature of Museum Official: _____

Author's Note:

[a]Optional paragraph to be used when subject of the gift may fall within the museum's policy on illegally excavated or exported objects.

Tax Considerations Relevant to Gifts

A. The Tax Status of the Donee-Museum

No member of a museum's staff should attempt to play the role of a tax adviser to donors or prospective donors. Nevertheless, a general understanding of the tax consequences of charitable gifts is necessary if the museum expects to act intelligently and with integrity when matters of this nature are at issue.[1] In some instances it is quite appropriate for the museum to suggest to a potential donor a possibly advantageous method of giving (with

1. See also Chapter IV, "The Acquisition of Objects: Accessioning," Section F, "Acquisition Procedures," regarding such issues as record-keeping for tax purposes and when a gift is complete for tax purposes. See Chapter II, "Museums Are Accountable to Whom?," Section E, "Oversight by Taxing Authorities," and Chapter XIII, "Appraisals and Authentications," Section A, "Appraisals."

the understanding that the donor will pursue this with his or her own advisers), just as on some occasions a museum should give a firm "No, thank you" to certain offers. Without some knowledge of the intricacies of the tax consequences of various gifts, a museum is hardly able to comport itself with any assurance. What follows, however, is only a basic outline of the most common gift situations and relevant federal tax law.[2]

In this discussion, it is assumed that the museum has requested and received a determination letter from the Internal Revenue Service (IRS) recognizing the museum as an exempt organization under § 501(c)(3) of the Internal Revenue Code.[3] Section 501(c)(3) provides an exemption from federal income taxes for organizations that are formed and operated exclusively for charitable (including educational) purposes.[4] If such organizations also can demonstrate that they receive a substantial part of their support from governmental units or from the general public, they qualify as "publicly supported" charities.[5] Under § 170(c) of the code, donors to such publicly supported charities receive the maximum possible deductions for their charitable contributions.

B. Income Tax Consequences of Charitable Gifts to "Publicly Supported" Museums

As a general rule, a charitable contribution must be reported in the year it is completed and at its full value. In addition, a donor is limited in the total amount of charitable contributions that can be deducted in any one year. The limit is a percentage of the donor's "adjusted gross income," as that term is defined in the Internal Revenue Code, and the limits differ depending on the type of property at issue, the time period that the donor owned the property, and the way the property is valued. The totals that an individual donor can deduct each year are, therefore, unique to his or her situation; thus, applicable rules are not discussed here. However, what is of interest to a donee organization is that even though these limits exist, a donor can legitimately "carry over" to future tax years major charitable donations that exceed the permissible limits in the current year. More is said about this in Section D, "Spreading Out Charitable Deductions."

2. For more comprehensive discussions of tax considerations, see Comment, "Tax Incentives for Support of the Arts: In Defense of the Charitable Deduction," 85 Dick. L. Rev. 663 (1981); IRS Publication 526, "Charitable Contributions"; and IRS Publication 561, "Determining the Value of Donated Property."

3. IRS Publication 557, "How to Apply for Recognition of Exemption for an Organization," should be consulted for instructions regarding application for exempt status.

4. Under IRS regulations, an organization will be regarded as "operated exclusively" for an exempt purpose if it engages "primarily" in activities that accomplish such purpose. Treasury Regulations 26 C.F.R. § 1–501(c)(3)-1(c)(1).

5. If a 501(c)(3) organization such as a museum cannot demonstrate "publicly supported" status (by one of several tests), it is treated as a private foundation. A private foundation is subject to special record-keeping and reporting requirements, is restricted in its dealings with certain organizations and individuals, and offers less-favorable tax benefits to its donors.

Regarding the "value" placed on gifts to charitable organizations, the following basic rules should be kept in mind.

Cash. For purposes of a charitable contribution deduction, a gift of cash is valued at its dollar amount. There is an exception to this rule, however, when the donor could receive or does receive something of substantial value in return for the gift. This exception is explained in Section F, "Premiums or Benefits Associated with Gifts and Substantiation of Gifts."

Capital Gain Property. Capital gain property is property that is held by the donor usually for more than one year (but consult current law, since the time period can vary) and that, if sold at fair market value on the date of contribution, would result in long-term capital gain.[6] Most gifts of tangible personal property that are given to museums qualify as capital assets and, as a rule, can be valued at their "fair market value" for charitable contribution purposes. Fair market value is defined by the IRS as "the price that property would sell for on the open market. It is the price that would be agreed on between a willing buyer and a willing seller, with neither being required to act, and both having reasonable knowledge of the relevant facts."[7] However, there are some exceptions to the general rule of valuing gifts of capital assets at fair market value. One concerns restrictions that may have been placed on the gift. If the restrictions are such that they would impact on "fair market value," as that term is defined, then the value placed on the gift has to reflect these restrictions.[8] Another exception, the unrelated use exception, frequently applies to museums. A fair market value deduction for a gift of capital gain property is allowed only if the property will be used by the museum for a purpose "related to" its educational purposes.[9]

Ordinary Income Property. Ordinary income property is property that, if sold at fair market value on the date of contribution, would result in ordinary income or in short-term capital gain. The value of a gift of ordinary income property for purposes of the charitable deduc-

6. In 1997, the holding period to turn short-term capital gain into long-term capital gain is one year. This period is adjusted occasionally by legislation, so current law should be checked.

7. See IRS Publication 561, "Determining the Value of Donated Property," 2. For a general discussion of perceived or real abuses of the charitable contribution deduction, see J. Lyon, "Charitable Contributions of Appreciated Property: A Perspective," in American Law Institute–American Bar Association (ALI-ABA), *Course of Studies Materials: Legal Problems of Museum Administration* (Philadelphia: ALI-ABA, 1987). For information regarding the valuation of unique objects, see N. Ward, "What Is Fair Market Value and How Is It Established?" in American Law Institute–American Bar Association (ALI-ABA), *Course of Studies Materials: Legal Problems of Museum Administration* (Philadelphia: ALI-ABA, 1986); P. Geolat, "Valuation of Natural History and Other 'Non-Art' Objects for Charitable Deduction Purposes," in American Law Institute–American Bar Association (ALI-ABA), *Course of Studies Materials: Legal Problems of Museum Administration* (Philadelphia: ALI-ABA, 1990); and N. Ward, "Valuation of Natural History and Other 'Non-Art' Objects for Charitable Deduction Purposes," in American Law Institute–American Bar Association (ALI-ABA), *Course of Studies Materials: Legal Problems of Museum Administration* (Philadelphia: ALI-ABA, 1990).

8. IRS Publication 561, "Determining the Value of Donated Property," 2. On the somewhat related issue of whether there are conditions that affect the "delivery" of the gift, see Chapter IV, Section F(4), "Special Tax Considerations."

9. The "related use" restriction applies to gifts for which an income tax charitable contribution deduction is taken. There is no similar restriction on estate tax charitable contribution deductions except for § 2055(e)(4) of the Internal Revenue Code, which applies to bequests of property with copyright ramifications.

tion is the fair market value of the gift less the amount that would be ordinary income or short-term capital gain if the property was sold for the fair market value. In essence, this amounts to what the donor actually paid for the property. Examples of ordinary income property most frequently donated to museums include works of art created by the donor, manuscripts prepared by the donor, and capital gain property held by the donor for less than the period prescribed for long-term capital gain.[10]

C. Concept of "Unrelated Use"

As defined by the IRS, the term "unrelated use" is a "use which is unrelated to the purpose or function constituting the basis of the charitable organization's exemption under § 501 of the Internal Revenue Code."[11] Clearly, therefore, an object accepted for a museum's collections or for use in one of its educational activities is designated for a related use, and the donor is entitled to a charitable contribution deduction at the fair market value. Similarly, if furnishings are contributed to a museum and are used by it in its offices and buildings in the course of carrying out its functions, this is a related use. However, if the museum intends to sell the donated objects—even though the proceeds of the sale are to be used to purchase objects for the collections—this is considered an unrelated use. If tangible personal property is given for an unrelated use, the donor's allowable deduction is substantially changed. In this case, the donor's allowable deduction is limited to the fair market value reduced by any amount that would have been long-term capital gain if the donor had sold the property for its fair market value. In other words, the tax consequences for a donor are usually much less favorable when the gift will be put to an "unrelated use" by the donee organization. The museum has a responsibility to inform the donor if it does not intend to use the offered property for a related use, so that the donor is not misled as to tax consequences. Museum records should show that this information was conveyed.[12]

One question is often asked by museum people: In order to avoid an unrelated use situation, how long must the museum hold a donated object before selling it? The only reasonable answer is that no object should be accepted as a "related use object" unless there is a good-faith intention at that time to put it to a related use for the indefinite future. In effect, the integrity of the individual empowered to accept the object is at stake. Within a year, five years, or ten years certain circumstances could make the sale of that object appropriate, but the records of the organization will confirm whether the original acceptance was made in good faith or not. Put another way, every museum is supposed to keep accurate records of when each object is accessioned and also of why and when, if ever, it is disposed of. If there is a pattern of "in, hold for a period, and out" or if the records do not support the

10. See Note, "Tax Treatment of Artists' Charitable Contributions," 89 *Yale L. J.* 144 (1979). Numerous bills have been introduced into Congress to give relief to artists and others who want to donate their own work to charity, but as of mid-1997, none have been enacted.

11. Regulations 26 C.F.R. § 1.170.A-4(b)(3). See also Code § 170(e)(1)(B).

12. See IRS Publication 526, "Charitable Contributions."

reasons given for disposal (more important gifts received in this area or a change in the overall focus of collecting, for example), then the integrity of the accepting authority is in question. Simply put, if staff members are aware of the IRS guidelines on "unrelated use" and if the rule in the museum is that meticulous collection records are to be maintained, serious problems in this area should not occur.[13]

Another frequent question concerns the appropriate handling of a group or collection of objects offered to a museum when probably only a portion of the objects will prove suitable for the collections. Assuming that the museum can justify accepting the entire offering, does the fact that some of it will not be put to a related use jeopardize the status of the entire gift? IRS regulations contain the following statement: "If a set or collection of items of tangible personal property is contributed to a charitable organization or governmental unit, the use of the set or collection is not an unrelated use if the donee sells or otherwise disposes of only an insubstantial portion of the set or collection."[14] Whether "insubstantial portion" refers to quantity, quality, or dollar value is not clear, but a commonsense decision by the museum based on the particular situation should not be so far off the mark as to cause concern.

D. Spreading Out Charitable Deductions

1. EXPLANATION

Although there is a limit to the amount of charitable deductions a donor can claim in a year, there is also a five-year carryover period. If a donor's allowable deductions for charitable gifts in one year exceed the permissible limits, based on his or her adjusted gross income for that year, the donor may deduct the excess in each of the five succeeding years until it is used up.[15] Thus, a donor, in effect, has six years in which to absorb the tax benefit of a substantial gift to charity.

Still, the six-year period may not be enough to take the full tax advantage of a major gift, or the donor may anticipate a substantial rise in the value of the gift in the years to come. In such cases, a fractional gift (also known as a partial gift) might be considered.[16] In a fractional gift situation, the donor gives the museum ownership in a portion of the property,

13. See also the comments in Section B(2)(e) of Chapter V, "The Disposal of Objects: Deaccessioning," which explains IRS notification requirements if certain gifts are transferred by a museum within two years of receipt.

14. 26 C.F.R. § 1.170.A-4(b)(3).

15. However, each year's maximum deduction must be utilized before there can be a carryover to the following year.

16. Tax considerations need not be the sole reason for using the fractional gift. Consider the following example. Mr. Y has a collection of gems that he would like to give to the local natural history museum. However, he is in the process of writing a treatise on gems, and for several years he will need periodic access to the collection. Through a fractional gift arrangement, the collection could be placed in the museum, with Mr. Y having the right to withdraw all or a portion for stated periods of time (reflecting the portion of ownership still retained) pending completion of the gift.

with (one hopes) the understanding that the remaining portion(s) will be given at a later date. Suppose, for instance, that Mrs. X has a very valuable collection of dolls and that she wants to give the collection to the local historical society. In her tax bracket, however, six years will be insufficient time for her to use up the allowable charitable deduction. Mrs. X can immediately give the historical society an undivided one-half interest in the collection, with the understanding that six years later she will convey the remaining one-half interest. The entire collection could be turned over to the historical society, with Mrs. X's one-half undivided interest held as a loan with an appropriate loan agreement in effect (an agreement that should allow her to recall the loan for half of the year at her option). Properly done, this arrangement would give Mrs. X twelve years to absorb the tax benefits of her gift. The fractional gift can be a single item or a group of items.

Fractional gifts should be prepared with expert assistance so that IRS criteria are met and eventualities are provided for in writing. For tax purposes, each party should at least have the right (even though the right need not be exercised) to possess the property for a portion of the year that is equal to the undivided interest then owned by the party.[17] Another important consideration is assurance that the gift will be completed. The museum, for example, does not want to find itself one day holding an undivided fractional interest in an object with the remaining fractional interest shared by numerous heirs of a deceased donor. Legal counsel should be consulted about the appropriate language to secure to the museum the passage of any remainder interest under the donor's will and/or the advisability of asking the donor to execute a binding pledge to convey any remainder interest.[18] Such decisions are best made with a knowledge of the law of the state that will apply. Other questions concern practical considerations: How will the object be insured? If the property is to move between fractional owners, who is responsible for costs and transportation arrangements? How are decisions made regarding conservation work, loans to third parties, reproduction rights?[19]

2. SAMPLE DEEDS OF PARTIAL GIFT

Two samples of instruments designed to convey a fractional interest in a gift are shown here (see Figure XII.1). Like all other sample forms, these should not be adopted by a museum without independent review by competent professionals. Also, state laws vary regarding the formalities (notary seal, for example) needed to produce a binding deed of gift executed within a particular jurisdiction. State formalities should be checked by local legal counsel.

17. See IRS Code 170(f)(3)(b)(ii) and *Winokur v. Commissioner,* 90 T.C. 733 (1988).

18. See the discussion of promised gifts in Chapter XI.

19. See M. Shaines, "Partial Gifts: When Half a Loaf Is Better Than None," *Museum News* 68 (July–Aug. 1991); C. Clark, "Promised Gifts and Partial Gifts: Guidelines for Negotiation and Administration," in American Law Institute–American Bar Association (ALI-ABA), *Course of Studies Materials: Legal Problems of Museum Administration* (Philadelphia: ALI-ABA, 1989); F. Feldman and S. Weil, *Art Law* (Boston: Little Brown, 1986, supp. 1993), § 13.8.1; P. Jessup, "Partial Gifts to Museums," in American Law Institute–American Bar Association (ALI-ABA), *Course of Studies Materials: Legal Problems of Museum Administration* (Philadelphia: ALI-ABA, 1995).

Figure XII.1

Sample Deeds of Partial Gift Forms

SAMPLE FORM 1

_____ **Museum**

Partial Interest Deed of Gift

I hereby give, assign and transfer to the ____ Museum (hereafter "the Museum"), an undivided ____% right, title and interest, together with an equal percentage of copyright[a] and associated interests which I may have, in the following works as an absolute and unrestricted gift:

TITLE OF WORK ARTIST

I wish that this gift be identified to the public and in the permanent records of the Museum as:

Gift of _____

By virtue of this and previous gifts by me, the Museum is now the owner of an undivided ____% interest in the property, and the Museum shall be entitled to possession, dominion and control of these works of art for that number of months during each calendar year which the interest owned by the Museum bears to the entire interest, and during the remainder of the year I shall be entitled to the possession, dominion and control of these works of art.

I intend to give further fractional interests in these works of art from time to time with the expectation that the Museum will eventually be the sole owner, it being my intention that the remaining interest in these works of art shall pass to the Museum through lifetime gifts or through a bequest. In the event my Will should fail to make a specific provision to this effect, I hope that my executors and heirs will be able to take such steps as may be necessary to complete my gift.

When the works of art are in my possession, I will carry insurance in an amount sufficient to protect me and the Museum against physical loss or damage to the works of art, and will cause the insurer to furnish the Museum with evidence of such insurance. When the works of art are in the Museum's possession, the Museum will provide insurance in an amount sufficient to protect me and the Museum against physical loss or damage to the works of art under its Fine Arts Insurance Policy.

Further, the cost of packing and delivering these works of art to me or to the Museum, pursuant to the terms and conditions of this instrument, shall be paid by me.

I understand that the Museum will not sell or partition its partial interest without my consent, and I agree I will not sell or partition my partial interest without the Museum's consent.

Continued on next page

Figure XII.1 continued

> If the art is owned by more than one person, the signatures below shall indicate joint and several obligations of the owners to this pledge for their respective interests in the art.
>
> Date: _____ Signature of Donor: _____
>
> Date: _____ Signature of Donor: _____
>
> Address of Donor: _____
> _____
>
> ACCEPTED:
> The _____ Museum
> By: _____
> Title _____
>
> I certify that this deed of gift was presented to the authority empowered to accept such gifts for the museum on _____ and was duly accepted.
>
> Signed: _____
> Title _____

Author's Note:

[a]See Chapter IV, Section E(2), "Copyright Considerations," which addresses issues relating to the language used to transfer copyrights. Note also the language regarding copyright used in the various sample deeds of gift printed in Chapter IV. When a fractional (partial) gift is at issue, a museum may want to consult its legal counsel regarding the appropriate wording to describe accurately what copyright interests are passing.

SAMPLE FORM 2

> ### Partial Interest Deed of Gift to the _____ **Museum**
>
> On this the _____ day of _____, 199__, I/we,
> _____, hereby give to the _____ Museum
> ("the Museum") absolute and unconditional ownership of an undivided _____
> percent of my/our right, title and interest in the "_____" by _____
> ("the work") together with all copyright[a] and associated rights which I/we have therein. The Museum shall be entitled to possession of the work for a total of _____ days out of each calendar year. The undersigned shall be entitled to possession of the work for the balance of each calendar year.
>
> To the best of my/our belief, the work is free and clear of all encumbrances and restrictions and since _____ has not been imported or exported into or from any country contrary to its laws.[b]
>
> I/we wish that the work be identified in the permanent records of the Museum, and when on exhibition, as a partial and promised gift of _____.

Figure XII.1 continued

I/we hereby promise to give the balance of my/our remaining _____ percent right, title and interest in the work to the Museum not later than by bequest in my/our last will and testament. Until then, while the work is in my/our possession, I/we will make adequate provision for its care and security and will keep the Museum apprised of its location. The Museum will have the right to inspect the work periodically, at mutually agreeable times, to check on its condition.

It is my/our understanding that the Museum's insurance will cover the fraction of the work owned by the Museum while the work is in my/our possession and will cover the entire value of the work while the work is at the Museum and in transit to and from the Museum.

Before agreeing to lend the work or authorize its reproduction, I/we agree to notify the Museum of my/our intentions and to obtain its concurrence as co-owner of the work.

Date: _____ Signature of Donor: _____

Date: _____ Signature of Donor: _____

Address of Donor: _____

I certify that the above Deed of gift was accepted by the appropriate museum authority on

_____.

Signed: _____ Title _____

Author's Notes:

[a]See Chapter IV, Section E(2), "Copyright Considerations," which addresses issues relating to the language used to transfer copyrights. Note also the language regarding copyright used in the various sample deeds of gift printed in Chapter IV. When a fractional (partial) gift is at issue, a museum may want to consult its legal counsel regarding the appropriate wording to describe accurately what copyright interests are passing.

[b]This optional paragraph is used when the museum has an internal policy concerning illegally excavated or exported objects.

E. The Bargain Sale

A bargain sale (or donative sale) arrangement may be proposed by the owner of an object that is desired by a museum. Here the owner offers to sell the object to the museum for less than its fair market value because, in this way, the owner receives some remuneration plus a charitable contribution for the portion "given" to the museum.[20] Such an arrangement is legitimate if, in fact, it is a true "bargain sale." Although the burden of proving fair market value to the IRS rests with the donor, this is one instance in which it may be proper

20. For information on determining the tax consequences of a bargain sale, see IRS Publication 526 and "Other Dispositions" in Chapter 4 of IRS Publication 544.

for the museum to comment on the value of a donated object—by acknowledging in writing that it perceives it is purchasing the object at less than fair market value. Such an acknowledgment, which should not attempt to state or confirm a fair market value dollar figure, merely rebuts the normal presumption that the sale is an arm's-length transaction.

In handling a bargain sale, a museum should keep in mind the following points: (1) the museum should have written evidence that the owner has a donative intent in setting the sale price (that is, evidence that the donor is intentionally setting a low price); (2) the museum should make an informed judgment that the purchase price is significantly less than apparent fair market value; (3) the museum should not approve or appear to approve any dollar figure as constituting fair market value; and (4) clearly, the museum should not endorse or appear to endorse an inflated value in order to give the owner undeserved tax advantages. The prudent museum proceeds very cautiously if there appears to be inflated value, and at a certain point, a rather frank discussion with the owner may be in order before negotiations continue.

If the museum enters into the bargain sale, a standard deed of gift would not be used because title has passed by virtue of the contract of sale. It is appropriate, however, to note on the contract of sale and on accession records that the transaction is a bargain sale or donative sale. After payment has been made and the object received, usually a letter is sent to the seller acknowledging the museum's perception that the transaction was a bargain sale and expressing gratitude for the resulting "gift" to the museum. Also, in light of the gift element of the transaction, two additional factors need to be considered.

First, when the value of the gift portion of the bargain sale exceeds $5,000, IRS requirements concerning "qualified appraisals" (see Section A of Chapter XIII) are triggered, if the donor intends to seek a tax deduction. This means the museum will be required to complete a portion of the seller's IRS Form 8283, "Noncash Charitable Contributions," whereby the museum acknowledges receipt of the "gift" element of the transaction. (On Form 8283, the donor should have noted the receipt of the "sale price" from the museum.)

Second, when the value of the gift portion of the bargain sale exceeds $250, the museum must provide the seller with the receipt explained in Section F(2) of this chapter, in order to enable the seller to claim a charitable deduction.

F. Premiums or Benefits Associated with Gifts and Substantiation of Gifts

1. PREMIUMS OR BENEFITS

As noted in Section B of this chapter, the simple rule is that a gift of cash is valued at its dollar amount for purposes of a charitable contribution deduction. But human ingenuity allows few tax rules to remain simple for long.

As charitable organizations became more competitive and inventive in seeking support, their fund-raising endeavors entered the marketing age. No longer did the organizations issue simple pleas for funds; rather, prospective contributors were encouraged—by ever escalating offers of gifts, parties, or services—to join "friends" groups, to contribute money,

or to take part in charity auctions. As a result, many checks were being written to charities—and then reported as charitable contributions—when in fact the checks were buying valuable benefits.

The position of the IRS on the deductibility of payments made to charities conducting fund-raising events has long been as follows: "Only that portion of a charitable contribution which exceeds fair market value of a 'premium' or other substantial benefit given to the donor in exchange for a contribution is considered to be a gift and is therefore deductible."[21] Two corollary positions of the IRS are as follow:

- If a charitable contribution deduction is claimed for a payment to a charity and the payment carried with it some premium or other substantial benefit, the burden is on the taxpayer to establish that the amount paid is not the purchase price of the premium or other substantial benefit and that part of the payment, in fact, does qualify as a gift. (But note, as explained hereafter, that as of 1993, the charity now shares some of this burden.)
- The fact that the premium or other substantial benefit was not used by the taxpayer is not relevant. What is relevant is whether the taxpayer was entitled to receive something of substantial value in return.[22]

To cover themselves in this regard, charities, when issuing tickets or publicity regarding solicitations that carry benefits of some type, began a practice of adding the phrase "deductible to the extent provided by law." In fact, this statement helped the average taxpayer little because even if the taxpayer was aware of the relevant Internal Revenue Code provisions, he or she usually was poorly prepared to set a dollar value on the benefits offered. In the late 1980s, in response to evidence that more and more taxpayers were reporting as charitable contributions checks that in fact resulted in substantial benefits, the IRS initiated a strong appeal to charities, urging their cooperation.[23] In 1988, the commissioner of the IRS took the unusual step of writing directly to over four hundred thousand charities, expressing his concern that charities, as sponsors of fund-raising events, often failed to provide sufficient information to taxpayers regarding the extent to which payments for such events were deductible as charitable contributions. He directed their attention to a 1967 Revenue Ruling[24] on this subject and said:

I would particularly like to emphasize that part of the ruling which states the importance of determining in advance of solicitation the portion of payment attributable to the purchase of admission or other privilege and the portion solicited as a gift.

21. *How Much Really Is Tax Deductible?* (Washington, D.C.: Independent Sector, 1988), 3.

22. The Revenue Ruling cited most often on this issue is Rev. Rul. 67-246, 1967-2, C.B. 104. See also Rev. Rul. 86-63, 1986-1, C.B. 88, 19.

23. See IRS Publication 1391 (6-88), "Deductibility of Payments Made to Charities Conducting Fund-Raising Events."

24. See footnote 22, above.

The ruling says that in those cases in which a fund-raising activity is designed to solicit payment intended to be in part a gift and in part the purchase price of admission or other participation in an event, separate amounts should be stated in the solicitation and clearly indicated on any ticket or other evidence of payment furnished to the contributor.[25]

Efforts were then renewed within the museum community to encourage more careful adherence to IRS directives on this subject, and quite naturally many questions arose. A good number of these questions concerned the method that should be used to put a dollar figure on the unique benefits that were frequently offered to contributors but that had no discernible fair market value (e.g., a discount privilege in museum shops; invitations to preview exhibitions with a curator acting as a guide; the use of a museum space, not normally rented, to host a private party).[26] Progress in clarifying these issues and educating the public was slow.

In 1993, what had been essentially voluntary cooperation was, by statute, made mandatory. Under the Omnibus Budget Reconciliation Act of that year,[27] charities were required, as of January 1, 1994, to provide donors with a good-faith estimate of the value of any goods or services offered in return for a gift. In addition to providing this good-faith estimate, the charity also has to provide a written statement to the donor explaining that the amount of the contribution that is deductible is limited to the excess of the amount contributed over the value of the goods or services connected with the gift.[28] These statutory requirements went into effect for gifts solicited or made after December 31, 1993, and they apply when a donor, either an individual or a corporation, makes a gift in which the payment to the charity exceeds $75. Charities failing to comply with the statutory requirements are subject to penalties.[29]

In December 1996, the IRS issued final regulations that clarified how these new provisions are to be implemented.[30] The regulations state that certain offered benefits can be deemed insubstantial and need not be included when calculating quid pro quo. Insubstantial benefits include a membership privilege of free or discounted admission or parking, a discount in the organization's shop, or admission to an event open only to members if the cost per person of what is provided is nominal. Newsletters and other publications sent to members (as long as the publications are not sold to others) are deemed insubstantial benefits also. If the total value of benefits associated with a gift is nominal, the donee organization can

25. IRS Publication 1391, "Deductibility of Payments Made to Charities Conducting Fund-Raising Events," 2.

26. N. Ward, "What Is a Reasonable Estimate of the Fair Market Value of a Wrong Note?" *Exempt Organization Tax Review* (April–May 1989); J. Blazek et al., "Fund Raising Events after Publication 1391," in American Law Institute–American Bar Association (ALI-ABA), *Course of Studies Materials: Legal Problems of Museum Administration* (Philadelphia: ALI-ABA, 1990).

27. H.R. 2264 (1993).

28. The statement must be in a form and size that make it easily visible to the donor.

29. See the American Association of Museums' *Government Affairs Bulletin* dated Aug. 30, 1993.

30. Proposed regulations were issued in the *Federal Register* on Aug. 4, 1995, pp. 39896–902. The regulations were effective upon publication and remained in effect until the final regulations were promulgated on Dec. 16, 1996. See 61 *Fed. Reg.* 65946–55 (Dec. 16, 1996).

inform the donor that there is no quid pro quo associated with the gift, and if a written acknowledgment is required because the gift exceeded $75, the donee organization can state on that acknowledgment that no goods or services were provided in exchange for the gift. What constitutes "nominal" benefits is defined in dollars and cents by the IRS, subject to annual adjustment. As of late 1996, the definition was "$6.70 or less."

2. SUBSTANTIATION OF GIFTS

The Omnibus Budget Reconciliation Act of 1993 imposed another requirement that indirectly affects donee organizations.[31] Under that act, as of January 1, 1994, donors who claim an income tax deduction for a contribution of $250 or more must obtain a receipt from the donee organization before filing their income tax returns.[32] The receipt must include the amount of cash donated or a description of the property donated (no dollar value need be placed on the property by the donee organization), and if any goods or services accrue to the donor in exchange for the gift, an estimate of the fair market value of such goods or services must also appear on the receipt. If no goods or services were provided in exchange for the gift, the receipt must specifically make that statement. The before-mentioned IRS regulations applicable to gifts with premiums and benefits—regulations concerning what is reportable as a premium or benefit, methods for determining fair market value of goods and services, and what constitutes "nominal" value regarding quid pro quo benefits—can be used by donee organizations when preparing receipts requested by those who have donated $250 or more.[33] Because donors can be denied a charitable contribution deduction when the receipts, as described in this section, have not been obtained within appropriate time periods, museums should have their procedures in order so that no donor suffers as a result of the donee organization's inefficiency.

For purposes of clarity, we should note that as of 1985, other Internal Revenue Code requirements that fall under the general heading of "substantiation of gifts" have also been in effect. The 1985 requirements are distinct from the 1993 substantiation rules (and are not affected by those rules). They are essentially as follows (see the following chapter, "Appraisals and Authentications," for a fuller description). As of 1985, a donor who makes a gift or group of gifts that exceeds $5,000 in value must, for purposes of documenting a charitable contribution deduction, obtain a "qualified appraisal." When a donee organization is the recipient of such a gift, it must sign a form presented by the donor (Section B of IRS Form 8283), verifying receipt of the property, and it must give the donor and the IRS written notice (IRS Form 8282) if it disposes of the property within two years of receipt. See Section A, "Appraisals," of Chapter XIII and Section B(2)(e), "Notification to Donor of Deaccession," of Chapter V for more detailed information on these particular substantiation requirements.

31. H.R. 2264 (1993).

32. Failure to obtain a receipt in a timely manner invalidates the claimed deduction. When the statute first went into effect, a time extension was granted for obtaining receipts.

33. See the final regulations cited in footnote 30, above.

G. The Museum's Position on Donor Deductions

Considerable discussion is generated whenever the topic is the museum's proper role regarding the tax consequences of donors' gifts. Some favor a complete "hands off, it's not our problem" approach, whereas others argue that museums should take an active role in probing apparent abuses. If there is a "right" answer for a museum, it probably lies somewhere in between. Good intentions must be reconciled with what is possible, and even with a prudent general policy, staff must stay informed and be vigilant for the unusual circumstances that require special treatment. Consider the following examples.

Hypothetical Example 1. A respected friend of the museum donates a painting represented as a work of artist X and appraised at $15,000. The painting is accepted but not put on display. Some years later, several researchers establish that the painting is not authentic. On investigation, the researchers discovered that the curatorial staff of the museum had serious doubts about the authenticity of the work when the gift was made but that no one wanted to offend a donor who might offer something more interesting next time. Instead, the appropriate IRS form was signed acknowledging receipt of the object after museum staff convinced themselves there was nothing to be gained by stepping into a matter that essentially involved the donor and the IRS.[34] The painting was stored out of public view for over three years, the statutory period during which the IRS could have questioned the deduction taken (that is, the claimed value of the charitable donation).

Hypothetical Example 2. A museum has on loan an unusual ethnographic object that it would like to have for its collections. The owner explains that he cannot afford to give the work but asks the museum to help him search for a prospective donor who will buy the object and then, after an appropriate period, give the piece to the museum. A prospective donor is located, and the museum becomes privy to the fact that the donor will pay a reasonable sum for the object but plans to overvalue it grossly for gift purposes. Appraisals that support the exaggerated valuation are shown to the museum. Nothing is said, and the museum waits patiently for the deed of gift, anticipating its arrival as soon as sufficient time has passed so that the donation will qualify as long-term capital gain property.

Hypothetical Example 3. Curator X finds himself flooded with offers of donations of a particular type of property that he knows is being promoted as a tax shelter. The museum's collections are already well-represented in this area, but nothing is refused. The donors have obviously acquired the property items merely to be donated later for tax benefits far in excess of their investments. Valuations substantially over the purchase price are being sought. Curator X plans in due time, after donations have been made, to sell or exchange most of this material, but the realities are never openly discussed by the donors or the museum.

In each of the above examples, it is quite possible that a museum might come forward

34. Because the gift was represented to be worth over $5,000, the donee museum was asked by the donor to sign Section B of IRS Form 8283, "Noncash Charitable Contributions," in which the donee organization verifies that it has received from the donor the described gift.

with a legitimate explanation for its conduct, based on particular circumstances, but such explanations tend to wear thin when a pattern develops. To the careful observer, museum personnel who "look the other way" appear (at a minimum) unethical; a consistent pattern of such behavior in recurring situations might amount to participation as a silent coconspirator in a tax-evasion scheme. In any event, even the mere appearance of participation in systematic abuse can tarnish a museum's reputation in the eyes of the general public.

And even those who are not particularly motivated by ethical exhortations regarding the importance of personal integrity should review the practical consequences of pushing the edge of the law in the area of charitable contribution deductions. Over the past decade or two, publicly supported charitable organizations have become burdened with numerous regulatory requirements spawned by public perceptions that these organizations have been cooperating in or condoning abuses of the charitable contribution deduction. At one point, the charitable deduction itself was at stake.[35] Even the most pragmatic individual who takes the time to review this history should come to this conclusion: A charity that engages in simply "perceived abuse" of the charitable contribution deduction is incredibly shortsighted.

35. See, for example, J. Lyon, "Charitable Contributions of Appreciated Property: A Perspective," in American Law Institute–American Bar Association (ALI-ABA), *Course of Studies Materials: Legal Problems of Museum Administration* (Philadelphia: ALI-ABA, 1987), and J. Simon, "The Tax Treatment of Nonprofit Organizations: A Review of Federal and State Policies," in W. Powell, ed., *The Nonprofit Sector: A Research Handbook* (New Haven: Yale U. Press, 1987).

Appraisals and Authentications

A. Appraisals

1. THE MUSEUM'S POSITION

Should a museum provide monetary appraisals for donors or prospective donors?[1] This question prompts much discussion. On the one extreme are those who view the practice as an essential service in the competition for important donations. On the other extreme, such

[1]. Note that this discussion concerns the role of the museum in providing monetary appraisals, not in providing opinions regarding authenticity. Although value directly relates to authenticity, museums can point to scholarly and educational reasons for providing opinions on authenticity that separate that activity from one that focuses on monetary value. Hence, the matter of appraisals and the matter of authentications are treated

museum activity is looked on as a practice bordering on illegality. We need to examine the question in the context of the times. Although the practice may have been quite common years ago, it now must be more closely scrutinized in light of the increasing importance, to donors, of the tax consequences of their gifts.[2] Decisions about museum policy on providing monetary appraisals should be made on the basis of what is the right thing to do in order to maintain the integrity of the charitable gift process. For museums, this is, or should be, the overriding concern.

One basic fact that is frequently overlooked by donors and museum staff alike is that in any gift situation, the museum is an interested party. The museum is the donee or prospective donee. Invariably an appraisal is being sought for tax purposes, and the Internal Revenue Service wants impartial appraisals. One from a donee is immediately suspect. When this is explained to donors, many gratefully look elsewhere for their appraisals. This self-interest problem of the museum-donee was recognized in the Tax Reform Act of 1984.[3] Under that legislation, effective 1985, a museum-donee is disqualified from appraising, for federal income tax purposes, property that is over a certain value and that is contributed to the museum. More will be said later about these particular situations (see Section A[4]).

Some museums pay for third-party appraisals of donated objects. They argue that this is a courtesy deserved by a donor and that the procedure affords the donor a more creditable opinion. There is much to be said for this practice, but it also involves major drawbacks. If appraisals are provided to all donors, the service can prove to be costly and beyond a museum's budget. If appraisals are provided to only certain donors, the selection criteria can be difficult to draft. If a particular appraiser is routinely used, his or her impartiality may be open to question. For example, under the previously mentioned Tax Reform Act of 1984, not only is a museum-donee (and its employees) disqualified from acting as an appraiser in certain gift situations, but "an appraiser who is regularly used by . . . [the donee museum] and who does not perform a majority of his or her appraisals made during his or her taxable year for other . . . [clients] is also disqualified."[4] In other words, when deciding whether to provide a donor with an outside appraisal, the museum should consider whether there is a

separately. Another question concerns museum employees who, on their own time, may want to serve as appraisers for a fee. The question of such outside employee activity is not discussed here, but it clearly needs to be addressed by a museum as part of a code of ethics for employees. See, for example, R. Lind, "Legal Risks Associated with Providing Expert Opinions and Authentications," in American Law Institute–American Bar Association (ALI-ABA), *Course of Studies Materials: Legal Problems of Museum Administration* (Philadelphia: ALI-ABA, 1991). See also footnote 21, below.

2. Changes in opinion on the matter are reflected in various codes of ethics. The "Code of Ethics for Art Museum Directors," published as an appendix to Association of Art Museum Directors, *Professional Practices in Art Museums* (New York: Association of Art Museum Directors, 1991, amended 1992), reads as follows: "When accepting gifts, the Board and the Director must stipulate that responsibility for securing evaluations and furnishing information for government agencies rests with the donor" (paragraph 17). "A Code of Ethics for Curators" contains the following statement: "Curators may prepare appraisals only for internal use at their institution (e.g., insurance valuations for loans) and, with the approval of the curator's museum, for other nonprofit institutions" (*Museum News* 36, 38 [Feb. 1983]).

3. See, more specifically, Section 155a of the Tax Reform Act of 1984 (Pub. L. 98–369, 96 Stat. 494).

4. See IRS regulations at 26 C.F.R. § 1.170A-13. See also IRS Publication 526, "Charitable Contributions."

pattern of regularity that would cause a reasonable person to question the independence of the appraiser. If the answer could be yes, common sense indicates that the situation should be avoided. One additional consideration should not be forgotten. For some donors, an appraisal is a matter of vital interest. The closer the museum is to the appraisal process, the greater is the likelihood that the museum could be drawn into controversy if appraisal results are disappointing.[5]

Many museums establish a general policy that monetary appraisals will not be provided. This is perhaps the easiest solution for the museum, but it too is not without drawbacks. Some prospective donors may be offended and go elsewhere, and true hardship cases can arise. However, hardship cases can usually be handled intelligently on an individual basis when the museum understands the earlier described pitfalls and is comfortable defending publicly, if necessary, each deviation from standard policy.

In some situations, museum staff may feel uncomfortable about an apparent intention on the part of a donor to inflate grossly the value of his or her gift for tax purposes.[6] Suppose, for example, that a donor has sent the museum an unsolicited copy of an appraisal obtained on a proposed gift. (In this situation a "qualified appraisal" is not required; hence, there is no need for the donor to give the museum any notice of the appraisal process.) The museum staff members are shocked to see the appraisal figure. In such a case, merely placing the appraisal in the museum's file, and saying nothing, could be viewed as contributing to the suspected manipulation. The museum could be accused of the same complicity if it destroys its copy of the appraisal and says nothing. This is a difficult situation, and the museum may decide it must take a more active role. Sometimes just informing a prospective donor that a known appraisal might not withstand an IRS audit has a salutary effect. Alternatively, the gift can be declined. A polite refusal can convey a message as effectively as a dogmatic judgment.

Another situation involves the museum's position when it is asked to sign the "donee acknowledgment" under in Section B of IRS Form 8283, "Noncash Charitable Contributions" (a form used when a "qualified appraisal" is required by the IRS). On the form, appraisal values are listed, but under Part IV of the form the donee museum is asked only to acknowledge receipt of the described donated objects. Suppose the museum is shocked by the appraisal value? IRS regulations regarding this form clearly state that the signature of the donee museum does not represent concurrence in the appraised value of the contributed property—the signature only acknowledges receipt of the described property by the museum on the date given on the form. IRS regulations place the burden of substantiating the valuation figure on the "qualified" appraiser, who must also sign the form. If the museum has serious reservations about the value that appears on the form, it should proceed with

5. Provisions in the Internal Revenue Code (26 U.S.C. § 6659) impose additional penalties on taxpayers who substantially overvalue property reported as charitable contributions. The additional tax is imposed only when the value overstatement exceeds 150 percent of the amount determined to be the correct value and when the resulting tax underpayment exceeds $1,000. Although these penalties should encourage more caution on the part of donors, they also raise the stakes when serious disputes develop between donors and the IRS.

6. See also Chapter XII, "Tax Considerations Relevant to Gifts."

caution and seek advice from its own tax counsel. Even though the values in question are technically not its problem, exceptional circumstances may warrant discreet action by the museum in an effort to avoid serious consequences for an apparently misinformed donor.[7]

It is difficult to defend the position that there is only one acceptable way for all museums to handle the appraisal question. Nevertheless, these comments are worth mentioning:

1. For the guidance of staff, the museum should establish in advance a general rule that is in accord with current IRS regulations regarding appraisals. A strictly ad hoc approach makes the museum more vulnerable and can result in unfairness to donors, embarrassment to staff, and possible liability for the museum.
2. The general rule should afford the museum a reasonably practical way to avoid abuses, and museum staff should understand the underlying reasons for the rule so that truly unusual situations that warrant special consideration can be identified.
3. There should be an avenue of appeal to designated museum officials for exceptions to the general rule. Before an exception is granted, its precedential effect should be weighed carefully.

Even if a museum's policy does not permit the giving of monetary appraisals, knowledgeable staff members can still offer certain practical advice to members of the public. IRS Publication 561, "Determining the Value of Donated Property," explains when appraisals are necessary to support a claimed charitable contribution tax deduction, lists what should be included in an appraisal, and describes how the IRS reviews appraisals. Information also is given on methods of valuing various types of property. Staff members familiar with the publication can, in appropriate cases, call it to the attention of donors or prospective donors. A current copy of Publication 561, which can be obtained from any IRS office, is a handy reference to have on file.[8]

2. WHEN APPRAISALS ARE REQUIRED

Appraisals are not necessary to support every claimed charitable contribution deduction:

- If the property donated is worth $500 or less, minimal documentation of value is needed. Often a description of the property will suffice.
- If the property exceeds $500 in value but does not exceed $5,000 in value (and if similar items given to all charitable donees in the year do not have an aggregate value in excess of $5,000), IRS regulations require that certain information, such as the fair market value of the contributed property and the method used to determine value,

7. When there is serious overvaluation in a "qualified appraisal," the penalties imposed on the donor by the IRS involve an assessment of the "good faith" of the donor in relying on the appraisal. Accordingly, the donee museum should exercise caution before interposing itself between the donor and the appraiser. (See Section 155a of the Tax Reform Act of 1984.)

8. IRS Publication 526 treats the general subject of charitable contributions and is a useful companion to Publication 561.

be filed with the tax return. This information can be in the form of a professional appraisal signed by an appraiser, but a formal appraisal is not always the only alternative.[9] In some instances, fair market value may be established with some certainty by supplying evidence to the IRS of contemporary sales of similar property at public auction. If the museum is aware of published records of such sales, there is no reason why these cannot be called to the attention of a donor who requests assistance. As a rule, the museum should supply such references with the caution that additional research by the taxpayer may be in order to confirm the relevance of the published sales to the gift at issue and/or to verify that the published sales reflect market conditions similar to those that would govern the valuation at issue.

- Under the Tax Reform Act of 1984, if the amount claimed as a charitable deduction by a taxpayer for a year exceeds $5,000 for any single item or exceeds $5,000 for the aggregate of items of a similar nature given by the taxpayer to all charities, then the taxpayer must fulfill certain statutorily prescribed appraisal requirements. If these statutory requirements are not followed, the charitable deduction will be disallowed. The requirements, explained more fully in Section A(4) below, apply to charitable contributions made after December 31, 1984.

- Current IRS regulations should always be consulted when the issue is the documentation needed to support a noncash charitable contribution. This is a matter that is subject to frequent modification.

3. IRS APPRAISAL FORMAT

The purpose of an appraisal for tax purposes is to establish the fair market value of the donated property as of the date of the contribution. "Fair market value is the price at which property would change hands between a willing buyer and a willing seller where neither is under any compulsion to buy or sell and both are cognizant of the relevant facts."[10] As explained earlier, a formal appraisal must be sought when fair market value exceeds $5,000 or may be sought when the donor cannot establish fair market value, within the $500–$5,000 range, using readily obtainable figures of comparable sales or replacement costs.

The weight given to an appraisal depends first and foremost on the completeness of the report—the facts given to support the conclusion of the appraiser. The qualifications of the appraiser and the appraiser's demonstrated knowledge of the property in question are also considered, but the IRS notes, "The appraiser's opinion is never more valid than the facts on which it is based."[11] When an appraisal is required by the IRS, or when a donor elects to obtain a formal appraisal, the following information, where relevant, should be provided:

1. A description of the property in sufficient detail for a person who is not generally familiar with the type of property to determine that the property appraised is the property that was (or will be) contributed

9. IRS Regulation 26 C.F.R. § 1.170A-1(a)(2)(ii).

10. *Posner v. Commissioner,* T.C. Memo 1976-216, 35 T.C.M. (CCH) 943 (1976). See also IRS Publication 561, "Determining the Value of Donated Property."

11. IRS Publication 561, "Determining the Value of Donated Property."

2. The physical condition of any tangible property

3. The date (or expected date) of contribution

4. The terms of any agreement or understanding entered into (or expected to be entered into) by or on behalf of the donor that relates to the use, sale, or other disposition of the donated property

5. The name, address, and taxpayer identification number of the qualified appraiser and, if the appraiser is a partner, an employee, or an independent contractor engaged by a person other than the donor, the name, address, and taxpayer identification number of the partnership or the person who employs or engages the appraiser

6. The qualifications of the qualified appraiser who signs the appraisal, including the appraiser's background, experience, education, and any membership in professional appraisal associations

7. A statement that the appraisal was prepared for income tax purposes

8. The date (or dates) on which the property was valued

9. The appraised fair market value on the date (or expected date) of contribution

10. The method of valuation used to determine fair market value, such as the income approach, the comparable sales or market data approach, or the replacement cost less depreciation approach

11. The specific basis for the valuation, such as any specific comparable sales transaction

The following are examples of information that should be included in a description of donated property. These examples are for art objects. A similar detailed breakdown should be given for other property. Appraisals of art objects—paintings in particular—should include the following:

1) A complete description of the object, indicating the size, the subject matter, the medium, the name of the artist, and the approximate date created.

2) The cost, date, and manner of acquisitions.

3) A history of the ownership, citations in literature, and public exhibitions of the item, including any documentation regarding the authenticity.

4) A photograph of a size and quality fully showing the object, preferably an 8 × 10 inch color print, or a color transparency no smaller than 4 × 5 inches (must be provided upon request).

5) The facts on which the appraisal was based, such as:
 Sales or analyses of similar works by the artist, particularly on or around the valuation date.
 The state of the art market at the time of valuation, particularly with respect to the specific property, artist, school, or price range.
 The standing of the artist in his profession and in the particular school or time period.[12]

4. THE "QUALIFIED APPRAISAL"

If the claimed deduction for an item, or group of similar items, of property donated within the tax year is more than $5,000 (other than money or publicly traded securities), the donor must obtain a "qualified appraisal" in order to attain favorable tax consequences. As used in the above sentence, the phrase "similar items" means property of the same generic cate-

12. Verbatim from ibid.

gory or type, such as paintings, photographs, books, coins, and pottery; the property need not have been donated to the same donee. The qualified appraisal must contain the information described in the preceding section, it must relate to an appraisal made not earlier than sixty days before the date of contribution of the appraised property, it must not involve a "prohibited appraisal fee," and it must be prepared, signed, and dated by a "qualified appraiser." A "prohibited appraisal fee" normally is one based on a percentage of the appraised value of the property.[13] "Qualified appraisers" are those who declare on appropriate IRS forms that

- they regularly perform appraisals and present themselves as appraisers;
- they are qualified to make appraisals;
- they understand that there is personal liability for intentionally false overstatement of value; and
- they are not excluded individuals.

The following people are "excluded individuals" for purposes of being considered as "qualified appraisers":

1) the donor or taxpayer claiming the deduction.
2) the donee of the property.
3) A party to the transaction in which the donor acquired the property being appraised, unless the property is donated within 2 months of the date of acquisition and its appraised value does not exceed its acquisition price. This applies to the person who sold, exchanged, or gave the property to the donor, or any person who acted as an agent for the transferor or donor in the transaction.
4) Any person employed by, married to, or related under section 267(b) of the Internal Revenue Code, to any of the above persons. For example, if the donor acquired a painting from an art dealer, neither the dealer nor persons employed by the dealer can be qualified appraisers for that painting.
5) An appraiser who appraises regularly for a person in (1), (2), or (3), and who does not perform a majority of his or her appraisals made during his or her tax year for other persons.[14]

As a general rule, the donor is not required to attach to the tax return a complete copy of the signed "qualified appraisal"; rather, an appraisal summary (Section B of Form 8283) is attached to the return.[15] (The donor should consult IRS regulations concerning when separate copies of the appraisal summary are necessary in cases of multiple gifts involving one

13. There is an exception when the fee is paid to a generally recognized association that regulates appraisers. See IRS regulations for more information on the exception.

14. Verbatim from IRS Publication 561, "Determining the Value of Donated Property."

15. Note that if a deduction of more than $20,000 is being claimed for donations of art (and "art" is defined broadly to include paintings, sculpture, prints, drawings, ceramics, antique furniture, decorative arts, textiles, silver, rare manuscripts, historical memorabilia, etc.), a complete copy of the signed appraisal must accompany the tax return. (See the following section, "IRS Review of Valuations.")

or more donees.) Museums should be familiar with Form 8283 and its companion Form 8282 because, as mentioned in this chapter and in Chapter XII, "Tax Considerations Relevant to Gifts," a museum usually must complete Part IV of Form 8283 when certain gifts are made to it. On Part IV of the form, the museum verifies receipt of the described property on the date of the gift specified on the form.[16] A copy of the signed Form 8283 should then be kept in the museum's accession file on the acquisition in question. If the museum disposes of any of the property described in Part IV of the form within two years of the date of the gift, it must file with the IRS a completed Form 8282, "Donee Information Return," and send an information copy of the completed Form 8282 to the donor. There are exceptions to the reporting of disposals:

- The donee is not required to report a disposal if the donee consumes or distributes the item without payment for a purpose or function that is a basis for its charitable exemption. For example, no reporting would be required if a museum uses up, in educational demonstrations for school groups, natural history specimens included in a gift that triggered the filing of a Form 8283.
- The donee is not required to report the disposition of property listed as having an appraisal value not exceeding $500 if the statement of value was on Form 8283 when the museum signed the donee acknowledgment (Part IV of Section B of Form 8283).

5. IRS REVIEW OF VALUATIONS

Since the late 1960s the IRS has utilized the Art Advisory Panel to review valuation on artworks in estate, gift, and charitable contribution tax cases.[17] Currently, twenty-five members sit on the panel, and they represent areas of expertise in traditional painting and sculpture and specialty areas of Far Eastern and Asian, primitive, and pre-Columbian art. Regarding claimed charitable contributions, a work of art with an alleged market value of $20,000 or more is usually referred to the panel for review. Administrative support for the panel is provided by the Art Appraisal Services, an office within the IRS.

Before meetings, members of the Art Advisory Panel are provided with information packets on each claimed valuation set for review. Regarding charitable contribution valuations, the panel may accept the donor's valuation, may recommend a lower valuation, or may recommend a higher valuation. The general pattern of panel activity in this area shows a

16. The date of receipt of the gift by the museum should be interpreted to mean the date on which the last step needed to complete the gift took place. Normally, the three steps necessary to complete the gift for tax purposes are (1) evidence of donative intent, (2) control of the object by the museum, and (3) acceptance of the gift by the museum. These steps can take place in any sequence. (See Section F(4), "Special Tax Considerations," in Chapter IV for more information on when a gift is complete for tax purposes.)

17. The Art Advisory Panel was first authorized in 1968. Originally, the panel was composed of twelve members with expertise in paintings and sculpture. Today, the twenty-five members have wider areas of expertise. See K. Carolan, "Documenting Art Appraisals for Federal Tax Purposes," in *The Law and Business of Art,* 297 PLI/Pat 787, Patents, Copyrights, Trademarks, and Literary Property Course Handbook Series, ed. R. Lerner (New York: Practicing Law Institute, 1990), PLI Order No. G4-3851.

very substantial number of valuations recommended for reduction and a very minor num-
ber recommended for higher valuation. Typically, the panel's recommendations are ac-
cepted by the IRS, and the burden then falls on donors of contested valuations to defend
their positions. The Art Advisory Panel has been effective in providing a consistent form of
review in an area in which differences of opinion can vary greatly. A general complaint,
however, has been that reviews take place a year or more after a contribution has been
made and that this delay can make it more difficult to resolve disputes.

In response to this complaint, the IRS initiated, as of January 15, 1996, a procedure for
expedited review of statements of value of art for income, estate, or gift tax purposes. In
this new procedure, "art" is defined to include "paintings, sculpture, watercolors, prints,
drawings, ceramics, antique furniture, decorative arts, textiles, carpets, silver, rare manu-
scripts, historical memorabilia, and other similar objects."[18] The expedited procedure ap-
plies, as a rule, to an item of art that has been appraised at $50,000 or more and has
been transferred as a charitable contribution. The taxpayer seeking the expedited state-
ment of value must apply for it before filing the income tax return that first reports the
charitable contribution. Completed requests filed after July 15 but on or before January
15 are processed by the following June 30. Completed requests received after January 15
but on or before July 15 are processed by the following December 31. It is the responsibility
of the taxpayer to seek extensions, if necessary, for filing appropriate tax returns re-
garding the contribution in question. The information required of the taxpayer in the ex-
pedited process is similar to that required in a standard income tax return for a charitable
contribution of that nature. There is, however, a substantial fee for requesting expedited
review.

6. RECOMMENDING APPRAISERS

Many times museums are asked to recommend appraisers. Such a request raises problems.
Regarding appraisers of objects normally collected by museums, there are no generally rec-
ognized procedures for certification regarding expertise. The IRS does not prejudge the
qualifications of people representing themselves as appraisers. It accepts their representa-
tions of expertise, but with the Tax Reform Act of 1984, appraisers are now subject to being
barred from presenting evidence or testimony in matters before the IRS if they are found
guilty of aiding and abetting an understatement of tax liability.[19] In other words, for the IRS,
appraisers are "qualified" until they are ruled "unqualified" because of established violation
of specific IRS rules. Nor do professional organizations of object appraisers normally certify
their members for competence. Accordingly, when museums are asked to recommend ap-
praisers, there is no objective test to cite as a basis for judging competence. The museum
often must rely on subjective impressions of staff or word of mouth. An added concern is
that the museum does not want to create the appearance that it is recommending an ap-

18. See Rev. Proc. 96-15 (1996).
19. See 31 C.F.R. pt. 10.

praiser who could be viewed as "unqualified" if the object appraised is later given to the museum.[20]

The suggested approach is never to recommend just one appraiser but to offer several sources, urging the individual to investigate and make the final selection. Also, a more cautious procedure is not to have a printed list of appraisers for distribution to requestors unless the museum is prepared to review and update the list periodically. The fact that there is a prescribed list may be construed as a museum endorsement, despite a disclaimer. In addition, the existence of such a list may cause those appraisers not on the list to demand inclusion. This can raise awkward situations if the appraiser is not known to the museum or is not held in high regard.

Professional organizations of appraisers sometimes publish brochures on how to locate and interview appraisers. The Art Dealers Association of America (New York City) has for many years maintained a tightly controlled appraisal service for art. Information on its procedures would be a helpful guide to anyone searching for a competent appraiser.

B. Authentications

Invariably, an initial issue raised is whether it is appropriate for a museum to provide, gratis to the public, opinions on the authenticity of objects or works of art.[21] As is so often the case, this is essentially a policy question rather than a legal one, and it must be weighed in light of a museum's particular circumstances. Some museums view it as a public service and/or find that such activity ultimately benefits their ability to advance scholarship because through the authentication process, a wide variety of interesting objects and information is brought to the attention of curatorial staff. For others, any such benefits are outweighed by undue burdens on staff time and/or by real or apparent misuse of the service by individuals or businesses.[22] To ensure that a prudent policy is set, a museum must carefully balance the

20. Note the previous comments regarding a possible disqualification of an appraiser because of close ties with a donee organization.

21. As noted in footnote 1, above, this discussion does not cover the question of museum personnel who appraise or authenticate for a fee in addition to their museum employment. Such "outside employment" raises additional ethical and legal issues and is beyond the scope of this text. For information on this question, see "A Code of Ethics for Art Museum Directors," published as an appendix to Association of Art Museum Directors, *Professional Practices in Art Museums* (1992); "A Code of Ethics for Curators," published in *Museum News* 36 (Feb. 1983); College Art Association, "A Code of Ethics for Art Historians" (revised as of Jan. 1995), Section VII, and also its companion document "Guidelines for Professional Practice"; and Part 8 of International Council of Museums, *Code of Professional Ethics* (Paris: ICOM, 1990). See also R. Lind, "Legal Risks Associated with Providing Expert Opinions and Authentications," in American Law Institute–American Bar Association (ALI-ABA), *Course of Studies Materials: Legal Problems of Museum Administration* (Philadelphia: ALI-ABA, 1991).

22. As cultural objects become more valuable in the marketplace and more often the subject of request for return or restitution by countries of origin, potential liability increases for the appraiser or authenticator. A growing concern is expected and is evidenced, for example, in a comparison of the College Art Association's "Code of Ethics for Art Historians" of 1973 and its revised code of ethics of Jan. 1995 (plus the companion "Guidelines for Professional Practice").

pros and cons in light of the museum's resources, the type of collections it may hold, and the circumstances that may be unique to it. One statement can be made with confidence, however. A museum should have a policy on the matter, and the policy should be well promulgated among staff. When there is no policy, the museum is most vulnerable to criticism and possible liability.

If a decision is made that authentications will be given as a matter of policy, a few precautions should protect the museum and its staff from undue liability. The museum wants to avoid possible claims—claims usually based on a theory of misrepresentation, disparagement, or defamation. The lines distinguishing each of these causes of action from the other are not always clear, and what follows is a very general discussion. The purpose is to acquaint the reader with the usual issues raised by those disappointed by statements regarding authenticity and to present the usual defenses, thus providing a basis for formulating a museum's policy on the issue of authentications.

1. MISREPRESENTATION

In general, a misrepresentation is "any manifestation by words or conduct by one person to another that under the circumstances amounts to an assertion not in accordance with the facts."[23] To create liability, a misrepresentation usually must be intentional,[24] but in some instances negligent misstatements can invite lawsuits. Such instances usually occur when there is direct, foreseeable harm to an individual because of a misstatement and when the injured party is considered justified in relying on the information given.[25] In other words, in some situations it is reasonable to expect that the party will rely on the information.[26] If this test is applied to museum situations involving authentications, two other considerations frequently bear on the "reasonable reliance" issue: (1) the fact that the authentications are given gratis and (2) the issue of whether the authentications can be construed as opinions.

Regarding the first consideration, it is commonly held that for a court to find liability for a negligent misrepresentation, the giver of the information must have a direct or indirect pecuniary interest. A direct pecuniary interest would be an authentication done for a fee, not the type of situation under discussion in this chapter. An example of an indirect interest is illustrated by the following. A physician on the way to his office meets a neighbor who is not a patient and in the course of a conversation offers some curbside medical advice. On

23. *Black's Law Dictionary* (6th ed. 1990).

24. For this reason, misrepresentation is frequently associated with the tort of deceit.

25. Courts are often reluctant to find a duty of care if the resulting liability might be "an indeterminate amount for an indeterminate time to an indeterminate class." *Ultramares Corp. v. Touche*, 255 N.Y. 170 and 179, 174 N.E. 441, 444 (1931). See also W. Prosser, "Misrepresentation and Third Persons," 19 *Vand. L. Rev.* 231 (1966), and W. Prosser, *Law of Torts* § 107 (5th ed. 1984). But see *Citizens State Bank v. Timm, Schmidt, and Co.*, 113 Wisc. 2d 376, 335 N.W.2d 361 (1983); *H. Rosenblum, Inc. v. Adler*, 93 N.J. 324, 461 A.2d 138 (1983); *Page v. Frazier*, 388 Mass. 55, 445 N.E.2d 148 (1983).

26. The issue of reliance sometimes takes the form of finding a duty—between the plaintiff and the defendant—that requires the defendant to exercise reasonable care.

reaching his office, the physician receives a call from another neighbor who is a patient, and he offers free medical advice. In the first instance, a truly gratis situation, all that is required is an honest "off-the-cuff" answer because one would not expect that a physician placed in such a position could do more. Thus, as a rule, it would not be reasonable for the neighbor to rely solely on that casual conversation for direction regarding treatment of his medical problem. In the second instance, however, there is indirect pecuniary benefit. The physician has in the past provided paid services to the party and may well be asked to do so in the future. In this second case, because of the established relationship, it might not be unreasonable for the caller to put more reliance on the "free advice" offered. But even the first, "truly gratis" situation might not protect a defendant. There is a strong temptation for a court to find liability when services are offered without even an indirect pecuniary benefit if there is evidence of blatant carelessness and disregard for consequences.[27]

As for the second consideration, authentications frequently amount to expressions of opinion, and like the gratis situation, this also can affect the reasonableness of a plaintiff's reliance on the representation. But whether a statement is a fact or an opinion can generate much discussion. From one viewpoint, any opinion is a factual statement of an individual's conclusions; that is, it is a statement of what is in one's mind. If there is evidence that an opinion is not given in good faith, for some this amounts to a misstatement of fact.[28] If an opinion is given in the form of a statement of fact by someone who purports to be an expert, does this justify reliance by the nonexpert? Possibly it could, on the theory that in expressing the opinion, the expert implies the existence of facts that are known to him or her to be true and that justify his or her opinion. This situation could be further colored if the expert knows or should realize that the recipient intends to rely on the opinion. As stated in *Reeves v. Corning* many years ago:

There is no certain rule of law by the application of which it can be determined when false representations constitute matters of opinion, or matters of fact. Each case must, in large measure, be adjudged upon its own circumstances. In reaching its conclusion, the court will take into consideration the intelligence and situation of the parties, the general information and experience of the people as to the nature and use of the property, [and] the habits and methods of those dealing in or with it, and then determine, upon all the circumstances of the case, whether the representations ought to have been understood as affirmations of fact, or as matters of opinion or judgment.[29]

27. See *International Products Co. v. Erie Railroad Co.,* 244 N.Y. 331, 155 N.E. 662, *cert. denied,* 275 U.S. 527 (1927).

28. "Fraud includes the pretense of knowledge when knowledge there is none." *Ultramares Corp. v. Touche,* 255 N.Y. 170, 174 N.E. 441, 444 (1931)

29. 51 F. 774, 780 (C.C.D. Ind. 1892). An analogy can be drawn to breach of warranty cases involving misattributed art. For example, in two classic English cases—*Jendwine v. Slade,* 170 Eng. Rep. 459 Nisi Prius 1797, and *Power v. Barham,* 111 Eng. Sep. 865 K.B. 1836—different results were reached on the issue of the seller's liability. In *Jendwine,* the seller's attribution was held to be only "opinion" because the artist in question had lived centuries before. In *Power,* the seller's attribution was found to be a fact or "warranty" probably because the artist in question lived more recently. The *Power* court refused to follow *Jendwine,* saying that each case must be decided on its own circumstances.

A longer discussion of "fact versus opinion" can be found in the following section on defamation, but some simple observations on curatorial conduct can be made here. Consider the following situation. Museum M routinely allows staff members to give, as part of their employment, opinions regarding authenticity. No cautions are prescribed. Curator X receives from Miss Y a letter with a photograph of an early American portrait. Miss Y explains that the portrait has been in her family for years and that it has always been attributed to the well-known artist Z. Circumstances now force her to sell many of her possessions, and she needs an expert's opinion of the portrait. Curator X writes on the bottom of the inquiry, "Clearly, this is not the work of artist Z," and returns the correspondence. Shortly thereafter, Miss Y sells the work for a pittance. Within months, it is resold for $50,000 as a portrait by W, a respected artist much influenced by Z.

A similar situation is presented to Curator A of the Q Historical Society. Curator A's reply reads as follows: "After studying the photograph you sent me, I do not believe that the portrait is by Artist Z. However, this opinion is based on the limited information provided me, and it should not be relied on as definitive." Curator A took simple precautions that make it highly unlikely that Miss Y would even threaten to sue. Curator X's conduct, on the other hand, is such that the museum could well be drawn into a lawsuit, with the volatile issue of "reasonable reliance" as pivotal.

In summary, a museum's exposure to a suit based on misrepresentation should be slight if some caution is exercised. The balance of this chapter, concerning the somewhat related actions of disparagement and defamation, as well as the discussion of the use of release forms, should flesh out the appropriate cautions to be taken when a museum gives, gratis, an authentication to an owner of an object.

2. DISPARAGEMENT

In the preceding discussion on misrepresentation, the complained-of activity concerns communication between the giver of information and the owner of an object. However, when derogatory information about an object is conveyed to someone other than the owner, additional causes of action can arise. The most frequent are an action for disparagement and an action for defamation. We will briefly describe disparagement first and then, in the next section, defamation.

An action for disparagement is sometimes called an action for "injurious falsehood." The gist of the alleged wrong is interference with the prospect of sales or some other advantageous use of the property. For example, if in giving an authentication, a museum staff person, without the permission of the owner of the article, makes statements to third parties and discredits the quality of the article, the elements for an action for disparagement could exist.[30] To prevail in an action for disparagement, the plaintiff has the burden of proving at least the following:

30. If the owner of the object requests the authentication, there can be no cause of action for disparagement when the information is conveyed to him or her because there is no disclosure to a third party. (The owner might have a cause of action for misrepresentation, however.) If the owner requests that the information be

1. The plaintiff's interest in the object in question
2. The nature of the derogatory statements made
3. The falsity of the derogatory statements
4. The publication of these statements to a third party (or parties) without the plaintiff's consent
5. As a result of the publication, the incurrence of a definite pecuniary loss

There is confusion as to whether another element, that of malice or intent, must also be proved. Some experts and cases support the view that the intent of the defendant is not relevant in establishing disparagement as long as the above five elements are present. In other words, if a false statement causes pecuniary loss, there is liability regardless of intent. This view is countered by other experts and cases arguing that proof of injurious intent or malice is required. Also, some have suggested that the best rule takes the middle ground and holds the defendant liable for disparagement "only when a reasonable man would have foreseen that his statement would disparage and would have ascertained that the statement was false."[31] The issue is, understandably, still debated. Because of their very nature, disparagement cases usually involve a balancing of interests. The individual making the statement invariably claims a sufficiently important reason for the publication (usually referred to as a privilege), and this must be weighed against the interests of the complaining party. In difficult cases, the malice issue can be used by the court as the pivotal point in achieving what is perceived to be the desirable result.[32]

The law recognizes that certain derogatory statements should be privileged (that is, permitted without liability) because the public good to be gained by permitting free expression outweighs the harm that may be done to the individual. A few privileges are classified as absolute because they protect the individual even from inquiry into the truth of his or her

conveyed to someone else, this disclosure would normally be protected from suit provided the publication did not exceed the scope of the consent. On this general issue, see *Restatement (Second) of Torts* § 635 (1976). In *Fisher v. Washington Post Co.*, 212 A.2d 335, 337 (D.C. 1965), an art gallery owner requested that a newspaper art critic review his new exhibition. When the review proved to be most unflattering, the gallery owner sued the newspaper. The court stated, "He should not be heard to complain if the criticism *so invited* is not gentle" (emphasis added).

31. T. Stebbins, "Possible Tort Liability for Opinions Given by Art Experts," reprinted in F. Feldman and S. Weil, *Art Law* (Boston: Little Brown, 1986), Vol. 2. Stebbins's treatise is often cited on the subject of defamation, and his views are liberally represented here.

32. Two often-cited cases involving disparagement of art highlight the problem of balancing the interests of complaining parties and those of the public or other individuals. In *Hahn v. Duveen*, 133 Misc. 871, 234 N.Y.S. 185 (1929), the flamboyant art dealer Sir Joseph Duveen, after seeing only a photograph of a picture claimed to be *La Belle Ferroniere* by Leonardo da Vinci, declared to a newspaper reporter that the picture was a copy. The owner, who was engaged in negotiating the sale of the picture to an art museum, sued Duveen for disparagement. When a long trial proved inconclusive, Duveen settled the claim for a sizable sum of money. In *Gott v. Pulsifer*, 122 Mass. 235 (1877), there had been much publicity over a statue called *Cardiff Gran* or *Onondaga Statue*, which was purported to be a major archaeological find. The defendant newspaper wrote an article stating that the statue was a fake and that it had been purchased by the owner for $8. The owner, who was in the process of selling the statue for $30,000, sued the newspaper. The newspaper prevailed on the trial level, but on appeal the case was returned for a new trial on the issue of malice. Both cases raised questions of "privilege."

statement or motivation. Absolute privilege is usually conferred by virtue of one's office or position, which, for the public good, requires freedom from threat of suit.[33] Examples would be judges or legislators, who usually enjoy absolute immunity for statements made in the course of their official proceedings. Other privileges are commonly referred to as "conditional" or "qualified." The justification for these qualified privileges is explained as follows:

These are based upon a public policy that recognizes that it is desirable that true information be given whenever it is reasonably necessary for the protection of the actor's own interests, the interests of a third person, or certain interests of the public. In order that this information may be freely given, it is necessary to protect from liability those who, for the purpose of furthering the interests in question, give information which, without their knowledge or reckless disregard as to its falsity, is in fact untrue.[34]

This second type of privilege is "conditional" or "qualified" because it can be lost if the plaintiff can show that the defendant knew the statement was false or exhibited gross disregard as to whether the statement was true or false, if there is sufficient evidence to impute improper motive, or if the extent of publication is deemed excessive.[35] Thus, even though curators may believe that their motives for making certain statements are purely to advance scholarship, some degree of caution is necessary. The appearance that a curator is cocksure or "grandstanding" (seeking headlines) only invites a challenge as to whether any privilege that may exist has been misused. The test frequently used is whether the privilege has been exercised for the purpose for which it was given and has been exercised with reasonable care to ensure that no more harm be done than is necessary to accomplish the permitted end.

Occasions that may be covered by a "conditional" or "qualified" privilege include the following:

- The information protects a lawful interest of the person making the statement, other than an interest in competition for prospective pecuniary benefits.
- The person making the statement desires to protect a lawful interest of a third person or to enable that third person to protect the interest. The publication, however, must be within current standards of permissible conduct, and hence it is usually important whether the information was volunteered or was given in response to a request.
- The information affects a sufficiently important public interest, and certain communications are required to protect the public interest.

33. If a museum is part of a governmental unit, inquiry should be made to see if employees, as public officials, have any form of absolute immunity from suits based on another theory—that the governmental unit has not waived its immunity regarding certain types of actions. Such immunity is not a "privilege" but is another form of effective defense.

34. See *Restatement (Second) of Torts* §§ 635–650A (1976). See also W. Prosser, *Law of Torts* §§ 114–115 (5th ed. 1984).

35. As previously discussed, scholars still debate whether malice is a necessary element for a disparagement action. In part, the controversy is due to the interaction of elements of privilege in many disparagement actions. If malice is in fact a necessary element, there should be far fewer cases requiring the defense of a conditional privilege.

The existence of conditional or qualified privilege can be an important consideration for a museum, and here the law of the state must be examined to determine the extent and interpretation of such privileges.[36] Questions of authenticity arise in a museum not just when an individual seeks the advice of a curator regarding an object but also when objects are offered for donation or purchase, when the curator is preparing a scholarly work, when the curator may be a recognized expert and his or her advice is sought by the media or an interested party, or when the museum is confronted with a situation in which a previous authentication given by a staff member is now subject to doubt. In each of these situations, the interests of the owner of the object should be weighed in light of the interest of the public, the museum, and/or other parties. This exercise, carried out in light of existing state law regarding privilege, usually guides the museum to a course of action that withstands legal challenge. If an authentication is offered, the museum wants to be able to justify it as reasonably arrived at, as noninflammatory in tone, and as publicized in a manner directed to reach those with a legitimate interest. If an authentication meets these tests, even if the plaintiff can prove that the giver of the authentication was wrong (a difficult task in itself), privilege usually provides the museum with an effective defense.

3. DEFAMATION

Defamation is an invasion of a person's interest in his or her reputation. To be actionable, it requires a communication to another or others, communication that has a derogatory effect on that reputation: "A communication is defamatory if it tends so to harm the reputation of another as to lower him in the estimation of the community or to deter third persons from associating or dealing with him."[37] Defamation can be in the forms of libel (the written word) or slander (the spoken word).[38] Historically, the law has been harsher on libel than on slander, with libel actionable without proof of damage but with slander requiring such proof. This distinction is gradually fading, with many courts permitting an action for slander without proof of damage if the slander involves a major social disgrace (such as commission of a crime) or describes conduct or a condition that adversely affects the fitness of an individual to conduct his or her business or profession.[39]

In the authentication process, the threat of a suit for defamation could arise if, for example, the statements made about the object in question are construed to reflect poorly on the reputation of the owner of the object, an interested dealer, or a fellow critic. Defamation is primarily a matter of state law; hence, a determination of what is actionable can vary

36. These privileges also apply to actions of defamation. The effectiveness of such privileges, however, can be affected by federal and possibly state constitutional protections of free speech. See the discussion of these constitutional ramifications in the following section on defamation.

37. *Restatement (Second) of Torts* § 559 (1976); *Kraushaar v. La Vin,* 181 Misc. 508, 42 N.Y.S.2d 857 (1943) (questioning professional competence). In some states, publicity that puts someone in a false light in the public eye may also cause an action for invasion of privacy.

38. Libel can include pictures, signs, statues, motion pictures, or even conduct that tends to defame. See, for example, *Yorty v. Chandler,* 13 Cal. App. 3d 467, 91 Cal. Rptr. 709 (1970), and *Silberman v. Georges,* 91 A.D. 2d 520, 456 N.Y.S.2d 395 (1982).

39. See *Restatement (Second) of Torts* §§ 570–74 (1976) and Prosser, *Law of Torts,* § 116A (5th ed. 1984).

from state to state. As a general rule, however, in order to prevail in a defamation action, the plaintiff must establish the following:

- There was a false statement of purported fact.
- The false statement was injurious to the plaintiff's reputation.
- The false statement was published by the defendant to a third party, and the third party recognized the statement as defaming the plaintiff.
- If necessary, damages have been specifically established.

Proving a cause of action for defamation can be difficult. First of all, the complained-of statement must be capable of verification.[40] Closely allied is the issue of whether the statement is a fact or an opinion. As mentioned earlier, the law has long struggled with the distinction between fact and opinion in disparagement and defamation cases because, arguably, an opinion can be wrong yet, at the same time, can be a true representation of what an individual believes. The importance of clarifying the distinction between fact and opinion was raised to a higher level in more recent times as defendants in defamation cases put forth constitutional arguments to protect what they called expression of opinion. Either the First Amendment (free speech) to the U.S. Constitution or a similar provision of a state constitution would be cited. As of now, the U.S. Supreme Court recognizes some First Amendment applications in defamation cases. In most simplistic terms, the protection can be described as follows:

- The alleged statement of opinion addresses a matter of public concern.
- The alleged statement of opinion is expressed in terms that are probably true or false.
- If probably true or false, the terms can reasonably be interpreted as intending to convey actual facts about a person.[41]

In *McNally & McNally v. Yarnall and The Metropolitan Museum of Art*,[42] a court applied these criteria in a case charging a scholar and a museum with defamation and tortious interference with business relations growing out of controversy concerning the authenticity of certain stained-glass work attributed to the artist John La Farge. The court had little trouble in classifying the controversy as a matter of public concern: "Where . . . as here, the statements of . . . [the defendant] on the authenticity and value of works attributed to La Farge affect the market for and the tax implications of donating La Farge's works among the segment of the population that trades such works as well as the community of scholars with an interest in La Farge, such statements are of public import."[43] On the other issues—those regarding the provability of certain statements and whether those statements can reason-

40. See, for example, *Janklow v. Newsweek, Inc.*, 788 F.2d 1300 (8th Cir. 1986), *cert. denied*, 479 U.S. 883, 107 S. Ct. 272 (1986).

41. See *McNally v. Yarnall*, 764 F. Supp. 838 (S.D.N.Y. 1991). The *McNally* court relied heavily on *Milkovich v. Lorain Journal Co.*, 497 U.S. 1, 110 S. Ct. 2695 (1990).

42. *McNally v. Yarnall*, 764 F. Supp. 838 (S.D.N.Y. 1991).

43. Ibid.

ably be interpreted to convey actual facts about a person—the *McNally* case demonstrates that these tasks can be significant hurdles for a plaintiff when the authenticity of art objects is in question. Authentication of art, especially when the artist in question is dead, invariably involves "educated guessing," and this, in turn, affects the ability to prove certain statements, as well as the difficulty in establishing that such statements can reasonably be interpreted by third parties as conveying facts about a person.

In the area of art criticism, especially when the contesting parties are experts or present themselves as experts, defamation (and disparagement) cases are difficult to win. Courts seem reluctant to discourage exchanges that can reasonably be described as scholarly debate even though the stakes may be high and tempers are not always cool. The above-mentioned *McNally* case is one example. Two other instances, *Porcella v. Times, Inc.*[44] and *Mount v. Sadik,*[45] were decided much earlier, and in both situations the courts dismissed the cases on the basis that opinion, not fact, was at issue.

In *Porcella,* the plaintiff presented himself as an art expert, and he frequently did appraisals and authentications for museums, collectors, and others. The defendant, in one of its magazine articles, described some of Porcella's activities, and Porcella alleged that the article libeled him because it charged or implied that he was incompetent as an art expert and untrustworthy. The defendant's answer was that the article fell within the limits of fair comment. The trial court dismissed the suit on motion of the defendant, and Porcella appealed. In affirming the lower court opinion, the appeals court stated:

Certainly plaintiff would be entitled, as any other person would be, to redress against any false statements of fact maliciously published in regard to him. However, . . . [o]ur analysis of the alleged libelous article convinces us that, insofar as the complaint charged it to be false, it is an expression of the publisher's comments and opinions upon the activities of plaintiff as an art expert with a description of the entire setting in which he was active. It might well be characterized as a satirical recital by an author who made no effort to conceal his belief that there were some authenticators of paintings less reliable than others. The article, insofar as it offended plaintiff, merely expressed the author's opinion, rather than made a false statement of any fact. Plaintiff was engaged in a field which he admits (and even boasts) was in the public domain and, as such, he was subject to comment by the public press as to his activities in that field.[46]

In the second case, Mount, an art critic, authenticated a portrait of George Washington as painted by Gilbert Stuart. The organization owning the portrait sent a photograph of the picture to the defendant, Sadik, a museum director, asking for his opinion. Sadik wrote in reply: "There is no possibility whatever in my opinion that your portrait of George Washington could be by Gilbert Stuart." Later, Sadik studied the painting itself and confirmed his belief. The dispute between Mount and Sadik was widely covered by the press, and two

44. 300 F.2d 162 (7th Cir. 1962).

45. No. 78 Civ. 2279 (S.D.N.Y. Oct. 26, 1978). See also *Mount v. Sadik,* No. 78 Civ. 2279 (S.D.N.Y. April 7, 1980), which discusses the liability of the magazine that published a story on the controversy.

46. No. 78 Civ. 2279 (S.D.N.Y. Oct. 26, 1978), 166–67. See also *Brewer v. Hearst Publishing Co.,* 185 F.2d 846 (7th Cir. 1950).

such articles formed the basis of the defamation suit. Sadik moved to have the case against him dismissed. In granting the motion, the court said:

The statements in the articles attributed to Sadik are expressions of his belief, concededly differing from that of Mount, that the painting was not by Stuart. The words of Sadik as quoted or paraphrased even if construed to be a rejection of plaintiff's views, are not defamatory. They merely indicate to the reader that Sadik and Mount have differing opinions of the painting's origin. They do not attack Mount personally, but merely call into question one opinion he has expressed. The law of defamation has never gone so far as to provide that, once an expert has expressed an opinion, all other experts must keep silent on the matter, lest they expose themselves to legal action.[47]

From the above discussion of "fact versus opinion," certain conclusions can be drawn.

- When an opinion is based on disclosed nondefamatory facts (or when such facts are assumed by the parties because the parties are knowledgeable in the area), the opinion rarely is actionable no matter how unreasonable it may be. This is because the recipient of the opinion knows what the facts are and, hence, knows what is opinion.
- When an opinion is not based on disclosed or reasonably assumed facts, there is a greater chance of liability. This is because the recipient of the opinion may reasonably conclude that the derogatory opinion is based on undisclosed defamatory facts. The reasonableness of such a conclusion usually depends on the relative sophistication of the giver of the opinion and of the recipient.

When these conclusions are applied to typical museum situations, the following guidelines emerge:

- It is better practice to recite the facts (including limitations) that form the basis for an opinion.
- In any event, the sophistication of the recipient should be considered. The more unsophisticated the recipient, the more important it is to recite the facts (including limitations) that form the basis of an opinion.

4. RELEASE FORMS AND OTHER PRECAUTIONS

If as a public service a museum adopts a practice of providing, gratis to the public, opinions on authenticity, it should have an effective way of promulgating this policy to staff. (See the sample policy, Figure XIII.1.) In addition, it should consider the following suggestions and cautions regarding the implementation of any such policy.[48]

47. *Mount v. Sadik,* No. 78 Civ. 2279, slip op. at 6 (S.D.N.Y. Oct. 26, 1978).

48. Note that these remarks concern gratis opinions given at the request of owners or their agents, not the scholarly debate or scholarly article situations or other situations in which nonowners seek opinions on authenticity.

Figure XIII.1

Sample Museum Policy Regarding Appraisals/Authentications

Often, guidance to staff on the question of the museum's position on providing appraisals and/ or authentications is made a part of a staff code of ethics or similar documents. The following is an example of how one art museum addressed this issue in its staff guidelines for professional practice. It is offered merely as an illustration. As mentioned in the earlier discussion, each museum should consider its particular circumstances before framing guidance for its staff.

SAMPLE

It is beneficial to the Museum and its constituency for staff members to assist collectors and other museum professionals in identifying, authenticating, and assessing the aesthetic quality and condition of works of art. Information of this kind may be provided freely on an oral basis, but written statements must be accompanied by the Museum's disclaimer form. All assistance, whether written or oral, shall be provided free of monetary or other compensation to staff members. Staff members are not permitted to issue a written statement of monetary valuation of any object other than those belonging to the Museum.

When called on to recommend appraisers, staff members should always endeavor to provide more than a single source to avoid the appearance of endorsement or favoritism.

- Clarify the type of service being offered and be consistent. If the purpose is to give the owner (or the owner's agent) a rather quick opinion from a knowledgeable staff member, arrange the process so that this is quite clear to the requestor. In other words, it should be obvious that substantial research is not being offered.
- Caution staff to confine themselves to areas of expertise.
- Decide if only oral opinions are going to be given. Some museums prefer this very informal approach.
- If written opinions are an option, establish, with professional advice, a format that lessens liability.
- Establish procedures that require requestors to verify their status as owners (or the agents of owners).
- Consider the use of release forms.

A release form in such situations can play a positive role if its chief purpose is properly understood. The chief purpose of a release form is to put the signer on notice (and to provide evidence of such notice) that the service being offered has specific limitations. A release should not be viewed as a way to absolve the museum of any and all liability—this would be against public policy. (When a service is offered to the public, one should be able to assume that the service, as described, will be performed without serious negligence.) Accordingly, regarding a release for those who may be requesting gratis opinions on the

authenticity of their objects, the release should caution the signer that the opinion is not a carefully researched one and that the opinion should not be relied on for important transactions. The "hold harmless" clause in such a release would then usually protect the museum from any damage that the signer suffers as a result of failure to heed these cautions. This is because the prime cause of the damage would have been the negligence of the owner in not heeding the cautions. But the "hold harmless" clause would offer little protection if the complained-of damage was caused by the museum employee dropping the article or if the signer could establish that the employee offering the opinion had absolutely no expertise in that type of object. In these last two examples, the causes of the damage would fall outside the described risks, and it would not be appropriate for the museum to seek, in a release form, protection from serious negligence.

An example of a release form used by an art museum follows (see Figure XIII.2). The form makes clear what is being offered, it requires the requesting party to verify ownership of the objects in question, and it provides a way to document for future reference, if necessary, the gist of an oral opinion. Like any other form printed in the text, this release form should not be adopted or adapted for internal use before a museum seeks professional advice.[49]

49. For more information on the subject of appraisals and authentications, see R. Lind, "Legal Risks Associated with Providing Expert Opinions and Authentications," in American Law Institute–American Bar Association (ALI-ABA), *Course of Studies Materials: Legal Problems of Museum Administration* (Philadelphia: ALI-ABA, 1991); L. Wise, "Suggested Precautions to Be Taken When Giving Opinions on Works of Art," in American Law Institute–American Bar Association (ALI-ABA), *Course of Studies Materials: Legal Problems of Museum Administration* (Philadelphia: ALI-ABA, 1991); B. Wolff, "The Contents of Museum Catalogues and Other Questions of Authenticity: When Can Museum Be Held Liable?" in American Law Institute–American Bar Association (ALI-ABA), *Course of Studies Materials: Legal Problems of Museum Administration* (Philadelphia: ALI-ABA, 1993); S. Levy, "Liability of the Art Expert for Professional Malpractice," 1991 *Wis. L. Rev.* 595 (No. 4); and F. Feldman and S. Weil, *Art Law* (Boston: Little Brown, 1986), 2:508–47.

Figure XIII.2

Release Form Regarding Appraisals/Authentications

[Front of card]

The X Museum

Opinions on Works of Art

No estimate or opinion concerning monetary value will be given or may any member of the staff give a written opinion or formal authentication.

The undersigned certifies that he or she is the owner of the work or works of art described here, and that he or she requests an examination and an informed oral opinion by a member of the staff of The X Museum as to the probable date and attribution of such work or works for his or her personal information only and not for use in connection with any past or contemplated commercial transaction.

In consideration of the giving of the informal oral opinion requested above, the undersigned owner agrees to indemnify The X Museum, its board of trustees, and the members of its staff, and save them harmless from any and all liability and expenses in the event of any claim by any other person or persons based in any way upon the rendition of such opinion.

Owner's Name:

Owner's Address:

Date: _____

(over)

· · · · · · · · · · · · · · · · ·

[Back of card]

Owner's Brief Description of Work or Works of Art:

Pursuant to the request and agreement on the reverse side of this card, the examination was made by the undersigned member of the staff of The X Museum, whose oral opinion, as recorded at the time of its rendition, was given as follows and no other opinion, oral or written, has been given.

Staff member:

Care of Collections

A. The Duty

A museum has a responsibility to provide reasonable care for the objects entrusted to it. Regarding objects owned by the museum, this responsibility springs from the museum's status, which resembles that of a charitable trust, as explained in Chapter I. In preserving property, museum trustees have a responsibility to use the same care and skill as would people of ordinary prudence, and they have a similar duty to use care in preventing the theft and damage of property by the unlawful acts of third parties.[1] Regarding objects on loan to the museum, the responsibility to provide care is governed by the bailment relationship created by the loan agreement.[2] Regarding all other objects placed in the custody of the museum, the degree of responsibility assumed by the museum should be set forth in

1. *Scott on Trusts* § 176 (3d ed.).

2. See Chapter VI, "Loans: Incoming and Outgoing," Section A(1), "Liability Exposure." See also *Johnson Estate,* 51 Pa. D&C 2d 147 (1970), wherein the court discussed appropriate protection measures for the John G. Johnson Collection held in custody by the Philadelphia Museum of Art. When making decisions about the type of care given an object, however, the museum must be guided by the title status of the object. If the object is on loan, the museum should be guided by the terms of the loan agreement and by common sense. In other

the temporary custody receipt, described in Chapter IX. As a practical matter, this means that a museum's governing body should be able to assure itself that museum policies and procedures afford prudent care and protection for all museum objects in light of existing circumstances.[3]

But the importance of collection care has not always been evident to museum boards. Collection care is costly, time-consuming, and relatively "invisible" to those who are not intimately acquainted with museum work. As a result, when budgets are being discussed or donors are being approached, collection care is usually the dowdy stepsister who is expected to defer to her more appealing siblings: public programming, new construction, and marketing. Signs indicate that some of this attitude is changing because of aggressive education campaigns being conducted by a small group of funding organizations and professionals, but there is still progress to be made. Codes of ethics promulgated within the museum profession are clear on the subject of collection care:

The development and preservation of the collection are cardinal responsibilities of the Museum.[4]

The distinctive character of museum ethics derives from the ownership, care, and use of objects, specimens, and living collections representing the world's natural and cultural commonwealth. . . . Thus, the museum ensures that . . . collections in its custody are protected, secure, unencumbered, cared for, and preserved.[5]

One of the essential ethical obligations of each member of the museum profession is to ensure the proper care and conservation of both existing and newly-acquired collections and individual items for which the member of the profession and the employing institutions are responsible, and to en-

words, the owner should be consulted when there is doubt whether consent has been given for a particular treatment, and in emergencies, the museum should use its best judgment. The same rules hold true for other situations in which the museum has custody of an object but is on notice that it does not have title to the object.

3. *Harris v. Attorney General,* 31 Conn. Supp. 93, 324 A.2d 279 (1974), discusses the responsibility of museum trustees to provide insurance and adequate security against theft and fire. In weighing the conduct of the trustees, the court considered the particular circumstances of the museum. In *Parkinson v. Murdock,* 183 Kan. 706, 332 P.2d 273 (1958), a question at issue was whether the trustees of an art collection had the implied authority to employ a conservator to evaluate the care and condition of objects in the collection. The court stated: "As a necessary incident to the carrying out of the expressed intention to provide an art collection that would last throughout the years, the trustees also have the duty to see that the objects of art purchased are properly housed and cared for so as not to deteriorate after a relatively short period of time. To achieve this end, the trustees have the power . . . to use all reasonable and necessary means to ascertain the condition of the objects of art" (277). See also *State of Washington v. Lappaluoto,* No. 11781 (Wash. Super. Ct., Klickitat County, April 5, 1977). In this case, which was eventually settled without going to judgment, the attorney general alleged that the defendant trustees had failed to require proper maintenance of the museum's collection and that this failure constituted a breach of their fiduciary duties. See also *People of the State of Illinois v. Silverstein,* No. 76, Ch. 6446 (Ill. Cir. Ct., Cook County, Oct. 1976), where the attorney general sued the museum trustees for, among other things, permitting a large portion of the museum's collection to remain in storage under poor conditions and thus accelerating deterioration. The case was eventually settled.

4. Association of Art Museum Directors, *Professional Practices in Art Museums,* (New York: Association of Art Museum Directors, 1991, amended 1992), 4.

5. American Association of Museums, "Code of Ethics for Museums" (1994), 8.

sure that as far as is reasonable the collections are passed on to future generations in as good and safe a condition as practicable having regard to current knowledge and resources.[6]

Museums should periodically review these ethical standards, which lend substance to the rather abstract legal duties imposed on museum trustees.[7] Too often the real impact of these duties is slow in coming. Consider the hypothetical situation of Historic Midland, an established museum complex composed of a well-known historic house, several archaeological sites, and a large craft museum. The museum is incorporated as a nonprofit organization and is governed by a twelve-member board of trustees.

Some closely associated with the organization have expressed concern about its long-term health. Despite its thriving appearance (well-designed exhibit areas, attractive shops, and high tourist attendance), over the past five years the organization has been able to meet expenses only because of a few grants it was fortunate to receive. There is no endowment fund. More worrisome is the fact that the collections are in disarray. Objects not on display remain uncatalogued and are stored haphazardly in storage areas with no environmental controls. All units within the organization continue to collect, with no central guidance.

Whenever the subject of the overall health of the organization is raised, both board members and staff wring their hands, talk about getting more grants—and continue in the same pattern. If someone were to suggest to board members that they may be facing a legal problem, they would be stunned. "How could anyone raise the issue of liability?" they might ask. It is not an inappropriate question when one remembers that a central purpose of most museums is to preserve for future generations well-maintained and well-documented collections. If this purpose is not getting reasonable attention in a museum, the governing board's adherence to its duty of obedience (the duty to be faithful to the mission of the organization) is rightfully at issue.

A museum's collection management policy can be the vehicle for implementing prudent measures concerning collection care. The policy can articulate the desired objectives, assign responsibility to staff for making certain decisions, establish procedures for bringing problems to the attention of appropriate staff, and require periodic reports for the museum's governing board on the status of care and security of the collections. If such reports indicate that collections are in serious peril for want of better care and/or security, the board becomes quite vulnerable if it takes no action. With reports of this nature before it, a prudent

6. International Council of Museums, *Code of Professional Ethics* (Paris: ICOM, 1990), § 6.3.

7. M. Malaro, "Collection Care and Accountability: Legal and Ethical Standards," in American Law Institute–American Bar Association (ALI-ABA), *Course of Studies Materials: Legal Problems of Museum Administration* (Philadelphia: ALI-ABA, 1989); A. Ullberg and R. Lind, "Consider the Potential Liability of Failing to Conserve Collections," *Museum News* 32–33 (Jan.–Feb. 1989); J. Fishman, "Standards of Conduct for Directors of Nonprofit Corporations," 7 *Pace L. Rev.* 389 (1987); and W. Boyd, "The Case of the Harding Museum: What Have We Finally Learned about Trustees' Liability?" in American Law Institute–American Bar Association (ALI-ABA), *Course of Studies Materials: Legal Problems of Museum Administration* (Philadelphia: ALI-ABA, 1984). For an interesting case study of a museum that could not effectively address long-simmering problems in collection care and security, see K. Guthrie, *The New York Historical Society: Lessons from One Nonprofit's Long Struggle for Survival* (San Francisco: Jossey-Bass, 1996).

board will look at available resources and will institute and oversee a plan for remedial action. But with no established mechanism for monitoring problems of this nature and for requiring reports to the board, the museum faces two unfortunate consequences: (1) A dedicated board does not get the information it needs to make wise budgetary decisions, and (2) a not-so-dedicated board need not worry about any paper trail that points to poor governance on its part.

The collection management policy could address various topics relating to collection care and security:

- Inventory procedures and the reporting of missing objects
- Security controls
- Conservation
- Fire and natural disaster protection
- Insurance (discussed in Chapter XV)

B. Inventory Procedures and the Reporting of Missing Objects

The task of doing a complete inventory of a museum's collections is frequently viewed as an unrealistic goal. It requires a major diversion of staff time, much careful planning, and a willingness to forgo projects that promise more immediate gratification. As a museum grows, however, effective management usually demands that a continuing inventory system be in place if intelligent decisions are to be made regarding collection use, growth, storage, and security. And it is never too late to begin such an inventory project, as evidenced by the experience of the Smithsonian Institution's National Museum of American History. That museum initiated a complete inventory when its collections were estimated to include more than fourteen million stamps, eight hundred thousand numismatic specimens, a half-million photographs, and over one million additional objects ranging from political memorabilia to locomotives.[8]

In addition to facilitating the improvement of research, documentation, and storage, an ongoing inventory system can be an essential security device. The knowledge that spot-inventory checks can and will be done routinely is an effective deterrent to misappropriation of collection objects; and if in fact a theft occurs, the museum is in a better position to detect the loss and take necessary action. If a museum is unable to demonstrate with certainty that a collection object is missing and, as a result, if reasonable efforts are not made to retrieve the property, the museum could be vulnerable to charges of mismanagement.

Consider the following situation. Museum X learns that two of its paintings are in the possession of Mr. Y. The museum demands that Mr. Y return the works, but he refuses, stating that he purchased the paintings in good faith from a dealer many years ago. The

8. D. Evelyn, "Taking Stock in the Nation's Attic," *Museum News* 39 (July–Aug. 1981). The article discusses practical problems encountered in initiating an effective inventory.

museum turns to its lawyer for advice. On investigation, the museum discovers that it cannot establish when the paintings might have been taken because it has no ongoing inventory system. In addition, staff members admit that they had previously looked for the paintings but had decided not to say anything when the works could not be found. They assumed that someday the paintings would turn up and that the museum did not want the embarrassment of reporting a loss.

On learning all the circumstances, the museum's lawyer is less than enthusiastic about bringing suit. He cites the case of *O'Keeffe v. Snyder*.[9] In *O'Keeffe*, a case decided in the state of New Jersey, the plaintiff, O'Keeffe, sought the return of paintings that she claimed had been stolen from her many years previously. The defendant, the present holder, alleged that he had purchased the paintings in good faith from another party. The court held that the plaintiff would be barred from pursuing her claim after the passage of so much time unless she could establish that she had exercised reasonable diligence in discovering the facts that formed the basis of her cause of action. Under this test, the burden was on the plaintiff to prove that she had been diligent and prompt in trying to establish when her paintings had been stolen and that she had taken reasonable measures at that time to alert law enforcement officials and the art world that the works had been unlawfully removed from her possession. In the given hypothetical case, if Museum X sues to retrieve the paintings and if the court adopts the *O'Keeffe* case reasoning, the museum will not be in a strong position to prove due diligence in keeping track of its property and in taking constructive action to pursue an apparent loss.

The museum's lawyer also cites *Guggenheim v. Lubell*,[10] a case very similar to the hypothetical case. Here the New York court used a different test for resolving a claim between a good-faith purchaser of art and a museum that was the victim of theft. Instead of looking to see whether a statute of limitations may have run because of the museum's lack of diligence in advertising the loss (the test used by the New Jersey court), the New York court turned to the equitable doctrine of laches as the appropriate test. Under the doctrine of laches, the court examines both the conduct of the victim and that of the good-faith purchaser; if the court finds that the victim's lack of diligence in searching for the stolen property caused the good-faith purchaser harm, then the plaintiff, in fairness, is barred from recovery. Accordingly, even under the laches approach, a museum could suffer because of its lack of diligence.[11]

Taking the hypothetical situation one step further, if the museum is barred from recovering because of negligence, can the museum board members be charged with the loss on

9. 170 N. J. Super. 75, 405 A.2d 840 (1979), 416 A.2d 862 (1980). This case is discussed in more detail in Section D(5), "Stolen Property," in Chapter IV.

10. *Solomon R. Guggenheim Foundation v. Lubell*, 569 N.E.2d 426 (N.Y. Ct. App. 1991).

11. Under an earlier New York case, *Menzel v. List*, 267 N.Y.S.2d 804, 49 Misc. 2d 300 (1966), *modified*, 28 A.D. 2d 516, 279 N.Y.S.2d 608 (1967), *third-party claim rev'd on other grounds*, 24 N.Y. 2d 91, 298 N.Y.S.2d 979, 246 N.E.2d 742 (1969), the museum would not be required to explain its lack of diligence. In *State v. West*, 293 N.C. 18, 235 S.E.2d 150 (1977), the state was held immune from the running of a statute of limitations.

the grounds of mismanagement?[12] There is no one answer; the facts of each situation will determine if there is negligence and if it amounts to misfeasance by board members. However, the lesson is that a museum is advised to have some reasonable system for keeping track of its collection objects; if a loss is suspected, museum policy should be to pursue the matter with diligence.[13] Also, as a review of cases discussed in Chapter IV, Section D(5), "Stolen Property," points out, "diligence" may require periodic efforts to publicize the loss over many years pending recovery.

C. Other Security Precautions

Security is one of the topics weighed in the accreditation of a museum by the American Association of Museums. The following questions, which are used as guides in the accreditation process, reflect a common understanding of what constitutes museum security:

1. Are the museum and its collections protected against burglary? against theft and pilferage?[14] against vandalism?
2. Are guards on regular schedules?
3. Are all parts of the collections kept locked or under scrutiny during open hours?
4. Are mechanical or electronic systems in operation?
5. Are there written procedures to be followed in case of fire? in case of holdup? in case of vandalism? in case of rowdyism?
6. Are these procedures known to all employees?
7. Do all employees know the procedures in case of illness or personal injury to staff or visitors?

12. See, for instance, *Lynch v. John M. Redfield Foundation*, 9 Cal. App. 3d 293, 88 Cal. Rptr. 86 (1970), where trustees of a charitable corporation were held personally liable for sums lost to the corporation because of their negligence. See also *Stuart v. Continental Illinois Nat'l Bank and Trust Co.*, 68 Ill. 2d 502, 369 N.E.2d 1262 (1977), *cert. denied*, 444 U.S. 844 (1979).

13. Diligent pursuit could involve some or all of the following: reporting to local police; reporting to the Federal Bureau of Investigation (FBI) and Interpol if property exceeds a certain value and if interstate and/or international traffic is suspected; and seeking publication in the *Art Theft Register* (maintained by the International Foundation for Art Research, New York, NY 10021) and in similar publications. In 1997 the FBI established the National Stolen Art File to help law enforcement agencies solve art theft cases. A missing object of artistic or historical significance, if valued at $2,000 or more, can be listed on this information database, but access to the file, whether for listing or searching, must come through a law-enforcement agency. Information on how the file operates can be obtained from National Stolen Art File, FBI, IT/GRCU, R. 5096, 935 Pennsylvania Avenue, N.W., Washington, D.C. 20535. See also H. Dudar, "Making a Dent in the Trafficking of Stolen Art," *Smithsonian* (Sept. 1995). BAMBAM (Brookline Alert Missing Books and Manuscripts, New York, NY 10021) operates a rare book and manuscript database to assist in the identification and recovery of stolen material of this type. A museum's ability to recover under an insurance policy when inventory records are incomplete is discussed in *Insurance Co. of North America v. Univ. of Alaska*, 669 P.2d 954 (Alaska 1983).

14. Insider theft is a common problem. See C. Lowenthal, "Insider Theft: A Trust Betrayed," *Museum News* 32 (May–June 1994).

8. Are records adequate to furnish the police with usable descriptions of missing specimens?[15]

9. Is the building adequately insured?

10. Is there a disaster plan in place?[16]

In seeking to provide reasonable security for its collections, a museum may also take several other precautions. Many of these additional precautions involve the establishment of internal rules that require staff to be conscious of security and accountability. For example, museum procedures can require that a written notation be made on appropriate records whenever a collection object is moved, even if the move is only internal. With such a requirement in effect, the staff receives an immediate warning of possible misappropriation when a collection object is missing without a written explanation. A package pass system and/or a requirement that all packages must leave through a designated checkout area is another precaution worth considering. Policies regarding collection access, whether by staff or outsiders, also can be reviewed to be sure that the procedures afford reasonable protection yet do not unduly inhibit collection use. More is said about the issue of access in Chapter XVI.

Whether a museum's security procedures fall so short of accepted professional standards as to constitute a violation of legal responsibilities depends on the facts of a particular situation. But if little thought has been given to security, a museum is placing itself in a vulnerable position.[17]

D. Conservation

The approach to conservation has changed radically in many U.S. museums—and with good reason. Historically, the conservator was trained to focus on the individual objects: the

15. With the rapid advances in computer technology, it is becoming easier to transmit clear photographic reproductions electronically. This makes good pictures of collection objects particularly valuable when theft occurs. Pictures can be transmitted worldwide to law enforcement agencies in little time.

16. See Section E for a discussion of disaster plans.

17. Insurance industry publications can often provide useful information. For example, the Inland Marine Underwriters Association pamphlet "Museums and Galleries Guide to Property Loss Control" (New York, 1988) gives a checklist of liability exposures and hazards commonly associated with the management of museum collections. See also *Museum Security and Protection: A Handbook for Cultural Heritage Institutions* (New York: International Committee on Museum Security, 1993), and F. Howse, ed., "Safety in Museums and Galleries," special supplement to *International Journal of Museum Management and Curatorship* (1987). See also R. Dierker and R. Burke, "Legal Questions in Providing Security for Museum Objects," in American Law Institute–American Bar Association (ALI-ABA), *Course of Studies Materials: Legal Problems of Museum Administration* (Philadelphia: ALI-ABA, 1980), 163, for an annotated outline of legal issues associated with security measures; M. Shaines and R. Dierker, "Problems Relating to Theft by Museum Staff: The Legal Risks of Catching the Employee Thief," in American Law Institute–American Bar Association (ALI-ABA), *Course of Studies Materials: Legal Problems of Museum Administration* (Philadelphia: ALI-ABA, 1982), 121; L. Fennelly, *Museum, Archive, and Library Security* (Boston: Butterworths, 1983); and S. Keller and D. Willson, "Security Systems," in C. Rose et al., eds., *Storage of Natural History Collections: A Preventive Conservation Approach* (York, Pa.: Society for the Preservation of Natural History Collections, 1995).

object in serious need of treatment or the object that warranted special attention because it was to go on exhibit. Within the museum the conservators' talents were usually limited to this type of service. But by the mid-1970s a number of museums in the United States began to take a more holistic approach to the management of their collections. The early emphasis was on the quality of documentation and record-keeping. Standards were established in these areas within the museum as a whole, and the authority to implement and oversee these standards was centralized in one individual or office. This change reflected the heightened consciousness of those governing museums, who now realized that they had a trustlike responsibility to see that collections were managed prudently for the benefit of the public. And when standards were being established for documentation and record-keeping, a major goal was to prevent problems. In other words, a central test was the following question: "Based on our experience to date, are these standards designed to avoid problems now and in the future?" Using this holistic approach, museums made dramatic advances in gaining control over collections.

All of this was not lost on some conservators. If problems could be avoided in the areas of documentation and record-keeping through coordinated effort within the museum, why could not this approach be used to prevent or mitigate damage to collection objects? These conservators began to look at collections as a whole and to identify steps that could be taken to slow deterioration, to prevent damage, or to control loss. This new approach is commonly called "preventive conservation."[18] "Preventive conservation can be defined as any measure that prevents damage or reduces the potential for it. It focuses on collections rather than individual objects, nontreatment rather than treatment. In practical terms, the handling, storage, and management of collections (including emergency planning) are critical elements in a preventive conservation methodology."[19]

Two major steps have been taken since the late 1980s to advance the preventive conservation approach within museums. One is the development and utilization of the "conservation assessment" as a management tool; the other is the recognition that preventive conservation principles need to be woven into the museum's collection management policy.

Because preventive conservation involves all aspects of object care and use, a museum must look at many facets of its operation just to determine the adequacy of its current practices regarding collection care. The National Institute of Conservation and the Getty Conservation Institute cooperated in a two-year study to develop a methodology for gather-

18. The conservation profession's endorsement of the preventive conservation approach is articulated in the "Code of Ethics and Guidelines for Practice" of the American Institute for Conservation of Historic and Artistic Works (revised as of Aug. 1994). Section 20 of the guidelines reads: "The conservation professional should recognize the critical importance of preventive conservation as the most effective means of promoting the long-term preservation of cultural property. The conservation professional should provide guidelines for continuing use and care, recommend appropriate environmental conditions for storage and exhibition, and encourage proper procedures for handling, packing and transport."

19. "Preventive Conservation," VII *Conservation* (No. 1, winter 1992). For a volume dedicated to natural history collections, see C. Rose et al., eds., *Storage of Natural History Collections.: A Preventive Conservation Approach* (York, Pa.: Society for the Preservation of Natural History Collections, 1995).

ing this needed information. The study report, "The Conservation Assessment: A Tool for Planning, Implementing, and Funding," set forth the standards for what is now commonly called a "conservation assessment."[20] A conservation assessment "should cover all topics affecting the care of collections, such as: museum staffing and training; policies and procedures concerning the use of collections, storage and exhibition conditions; and the museum environment, including the fabrication and the condition of structures housing collections. In the case of historic buildings, the proper care and stabilization of the structure must also be considered in the planning process."[21]

Once information is gathered, the process requires those conducting the assessment to describe and list, in order of priority, the steps that need to be taken to improve the overall care of the organization's collections. These recommendations are to be further defined according to immediate, medium-range, and long-range goals. In other words, the assessment report should list

1. those improvements that can be made with minimal or existing resources;
2. those improvements that require more effort and expenditures; and
3. those improvements that require long-range planning and fund-raising.[22]

A museum that is serious about collection care should have in hand a conservation assessment, as described above, and that document should be on the agenda for discussion whenever budgets and long-range plans are being voted on. A museum will have difficulty insisting that informed decisions are being made regarding the allocation of museum resources if information on the important topic of collection care is not routinely available to the deciding authorities.[23]

Because preventive conservation is so broad in scope, it affects just about all aspects of museum activity. Conservation concerns should be on the table when the subject is the acquisition of an object for the collection. This is the time to consider the probable demands on the museum to use and care for the object for an indefinite period of time. Many museums, when they find themselves burdened with objects that they cannot effectively use and/ or with objects that need extensive conservation care, realize too late that better-designed acquisition procedures could have helped them avoid these situations.[24] Conservation con-

20. S. Wolf, ed., *NIC and the Getty Conservation Institute* (Washington, D.C.: NIC, 1990), available from NIC, 3299 K St., N.W., Washington, D.C. 20007.

21. C. Rose, "Collections Care and Accountability: Practical Concerns about Storage, Conservation, and Inventory Control," in American Law Institute–American Bar Association (ALI-ABA), *Course of Studies Materials: Legal Problems of Museum Administration* (Philadelphia: ALI-ABA, 1989), 445–59, 448.

22. Ibid. See also American Association of Museums, *Caring for Collections* (Washington, D.C.: AAM, 1984), 44, and B. Appelbaum and P. Himmelstein, "Planning for a Conservation Survey," *Museum News* 5 (Feb. 1986).

23. See the discussion of "Process" in M. Malaro, "Education of Nonprofit Boards," *Museum Governance: Mission, Ethics, Policy* (Washington, D.C.: Smithsonian Institution Press, 1994), 32.

24. See, for example, J. Bethell, "Damaged Goods," *Harvard Magazine* 24 (July–Aug. 1988), which recounts Harvard's experience with a set of five huge murals painted by Mark Rothko. Harvard acquired the works in 1962, and by the late 1970s, the works were all severely damaged by light and were confined, apparently for-

cerns should also be factored into decisions to lend or borrow. (Can the object safely make the proposed trip? Is the composition of the proposed incoming loan such that an object may need special care?) Finally, conservation concerns should be considered in decisions to deaccession. Consider this situation. A small historical society held as a restricted gift a rare and valuable collection of natural history and science books. Over the years the books suffered from extensive "foxing," a discoloration believed to be caused by mold and impurities in the text paper. The historical society sought court approval to sell the collection because it estimated that to arrest the damage and provide a secure environment would cost almost $100,000. After a hearing, the court refused to allow the society to deviate from the terms of the gift and instead ordered the society to begin a legal proceeding that would allow the court to remove the collection from the control of the society and place it with another organization willing to care for it properly.[25] At this point, the historical society undoubtedly wished it had explored its options more fully before seeking permission to dispose of the material. Likewise, the care and the use of collections from indigenous peoples are increasingly raising practical and ethical problems that should have the attention of conservators. Well-informed conservators can play a pivotal role in finding solutions to difficult situations when native peoples object to standard museum methods of caring for or handling collection objects or human remains.[26]

The above examples illustrate that conservation concerns cannot be confined to a discrete paragraph in a museum's collection management policy but that the issue of proper object care and use has to be woven into many decision-making processes. This means that collection management policies have to be reviewed and, where necessary, revised to accommodate these broader concerns. It also means that the museum staff charged with drafting and overseeing the implementation of collection management policies have to add to their professional training instruction in preventive conservation principles so that they can effectively advocate a sensible and balanced approach to collection concerns within their museums.[27]

ever, to a darkened storeroom. The cause of the problem was the quality of the paint used by the artist. The permanence of materials used in more contemporary art and design objects should be considered when collecting. The life span of certain plastics, foams, and paint used in mid- to late-twentieth-century products is proving to be quite short, no matter what preservation techniques are used. See J. Iovine, "Museums Weep for Their Tupperware," *New York Times*, Oct. 10, 1996. For a dramatic case of simply overcollecting without thought of curation costs, see footnote 7, above, on the story of the New York Historical Society.

25. See, for example, *Susquehanna County Historical Society and Free Library Assoc. v. Theodora Cape Gray and J. Morris Evans,* Court of Common Pleas, Susquehanna County, Pa., Civil Action, Orphans' Ct. Division, No. 1986-43 O.C. and No. 1986-489 C.P.

26. See, for example, M. Clavir, "Reflections on Changes in Museums and the Conservation of Collections from Indigenous Peoples," 35 *Journal of the American Institute for Conservation* (1996), and G. McGowan et al., "The Ethical Dilemma Facing Conservation: Care and Treatment of Human Skeletal Remains and Mortuary Objects," 35 *Journal of the American Institute for Conservation* (1996).

27. Several organizations provide up-to-date information on conservation concerns of interest to museums. Among these organizations are the American Institute for Conservation of Historic and Artistic Works, Washington, D.C.; the National Institute for the Conservation of Cultural Property, Washington, D.C.; and the Getty Conservation Institute, Marina del Rey, Calif. The Office of the Chief Curator, National Park Service, U.S. De-

E. Disaster Planning

1. THE INDIVIDUAL MUSEUM

When a duty of care is imposed on an organization, those who govern the organization are responsible for protecting against reasonably foreseeable dangers. If a particular danger frequently has catastrophic effects, the responsibility to protect is heightened. Considering the frequency and severity of disasters in this country in recent years and the extensive media coverage of these events, those who govern museums cannot argue that a disaster is an unforeseen danger.[28] In addition, disaster planning is now a common topic at professional meetings, and there are numerous publications on the subject. From a legal point of view, a museum has little excuse not to give a reasonable amount of attention to such planning.

"Disaster planning" is another term for emergency preparedness for such events as flood, fire, hurricane, tornado, earthquake, explosion, riot, or other foreseeable forces of nature or people. Disaster planning involves advanced planning, assignment of responsibility, coordination with other organizations, education, and vigilance. It should be an ongoing process with periodic reviews for key staff and with organization-wide drills. Disaster plans carefully folded away in drawers to gather dust do not satisfy a duty of care.

The purpose of this section is not to explore the details of preparing and implementing a disaster plan, since many guides provide this information.[29] Rather, the goal is to impress on museums the importance of disaster planning and to offer some guidance on legal ramifications.

As stated, a duty of care encompasses a responsibility to plan for normally foreseeable disasters. The level of sophistication in the planning will depend on the resources available to the museum. What is "normally foreseeable" is a matter of common sense. To ensure that sensible decisions are made regarding the adequacy of its planning, a museum should have records showing that policymakers were asked to consider the matter of disaster plan-

partment of the Interior, Washington, D.C., issues numerous publications concerning the care of museum collections. See also A. Ullberg and R. Lind, "Consider the Potential Liability of Failing to Conserve Collections," *Museum News* 32–33 (Jan.–Feb. 1989). For books on museum conservation concerns, see, for example, B. Appelbaum, *Guide to Environmental Protection of Collections* (Madison, Conn.: Sound View Press, 1991); K. Bachmann, ed., *Conservation Concerns* (Washington, D.C.: Smithsonian Institution Press, 1992); S. Butcher-Youngham, *Historic House Museums: A Practical Handbook for Their Care, Preservation, and Management* (New York: Oxford U. Press, 1993); National Institute for Conservation, *Collections Care: A Selected Bibliography* (Washington, D.C.: National Institute for Conservation, 1990); National Park Service, *Museum Handbook, Part I: Museum Collections* (Washington, D.C.: National Park Service, 1990); and National Committee to Save America's Cultural Collections, *Caring for Your Collections* (New York: Henry N. Abrams, 1992).

28. See, for example, J. Levin, "In the Wake of Disaster: FEMA and the Preservation of Cultural Property," *Museum News* 36 (May–June 1994).

29. See, for example, C. Nelson, *Protecting the Past from Natural Disasters* (Washington, D.C.: National Trust for Historic Preservation, 1991); Texas Museum Association, *PREP: Planning for Response and Emergency Preparedness* (Austin: Texas Museum Association, 1993); B. Jones, *Protecting Historic Architecture and Museum Collections from Natural Disasters* (Boston: Butterworths, 1986); and A. Lord et al., *Steal This Handbook: A Template for Creating a Museum's Emergency Preparedness Plan* (Columbia, S.C.: Southeastern Registrar's Assoc., 1994). Check also the current bibliographies produced by the Getty Conservation Institute, Marina del Ray, Calif., and by the National Institute for the Conservation of Cultural Property, Washington, D.C.

ning, that they were provided with good background information, that they deliberated, and that they reached an agreement on how their museum should proceed. With records of this nature, courts are reluctant to fault decision-makers unless it can be shown that reasonable people could not have reached such decisions based on the information available. In other words, if decision-makers take the time to inform themselves, reach an agreement, and make a record of the process, the chances are quite good that their decision not only will be a sensible one but also will withstand any legal challenge.

Policymakers will also want to be sure that the responsibility for the development and implementation of emergency plans has been clearly delegated and that efforts to keep plans current and to keep staff aware of their respective roles are ongoing. Plans should cover the human factor (e.g., staff, volunteers, visitors) and property (buildings and objects owned by or in the custody of the museum).

Disaster plans should be in writing and should include such useful information as plans and diagrams of buildings, locations of important equipment, and telephone numbers of organizations or individuals capable of providing expert advice. Duplicates of disaster plans should be kept in a separate facility.

2. A NATIONAL APPROACH

The museum community is becoming more organized in its approach to disaster planning, and this should prove to be a boon to the individual museum. In December 1994, the Getty Conservation Institute, the National Institute for Conservation of Cultural Property, and the Federal Emergency Management Agency met with representatives of many national cultural and historical preservation organizations to plan a more cohesive approach to emergency preparedness. The director of the Getty Conservation Institute noted: "For too long we have been reinventing the wheel each time a disaster strikes. We need a national partnership to create an emergency infrastructure that can provide help in a coordinated way."[30]

As a result of the meeting, a National Task Force on Emergency Response was formed in 1995. The first three priorities of the group are

1. a more efficient system for disseminating information;
2. on-site assistance such as the training and organization of conservation "SWAT teams"; and
3. improved funding for recovery.

The progress of this national task force is definitely worth monitoring.[31]

30. Remarks of Miguel Angel Corzo, from J. Long, "When Disaster Strikes: A National Response," X *Conservation* 12 (No. 1, 1995).

31. See also J. Teichman, "Selected Materials on Disaster Planning for Collections, Visitors, Staff, and Facilities," in American Law Institute–American Bar Association (ALI-ABA), *Course of Studies Materials: Legal Problems of Museum Administration* (Philadelphia: ALI-ABA, 1991); M. Munizer and M. Williard, "Disaster Management," *The Sourcebook* (Washington, D.C.: American Association of Museums, 1995); and P. Miller, "Emergency Preparedness in Museums and Historic Sites," *Technical Insert* (Champaign: Illinois Heritage Assoc., 1989).

Insurance

A. Scope of Discussion

B. Obligation to Insure

C. The Role of Insurance

D. Selecting a Policy

E. Insurance Professionals

F. Model Policy

A. Scope of Discussion

This chapter discusses insuring collection objects owned or under the control of a museum. It does not cover what might be called "people insurance," such as trustees' and officers' liability insurance, personal injury insurance, and bond coverage on employees. Nor does it discuss the property insurance typically secured by any nonprofit organization. These types of protection are certainly of interest to a museum and should be weighed when reviewing the organization's overall insurance programs, but they are outside the scope of this text, which focuses on collection objects.[1] Nor does this chapter attempt to give a comprehensive treatment of the subject of collection insurance. More and more insurance providers are publishing newsletters and information packets that focus on collection insur-

1. Books and articles that address insurance include the following: "Am I Covered for . . . ?" *A Guide to Insurance for Non-Profits,* 2d ed. (Washington, D.C.: Nonprofit Risk Management Center, 1992); D. Kurtz, *Board Liability: Guide for Nonprofit Directors* (Mt. Kisco, N.Y.: Moyer Bell, 1988), specifically Chapter 6, "Indemnification and Insurance"; B. Smith, *How Insurance Works: An Introduction to Property and Liability Insurance* (Malvern, Ga.: Insurance Institute of America, 1984); *Insurance and Risk Management for Museums and Historical Societies* (New York: Gallery Assoc. of N.Y., 1985); C. Tremper, *Reconsidering Legal Liability and Insurance for Nonprofit Organizations* (Washington, D.C.: Law College Education Services, 1989).

ance, and museums should find ample current information on an ever-growing variety of forms of coverage. Rather, the purpose of this discussion is (1) to comment, from a lawyer's point of view, on the museum's obligation, if any, to insure collection objects and (2) to suggest an insurance approach that is consonant with a museum's overall responsibilities. Specific insurance questions arising in matters such as the management of loans and the care of objects placed in the custody of the museum are discussed in the chapters that address those specific arrangements (Chapters VI and IX).

B. Obligation to Insure

Collection objects that may be the subject of insurance fall into various categories:

1 Objects owned by the museum (whether on premises or off)[2]
2. Objects borrowed by the museum for exhibition, study, and the like[3]
3. Objects placed in the custody of the museum for other than loan purposes (for example, for identification or possible purchase)

Whether the museum has an obligation to insure for each category and, if not, whether the museum should insure depend on the circumstances. If the objects are owned by the museum, an obligation to insure is not normally mandated as a requirement of due care.[4] Frequently museum collections are irreplaceable; therefore, prudent management may dictate that available funds be spent for the security and care of the objects rather than for insurance, which can only compensate for loss. This argument is more persuasive when the objects are on the premises and under the museum's immediate control. When the objects are off-premises, however, insurance may be a prudent safeguard. The likelihood of loss or damage that cannot be controlled by museum staff is greater off-premises, and frequently the cost of insuring can be imposed on the recipient of the objects.

General guidance concerning the insuring of a museum's own collections should properly come from the museum's board of trustees. The board is charged with providing due care

2. For the historic house property, the building itself is part of the "collection" for insurance purposes, and coverage should be tailored to its unique problems. Also, records associated with collection objects have a value of their own. Some insurers offer coverage for the duplication of such records.

3. If an international loan is involved, check to see if the U.S. Indemnity Program (described in Chapter VIII) may be applicable. Also, some states offer indemnity coverage. In 1981, Florida passed an Arts Indemnification Act (Fla. Stat. Ann. 265.51) designed to insure works of art or exhibitions borrowed from within the United States for display in Florida. Florida was the first state to adopt such a program. In 1984, Iowa passed a similar statute. The Iowa Arts Council administers the statute (Iowa Code Ann. 304 A. 21–30). In 1989, Texas enacted an indemnity statute (Tex. Gov't Code Ann. 481.271 et seq., [Vernon 1990]). According to one commentator, there has been relatively little use of these state statutes. See N. Morris, "State Art and Artifacts Indemnity: A Solution without a Problem?" 12 Hastings Comm. & Ent. L.J. 413 (No. 3, spring 1990).

4. See Harris v. Attorney General, 31 Conn. Supp. 93, 324 A.2d 279 (1974); In re Petition of Trustees of the Hyde Collection Trust, No. 17023 (N.Y. Sup. Ct., Warren County, decision, March 25, 1974; judgment, June 18, 1974). See also Restatement (Second) of Trusts § 176 (1959) and Scott on Trusts § 176 (3d ed.).

for the collections, and it must determine how best to carry out this obligation within the museum's resources. Barring specific restrictions to the contrary and based on a museum's particular circumstances, a board, acting prudently, could determine that not insuring the collections is more practical, or that the collections should be insured but only for a portion of their value, or that the collections should be insured for full value, or that the collections should be insured only when off-premises. What is important is that the board periodically reviews the situation and makes an informed decision regarding the insurance program. An informed decision means that the board weighs, in the decision-making process, staff reports and recommendations, suggestions from outside experts, and information on how similar museums are addressing these issues. The board should then consider the museum's particular circumstances: the types of risks facing its collections, the level of risk-preventive techniques currently in place, and the resources of the museum, for example. If the decision-making process is taken seriously and if a record is made of the process, the board's decision should withstand legal challenges. The law does not require that the board make the "right" decision (known, of course, only with the benefit of hindsight)—only that the board inform itself and make a reasonable decision based on the information before it.

If the objects in question are items on loan to the museum, different considerations arise regarding insurance. The loan agreement may require insurance by the museum; so clearly, the museum has a contractual obligation to provide coverage. If the loan agreement is silent on the issue or if the lender merely has waived insurance, this does not necessarily preclude the lender from suing to recover for loss or damage caused by the museum's negligence.[5] The museum may well determine that it should insure to protect itself from possible claims (or from such claims that exceed an amount that the museum can self-insure). If a lender has waived insurance and has agreed in writing to hold the museum harmless from loss or damage arising out of the loan, there may be little need to insure.[6]

If the objects in question are in the custody of the museum primarily for the benefit of the owners (for example, for identification), the law usually imposes a less demanding standard of care. As explained in Chapter IX, "Objects Left in the Temporary Custody of the Museum," a special museum form (normally the temporary custody receipt that is given to the owner) should document the receipt of such objects and explain the degree of care that will be afforded them. Such clear notice to owners strengthens the museum's position if there is an accident. Barring a specific agreement with the owner to the contrary, it is difficult to infer that the museum is obligated to insure such objects. Whether a museum should carry insurance on this category of objects or should self-insure is a decision for each museum. Much will depend on the volume of objects involved, their relative value, the efficiency of the museum in processing such objects, and the ability of the museum to absorb

5. As noted in Chapter VI, "Loans: Incoming and Outgoing," the museum, as a bailee, has an obligation to exercise reasonable care in the handling of the loaned property. If the property is damaged or lost while in the museum's custody, refuting a charge of negligence is usually difficult. See also in that chapter the difference between waiving insurance and waiving any right to sue.

6. Even with a waiver of liability, a museum could be held liable for gross negligence. A "legal liability" clause in an insurance policy can provide coverage for situations of this type, but the exact scope of such a clause must be clarified with the insurer.

some liability. If the museum decides to insure, it should be able to negotiate a very reasonable rate for the coverage, assuming that it has a thoughtfully prepared temporary custody receipt form and a system for implementation.

C. The Role of Insurance

Insurance should not be used as a cure-all for poor management. The "Don't worry, we're insured" approach may be the simplest, but it hardly comports with responsibilities to care for and preserve cultural objects. If viewed from the proper perspective, insurance, as a rule, should be the last resort for the museum manager. Prevention, rather than reimbursement, should be the primary goal.

The term "risk management" is in vogue. Fundamentally, this is the application of analysis and common sense to perceived risks. Those museum officials who are responsible for advising on insurance needs should be familiar with the risk management technique, which puts insurance in its proper place. Risk management deals with the identification, analysis, and evaluation of risk and with the selection of the most advantageous methods for handling risk. It is an aggressive approach that seeks first to avoid, control, reduce, or accept an identified risk before insuring against it.[7] For example, if a museum has many valuable small objects in its collections and if the question is whether they should be insured on-premises, the risk manager looks at storage security, exhibit procedures, display cases, detection equipment, crowd control, and inventory and record procedures, all with an eye to avoiding or reducing possible loss or damage. Such a review might demonstrate that museum time and funds would be better spent on improving preventive procedures and equipment rather than on paying for insurance coverage. Similarly, if the museum is experiencing a high rate of loss for incoming loans, the risk manager does not automatically budget more for insurance. First the risk manager investigates why losses are increasing. Are too fragile objects being accepted? Are unpacking and packing procedures at fault? Are condition reports being filed routinely so that the museum knows when loss or damage occurs? An elevated loss rate is accepted only when the risk manager is satisfied that reasonable care has been taken down the line to avoid or control the situation. The general risk management approach is inherent in any prudent review of a museum's collection procedures, with the insurance program viewed as the last bastion in the defense.

D. Selecting a Policy

For the insurance industry, collection insurance falls under the heading of "fine arts" insurance, no matter what type of museum collection is at issue (butterflies, muskets, or photographs). Fine arts insurance is a form of "Inland Marine" coverage.

An insurance policy amounts to a contractual arrangement, between the museum and

7. See D. Meyer, "A Risk Management Policy," in American Law Institute–American Bar Association (ALI-ABA), *Course of Studies Materials: Legal Problems of Museum Administration* (Philadelphia: ALI-ABA, 1986).

the insurance company, regarding specified risks. Having identified the types of risks it wants to cover, a museum should be able to bargain intelligently regarding the terms of its insurance contracts. Effective bargaining requires some comprehension of the factors that will be weighed by the insurance company in deciding whether to accept a risk (and at what price);[8] otherwise, the museum cannot hope to put its best foot forward. Effective bargaining also requires that the museum accept only a policy that meets its precise needs and that does not strain staff capabilities.

Historically, insurance specialists have listed the following as the most common problems encountered when evaluating a museum risk:

1 *Record-keeping.* The museum's records do not accurately reflect what is in storage, what is on display, or what is on loan. As a result, insurance is either insufficient or excessive.
2. *Security.* There may be little protection against theft.
3. *Valuation.* There can be a range of problems associated with setting values and keeping them current.[9]
4. *Hazards.* These involve fire and the related perils of smoke and water damage.
5. *Storage.* Artifacts may be carelessly placed in storage containers and in poor storage areas.
6. *Transportation.* Packing and shipping methods frequently fall below acceptable standards.[10]

A museum preparing to bargain for insurance coverage is advised to review its situation regarding these listed problem areas, compile needed statistics, and if necessary, initiate corrective measures that improve its attractiveness as a risk. Once again, the museum's collection management policy can come into play as a means of implementing good internal procedures and of demonstrating to a prospective insurer that management in the museum is not left to chance. Armed with relevant facts and figures on its operation, the museum is in a better position to bargain realistically (that is, sell its risk, not buy insurance) for the insurance it actually needs.

8. The insurance underwriter actually evaluates the risk and decides whether the company should accept certain coverage and at what rates. Naturally, a museum wants its circumstances to be presented to the underwriter in a favorable light. See Section E, "Insurance Professionals," for a definition of "underwriter." See also D. Kaiser, "How an Underwriter Rates Your Museum for Fine Arts Coverage," in American Law Institute–American Bar Association (ALI-ABA), *Course of Studies Materials: Legal Problems of Museum Administration* (Philadelphia: ALI-ABA, 1986).

9. P. Nauert and C. Black, *Fine Arts Insurance: A Handbook for Art Museums* (Savannah, Ga.: Association of Art Museum Directors, 1979), 27, lists these first three problems as the most common in museums.

10. I. Pfeffer, "Insuring Museum Exhibitions," 27 *Hastings L. J.* 1123 (1976), lists the last three problems as the ones he believes are most common in museums. One well-known insurance broker, Huntington Block, cites as the number-one cause of museum collection claims "accidents while objects are being handled or transported." See D. Dudley et al., *Museum Registration Methods* (Washington, D.C.: American Association of Museums, 1979), Chapter 9.

Any insurance policy that is under discussion should be carefully reviewed to be sure that it offers adequate protection and that it does not impose unrealistic demands on the museum.[11] A wise precaution is to involve in the review those museum staff who will bear the burden of implementing the policy requirements. Several points warrant special scrutiny:

1. Does the coverage clearly define the property the museum wants to cover? For example, if a museum maintains several types of collections (permanent, study, education), is it clear which are covered? Is it clear which incoming and outgoing loan situations are covered and when coverage goes into effect? Are such items as partial gift situations, jointly held property, and remainder interest in property covered? Are frames, display cases, and other auxiliary materials covered?

2. Are the territorial limits of coverage adequate, and what is the most economical method for obtaining coverage for occasional shipments beyond normal traffic areas?

3. Are the perils and the exclusions realistic? Most policies are "all risks" with named exclusions. This is a more advantageous approach for museums because evaluating specified exclusions is easier than listing all possible perils. A museum has some leeway in negotiating certain exclusions, with corresponding rate adjustments, but the following exclusions usually survive in an "all risks" policy:

 • Wear and tear, gradual deterioration, insect, vermin, inherent defects (sometimes referred to as inherent vice), or damages caused by repairing, restoration, or retouching
 • War, insurrection, rebellion, revolution, or civil war
 • Nuclear damage
 • Shipments by mail, unless registered, first-class, or insured parcel post (and with possible limitations on dollar value)[12]

4. Are the procedures for establishing valuations realistic? For example, if valuation is based on the fair market value at the time of loss, there is no critical pressure to constantly readjust book valuations. But what if a claim is for a borrowed object with an insurance value preset by the owner under the terms of the loan agreement? The museum may need to distinguish between the procedures used in valuing objects loaned to the museum and those used in valuing the museum's own objects. In any event, the museum should clearly understand the policy terms in this area and should make sure that its internal methods for setting values mesh.

11. For example, if the policy calls for the museum to "warrant" or "guarantee" that something will be done, it is worth requesting that this be changed to read that the museum, "to the best of its ability," will do as stated. Time limits should be checked for reasonableness; rather than agreeing to do something "immediately," the museum might request a change to "as soon as practicable." Regarding "proof of loss" provisions, see *Insurance Co. of North America v. Univ. of Alaska,* 669 P.2d 954 (Alaska 1983).

12. D. Dudley et al., *Museum Registration Methods* (Washington, D.C.: American Association of Museums, 1979), 144.

5. A "pairs and sets" clause can be important. Such a clause provides that if any of the pieces that make up a pair or set is lost, the insured has the option to claim a total loss for the pair or set. However, if total loss is paid, the remainder of the pair or set becomes the property of the insurance company (as also happens when an object is declared a total loss).

6. Consider, also, a "buy back" provision. This gives the insured the right to buy back from the insurance company a lost or stolen item that is recovered after the claim has been paid.

7. Clarify with the insurer who bears the responsibility of "diligently pursuing a loss" once the museum has been reimbursed for an apparent theft of an object. As explained in Section D(5), "Stolen Property," in Chapter IV, to preserve a right of recovery in case a stolen object surfaces later, the owner should take reasonable efforts to continue to pursue the loss. Once the insurance company pays on the loss, the insurance company technically acquires the rights of the owner. As a practical matter, the museum usually wants to be able to claim a stolen object if that object eventually surfaces. Clarification with the insurer on how "diligent pursuit" is managed in such instances is a wise precaution.[13]

8. Is it prudent to include deductibles or franchises in order to reduce premiums? With a deductible, no claim is made if the loss is less than the stated deductible. With a franchise, the insurance pays the entire amount if the loss equals or exceeds the amount of the franchise. In deciding whether such clauses are prudent, the museum must consider its ability to respond with museum funds to cover losses or repairs falling below these limitations.

E. Insurance Professionals

The insurance industry has a range of specialists who assist the public in the purchase of coverage, in the control of risk, and in the settlement of claims. A rudimentary knowledge of who these specialists are can be extremely helpful to museum personnel. The following listing describes those specialists most likely to interact with museum staff. The descriptions are the work of Nancy Powell, Registrar and Fine Arts Specialists for the CIGNA Museum and Art Collection of Philadelphia, Pennsylvania.[14]

13. This issue came up in the case of *Erisoty v. Rizik,* Civ. Action #93-6215 (U.S.D.C., E.D. of Pa., decided Feb. 23, 1995). In this case, the owners, after being reimbursed by their insurance company, continued to search for lost art. When the art surfaced and they asserted their ownership rights, they were challenged by the possessors of the art on the issue of their standing to sue. The owners prevailed (their insurer was not an adversary), but the court's comments suggest that this is an issue that should be clarified between the insurer and the insured.

14. These definitions first appeared in an article by Powell: "Insurance 101 & 102: The Basics for Collections," *Courier* (Sept.–Oct. 1995). They are reprinted through the courtesy of the Mid-Atlantic Association of Museums, Newark, Del., and the author.

Agents and Brokers. There are numerous ways to purchase insurance. Some companies sell directly to the consumer through agents. Independent agents represent two or more insurance companies. A broker represents the buyer, not the insurance company. A broker-agent is an independent salesperson who, though representing certain insurance companies, may also use other companies in his or her search to maximize protection and minimize cost. Ultimately, a museum's insurance may be placed with more than one company, depending on the museum's needs. Insurance salespeople are regulated by each individual state.

Underwriter. The underwriter reviews applications for insurance coverage, assesses the risk, and decides whether to reject or accept that risk. If the risk is accepted, the underwriter determines which classification of rates (premium) is most appropriate for the risk the applicant has presented.

Loss Control Representatives. Sometimes called "safety engineers" or "loss control consultants," loss control representatives may work for an insurance company or for an independent firm. Their job is to help the insurance company and the insured avoid risks by identifying, and offering solutions to, potential problems that could affect the safety of people and property. They do this by physically surveying the insured's property and operations, inspecting systems such as alarms, fire protection, utilities (e.g., electrical, plumbing), storage facilities, and procedures. Loss control representatives compare what they find with industry and national standards. They can review renovation plans, analyze accidents, and suggest employee training. By offering ways to maintain or improve grounds, buildings, equipment, or procedures, loss control representatives can help reduce the possibility of harm coming to museum staff or the collections. They can work with museum personnel on an ongoing basis. The best ones take budget realities into account and offer creative solutions.

Claims Adjustor. An adjustor reviews the cause of loss, the extent of loss, and the payment for loss. Adjustors are either employees of an insurance company or employees of independent adjusting firms. A few firms specialize in adjusting fine arts losses for insurance companies. Typically, the adjustor is responsible for visiting the site of the loss or disaster, reporting on the loss to the broker or the insurance company (whoever assigned the adjustor), working with museum staff and the agent-broker in finding the most appropriate way to handle restoration of a damaged object, and negotiating with the broker-agent and the museum in determining the payment(s) to be made for restoration and/or conservation costs, loss in value, or total loss (according to the specifications of the policy). The adjustor is legally responsible to the insurance company.

F. Model Policy

A museum purchasing insurance coverage for collection objects can be faced with a variety of proposals. In 1981, two insurance experts, Phillip Babcock and Marr Haack, produced a suggested "model policy" for museum collections. Since that time, their model has served

as a useful reference for a number of insurance companies offering collection coverage.[15] A particularly appealing feature of the model is that it is written in "plain English" so that it can be understood even by the novice. The model, with an introductory summary,[16] is reproduced here (see Figure XV.1). For anyone unfamiliar with such coverage, a careful reading of the model policy should provide a framework for intelligently reviewing the policies currently being offered for collection coverage.

15. See P. Babcock and M. Haack, "Plain English Collections Insurance," *Museum News* 22 (July–Aug. 1981).

16. This introductory summary was first published in *F.C.&S. Bulletins* (Aug. 1981). The summary and the sample policy are reproduced in this text with the approval of the authors.

Figure XV.1

Model Insurance Policy

INTRODUCTORY SUMMARY

The Museum Collections form contains three insuring agreements, relating to permanent collections, loan collections, and legal liability for loan collections in the insured's care. The permanent collection can be insured for different amounts while on premises, in transit, and at other locations. The loan collections agreement provides "wall-to-wall" coverage on borrowed collections the insured has agreed to insure, regardless of the duration of the loan. This agreement also applies to property owned by the insured that has been loaned to others. As with the permanent collection agreement, separate amounts can be arranged for loan collections on premises, in transit, and at other locations. The legal liability agreement applies to the insured's liability (and related defense costs) for loss to collectibles in the insured's care when the insured has been instructed *not* to insure the property.

Coverage under all agreements is on an *all risks* basis, with the usual exclusions of wear and tear, gradual deterioration, insect or animal damage, inherent vice, nuclear risks, and war. In addition, loss by extremes of temperature or humidity (mold or mildew, for example) are excluded if the property is not protected by environmental controls, unless loss results from another covered peril. Especially pertinent to museum exposures, loss resulting from repairing, restoration, or retouching processes is also excluded. There are also exclusions of loss due to inventory shortage, loss to property shipped under an "on deck" bill of lading, and loss to property sent by mail (other than first-class or registered mail—see sample form).

Finally, there is an exclusion of loss caused by dishonest acts of officers or employees—an often underestimated loss exposure faced by museums. However, the form does cover such losses to the extent they exceed the museum's Fidelity bond limit or the Fidelity coverage deductible shown in the declarations. In other words, the policy can be written to provide excess Fidelity coverage.

Valuation of lost or damaged property is stated to be fair market value at the time of loss not to exceed the applicable limit of liability. There are a number of special provisions that apply to valuation in some instances, however. Loaned property, for example, is valued at the amount agreed upon by the lender and borrower. If there is no agreement, the amount of loss is valued at fair market value at the time of loss. Another special provision states that if the lost or damaged property is contemporary art that was designed by an artist and then constructed by the artist or a technician, the insurer may pay only for the cost of repair or replacement if

Figure XV.1 continued

the work can be repaired or replaced to the artist's specifications. Another clause permits the museum to buy back property for whose loss the insurer has already paid the museum. The terms of this provision are clearly stated in the sample form under "Buy-back option." The form also contains a "Pairs and Sets" clause.

Of special interest is a condition stipulating that insured property will be packed and unpacked only by trained packers. There is also a clause entitled *Conflicting terms* stating that the terms and conditions of the Museum Collections form prevail whenever they are in conflict with any other terms or conditions of the museum's policy. This refers to the fact that the Museum Collections form is not a free-standing document and is intended to be attached to the museum's regular Property insurance policy or, perhaps, the insurer's skeleton form for Inland Marine coverages.

Endorsements

The drafters have prepared two endorsements for use with the policy. One provides for reporting of values on either a monthly or an annual basis, and the other provides international coverage for property in transit or at another location. Without the latter endorsement, the regular policy territory is the continental United States, Alaska, Hawaii, and Canada, including losses occurring in transit between these places.

MUSEUM COLLECTIONS COVERAGE

This agreement is designed to protect museum collections against all risks of direct physical loss or damage with some limitations.

Coverage Summary	Limits of coverage
Permanent Collection — locations.	
1.	$
2.	$
• All other locations	$
• In transit	$
Loan Collection — locations.	
1.	$
2.	$
• All other locations	$
• In transit	$

Continued on next page

Figure XV.1 continued

Legal Liability.	$

International Coverage.	$

This coverage applies only if a limit is shown and the International Coverage Endorsement is attached.

All Loss from Any One Event.	$

This is the most we'll pay for all loss from any one event no matter how many protected persons, property owners or financial interests are involved. This applies to all losses, expenses and salvage charges combined. Any amount we pay for a loss won't reduce this limit for loss from other events.

Deductibles.

$	Permanent Collection
$	Loan Collection
$	Fidelity Coverage

Reporting.

If the museum Collection Reporting Endorsement is attached, we'll figure your premium on the basis of written reports you make to us. You'll report on a monthly or annual basis and pay the rate as indicated below.

☐ Monthly — Rate per $100
☐ Annual — Rate per $100

If we issue this agreement after the date your policy takes effect, we must complete these spaces and our representative must sign below.

Policy issued to

Authorized representative

Agreement takes effect

Policy number

. .

What This Agreement Covers

This agreement protects museum collections indicated in your Coverage Summary against all risks of direct physical loss or damage. By museum collections we mean property of rarity or of artistic, scientific or historical significance. This includes property such as paintings, statuary, ancient artifacts and other property normally exhibited in museums. Frames, glasses,

shadow boxes and other protective enclosures used to display the property are also covered.

Of course, there are some limitations to your coverage which will be explained later in this agreement.

Permanent collection. Your permanent collection consists of property you own and is covered on your premises. It's also covered while in transit to and from

Figure XV.1 continued

another location and while it's temporarily kept at that location for repair, restoration or storage.

We'll cover your permanent collection up to the separate limits shown in your Coverage Summary for premises, other locations and in transit.

Loan collection. Your loan collection consists of property of others loaned to you which you've been instructed to insure (verbally or in writing) and property owned by you which you've loaned to others. Your loan collection includes property on extended loan of six months or more as well as temporary loans. We'll cover this property on a "wall to wall" basis, whether on exhibition or not. "Wall to wall" means that we cover from the time Insured property is removed for shipping from the place it's normally kept, until it's returned there. Coverage also applies during transit and all phases of shipping and exhibition. If, before the return shipment, the owner specified that the property be returned elsewhere, we'll cover the property until it's returned to that place.

We'll cover your loan collection up to the separate limits shown in your Coverage Summary for premises, other locations and in transit.

Legal liability. If a limit is shown in the Coverage Summary for legal liability, we'll defend any suit brought against you for loss or damage to other people's collectibles in your care. This coverage applies when the owners of the property have instructed you not to insure it. Of course, if you have a signed release of liability from the owner, this coverage doesn't apply.

The limit shown in the Coverage Summary is the most we'll pay for defense costs and any judgment in any one loss.

Who's protected under this agreement. While this agreement is in effect, we'll cover your interest and the interest of the owners of covered property. We'll also cover the interest of temporary borrowers you've given custody of the property. But we won't cover the interest of transportation carriers, packers or shippers. Nor will we cover the interest of others having temporary custody of property for storage or for any repairing, retouching or restoring process.

Where We Cover

We'll cover losses that occur in the continental United States, Alaska, Hawaii and in Canada. We'll also cover losses that occur in transit between these places.

If the International Coverage Endorsement is attached, we will also cover losses according to that endorsement.

Exclusions—Losses We Won't Cover

Wear—deterioration—pests. We won't cover loss or damage resulting from any of the following causes:
- Wear and tear;
- Gradual deterioration; or
- Insect or animal pests like termites, moths or mice.

Inherent nature. We won't cover loss or damage resulting from the inherent nature of the property. By inherent nature, we mean a quality in the property that causes it to deteriorate or to destroy itself.

Extremes of temperature or humidity. We won't cover loss or damage that results because covered property is kept at a location that isn't protected from extremes of humidity or temperature, unless the loss or damage results directly from another covered peril. For example, if your museum doesn't have the environmental controls to prevent excessive humidity, we won't cover mold or mildew damage to a painting unless that damage was directly caused by flooding or a leaking water pipe.

Repair. We won't cover loss or damage resulting from any repairing, restoration or retouching process if the loss results from this work. But if the work results in a loss that would otherwise be covered, we'll pay for the loss that results directly from the covered peril.

Mail. We won't cover loss or damage to property sent by mail unless it's sent by registered or by first class mail. But property sent by first class mail isn't covered if its value is more than $1,000.

Inventory shortage. We won't cover loss resulting from inventory shortage. Inventory shortage means a loss reflected in your records, but it can't be determined where, when or how the loss occurred.

Fidelity. We won't cover loss caused by any fraudulent, dishonest, or criminal act or series of related acts committed by your officers or employees even if there are others involved. However, we'll cover this loss once it exceeds your fidelity bond limit or the fidelity coverage deductible shown in the Coverage Summary, whichever is greater.

Continued on next page

Figure XV.1 continued

"On deck" shipments. We won't cover loss or damage to property shipped under an "on deck" Bill of Lading.

Nuclear activity. We won't cover any loss caused by nuclear reaction, nuclear radiation or radioactive contamination. And we don't intend these causes of loss to be considered fire, smoke, explosion or any other insured peril. But we will cover direct loss by fire resulting from nuclear reaction, nuclear radiation or radioactive contamination if the loss would otherwise be covered under this agreement.

War and government seizure. We won't cover any loss, damage or injury caused by: war (declared or undeclared), invasion, insurrection, rebellion, revolution, civil war, seizure of power, or anything done to hinder or defend against these actions. We won't cover seizure or destruction of your property under quarantine or Customs regulations, or confiscation by any government or public authority. Nor will we cover illegal transportation or trade.

Setting a Value on Property

If there's a covered loss, we'll consider the value of covered property to be the fair market value of your interest in the property, at the time of loss. But in no case will we pay more than the applicable limits shown in the Coverage Summary.

The following special rules apply.

Loaned property. Property loaned to you which you've been instructed to insure or for which you may be liable will be valued at the amount agreed upon by you and the owner. If you and the owner didn't agree upon a value in advance, you and we will agree upon a value based on the fair market value at the time of loss.

Pairs and sets. There may be a total loss of one or more articles which are part of a pair or set. If you choose, we'll pay you the fair market value of the pair or set up to the limits of your coverage. If you choose this option, you'll give us whatever remains of the pair or set.

Contemporary art. Some contemporary art is designed by artists and then constructed by them or by technicians. If such a work is damaged and can be repaired or replaced to the artist's specifications, we'll pay only the cost of repair or replacement.

Buy-back Option. If we recover property for which we have already paid you, you have the right to buy the property back from us. If the property is not damaged, you'll pay the same amount we paid you, plus an amount for loss adjustment, recovery expenses and interest.

The interest will be computed at 1% above the prime rate during the period between the date we paid you and the date you chose to repurchase.

If we paid you for a total loss on damaged property, you have the right to buy back the damaged property. You'll pay the fair market value of the damaged property at the time of repurchase.

We'll make every effort to notify you of your right to buy back damaged or recovered property. You'll have 60 days from the time you receive our notice to repurchase the property.

Who We'll Pay

We'll adjust any loss with you or with the owners of the covered property. Our payments for losses will be made to you or any other person or organization you name.

Your Deductible

Your Coverage Summary may show deductibles for your permanent and your loan collections or for fidelity loss. If so, you'll be responsible up to that amount for each loss. We'll pay the rest of your covered loss up to the applicable limit of your coverage.

Other Insurance

Other insurance may be available to cover a loss. If so, we'll pay the amount of your loss that's left after the other insurance has been used up. But we won't pay more than the applicable limit of coverage under this agreement.

This section doesn't apply to insurance that the owners of property loaned to you may have. And the existence of the owners' insurance won't affect our responsibility to pay for a covered loss.

Of course, we won't pay a loss if you or the owner have already collected the loss from others.

Excess insurance. You agree not to purchase excess insurance without our permission. Excess insurance is insurance that applies after the limits of coverage under this agreement are used up.

Figure XV.1 continued

Other Rules for This Agreement

Packing. You agree that the insured property will be packed and unpacked by trained packers.

Preserving your rights. You must do all you can to preserve any rights you have to recover your loss from others. If you do anything to impair these rights, we won't pay for your loss. You can, however, accept ordinary bills of lading from a shipper, even if they limit the carrier's liability for losses.

We won't attempt to recover any loss from museums or any other place borrowing covered property for exhibition. However, we must give our permission before you give a written release from responsibility of loss to any person or organization other than a museum.

Conflicting terms. The terms and conditions of this agreement apply whenever they are in conflict with any other terms or conditions in your policy, such as the General Rules or Conditions.

Expenses for reducing loss. When a covered loss occurs, you must do everything possible to protect the property from further damage. Keep a record of your expenses. We'll pay our share of reasonable and necessary expenses incurred to reduce the loss or protect covered property from further damage. We'll figure our share and your share of these expenses in the same proportion as each of us will benefit from them.

Insurance for your benefit. This insurance is for your benefit. No third party having temporary possession of the property, such as a transportation company, can benefit directly or indirectly from it.

Certificate of insurance. We may issue certificates of insurance to you. You'll have the authority to give these certificates to others.

MUSEUM COLLECTIONS REPORTING ENDORSEMENT

This endorsement changes your Museum Collections Coverage

How Your Coverage Is Changed

Your Coverage Summary indicates that your premium is based on either annual or monthly written reports you make to us. We'll figure your premium by applying the rate shown for monthly or annual reporting to the values you report. You agree to keep accurate records of the location of covered property for the purpose of these reports.

Monthly Reporting. Based on your records, you agree to make monthly reports to us in writing. Each month you'll report the total values of your loan collection (loans of less than 6 months' durations) that were covered the previous month. Your reports are due within ten days after the last day of each month.

If the International Endorsement is attached, these conditions also apply to it. You'll also report the total values of your loan collection, that were covered while in international transit and at international locations during the previous month.

Annual Reporting. Based on your records, you agree to make an annual report to us in writing. Each year you'll report the total values of your loan collection that were covered during each month. Your annual report is due within thirty days after the anniversary date of your policy or whenever your policy ends.

Other Terms. All other terms of your policy remain the same.

Continued on next page

Figure XV.1 continued

INTERNATIONAL COVERAGE ENDORSEMENT

This endorsement changes your Museum Collections Coverage

If a limit is shown for International Coverage in your Coverage Summary, we'll cover losses that occur at locations outside the continental United States, Alaska, Hawaii and Canada, except as noted below.

We'll also cover losses that occur while in transit to and from these locations.

Reporting Terms. The terms of the Museum Collection Reporting Endorsement also apply to International Coverage. You'll report on a monthly basis and pay the rate as indicated.

International Transit rate per shipment:	
Airborne Shipments	Per $100
Waterborne Shipments	Per $100
International Locations	
Rate per month	Per $100

Where We Won't Cover. We won't cover losses that occur in transit to and from or at locations in:

Ocean Marine Terms. International Coverage as provided in this endorsement is also subject to the following American Institute Clauses:

- Delay
- Marine Extension Clauses

All other terms and conditions of the Policy not in conflict with the foregoing remain unchanged, it being particularly understood and agreed that the F.C. & S. clause remains in full force and effect, and that nothing in the foregoing shall be construed as extending this insurance to cover any risks of war or consequences of hostilities.

Access to the Collections

Legal issues regarding access to museum collections can take various forms. The sufficiency of a museum's visiting hours may be questioned, disputes may arise concerning access to the objects themselves or to records concerning the objects, or disabled individuals may protest their inability to take part in a museum program or activity.

A. Visiting Hours

The issue of the adequacy of visiting hours usually does not rise to the level of a legal question unless visitors are so restricted that the status of the museum as a public-oriented or "charitable" organization is placed in doubt. The challenge might come in the form of a denial of tax-exempt status or as a charge of mismanagement against trustees for failure to

carry out the purposes of the museum.[1] The classic illustration is the litigation involving the Barnes Foundation of Pennsylvania.

The Barnes Foundation, a nonprofit corporation, was established in 1922 under terms set down by Albert C. Barnes. The foundation administers an art gallery and arboretum as an "educational experiment" to benefit primarily students of art.

The donor's instructions noted:

[T]he gallery and the arboretum shall be open five days in each week, except during the months of July and August of each year, and solely and exclusively for educational purposes, to students and instructors of institutions which conduct courses in art and art appreciation, which are approved by the trustees of Donor. On Saturday of each week, except during the months of July and August of every year, the gallery and the arboretum shall be open to the public between the hours of ten o'clock in the morning and four o'clock in the afternoon, under such rules and regulations as the Board of Trustees of Donor may make. It will be incumbent upon the Board of Trustees to make such rules and regulations as will ensure that the plain people, that is men and women who gain their livelihood by daily toil in shops, factories, schools, stores and similar places, shall have free access to the art gallery, and the arboretum upon those days when the gallery and arboretum are to be open to the public, as hereintofore provided. On Sunday of each week during the entire year, the gallery and the arboretum shall be closed to students and public alike.[2]

The art gallery and the arboretum were denied exemption from state and local taxes on the grounds that they were not "purely public" as required by state law. The admission policy, according to the exemption denial, was so restrictive that neither entity could meet the "purely public" test. The trustees of the foundation contested this interpretation and won. The court stated:

It must be borne in mind that the gallery is used not as an art gallery as that term is ordinarily understood, but that it is an integral part of a new educational experiment, and the unrestrictive admission of the public would be as detrimental to the work of the Barnes Foundation as it would be to the work carried on in the laboratories and clinics of the University of Pennsylvania. . . . Reasonable regulations for admission of the public do not destroy the charitable nature of a gift where it is otherwise found to be so.[3]

In effect, the court said that the admission policy of a charity should be judged in light of the mission of the organization. In this case, although the Barnes Foundation is an "art gallery," its major purpose is to serve as a teaching facility, and an admission policy that favors this teaching function does not diminish the public nature of the foundation.

The foundation continued to pursue a very restrictive admissions policy, and a private

1. Access by the public also may bear on eligibility for federal grants. See, for instance, the regulations implementing the Institute of Museum Services, 45 C.F.R. pt. 1180, which are mentioned hereafter.

2. *Barnes Foundation v. Keely,* 314 Pa. 112, 171 A. 267 (1934).

3. Ibid.

citizen's later attempt to question the policy was unsuccessful.[4] Then, in 1958, the attorney general of the state initiated legal action, claiming that as the representative of the people of the state, he had the obligation to ascertain why the foundation, as a public charity, had closed the doors of the art gallery to the public. The court affirmed the power of the attorney general to bring such a suit, found a general intent on the part of the donor to give the public at least limited access to the gallery, and ordered the foundation to justify its admission policy.[5] The court stated:

Naturally, the general public cannot use the gallery at will. The general public cannot even use a public library at will. Orderliness requires that there be hours of opening and closing of libraries, that hours or days be set aside for rest of personnel, for taking inventory, for cleaning and repairing the property and facilities. But no library would be considered public if the public could be admitted only upon the caprice, whim and arbitrary will of its administrators.[6]

At this point, the foundation and the attorney general entered into an agreement, later approved by the court, that permitted limited but regular public access to the gallery.

A more recent case questioning the hours of a museum is *People ex rel. Scott v. Silverstein*,[7] also known as the *Harding Museum* case. The Harding Museum, a not-for-profit organization incorporated under the laws of Illinois, was for a number of years an active museum in the city of Chicago. The attorney general of Illinois in 1976 began legal proceedings against the museum's trustees; he charged, among other things, that since the museum had relocated within the city in the mid-1960s, its collections had been kept mainly in storage, with only a small portion open to the public on a limited basis. This, he argued, amounted to mismanagement on the part of the museum trustees because such a lack of access was in derogation of the intended purpose of the museum. The trustees did not dispute that the general public had not been welcomed since the relocation and that parts of the collection were shown only by appointment. Nor could the trustees point to any unique organizational purpose that warranted restricting access by the general public. The case developed into a long legal battle that centered on the issue of the quality of the governance by the museum's board—that is, on whether the board was acting negligently in failing to reopen the museum in a timely manner. The issue of access became moot in 1982 when, under an agreement reached by the board with the attorney general, the collections of the museum (and title thereto) were transferred to the Art Institute of Chicago, an organization with generous and regular visiting hours.

Another case dealing with public access is *In re Stuart's Estate*.[8] Here, a donor had left a

4. *Wiegand v. Barnes Foundation*, 374 Pa. 149, 97 A.2d 81 (1953).

5. *Commonwealth v. Barnes Foundation*, 398 Pa. 458, 159 A.2d 500 (1960).

6. Ibid., 506.

7. No. 76 CH 6446 (Ill. Cir. Ct. of Cook County, Oct. 1976) and 408 N.E.2d 243 (Ill. 1980). See also *People ex rel. Scott v. George F. Harding Museum*, 58 Ill. App. 3d 408, 374 N.E.2d 756 (1978), and *People ex rel. Scott v. Silverstein*, 412 N.E.2d 692 (Ill. 1980) and 418 N.E.2d 1087 (Ill. 1981).

8. 183 Misc. 20, 46 N.Y.S.2d 911 (1944).

collection of books, manuscripts, and paintings to a library with the condition, among others, that the collection be exhibited to the public at all reasonable times but "never on the Lord's Day." Years later, the library sought court approval to waive the Sunday restriction, which it deemed impractical and ill-suited to public need.[9] The library pointed out that most people had the time to visit the collection on Sundays. In this case, the museum itself was seeking to adjust public access so that visiting hours would further the mission of the organization. The court agreed to the waiver, stating that the dominant purpose of the donor was to provide for the public to see his collection and that, in this day and age, access on Sunday served this purpose.

In looking for evidence of current interpretations of "reasonable access," two sources are useful. In the definition of "museum" as used in the Museum Services Act, objects must be exhibited to the public "on a regular basis."[10] The regulations interpreting this phrase read as follows:

(1) An institution which exhibits objects to the general public for at least 120 days a year shall be deemed to meet this requirement.

(2) An institution which exhibits objects by appointment may meet this requirement if it can establish in light of the facts under all the relevant circumstances that this method of exhibition does not unreasonably restrict the accessibility of the institution's exhibits to the general public.[11]

This definition is used to determine eligibility for grants from the Institute of Museum Services, not to determine the tax status of the organization or the trustee liability for adherence to mission. Nevertheless, the definition reflects a consensus within the profession. A code of ethics promulgated by a professional group is the second source, offering similar insight. The Association of Art Museum Directors, in its *Professional Practices in Art Museums,* defines the "art museum" as an institution that exhibits works of art to the public "on some regular schedule."[12] Current practice, then, as well as case law, supports the position that a museum should have an articulated admission policy that is designed to serve its particular constituency. In setting this policy, the museum should consider its mission, its resources, and the convenience of the public to be served.[13]

B. Availability of Collection Objects

What responsibility does the museum have to provide access to objects that are not on public display? A museum often has difficulty answering this question to the satisfaction of

9. See Chapter IV Section E(1), "Restricted Gifts."

10. 20 U.S.C. §§ 961–68.

11. See 48 *Fed. Reg.* 27729 (June 17, 1983).

12. Association of Art Museum Directors, *Professional Practices in Art Museums* (New York: Association of Art Museum Directors, 1991, amended 1992).

13. In *In re Estate of Hermann,* 454 Pa. 292, 312 A.2d 16 (1973), the court discusses the question of whether a museum ceases to exist if, in fact, the public never visits it.

all, since so much depends on the eye of the beholder. Some insist that if a museum is publicly supported, the emphasis should be on access. Others stress the museum's responsibility to protect and conserve objects for future generations. Another issue concerns who is asking for access. Is it a scholar, and if so, does this type of request take precedence over one from a commercial entity or from a high school student? Is preference given to those who fall within the public immediately served by the museum? Consider, for example, this paragraph from the "Code of Ethics for Art Historians."

The . . . [College Art Association] believes that as much as possible there should be full, free, equal, and nondiscriminatory access to research materials for all qualified art historians. All art historical research materials, including but not limited to works of art, photographs, diaries, letters, and other documents in the possession of publicly supported or tax exempt, non-profit, educational institutions, whether in the United States or elsewhere, where not legally restricted as to use, shall be freely and fully accessible to art historians for research and publication.[14]

The "Code of Ethics" promulgated by the American Association of Museums states, "[T]he museum ensures that collections in its custody support *its mission* and public trust responsibilities" (emphasis added).[15] There is some conflict in emphasis when both codes are consulted.

For the museum, the problem is how to balance a desire to accommodate requests for special access with the need to protect its collections. As has been clearly demonstrated over the years, unproctored access to storage areas is an invitation to mishandling, misplacement, and even misappropriation of collection objects. Ideally, no person, other than staff members regularly assigned to a storage area, should be allowed unaccompanied within such a restricted area, but few museums have the personnel to accomplish the ideal.[16] Instead, the museum must devise reasonable policies and procedures for access to its various types of collections. These policies and procedures are bound to differ depending on the type of collection, the resources of the museum, and the constituency served by the museum. Managing visitor access to an extensive collection of rare stamps and managing a room full of historic farm machinery usually call for different procedures.

When writing such policies and procedures, a museum should consider the following points:

14. Adopted by the College Art Association, Jan. 1995. See part A under "1. Right of Access."

15. Code adopted in 1994.

16. Within a museum, employee theft is not uncommon; so in framing access policies, a museum needs to consider staff as well as outsiders. See, for instance, C. Lowenthal, "Insider Theft: A Trust Betrayed," *Museum News* 32 (May–June 1994); J. Douglas, "Employee Theft in the Museum: What Duty to Pursue? What Duty to Prosecute?" in American Law Institute–American Bar Association (ALI-ABA), *Course of Studies Materials: Legal Problems of Museum Administration* (Philadelphia: ALI-ABA, 1993). For other than employee theft, see B. Wolff, "Theft in the Museum: What Duty to Pursue? What Duty to Prosecute?" in American Law Institute–American Bar Association (ALI-ABA), *Course of Studies Materials: Legal Problems of Museum Administration* (Philadelphia: ALI-ABA, 1993).

- All those involved in developing a policy should share a common understanding of the mission of the museum and of the public that is served by the museum. (In other words, what group or groups form the prime beneficiaries of the museum?)
- There should be a consensus regarding acceptable risks when balancing access and protection.
- Policies and procedures are only as good as the ability and the commitment of the museum to implement them. A museum is especially vulnerable to criticism and liability when it has suffered a loss because it failed to do what its policies and procedures require.
- Access policies and procedures should be written in coordination with other collection management issues. For example, are the objects well-documented, and is it relatively easy for staff to spot—and identify—an object that may be misplaced or stolen? If the answer to both of these questions is "no," how does the museum expect to follow through if there is an apparent violation of its access policies?
- Access policies and procedures should not be written without coordination with security experts. The museum needs to know what information can and should be elicited from individuals seeking access and what can and should be done immediately if damage or loss due to visitor access is suspected.[17]

The small museum may assume that it does not need to formulate a policy regarding visitor access to objects not on display. But only one unfortunate incident is needed to demonstrate that this assumption is wrong. A museum is supposed to be acting as the custodian of material that is deemed important, at least to its community. A custodian is expected to be prepared to handle, intelligently, foreseeable events. Requests for access to objects not on display are quite foreseeable in a museum. A policy need not be elaborate; it need only show that the museum has thought about the problem and has set forth commonsense internal guidance, based on its particular circumstances, for how such requests should be handled, what information should be asked of the requestor, what records should be made, and what monitoring is expected of the staff.

C. Access to Collection Records

In weighing an object access policy, a museum must also consider a corollary policy on access to collection records. Museum professionals would be the first to agree that an object

17. With rapid changes in technology, it is important for everyone, including security experts, to keep up-to-date. Consider the following news report. In 1995, staff at a collecting organization in Baltimore discovered a visitor slicing a map from a rare eighteenth-century book. When police and legal counsel were consulted, staff members were advised to have the individual pay an on-the-spot restitution of a few hundred dollars to repair the page because they believed he would probably evade any criminal prosecution. The staff followed these instructions. After the individual was gone, they discovered damage to numerous other books he had had access to that day, and a search on the Internet showed that a string of major collecting organizations on the East Coast were reporting similar damage after visits by an individual using the same name. F. Shen, "They Didn't Throw the Book at Him," *Washington Post*, Dec. 16, 1995.

without its documentation has limited value, and the same professionals, as a rule, would vehemently protest if documentation was censored before it was made available to them. A museum must reconcile this attitude with some very practical problems regarding record access.

For purposes of this discussion, collection records are deemed to include two general categories of material.[18] The first covers records that are commonly associated with registration functions. These primarily document the legal status of an object within the museum, possibly the object's value, and that object's movement and care while under the control of the museum. The second category covers records associated with curatorial functions. These provide a broad body of information that establishes the object's proper place and importance within its cultural or scientific sphere. Regarding the first category, common access problems concern possible privacy considerations of donors or lenders, commercially motivated requests (such as the dealer who wants to check appraisal data), and the very legitimate fear that important documents will be lost or damaged if registration folders are handled by outsiders. Regarding requests for records in the second category, a museum may be reluctant to provide access for fear that research notes will be pirated or curatorial observations or correspondence will be misused.[19]

Before attempting to establish a record access policy, a museum should determine whether any laws or regulations affect the release of its collection records. The federal government and all states have freedom of information statutes (hereafter FOI statutes) that require the release, on request, of certain "public records." In addition, the federal government and most states have open-meeting or "sunshine" laws requiring that certain governmental bodies conduct their proceedings in public. Municipalities may have similar requirements. If a museum is part of a governmental unit, or is closely associated with a governmental unit, or receives a substantial portion of its funding from government, laws of this nature could dramatically affect access to its collection records. On the other side of the coin, the federal government and many states have privacy statutes restricting the release of most information that could be classified as personal to an individual. If a museum's collection records are covered by both a privacy statute and an open-record (FOI) statute, thorny problems can arise.

The federal government has had a freedom of information act, a privacy act, and a sunshine act for many years, and these statutes have been the subject of many court interpretations. Even though the federal statutes apply only to the activities of federal agencies (as defined in those statutes), these statutes are worth reviewing, for several reasons:

- They provide a good introduction to understanding the general scope and purpose of FOI, privacy, and sunshine laws.

18. Archival collections can raise even more complex questions. Archives as such are not covered in this discussion.

19. An associated problem is the case of the curator who wants exclusive access to certain records (and possibly collection objects) because he or she is engaged in active research. Such situations are especially prone to criticism, and a strictly enforced internal method for reviewing all such arrangements affords protection to all concerned.

- Some states used or referenced the federal legislation when drafting their own laws. At times, therefore, knowledge of the federal law can help in understanding state laws.
- Because the federal laws have been heavily litigated, those interpreting state laws frequently look to court interpretations of federal statutes for insight.

1. FEDERAL FREEDOM OF INFORMATION ACT

The purpose of the federal freedom of information act is to change drastically the way the executive branch of the federal government approaches the collection and dissemination of information. The act applies to an "agency" defined as "any executive department, military department, Government corporation, Government-controlled corporation, or other establishment in the executive branch of the Government (including the Executive Office of the President), or any independent regulatory agency."[20] The term "record" is not specifically defined in the original legislation, and what constitutes an "agency record" is frequently a matter of court interpretation. However, the "Electronic Freedom of Information Act Amendments of 1996" clearly stated that "record" should be interpreted to include information maintained in an electronic format.[21]

The federal statute is divided into two major parts. The first part sets forth affirmative steps that agencies must take to inform the public fully about their activities. The second part qualifies full disclosure by listing certain matters that are exempt from mandatory disclosure.

Under part I, federal agencies are required to publish and update general information on the operation of their agencies, with a clear description of how individuals can submit formal requests for specific agency records. Strict time limits are imposed on agencies for responding to record requests, and the burden is on an agency to explain why a request for a record is denied. If an individual is not satisfied with an agency's reason for denying an information request, that individual can force the agency into court. Thus, part I clearly emphasizes complete and prompt disclosure, with an agency bearing a heavy burden to justify the retention of records under its control.

Under part II of the law, certain types of records are exempt from mandatory disclosure. The exemptions focus on matters relating to such areas as law enforcement, national defense, trade secrets, litigation files, and personnel files—topics that do not, as a rule, cover material normally found in museum collection records.

20. Pub. L. 89–487 codified as 5 U.S.C. § 552 (enacted 1966), as amended.

21. See H.R. 3802, 104th Cong., 2d sess. (1996), for the text of the "Electronic Freedom of Information Act Amendments of 1996" (now Pub. L. 104–231). Note also that records produced under a federal grant would not normally be subject to the federal freedom of information statute unless such records were on file in a federal executive branch agency. Possibly, the terms of a particular federal grant could impose conditions concerning the accessibility of records produced by the grantee, but such conditions would not normally flow from the freedom of information statute.

2. FEDERAL PRIVACY ACT

The federal privacy act[22] seeks to accomplish four objectives:

- To force agencies to use caution in collecting and using personal information
- To enable individuals to find out the information an agency maintains on them
- To allow individuals to review and correct agency records that pertain to them
- To give individuals some control over how agencies use information about them

The act applies to a federal "agency" as defined in the federal freedom of information act. The federal privacy act addresses specifically information records, with "record" defined to mean any item, collection, or grouping of information that an agency maintains about an individual and that is retrievable by the individual's name, identification number, or other unique feature personal to that individual. The act includes a general prohibition against the disclosure of information in a "record" without the consent of the subject. The act also sets forth procedures whereby individuals can seek access to agency records about them.

3. FEDERAL SUNSHINE ACT

The federal sunshine act requires that governing bodies of public agencies hold their board meetings in public.[23] The act applies to an "agency" as that term is defined in the federal freedom of information act, provided the agency is headed by a board.

To ensure openness, the act requires that a covered agency publicly announce, at least one week before a board meeting, the time and place of the meeting and the subject matter to be discussed. The meeting must be open to the public unless the agency can show statutory authority to close the meeting. The act lists exceptions when a meeting or a portion of a meeting may be closed to the public. These exceptions are similar to those found in the freedom of information act. When a meeting or portion thereof is closed, a sanitized record of what occurred must be made available to the public.

From these very brief descriptions, we can see that for a museum subject to statutes of this nature, all of its collection records, as well as the minutes of all board meetings, must be made available to any member of the public on demand. At the same time, all such records, before their release, have to be scrutinized for information that might be protected from disclosure to third parties.

State statutes of this nature vary in their coverage. For an organization to determine whether it falls under the purview of a particular state statute, it must look to the language of the statute (and any court interpretations of such language). Coverage is usually stated in a definition of "public agency" or similar term. Listed below are examples of how the

22. Pub. L. 93–579 codified as 5 U.S.C. § 552a (enacted 1974).
23. Pub. L. 94–409 codified as 5 U.S.C. § 552b (enacted 1976).

term "public agency" is defined in a selection of state FOI statutes. (Privacy and sunshine statutes tend to follow the coverage of the state FOI statute.)

[A]ny state, county, district, authority, or municipal officer, department, division, board, bureau, commission, or other separate unit of government created or established by law including, for the purposes of this chapter, the Commission on Ethics, the Public Service Commission, and the Office of Public Counsel, and any other public or private agency, person, partnership, corporation, or business entity acting on behalf of any public agency. (Florida)

[E]very state officer, agency, department, including the executive, legislative and judicial departments, division, bureau, board and commission; every county and city governing body, school district, special district, municipal corporation, and any board, department, commission, council or agency thereof; and any other body which is created by state or local authority or which is primarily funded by the state or local authority. (West Virginia)

[A]ny department of the State, any state board, commission, agency, and authority, any public or governmental body or political subdivision of the State, including counties, municipalities, townships, school districts, and special purpose districts, or any organization, corporation, or agency supported in whole or in part by public funds or expending public funds. (South Carolina)

[A]ny state or municipal department, board, bureau, division, commission, committee, public authority, public corporation, council, office or other governmental entity performing a governmental or proprietary function for the state or any one or more municipalities thereof, except the judiciary or the state legislature. (New York)[24]

A definition that does not mention funding is usually interpreted more narrowly, with a need to show participation in government activity in order to trigger coverage. When funding is listed as a criterion, the net is wider, but courts have varied in their interpretations of what constitutes funding.[25]

Experience demonstrates that museums should favor openness regarding their collection records. When viewed objectively, most of what is in these records should be available to the public. Normally, how a museum acquires and disposes of objects is a proper public concern, and provenance records are gathered primarily to further scholarship and public appreciation of collection objects. A policy of secrecy only breeds distrust and may produce an atmosphere in which the public is intolerant of even legitimate reasons for withholding information. A more prudent approach is to treat information in collection records as open

24. Florida sec. 119.011(2); West Virginia 29B-1-2 (3); South Carolina sec. 30-4-20(a); New York Pub. Off. Law sec. 86(3).

25. For more information, see I. DeAngelis, "The Impact of Freedom of Information Laws on Museum Collections and Collection Records," in American Law Institute–American Bar Association (ALI-ABA), *Course of Studies Materials: Legal Problems of Museum Administration* (Philadelphia: ALI-ABA, 1994); J. Douglas, "Access to Selected Museum Records," in American Law Institute–American Bar Association (ALI-ABA), *Course of Studies Materials: Legal Problems of Museum Administration* (Philadelphia: ALI-ABA, 1994); and B. Braverman and F. Chetwynd, *Information Law: Freedom of Information, Privacy, Open Meeting, Other Access Laws* (New York: Practising Law Institute, 1985).

to the public unless there is a clearly defensible reason, consonant with any applicable stat-
utes, for denying a specific request.[26] With such a policy of openness in force, however, a
museum usually needs to delegate, to one or two well-informed staff members, the respon-
sibility for deciding the hard cases.[27] Consistency and fairness are essential. Also, a policy of
openness does not mean that access must be granted on demand. It assumes that a request
will be made with some precision and that the person who has custody of the records will
have sufficient time to review the request in order to determine whether all of the material
can be released.

Any policy on access to collection records must also consider record security and the
ability of the museum financially to accommodate requests. Duplicating records and moni-
toring record use by outsiders are costly and time-consuming activities. Inordinate demands
in these areas invariably reduce the resources available for other museum programs. In
recent years, many museums have experienced a dramatic increase in requests from the
public for collection record information. Many of these requests come from people engaged
in commercial ventures and/or from people who need constant staff assistance. Obviously,
decisions have to be made as to what the museum can and should do to promote equitable
use of its resources. With the explosion of the information age, these decisions are compli-
cated by the lure of using collection records as a means of generating significant income.
Before decisions are made in this area, a museum should go back and review its mission

26. Information is generally withheld if its disclosure would constitute an unwarranted invasion of personal
privacy, would encourage theft or would expose an individual to physical harm, would release business secrets
or propriety information, or would inhibit ongoing negotiations or litigation. However, statutes vary, and a mu-
seum should carefully study any statutes applicable to it. Of general interest to museums are two exceptions to
the federal freedom of information statute. Section 501 of the National Historic Preservation Act Amendments
of 1980 (now 16 U.S.C. § 470w-3) reads as follows:

The head of any Federal agency, after consultation with the Secretary shall withhold from disclosure to the public informa-
tion relating to the location or character of historic resources whenever the head of the agency or the Secretary determines
that the disclosure of such information may create a substantial risk of harm, theft, or destruction of such resources or to the
area or place where such resources are located.

Section 9 of "The Archaeological Resources Protection Act of 1979," Pub. L. 96–95 (now 16 U.S.C. §§ 470aa–
470ll), states:

(a) Information concerning the nature and location of any archaeological resource for which the excavation or removal re-
quires a permit or other permission under the Act or under any other provision of Federal law may not be made available to
the public under subchapter II of chapter 5 of title 5 of the United States Code or under any other provision of law unless the
Federal land manager concerned determines that such disclosure would—(1) further the purposes of this Act or the Act of
June 27, 1960 (16 U.S.C. §§ 469–469c), and (2) not create a risk of harm to such resources or to the site at which such resources
are located. (b) Notwithstanding the provisions of subsection (a), upon the written request of the Governor of any State,
which request shall state—(1) the specific site or area for which information is sought, (2) the purpose for which such informa-
tion is sought, (3) a commitment by the Governor to adequately protect the resource from commercial exploitation, the Fed-
eral land manager concerned shall provide to the Governor information concerning the nature and location of archaeological
resources within the State of the requesting Governor.

27. An "open records" policy should cause a museum seriously to consider in advance what information is
appropriate for its records. All relevant and important documents should be kept meticulously, but if files are
used as a catchall for such things as imprudent comments and irrelevant personal information, the museum
may one day find itself with little control over what it can withhold from disclosure.

and carefully examine the long-term consequences of looking at collection information through the lens of the entrepreneur.

D. Requests to Limit or Deny Access

In more recent years, another consideration concerning access to collections or collection records has come to the fore: requests from cultural groups to withhold access to objects or records, based on religious considerations. Often, such requests are from Native American groups who cite their cultural traditions that protect from public disclosure certain religious and ritual knowledge. Under their traditions, such information can be made available only to designated members of their groups and is to be used only in certain ways. Accordingly, museums may be asked to restrict access to such material or to return all vestiges of such information to the requesting group. Requests of this nature raise very serious problems for museums and archives that are committed to the preservation and dissemination of information. A request that falls under the Native American Graves Protection and Repatriation Act of 1990[28] would have to be resolved in light of that statute, but if the request pertains to restrictions on access to or destruction of records, there is little guidance. Here, one would hope that there would be broad consultation before a museum takes any irreversible action.[29]

E. Access for the Disabled

1. LEGAL REQUIREMENTS

The year 1990 brought a major advancement in statutory protection from discrimination for disabled individuals. Up until this time, most such protection for the disabled flowed from statutes forbidding government agencies or activities funded by government assistance from discriminating on the basis of a disability. As noted in Chapter II, Section F, "As Recipients of Federal Financial Assistance," since 1973 those museums that accept grant money and certain other forms of aid originating with the federal government have been required to provide the disabled with equal access to programs and activities that benefit from such federal financial assistance.[30] The Americans with Disabilities Act of 1990 (ADA)

28. See Section D(6)(f) of Chapter IV.

29. For insights into these problems, see C. Greene et al., "The Tipi with Battle Pictures: The Kiowa Tradition of Intangible Property Rights," *Trademark Reporter* (New York: International Trademark Assoc., 1994), and W. Merrill et al., "The Return of the Ahayu:da: Lessons for Repatriation from Zuni Pueblo and the Smithsonian Institution," 34 *Current Anthropology* (No. 5, 1993).

30. The Rehabilitation Act of 1973 (29 U.S.C. § 794) prohibits the federal government and those who receive federal financial assistance from the federal government from discriminating against any "otherwise qualified handicapped individual" regarding participating in or receiving benefits from any program or activity receiving federal financial assistance. Before that statute, the Federal Architectural Barriers Act of 1968, as amended (42

took a giant step forward and greatly expanded coverage to include all state and local government agencies, all commercial facilities, and all places of public accommodation. Museums fall within the definition of a "place of public accommodation." Hence, as of 1990, all museums in the United States, regardless of their sources of support, are subject to the Americans with Disabilities Act. Because many museums had been the recipients of federal grants since 1973 and were conscious of their disabled audiences, there was already a core of expertise and commitment within the museum community when the ADA went into effect. Still, much had to be done.

The ADA adopts a broad definition of "disability," one based on the definition set forth in the Rehabilitation Act of 1973. Under the ADA, a person with a disability is one who

1. has a physical or mental impairment that substantially limits that person in some major life activity; or
2. has a record of such an impairment; or
3. is regarded as having such an impairment.

An "impairment" includes such conditions as loss of mobility, visual impairment, speech impairment, hearing impairment, epilepsy, multiple sclerosis, cancer, heart disease, diabetes, emotional illness, mental impairment, HIV disease, drug addiction, and alcoholism, to name just some. And as the definition of "disability" points out, a person who once had such an impairment but is recovered and a person who is perceived to have such an impairment both fall within the coverage of the act.

How does the ADA affect the collection-related activities of a museum?[31] The act imposes definite rules regarding architectural barriers:

• As of 1993, all newly constructed buildings and facilities must be readily accessible.
• As of 1992, all altered portions of existing buildings and facilities must be readily accessible.
• All barriers to accessibility in existing buildings and facilities must be removed when it is "readily achievable" to do so.

Thus, for museums, all new construction of buildings, parking lots, walkways, and gardens must adhere to accessibility guidelines. All alterations to existing facilities are also covered. An alteration is "a change to a building or facility that affects or could affect its usability . . . [and] includes remodeling, renovation, rehabilitation, restoration, reconstruction, and

U.S.C. § 4151), required that buildings constructed, altered, or leased with federal money be accessible to the handicapped. During these same time periods, states and some municipalities were passing similar accessibility laws, and most tended to be tied to the use of government funds or other types of government support. The term "handicap" was in common usage until the late 1980s. As of 1990, the preferred term is "disability."

31. The ADA also has a section that addresses employment, which is not discussed in this text.

changes or rearrangement in structural parts or elements or in the configuration of walls and partitions."[32]

Equally important to museums is the removal of communications barriers, those that do not allow a person who may be physically present to participate meaningfully in the program or activity being offered. Into the communication barrier category would fall such situations as the absence of braille or voice for the visually impaired, the absence of amplification, signage, or text-telephone machines for the hearing impaired, and the absence of appropriate programs or scripts for the mentally impaired. Quite simply, the ADA asks a museum to think creatively not only about ways to bring more disabled people into its facilities but also about ways to provide those who come with all reasonable means to participate in programs and activities. The overall emphasis of the act is on inclusiveness.

If a museum plans to offer programs and activities to be enjoyed outside of its own premises—activities such as educational tours, traveling exhibitions, and museum publications—it should review the requirements not only of the ADA but also of any other federal or local accessibility laws that may affect the project. For example, if federal grant money will be sought to produce a major publication or a traveling exhibition, the museum's accessibility commitment will extend beyond the confines of its own buildings and facilities.

The ADA requires that barriers to accessibility in existing buildings and facilities be removed when it is "readily achievable" to do so. It is important to understand the interpretation of the quoted phrase. "Readily achievable" means easily accomplishable and able to be carried out without much difficulty or expense. Since what is difficult or expensive depends on the circumstances, factors such as the following need to be considered:

- The nature and cost of the action that needs to be taken
- The overall financial resources of the organization involved
- The number of people employed at the site in question
- The impact of the needed action on the overall operation of the site

These factors are used to determine whether the action is relatively easy and inexpensive, not whether it is possible. The law does not require burdensome expense.

If the museum determines that the removal of a barrier is not readily achievable, it has an obligation to provide an alternative method of accommodation if an alternative is readily achievable. Examples include directing disabled visitors to an accessible staff entrance to the museum when providing access through the main entrance would be burdensome. Another example would be offering an introductory film on the museum in a small accessible room in addition to showing it in a large but inaccessible auditorium that would be very costly to alter.

Experience has demonstrated that historic buildings and historic sites can raise special problems regarding accessibility requirements. At times the changes mandated by the ADA,

32. "The Impact of the Americans with Disabilities Act on Historic Structures," *Information Series #55* (Washington, D.C.: National Trust for Historic Preservation, 1991).

or similar legislation, appear to conflict with the statutory goals of historic preservation laws. In 1991, the U.S. Department of Justice published guidance on the subject of resolving differences between accessibility requirements and historic preservation requirements. The guidance is published in Part 36 of Volume 28 of the *Code of Federal Regulations,* beginning at Section 36.405. Essentially, the guidelines state that if removing barriers or accommodating an activity or program would threaten or destroy the historic significance of a building, the action will not be considered "readily achievable." At that point, alternative methods that are readily achievable need to be considered.

As of 1997, the most current guidance on the ADA is found in 28 C.F.R. Part 36, the regulations issued by the U.S. Department of Justice for implementing the act.[33] Technical guidance for achieving accessibility (e.g., slope of ramps, door width) appears in the "ADA Accessibility Guidelines," published by the Architectural and Transportation Barriers Compliance Board.[34] These guidelines appear in the *Code of Federal Regulations* as Appendix A to the Justice Department's ADA regulations.[35]

2. A SUGGESTED APPROACH TO COMPLIANCE

In the 1970s, when a number of museums first had to focus on accessibility because they were receiving some form of federal financial assistance, there was considerable confusion and apprehension. Demands placed on these organizations seemed overwhelming because of the breadth of the impairments covered and the lack of certainty as to what constituted "accommodation." There was also the cost factor. Most museums had to find their own money to meet accessibility requirements because, as a rule, funding for compliance was not made a part of most legislative packages. Some museums were almost immobilized by the challenge, but with time, several important lessons were learned.

A first lesson is that someone or some group in the museum needs to become very familiar with the accessibility laws and regulations that apply to the museum. Reading the actual laws and regulations, as well as the history of the regulations, is time-consuming, but this is the quickest and most accurate method for gaining a full understanding of the letter and the spirit of the law. A knowledge of what the law really says allows the museum to

33. These regulations were first published in the *Federal Register* on July 26, 1991, and a revised version was published on July 1, 1994.

34. The "ADA Accessibility Guidelines" were first published in the *Federal Register* on July 26, 1991, and they appear in 28 C.F.R. pt. 36 as Appendix A.

35. In addition to the federal regulations and guidelines mentioned in the text, other useful sources of information are J. Majewski, *Part of Your General Public Is Disabled: A Handbook for Guides in Museums, Zoos, and Historic Houses* (Washington, D.C.: Smithsonian Institution Press, 1987); *The Arts and 504* (Washington, D.C.: National Endowment for the Arts, 1992); "The Impact of the Americans with Disabilities Act on Historic Structures," *Information Series #55* (Washington, D.C.: National Trust for Historic Preservation, 1991); J. Teichman, "Selected Materials on the Americans with Disabilities Act," in American Law Institute–American Bar Association (ALI-ABA), *Course of Studies Materials: Legal Problems of Museum Administration* (Philadelphia: ALI-ABA, 1991); and J. Douglas, "Requirements for Accessibility in Historic Buildings under the Americans with Disabilities Act," in American Law Institute–American Bar Association (ALI-ABA), *Course of Studies Materials: Legal Problems of Museum Administration* (Philadelphia: ALI-ABA, 1992).

distinguish between fact and fiction. A second lesson concerns the importance of making contacts with disabled individuals or groups in the vicinity and soliciting their help in identifying barriers, special needs, priorities, and possible solutions. A third lesson learned is the wisdom of surveying what must be done and arriving at a plan that has a list of priorities. As a rule, full accessibility cannot be accomplished quickly, but if a museum has taken the above-described steps and is proceeding in good faith to accomplish tasks according to priority, there should be less anxiety about liability. Although museums are subject to suit for failure to abide by mandated accessibility standards, a record of honest effort goes a long way in encouraging complainants to settle claims in a nonadversarial manner.[36]

36. The ADA permits individuals to sue in their own name, and it permits suits by the attorney general of the United States. The U.S. Department of Justice is the federal agency with primary responsibility for implementing the ADA.

Visitor and Employee Safety
as It Relates to Collections

A. Responsibility Owed the Public

B. Responsibility Owed Employees

C. Safety and Health Guides and Other Assistance

 1. Fire and Related Hazards

 2. Employee Safety

 3. General Health and Safety

A. Responsibility Owed the Public

A museum invites the public to enter its premises and view its displays. The law infers, therefore, that the museum will act in a reasonably prudent manner to ensure that the visiting public is safe from hazards. This duty applies not just to the condition of the museum stairs and walkways, which are the traditional slip and fall areas, and to the coat-check booths, which spawn umbrella claims, but also to the exhibits themselves. Consider the following situations.

Hypothetical Example 1. The Mellow Museum of Modern Art has a light show exhibit that is described by the critics as "Stunning! An Emotional Tour de Force!" The euphoria generated by the show's reception is somewhat dampened when the museum is sued by Ms. Delicate for injuries sustained in a fall when she became "disoriented" by the exhibit. Shortly thereafter, a similar suit is filed by Mr. Elderly, who claims he became nauseous when viewing the exhibit and "blacked out" on leaving the museum. Obviously, Mellow Museum has a problem, and expert advice is needed.[1]

1. In 1982, the Whitney Museum in New York City was faced with such lawsuits, caused by a light show featured on its premises.

Hypothetical Example 2. The Hoosier Historical Society plans to refurbish the grand salon of its Governor Grover House. Much care is being taken to find authentic fabrics, carpets, and decorative items. Someone asks whether fire safety must be considered when selections are made and installed even if this jeopardizes the "integrity" of the finished exhibit.

Hypothetical Example 3. The Seaside Science Museum is exhibiting space capsules and related equipment. Children are particularly attracted to the display, and as a precautionary measure, several signs are posted that say "Do not climb on exhibits." During the course of a busy morning, a five-year-old boy, while touring the museum with his kindergarten class, manages to injure himself seriously when attempting to climb into one of the artifacts. How will the museum fare when the inevitable claim is brought?

Art, historical integrity, and "meaningful educational experiences" usually must bow to safety and health considerations, according to the law. Local fire and safety codes, local building codes, and the law's traditional test in negligence cases—"the reasonably prudent man rule"[2]—invariably apply to museums and historic structures.[3] A museum is advised, therefore, to make safety a prime consideration when choosing the objects it collects, the objects it displays, and the exhibit methods it uses. A few practices can be instituted to draw safety into these routine museum activities in a timely manner.

A museum's collection management policy can require a safety evaluation among its accessioning criteria as well as among its incoming loan criteria. Objects posing safety problems usually demand special handling, special display, and/or special insurance, none of which a museum, on reflection, may want to assume. Calling attention to the safety factor before a decision is made to accession or borrow an object allows for a more objective analysis of the merits of the acquisition. The spinning mobile, the angular piece of fabricated art, or the highly flammable but authentic carpeting may lose some of its attractiveness when considered for display in a crowded museum setting. What is the potential for injury? Are there simple yet effective measures that can be taken to protect the public? A sign saying "Don't climb" is not effective for the young child who cannot read,[4] and a movable stanchion may be a totally inadequate guard if surrounding exhibits draw a visitor's attention upward.

2. In most negligence cases, the standard of care imposed is that of a "reasonably prudent man." In other words, the individual charging negligence must demonstrate that the act or condition complained of was not something that a reasonably prudent person would do or permit.

3. If a museum is part of or associated with a governmental unit, local statutes and case law should be checked to see if the museum benefits from the doctrine of sovereign immunity. Under the traditional doctrine of sovereign immunity, a government cannot be sued (i.e., the king is above the law), but today, in most jurisdictions within the United States, this doctrine has been modified or waived by statute. These waiver statutes take a variety of forms, but they usually permit designated types of claims to be brought against the governmental unit as long as certain procedural requirements are followed. Also to be considered is the doctrine of charitable immunity. Traditionally, charitable organizations were not subject to suit on the theory that their charitable endeavors would suffer if private individuals were permitted to obtain large judgments. In most jurisdictions, this doctrine has been abolished or seriously modified. A museum may find it advisable to have a professional opinion on record regarding the applicability of both doctrines (sovereign immunity and charitable immunity) to its activities.

4. As a rule, more caution is expected of the museum when children are known to frequent an area or when the object or location at issue is one that would normally attract children.

Is the object one that can be viewed satisfactorily from a distance or from behind protective barriers, or will such methods of display only frustrate the visiting public? Each proposed acquisition or use of a potentially hazardous item raises its own safety consideration that deserves early and thoughtful evaluation.

Frequently the mode of exhibit can ameliorate a safety hazard inherent in a collection object, but just as frequently the manner of exhibit, not the object, can create the hazard. This is especially true if the exhibit is an elaborate one utilizing background construction and special lighting and audiovisual equipment. The curator and the designer, in their efforts to achieve an authentic and effective display, may lose sight of safety factors. The change of lighting in the exhibit area may be too drastic, or an inadequate demarcation of levels may cause tripping hazards. Both conditions are particularly hazardous in an area that may be crowded and in which visitors are encouraged to look at displayed objects and not at the walkway. Proper ventilation is another important consideration, as are adequate traffic patterns and unobstructed, visible exit routes. A museum should have a firm policy that no exhibit proceeds beyond the preliminary design stage without review for safety considerations.[5] As a rule, aesthetics, authenticity, and the law coexist quite comfortably and economically if time is allowed for consultation and adjustment.

The above-described procedures for early consideration of safety issues will not work unless someone within the museum has been assigned the responsibility to keep abreast of applicable rules and regulations so that information is available in an efficient manner. Also, when a museum is contracting out for exhibition design or any other type of work that affects its premises, the contractors, as appropriate, should be required to adhere to recognized safety standards. Equally important is a commitment by the museum to budget for safety needs. Too often, safety is very low on the list of priorities when museum funds are being allocated.

B. Responsibility Owed Employees

The Occupational Safety and Health Act of 1970[6] affects the working conditions of just about everyone employed in a museum located in the United States. The act extends to all employers "engaged in a business affecting commerce"[7] and to their employees. It requires that each employer "furnish to each of his employees employment and a place of employment which is free from recognized hazards that are causing or are likely to cause death or serious physical harm to his employees."[8]

5. At the same time, a review for any applicable access requirements for the disabled can be conducted (see Chapter XVI).

6. 29 U.S.C. §§ 651 *et seq.*

7. "Commerce" is defined to mean "trade, traffic, commerce, transportation, or communication among the several states or between a state and any place outside thereof, or within the District of Columbia, or a possession of the United States . . . , or between points in the same state but through a point outside thereof." 29 U.S.C. § 652(3).

8. 29 U.S.C. § 654(a).

This general duty has been translated by the U.S. Department of Labor, through its Occupational Safety and Health Administration (OSHA), into numerous, quite specific OSHA standards that regulate the work environment and work practices. All OSHA standards are found in Title 29 of the *Code of Federal Regulations* (Parts 1910 *et seq.*). Although OSHA has broad regulatory control over worker health and safety, it interacts with other government agencies in carrying out its work. The federal Environmental Protection Agency (EPA), for example, is directly involved in such areas as the control of toxic substances, the regulation of insecticides and fungicides, and the disposal of toxic waste. Each state invariably has a state agency (or agencies) that may have the authority to implement federal safety and health requirements within its borders, in addition to administering any requirements specific to that state.[9] Therefore, if a museum does not have its own safety expert, a good place to start looking for help in identifying employee-related safety and health hazards would be the nearest regional or area office of the U.S. Department of Labor, Occupational Safety and Health Administration[10] or, if known, the state agency that has the authority to implement OSHA requirements.

As a rule, OSHA provides free inspection services and instruction booklets to assist employers in meeting their obligations. Another source of help can be the museum's insurer. Major insurers normally offer a range of risk management services to their customers, viewing this as an effective way to reduce claims. Under OSHA, employees have the right to file health and safety grievances with their employer or directly with the enforcement authority without fear of retribution,[11] and failure to comply with the act's requirements can expose an employer to civil and possibly criminal penalties. But on the positive side, a museum inspection that focuses on employee health and safety and on the accomplishment of required reforms usually has a twofold effect. It not only avoids employee injury claims but also contributes to a safer environment for visitors, thus reducing the museum's liability exposure in this area as well.

Health and safety requirements can bear directly on the museum's collecting activities in a variety of ways. Frequently targeted for safety inspection are mineral collections that may contain radioactive specimens. Trained health physicists can identify hazardous specimens and recommend risk-reducing steps. These steps may include the following:

9. Although implementation of the Occupational Safety and Health Act is the responsibility of the U.S. Department of Labor, by statutory design most local compliance is administered through the states under federally approved state programs. (See 29 C.F.R. pt. 1901, "Procedures for State Agreements.") Since this enforcement pattern is also used for other federal statutes that bear on health and safety, a museum's point of contact may often be its state's regulatory department concerned with health and safety, even though federal laws are at issue.

10. Offices are located in Boston, Mass.; New York, N.Y.; Philadelphia, Pa.; Atlanta, Ga.; Chicago, Ill.; Dallas, Tex.; Kansas City, Mo.; Denver, Colo.; San Francisco, Calif.; and Seattle, Wash.

11. 29 U.S.C. § 660(c)(1) states: "No person shall discharge or in any manner discriminate against any employee because such employee has filed a complaint or instituted or caused to be instituted any proceeding under or related to . . . [the Occupational Safety and Health Act] or has testified or is about to testify in any such proceeding or because of the exercise by such employee on behalf of himself or others of any right afforded by this . . . [Act]." Violation of this provision can subject an employer to suit.

- Safe disposal of any specimens found to be surplus to the needs of the collecting goals of the museum
- Proper housing and signage for all retained specimens while in storage
- Special attention to what is exhibited and to the adequacy of protective cases used to display specimens
- Mastery of simple monitoring techniques by staff

Other types of hazardous substances found in collection objects include arsenic, asbestos, cadmium, cyanide, formaldehyde, and lead. Experts can help identify the presence of such contaminants and recommend remedial measures. Displays and demonstrations of certain historic machinery and craft techniques have been known to run afoul of OSHA standards because required protective shields or safety equipment are not used. Historic buildings often contain lead-based paint and asbestos-contaminated building materials. Other museum locations that may need special attention in the search for safety and health hazards are conservation laboratories and exhibition fabrication shops.[12]

Another federal safety statute that bears on collection activity and employee health is the Federal Insecticide, Fungicide, and Rodenticide Act (FIFRA), as amended.[13] All museum collections, whether they be paintings, textiles, manuscripts, archaeological specimens, botanical specimens, or historic structures, are susceptible to damage or destruction by a variety of pests. In attempting to conserve their objects, museums use a variety of chemicals and techniques for pest control, and a good portion of such activity is now subject to government regulations. FIFRA, for example, requires that all pesticides be properly labeled and that consumer use be in accordance with label instructions. The act further provides that some pesticides (those labeled for "restricted use") be applied only by a certified pesticide applicator or by someone under the direct supervision of a certified pesticide applicator. Thus museums must adhere to the following rules:

1. A museum cannot mix its own pesticides.
2. Labels on registered pesticides must be read to see if the use intended by the museum is one enumerated on the label.
3. Label instructions regarding procedures must be followed carefully.
4. If pesticides labeled for "restricted use" are to be applied by museum staff, a sufficient number of people must be certified as applicators to comply with FIFRA requirements.[14]

12. In the application of all health and safety standards, common sense is an important ingredient. Touring a museum sculpture garden, an OSHA official, who fortunately is an art lover, pointed out several figures with extended arms posed possible "striking hazards." Under OSHA standards, such hazards are to be marked with bright-yellow paint. To the museum's great relief, no recommendation was made that the limbs of the figures be painted. However, not long afterward, the museum did confer with safety experts about the placement of barriers to direct walkways beyond possible points of contact.

13. 7 U.S.C. § 135 *et seq.*, 40 C.F.R. pt. 162 *et seq.* This statute falls under the jurisdiction of the EPA.

14. If a museum has a fumigation chamber, the applicable regulations will most likely require that the chamber be operated by or under the direct supervision of a certified individual.

In many states, FIFRA requirements are enforced by state agencies under programs approved by the EPA. If a state does not have an approved program in place, enforcement is handled directly by the EPA. Here again, a museum should be familiar with local requirements and local enforcement authorities.

In a related area, OSHA has now revised its "Hazardous Communication Standard" so that as of May 1988, employers of workers at most workplaces (including museums) where hazardous chemicals are present must inform workers and educate them about all hazardous chemicals that are in use.[15] "Hazardous chemicals" is defined broadly and includes any chemical that poses a physical hazard (such as flammability) and/or a health hazard (such as lung irritation). Chemicals in all forms are covered: liquids, solids, gases, fumes. "Using hazardous chemicals" means "any situation where a chemical is present in such a way that employees may be exposed under normal conditions of use or in any foreseeable emergency."[16] Under this broad definition, hazardous chemicals can include most commercially used cleaning products, darkroom supplies, copying machine chemicals, exhaust fumes, artist supplies, glues, and the like. This particular OSHA standard spells out specific employer duties aimed at protecting employees:

- Proper labeling and marking of all hazardous chemicals used
- Maintenance of material safety data sheets on each such hazardous chemical (these data sheets must be readily available to employees)
- An ongoing information and training program for employees who are exposed to hazardous chemicals
- Designation of the people responsible for carrying out the on-site hazardous communication program[17]

C. Safety and Health Guides and Other Assistance

In pursuing its safety programs for both visitors and employees, a museum will find the publications discussed below particularly helpful.

15. *52 Fed. Reg.* 31852 (1987), now 29 C.F.R. 1910.1200.

16. Contact the nearest OSHA office for the free booklet "Hazardous Communication Standard."

17. A first stop for information on the "Hazardous Communication Standard" is the state office charged with implementing OSHA standards or the nearest OSHA regional office. (See footnote 10, above.) See also C. Shattuck, "The Occupational Safety and Health Act in the Next Administration," in American Law Institute–American Bar Association (ALI-ABA), *Course of Studies Materials: Legal Problems of Museum Administration* (Philadelphia: ALI-ABA, 1989); S. Grey, "Don't Worry, but the OSHA Is Here," *Exhibit Builder* (Sept.–Oct. 1989); J. Hancock, "Museums and Hazardous Substances: Identifying and Managing the Problem," in American Law Institute–American Bar Association (ALI-ABA), *Course of Studies Materials: Legal Problems of Museum Administration* (Philadelphia: ALI-ABA, 1988); and K. Makos and E. Detrich, "Health and Environmental Safety," in C. Rose et al., eds., *Storage of Natural History Collections: A Preventive Conservation Approach* (Washington, D.C.: Society for the Preservation of Natural History Collections, 1995).

1. FIRE AND RELATED HAZARDS

"The Life Safety Code" (NFPA 101), the product of the National Fire Protection Association Inc., is a generally accepted standard code for establishing minimum requirements for a reasonable degree of safety from fire in buildings and structures. Each museum must conform to its local fire safety regulations, and these can vary from municipality to municipality. However, most local standards do not vary significantly from NFPA 101, and with a copy of that publication in hand a museum has a comprehensive source of reference. Several other NFPA publications treat both general and specific museum fire problems:

- NFPA 910—"Protection of Libraries and Library Collections"
- NFPA 911—"Protection of Museums and Museum Collections"
- NFPA 30—"Flammable and Combustible Liquids"
- NFPA 40—"Cellulose Nitrate Motion Picture Films"[18]

Pamphlets 910 and 911 contain handy fire safety self-inspection forms designed to disclose conditions that need correction.

For historic properties, the Advisory Council on Historic Preservation and the U.S. General Services Administration have a useful 1989 publication titled "Fire Safety Retrofitting in Historic Buildings." This is available from the Advisory Council on Historic Preservation, located in Washington, D.C. Another national organization that should be checked for information on fire and related hazards common to historic properties is the National Trust for Historic Preservation. The main office is in Washington, D.C., but regional offices are located in Philadelphia, Chicago, Boston, Denver, Fort Worth, San Francisco, and Charleston, S.C.

Frequently, a museum's insurance company may have fire and safety consultants who can offer advice, and the local fire department or regulatory agency may provide similar assistance. In addition, professional fire and safety consultants can be retained to evaluate existing or proposed conditions.

2. EMPLOYEE SAFETY

OSHA standards cover hundreds of pages in the U.S. *Code of Federal Regulations.* Certain standards, however, are of recurring interest to a museum. These include but are not limited to the following, which all appear in Part 1910 of Title 29 of the *Code of Federal Regulations:*

- Subpart D—"Walking-Working Surfaces"
- Subpart E—"Means of Egress"
- Subpart G—"Occupational Health and Environmental Control," with special emphasis on § 1910.95, "Occupational Noise Exposure"

18. All publications are available from the National Fire Protection Association, Batterymarch Park, Quincy, MA 02269.

- Subpart H—"Hazardous Materials"
- Subpart I—"Personal Protective Equipment," with special emphasis on § 1910.134, "Respiratory Protection"
- Subpart J—"General Environmental Controls"
- Subpart K—"Medical and First Aid"
- Subpart L—"Fire Protection"
- Subpart N, § 1910.176—"Handling Materials, General"
- Subpart O, § 1910.212—"General Requirements for All Machines"; § 1910.213—"Woodworking Machinery Requirements"; § 1910.215—"Abrasive Wheel Machinery"
- Subpart P—"Hand and Portable Powered Tools and Other Hand-held Equipment"
- Subpart Q—"Welding, Cutting, and Brazing"
- Subpart S—"Electrical"
- Subpart Z—"Toxic and Hazardous Substances," with special emphasis on § 1910.1047, "Ethylene Oxide," and § 1910.1200 "Hazardous Communication"

3. GENERAL HEALTH AND SAFETY

Other guides on health and safety matters are frequently used by museums. Popular publications from the Occupational Safety and Health Administration (contact the U.S. Superintendent of Documents, P.O. Box 371954, Pittsburgh, PA 15250-7954 for verification of the most current editions and costs) are "OSHA Handbook for Small Businesses" (OSHA No. 2209) and "Hazard Communication: A Compliance Kit" (OSHA No. 3104).

The National Trust for Historic Preservation (Washington, D.C.) publishes "Coping with Contamination: A Primer for Preservationists" (Information Booklet #70). The National Park Service (Curatorial Services Division, Washington, D.C.) offers a technical bulletin "Asbestos and Historic Buildings" and an extensive guide titled *Museum Property Handbook,* Vol. 1, "Preservation and Protection of Museum Property." The latter is a comprehensive manual designed primarily for those charged with the management of federal museum property, but it is very helpful to an even broader audience. Section 13B of the manual addresses health and safety concerns.

The Artist's Complete Health and Safety Guide, by M. Rossol (2d ed., New York: Allworth Press, 1990), covers OSHA compliance for those using paints, dyes, solvents, and other arts-and-crafts materials. *Safety in Museums and Galleries,* edited by F. Howie (Boston, Mass.: Buttersworth, 1987), has an English orientation, but its explanation of safety hazards associated with museums has broad application.

Convention on the Means of Prohibiting and Preventing the Illicit Import, Export, and Transfer of Ownership of Cultural Property, Adopted by the General Conference, UNESCO, at Its Sixteenth Session, Paris, November 14, 1970

Having decided, at its fifteenth session, that this question should be made the subject of an international convention.

Adopts this Convention on the fourteenth day of November 1970.

The General Conference of the United Nations Educational, Scientific and Cultural Organization, meeting in Paris from 12 October to 14 November 1970, at its sixteenth session,

Recalling the importance of the provisions contained in the Declaration of the Principles of International Cultural Co-operation, adopted by the General Conference at its fourteenth session,

Considering that the interchange of cultural property among nations for scientific, cultural and educational purposes increases the knowledge of the civilization of Man, enriches the cultural life of all peoples and inspires mutual respect and appreciation among nations,

Considering that cultural property constitutes one of the basic elements of civilization and national culture, and that its true value can be appreciated only in relation to the fullest possible information regarding its origin, history and traditional setting,

Considering that it is incumbent upon every State to protect the cultural property existing within its territory against the dangers of theft, clandestine excavation, and illicit export,

Considering that, to avert these dangers, it is essential for every State to become increasingly alive to the moral obligations to respect its own cultural heritage and that of all nations,

Considering that, as cultural institutions, museums, libraries and archives should ensure that their collections are built up in accordance with universally recognized moral principles,

Considering that the illicit import, export and transfer of ownership of cultural property is an obstacle to that understanding between nations which it is part of Unesco's mission to promote by recommending to interested States, international conventions to this end,

Considering that the protection of cultural heritage can be effective only if organized both nationally and internationally among States working in close co-operation,

Considering that the Unesco General Conference adopted a Recommendation to this effect in 1964,

Having before it further proposals on the means of prohibiting and preventing the illicit import, export and transfer of ownership of cultural property, a question which is on the agenda for the session as item 19.

Article 1

For the purposes of this Convention, the term "cultural property" means property which, on religious or secular grounds, is specifically designated by each State as being of importance for archaeology, prehistory, history, literature, art or science and which belongs to the following categories:

(a) Rare collections and specimens of fauna, flora, minerals and anatomy, and objects of palae-ontological interest;

(b) property relating to history, including the history of science and technology and military and social history, to the life of national leaders, thinkers, scientists and artists and to events of na-tional importance;

(c) products of archaeological excavations (including regular and clandestine) or of archaeologi-cal discoveries;

(d) elements of artistic or historical monuments or archaeological sites which have been dismembered;

(e) antiquities more than one hundred years old, such as inscriptions, coins and engraved seals;

(f) objects of ethnological interest;

(g) property of artistic interest, such as:
 (i) pictures, paintings and drawings produced entirely by hand on any support and in any material (excluding industrial designs and manufactured articles decorated by hand);
 (ii) original works of statuary art and sculpture in any material;
 (iii) original engravings, prints and lithographs;
 (iv) original artistic assemblages and montages in any material;

(h) rare manuscripts and incunabula, old books, documents and publications of special interest (historical, artistic, scientific, literary, etc.) singly or in collections;

(i) postage, revenue and similar stamps, singly or in collections;

(j) archives, including sound, photographic and cinematographic archives;

(k) articles of furniture more than one hundred years old and old musical instruments.

Article 2

1. The States Parties to this Convention recognize that the illicit import, export and transfer of ownership of cultural property is one of the main causes of the impoverishment of the cultural heri-tage of the countries of origin of such property and that international co-operation constitutes one of the most efficient means of protecting each country's cultural property against all the dangers resulting therefrom.

2. To this end, the States Parties undertake to oppose such practices with the means at their dis-posal, and particularly by removing their causes, putting a stop to current practices, and by helping to make the necessary reparations.

Article 3

The import, export or transfer of ownership of cultural property effected contrary to the provisions adopted under this Convention by the States Parties thereto, shall be illicit.

Article 4

The States Parties to this convention recognize that for the purpose of the Convention property which belongs to the following categories forms part of the cultural heritage of each State:

(a) Cultural property created by the individual or collective genius of nationals of the State concerned, and cultural property of importance to the State concerned created within the territory of that State by foreign nationals or stateless persons resident within such territory;

(b) cultural property found within the national territory;

(c) cultural property acquired by archaeological, ethnological or natural science missions, with the consent of the competent authorities of the country of origin of such property;

(d) cultural property which has been the subject of a freely agreed exchange;

(e) cultural property received as a gift or purchased legally with the consent of the competent authorities of the country of origin of such property.

Article 5

To ensure the protection of their cultural property against illicit import, export and transfer of ownership, the States Parties to this Convention undertake, as appropriate for each country, to set up within their territories one or more national services, where such services do not already exist, for the protection of the cultural heritage, with a qualified staff sufficient in number for the effective carrying out of the following functions:

(a) Contributing to the formation of draft laws and regulations designed to secure the protection of the cultural heritage and particularly prevention of the illicit import, export and transfer of ownership of important cultural property;

(b) establishing and keeping up to date, on the basis of a national inventory of protected property, a list of important public and private cultural property whose export would constitute an appreciable impoverishment of the national cultural heritage;

(c) promoting the development or the establishment of scientific and technical institutions (museums, libraries, archives, laboratories, workshops . . .) required to ensure the preservation and presentation of cultural property;

(d) organizing the supervision of archaeological excavations, ensuring the preservation "in situ" of certain cultural property, and protecting certain areas reserved for future archaeological research;

(e) establishing, for the benefit of those concerned (curators, collectors, antique dealers, etc.) rules in conformity with the ethical principles set forth in this Convention; and taking steps to ensure the observance of those rules;

(f) taking educational measures to stimulate and develop respect for the cultural heritage of all States, and spreading knowledge of the provisions of this Convention;

(g) seeing that appropriate publicity is given to the disappearance of any items of cultural property.

Article 6

The States Parties to this Convention undertake:

(a) To introduce an appropriate certificate in which the exporting State would specify that the export of the cultural property in question is authorized. The certificate should accompany all items of cultural property exported in accordance with the regulations;

(b) to prohibit the exportation of cultural property from their territory unless accompanied by the above-mentioned export certificate;

(c) to publicize this prohibition by appropriate means, particularly among persons likely to export or import cultural property.

Article 7

The State Parties to this Convention undertake:

(a) To take the necessary measures, consistent with national legislation, to prevent museums and similar institutions within their territories from acquiring cultural property originating in another State Party which has been illegally exported after entry into force of this Convention, in the States concerned. Whenever possible, to inform a State of origin Party to this Convention of an offer of such cultural property illegally removed from that State after the entry into force of this Convention in both States;

(b) (i)　to prohibit the import of cultural property stolen from a museum or a religious or secular public monument or similar institution in another State Party to this Convention after the entry into force of this Convention for the States concerned, provided that such property is documented as appertaining to the inventory of that institution;

(ii)　at the request of the State Party of origin, to take appropriate steps to recover and return any such cultural property imported after the entry into force of this Convention in both States concerned, provided, however, that the requesting State shall pay just compensation to an innocent purchaser or to a person who has valid title to that property. Requests for recovery and return shall be made through diplomatic offices. The requesting Party shall furnish, at its expense, the documentation and other evidence necessary to establish its claim for recovery and return. The Parties shall impose no customs duties or other charges upon cultural property returned pursuant to this Article. All expenses incident to the return and delivery of the cultural property shall be borne by the requesting Party.

Article 8

The States Parties to this Convention undertake to impose penalties or administrative sanctions on any person responsible for infringing the prohibitions referred to under Articles 6 (b) and 7 (b) above.

Article 9

Any State Party to this Convention whose cultural patrimony is in jeopardy from pillage of archaeological or ethnological materials may call upon other States Parties who are affected. The States Parties to this Convention undertake, in these circumstances, to participate in a concerted international effort to determine and to carry out the necessary concrete measures, including the control of exports and imports and international commerce in the specific materials concerned. Pending agreement each State concerned shall take provisional measures to the extent feasible to prevent irremediable injury to the cultural heritage of the requesting State.

Article 10

The States Parties to this Convention undertake:

(a) To restrict by education, information and vigilance, movement of cultural property illegally removed from any State Party to this Convention and, as appropriate for each country, oblige antique dealers, subject to penal or administrative sanctions, to maintain a register recording

the origin of each item of cultural property, names and addresses of the supplier, description and price of each item sold and to inform the purchaser of the cultural property of the export prohibition to which such property may be subject;

(b) to endeavor by educational means to create and develop in the public mind a realization of the value of cultural property and the threat to the cultural heritage created by theft, clandestine excavations and illicit exports.

Article 11

The export and transfer of ownership of cultural property under compulsion arising directly or indirectly from the occupation of a country by a foreign power shall be regarded as illicit.

Article 12

The States Parties to this Convention shall respect the cultural heritage within the territories for the international relations of which they are responsible, and shall take all appropriate measures to prohibit and prevent the illicit import, export and transfer of ownership of cultural property in such territories.

Article 13

The States Parties to this Convention also undertake, consistent with the laws of each State:

(a) To prevent by all appropriate means transfers of ownership of cultural property likely to promote the illicit import or export of such property;

(b) to ensure that their competent services cooperate in facilitating the earliest possible restitution of illicitly exported cultural property to its rightful owner;

(c) to admit actions for recovery of lost or stolen items of cultural property brought by or on behalf of the rightful owners;

(d) to recognize the indefeasible right of each State Party to this Convention to classify and declare certain cultural property as inalienable which should therefore *ipso facto* not be exported, and to facilitate recovery of such property by the State concerned in cases where it has been exported.

Article 14

In order to prevent illicit export and to meet the obligations arising from the implementation of this Convention, each State Party to the Convention should, as far as it is able, provide the national services responsible for the protection of its cultural heritage with an adequate budget and, if necessary, should set up a fund for this purpose.

Article 15

Nothing in this Convention shall prevent States Parties thereto from concluding special agreements among themselves or from continuing to implement agreements already concluded regarding the restitution of cultural property removed, whatever the reason, from its territory of origin, before the entry into force of this Convention for the States concerned.

Article 16

The States Parties to this Convention shall in their periodic reports submitted to the General Conference of the United Nations Educational, Scientific and Cultural Organization on dates and in a man-

ner to be determined by it, give information on the legislative and administrative provisions which they have adopted and other action which they have taken for the application of this Convention, together with details of the experience acquired in this field.

Article 17

1. The States Parties to this Convention may call on the technical assistance of the United Nations Educational, Scientific and Cultural Organization, particularly as regards:
 (a) information and education;
 (b) consultation and expert advice;
 (c) co-ordination and good offices.
2. The United Nations Educational, Scientific and Cultural Organization may, on its own initiative, conduct research and publish studies on matters relevant to the illicit movement of cultural property.
3. To this end, the United Nations Educational, Scientific and Cultural Organization may also call on the cooperation of any competent nongovernmental organization.
4. The United Nations Educational, Scientific and Cultural Organization may, on its own initiative, make proposals to States Parties to this Convention for its implementation.
5. At the request of at least two States Parties to this Convention which are engaged in a dispute over its implementation, Unesco may extend its good offices to reach a settlement between them.

Article 18

This Convention is drawn up in English, French, Russian and Spanish, the four texts being equally authoritative.

Article 19

1. This Convention shall be subject to ratification or acceptance by States members of the United Nations Educational, Scientific and Cultural Organization in accordance with their respective constitutional procedures.
2. The instruments of ratification or acceptance shall be deposited with the Director-General of the United Nations Educational, Scientific and Cultural Organization.

Article 20

1. This Convention shall be open to accession by all States not members of the United Nations Educational, Scientific and Cultural Organization which are invited to accede to it by the Executive Board of the Organization.
2. Accession shall be effected by the deposit of an instrument of accession with the Director-General of the United Nations Educational, Scientific and Cultural Organization.

Article 21

This Convention shall enter into force three months after the date of the deposit of the third instrument of ratification, acceptance or accession, but only with respect to those States which have deposited their respective instruments on or before that date. It shall enter into force with respect to any other State three months after the deposit of its instrument of ratification, acceptance or accession.

Article 22

The States Parties to this Convention recognize that the Convention is applicable not only to their metropolitan territories but also to all territories for the international relations of which they are responsible; they undertake to consult, if necessary, the governments or other competent authorities of these territories on or before ratification, acceptance or accession with a view to securing the application of the Convention to those territories, and to notify the Director-General of the United Nations Educational, Scientific and Cultural Organization of the territories to which it is applied, the notification to take effect three months after the date of its receipt.

Article 23

1. Each State Party to this Convention may denounce the Convention on its own behalf or on behalf of any territory for whose international relations it is responsible.
2. The denunciation shall be notified by an instrument in writing, deposited with the Director-General of the United Nations Educational, Scientific and Cultural Organization.
3. The denunciation shall take effect twelve months after the receipt of the instrument of denunciation.

Article 24

The Director-General of the United Nations Educational, Scientific and Cultural Organization shall inform the States members of the Organization, the States not members of the Organization which are referred to in Article 20, as well as the United Nations, of the deposit of all the instruments of ratification, acceptance and accession provided for in Articles 19 and 20, and of the notifications and denunciations provided for in Articles 22 and 23 respectively.

Article 25

1. This Convention may be revised by the General Conference of the United Nations Educational, Scientific and Cultural Organization. Any such revision shall, however, bind only the States which shall become Parties to the revising convention.
2. If the General Conference should adopt a new convention revising this Convention in whole or in part, then, unless the new convention otherwise provides, this Convention shall cease to be open to ratification, acceptance or accession, as from the date on which the new revising convention enters into force.

Article 26

In conformity with Article 102 of the Charter of the United Nations, this Convention shall be registered with the Secretariat of the United Nations at the request of the Director-General of the United Nations Educational, Scientific and Cultural Organization.

Done in Paris this seventeenth day of November 1970, in two authentic copies bearing the signature of the President of the sixteenth session of the General Conference and of the Director-General of the United Nations Educational, Scientific and Cultural Organization, which shall be deposited in the archives of the United Nations Educational, Scientific and Cultural Organization, and certified true copies of which shall be delivered to all the States referred to in Articles 19 and 20 as well as to the United Nations. The foregoing is the authentic text of the Convention duly adopted by the General

Conference of the United Nations Educational, Scientific and Cultural Organization during its sixteenth session, which was held in Paris and declared closed the fourteenth day of November 1970.

IN FAITH WHEREOF we have appended our signatures this seventeenth day of November 1970.

The President of the General Conference
ATILIO DELL'ORO MAINI
The Director-General
RENE MAHEU

Certified copy
Paris,

Director, Office of International
Standards and Legal Affairs,
United Nations Educational,
Scientific and Cultural Organization

Title III of Public Law 97–446

Convention on Cultural Property Implementation Act

United States Code, Title 19

§ 2601. Definitions.

For purposes of this chapter—

(1) The term "agreement" includes any amendment to, or extension of, any agreement under this chapter that enters into force with respect to the United States.

(2) The term "archaeological or ethnological material of the State Party" means—

(A) any object of archaeological interest;

(B) any object of ethnological interest; or

(C) any fragment or part of any object referred to in subparagraph (A) or (B); which was first discovered within, and is subject to export control by, the State Party. For purposes of this paragraph—

(i) no object may be considered to be an object of archaeological interest unless such object—

(I) is of cultural significance;

(II) is at least two hundred and fifty years old; and

(III) was normally discovered as a result of scientific excavation, clandestine or accidental digging, or exploration on land or under water; and

(ii) no object may be considered to be an object of ethnological interest unless such object is—

(I) the product of a tribal or nonindustrial society, and

(II) important to the cultural heritage of a people because of its distinctive characteristics, comparative rarity, or its contribution to the knowledge of the origins, development, or history of that people.

(3) The term "Committee" means the Cultural Property Advisory Committee established under section 2605 of this title.

(4) The term "consignee" means a consignee as defined in section 1483 of this title.

(5) The term "Convention" means the Convention on the means of prohibiting and preventing the illicit import, export, and transfer of ownership of cultural property adopted by the General Conference of the United Nations Educational, Scientific, and Cultural Organization at its sixteenth session.

(6) The term "cultural property" includes articles described in article 1(a) through (k) of the Convention whether or not any such article is specifically designated as such by any State Party for the purposes of such article.

(7) The term "designated archaeological or ethnological material" means any archaeological or ethnological material of the State Party which—

(A) is—

(i) covered by an agreement under this chapter that enters into force with respect to the United States, or

(ii) subject to emergency action under section 2603 of this title, and

(B) is listed by regulation under section 2604 of this title.

(8) The term "Secretary" means the Secretary of the Treasury or his delegate.

(9) The term "State Party" means any nation which has ratified, accepted, or acceded to the Convention.

(10) The term "United States" includes the several States, the District of Columbia, and any territory or area the foreign relations for which the United States is responsible.

(11) The term "United States citizen" means—

(A) any individual who is a citizen or national of the United States;

(B) any corporation, partnership, association, or other legal entity organized or existing under the laws of the United States or any State; or

(C) any department, agency, or entity of the Federal Government or of any government of any State.

§ 2602. Agreements to Implement Article 9 of the Convention.

(a) Agreement Authority.—

(1) In general.—If the President determines, after request is made to the United States under article 9 of the Convention by any State Party—

(A) that the cultural patrimony of the State Party is in jeopardy from the pillage of archaeological or ethnological materials of the State Party;

(B) that the State Party has taken measures consistent with the Convention to protect its cultural patrimony;

(C) that—

(i) the application of the import restrictions set forth in section 2606 of this title with respect to archaeological or ethnological material of the State Party, if applied in concert with similar restrictions implemented, or to be implemented within a reasonable period of time, by those nations (whether or not State Parties) individually having a significant import trade in such material, would be of substantial benefit in deterring a serious situation of pillage, and

(ii) remedies less drastic than the application of the restrictions set forth in such section are not available; and

(D) that the application of the import restrictions set forth in section 2606 of this title in the particular circumstances is consistent with the general interest of the international

community in the interchange of cultural property among nations for scientific, cultural, and educational purposes;

the President may, subject to the provisions of this chapter, take the actions described in paragraph (2).

(2) Authority of president.—For purposes of paragraph (1), the President may enter into—

(A) a bilateral agreement with the State Party to apply the import restrictions set forth in section 2606 of this title to the archaeological or ethnological material of the State Party the pillage of which is creating the jeopardy to the cultural patrimony of the State Party found to exist under paragraph (1)(A); or

(B) a multilateral agreement with the State Party and with one or more other nations (whether or not a State Party) under which the United States will apply such restrictions, and the other nations will apply similar restrictions, with respect to such material.

(3) Requests.—A request made to the United States under article 9 of the Convention by a State Party must be accompanied by a written statement of the facts known to the State Party that relate to those matters with respect to which determinations must be made under subparagraphs (A) through (D) of paragraph (1).

(4) Implementation.—In implementing this subsection, the President should endeavor to obtain the commitment of the State Party concerned to permit the exchange of its archaeological and ethnological materials under circumstances in which such exchange does not jeopardize its cultural patrimony.

(b) Effective Period.—The President may not enter into any agreement under subsection (a) of this section which has an effective period beyond the close of the five-year period beginning on the date on which such agreement enters into force with respect to the United States.

(c) Restrictions on Entering into Agreements.—

(1) In general.—The President may not enter into a bilateral or multilateral agreement authorized by subsection (a) of this section unless the application of the import restrictions set forth in section 2606 of this title with respect to archaeological or ethnological material of the State Party making a request to the United States under article 9 of the Convention will be applied in concert with similar restrictions implemented, or to be implemented, by those nations (whether or not State Parties) individually having a significant import trade in such material.

(2) Exception to restrictions.—Notwithstanding paragraph (1), the President may enter into an agreement if he determines that a nation individually having a significant import trade in such material is not implementing; or is not likely to implement; similar restrictions, but—

(A) such restrictions are not essential to deter a serious situation of pillage, and

(B) the application of the import restrictions set forth in section 2606 of this title in concert with similar restrictions implemented, or to be implemented, by other nations (whether or not State Parties) individually having a significant import trade in such material would be of substantial benefit in deterring a serious situation of pillage.

(d) Suspension of Import Restrictions Under Agreements.—If, after an agreement enters into force with respect to the United States, the President determines that a number of parties to the agreement (other than parties described in subsection (c)(2) of this section) having significant import trade in the archaeological and ethnological material covered by the agreement—

(1) have not implemented within a reasonable period of time import restrictions that are similar to those set forth in section 2606 of this title, or

(2) are not implementing such restrictions satisfactorily with the result that no substantial benefit in deterring a serious situation of pillage in the State Party concerned is being obtained,

the President shall suspend the implementation of the import restrictions under section 2606 of this title until such time as the nations take appropriate corrective action.

(e) Extension of Agreements.—The President may extend any agreement that enters into force with respect to the United States for additional periods of not more than five years each if the President determines that—

(1) the factors referred to in subsection (a)(1) of this section which justified the entering into of the agreement still pertain, and

(2) no cause for suspension under subsection (d) of this section exists.

(f) Procedures.—If any request described in subsection (a) of this section, is made by a State Party, or if the President proposes to extend any agreement under subsection (e) of this section, the President shall—

(1) publish notification of the request or proposal in the Federal Register;

(2) submit to the Committee such information regarding the request or proposal (including, if applicable, information from the State Party with respect to the implementation of emergency action under section 2603 of this title) as is appropriate to enable the Committee to carry out its duties under section 2605(f) of this title; and

(3) consider, in taking action on the request or proposal, the views and recommendations contained in any Committee report—

(A) required under section 2605(f)(1) or (2) of this title, and

(B) submitted to the President before the close of the one-hundred-and-fifty-day period beginning on the day on which the President submitted information on the request or proposal to the Committee under paragraph (2).

(g) Information on Presidential Action.—

(1) In general.—In any case in which the President—

(A) enters into or extends an agreement pursuant to subsection (a) or (e) of this section, or

(B) applies import restrictions under section 2603 of this title,

the President shall, promptly after taking such action, submit a report to the Congress.

(2) Report.—The report under paragraph (1) shall contain—

(A) a description of such action (including the text of any agreement entered into),

(B) the differences (if any) between such action and the views and recommendations contained in any Committee report which the President was required to consider, and

(C) the reasons for any such difference.

(3) Information relating to committee recommendations.—If any Committee report required to be considered by the President recommends that an agreement be entered into, but no such agreement is entered into, the President shall submit to the Congress a report which contains the reasons why such agreement was not entered into.

§ 2603. Emergency Implementation of Import Restrictions.

(a) Emergency Condition Defined.—For purposes of this section, the term "emergency condition" means, with respect to any archaeological or ethnological material of any State Party, that such material is—

(1) a newly discovered type of material which is of importance for the understanding of the history of mankind and is in jeopardy from pillage, dismantling, dispersal, or fragmentation;

(2) identifiable as coming from any site recognized to be of high cultural significance if such site

is in jeopardy from pillage, dismantling, dispersal, or fragmentation which is, or threatens to be, of crisis proportions; or

(3) a part of the remains of a particular culture or civilization, the record of which is in jeopardy from pillage, dismantling, dispersal, or fragmentation which is, or threatens to be, of crisis proportions;

and application of the import restrictions set forth in section 2606 of this title on a temporary basis would, in whole or in part, reduce the incentive for such pillage, dismantling, dispersal or fragmentation.

(b) Presidential Action.—Subject to subsection (c) of this section, if the President determines that an emergency condition applies with respect to any archaeological or ethnological material of any State Party, the President may apply the import restrictions set forth in section 2606 of this title with respect to such material.

(c) Limitations.—

(1) The President may not implement this section with respect to the archaeological or ethnological materials of any State Party unless the State Party has made a request described in section 2602(a) of this title to the United States and has supplied information which supports a determination that an emergency condition exists.

(2) In taking action under subsection (b) of this section with respect to any State Party, the President shall consider the views and recommendations contained in the Committee report required under section 2605(f)(3) of this title if the report is submitted to the President before the close of the ninety-day period beginning on the day on which the President submitted information to the Committee under section 2602(f)(2) of this title on the request of the State Party under section 2602(a) of this title.

(3) No import restrictions set forth in section 2606 of this title may be applied under this section to the archaeological or ethnological materials of any State Party for more than five years after the date on which the request of a State Party under section 2602(a) of this title is made to the United States. This period may be extended by the President for three more years if the President determines that the emergency condition continues to apply with respect to the archaeological or ethnological material. However, before taking such action, the President shall request and consider, if received within ninety days, a report of the Committee setting forth its recommendations, together with the reasons therefor, as to whether such import restrictions shall be extended.

(4) The import restrictions under this section may continue to apply in whole or in part, if before their expiration under paragraph (3), there has entered into force with respect to the archaeological or ethnological materials an agreement under section 2602 of this title or an agreement with a State Party to which the Senate has given its advice and consent to ratification. Such import restrictions may continue to apply for the duration of the agreement.

§ 2604. Designation of Materials Covered by Agreements or Emergency Actions.

After any agreement enters into force under section 2602 of this title, or emergency action is taken under section 2603 of this title, the Secretary, after consultation with the Director of the United States Information Agency, shall by regulation promulgate (and when appropriate shall revise) a list of the archaeological or ethnological material of the State Party covered by the agreement or by such action. The Secretary may list such material by type or other appropriate classification, but each listing made

under this section shall be sufficiently specific and precise to insure that (1) the import restrictions under section 2606 of this title are applied only to the archeological and ethnological material covered by the agreement or emergency action; and (2) fair notice is given to importers and other persons as to what material is subject to such restrictions.

§ 2605. Cultural Property Advisory Committee.

(a) Establishment.—There is established the Cultural Property Advisory Committee.
(b) Membership.—
 (1) The Committee shall be composed of eleven members appointed by the President as follows:
 (A) Two members representing the interests of museums.
 (B) Three members who shall be experts in the fields of archaeology, anthropology, ethnology, or related areas.
 (C) Three members who shall be experts in the international sale of archaeological, ethnological, and other cultural property.
 (D) Three members who shall represent the interest of the general public.
 (2) Appointments made under paragraph (1) shall be made in such a manner so as to insure—
 (A) fair representation of the various interests of the public sectors and the private sectors in the international exchange of archaeological and ethnological materials, and
 (B) that within such sectors, fair representation is accorded to the interests of regional and local institutions and museums.
 (3) (A) Members of the Committee shall be appointed for terms of three years and may be reappointed for one or more terms. With respect to the initial appointments, the President shall select, on a representative basis to the maximum extent practicable, four members to serve three-year terms, four members to serve two-year terms, and the remaining members to serve a one-year term. Thereafter each appointment shall be for a three-year term.
 (B) (i) A vacancy in the Committee shall be filled in the same manner as the original appointment was made and for the unexpired portion of the term, if the vacancy occurred during a term of office. Any member of the Committee may continue to serve as a member of the Committee after the expiration of his term of office until reappointed or until his successor has been appointed.
 (ii) The President shall designate a Chairman of the Committee from the members of the Committee.
(c) Expenses.—The members of the Committee shall be reimbursed for actual expenses incurred in the performance of duties for the Committee.
(d) Transaction of business.—Six of the members of the Committee shall constitute a quorum. All decisions of the Committee shall be by majority vote of the members present and voting.
(e) Staff and Administration.—
 (1) The Director of the United States Information Agency shall make available to the Committee such administrative and technical support service and assistance as it may reasonably require to carry out its activities. Upon the request of the Committee, the head of any other Federal agency may detail to the Committee, on a reimbursable basis, any of the personnel of such agency to assist the Committee in carrying out its functions, and provide such information and assistance as the Committee may reasonably require to carry out its activities.
 (2) The Committee shall meet at the call of the Director of the United States Information Agency, or when a majority of its members request a meeting in writing.

(f) Reports by Committee.—

 (1) The Committee shall, with respect to each request of a State Party referred to in section 2602(a) of this title, undertake an investigation and review with respect to matters referred to in section 2602(a)(1) of this title as they relate to the State Party or the request and shall prepare a report setting forth—

 (A) the results of such investigation and review;

 (B) its findings as to the nations individually having a significant import trade in the relevant material; and

 (C) its recommendation, together with the reasons therefor, as to whether an agreement should be entered into under section 2602(a) of this title with respect to the State Party.

 (2) The Committee shall, with respect to each agreement proposed to be extended by the President under section 2602(e) of this title, prepare a report setting forth its recommendations together with the reasons therefor, as to whether or not the agreement should be extended.

 (3) The Committee shall in each case in which the Committee finds that an emergency condition under section 2603 of this title exists prepare a report setting forth its recommendations, together with the reasons therefor, as to whether emergency action under section 2603 of this title should be implemented. If any State Party indicates in its request under section 2602(a) of this title that an emergency condition exists and the Committee finds that such a condition does not exist, the Committee shall prepare a report setting forth the reasons for such finding.

 (4) Any report prepared by the Committee which recommends the entering into or the extension of any agreement under section 2602 of this title or the implementation of emergency action under section 2603 of this title shall set forth—

 (A) such terms and conditions which it considers necessary and appropriate to include within such agreement, or apply with respect to such implementation, for purposes of carrying out the intent of the Convention; and

 (B) such archaeological or ethnological material of the State Party, specified by type or such other classification as the Committee deems appropriate, which should be covered by such agreement or action.

 (5) If any member of the Committee disagrees with respect to any matter in any report prepared under this subsection, such member may prepare a statement setting forth the reasons for such disagreement and such statement shall be appended to, and considered a part of, the report.

 (6) The Committee shall submit to the Congress and the President a copy of each report prepared by it under this subsection.

(g) Committee Review.—

 (1) In general.—The Committee shall undertake a continuing review of the effectiveness of agreements under section 2602 of this title that have entered into force with respect to the United States, and of emergency action implemented under section 2603 of this title.

 (2) Action by committee.—If the Committee finds, as a result of such review, that—

 (A) cause exists for suspending, under section 2602(d) of this title, the import restrictions imposed under an agreement;

 (B) any agreement or emergency action is not achieving the purposes for which entered into or implemented; or

 (C) changes are required to this chapter in order to implement fully the obligations of the United States under the Convention; the Committee may submit a report to the Congress

and the President setting forth its recommendations for suspending such import restrictions or for improving the effectiveness of any such agreement or emergency action or this chapter.

(h) Federal Advisory Committee Act.—The provisions of the Federal Advisory Committee Act (Public Law 92–463; 5 U.S.C. Appendix I) shall apply to the Committee except that the requirements of subsections (a) and (b) of section 10 and section 11 of such Act (relating to open meetings, public notice, public participation, and public availability of documents) shall not apply to the Committee, whenever and to the extent it is determined by the President or his designee that the disclosure of matters involved in the Committee's proceedings would compromise the Government's negotiating objectives or bargaining positions on the negotiations of any agreement authorized by this chapter.

(i) Confidential Information.—

 (1) In general.—Any information (including trade secrets and commercial or financial information which is privileged or confidential) submitted in confidence by the private sector to officers or employees of the United States or to the Committee in connection with the responsibilities of the Committee shall not be disclosed to any person other than to—

 (A) officers and employees of the United States designated by the Director of the United States Information Agency;

 (B) members of the Committee on Ways and Means of the House of Representatives and the Committee on Finance of the Senate who are designated by the chairman of either such Committee and members of the staff of either such Committee designated by the chairman for use in connection with negotiation of agreements or other activities authorized by this chapter; and

 (C) the Committee established under this chapter.

 (2) Governmental information.—Information submitted in confidence by officers or employees of the United States to the Committee shall not be disclosed other than in accordance with rules issued by the Director of the United States Information Agency, after consultation with the Committee. Such rules shall define the categories of information which require restricted or confidential handling by such Committee considering the extent to which public disclosure of such information can reasonably be expected to prejudice the interests of the United States. Such rules shall, to the maximum extent feasible, permit meaningful consultations by Committee members with persons affected by proposed agreements authorized by this chapter.

(j) No Authority to Negotiate.—Nothing contained in this section shall be construed to authorize or to permit any individual (not otherwise authorized or permitted) to participate directly in any negotiation of any agreement authorized by this chapter.

§ 2606. Import Restrictions.

(a) Documentation of Lawful Exportation.—No designated archaeological or ethnological material that is exported (whether or not such exportation is to the United States) from the State Party after the designation of such material under section 2604 of this title may be imported into the United States unless the State Party issues a certification or other documentation which certifies that such exportation was not in violation of the laws of the State Party.

(b) Customs Action in Absence of Documentation.—If the consignee of any designated archaeological or ethnological material is unable to present to the customs officer concerned at the time of making entry of such material—

(1) the certificate or other documentation of the State Party required under subsection (a) of this section; or

(2) satisfactory evidence that such material was exported from the State Party—

(A) not less than ten years before the date of such entry and that neither the person for whose account the material is imported (or any related person) contracted for or acquired an interest, directly or indirectly, in such material more than one year before that date of entry, or

(B) on or before the date on which such material was designated under section 2604 of this title,

the customs officer concerned shall refuse to release the material from customs custody and send it to a bonded warehouse or store to be held at the risk and expense of the consignee, notwithstanding any other provision of law, until such documentation or evidence is filed with such officer. If such documentation or evidence is not presented within ninety days after the date on which such material is refused release from customs custody, or such longer period as may be allowed by the Secretary for good cause shown, the material shall be subject to seizure and forfeiture. The presentation of such documentation or evidence shall not bar subsequent action under section 2609 of this title.

(c) Definition of Satisfactory Evidence.—The term "satisfactory evidence" means—

(1) for purposes of subsection (b)(2)(A) of this section—

(A) one or more declarations under oath by the importer, or the person for whose account the material is imported, stating that, to the best of his knowledge—

(i) the material was exported from the State Party not less than ten years before the date of entry into the United States, and

(ii) neither such importer or person (or any related person) contracted for or acquired an interest, directly or indirectly, in such material more than one year before the date of entry of the material; and

(B) a statement provided by the consignor, or person who sold the material to the importer, which states the date, or, if not known, his belief, that the material was exported from the State Party not less than ten years before the date of entry into the United States, and the reasons on which the statement is based; and

(2) for purposes of subsection (b)(2)(B) of this section—

(A) one or more declarations under oath by the importer or the person for whose account the material is to be imported, stating that, to the best of his knowledge, the material was exported from the State Party on or before the date such material was designated under section 2604 of this section, and

(B) a statement by the consignor or person who sold the material to the importer which states the date, or if not known, his belief, that the material was exported from the State Party on or before the date such material was designated under section 2604 of this title, and the reasons on which the statement is based.

(d) Related Persons.—For purposes of subsections (b) and (c) of this section, a person shall be treated as a related person to an importer, or to a person for whose account material is imported, if such person—

(1) is a member of the same family as the importer or person of account, including, but not limited to, membership as a brother or sister (whether by whole or half blood), spouse, ancestor, or lineal descendant;

(2) is a partner or associate with the importer or person of account in any partnership, association, or other venture; or

(3) is a corporation or other legal entity in which the importer or person of account directly or indirectly owns, controls, or holds power to vote 20 percent or more of the outstanding voting stock or shares in the entity.

§ 2607. Stolen Cultural Property.

No article of cultural property documented as appertaining to the inventory of a museum or religious or secular public monument or similar institution in any State Party which is stolen from such institution after the effective date of this chapter, or after the date of entry into force of the Convention for the State Party, whichever date is later, may be imported into the United States.

§ 2608. Temporary Disposition of Materials and Articles Subject to Title.

Pending a final determination as to whether any archaeological or ethnological material, or any article of cultural property, has been imported into the United States in violation of section 2606 of this title or section 2607 of this title, the Secretary shall, upon application by any museum or other cultural or scientific institution in the United States which is open to the public, permit such material or article to be retained at such institution if he finds that—

(1) sufficient safeguards will be taken by the institution for the protection of such material or article; and

(2) sufficient bond is posted by the institution to ensure its return to the Secretary.

§ 2609. Seizure and Forfeiture.

(a) In General.—Any designated archaeological or ethnological material or article of cultural property, as the case may be, which is imported into the United States in violation of section 2606 of this title or section 2607 of this title shall be subject to seizure and forfeiture. All provisions of law relating to seizure, forfeiture, and condemnation for violation of the customs laws shall apply to seizures and forfeitures incurred, or alleged to have been incurred, under this chapter, insofar as such provisions of law are applicable to, and not inconsistent with, the provisions of this chapter.

(b) Archaeological and Ethnological Material.—Any designated archaeological or ethnological material which is imported into the United States in violation of section 2606 of this title and which is forfeited to the United States under this chapter shall—

(1) first be offered for return to the State Party;

(2) if not returned to the State Party, be returned to a claimant with respect to whom the material was forfeited if that claimant establishes—

(A) valid title to the material,

(B) that the claimant is a bona fide purchaser for value of the material; or

(3) if not returned to the State Party under paragraph (1) or to a claimant under paragraph (2), be disposed of in the manner prescribed by law for articles forfeited for violation of the customs laws.

No return of material may be made under paragraph (1) or (2) unless the State Party or claimant, as the case may be, bears the expenses incurred incident to the return and delivery, and complies with such other requirements relating to the return as the Secretary shall prescribe.

(c) Articles of Cultural Property.—

 (1) In any action for forfeiture under this section regarding an article of cultural property imported into the United States in violation of section 2607 of this title, if the claimant establishes valid title to the article, under applicable law, as against the institution from which the article was stolen, forfeiture shall not be decreed unless the State Party to which the article is to be returned pays the claimant just compensation for the article. In any action for forfeiture under this section where the claimant does not establish such title but establishes that it purchased the article for value without knowledge or reason to believe it was stolen, forfeiture shall not be decreed unless—

 (A) the State Party to which the article is to be returned pays the claimant an amount equal to the amount which the claimant paid for the article, or

 (B) the United States establishes that such State Party, as a matter of law or reciprocity, would in similar circumstances recover and return an article stolen from an institution in the United States without requiring the payment of compensation.

 (2) Any article of cultural property which is imported into the United States in violation of section 2607 of this title and which is forfeited to the United States under this chapter shall—

 (A) first be offered for return to the State Party in whose territory is situated the institution referred to in section 2607 of this title and shall be returned if that State Party bears the expenses incident to such return and delivery and complies with such other requirements relating to the return as the Secretary prescribes; or

 (B) if not returned to such State Party, be disposed of in the manner prescribed by law for articles forfeited for violation of the customs laws.

§ 2610. Evidentiary Requirements.

Notwithstanding the provisions of section 1615 of this title, in any forfeiture proceeding brought under this chapter in which the material or article, as the case may be, is claimed by any person, the United States shall establish—

 (1) in the case of any material subject to the provisions of section 2606 of this title, that the material has been listed by the Secretary in accordance with section 2604 of this title; and

 (2) in the case of any article subject to section 2607 of this title, that the article—

 (A) is documented as appertaining to the inventory of a museum or religious or secular public monument or similar institution in a State Party, and

 (B) was stolen from such institution after the effective date of this chapter, or after the date of entry into force of the Convention for the State Party concerned, whichever date is later.

§ 2611. Certain Material and Articles Exempt from Title.

The provisions of this chapter shall not apply to—

 (1) any archaeological or ethnological material or any article of cultural property which is imported into the United States for temporary exhibition or display if such material or article is immune from seizure under judicial process pursuant to section 2459 of Title 22; or

 (2) any designated archaeological or ethnological material or any article of cultural property imported into the United States if such material or article—

 (A) has been held in the United States for a period of not less than three consecutive years by

a recognized museum or religious or secular monument or similar institution, and was purchased by that institution for value, in good faith, and without notice that such material or article was imported in violation of this chapter, but only if—

(i) the acquisition of such material or article has been reported in a publication of such institution, any regularly published newspaper or periodical with a circulation of at least fifty thousand, or a periodical or exhibition catalog which is concerned with the type of article or materials sought to be exempted from this chapter,

(ii) such material or article has been exhibited to the public for a period or periods aggregating at least one year during such three-year period, or

(iii) such article or material has been cataloged and the catalog material made available upon request to the public for at least two years during such three-year period;

(B) if subparagraph (A) does not apply, has been within the United States for a period of not less than ten consecutive years and has been exhibited for not less than five years during such period in a recognized museum or religious or secular monument or similar institution in the Unites States open to the public; or

(C) if subparagraphs (A) and (B) do not apply, has been within the United States for a period of not less than ten consecutive years and the State Party concerned has received or should have received during such period fair notice (through such adequate and accessible publication, or other means, as the Secretary shall by regulation prescribe) of its location within the United States; and

(D) if none of the preceding subparagraphs apply, has been within the United States for a period of not less than twenty consecutive years and the claimant establishes that it purchased the material or article for value without knowledge or reason to believe that it was imported in violation of law.

§ 2612. Regulations.

The Secretary shall prescribe such rules and regulations as are necessary and appropriate to carry out the provisions of this chapter.

§ 2613. Enforcement.

In the customs territory of the United States, and in the Virgin Islands, the provisions of this chapter shall be enforced by appropriate customs officers. In any other territory or area within the United States, but not within such customs territory or the Virgin Islands, such provisions shall be enforced by such persons as may be designated by the President.

Curation of Federally Owned and Administered Archaeological Collections

The regulations that appear below are discussed in Chapter IV, Section D(8)(d), which concerns the impact on museums of U.S. statutes that regulate archaeological material found on federally controlled property. These regulations appear as Part 79 of Chapter 36 of the *Code of Federal Regulations*.

PART 79—CURATION OF FEDERALLY-OWNED AND ADMINISTERED ARCHEOLOGICAL COLLECTIONS

Authority: 15 U.S.C. §§ 470aa–mm, 16 U.S.C. §§ 470, *et seq.*

§ 79.1 Purpose.

(a) The regulations in this part establish definitions, standards, procedures and guidelines to be followed by Federal agencies to preserve collections of prehistoric and historic material remains, and associated records, recovered under the authority of the Antiquities Act (16 U.S.C. §§ 431–433), the Reservoir Salvage Act (16 U.S.C. §§ 469–469c), section 110(g) of the National Historic Preservation Act (16 U.S.C. § 470h-2) or the Archeological Resources Protection Act (16 U.S.C. §§ 470aa–mm). They establish:

 (1) Procedures and guidelines to manage and preserve collections;

 (2) Terms and conditions for Federal agencies to include in contracts, memoranda, agreements or other written instruments with repositories for curatorial services;

 (3) Standards to determine when a repository has the capability to provide long-term curatorial services; and

 (4) Guidelines to provide access to, loan and otherwise use collections.

(b) The regulations in this part contain three appendices that provide additional guidance for use by the Federal Agency Official.

 (1) Appendix A to these regulations contains an example of an agreement between a Federal agency and a non-Federal owner of material remains who is donating the remains to the Federal agency.

 (2) Appendix B to these regulations contains an example of a memorandum of understanding between a Federal agency and a repository for long-term curatorial services for a federally-owned collection.

 (3) Appendix C to these regulations contains an example of an agreement between a repository and a third party for a short-term loan of a federally-owned collection (or a part thereof).

 (4) The three appendices are meant to illustrate how such agreements might appear. They should be revised according to the:

 (i) Needs of the Federal agency and any non-Federal owner;

 (ii) Nature and content of the collection; and

 (iii) Type of contract, memorandum, agreement or other written instrument being used.

 (5) When a repository has preexisting standard forms (e.g., a short-term loan form) that are consistent with the regulations in this part, those forms may be used in lieu of developing new ones.

§ 79.2 Authority.

(a) The regulations in this part are promulgated pursuant to section 101(a)(7)(A) of the National Historic Preservation Act (16 U.S.C. § 470a), which requires that the Secretary of the Interior issue regulations ensuring that significant prehistoric and historic artifacts, and associated records, recovered under the authority of section 110(g) of that Act (16 U.S.C. § 470h-2), the Reservoir Salvage Act (16 U.S.C. §§ 469–469c) and the Archeological Resources Protection Act (16 U.S.C. §§ 470aa–mm) are deposited in an institution with adequate long-term curatorial capabilities.

(b) In addition, the regulations in this part are promulgated pursuant to section 5 of the Archeological Resources Protection Act (16 U.S.C. § 470dd) which gives the Secretary of the Interior discretionary authority to promulgate regulations for the:

 (1) Exchange, where appropriate, between suitable universities, museums or other scientific or educational institutions, of archeological resources recovered from public and Indian lands under that Act; and

(2) Ultimate disposition of archeological resources recovered under that Act (16 U.S.C. §§ 470aa–mm), the Antiquities Act (16 U.S.C. §§ 431–433) or the Reservoir Salvage Act (16 U.S.C. §§ 469–469c).

(3) It further states that any exchange or ultimate disposition of resources excavated or removed from Indian lands shall be subject to the consent of the Indian or Indian tribe that owns or has jurisdiction over such lands.

§ 79.3 Applicability.

(a) The regulations in this part apply to collections, as defined in § 79.4 of this part, that are excavated or removed under the authority of the Antiquities Act (16 U.S.C. §§ 431–433), the Reservoir Salvage Act (16 U.S.C. §§ 469–469c), section 110(g) of the National Historic Preservation Act (16 U.S.C. § 470h-2) or the Archeological Resources Act (16 U.S.C. §§ 470aa–mm). Such collections generally include those that are the result of a prehistoric or historic resource survey, excavation or other study conducted in connection with a Federal action, assistance, license or permit.

(1) Material remains, as defined in § 79.4 of this part, that are excavated or removed from a prehistoric or historic resource generally are the property of the landowner.

(2) Data that are generated as a result of a prehistoric or historic resource survey, excavation or other study are recorded in associated records, as defined in § 79.4 of this part. Associated records that are prepared or assembled in connection with a Federal or federally authorized prehistoric or historic resource survey, excavation or other study are the property of the U.S. Government, regardless of the location of the resource.

(b) The regulations in this part apply to preexisting and new collections that meet the requirements of paragraph (a) of this section. However, the regulations shall not be applied in a manner that would supersede or breach material terms and conditions in any contract, grant, license, permit, memorandum, or agreement entered into by or on behalf of a Federal agency prior to the effective date of this regulation.

(c) Collections that are excavated or removed pursuant to the Antiquities Act (16 U.S.C. §§ 431–) remain subject to that Act, the Act's implementing rule (43 C.F.R. pt. 3), and the terms and conditions of the pertinent Antiquities Act permit or other approval.

(d) Collections that are excavated or removed pursuant to the Archeological Resources Protection Act (16 U.S.C. §§ 470aa–mm) remain subject to that Act, the Act's implementing rules (43 C.F.R. pt. 7, 36 C.F.R. pt. 296, 18 C.F.R. pt. 1312, and 32 C.F.R. pt. 229), and the terms and conditions of the pertinent Archeological Resources Protection Act permit or other approval.

(e) Any repository that is providing curatorial services for a collection subject to the regulations in this part must possess the capability to provide adequate long-term curatorial services, as set forth in § 79.9 of this part, to safeguard and preserve the associated records and any material remains that are deposited in the repository.

§ 79.4 Definitions.

As used for purposes of this part:

(a) *Collection* means material remains that are excavated or removed during a survey, excavation or other study of a prehistoric or historic resource, and associated records that are prepared or assembled in connection with the survey, excavation or other study.

(1) *Material remains* means artifacts, objects, specimens and other physical evidence that are excavated or removed in connection with efforts to locate, evaluate, document, study, pre-

serve or recover a prehistoric or historic resource. Classes of material remains (and illustrative examples) that may be in a collection include, but are not limited to:

(i) Components of structures and features (such as houses, mills, piers, fortifications, raceways, earthworks and mounds);

(ii) Intact or fragmentary artifacts of human manufacture (such as tools, weapons, pottery, basketry and textiles);

(iii) Intact or fragmentary natural objects used by humans (such as rock crystals, feathers and pigments);

(iv) By-products, waste products or debris resulting from the manufacture or use of man-made or natural materials (such as slag, dumps, cores and debitage);

(v) Organic material (such as vegetable and animal remains, and coprolites);

(vi) Human remains (such as bone, teeth, mummified flesh, burials and cremations);

(vii) Components of petroglyphs, pictographs, intaglios or other works of artistic or symbolic representation;

(viii) Components of shipwrecks (such as pieces of the ship's hull, rigging, armaments, apparel, tackle, contents and cargo);

(ix) Environmental and chronometric specimens (such as pollen, seeds, wood, shell, bone, charcoal, tree core samples, soil, sediment cores, obsidian, volcanic ash, and baked clay); and

(x) Paleontological specimens that are found in direct physical relationship with a prehistoric or historic resource.

(2) *Associated records* means original records (or copies thereof) that are prepared, assembled and document efforts to locate, evaluate, record, study, preserve or recover a prehistoric or historic resource. Some records such as field notes, artifact inventories and oral histories may be originals that are prepared as a result of the field work, analysis and report preparation. Other records such as deeds, survey plats, historical maps and diaries may be copies of original public or archival documents that are assembled and studied as a result of historical research. Classes of associated records (and illustrative examples) that may be in a collection include, but are not limited to:

(i) Records relating to the identification, evaluation, documentation, study, preservation or recovery of a resource (such as site forms, field notes, drawings, maps, photographs, slides, negatives, films, video and audio cassette tapes, oral histories, artifact inventories, laboratory reports, computer cards and tapes, computer disks and diskettes, printouts of computerized data, manuscripts, reports, and accession, catalog and inventory records);

(ii) Records relating to the identification of a resource using remote sensing methods and equipment (such as satellite and aerial photography and imagery, side scan sonar, magnetometers, subbottom profilers, radar and fathometers);

(iii) Public records essential to understanding the resource (such as deeds, survey plats, military and census records, birth, marriage and death certificates, immigration and naturalization papers, tax forms and reports);

(iv) Archival records essential to understanding the resource (such as historical maps, drawings and photographs, manuscripts, architectural and landscape plans, correspondence, diaries, ledgers, catalogs and receipts); and

(v) Administrative records relating to the survey, excavation or other study of the resource (such as scopes of work, requests for proposals, research proposals, con-

tracts, antiquities permits, reports, documents relating to compliance with section 106 of the National Historic Preservation Act (16 U.S.C. § 470f), and National Register of Historic Places nomination and determination of eligibility forms).

(b) *Curatorial services.* Providing curatorial services means managing and preserving a collection according to professional museum and archival practices, including, but not limited to:

(1) Inventorying, accessioning, labeling and cataloging a collection;

(2) Identifying, evaluating and documenting a collection;

(3) Storing and maintaining a collection using appropriate methods and containers, and under appropriate environmental conditions and physically secure controls;

(4) Periodically inspecting a collection and taking such actions as may be necessary to preserve it;

(5) Providing access and facilities to study a collection; and

(6) Handling, cleaning, stabilizing and conserving a collection in such a manner to preserve it.

(c) *Federal Agency Official* means any officer, employee or agent officially representing the secretary of the department or the head of any other agency or instrumentality of the United States having primary management authority over a collection that is subject to this part.

(d) *Indian lands* has the same meaning as in § -.3(e) of uniform regulations 43 C.F.R. pt. 7, 36 C.F.R. pt. 296, 18 C.F.R. pt. 1312, and 32 C.F.R. pt. 229.

(e) *Indian tribe* has the same meaning as in § -.3(f) of uniform regulations 43 C.F.R. pt. 7, 36 C.F.R. pt. 296, 18 C.F.R. pt. 1312, and 32 C.F.R. pt. 229.

(f) *Personal property* has the same meaning as in 41 C.F.R. 100–43.001–14. Collections, equipment (e.g., a specimen cabinet or exhibit case), materials and supplies are classes of personal property.

(g) *Public lands* has the same meaning as in § -.3(d) of uniform regulations 43 C.F.R. pt. 7, 36 C.F.R. pt. 296, 18 C.F.R. pt. 1312, and 32 C.F.R. pt. 229.

(h) *Qualified museum professional* means a person who possesses knowledge, experience and demonstrable competence in museum methods and techniques appropriate to the nature and content of the collection under the person's management and care, and commensurate with the person's duties and responsibilities. Standards that may be used, as appropriate, for classifying positions and for evaluating a person's qualifications include, but are not limited to, the following:

(1) The Office of Personnel Management's "Position Classification Standards for Positions under the General Schedule Classification System" (U.S. Government Printing Office, stock No. 906-028-00000-0 [1981]) are used by Federal agencies to determine appropriate occupational series and grade levels for positions in the Federal service. Occupational series most commonly associated with museum work are the museum curator series (GS/GM-1015) and the museum technician and specialist series (GS/GM-1016). Other scientific and professional series that may have collateral museum duties include, but are not limited to, the archivist series (GS/GM-1420), the archeologist series (GS/GM-193), the anthropologist series (GS/GM-190), and the historian series (GS/GM-170). In general, grades GS-9 and below are assistants and trainees while grades GS-11 and above are professionals at the full performance level. Grades GS-11 and above are determined according to the level of independent professional responsibility, degree of specialization and scholarship, and the nature, variety, complexity, type and scope of the work.

(2) The Office of Personnel Management's "Qualification Standards for Positions under the General Schedule (Handbook X-118)" (U.S. Government Printing Office, stock No. 906-030-00000-4 [1986]) establish educational, experience and training requirements for employment with the Federal Government under the various occupational series. A graduate degree in museum science or applicable subject matter, or equivalent training and experience, and three

years of professional experience are required for museum positions at grades GS-11 and above.

(3) The "Secretary of the Interior's Standards and Guidelines for Archeology and Historic Preservation" (48 FR 44716, Sept. 29, 1983) provide technical advice about archeological and historic preservation activities and methods for use by Federal, State and local Governments and others. One section presents qualification standards for a number of historic preservation professions. While no standards are presented for collections managers, museum curators or technicians, standards are presented for other professions (i.e., historians, archeologists, architectural historians, architects, and historic architects) that may have collateral museum duties.

(4) Copies of the Office of Personnel Management's standards, including subscriptions for subsequent updates, may be purchased from the Superintendent of Documents, U.S. Government Printing Office, Washington, DC 20402. Copies may be inspected at the Office of Personnel Management's Library, 1900 E Street NW, Washington, DC, at any regional or area office of the Office of Personnel Management, at any Federal Job Information Center, and at any personnel office of any Federal agency. Copies of the "Secretary of the Interior's Standards and Guidelines for Archeology and Historic Preservation" are available at no charge from the Interagency Resources Division, National Park Service, P.O. Box 37127, Washington, DC 20013-7127.

(i) *Religious remains* means material remains that the Federal Agency Official has determined are of traditional religious or sacred importance to an Indian tribe or other group because of customary use in religious rituals or spiritual activities. The Federal Agency Official makes this determination in consultation with appropriate Indian tribes or other groups.

(j) *Repository* means a facility such as a museum, archeological center, laboratory or storage facility managed by a university, college, museum, other educational or scientific institution, a Federal, State of local Government agency or Indian tribe that can provide professional, systematic and accountable curatorial services on a long-term basis.

(k) *Repository Official* means any officer, employee or agent officially representing the repository that is providing curatorial services for a collection that is subject to this part.

(l) *Tribal Official* means the chief executive officer or any officer, employee or agent officially representing the Indian tribe.

§ 79.5 Management and preservation of collections.

The Federal Agency Official is responsible for the long-term management and preservation of preexisting and new collections subject to this part. Such collections shall be placed in a repository with adequate long-term curatorial capabilities, as set forth in § 79.9 of this part, appropriate to the nature and content of the collections.

(a) *Preexisting collections.* The Federal Agency Official is responsible for ensuring that preexisting collections, meaning those collections that are placed in repositories prior to the effective date of this rule, are being properly managed and preserved. The Federal Agency Official shall identify such repositories, and review and evaluate the curatorial services that are being provided to preexisting collections. When the Federal Agency Official determines that such a repository does not have the capability to provide adequate long-term curatorial services, as set forth in § 79.9 of this part, the Federal Agency Official may either:

(1) Enter into or amend an existing contract, memorandum, agreement or other appropriate written instrument for curatorial services for the purpose of:

 (i) Identifying specific actions that shall be taken by the repository, the Federal agency or other appropriate party to eliminate the inadequacies;

 (ii) Specifying a reasonable period of time and a schedule within which the actions shall be completed; and

 (iii) Specifying any necessary funds or services that shall be provided by the repository, the Federal agency or other appropriate party to complete the actions; or

(2) Remove the collections from the repository and deposit them in another repository that can provide such services in accordance with the regulations in this part. Prior to moving any collection that is from Indian lands, the Federal Agency Official must obtain the written consent of the Indian landowner and the Indian tribe having jurisdiction over the lands.

(b) *New collections.* The Federal Agency Official shall deposit a collection in a repository upon determining that:

(1) The repository has the capability to provide adequate long-term curatorial services, as set forth in § 79.9 of this part;

(2) The repository's facilities, written curatorial policies and operating procedures are consistent with the regulations in this part;

(3) The repository has certified, in writing, that the collection shall be cared for, maintained and made accessible in accordance with the regulations in this part and any terms and conditions that are specified by the Federal Agency Official;

(4) When the collection is from Indian lands, written consent to the disposition has been obtained from the Indian landowner and the Indian tribe having jurisdiction over the lands; and

(5) The initial processing of the material remains (including appropriate cleaning, sorting, labeling, cataloging, stabilizing and packaging) has been completed, and associated records have been prepared and organized in accordance with the repository's processing and documentation procedures.

(c) *Retention of records by Federal agencies.* The Federal Agency Official shall maintain administrative records on the disposition of each collection including, but not limited to:

(1) The name and location of the repository where the collection is deposited;

(2) A copy of the contract, memorandum, agreement or other appropriate written instrument, and any subsequent amendments, between the Federal agency, the repository and any other party for curatorial services; (3) A catalog list of the contents of the collection that is deposited in the repository;

(4) A list of any other Federal personal property that is furnished to the repository as a part of the contract, memorandum, agreement or other appropriate written instrument for curatorial services;

(5) Copies of reports documenting inspections, inventories and investigations of loss, damage or destruction that are conducted pursuant to § 79.11 of this part; and

(6) Any subsequent permanent transfer of the collection (or a part thereof) to another repository.

§ 79.6 Methods to secure curatorial services.

(a) Federal agencies may secure curatorial services using a variety of methods, subject to Federal procurement and property management statutes, regulations, and any agency-specific statutes and

regulations on the management of museum collections. Methods that may be used by Federal agencies to secure curatorial services include, but are not limited to:

(1) Placing the collection in a repository that is owned, leased or otherwise operated by the Federal agency;

(2) Entering into a contract or purchase order with a repository for curatorial services;

(3) Entering into a cooperative agreement, a memorandum of understanding, a memorandum of agreement or other agreement, as appropriate, with a State, local or Indian tribal repository, a university, museum or other scientific or educational institution that operates or manages a repository, for curatorial services;

(4) Entering an interagency agreement with another Federal agency for curatorial services;

(5) Transferring the collection to another Federal agency for preservation; and

(6) For archeological activities permitted on public or Indian lands under the Archeological Resources Protection Act (16 U.S.C. §§ 470aa–mm), the Antiquities Act (16 U.S.C. §§ 431–433) or other authority, requiring the archeological permittee to provide for curatorial services as a condition to the issuance of the archeological permit.

(b) *Guidelines for selecting a repository.*

(1) When possible, the collection should be deposited in a repository that:

 (i) Is in the State of origin;

 (ii) Stores and maintains other collections from the same site or project location; or

 (iii) Houses collections from a similar geographic region or cultural area.

(2) The collection should not be subdivided and stored at more than a single repository unless such subdivision is necessary to meet special storage, conservation or research needs.

(3) Except when non-federally-owned material remains are retained and disposed of by the owner, material remains and associated records should be deposited in the same repository to maintain the integrity and research value of the collection.

(c) *Sources for technical assistance.* The Federal Agency Official should consult with persons having expertise in the management and preservation of collections prior to preparing a scope of work or a request for proposals for curatorial services. This will help ensure that the resulting contract, memorandum, agreement or other written instrument meets the needs of the collection, including any special needs in regard to any religious remains. It also will aid the Federal Agency Official in evaluating the qualifications and appropriateness of a repository, and in determining whether the repository has the capability to provide adequate long-term curatorial services for a collection. Persons, agencies, institutions and organizations that may be able to provide technical assistance include, but are not limited to the:

(1) Federal agency's Historic Preservation Officer;

(2) State Historic Preservation Officer;

(3) Tribal Historic Preservation Officer;

(4) State Archeologist;

(5) Curators, collections managers, conservators, archivists, archaeologists, historians and anthropologists in Federal and State Government agencies and Indian tribal museum;

(6) Indian tribal elders and religious leaders;

(7) Smithsonian Institution;

(8) American Association of Museums; and

(9) National Park Service.

§ 79.7 Methods to fund curatorial services.

A variety of methods are used by Federal agencies to ensure that sufficient funds are available for adequate, long-term care and maintenance of collections. Those methods include, but are not limited to, the following:

(a) Federal agencies may fund a variety of curatorial activities using monies appropriated annually by the U.S. Congress, subject to any specific statutory authorities or limitations applicable to a particular agency. As appropriate, curatorial activities that may be funded by Federal agencies include, but are not limited to:

 (1) Purchasing, constructing, leasing, renovating, upgrading, expanding, operating, and maintaining a repository that has the capability to provide adequate long-term curatorial services as set forth in § 79.9 of this part;

 (2) Entering into and maintaining on a cost-reimbursable or cost-sharing basis a contract, memorandum, agreement, or other appropriate written instrument with a repository that has the capability to provide adequate long-term curatorial services as set forth in § 79.9 of this part;

 (3) As authorized under section 110(g) of the National Historic Preservation Act (16 U.S.C. § 470h-2), reimbursing a grantee for curatorial costs paid by the grantee as a part of the grant project;

 (4) As authorized under section 110(g) of the National Historic Preservation Act (16 U.S.C. § 470h-2), reimbursing a State for curatorial costs paid by the State agency to carry out the historic preservation responsibilities of the Federal agency;

 (5) Conducting inspections and inventories in accordance with § 79.11 of this part; and

 (6) When a repository that is housing and maintaining a collection can no longer provide adequate long-term curatorial services, as set forth in § 79.9 of this part, either:

 (i) Providing such funds or services as may be agreed upon pursuant to § 79.5(a)(1) of this part to assist the repository in eliminating the deficiencies; or

 (ii) Removing the collection from the repository and depositing it in another repository that can provide curatorial services in accordance with the regulations in this part.

(b) As authorized under section 110(g) of the National Historic Preservation Act (16 U.S.C. § 470h-2) and section 208(2) of the National Historic Preservation Act Amendments (16 U.S.C. § 469c-2), for federally licensed or permitted projects or programs, Federal agencies may charge licensees and permittees reasonable costs for curatorial activities associated with identification, surveys, evaluation and data recovery as a condition to the issuance of a Federal license or permit.

(c) Federal agencies may deposit collections in a repository that agrees to provide curatorial services at no cost to the U.S. Government. This generally occurs when a collection is excavated or removed from public or Indian lands under a research permit issued pursuant to the Antiquities Act (16 U.S.C. §§ 431–433) or the Archeological Resources Protection Act (16 U.S.C. §§ 470aa–mm). A repository also may agree to provide curatorial services as a public service or as a means of ensuring direct access to a collection for long-term study and use. Federal agencies should ensure that a repository that agrees to provide curatorial services at no cost to the U.S. Government has sufficient financial resources to support its operations and any needed improvements.

(d) Funds provided to a repository for curatorial services should include costs for initially processing, cataloging and accessioning the collection as well as costs for storing, inspecting, inventorying, maintaining, and conserving the collection on a long-term basis.

(1) Funds to initially process, catalog and accession a collection to be generated during identification and evaluation surveys should be included in project planning budgets.

(2) Funds to initially process, catalog and accession a collection to be generated during data recovery operations should be included in project mitigation budgets.

(3) Funds to store, inspect, inventory, maintain and conserve a collection on a long-term basis should be included in annual operating budgets.

(e) When the Federal Agency Official determines that data recovery costs may exceed the one percent limitation contained in the Archeological and Historic Preservation Act (16 U.S.C. § 469c), as authorized under section 208(3) of the National Historic Preservation Act Amendments (16 U.S.C. § 469c-2), the limitation may be waived, in appropriate cases, after the Federal Agency Official has:

(1) Obtained the concurrence of the Secretary of the U.S. Department of the Interior by sending a written request to the Departmental Consulting Archeologist, National Park Service, P.O. Box 37127, Washington, DC 20013-7127; and

(2) Notified the Committee on Energy and Natural Resources of the U.S. Senate and the Committee on Interior and Insular Affairs of the U.S. House of Representatives.

§ 79.8 Terms and conditions to include in contracts, memoranda and agreements for curatorial services.

The Federal Agency Official shall ensure that any contract, memorandum, agreement or other appropriate written instrument for curatorial services that is entered into by or on behalf of that Official, a Repository Official and any other appropriate party contains the following:

(a) A statement that identifies the collection or group of collections to be covered and any other U.S. Government-owned personal property to be furnished to the repository;

(b) A statement that identifies who owns and has jurisdiction over the collection;

(c) A statement of work to be performed by the repository;

(d) A statement of the responsibilities of the Federal agency and any other appropriate party;

(e) When the collection is from Indian lands:

(1) A statement that the Indian landowner and the Indian tribe having jurisdiction over the lands consent to the disposition; and

(2) Such terms and conditions as may be requested by the Indian landowner and the Indian tribe having jurisdiction over the lands;

(f) When the collection is from a site on public lands that the Federal Agency Official has determined is of religious or cultural importance to any Indian tribe having aboriginal or historic ties to such lands, such terms and conditions as may have been developed pursuant to § -.7 of uniform regulations 43 C.F.R. pt. 7, 36 C.F.R. pt. 296, 18 C.F.R. pt. 1312, and 32 C.F.R. pt. 229;

(g) The term of the contract, memorandum or agreement; and procedures for modification, suspension, extension, and termination;

(h) A statement of costs associated with the contract, memorandum or agreement; the funds or services to be provided by the repository, the Federal agency and any other appropriate party; and the schedule for any payments;

(i) Any special procedures and restrictions for handling, storing, inspecting, inventorying, cleaning, conserving, and exhibiting the collection;

(j) Instructions and any terms and conditions for making the collection available for scientific, educational and religious uses, including procedures and criteria to be used by the Repository Official to

review, approve or deny, and document actions taken in response to requests for study, laboratory analysis, loan, exhibition, use in religious rituals or spiritual activities, and other uses. When the Repository Official [is] to approve consumptive uses, this should be specified; otherwise, the Federal Agency Official should review and approve consumptive uses. When the repository's existing operating procedures and criteria for evaluating requests to use collections are consistent with the regulations in this part, they may be used, after making any necessary modifications, in lieu of developing new ones;

(k) Instructions for restricting access to information relating to the nature, location and character of the prehistoric or historic resource from which the material remains are excavated or removed;

(l) A statement that copies of any publications resulting from study of the collection are to be provided to the Federal Agency Official and, when the collection is from Indian lands, to the Tribal Official and the Tribal Historic Preservation Officer, if any, of the Indian tribe that owns or has jurisdiction over such lands;

(m) A statement that specifies the frequency and methods for conducting and documenting the inspections and inventories stipulated in § 79.11 of this part;

(n) A statement that the Repository Official shall redirect any request for transfer or repatriation of a federally-owned collection (or any part thereof) to the Federal Agency Official, and redirect any request for transfer or repatriation of a federally administered collection (or any part thereof) to the Federal Agency Official and the owner;

(o) A statement that the Repository Official shall not transfer, repatriate or discard a federally-owned collection (or any part thereof) without the written permission of the Federal Agency Official, and not transfer, repatriate or discard a federally administered collection (or any part thereof) without the written permission of the Federal Agency Official and the owner;

(p) A statement that the Repository Official shall not sell the collection; and

(q) A statement that the repository shall provide curatorial services in accordance with the regulations in this part.

§ 79.9 Standards to determine when a repository possesses the capability to provide adequate long-term curatorial services.

The Federal Agency Official shall determine that a repository has the capability to provide adequate long-term curatorial services when the repository is able to:

(a) Accession, label, catalog, store, maintain, inventory and conserve the particular collection on a long-term basis using professional museum and archival practices; and

(b) Comply with the following, as appropriate to the nature and consent of the collection;

 (1) Maintain complete and accurate records of the collection, including:

 (i) Records on acquisitions;

 (ii) Catalog and artifact inventory lists;

 (iii) Descriptive information, including field notes, site forms and reports;

 (iv) Photographs, negatives and slides;

 (v) Locational information, including maps;

 (vi) Information on the condition of the collection, including any completed conservation treatments;

 (vii) Approved loans and other uses;

 (viii) Inventory and inspection records, including any environmental monitoring records;

(ix) Records on lost, deteriorated, damaged or destroyed Government property; and

(x) Records on any deaccessions and subsequent transfers, repatriations or discards, as approved by the Federal Agency Official;

(2) Dedicate the requisite facilities, equipment and space in the physical plant to properly store, study and conserve the collection. Space used for storage, study, conservation and, if exhibited, any exhibition must not be used for non-curatorial purposes that would endanger or damage the collection;

(3) Keep the collection under physically secure conditions within storage, laboratory, study and any exhibition areas by:

(i) Having the physical plant meet local electrical, fire, building, health and safety codes;

(ii) Having an appropriate and operational fire detection and suppression system;

(iii) Having an appropriate and operational intrusion detection and deterrent system;

(iv) Having an adequate emergency management plan that establishes procedures for responding to fires, floods, natural disasters, civil unrest, acts of violence, structural failures and failures of mechanical systems within the physical plant;

(v) Providing fragile or valuable items in a collection with additional security such as locking the items in a safe, vault or museum specimen cabinet, as appropriate;

(vi) Limiting and controlling access to keys, the collection and the physical plant; and

(vii) Inspecting the physical plant in accordance with § 79.11 of this part for possible security weaknesses and environmental control problems, and taking necessary actions to maintain the integrity of the collection;

(4) Require staff and any consultants who are responsible for managing and preserving the collection to be qualified museum professionals;

(5) Handle, store, clean, conserve and, if exhibited, exhibit the collection in a manner that:

(i) Is appropriate to the nature of the material remains and associated records;

(ii) Protects them from breakage and possible deterioration from adverse temperature and relative humidity, visible light, ultraviolet radiation, dust, soot, gases, mold, fungus, insects, rodents and general neglect; and

(iii) Preserves data that may be studied in future laboratory analyses. When material remains in a collection are to be treated with chemical solutions or preservatives that will permanently alter the remains, when possible, retain untreated representative samples of each affected artifact type, environmental specimen or other category of material remains to be treated. Untreated samples should not be stabilized or conserved beyond dry brushing;

(6) Store site forms, field notes, artifacts inventory lists, computer disks and tapes, catalog forms and a copy of the final report in a manner that will protect them from theft and fire such as:

(i) Storing the records in an appropriate insulated, fire resistant, locking cabinet, safe, vault or other container, or in a location with a fire suppression system;

(ii) Storing a duplicate set of records in a separate location; or

(iii) Ensuring that records are maintained and accessible through another party. For example, copies of final reports and site forms frequently are maintained by the State Historic Preservation Officer, the State Archeologist or the State museum or university. The Tribal Historic Preservation Officer and Indian tribal museum ordinarily maintain records on collections recovered from sites located on Indian

lands. The National Technical Information Service and the Defense Technical Information Service maintain copies of final reports that have been deposited by Federal agencies. The National Archeological Database maintains summary information on archeological reports and projects, including information on the location of those reports.

(7) Inspect the collection in accordance with § 79.11 of this part for possible deterioration and damage, and perform only those actions as are absolutely necessary to stabilize the collection and rid it of any agents of deterioration;

(8) Conduct inventories in accordance with § 79.11 of this part to verify the location of the material remains, associated records and any other Federal personal property that is furnished to the repository; and

(9) Provide access to the collection in accordance with § 79.10 of this part.

§ 79.10 Use of collections.

(a) The Federal Agency Official shall ensure that the Repository Official makes the collection available for scientific, educational and religious uses, subject to such terms and conditions as are necessary to protect and preserve the condition, research potential, religious or sacred importance, and uniqueness of the collection.

(b) *Scientific and educational uses.* A collection shall be made available to qualified professionals for study, loan and use for such purposes as in-house and traveling exhibits, teaching, public interpretation, scientific analysis and scholarly research. Qualified professionals would include, but not be limited to, curators, conservators, collection managers, exhibitors, researchers, scholars, archeological contractors and educators. Students may use a collection when under the direction of a qualified professional. Any resulting exhibits and publications shall acknowledge the repository as the curatorial facility and the Federal agency as the owner or administrator, as appropriate. When the collection is from Indian lands and the Indian landowner and the Indian tribe having jurisdiction over the lands wish to be identified, those individuals and the Indian tribe shall also be acknowledged. Copies of any resulting publications shall be provided to the Repository Official and the Federal Agency Official. When Indian lands are involved, copies of such publications shall also be provided to the Tribal Official and the Tribal Historic Preservation Officer, if any, of the Indian tribe that owns or has jurisdiction over such lands.

(c) *Religious uses.* Religious remains in a collection shall be made available to persons for use in religious rituals or spiritual activities. Religious remains generally are of interest to medicine men and women, and other religious practitioners and persons from Indian tribes, Alaskan Native corporations, Native Hawaiians, and other indigenous and immigrant ethnic, social and religious groups that have aboriginal or historic ties to the lands from which the remains are recovered, and have traditionally used the remains or class of remains in religious rituals or spiritual activities.

(d) *Terms and conditions.*

(1) In accordance with section 9 of the Archeological Resources Protection Act (16 U.S.C. § 470hh) and section 304 of the National Historic Preservation Act (16 U.S.C. § 470w-3), the Federal Agency Official shall restrict access to associated records that contain information relating to the nature, location or character of a prehistoric or historic resource unless the Federal Agency Official determines that such disclosure would not create a risk of harm, theft or destruction to the resource or to the area or place where the resource is located.

(2) Section -.18(a)(2) of uniform regulations 43 C.F.R. pt. 7, 36 C.F.R. pt. 296, 18 C.F.R. pt. 1312, and 32 C.F.R. pt. 229 sets forth procedures whereby information relating to the nature, location or character of a prehistoric or historic resource may be made available to the Governor of any State. The Federal Agency Official may make information available to other persons who, following the procedures in § -.18(a)(2) of the referenced uniform regulations, demonstrate that the disclosure will not create a risk of harm, theft or destruction to the resource or to the area or place where the resource is located. Other persons generally would include, but not be limited to, archeological contractors, researchers, scholars, tribal representatives, Federal, State and local agency personnel, and other persons who are studying the resource or class [of] resources.

(3) When a collection is from Indian lands, the Federal Agency Official shall place such terms and conditions as may be requested by the Indian landowner and the Indian tribe having jurisdiction over the lands on:

(i) Scientific, educational or religious uses of material remains; and

(ii) Access to associated records that contain information relating to the nature, location or character of the resource.

(4) When a collection is from a site on public lands that the Federal Agency Official has determined is of religious or cultural importance to any Indian tribe having aboriginal or historic ties to such lands, the Federal Agency Official shall place such terms and conditions as may have been developed pursuant to § -.7 of uniform regulations 43 C.F.R. pt. 7, 36 C.F.R. pt. 296, 18 C.F.R. pt. 1312, and 32 C.F.R. pt. 229 on:

(i) Scientific, educational or religious uses of material remains; and

(ii) Access to associated records that contain information relating to the nature, location or character of the resource.

(5) The Federal Agency Official shall not allow uses that would alter, damage or destroy an object in a collection unless the Federal Agency Official determines that such use is necessary for scientific studies or public interpretation, and the potential gain in scientific or interpretive information outweighs the potential loss of the object. When possible, such use should be limited to unprovenienced, nonunique, nonfragile objects, or to a sample of objects drawn from a larger collection of similar objects.

(e) No collection (or a part thereof) shall be loaned to any person without a written agreement between the Repository Official and the borrower that specifies the terms and conditions of the loan. Appendix C to the regulations in this part contains an example of a short-term loan agreement for a federally-owned collection. At a minimum, a loan agreement shall specify:

(1) The collection or object being loaned;

(2) The purpose of the loan;

(3) The length of the loan;

(4) Any restrictions on scientific, educational or religious uses, including whether any object may be altered, damaged or destroyed;

(5) Except as provided in paragraph (e)(4) of this section, that the borrower shall handle the collection or object being borrowed during the term of the loan in accordance with this part so as not to damage or reduce its scientific, educational, religious or cultural value; and

(6) Any requirements for insuring the collection or object being borrowed for any loss, damage or destruction during transit and while in the borrower's possession.

(f) The Federal Agency Official shall ensure that the Repository Official maintains administrative

records that document approved scientific, educational and religious uses of the collection.

(g) The Repository Official may charge persons who study, borrow or use a collection (or a part thereof) reasonable fees to cover costs for handling, packing, shipping and insuring material remains, for photocopying associated records, and for other related incidental costs.

§ 79.11 Conduct of inspections and inventories.

(a) The inspections and inventories specified in this section shall be conducted periodically in accordance with the Federal Property and Administrative Services Act (40 U.S.C. § 484), its implementing regulation (41 C.F.R. pt. 101), any agency-specific regulations on the management of Federal property, and any agency-specific statutes and regulations on the management of museum collections.

(b) Consistent with paragraph (a) of this section, the Federal Agency Official shall ensure that the Repository Official:

(1) Provides the Federal Agency Official and, when the collection is from Indian lands, the Indian landowner and the Tribal Official of the Indian tribe that has jurisdiction over the lands with a copy of the catalog list of the contents of the collection received and accessioned by the repository;

(2) Provides the Federal Agency Official with a list of any other U.S. Government-owned personal property received by the repository;

(3) Periodically inspects the physical plant for the purpose of monitoring the physical security and environmental control measures;

(4) Periodically inspects the collection for the purposes of assessing the condition of the material remains and associated records, and of monitoring those remains and records for possible deterioration and damage;

(5) Periodically inventories the collection by accession, lot or catalog record for the purpose of verifying the location of the material remains and associated records;

(6) Periodically inventories any other U.S. Government-owned personal property in the possession of the repository;

(7) Has qualified museum professionals conduct the inspections and inventories;

(8) Following each inspection and inventory, prepares and provides the Federal Agency Official with a written report of the results of the inspection and inventory, including the status of the collection, treatments completed and recommendations for additional treatments. When the collection is from Indian lands, the Indian landowner and the Tribal Official of the Indian tribe that has jurisdiction over the lands shall also be provided with a copy of the report;

(9) Within five (5) days of the discovery of any loss or theft of, deterioration and damage to, or destruction of the collection (or a part thereof) or any other U.S. Government-owned personal property, prepares and provides the Federal Agency Official with a written notification of the circumstances surrounding the loss, theft, deterioration, damage or destruction. When the collection is from Indian lands, the Indian landowner and the Tribal Official and the Indian tribe that has jurisdiction over the lands shall also be provided with a copy of the notification; and

(10) Makes the repository, the collection and any other U.S. Government-owned personal property available for periodic inspection by the:

(i) Federal Agency Official;

(ii) When the collection is from Indian lands, the Indian landowner and the Tribal

Official of the Indian tribe that has jurisdiction over the lands; and

(iii) When the collection contains religious remains, the Indian tribal elders, religious leaders and other officials representing the Indian tribe or other group for which the remains have religious or sacred importance.

(c) Consistent with paragraph (a) of this section, the Federal Agency Official shall have qualified Federal agency professionals:

(1) Investigate reports of a lost, stolen, deteriorated, damaged or destroyed collection (or a part thereof) or any other U.S. Government-owned personal property; and

(2) Periodically inspect the repository, the collection and any other U.S. Government-owned personal property for the purposes of:

(i) Determining whether the repository is in compliance with the minimum standards set forth in § 79.9 of this part; and

(ii) Evaluating the performance of the repository in providing curatorial services under any contract, memorandum, agreement or other appropriate written instrument.

(d) The frequency and methods for conducting and documenting inspections and inventories stipulated in this section shall be mutually agreed upon, in writing, by the Federal Agency Official and the Repository Official, and be appropriate to the nature and content of the collection:

(1) Collections from Indian lands shall be inspected and inventoried in accordance with such terms and conditions as may be requested by the Indian landowner and the Indian tribe having jurisdiction over the lands.

(2) Religious remains in collections from public lands shall be inspected and inventoried in accordance with such terms and conditions as may have been developed pursuant to § -.7 of uniform regulations 43 C.F.R. pt. 7, 36 C.F.R. pt. 296, 18 C.F.R. pt. 1312, and 32 C.F.R. pt. 229.

(3) Material remains and records of a fragile or perishable nature should be inspected for deterioration and damage on a more frequent basis than lithic or more stable remains or records.

(4) Because frequent handling will accelerate the breakdown of fragile materials, material remains and records should be viewed but handled as little as possible during inspections and inventories.

(5) Material remains and records of a valuable nature should be inventoried on a more frequent basis than other less valuable remains or records.

(6) Persons such as those listed in § 79.6(c) of this part who have expertise in the management and preservation of similar collections should be able to provide advice to the Federal Agency Official concerning the appropriate frequency and methods for conducting inspections and inventories of a particular collection.

(e) Consistent with the Single Audit Act (31 U.S.C. § 75), when two or more Federal agencies deposit collections in the same repository, the Federal Agency Officials should enter into an interagency agreement for the purposes of:

(1) Requesting the Repository Official to coordinate the inspections and inventories, stipulated in paragraph (b) of this section, for each of the collections;

(2) Designating one or more qualified Federal agency professionals to:

(i) Conduct inspections, stipulated in paragraph (c)(2) of this section, on behalf of the other agencies; and

(ii) Following each inspection, prepare and distribute to each Federal Agency Official a written report of findings, including an evaluation of performance and recommendations to correct any deficiencies and resolve any problems that were identified. When the collection is from Indian lands, the Indian landowner and the Tribal Official of

the Indian tribe that has jurisdiction over the lands shall also be provided with a copy of the report; and

(3) Ensuring consistency in the conduct of inspections and inventories conducted pursuant to this section.

Appendix A to Part 79—Example of a Deed of Gift.

<div style="text-align:center">

DEED OF GIFT TO THE

(Name of the Federal agency)
</div>

Whereas, the (name of the Federal agency), hereinafter called the Recipient, is dedicated to the preservation and protection of artifacts, specimens and associated records that are generated in connection with its projects and programs;

Whereas, certain artifacts and specimens, listed in Attachment A to this Deed of Gift, were recovered from the (name of the prehistoric or historic resource) site in connection with the Recipient's (name of the Recipient's project) project;

Whereas, the (name of the prehistoric or historic resource) site is located on lands to which title is held by (name of the donor), hereinafter called the Donor, and that the Donor holds free and clear title to the artifacts and specimens; and

Whereas, the Donor is desirous of donating the artifacts and specimens to the Recipient to ensure their continued preservation and protection;

Now therefore, the Donor does hereby unconditionally donate to the Recipient, for unrestricted use, the artifacts and specimens listed in Attachment A to this Deed of Gift; and The Recipient hereby gratefully acknowledges the receipt of the artifacts and specimens.

Signed: (signature of the Donor)

Date: (date)

Signed: (signature of the Federal Agency Official)

Date: (date)

Attachment A: Inventory of Artifacts and Specimens

Appendix B to Part 79—Example of a Memorandum of Understanding for Curatorial Services for a Federally-Owned Collection.

<div style="text-align:center">

MEMORANDUM OF UNDERSTANDING FOR
CURATORIAL SERVICES BETWEEN THE
(Name of the Federal agency)
AND THE
(Name of the Repository)
</div>

This Memorandum of Understanding is entered into this (day) day of (month and year), between the United States of America, acting by and through the (name of the Federal agency), hereinafter called the Depositor, and the (name of the Repository), hereinafter called the Repository, in the State of (name of the State).

The Parties do witnesseth that,

Whereas, the Depositor has the responsibility under Federal law to preserve for future use certain collections of archeological artifacts, specimens and associated records, herein called the Collec-

tion, listed in Attachment A which is attached hereto and made a part hereof, and is desirous of obtaining curatorial services; and

Whereas, the Repository is desirous of obtaining, housing and maintaining the Collection, and recognizes the benefits which will accrue to it, the public and scientific interests, by housing and maintaining the Collection for study and other educational purposes; and

Whereas, the Parties hereto recognize the Federal Government's continued ownership and control over the Collection and any other U.S. Government-owned personal property, listed in Attachment B which is attached hereto and made a part hereof, provided to the Repository, and the Federal Government's responsibility to ensure that the Collection is suitably managed and preserved for the public good; and

Whereas, the Parties hereto recognize the mutual benefits to be derived by having the Collection suitably housed and maintained by the Repository;

Now therefore, the Parties do mutually agree as follows:

1. The Repository shall:

 a. Provide for the professional care and management of the Collection from the (names of the prehistoric and historic resources) sites, assigned (list site numbers) site numbers. The collections were recovered in connection with the (name of the Federal or federally-authorized project) project, located in (name of the nearest city or town), (name of the county) county, in the State of (name of the State).

 b. Perform all work necessary to protect the Collection in accordance with the regulation 36 C.F.R. pt. 79 for the curation of federally-owned and administered archeological collections and the terms and conditions stipulated in Attachment C to this Memorandum.

 c. Assign as the Curator, the Collections Manager and the Conservator having responsibility for the work under this Memorandum, persons who are qualified museum professionals and whose expertise is appropriate to the nature and content of the Collection.

 d. Begin all work on or about (month, date and year) and continue for a period of (number of years) years or until sooner terminated or revoked in accordance with the terms set forth herein.

 e. Provide and maintain a repository facility having requisite equipment, space and adequate safeguards for the physical security and controlled environment for the Collection and any other U.S. Government-owned personal property in the possession of the Repository.

 f. Not in any way adversely alter or deface any of the Collection except as may be absolutely necessary in the course of stabilization, conservation, scientific study, analysis and research. Any activity that will involve the intentional destruction of any of the Collection must be approved in advance and in writing by the Depositor.

 g. Annually inspect the facilities, the Collection and any other U.S. Government-owned personal property. Every (number of years) years inventory the Collection and any other U.S. Government-owned personal property. Perform only those conservation treatments as are absolutely necessary to ensure the physical stability and integrity of the Collection, and report the results of inventories, inspections and treatments to the Depositor.

 h. Within five (5) days of discovery, report all instances of and circumstances surrounding loss of, deterioration and damage to, or destruction of the Collection and any other U.S. Government-owned personal property to the Depositor, and those actions taken to stabilize the Collection and to correct any deficiencies in the physical plant or operating procedures that may have contributed to the loss, deterioration, damage or destruction. Any actions

that will involve the repair and restoration of any of the Collection and any other U.S. Government-owned personal property must be approved in advance and in writing by the Depositor.

 i. Review and approve or deny requests for access to or short-term loan of the Collection (or a part thereof) for scientific, educational or religious uses in accordance with the regulation 36 C.F.R. pt. 79 for the curation of federally-owned and administered archeological collections and the terms and conditions stipulated in Attachment C of this Memorandum. In addition, refer requests for consumptive uses of the Collection (or a part thereof) to the Depositor for approval or denial.

 j. Not mortgage, pledge, assign, repatriate, transfer, exchange, give, sublet, discard or part with possession of any of the Collection or any other U.S. Government-owned personal property in any manner to any third party either directly or indirectly without the prior written permission of the Depositor, and redirect any such request to the Depositor for response. In addition, not take any action whereby any of the Collection or any other U.S. Government-owned personal property shall or may be encumbered, seized, taken in execution, sold, attached, lost, stolen, destroyed or damaged.

2. The Depositor shall:

 a. On or about (month, date and year), deliver or cause to be delivered to the Repository the Collection, as described in Attachment A, and any other U.S. Government-owned personal property, as described in Attachment B.

 b. Assign as the Depositor's Representative having full authority with regard to this Memorandum, a person who meets pertinent professional qualifications.

 c. Every (number of years) years, jointly with the Repository's designated representative, have the Depositor's Representative inspect and inventory the Collection and any other U.S. Government-owned personal property, and inspect the repository facility.

 d. Review and approve or deny requests for consumptively using the Collection (or a part thereof).

3. Removal of all or any portion of the Collection from the premises of the Repository for scientific, educational or religious purposes may be allowed only in accordance with the regulation 36 C.F.R. pt. 79 for the curation of federally-owned and administered archeological collections; the terms and conditions stipulated in Attachment C to this Memorandum; any conditions for handling, packaging and transporting the Collection; and other conditions that may be specified by the Repository to prevent breakage, deterioration and contamination.

4. The Collection or portions thereof may be exhibited, photographed or otherwise reproduced and studied in accordance with the terms and conditions stipulated in Attachment C to this Memorandum. All exhibits, reproductions and studies shall credit the Depositor, and read as follows: "Courtesy of the (name of the Federal agency)." The Repository agrees to provide the Depositor with copies of any resulting publications.

5. The Repository shall maintain complete and accurate records of the Collection and any other U.S. Government-owned personal property, including information on the study, use, loan and location of said Collection which has been removed from the premises of the Repository.

6. Upon execution by both parties, this Memorandum of Understanding shall be effective on this (day) day of (month and year), and shall remain in effect for (number of years) years, at which time it will be reviewed, revised, as necessary, and reaffirmed or terminated. This Memorandum may be revised or extended by mutual consent of both parties, or by issuance of a written amendment signed and dated by both parties. Either party may terminate this

Memorandum by providing 90 days' written notice. Upon termination, the Repository shall return such Collection and any other U.S. Government-owned personal property to the destination directed by the Depositor and in such manner to preclude breakage, loss, deterioration and contamination during handling, packaging and shipping, and in accordance with other conditions specified in writing by the Depositor. If the Repository terminates, or is in default of, this Memorandum, the Repository shall fund the packaging and transportation costs. If the Depositor terminates this Memorandum, the Depositor shall fund the packaging and transportation costs.

7. Title to the Collection being cared for and maintained under this Memorandum lies with the Federal Government.

In witness whereof, the Parties hereto have executed this Memorandum.

Signed: (signature of the Federal Agency Official)

Date: (date)

Signed: (signature of the Repository Official)

Date: (date)

Attachment A: Inventory of the Collection

Attachment B: Inventory of any other U.S. Government-owned Personal Property

Attachment C: Terms and Conditions Required by the Depositor

Appendix C to Part 79—Example of a Short-Term Loan Agreement for a Federally-Owned Collection.

<div align="center">

SHORT-TERM LOAN AGREEMENT

BETWEEN THE

(Name of the Repository)

AND THE

(Name of the Borrower)

</div>

The (name of the Repository), hereinafter called the Repository, agrees to loan to (name of the Borrower), hereinafter called the Borrower, certain artifacts, specimens and associated records, listed in Attachment A, which were collected from the (name of the prehistoric or historic resource) site which is assigned (list site number) site number. The collection was recovered in connection with the (name of the Federal or federally authorized project) project, located in (name of the nearest city or town), (name of the county) county in the State of (name of the State). The Collection is the property of the U.S. Government.

The artifacts, specimens and associated records are being loaned for the purpose of (cite the purpose of the loan), beginning on (month, day and year) and ending on (month, day and year).

During the term of the loan, the Borrower agrees to handle, package and ship or transport the Collection in a manner that protects it from breakage, loss, deterioration and contamination, in conformance with the regulation 36 C.F.R. pt. 79 for the curation of federally-owned and administered archeological collections and the terms and conditions stipulated in Attachment B to this loan agreement.

The Borrower agrees to assume full responsibility for insuring the Collection or for providing funds for the repair or replacement of objects that are damaged or lost during transit and while in

the Borrower's possession. Within five (5) days of discovery, the Borrower will notify the Repository of instances and circumstances surrounding any loss of, deterioration and damage to, or destruction of the Collection and will, at the direction of the Repository, take steps to conserve damaged materials.

The Borrower agrees to acknowledge and credit the U.S. Government and the Repository in any exhibits or publications resulting from the loan. The credit line shall read as follows: "Courtesy of the (names of the Federal agency and the Repository)." The Borrower agrees to provide the Repository and the (name of the Federal agency) with copies of any resulting publications. Upon termination of this agreement, the Borrower agrees to properly package and ship or transport the Collection to the Repository. Either party may terminate this agreement, effective not less than (number of days) days after receipt by the other party of written notice, without further liability to either party.

Signed: (signature of the Repository Official)
Date: (date)
Signed: (signature of the Borrower)
Date: (date)
Attachment A: Inventory of the Objects being Loaned
Attachment B: Terms and Conditions of the Loan

22 U.S.C. § 2459

Immunity from Seizure Statute

§ 2459. Immunity from Seizure Under Judicial Process of Cultural Objects Imported for Temporary Exhibition or Display

(a) Agreements; Presidential determination; publication in Federal Register

WHENEVER any work of art or other object of cultural significance is imported into the United States from any foreign country, pursuant to an agreement entered into between the foreign owner or custodian thereof and the United States or one or more cultural or educational institutions within the United States providing for the temporary exhibition or display thereof within the United States at any cultural exhibition, assembly, activity, or festival administered, operated, or sponsored, without profit, by any such cultural or educational institution, no court of the United States, any State, the District of Columbia, or any territory or possession of the United States may issue or enforce any judicial process, or enter any judgment, decree, or order, for the purpose or having the effect of depriving such institution, or any carrier engaged in transporting such work or object within the United States, of custody or control of such object if before the importation of such object the President or his designee has determined that such object is of cultural significance and that the temporary exhibition or display thereof within the United States is in the national interest, and a notice to that effect has been published in the Federal Register.

(b) Intervention of United States attorney in pending judicial proceedings

If in any judicial proceeding in any such court any such process, judgment, decree, or order is sought, issued, or entered, the United States attorney for the judicial district within which such proceeding is pending shall be entitled as of right to intervene as a party to that proceeding, and upon request made by either the institution adversely affected, or upon direction by the Attorney General if the United States is adversely affected, shall apply to such court for the denial, quashing, or vacating thereof.

(c) Enforcement of agreements and obligations of carriers under transportation contracts

Nothing contained in this section shall preclude (1) any judicial action for or in aid of the enforcement of the terms of any such agreement or the enforcement of the obligation of any carrier under any contract for the transportation of any such object of cultural significance; or (2) the institution or prosecution by or on behalf of any such institution or the United States of any action for or in aid of the fulfillment of any obligation assumed by such institution or the United States pursuant to any such agreement.

EXECUTIVE ORDERS
EXECUTIVE ORDER NO. 11312

Ex. Ord. No. 11312, Oct. 14, 1966, 31 F.R. 13415, formerly set out as a note under this section, which related to the delegation of functions to the Secretary of State, was revoked by Ex. Ord. No. 12047, Mar. 27, 1978, 43 F.R. 13359, set out under this section.

EXECUTIVE ORDER NO. 12047
< Mar. 27, 1978, 43 F.R. 13359, as amended by Ex. Ord. No. 12388, Oct. 14, 1982, 47 F.R. 46245 >

IMPORTED OBJECTS OF CULTURAL SIGNIFICANCE

By virtue of the authority vested in me by the Act of October 19, 1965, entitled "An Act to render immune from seizure under judicial process certain objects of cultural significance imported into the United States for temporary display or exhibition, and for other purposes" (79 Stat. 985, 22 U.S.C. § 2459) [this section], and as President of the United States of America, it is hereby ordered as follows:

Section 1. The Director of the United States information Agency is designated and empowered to perform the functions conferred upon the President by the above-mentioned Act and shall be deemed to be authorized, without the approval, ratification, or other action of the President, (1) to determine that any work of art or other object to be imported into the United States within the meaning of the Act is of cultural significance, (2) to determine that the temporary exhibition or display of any such work of art or other object in the United States is in the national interest, and (3) to cause public notices of the determinations referred to above to be published in the Federal Register.

Sec. 2. The Director of the United States Information Agency, in carrying out this Order, shall consult with the Secretary of State with respect to the determination of national interest, and may consult with the Secretary of the Smithsonian Institution, the Director of the National Gallery of Art, and with such other officers and agencies of the Government as may be appropriate, with respect to the determination of cultural significance.

Sec. 3. The Director of the United States Information Agency is authorized to delegate within the Agency the functions conferred upon him by this Order.

Sec. 4. Executive Order No. 11312 of October 14, 1966 is revoked.

Sec. 5. Any order, regulation, determination or other action which was in effect pursuant to the provisions of Executive Order No. 11312 shall remain in effect until changed pursuant to the authority provided in this Order.

Sec. 6. This Order shall be effective on April 1, 1978.

CROSS REFERENCES

Exemption from provisions of Convention on Cultural Property Implementation Act, see 19 U.S.C. § 2611.

Public Law 94–158

Arts and Artifacts Indemnity Act, as Amended

UNITED STATES CODE ANNOTATED
TITLE 20. EDUCATION
CHAPTER 26A—INDEMNITY FOR EXHIBITIONS OF ARTS AND ARTIFACTS
Current through P.L. 104–150, approved 6-3-96

§ 971. Agreements to Indemnify Against Loss or Damage.

(a) Authorization of Federal Council on the Arts and Humanities.—The Federal Council on the Arts and Humanities (hereinafter in this chapter referred to as the "Council"), established under section 958 of this title, is authorized to make agreements to indemnify against loss or damage such items as may be eligible for such indemnity agreements under section 972 of this title—

(1) in accordance with the provisions of this chapter; and

(2) on such terms and conditions as the Council shall prescribe, by regulation, in order to achieve the purposes of this chapter and, consistent with such purposes, to protect the financial interest of the United States.

(b) Council as "agency"—

(1) For purposes of this chapter, the Council shall be an "agency" within the meaning of the appropriate definitions of such term in Title 5.

(2) For purposes of this chapter, the Secretary of the Smithsonian Institution, the Director of the National Gallery of Art, the member designated by the Chairman of the Senate Commission of Art and Antiquities and the member designated by the Speaker of the House of Representatives shall not serve as members of the Council.

§ 972. Items Eligible for Indemnity Agreements.

(a) Works of art; printed or published materials; other artifacts or objects; photographs, motion pictures, or tapes The Council may make an indemnity agreement under this chapter with respect to—

(1) works of art, including tapestries, paintings, sculpture, folk art, graphics, and craft arts;

(2) manuscripts, rare documents, books, and other printed or published materials;

(3) other artifacts or objects; and

(4) photographs, motion pictures, or audio and video tape; which are (A) of educational, cultural, historical, or scientific value, and (B) the exhibition of which is certified by the Director of the United States Information Agency or his designee as being in the national interest.

(b) Extension of coverage; "on exhibition" defined—

(1) An indemnity agreement made under this chapter shall cover eligible items while on exhibition in the United States or elsewhere preferably when part of an exchange of exhibitions.

(2) For purposes of this subsection, the term "on exhibition" includes that period of time beginning on the date the eligible items leave the premises of the lender or place designated by the lender and ending on the date such items are returned to the premises of the lender or place designated by the lender.

§ 973. Application for Indemnity Agreements.

(a) Parties—Any person, nonprofit agency, institution, or government desiring to make an indemnity agreement for eligible items under this chapter shall make application therefor in accordance with such procedures, in such form, and in such manner as the Council shall, by regulation, prescribe.

(b) Contents—An application under subsection (a) of this section shall—

(1) describe each item to be covered by the agreement (including an estimated value of such item);

(2) show evidence that the items are eligible under section 972(a) of this title; and

(3) set forth policies, procedures, techniques, and methods with respect to preparation for, and conduct of, exhibition of the items, and any transportation related to such items.

(c) Approval—Upon receipt of an application under this section, the Council shall, if such application conforms with the requirements of this chapter, approve the application and make an indemnity agreement with the applicant. Upon such approval, the agreement shall constitute a contract between the Council and the applicant pledging the full faith and credit of the United States to pay any amount for which the Council becomes liable under such agreement. The Council, for such purpose, is hereby authorized to pledge the full faith and credit of the United States.

§ 974. Indemnity Limits.

(a) Approval of estimated values—Upon receipt of an application meeting the requirements of subsections (a) and (b) of section 973 of this title, the Council shall review the estimated value of the items for which coverage by an indemnity agreement is sought. If the Council agrees with such estimated value, for the purposes of this chapter, the Council shall, after approval of the application as provided in subsection (c) of section 973 of this title, make an indemnity agreement.

(b) Maximum limits of coverage—The aggregate of loss or damage covered by indemnity agreements made under this chapter shall not exceed $3,000,000,000 at any one time.

(c) Limit for single exhibition—No indemnity agreement for a single exhibition shall cover loss or damage in excess of $300,000,000.

(d) Deductible limit—If the estimated value of the items covered by an indemnity agreement for a single exhibition is—

(1) $2,000,000 or less, then coverage under this chapter shall extend only to loss or damage in excess of the first $15,000 of loss or damage to items covered;

(2) more than $2,000,000 but less than $10,000,000, then coverage under this chapter shall extend only to loss or damage in excess of the first $25,000 of loss or damage to items covered;

(3) not less than $10,000,000 but less than $125,000,000, then coverage under this chapter shall extend to loss or damage in excess of the first $50,000 of loss or damage to items covered; and

(4) not less than $125,000,000 but less than $200,000,000 then coverage under this chapter shall extend to loss or damage in excess of the first $100,000 of loss or damage to items covered; or

(5) $200,000,000 or more, then coverage under this chapter shall extend only to loss or damage in excess of the first $200,000 of loss or damage to items covered.

§ 975. Claims for Losses.

(a) Regulations for prompt adjustment—The Council shall prescribe regulations providing for prompt adjustment of valid claims for losses which are covered by an agreement made pursuant to section 974 of this title, including provision for arbitration of issues relating to the dollar value of damages involving less than total loss or destruction of such covered objects.

(b) Certification—In the case of a claim of loss with respect to an item which is covered by an agreement made pursuant to section 974 of this title, the Council shall certify the validity of the claim and the amount of the loss to the Speaker of the House of Representatives and the President pro tempore of the Senate.

§ 976. Authorization of Appropriations.

There are hereby authorized to be appropriated such sums as may be necessary (1) to enable the Council to carry out its functions under this chapter, and (2) to pay claims certified pursuant to section 975(b) of this title.

§ 977. Annual Report to Congress.

The Council shall report annually to the Congress (1) all claims actually paid pursuant to this chapter during the preceding fiscal year, (2) pending claims against the Council under this chapter as of the close of that fiscal year, and (3) the aggregate face value of contracts entered into by the Council which are outstanding at the close of that fiscal year.

Index